PIERRE GOUTHIÈRE

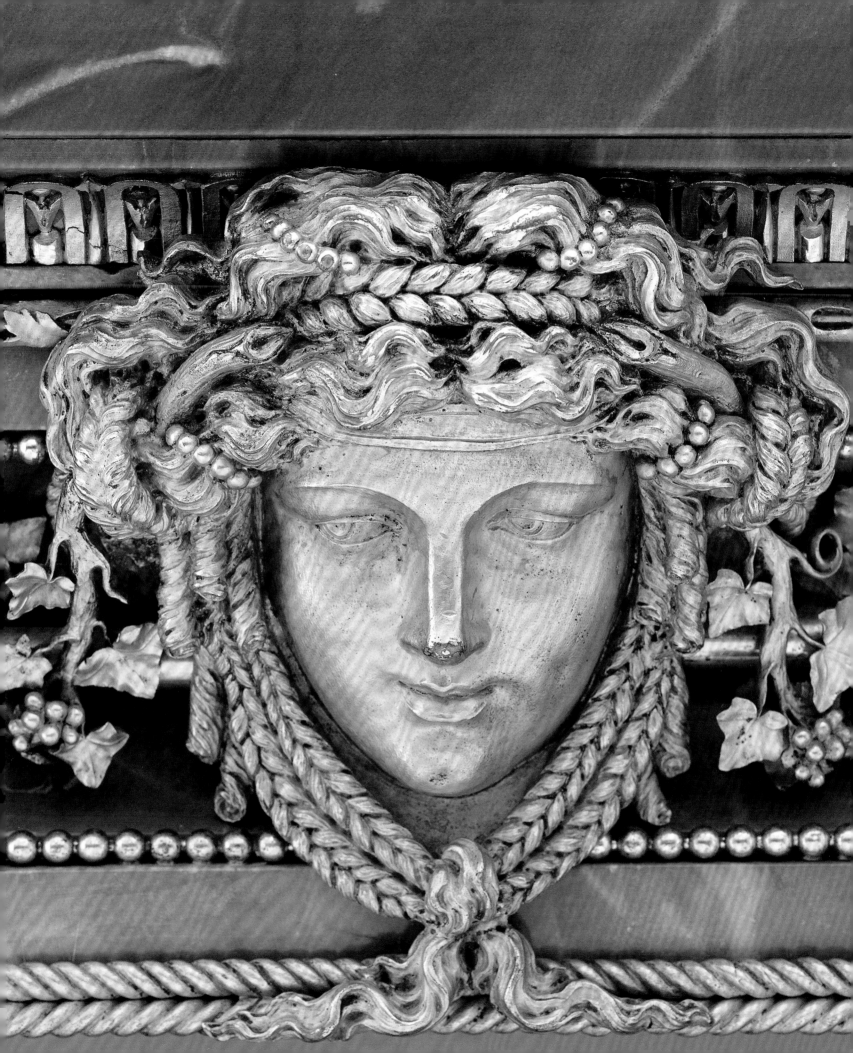

PIERRE GOUTHIÈRE

Virtuoso Gilder at the French Court

CHARLOTTE VIGNON AND CHRISTIAN BAULEZ

With contributions by Anne Forray-Carlier, Joseph Godla, Helen Jacobsen, Luisa Penalva,
Anna Saratowicz-Dudyńska, and Emmanuel Sarméo

The Frick Collection, New York
In association with D Giles Limited, London

g

This catalogue is published in conjunction with the exhibition *Pierre Gouthière: Virtuoso Gilder at the French Court*, organized by The Frick Collection and on view at the Frick from November 16, 2016, to February 19, 2017, and the Musée des Arts Décoratifs, Paris, from March 15 to June 25, 2017. The exhibition is supported by the Michel David-Weill Foundation, Barbara and Brad Evans, the Selz Foundation, and an anonymous gift in memory of Melvin R. Seiden, with additional contributions from Alfredo Reyes of Röbbig Munich and Edward Lee Cave.

Published by The Frick Collection
In association with
D Giles Limited

ISBN 978-1-907804-61-8

For The Frick Collection:
Michaelyn Mitchell,
Editor in Chief
Hilary Becker, Assistant Editor

For D Giles Limited:
Copy-edited and proofread by Sarah Kane
Translated from the French by Abigail Grater
Translated from the English by Jean-François Allain

Designed by Alfonso Iacurci
Typeset in Archer and DTLFleischmann

Printed and bound in China

Front cover: detail of cat. 11
Back cover: detail of cat. 12
Frontispiece: detail of cat. 39
Page 4: cat. 6
Page 6: detail of cat. 24
Page 12: detail of cat. 14
Page 16: detail of cat. 10
Page 19: detail of cat. 3
Page 24: detail of cat. 12
Page 94: detail of fig. 46
Page 106: detail of cat. 29
Page 138: detail of cat. 19
Page 150: detail of cat. 21
Page 326: detail of cat. 42
Page 388: detail of cat. 21
Page 402: detail of cat. 13

The Frick Collection
1 East 70th Street
New York, NY 10021
www.frick.org

D Giles Limited
4 Crescent Stables
139 Upper Richmond Road
London SW15 2TN

Library of Congress Cataloging-in-Publication Data

Names: Baulez, Christian, author. | Vignon, Charlotte, author. | Gouthière, Pierre, 1732-1813. Works. | Frick Collection, issuing body, host institution. | Musée des arts Décoratifs (France), host institution.

Title: Pierre Gouthière : virtuoso gilder at the French court / Christian Baulez and Charlotte Vignon ; with contributions by Anne Forray-Carlier, Joseph Godla, Helen Jacobsen, Luisa Penalva, Emmanuel Sarmeo, and Anna Saratowicz-Dudyñska.

Description: New York : The Frick Collection ; London: In association with D Giles Limited, [2016] | Published in conjunction with an exhibition organized by The Frick Collection and held at The Frick Collection, New York, November 16, 2016-February 19, 2017 and at the Musée des Arts Décoratifs, Paris, March 15-June 25, 2017. | Includes bibliographical references and index. Identifiers: LCCN 2016020922 | ISBN 9781907804618

Subjects: LCSH: Gouthière, Pierre, 1732-1813--Catalogues raisonnés. | Gouthière, Pierre, 1732-1813--Exhibitions. | Gilt bronzes, French--18th century--Exhibitions. | Gilt bronzes, French--19th century--Exhibitions.

Classification: LCC NB553.G73 A4 2016 | DDC 745.7/5092--dc23 LC record available at https://lccn.loc.gov/2016020922

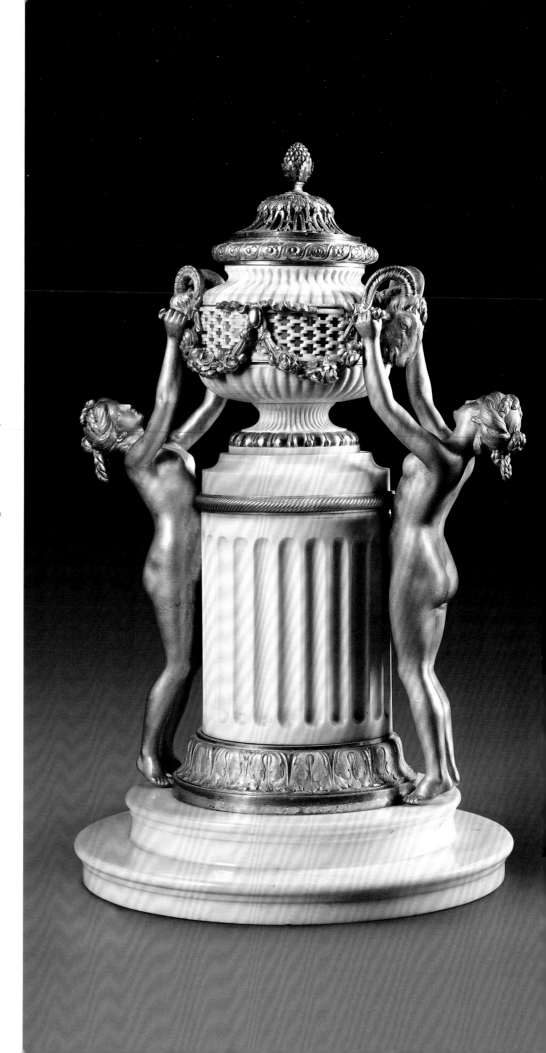

Contents

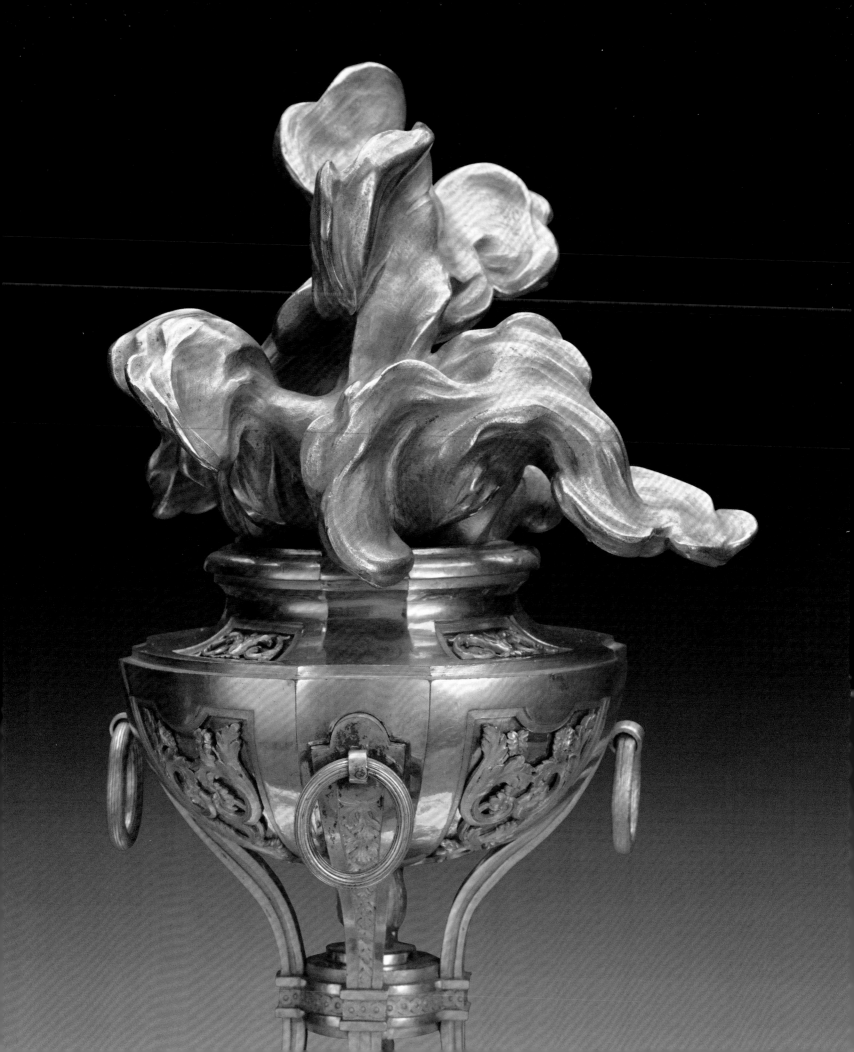

Director's Foreword

Eighteenth-century France was a period of consummate achievement in all the arts, the decorative arts in particular; during this time, Pierre Gouthière, the renowned chaser and gilder to the king under Louis XV and Louis XVI, reigned supreme as a maker of gilt bronze. This book and the exhibition it accompanies delve deeply into the life, work, and legacy of Gouthière, who collaborated with highly skilled craftsmen of the day to create exquisite gilt-bronze vases, clocks, and firedogs, as well as mounts for ewers, pots-pourris, and chimneypieces, for members of the royal family and the nobility. Such was the popularity and prestige of his work (most of which was unsigned) that, over the last two centuries, many French eighteenth-century gilt bronzes have been erroneously attributed to him. This book includes a wealth of new art historical and technical research that supports, for the first time, a compendium of those works that can be attributed to Gouthière with certainty. This important scholarly undertaking was expertly carried out by Charlotte Vignon, the Frick's Curator of Decorative Arts, and Christian Baulez, formerly Chief Curator at the Musée de Versailles.

First and foremost, our thanks go to the publication's primary authors, Charlotte Vignon and Christian Baulez, for their exemplary dedication and scholarship, the result of years of research. I'd also like to thank the other contributors, whose essays and entries enrich this publication: Anne Forray-Carlier, Chief Curator of Seventeenth- and Eighteenth-Century Decorative Arts, Musée des Arts Décoratifs, Paris; Joseph Godla, Chief Conservator, The Frick Collection; Helen Jacobsen, Chief Curator, The Wallace Collection, London; Luisa Penalva, Curator of Gold, Silver, and Jewelry Collections, Museu Nacional de Arte Antiga, Lisbon; Anna Saratowicz-Dudyńska, Curator of Silver and Bronze, Royal Castle, Warsaw; and Emmanuel Sarméo, independent scholar.

This ambitious project has itself been a grand collaboration, one involving the expertise and dedication of numerous staff members, in particular, Xavier F. Salomon, Peter Jay Sharp Chief Curator; Michael Bodycomb, Head of Photography and Digital Imaging; Tia Chapman, Deputy Director for External Affairs; Diane Farynyk, Registrar/Exhibition Manager; Joseph Godla, Chief Conservator; and Heidi Rosenau, Associate Director of Media Relations and Marketing. Others include Adrian Anderson, Rebecca Brooke, Rika Burnham, Julia Day, Allison Galea, Vivian Gill, Lisa Goble, Robert Goldsmith, Anita Jorgensen, Patrick King, Adrienne Lei, Alison Lonshein, Brittany Luberda, David W. Martin, Geoffrey Ripert, Stephen Saitas, Jeannette Sharpless, and Sean Troxell. The production of this important catalogue was overseen by Michaelyn Mitchell, Editor in Chief, with Hilary Becker, Assistant Editor, and editorial volunteer Serena Rattazzi.

It has been a pleasure to work with our publishing partner, D Giles Ltd., London, in particular, Dan Giles and Allison McCormick.

Public and private lenders have been very generous in sharing their treasures, and we are extremely grateful to them. Our thanks go to the Musée du Louvre, Paris; the Mobilier National, Paris; the Musée des Arts Décoratifs, Paris; the Musée Cognacq-Jay, Paris; the Bibliothèque Nationale de France, Paris; the Musée National des Châteaux de Versailles et de Trianon; the Royal Castle, Warsaw; the Museu Nacional de Arte Antiga, Lisbon; the Frick Art and Historical Center, Pittsburgh; as well as to Gustavo and Patricia Phelps de Cisneros, Madame François Pinault, and William W. and Nadine M. McGuire.

Finally, our profound gratitude for their largesse goes to the Michel David-Weill Foundation, Barbara and Brad Evans, the Selz Foundation, and an anonymous gift in memory of Melvin R. Seiden, as well as to Alfredo Reyes of Röbbig Munich, and Edward Lee Cave.

It gives all of us at the Frick great pleasure to present the work of this eighteenth-century master to a wider audience, and we are delighted that a version of the exhibition will be on view at the Musée des Arts Décoratifs in the spring of 2017.

Ian Wardropper
Director, The Frick Collection

*To Pierre Verlet and Geoffrey de Bellaigue, who paved the way
and built the foundation.* —CB

*To Lucie and to the next generation of students, art lovers, collectors, and
enthusiasts passionate about or interested in Pierre Gouthière.* —CV

Acknowledgments

Our idea for a major exhibition on Pierre Gouthière received the early blessing, in 2011, of Anne L. Poulet and Colin B. Bailey, the Frick's previous Director and Curator in Chief, respectively; their initial support, for which we are very grateful, provided the necessary impetus for this ambitious project. During the five years that followed, many others helped in the realization of this publication and first exhibition devoted to Pierre Gouthière. I would like to sincerely thank Christian Baulez, without whom this project could never have seen the light of day. He not only contributed to this publication with two important essays on Gouthière and an appendix rich with information for the study of Parisian bronze-makers, he also wrote part of the catalogue raisonné and proofread and corrected those texts he did not write himself, enhancing them with his insightful remarks. His generosity was without bounds when sharing the results of the research he has conducted over the last several decades; he gave me access to documents, archives, and references—often obscure ones—and mentioned many works sold at auction. I also thank him for readily accommodating my numerous requests with the utmost courtesy.

Of those at the Frick, I wish to extend particular thanks to Ian Wardropper, Director, and Xavier F. Salomon, Peter Jay Sharp Chief Curator, who have supported this project with unwavering conviction and passion. Joseph Godla, Chief Conservator, was also key to the project's success; his knowledge of production techniques and his meticulous examination of hundreds of gilt-bronze works, carefully documented with thousands of high-resolution images, allowed me to better understand the work of Gouthière and define the characteristics of his style and craftsmanship. The exhibition and this catalogue are as much his work as mine. My deep appreciation also goes to Curatorial Assistant Geoffrey Ripert, for proofreading the texts in English and French, for his insightful comments, for checking bibliographical and archival references, and for his assistance on all aspects of the project over the last twelve months. I also acknowledge Adrian Anderson, Michael Bodycomb, Rebecca Brooke, Rika Burnham, Tia Chapman, Julia Day, Diane Farynyk, Allison Galea, Lisa Goble, Robert Goldsmith, Caitlin Henningsen, Patrick King, Adrienne Lei, Genevra LeVoci, Alexis Light, Alison Lonshein, Brittany Luberda, David W. Martin, Aimee Ng, Serena Rattazzi, Heidi Rosenau, Jeannette Sharpless, Don Swanson, and Sean Troxell. We are indebted to Stephen Saitas, exhibition designer, and Anita Jorgensen, lighting designer, for their beautiful presentation of the exhibition.

This publication has been marvelously directed at the Frick by Michaelyn Mitchell, Editor in Chief, who, with Assistant Editor Hilary Becker, meticulously edited every word, supervising the book's creation with a discerning eye and good spirits and making important decisions that would determine its final aspect.

Anne Forray-Carlier, Joseph Godla, Helen Jacobsen, Luisa Penalva, Anna Saratowicz-Dudyńska, and Emmanuel Sarméo provided important information on the life and work of Gouthière, and this publication is enormously enriched by their essays and entries.

At D Giles Ltd., I wish to recognize Dan Giles, who directed the publication of this book with energy and intelligence, as well as Allison McCormick, Editorial Manager, and Sarah McLaughlin, Production Director.

I also thank John Elliott and Anne-Marie Fabianowska for translating texts written in Portuguese and Polish; Grace Chuang, for her implementation of a database and help during the preliminary phases of the project; and Samy Jelil, for his valuable research of sales catalogues of the late eighteenth century in search of artworks attributed to Gouthière and for checking bibliographical and archival references; as well as Julie Rohou and Benoit Delcourte, for carefully proofreading various versions of the manuscript.

For managing the difficult task of assembling the more than 150 illustrations so critical for this publication, I extend my warmest thanks to Brittany Luberda and Geoffrey Ripert. Michael Bodycomb, Joseph Godla, and Thomas Hennocque photographed numerous objects, splendidly capturing the beauty of Gouthiere's masterpieces.

I would also like to acknowledge many others, whose help was so generously and kindly given. My appreciation goes to the numerous museum curators and conservators who allowed Joseph Godla and me to examine works by, or attributed to, Gouthière, kept in the various collections they manage, giving us privileged access to their institutions when doors were closed to the public. I extend particular thanks to Frédéric Dassas, Senior Curator in the Decorative Arts Department at the Musée du Louvre, who allowed us a number of visits to examine, photograph, and evaluate a dozen works by Gouthiere; to Rufus Bird at the British Royal Collection; Rachel Boak and Ulrich Leben at Waddesdon Manor, Aylesbury; Charissa Bremer-David, Brian Considine, and Arlen Heginbotham at the J. Paul Getty Museum, Los Angeles; Vincent Cochet at the Château de Fontainebleau; Donna Corbin and Jack Hinton at the Philadelphia Museum of Art; Pierre Costerg and Anne Forray-Carlier at the Musée des Arts Décoratifs, Paris; Alan Darr, Cindy Lee Scott, and John Steele at the Detroit Institute of Arts; Jean-Jacques Gautier at the Mobilier National, Paris; Sarah Hall at the Frick Art and Historical Center, Pittsburgh; Stephen Harrison at the Cleveland Museum of Art; Catherine Hess at the Huntington Library, Art Collection, and Botanical Garden, San Marino; Jurgen Huber and Helen Jacobsen at the Wallace Collection, London; Saskia Hüneke at the Sanssouci Palace, Potsdam; Kirstin Kennedy and Tessa Murdoch at the Victoria and Albert Museum, London; Daniëlle Kisluk-Grosheide at the Metropolitan Museum of Art, New York; Sylvie Legrand-Rossi at the Musée Nissim de Camondo, Paris; Hélene Meyer at the Palais de Compiegne; Rose-Marie Mousseaux at the Musée Cognacq-Jay, Paris; Luisa Penalva at the Museu Nacional de Arte Antiga, Lisbon; Bertrand Rondot at the Châteaux de Versailles et de Trianon; Anna Saratowicz-Dudyńska and Maria Szczypek at the Royal Castle, Warsaw; and Clara Serra at the Museu Calouste Gulbenkian, Lisbon.

Numerous collectors generously opened their homes to allow us to see their fabulous treasures: Count and Countess Claude d'Anthenaise; Nicolas Cattelain; Gustavo and Patricia Phelps de Cisneros; Michel David-Weill; Gregory Mauge; William W. and Nadine M. McGuire; and Madame François Pinault, as well as several individuals who wish to remain anonymous.

I offer my deepest gratitude to the institutions and collectors who loaned pieces to the exhibition. First and foremost, I recognize at the Louvre, which has the largest number of Gouthière works in the world, Jean-Luc Martinez, President and Director; Jannic Durand, Head of the Department of Objets d'art; and Frédéric Dassas. I would also like to acknowledge Hervé Barbaret and Jean-Jacques Gautier at the Mobilier National, Paris; Gustavo and Patricia Phelps de Cisneros, founders of the Colección Patricia Phelps de Cisneros; Melanie Groves and Sarah Hall at the Frick Art and Historical Center, Pittsburgh; Rose-Marie Mousseaux at the Musée Cognacq-Jay, Paris; Skye Monson and Gabriel Perez-Barreiro at the CPPC; and Bruno Racine at the Bibliotheque Nationale de France, Paris; as well as William W. and Nadine M. McGuire, Madame François Pinault, and a few others who wish to remain anonymous.

My thanks go to Olivier Gabet for his support in the earliest stages of this project and for ensuring the presentation of a version of the exhibition at the Musée des Arts Décoratifs in Paris.

A number of colleagues provided invaluable new information: Vincent Bastien, Olga Bazhenova, Dario del Bufalo, Yannick Chastang, Caitlin Condell, Benjamin Couilleaux, Leon Dalva, Maxine Fox, Anna Geyko, Raniero Gnoli, Alvar Gonzàlez-Palacios, Alexey Guzanov, Philip Hewat-Jaboor, William Iselin, Alexis and Nicolas Kugel, Patrick Leperlier, Alexandre Pradère, Orlando Rock, Count Eric de Saint-Seine, Femke Speelberg, Will Strafford, Juliette Trey, Sylvia Vriz, and Jody Wilkie.

A reproduction of the Du Barry Louveciennes french-window knob was masterfully achieved by the sculptor Vincent Mouchez and bronze-makers Bernard and Gaël Deville, and its fabrication was photographed by Thomas Hennocque.

I would like to warmly thank my mother, Claudine Vignon-Zellweger, for looking after my daughter, Lucie, during my travels in Europe, which included countless trips to Paris, London, Berlin, Warsaw, and Lisbon.

Last but not least, this exhibition and catalogue could not have been realized without the generous support of our many patrons: the Michel David-Weill Foundation, Barbara and Brad Evans, the Selz Foundation, an anonymous gift in memory of Melvin R. Seiden, Alfredo Reyes of Röbbig Munich, and Edward Lee Cave. Many more names should undoubtedly be mentioned; may those who have involuntarily been omitted forgive me. —Charlotte Vignon

I join Charlotte in acknowledging the colleagues and friends whom we have met and spent time with, as well as those who worked with her to ensure the high quality of this publication and the exhibition it accompanies, both of which make a lasting contribution to the scholarship on the subject.

I would personally like to thank Vincent Bastien, Michel Baulez, Geoffrey de Bellaigue (†), Roland Bossard, Frances Buckland, Catherine Faraggi, Peter Hughes, Patricia Lemonnier, Patrick Leperlier, Hans Ottomeyer, Bruno Pons (†), Peter Pröschel, Sylvia Vriz, and of course Charlotte Vignon. —Christian Baulez

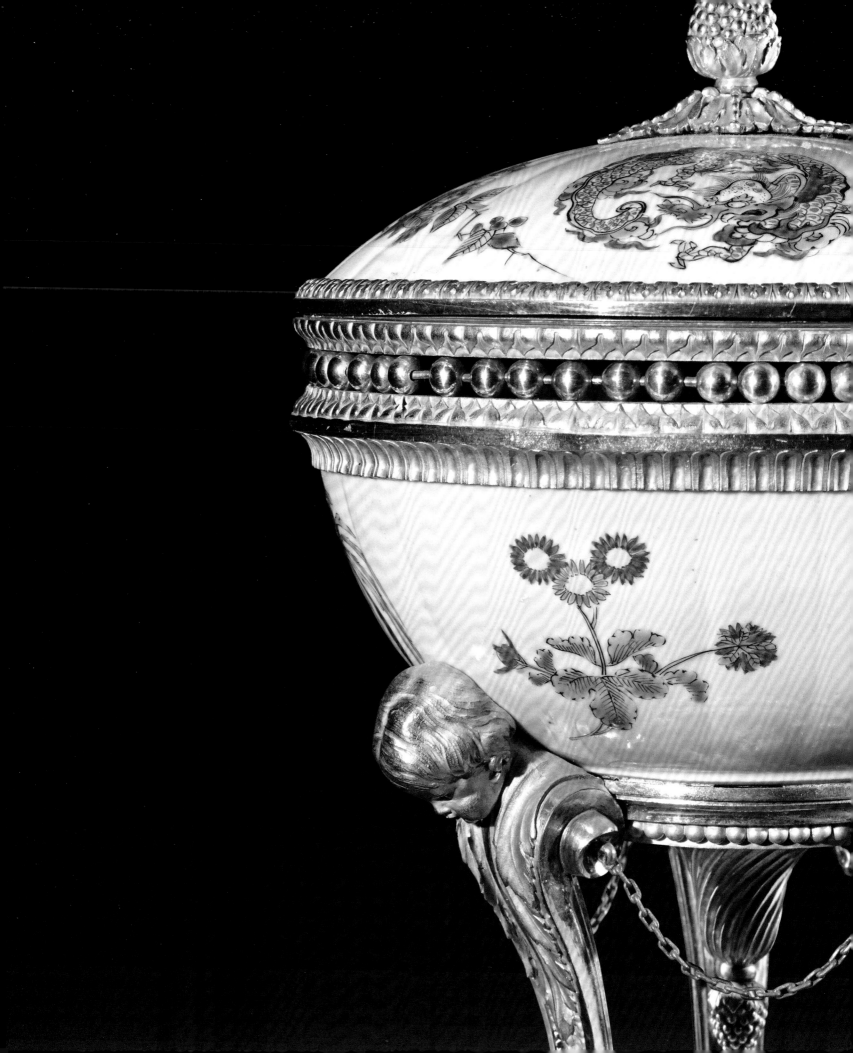

Note to the Reader

CHARLOTTE VIGNON

This book combines three complementary approaches to Pierre Gouthière's life and work: the curator's, the historian's, and the connoisseur's. Christian Baulez, whose knowledge of eighteenth-century France is unparalleled, reconstructs Pierre Gouthière's professional and personal life in order to shed new light on his circle of patrons and on how his workshop functioned. With his text in *Vergoldete Bronzen* (1986) providing the groundwork, he provides a wealth of additional information, including some important corrections, made possible by the discovery of numerous hitherto unknown documents found in the archives of the Garde-Meuble, the Menus-Plaisirs, and the Bâtiments du Roi, important administrative services of the French monarchy. Further material was found in the work journal of the famous bronze-maker François Rémond in the records of the Archives Nationales, and in the bankruptcy records of Parisian craftsmen. In order to facilitate future study and research on Gouthière, most of these documents are transcribed in Appendix 1.

The catalogue section includes all those works that can be attributed to Gouthière with certainty—including those lost or destroyed but known through a drawing, etching, or old photograph. The attributions were made using descriptions in Gouthière's invoices, inventories, and other contemporary documents, as well as from examination of the works, which was made possible through collaboration with Joseph Godla, who documented our analyses with hundreds of high-resolution photographs. This allowed us to study and compare the chasing, gilding, restoration, and assemblage of more than two hundred works dispersed across more than forty collections worldwide. Finally, the artworks' provenance—or lack thereof—was carefully examined. Provenance research is particularly important for objects like those created by Gouthière, as they were often produced in several different versions. Some may criticize the restrictive nature of this catalogue raisonné; however, given that Gouthière has long suffered from dubious attributions, we have taken a prudent approach. The works are presented in chronological order, within sections organized according to function.

A few words should be said about the guild system under the ancien régime. Most professions and all crafts were organized into independent and often rival "guilds," or communities. The judicial status of these guilds defined the rights and obligations of their members, whether these be *apprentis* (apprentices), *compagnons* (journeymen), or *maîtres* (masters). The nature of apprenticeship varied from one guild to another but for most craftsmen began at the age of fourteen and lasted for four to six years, in rare cases as long as eight years. A young apprentice was typically offered bed and board by a master, who would teach him the skills required of his craft in return for a salary paid by the apprentice's parents. The apprenticeship was formalized by a contract signed before a notary. After the apprenticeship came the *compagnonnage*, lasting about

a year, normally completed with a different master and often repeated until the young man was ready to pass the *maîtrise*, allowing him to become a master. In order to be a master, one must not only have completed an apprenticeship and the *compagnonnage* but also have produced what was referred to as a *chef d'œuvre* (masterpiece), a complex work of art that a young craftsman would realize on his own to prove he had become a master of his craft. Once the masterpiece was reviewed and accepted by a jury of elected members of the guild, the young craftsman would swear an oath in front of the jury and pay for the right to bear the title of master, which was often costly. The new master would then be able to open a shop, meaning he could produce and sell his own work. A wife's dowry often helped pay for the right to bear the title of master. Some *compagnons* never achieved master status and remained employees in a workshop. The regulations of these guilds generally privileged sons of masters, thus encouraging the children to follow the path of their elders or at least choose a related profession. For this reason, dynasties of craftsmen appeared, dedicated to similar professions and crafts. Hence, casters and gilders on metal often shared blood ties. One of the fundamental rules of a guild was that, in principle, no profession was to impinge on another: a master gilder on metal could not gild chairs since this was the work of master gilders on wood. This degree of specialization, together with rigorous control over the training and work of master craftsmen, insured the exceptionally high level of French craftsmanship during the ancien régime.

Biographies of most of the mentioned craftsmen can be found in Appendix 2.

We refer to Gouthière as both a craftsman and an artist. Through his training—he was received "master gilder and chaser on all metals" in the guild of Paris on April 13, 1758—he was a craftsman with virtuoso skill, but he transformed metal into supreme works of art and thus, over time, also acquired the title of *artiste*.

Like his contemporaries, Gouthière worked with brass, an alloy made by mixing chiefly copper and zinc in varying proportions. In the eighteenth century, however, this was erroneously called bronze, which is an alloy of copper and tin. It was then gilded using an amalgam of mercury and gold. We have chosen to continue using the term *gilt bronze*. Furthermore, we often refer to Gouthière and his fellow craftsmen as bronze-makers, a generic term referring to craftsmen producing gilt-bronze objects. However, we prefer to use the more precise terms of *caster, chaser,* and *gilder*.

A word about the *livre tournois*, the currency in France during Gouthière's lifetime. The value of the *livre* fluctuated substantially between the years 1758 (Gouthière's *maîtrise*) and 1813 (his death). Around 1770, the annual salary of a craftsman was between 300 and 1,000 *livres*; for a gilder or a cabinetmaker, it would be somewhere between 400 and 750 *livres*. Someone with a diploma or bearing a title generally received between 1,000 and 3,000 *livres*; for example, the annual salary of a tutor in a princely household was 2,000–3,000 *livres*, while a doctor would earn between 8,000 and 10,000. The annual income for a member of the nobility would be between 40,000 and 100,000 *livres*, depending on his rank and fortune; a prince's annual income was almost always in excess of 100,000 *livres*.

In eighteenth-century France, a *livre* was worth 20 *sous* and 1 *sol*, 12 *deniers*. For the sake of simplicity, *sous* and *deniers* are not transcribed in this monograph.

The *livre* was also a unit of weight; 16 *onces* add up to one *livre* or 489.5 grams.

A foot (*pied*) was the sum of 12 thumbs (*pouces*), or roughly 32 centimeters today. A thumb was equivalent to approximately 2.7 centimeters and divided into 12 "lines" (*lignes*).

Abbreviations:

AN Archives Nationales
AD 75 Archives de Paris
AD 78 Archives Départementales des Yvelines
M.C.N. Minutier Central des Notaires de Paris

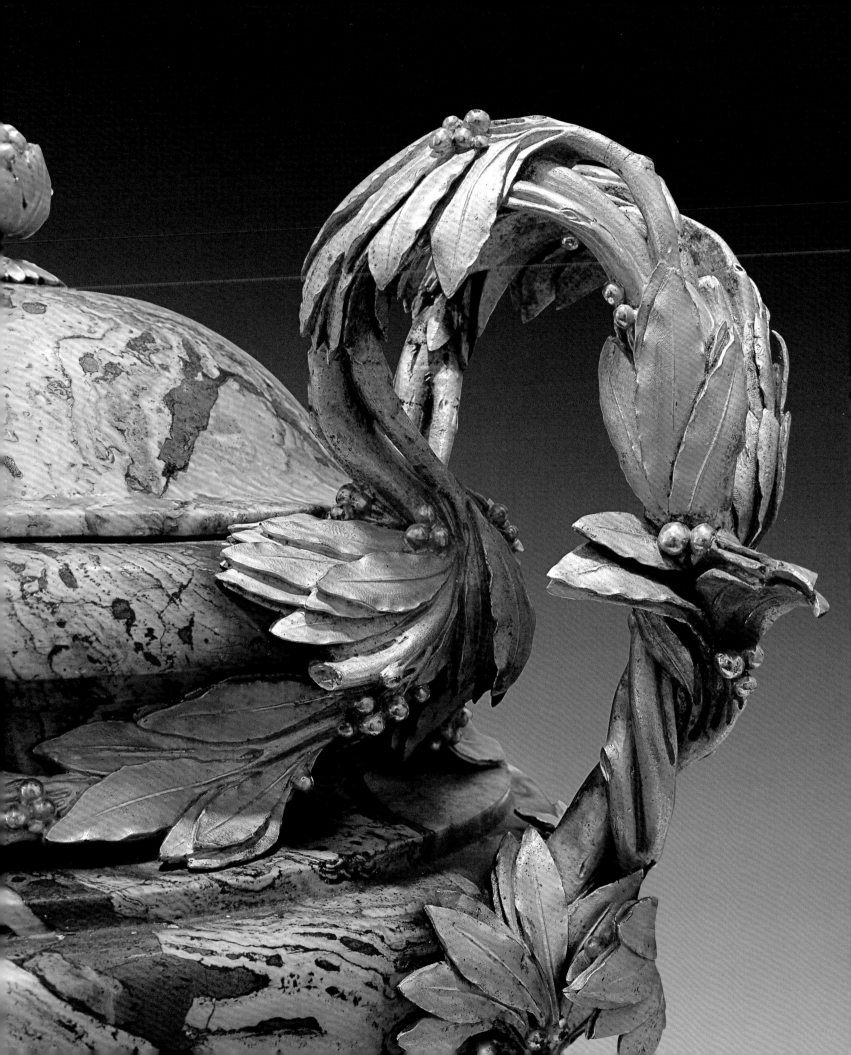

Gouthière: A Gilded Legend

CHARLOTTE VIGNON

Pierre Gouthière was one of the greatest artists of the eighteenth century in the field of the decorative arts; yet he is known today by only a small circle of art specialists, collectors, and dealers. This unfortunate situation stems from the fact that he was neither a painter nor a sculptor nor an architect but rather a "chaser and gilder on all metals." His profession involved working brass objects (incorrectly referred to as bronze) with instruments such as chasing tools (*ciselets*) and then gilding them. Although these objects were often practical items such as window knobs, firedogs, and wall lights, in his hands they took on the appearance of finely worked gold.

Gouthière was famous in his lifetime. He worked almost exclusively for a clientele of powerful and immensely wealthy men and women, who asked him to create extravagantly rich and exuberant objects. Whenever one of these items appeared in an auction, his name was mentioned in the catalogue: a privilege generally reserved for painters and sculptors. Another sign of his reputation was the pricing of his work, which was comparable to and sometimes higher than that of pictures by famous painters of the period. He asked for nearly 16,000 *livres* from Mme Du Barry for the ornamentation of a chimneypiece and several door and window handles for the Salon en Cul-de-Four at Louveciennes (cats. 27, 30), while Jean-Honoré Fragonard hoped for 20,000 *livres* for the four panels depicting *The Progress of Love*, now in The Frick Collection, painted for the same room.[1] Du Barry rejected the paintings, and they were replaced by four large pictures by Joseph-Marie Vien (1716–1809), who received 16,000 *livres* for his work—the same amount Gouthière received for his gilt-bronze pieces.[2]

Members of the refined echelons of eighteenth-century society appreciated the "minor arts," which signified their class perhaps even more than contemporary paintings. Thus, when the painter Élisabeth Vigée Le Brun wrote her *Souvenirs*, while in exile far from home and at a time when the people she had known under the ancien régime were dead, she recalled the bronzes by Gouthière that decorated Du Barry's pavilion:

Every day, after dinner, we would go to take coffee in this pavilion, so renowned for the taste and richness of its ornamentation . . . The salon was ravishing . . . the chimneypieces, the doors, everything was fashioned in the finest possible way; even the locks could be admired as masterpieces of the goldsmith's art . . .[3]

 Gouthière worked less after the French Revolution but remained famous until his death in 1813, as is proven by the eulogy that appeared in the *Journal de Paris* in 1810.[4] Throughout the nineteenth century, he continued to be admired and sought after by collectors—mainly French and English—who were passionate about the art that had flourished in France in the previous century. However, Gouthière's life was not studied until the second half of the nineteenth century. And he did not truly emerge from the shadows until 1865, when the historian Paul Mantz published the full inscription from the Avignon clock (cat. 19) in the *Gazette des Beaux-Arts*, stating that "its importance will intrigue those with inquiring minds," for it reveals the name of "Gouthière cizeleur et Doreur du Roy / A Paris / Quai Pelletier / à la Boucle d'Or" and gives the date of the work, 1771.[5] This signature has the merit of giving the correct spelling of Gouthière (who had previously also been known as Gontier, Gonthier, Gouttier, or Gouttières),[6] his address, and the sign on the building in which his shop was located, as well as a date at which he was working. The image of Gouthière as an exclusive and specially appointed craftsman to some of the most celebrated figures of the eighteenth century probably started to be painted by Mantz, who made Gouthière into "Marie Antoinette's favorite artist."[7] Even at this time, Mantz lamented the number of pieces that were too easily attributed to Gouthière, who, like all bronze-makers at the time, rarely signed his work. He quite rightly wrote: "An illustrious name curtails research, and, just as all the jewelry of the sixteenth century is by Benvenuto [Cellini], all the bronzes from the time of Louis XVI are by Gouthière."[8]

 Throughout the nineteenth century, Gouthière continued to intrigue French art historians, who rediscovered certain aspects of his life in archival documents, often incidentally, while working on other subjects. Thus in 1865 and 1891 Natalis Rondot published two biographical notices on Gouthière with purely factual information on the artist that was of varying importance and not always easy to verify.[9] The biography of Gouthière published in 1870 by Baron Charles Davillier was more ambitious and extensive.[10] Not only did the author have a considerable reputation as a writer and collector, but the twenty pages he wrote on Gouthière followed a brief biography of the Duke of Aumont, a famed eighteenth-century collector. These biographical notes were published as an introduction to a new edition of the catalogue from the sale of the duke's collections, which were auctioned in 1782. This auction made great waves in the press at the time and was also the occasion at which Louis XVI and Marie Antoinette acquired works by Gouthière at high prices. With this publication, Davillier forever linked the artist and his patron. As Jules Guiffrey wrote in 1877, the Duke of Aumont was "the intelligent and wealthy supporter, without whom Gouthière would have been unable to produce most of his masterpieces."[11]

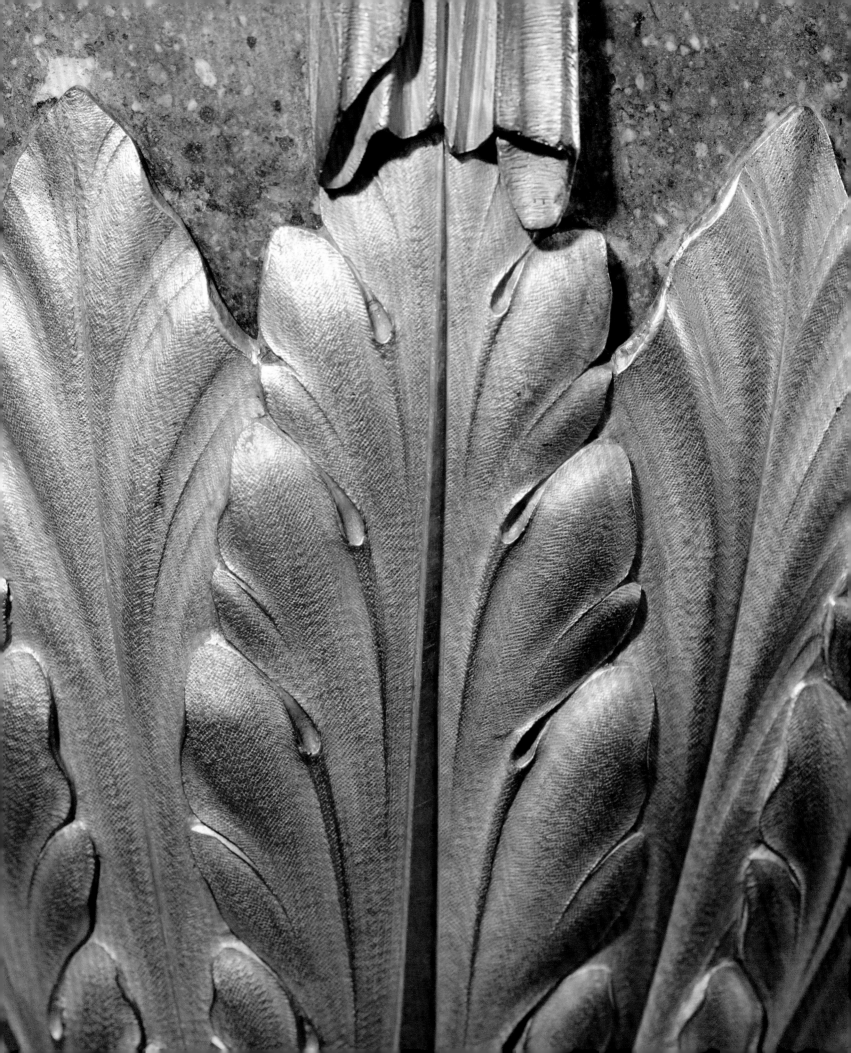

Davillier sought to fill in the gaps in the biography of this talented craftsman who he believed was wrongly overlooked by art historians. For him:

> [Gouthière] is an artist of the last century who rose as high in the art of chasing as André-Charles Boule [*sic*] did in that of marquetry; and whose name, which is familiar to all collectors today, was well known by those of yesteryear. In his lifetime . . . he was already referred to as "the celebrated Gouthière"; and yet until now very little has been published on this artist, whose bronzes are sought after today at prices that represent their weight in gold.[12]

Davillier also had a role in making Gouthière the "inventor of matte gilding."[13] On this subject, he recounted an anecdote "known by several collectors" in which "Gouthière one day presented to Marie Antoinette a matte-gilded bronze rose, which the queen took as being made of gold."[14]

In 1886 and 1887, Germain Bapst added to the scholarship on Gouthière by throwing light on a hitherto unknown aspect of his life: his collaboration in the 1760s with the silversmith to the king, François-Thomas Germain.[15] At the end of the century, Gouthière was featured in *La Grande Encyclopédie* with an entry written by Alfred de Champeaux, who had learned "a certain number of biographical details" from the historian Auguste Dupont-Auberville, who himself had gleaned them from "the chaser Jeannest, [Gouthière's] pupil and successor."[16] This was probably how he learned that Gouthière, "entirely absorbed by the love of his art and seeking perfection, endlessly retouched the models that he created, with no concern for costs. This constant preoccupation with art and this neglect of his interests had always been the cause of permanent predicaments for him."[17]

In 1901, Henri Vial published an article on Gouthière's bankruptcy, which occurred in 1787,[18] with essential information for the study of this artist. Vial was also the first to study the *hôtel particulier* that Gouthière built in the early 1770s in the Faubourg Saint-Martin.[19] He accurately wrote that "Gouthière one day had the ambition to become a landlord; this ambition was his downfall,"[20] seeing that this real estate project was the other major reason, along with his main clients' failure to pay, for his financial bankruptcy. Thus, at the dawn of the twentieth century, Gouthière was a well-known figure among art historians, but his work still remained little studied and subject to unsound attributions.

With the publication in 1912 of *Gouthière, sa vie, son œuvre: essai de catalogue raisonné*, Jacques Robiquet produced the first monograph on the artist, which was based as before on painstaking archival research but now carried out methodically rather than as an offshoot of other research.[21] He also sought to include Gouthière's production in his biographical study, with a first attempt at a catalogue raisonné.

The biographical part of Robiquet's volume is remarkable; he discovered Gouthière's humble origins as the son of a master saddler in Bar-sur-Aube, a small town near Troyes in the Champagne region.[22] He also realized that Gouthière's success depended upon "the modeling qualities that the chaser possessed, and on the personal use that he made of them."[23] He warned against any belief in the existence of a "Gouthière style," explaining:

I repeat that the most brilliant of chasers has no need to assert a style, in the broad sense in which the public understands it. A painter, a sculptor, creating their works of art from scratch, can and must leave the mark of their personality upon them, through not only the craftsmanship but also the composition. As for the chaser, though he may sometimes know how to draw, and above all how to model—and this is the case with Gouthière—he proves his worth more through his interpretation than through the inventiveness of the model . . . his true manner reveals itself, indeed, in the bright and flowing perfection of the craftsmanship. If, on the belly of a vase, our artist has to fashion a festoon of flowers, the roses, the carnations, the lilies blossom aplenty under the discerning hand that models them in wax, then transposes them into metal; the petals, elegant but real, spring up, curl over, or bend amid their lively foliage; they seem to be awaiting the morning dew, and the Bacchic figure holding the garland smiles strangely, so alive that it simultaneously evokes the wildness of Pagan festivals and the spiritual gaiety of an over-refined court . . . The virtuoso of chasing possesses a gift that is of the utmost importance in this art: the perfect adaptation of his processes to the nature of the subject that he is interpreting.[24]

Robiquet's catalogue is not, however, reliable. While he recognized that Gouthière's oeuvre "suffered from the ill caused by unfounded or self-interested attributions,"[25] he may well have assisted in worsening the situation he so lamented. Robiquet found several significant pieces with definite attributions, such as the Duke of Aumont's vases in the Musée du Louvre.[26] Even so, he continued too often to attribute works to Gouthière without a firm basis. It is regrettable that he made Gouthière the bronze-maker of Jean-Henri Riesener, the famous cabinetmaker to the king, and attributed to him numerous gilt-bronze mounts on furniture by Adam Weisweiler. There is no reason to believe that Gouthière worked for Riesener, and, as far as Weisweiler is concerned, it is now known that Rémond supplied his finest gilt bronzes.

Robiquet did, however, sketch out the typical characteristics of Gouthière's work with impeccable judgment and refined taste. "Thanks to this particular genius," he explained, "Gouthière was not content merely to display artistic and expressive qualities, but he asserted a taste that was rare in the eighteenth century, impregnated as it was by the artificiality of Greuze and Boucher: naturalism . . ."[27] According to Robiquet, Gouthière developed his fondness for nature at a very early stage:

From his earliest years [in the Champagne region], Pierre had subconsciously admired the sun at play on the bunches of grapes, the vines lithely twisting, and the whimsy of the meadow flowers. All these indelible impressions made their mark on his talent. Thus, when Gouthière had to contribute to the luxury of a decadent and mannered court, he graced it with an injection of sincerity, inspired by nature. And the autumnal light of the Champagne region, fine and golden, undoubtedly gave him a taste for the pale, matte golds that he was the first to obtain.[28]

In 1986, a new biography by Christian Baulez was published in Germany as part of the collective study of the art of gilt bronze edited by Hans Ottomeyer and Peter Pröschel.[29] Baulez amplified Robiquet's research with numerous archival documents, often hitherto unpublished, thus

enriching our knowledge of Gouthière's life while also considerably enhancing our awareness of his clientele and the way his workshop functioned. This text, a great addition to the study of Gouthière, had a limited impact, mainly because of the language in which it was published and the black-and-white reproductions of Gouthière's works.

The present book, published in conjunction with the first solo exhibition of the artist, is the culmination of forty years of research by Christian Baulez, who here revisits his 1986 text with additions and, in some cases, corrections, and five years' work for Joseph Godla and me, examining, analyzing, and studying more than two hundred pieces traditionally attributed to Gouthière in almost forty public and private collections in Europe and the United States (including all the objects illustrated here except for figs. 33, 34, 97, 117, 121, 122, 126, 217, and 318.

The portrait of Gouthière that emerges from this study is that of a greatly talented craftsman and passionate artist who drove his art to the point of perfection, as well as that of an ambitious, energetic, and probably highly charismatic man adept at seizing opportunities that came his way. One of his greatest strokes of good fortune was to have worked very early in his career with silversmiths, including François-Thomas Germain. As well as putting him in contact with a prestigious clientele, his relationship with Germain also supplied him with technical training: in gilding (which Germain claims to have revived in France) and in chasing on gold and silver—two materials that were softer and easier to work with than bronze. Gouthière imitated the flowing and wonderfully worked surfaces of Germain's pieces, surpassing the silversmith by obtaining the same result with a humbler and less costly material. Was he an alchemist?

Although Gouthière collaborated with numerous artists and artisans, he seems to have operated in a small workshop, and this may have allowed him to keep a close eye on the finishing of the pieces that emerged from it. Today we know only his most exceptional commissioned pieces, but he also made more everyday objects that he sold in his shop. This was certainly the case at the beginning of his career (see, for example, cat. 18), and one wonders whether he continued to produce such pieces. But what set Gouthière apart was his enormous talent: he was a very good modeler, an excellent chaser, and an innovative gilder. These skills brought him into contact with, and allowed him to retain, a select clientele. With the support of Mme Du Barry, the Duke of Aumont, the Duchess of Mazarin, and several others, he worked with the greatest architects, sculptors, and designers of his time, who supplied him with models that were both innovative and sumptuous. I would agree with Robiquet that there is no one "Gouthière style" but rather a highly personal manner of interpreting a model, a technique and talent that belonged to Gouthière alone.

Notes

1. Bailey 2011, 88.
2. Ibid., 88–89.
3. Vigée Le Brun 2015, 90–91.
4. See pp. 74–75 in this publication.
5. Mantz 1865, 472–73.
6. Ibid., 473; Davillier 1870, xiv.
7. Mantz 1865, 480.
8. Ibid.
9. Rondot 1865, 1891. We learn that his grandfather, Louis-Joseph Rondot, entered Gouthière's workshop in 1781. "Noël De Wailly, the grammarian, who was his cousin, wrote on January 5, 1782 to Jacques Rondot, silversmith in Troyes: 'He (your son) has been well placed for several months, he is content with his position, and I know that the merchants in whose house he is staying are also content with him.'" To date, Louis-Joseph Rondot's training has not been confirmed, but this information was repeated by Baron Charles Davillier in 1870 (Davillier 1870, xxiii). The plural "merchants," which implies that Gouthière was not the only head of his household, seems strange. However, Gouthière was indeed referred to as "merchant gilder in Paris" when he received the title of chaser-gilder to the king in 1767, which suggests, as Christian Baulez explains, that he had a shop next to his workshop (see p. 33 in this publication).
10. Davillier 1870.
11. Guiffrey 1877, 157.
12. Davillier 1870, xiii.
13. Gouthière had already been described as the inventor of matte gilding in an article published on March 17, 1810, in the *Journal de Paris*, but this document seems to have been unknown until its recent discovery by Christian Baulez (*Journal de Paris*, no. 81, 1510; see Baulez, pp. 74–75 in this publication). On this subject, see also Godla, pp. 129–31.
14. Davillier 1870, xxxi. Davillier explains that "the authenticity of this anecdote is confirmed by Mr. Denière, who heard it from Mr. Raymond, a friend of his father. Mr. Raymond, a pupil of Riesener, was chief cabinetmaker to the Garde-Meuble under Louis XVI, and still held this post under the Restoration. He was a man of stature in his profession, and he remained in the Mobilier de la Couronne until his death."
15. Bapst 1886, 1887. The relationship between Gouthière and Germain was also studied by Christian Baulez in 1986 and by Christiane Perrin in 1996 (Baulez 1986, 562–64, and Perrin 1996, 25, 170, 181, 190, 192, 238, 242).
16. Champeaux 1885-1902, 70.
17. Ibid., 71.
18. Vial 1901. In 1908, Vial published a second article on Gouthière in which he recounted the discovery of a police report that shows the chaser-gilder causing a disturbance to public order at the theater (Vial 1908).
19. Vial 1901, 137-42.
20. Ibid., 138.
21. Robiquet 1912. Ten years later, Robiquet published a new edition titled *Vie et œuvre de Pierre Gouthière*, which reproduced the 1912 text in its entirety while also including Errata, Additions, and an Appendix. (Robiquet 1920-21, 205-8).
22. Robiquet 1912 and 1920-21, 8.
23. Ibid., 38-40.
24. Ibid., 76-77.
25. Ibid., 2.
26. Ibid., 205.
27. Ibid., 77-78.
28. Ibid., 12-13.
29. Ottomeyer and Pröschel 1986.

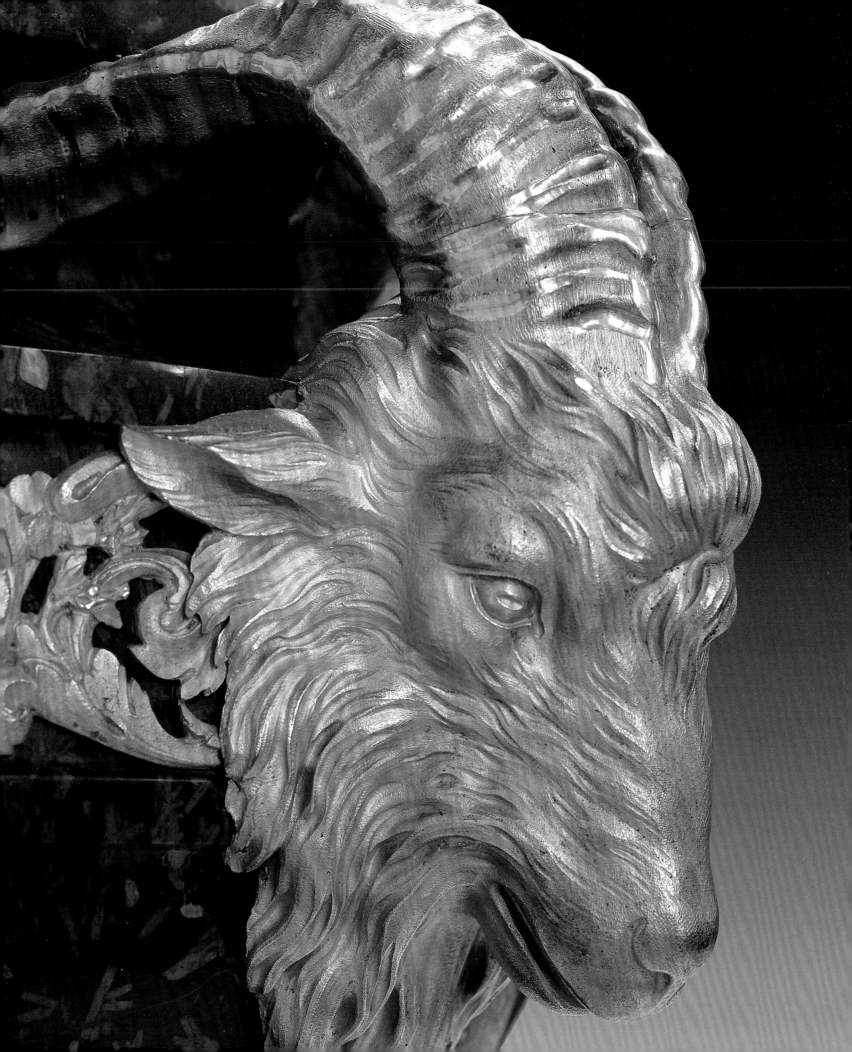

The Life and Work of Pierre Gouthière

CHRISTIAN BAULEZ

Pierre Gouthière is as celebrated by some as he is little known by most. Many of the facts of his life and work were set out in a 1912 monograph by Jacques Robiquet that was groundbreaking in its documentary research but unreliable in terms of the catalogue raisonné of his work.[1] As is too often the case with artists and craftsmen who do not sign their works, many pieces by Gouthière's contemporaries or later imitators were attributed to him, and some by him were attributed to others. Gouthière had mastered the art of chasing and gilding on metal to a level previously unseen in France; however, in the second half of the eighteenth century, there were several Parisian craftsmen capable of finely chasing bronze, and a few could imitate Gouthière's technique of matte gilding, giving their work the soft luster that enchanted a refined and frivolous clientele delighted to depart from the severe and cold *goût grec* (Greek taste) prevalent in the years 1755 to 1765.

Gouthière's clientele comprised first and foremost those wealthy members of the royal court with lavish lifestyles. He also worked for the Menus-Plaisirs et Affaires de la Chambre du Roi, an administrative body of the Maison du Roi (the king's household) that managed the king's personal effects and organized his entertainment, creating sets for theatrical productions and significant occasions such as marriages and funerals. The artists employed by the Menus-Plaisirs were free to develop new ideas without constraint, and their workshops were the locus for the forging of new fashions. A 1769 commission from the Menus-Plaisirs was among Gouthière's first documented works (cat. 41). The Premiers Gentilshommes de la Chambre, who headed the Menus-Plaisirs, were powerful members of the nobility whose luxurious and eccentric lives were well documented by the press. The best known among them, Louis-Marie-Augustin, the Duke of Aumont (1709–1782), was Gouthière's best client, not only commissioning works for himself but also encouraging members of his family—his brother-in-law, Emmanuel-Félicité de Durfort, the Duke of Duras (1715–1789); his daughter Jeanne-Louise-Constance d'Aumont, the Duchess of Villeroy (1731–1816); and his daughter-in-law, Louise-Jeanne de Durfort de Duras, the Duchess of Mazarin (1735–1781)—to do so as well.

Jeanne Bécu, the Countess Du Barry (1743–1793), can also be viewed as a charming creation of the Menus-Plaisirs: the tributes paid to her by the Duke of Duras and Louis-François-Armand de Vignerod, the Duke of Richelieu (1696–1788), both Premiers Gentilshommes de la Chambre, helped launch her brilliant career as Louis XV's mistress. The legend surrounding Gouthière has Du Barry as the principal cause of both his success and his downfall, but this is inaccurate on both counts. Gouthière was employed by the Menus-Plaisirs long before he ever worked for Louis XV's favorite, and he secured important commissions long after those he received from the countess, which became less frequent after the king's death in 1774. More significant for Gouthière were the deaths, in quick succession, of his primary patrons: the Duchess of Mazarin (1781) and the Duke of Aumont (1782). The lengthy process of settling their estates would deprive him of the capital he needed for his own business.

All of Paris knew of the memorable sales that followed the deaths of the Duchess of Mazarin and the Duke of Aumont and the high prices the extraordinary objets d'art executed by Gouthière had fetched. The sale of the duchess's collections served as a sort of general rehearsal for the sale of those of the duke. Organized with a modern sense of marketing, the Aumont sale included an illustrated catalogue produced as a tribute to Gouthière (whose name was indicated by the initial G). Louis XVI paid high prices for the finest pieces, which were destined for the Muséum du Louvre (the future Musée du Louvre), and Marie Antoinette did likewise to furnish her private apartments. The sale covered Gouthière in glory, but his fall from grace was not far off. He had to borrow more money to finish the bronzes that were included in the sale. He did, however, take advantage of the opportunity to gain some publicity for himself prior to the sale: "This week at the premises of Mr. Gouthière, Chaser-Gilder to the King, Rue du Faubourg St-Martin, near the Guardhouse, can be seen Tables, Vases, and Wall lights, in gilt bronze, with arabesques in reliefs, the execution of which is a great credit to this Artist and will surely arouse Connoisseurs' curiosity."[2]

Mme Du Barry's tragic end marked a new phase in the creation of Gouthière's legend. Shortly before the French Revolution, Louis XV's former favorite had ordered several pieces from Gouthière, but her imprisonment, the confiscation of her belongings by the Republic, and her subsequent sentencing to death in 1793 suspended their production and payment. In a lengthy dispute between Gouthière and the French state, Gouthière contested the amount of the debt, which came to 756,000 francs in devalued paper money. In 1829, during the period of the Bourbon Restoration, Gouthière's son took the Countess Du Barry's heirs to court to recover the full amount of this debt. The case, which was heard in 1836 under the July Monarchy,[3] was followed with interest in the Faubourg Saint-Germain, where the cult of the ancien régime flourished; eighteenth-century style was coming back into fashion, and a number of foreign collectors, including the fourth Marquess of Hertford (1800–1870), were assembling the finest pieces. A new vogue was emerging for gilt bronzes from the time of Louis XVI, and the best of these were too freely attributed to Gouthière. They remain so today.

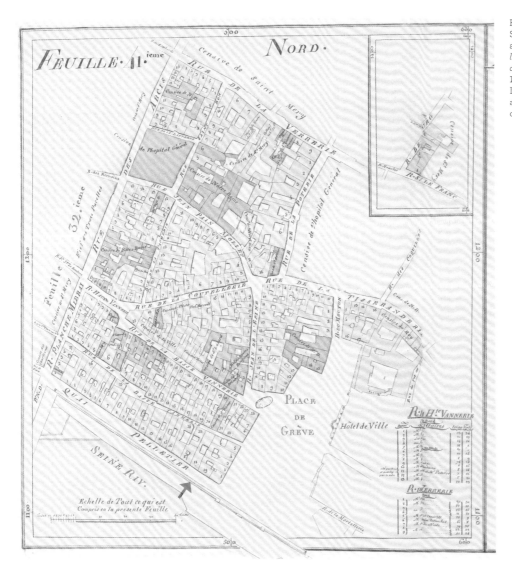

Fig. 1
Sheet 41 from M. Rittmann and Jean Junié, *Atlas de la censive de l'Archevêché dans Paris*, 1786 (Brette 1906). Getty Research Institute, Los Angeles. The arrow points to the location of the Soleil d'Or.

APPRENTICESHIP AND EARLY CAREER

We have no birth date for Pierre-Joseph-Désiré Gouthière; his baptism, however, was celebrated in the church of Saint-Pierre at Bar-sur-Aube on January 19, 1732.[4] His father, Claude, who had eleven children, was a master saddler there, and one of his sons would follow in his footsteps.[5] Jacques Robiquet suggests that Pierre may have come to the attention of the Duke of Aumont during one of his stays on the land he owned in the Champagne region.[6] A similarly fragile hypothesis posits that Denis-Pierre-Jean Papillon de la Ferté (1727–1794), steward of the Menus-Plaisirs—who, though born at Châlons-sur-Marne, had made the province of Champagne his home and was associated with a gilt-bronze business from 1755—took Gouthière under his wing.[7]

Almost nothing is known of Gouthière's initial training, which may have begun in Troyes but mostly took place in the Paris workshop of François Ceriset, a gilder based on the sixth floor of a building on the Quai Pelletier that bore the sign of the Soleil d'Or (Golden Sun) (fig. 1).[8] Ceriset died in 1756, two years after his first wife, Marguerite Vast. Their inventories testify to a comfortable lifestyle made possible by an impressive clientele of merchants of luxury goods, jewelers, clockmakers, and silversmiths, including François-Thomas Germain (1726–1791), the sculptor and silversmith to the king.[9] Among Ceriset's employees was a young woman called Henriette, possibly the same Marie-Madeleine Henriet who became his second wife in 1754[10] and

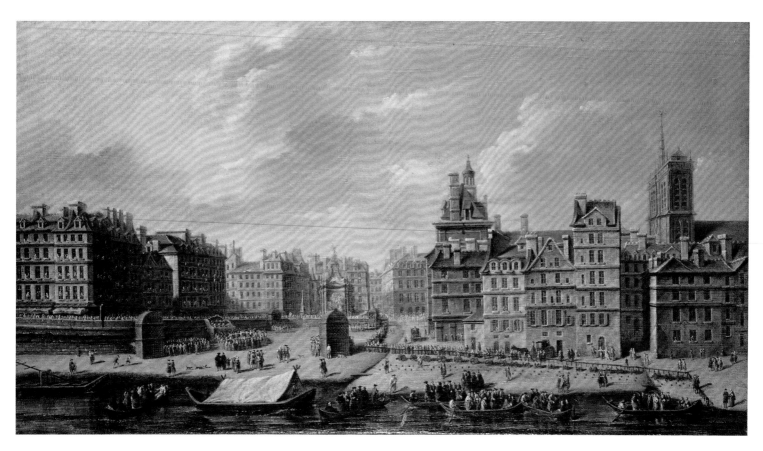

Fig. 2
Nicolas and Jean-Baptiste Raguenet,
*Party Given at Place de Grève on
the Occasion of the Birth of Princess
Marie-Thérèse, Daughter of the
Dauphin,* July 1746. Oil on canvas,
1754. Musée Carnavelet, Paris.
The Boucle d'Or was in one of the
buildings on the far left.

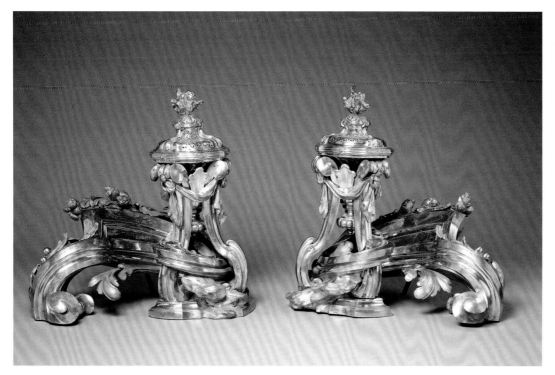

Fig. 3
François-Thomas Germain,
Pair of Firedogs, 1757. Gilt
bronze, 22½ × 23¼ × 15¾ in.
(57 × 59 × 40 cm). Musée du
Louvre, Paris (OA 8278-79)

Gouthière's first wife in 1758,[11] when Ceriset died. Marie-Madeleine Henriet brought Gouthière a dowry of 4,000 *livres* "in cash, merchandise from her business, and furniture, linen and livestock for her personal use." Gouthière's contribution was more modest, consisting of 600 *livres* "from his individual earnings and savings."[12] Gouthière's parents must have thought that Pierre had married well, as they went to great lengths—even mortgaging their property—to augment the dowry. Their efforts raised 1,400 *livres*, consisting mainly in vineyards with a value of 672 *livres* as an advance on inheritance, linen and fabrics worth 500 *livres*, and wine worth 150 *livres*. To that was added 677 *livres* in cash. Gouthière withdrew 1,000 *livres* from this dowry to pay for his admission as a Parisian master gilder, which was recorded on April 13, 1758.[13]

Upon Ceriset's death, his Soleil d'Or workshop was taken over by Gouthière, whose ambition infused new energy into the enterprise. This was reflected soon afterward in the change of address to a neighboring building at the sign of the Boucle d'Or (Golden Buckle),[14] a presumably larger space previously occupied by Jacques Lajoüe (1686–1761), painter to the king (fig. 2). Gouthière's family also grew, with the birth of his only son, Pierre, who was baptized on April 11, 1762.

At the beginning of the 1760s, Gouthière carried out a considerable amount of work for the silversmith François-Thomas Germain, who certainly played a role in his early success. Part of this activity is revealed in the bankruptcy records of the silversmith's business in 1765: they show that Gouthière was owed 19,006 *livres* for gilding work on both silver and bronze.[15] This col-

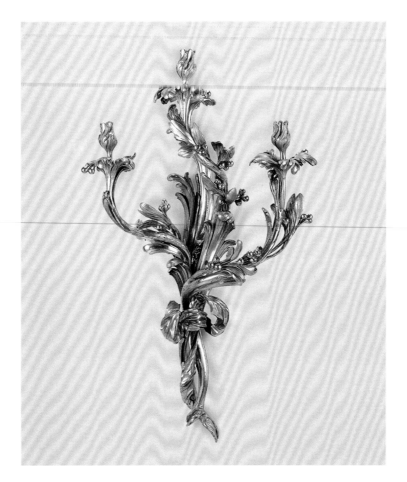

laboration calls into question the veracity of some of Germain's advertisements, notably one he placed in the *Avant-Coureur* on September 8, 1766, in which he boasted that he had "revived and perfected this line of business [gilding], which has fallen too much into decline in France." One might see this, as did historian Germain Bapst, as proof that Germain was claiming credit for innovations that were Gouthière's.[16] However, Gouthière's first credit notes for Germain's bankruptcy fell due on June 6, 1764, and there is no mention before this date of a collaboration between the silversmith and the gilder, though Germain had claimed as early as October 22, 1755, that he had "found the means to gild silver in a superior manner to all those that are known among artists."[17] He was also experimenting with a new technique for gilding bronze. He alluded to it in correspondence relating to the chimneypiece of the Danish ambassador Johan Hartvig Ernst von Bernstorff (1712–1772), in which he refers to new methods of gilding that cost three times as much as the ones in common use.[18] The chimneypiece in the Bernstorff Palace in Copenhagen, where it still adorns the main salon, is signed and dated 1756, and the gilt bronzes known to be by

Germain are all from this period, including the Creation of the World clock executed in 1754,[19] the candelabra of the Palais Royal signed and dated 1756 (see fig. 4),[20] and the Louvre firedogs signed and dated 1757 (fig. 3).[21] To attribute their gilding to Gouthière, as has been done for the Louvre firedogs,[22] would have required the collaboration between silversmith and gilder to date back to a period before Gouthière became a master craftsman. It may therefore be more fitting to partially credit the gilding to his master, François Ceriset, whose importance thus deserves reexamination.

Although Gouthière's name is not mentioned, a few objects known to be created by him for Germain were described in the *Mercure de France* of January 1766:

> Mr. Germain, sculptor-silversmith to the king and Company, ever driven by a desire to bring the works he undertakes to the highest level of perfection, notifies the public that on the 24th of this month, in the premises where his workshops are situated on Rue des Orties, opposite the Guichet Saint Nicaise, will be on view a collection of antique vases in various agreeable forms, and whose composition is equal in beauty to agate and the most precious of stones, all embellished in exquisite taste and with the finest of gilding, which he has perfected even further since it was presented to the king.

There is nothing in the literature of this presentation to Louis XV. The *Mercure* did, however, run a reworked version of the notice in February 1766:

> Mr. Germain, sculptor-silversmith to the king, and his patrons, have the honor of informing you that in the workshop are to be seen . . . a collection of vases in a new material, which so perfectly imitates the prisms of rubies and amethysts, alabaster and agate, that connoisseurs' eyes are deceived by them; they venture to say that the bronze ornaments and forms that adorn these vases are in good taste and that there is presently nothing similar in this manner.[23]

The creator of these marvelously imitative materials was also praised by Casimir Czempinski, the king of Poland's envoy in Paris, who wrote to his master on August 10, 1764 that he knew "a maker of stucco of the highest order here, who imitates all types of marble, admirable above all for chimneypieces." He was referring to Jean-François Hermand, a sculptor and stucco worker who himself boasted to Stanislas-August Poniatowski (1732–1798) that he had "composed the material of the vases that Mr. Germain produced for Your Majesty."[24] Three of these vases still survive in the Royal Castle in Warsaw (cat. 3). Gouthière claimed authorship of the gilt-bronze mounts of these vases in an undated letter he and the silversmith Jean Rameau boldly wrote to the Polish sovereign to circumvent Germain, in which they took

> the liberty of very humbly representing to Your Majesty that, for a long time, we have both been running the works of Germain, silversmith to the king of France; the former for gilding and chasing, being the only one to possess the color in which Your Majesty's works are gilded, and the latter, for silversmithing; that having had the honor of working for Your Majesty, they have been fortunate enough for their works to have been appreciated by

Yourself, and they dare to assert that Germain, who appeared to be their author, was absolutely incapable of making them, or indeed of bringing them to perfection; the disgraceful bankruptcy that he has just forced his creditors to endure, among whose number is Gouthière, one of the supplicants, is entire proof of it . . . [they offer themselves] to Your Majesty, that he might deign to look favorably upon them by accepting them, the first as his gilder chaser, the second to undertake his silver.[25]

Gouthière's career thereafter supports this declaration. And Rameau's role in "running" Germain's workshop, which numbered fifty laborers,[26] should not be viewed lightly. In 1752, Rameau had been employed by Germain as a sculptor at 1,800 *livres* per year with lodgings in his home on Rue des Orties.[27]

Many gilt vases from 1765 were found in Gouthière's workshop when the estimate of merchandise belonging to Germain was drawn up on October 16, 1767.[28] Gouthière still held, for gilding, a large proportion of the toilette and dining sets commissioned by the royal court of Portugal (cats. 1, 2), as well as some gold tableware and a sword in the same metal, which suggests that he may also have chased them. Among the less precious objects were "4 paperweights forming a platform surmounted by a bull, 2 of said paperweights being entirely in gilt bronze, valued at 640 *livres*; the 2 others with only the platforms in gilt bronze and the bulls in a smoky color, valued at 500 *livres*, amounting to a total sum of 1,140 *livres*."

Gouthière's collaboration with Germain put him in contact with the silversmith's dazzling clientele, thereby presenting the possibility for expansion of his business. In France, Germain supervised the decorations of many princely palaces, including those of Louis-Philippe, Duke of Orléans (1725–1785), and Charles de Rohan, Marshal Prince of Soubise (1715–1787).[29] He also worked for the foreign courts of Portugal, Denmark, and Poland. Marie-Thérèse Rodet, known as Mme Geoffrin (1699–1777), was a friend of King Stanislas-August and seems to have played the role of adviser in Franco-Polish artistic relationships. While she did not particularly like Germain—whom she strongly criticized in a letter written to the king of Poland on June 24, 1765 ("Germain is stupid, loose-tongued, deceitful and insolent, he has just gone bankrupt")[30]—she no doubt was more favorably inclined toward Gouthière, whom she patronized (cat. 6).

Gouthière may also have been responsible for the gilding of a Three Graces clock from a model by the bronze-maker François Vion (master in 1764), delivered in 1769 to the Countess Du Barry by the merchant of luxury goods Simon-Philippe Poirier (ca. 1720–1785) and said to be "gilded with Germain's gold," another example of which is in the Louvre (fig. 5).[31] All this suggests intense activity, all the more so since Gouthière was probably gilding for other bronze-makers or goldsmiths.

Gouthière's work during the second half of the 1760s is better known, largely because of pieces that are signed and dated 1767 (cats. 4, 18), the year his luck finally began to turn after ten years of relentless work. His ambition may have led him to overstep his social rank on occasion. As a result of calling a soldier from the king's musketeers a rogue during an evening honoring Madeleine-Augustine Courtois (d. ca. 1810) of the Académie Royale de Musique, he was jailed in the For-l'Évêque prison on April 1, 1767.[32]

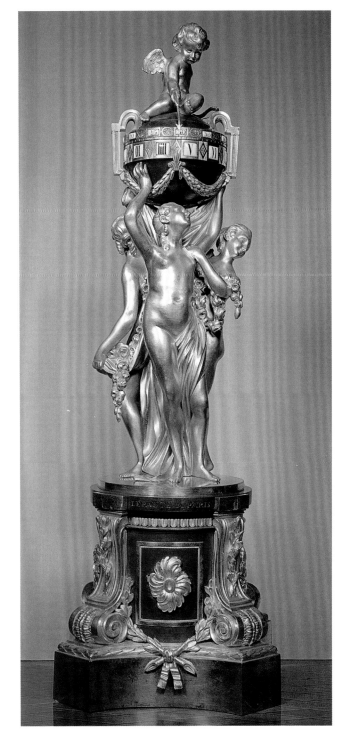

Fig. 5
Jean-André and Jean-Baptiste
Lepaute (clockmakers) and François
Vion (bronze-maker), *Three Graces
Clock*, 1769. Gilt bronze, base in
ebony, 20½ × 7⅛ in. (52 × 18 cm).
Musée du Louvre, Paris (OA 5433)

The year 1767 ended with professional success. On November 7, Gouthière received from the Duke of Aumont a certificate of his status as gilder (*doreur seul ordinaire*) to the Menus-Plaisirs "on the basis of testimony we possess as to the intelligence, ability and integrity of Mr. Gouthière, merchant gilder [*marchand doreur*] in Paris."[33] The term *marchand* implies that Gouthière ran a store in addition to his workshop. Gouthière thenceforth found himself at the heart of the Menus-Plaisirs' artistic activity. Fine marble and hardstones were coming back into fashion as technical advances allowed them to be cut more easily. The composite vases that Gouthière had mounted and gilded for Germain were now viewed with disdain by true connoisseurs such as the dukes of Richelieu and Aumont, who had ancient columns and rare fragments brought from Italy at great expense to have them reworked and mounted to their taste. At the same time, new quarries of granite in rare shades were being found in France. One of the most significant discoveries was made in Giromagny, near Belfort in Alsace, on land belonging to the Duchess of Mazarin. The sculptors and marble cutters (*marbriers*) Jean-Baptiste Feuillet and Charles Guillemain had acquired reputations through the technical advances they brought to the challenging art of working hardstones. Gouthière excelled in the art of creating bronze mounts and ornaments for these objects, and as early as 1768 he was owed 1,600 *livres* by Guillemain.[34] The inventory drawn up in 1769 after the death of the merchant for luxury goods Henri Lebrun informs us of the nature of their relationship, which was worth 17,855 *livres* and included a transaction on December 31, 1767, involving a sum of 8,600 *livres* for two vases in African marble, six small granite vases, and two porphyry vases at 4,000 *livres* "after designs agreed upon by them."[35]

Gouthière also had a significant number of private clients, but they are difficult to identify. One of the first recorded private commissions was carried out on Rue des Bons-Enfants at the residence of Marc-René de Voyer de Paulmy, Marquis of Voyer (1722-1782), for whom the architect Charles De Wailly (1730-1798) had designed an original interior.[36] On April 4, 1767, De Wailly wrote to his client: "The bronzes for the chimneypiece [in the salon] are in progress and Gouthière has promised me that in two months everything will be ready to be installed; the pilasters of the chimneypiece are chased and are very good."[37] Between April 1767 and November 1769, Gouthière executed for d'Argenson the bronzes for a Montalembert-type mechanism. In 1763, Marc-René de Montalembert (1714-1800) had invented a system that allowed fireplaces to be transformed into stoves by adding doors that closed off the hearth; the three engravings by John Ingram that were attached to the bill presented to the Académie Royale des Sciences show the kind of decoration typically applied to such doors, which quickly became

Fig. 6
William Chambers,
*Hôtel d'Argenson, Paris:
Details of a Montalembert
Chimneypiece*, 1774. Ink on
paper. Royal Institute of
British Architects, London
(RIBA A.F. 10/33)

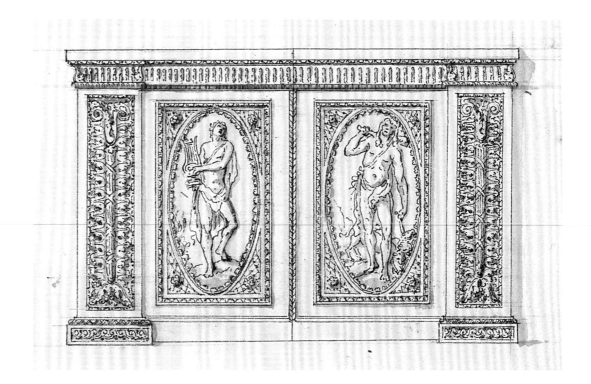

very popular.[38] The decoration created by Gouthière for d'Argenson, on a frame entrusted to the iron manufacturer Étienne-Henri Dumas,[39] is known from a drawing by William Chambers (1723–1796): between two pilasters, each door bears an oval medallion, one of which depicted Orpheus charming a snake and the other Hercules after taming Cerberus (fig. 6).

The bankruptcy of the journeyman chaser Jean-Nicolas Lebeau, declared on September 27, 1769, sheds additional light on Gouthière's work during this period. Gouthière subcontracted chasing work to Lebeau, whose file for bankruptcy contains a "statement of chasing works carried out . . . since May 10, 1765" for Gouthière.[40] This document relates primarily to vases with handles featuring the heads of eagles, rams, Hercules, or Midas, which may be related to the Jupiter Ammon heads that flank two vase-clocks made in 1774 for Armand-Louis-Joseph Paris de Montmartel, Marquis of Brunoy (1748–1781)[41] and now at Waddesdon Manor[42] (fig. 7). While the chasing may be by Lebeau (working for Gouthière), other artists were involved in their execution. The movements are by the clockmaker Joseph-Léonard Roque (master in 1770); and the marble and bronze, signed and dated *Doublet, inv. et Julia Px 1774*, were designed by the painter and designer Pierre-Louis Doublet and modeled by the sculptor Jean-Baptiste Julia.

By around 1772, Gouthière had escaped anonymity and was beginning to acquire a reputation. His name was given by the architect François-Joseph Bélanger (1744–1818) to Colonel St.

Paul of Ewart (1729–1812), secretary and later minister plenipotentiary to the king of England, who was preparing a directory of the best craftsmen in Paris. The resulting entry stated that "the man who makes the best hunting utensils, such as powder flasks etc. . . . he works for Gouthière, at the Boucle d'Or, on the Quai Pelletier."[43] Also noted were the names of the three best gilders on metals: Nicolas Boulez (or Boullez), Gouthière, "very famous, the one who works for Mme Du Barry," and Charles Léveillé, "another famous gilder."[44]

GOUTHIÈRE'S WORKSHOP, 1770–76

From 1770 to 1776, without having left the Quai Pelletier, Gouthière was to be found in a building that bore the Au Méridien sign.[45] However, since buildings took their names from those of their ground-floor shops, it is not clear whether Gouthière moved or the tenant on the ground-floor shop changed. Indeed, Gouthière's workshop would have been on an upper floor: the work of a chaser-gilder did not require much space, just enough for a few workers (a journeyman and some apprentices) and an assortment of small tools. It was in this workshop that some of Gouthière's masterpieces were executed and here that his reputation received a boost when, on January 6, 1775, he was appointed chaser-gilder to the Count of Artois, brother of Louis XVI:

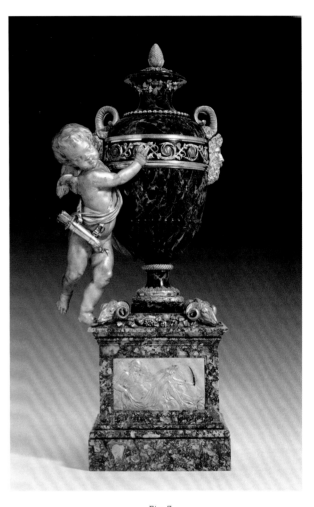

> His Excellency the Count of Artois being at Versailles, and desiring to have in his service a person who possesses the skill and talents necessary to chase and gild the works in bronze that it may so please him to commission, on the favorable report that has been made to him on Mr. Gouthière, His Excellency has accorded him the title of chaser and gilder for the said works, wishing and intending that the said Mr. Gouthière could use the said title in all public and private acts, without however being able to pretend to any appointment or assignment of any sort on the basis of the said title.[46]

Fig. 7
Pierre-Louis Doublet (designer), Jean-Baptiste Julia (sculptor), and Joseph-Léonard Roque (clockmaker), *Clock*, 1774. Marble and gilt bronze, 26⅛ × 11¼ × 9¾ in. (66.3 × 28.6 × 24.8 cm). Waddesdon Manor, The Rothschild Collection, The National Trust; Bequest of James de Rothschild (2484.1, 2)

During this period, Gouthière was linked to a project begun in October 1770 by the sculptors Rousseau de la Rottière and Nicolas-François-Daniel Lhuillier, who had entered into a twelve-year partnership "for works of sculpture, arabesque models, designs."[47] The following year, they presented a collection of drawings and studies made in Rome for the approval of the Académie Royale d'Architecture.[48] They were met with keen encouragement, and the pair subsequently undertook to publish them. Their partnership was, however, prematurely dissolved in October 1772; the following month, Lhuillier entered into an agreement with the painter and designer Pierre-Louis Doublet to publish—by subscription and in six folio volumes—a "compendium containing a selection of the finest antique and modern ornaments, drawn on site, by Mr. L'huillier, in the palaces of Italy and in our Royal Houses in France." These volumes presented "the simplicity of the

Greeks' imagination, the sublime genius of the Romans, the prodigious and unique invention of the Arabs, and finally the ingenious and prolific elegance of the French, that people so favored by Nature and the Arts, that seems to create that which it imitates, that embellishes all it touches and that imprints on the very things of which it is but the imitator, graces that belong to it alone."[49]

A supplement to these volumes was to include "bronzes, such as mantelpiece ornaments, firedogs, wall lights and candelabra, torchères and vases, drawn from the interiors of our great lords' apartments, most of them executed under the watchful eye of Mr. Gouthière, chaser and gilder to the king."[50] However, only a few plates intended for the first volume were published.[51] The phrase "under the watchful eye of Mr. Gouthière" probably meant supervision rather than execution.

Royal Commissions

The marriage of the dauphin, Louis XVI (1754–1793), to the Austrian Archduchess Marie Antoinette (1755–1793), which was scheduled for May 16, 1770, set the Menus-Plaisirs in full motion, with tasks as diverse as the design of the scenery and machinery of the new opera house at Versailles and the selection of gold boxes to be given to the wedding guests. Gouthière's role was relatively modest; he was asked only for a few ornamental parts for the dauphine's large jewelry cabinet, the design of which (by François-Joseph Bélanger) had been approved by the Duke of Aumont in August 1769 (cat. 41).[52]

When Marie Antoinette arrived at Versailles, she was surprised to learn of the king's official mistress, the Countess Du Barry (fig. 9), who had apartments near those of Louis XV in each

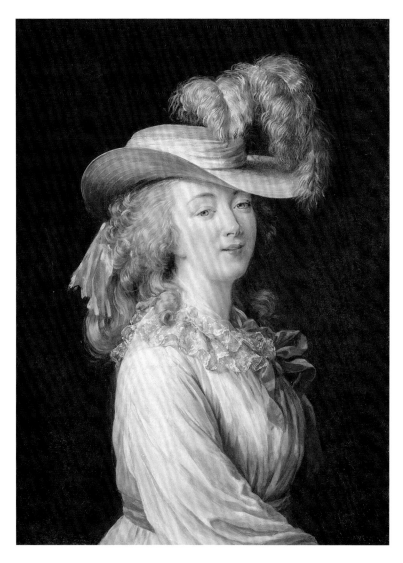

of the royal residences. With Du Barry's lodgings at Fontainebleau removed to allow for expansion of the king's private apartments, the king had a salon erected for her as an outbuilding in the Jardin de Diane. Construction of the salon took place in 1772-74 and 1777.[53] It is likely that Mme Du Barry insisted on hiring Gouthière, who was then working for her in Louveciennes. For the salon, Gouthière executed after a model by the sculptor Louis-Simon Boizot (1743-1809) the gilt bronze for the chimneypiece (cat. 28) ordered by the Bâtiments du Roi, the department of the king's household responsible for the building and maintenance of the royal residences, as well as the royal gardens, art workshops, and manufactories. He also delivered four candelabra-vases

Fig. 10
Detail of clock pendant
(fig. 7)

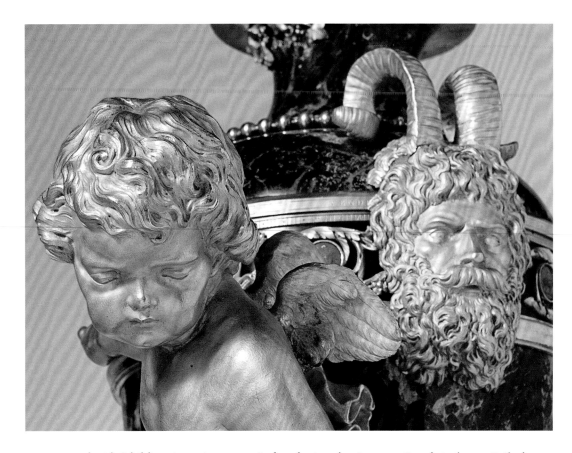

ornamented with "children in various poses" after designs by Jacques Gondoin (1737–1818), the architect and designer of the Garde-Meuble de la Couronne, the royal administrative body responsible for the furniture and objets d'art in the royal residences, which had commissioned them.[54]

The commissions from Joseph-Dominique de Moreton, Marquis of Chabrillan (1744–1793) and first equerry to the Countess of Artois, for the latter's carriages, represented a large proportion of Gouthière's activity and a major source of his income.[55] Bélanger had been "charged by the Court to set up the carriages to be used for the Prince and Princess's entrance after their marriage," and it was again Bélanger who designed the coach for Louis XVI's coronation (fig. 8); on both occasions, he had "exchanged bizarre forms [of the rococo] for the simple and noble [neo-classical] style prescribed by necessity and taste."[56]

The stables of the Countess of Artois were equipped between 1772 and 1775. Only Gouthière's invoice from 1773 has been found, showing a sum of 168,502 *livres* that was settled at 141,344 *livres*.[57] Carriages were a domain where luxury could be layered onto practicality to create incredibly lavish displays. There were an increasing number of models at the time, varying according to speed and comfort levels and whether the carriages were to be used in town or on the open

road. Gouthière's invoice lists a range of carriages—those for the city, countryside, travel, and hunting—from the great ceremonial carriage to sedan chairs. The stagecoach was varnished on a gold ground by Jean-Alexandre Martin (1743–after 1795), painter-varnisher to the king. For this commission, Gouthière did not limit himself to chasing and gilding but rather executed all the steps of making gilt bronzes, from modeling figures and ornaments in wax through the final stages. He probably had help with the modeling, but his invoices do not say so. We only know that from 1774 at least, he was in contact with Daniel Auber(t) (master in 1757), a sculptor who resided at the Petites Écuries du Roi in Paris, as well as with his brother-in-law, the varnisher Antoine-Paul Vincent, both of whom specialized in luxury coaches. The inventory drawn up after the death of Auber's wife, Marie-Jeanne Vincent, lists an account with Gouthière from June 5 to July 1, 1774.[58] Nor did Gouthière give the name of his caster, who may have been Jean-Claude-Thomas Chambellan Duplessis (known as Duplessis *fils*).[59] The Count of Artois was in no hurry to pay for his wife's coaches, which forced Gouthière to borrow money to pay his own subcontractors and tradesmen.[60]

Private Clientele

Unlike the commissions carried out in the royal residences for the Countess Du Barry's apartments, which were paid for by the Bâtiments du Roi, those at Louveciennes were paid for by Du Barry herself (fig. 11). On July 29, 1770, Gouthière went to Louveciennes for the first time, summoned by Du Barry's architect, Claude-Nicolas Ledoux (1736–1806), who was responsible for the design and production of the bronzes for the new pavilion,[61] specifying his involvement in "bronzes for M. Gouthière for which [he] made the large-scale drawings and managed the models and execution."[62] The invoice details the work for the embellishments on the doors, window frames, and chimneypieces, as well as for the execution of certain wall lights, chandeliers, and firedogs (cat. 24).[63] Gouthière's contemporaries mainly remembered[64] the architectural gilt bronzes, which had been fashioned with unprecedented refinement—abounding in garlands of roses, myrtle, and vines. Most of the door and window knobs were adorned with the countess's monogram (cat. 27); eventually ripped out of the pavilion, these knobs would become highly coveted by collectors.[65] The chimneypieces were particularly remarkable; though confiscated in 1793, they have not all disappeared (cats. 29, 30).

Gouthière valued these extraordinarily fine pieces at 134,218 *livres*, a sum reduced by the silversmiths Jacques Roettiers (1707–1784) and his son Jacques-Nicolas (1736–1788), who were responsible for settling the payment, to 99,298 *livres*, paid on December 31, 1773. A second invoice, paid on the same day, was for additional work by Gouthière, in particular, several pieces in vermeil (silver gilt).[66]

While Ledoux was designing the bronze models for Du Barry at Louveciennes, Gouthière was signing a contract with the Duke of Aumont, his greatest patron. Their collaboration is mentioned in a document written by Bélanger after the duke's death,[67] in which Bélanger requested 24,000 *livres* "for work done . . . as his architect and his designer during the space of ten consecutive years" and sought 1,307 *livres* "for the advanced payment made to various workers." To justify these claims, Bélanger produced "a large number of plans, designs and sketches made by himself

for the late duke . . . both for the architecture of his buildings and for vases, columns, tables, pedestals, and other objects for his cabinet of curiosities," together with 124 letters penned by the duke, concerning the same work. Bélanger settled at 15,000 *livres* and handed over the documents related to the debt. Among these was "a contract made between the late Duke of Aumont and Mr. Gouthière on November 29, 1770, for the gilding and chasing of some of the works made for the said lord, the Duke of Aumont, after designs by Mr. Bélanger . . . (and) a bundle of 36 sheets of plans, designs, and sketches." Bélanger also promised to turn over a bundle of twenty-nine designs over the next nine months, this being the time needed "to be able to produce copies of them for his own use and personal satisfaction." There is further evidence of Bélanger's role in Gouthière's work in a letter the architect wrote to the Duke of Aumont on November 17, 1774:

> I have the honor of sending you an invoice for the models that Mr. Gouthière has had made
> for you after my designs by Mr. [Pierre-Jean-Baptiste] Delaplanche, sculptor, which I paid
> to the sum of 368 *livres*, this appearing to me to be their fair value, but which I did not think

I should sign, not having received direct orders from you on this subject. Yesterday I saw again all the work that is being done for you at Mr. Gouthière's; I found all the pieces in the workers' hands, and at a very advanced stage of production; I am following them closely and will not let them out of my gaze until they are entirely finished.[68]

Bélanger's brother-in-law, the architect and designer Jean-Démosthène Dugourc (1749-1825), stated in his autobiography that he had supervised the execution of "all the precious gilt bronzes executed over ten years by the famous Gouthière for the Duke of Aumont, the Duchess of Mazarin, Mme Du Barry, Mr. de Bondy, etc."[69] The pieces made for Aumont entered the duke's cabinet of curiosities, which was renowned for its antique marble, mounted porphyry, and oriental porcelain.[70] Gouthière's gilt bronzes were familiar to connoisseurs of the time and attracted the attention of Horace Walpole (1717-1797), when he visited the Duke of Aumont's sumptuous *hôtel particulier* on the Place Louis XV (now the Hôtel Crillon, Place de la Concorde) in October 1775. Of his visit, Walpole wrote: "To the Hôtel d'Aumont. 2 millions in tables, columns, lustres and China. 2 beautiful porphyry tables with legs of same in ormolu exquisite par Gouthière who works only for him."[71]

Gouthière's work for the Duke of Aumont is among his best known, both through the records sealed upon the duke's death, on April 14, 1782, in which the bronze-maker appears on the forty-fifth line of his creditors,[72] and through the inventory begun after the duke's death, on May 1, 1782.[73] The gilt-bronze objects were listed and valued by the merchant of luxury goods Philippe-François Julliot (1727-1794) and the painter Alexandre-Joseph Paillet (1743-1814). Upon the duke's death, Gouthière still had several unfinished bronzes in his workshop and had to borrow 17,000 *livres* to complete and gild them.[74] The estimates for these pieces constitute an additional source of information. Apparently, the appraisers proved difficult to select. The first to be assigned the task, on September 5, 1782, were the bronze-makers François Rémond (1745 or 1747-1812) and Jean-Baptiste Guyart, and in case of disagreement, Pierre-Adrien Pâris (1745-1819), who was architect to the Menus-Plaisirs du Roi and also responsible for the interior decoration of the Duke of Aumont's *hôtel*. Guyart was discredited and replaced on October 29 by Duplessis *fils*,[75] while Pâris was replaced as the third-party expert by Jean-Baptiste-François Chéret (1728-after 1791).[76] The most generous of the estimates was Rémond's—at 102,175 *livres*, it was nearly 25 percent higher than Duplessis's (75,500 *livres*). Rémond was the only one who gave the names of several involved parties: the master joiner Nicolas Pigalle, the painter Louis (?) Aubert, and the *marbrier* Augustin Bocciardi.

Another valuable source of information on Gouthière's work for the Duke of Aumont is the catalogue of the sale that began on December 12, 1782, which included engraved plates (see fig. 12), and the two copies of the catalogue illustrated by Germain de Saint-Aubin,[77] one of which may have belonged to the Count of Artois.[78] The catalogue, written by Julliot and Paillet, specifies that "all the works [by Gouthière] are indicated at the ends of the entries by the initial letter G"; in total, fifty-five objects in thirty-four lots, the finest of which were bought for the king[79] and the queen. Intended "to enrich the Museum that His Majesty is establishing in his Louvre Gallery," most of the king's purchases are preserved in the Musée du Louvre (fig. 12 and cats. 8, 11,

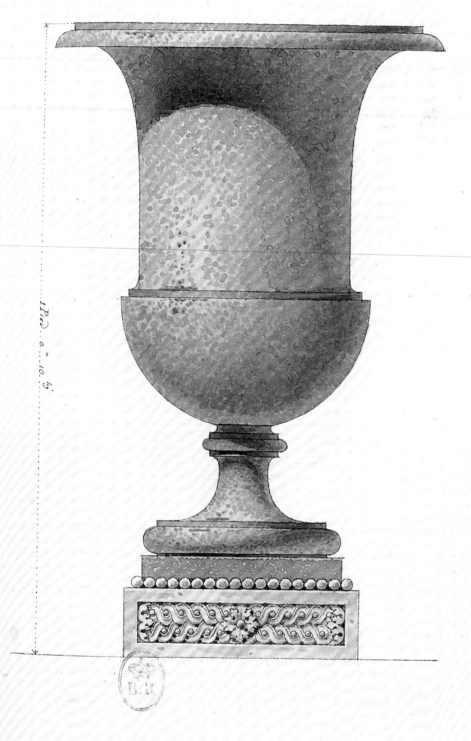

Fig. 12
Pierre-Adrien Pâris, *Preparatory Drawing for the Engraving, Representing a Vase from the Duke of Aumont*, 1782. Pencil, ink, and watercolor on paper, 7⅞ × 5⅛ in. (20 × 13 cm). Bibliothèque nationale de France, Paris (RES V 2586, pl. 3)

12, 15, 42–45), but not all of them are in the national collections (cats. 10, 14, 23, 40, 46, and 47); and the objects acquired by the queen are even less in evidence there (cats. 9, 13, 17, and 38).

Gouthière must have attended the sales with interest, knowing as he did the true value of his pieces. As is often the case in such situations, the good lots carried the bad ones along with them because of the bidders' enthusiasm. Thus Paillet pushed the Duke of Chabot to bid up to 1,500 *livres* for a lantern of unspecified authorship (lot 352) regarding which Gouthière assured Saint-Aubin "he would make the same lantern for 500 *livres*."[80]

After the sale, Chéret, the third-party expert, valued the bronze work that Gouthière had yet to be paid for at 88,470 *livres*. Of this amount, Gouthière had already received 11,504 *livres* in ten installments, between September 12, 1779, and March 23, 1782. Louis-Alexandre-Céleste, Duke of Villequier (1736–1814), son of the late Duke of Aumont, had advanced 3,600 *livres* to Gouthière in two installments, on September 26 and October 5, 1782; and he had further paid the sum of 52,979 *livres* directly to his creditors. Therefore, what remained was 20,386 *livres*, which he settled on January 30, 1783, directly with Gouthière's creditors.[81]

More speculative is the contribution of Gouthière to the execution of the gilt-bronze ornaments for the chimneypieces for the Duke of Aumont's residence. The chimneypiece in the duke's bedroom (figs. 14, 15), made after Pierre-Adrien Pâris's designs (fig. 13), is decorated with a female mask similar to those Gouthière made ten years earlier for François-Thomas Germain (cat. 3), and the laurel leaves recall those he made for the Duke of Aumont's alabaster vases, after a design by Bélanger (cat. 10). However, Pâris also worked at the duke's *hôtel particulier* with another bronze-maker, Jean-Baptiste Guyart, who submitted a bill for 4,532 *livres* to him in January 1778.[82]

In the euphoria of the 1770s, everyone was eager for Gouthière's work—from the high aristocracy to minor figures of the Parisian world of entertainment to financiers, art lovers, and the city of Avignon, for which he executed a large clock after a model by Louis-Simon Boizot and with a movement by Nicolas-Pierre Guichon Delunésy (cat. 19).

Between 1770 and 1776, Anne-Marguerite-Gabrielle de Beauvon-Craon, Duchess and Maréchale of Mirepoix (1707–1791)—a close acquaintance of the Countess Du Barry and a friend of the Marquise of Pompadour (1721–1764), whose debts were repeatedly paid by Louis XV (1710–1774)—ordered work from Gouthière that came to 3,244 *livres* (in ten invoices) that the Maréchale of Mirepoix struggled to pay. Although the invoices of Gouthière are not known, other sources may shed some light on the nature of the work. In 1775, Horace Walpole was able to admire "the grand cabinet" at the Maréchale of Mirepoix's residence, describing it as "round, all white and gold and glasses, with curtains in festoons of silk flambé and illuminated by four branches of lilies of ormolu, each as loose and graceful as that which Guido's angel holds in the Salutation . . . etc."[83] Also on April 13, 1782, the merchant of luxury goods Dominique Daguerre (d. 1796) demanded 300 *livres* for the "repair of two pairs of three-armed wall lights, which we regild with matte gilding, and for which we provided several screws and reattached several leaves"; and, an invoice of November 17, 1784, for 42 *livres*, for the supply of "twelve sockets [*binets*] specially made in gilt bronze, for the large lily wall lights." On April 13, 1782, Daguerre had also provided the Maréchale of Mirepoix with "a very large pair of wall lights with three arms decorated with lilies and ribbon tied in a knot, all in matte-gilded

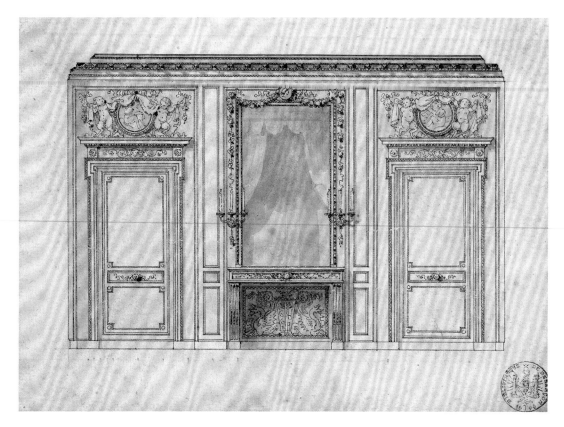

bronze" for 2,200 *livres*.[84] We cannot be sure that Gouthière had a hand in these items supplied and restored by Daguerre. In any case, the frequency of the maintenance work is surprising.

In 1772, Gouthière felt sufficiently confident about his prospects to purchase a large plot of land in the Faubourg Saint-Martin; he did not, however, possess the necessary funds. He approached Simon-Charles Boutin (1719–1794), receiver general of state finances, on August 18, 1772, to obtain 1,800 *livres* for the payment of the seigneurial duties to which his land was subject. His letter indicates that Boutin was a client for whom he had made firedogs and wall lights.[85]

On July 26, 1773, Gouthière, the architect Claude-Nicolas Ledoux, and the sculptor Jean-Baptiste Feuillet conferred on the price to be set for the sculptures made by Feuillet for the *hôtel particulier* of the Paris Opéra dancer Marie-Madeleine Guimard (1743–1816) on the Chaussée d'Antin: it was another chimneypiece designed by Ledoux, for which Feuillet had produced the wax model for bronzes then passed on to Gouthière.[86]

On December 17, 1773, Maria Leopoldina Palffy, dowager Princess Kinsky (1729–1794), who had just taken on the lifetime lease of an *hôtel particulier* on Rue Saint-Dominique, asked Gouthière to clean her gilt bronzes and, more importantly, supply some new ones. Gouthière requested 11,926 *livres* for the job, which included bronzes for "a chest of drawers, a secretaire and two corner-

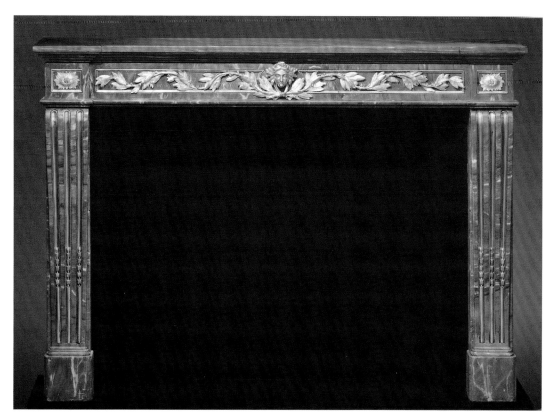

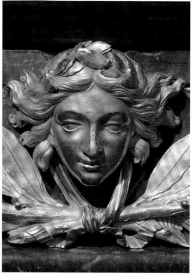

cabinets [*encoignures*], the supply and gilding of a large pair of firedogs with incense burners [*feu à cassolettes*] … two pairs of wall lights with arms for the chimneypiece" and several other items.[87] The princess, however, offered only 5,926 *livres*.[88] Part of the problem stemmed from the fact that the firedogs and wall lights were deemed too small for the drawing room where they were placed and had to be made larger; the princess had wanted them to resemble those of the Maréchale of Mirepoix, whose residence the experts visited to establish the comparison. Gouthière demanded 4,000 *livres* for the unforeseen increase in size. The judgment describes the wall lights with three arms in the form of lilies and roses tied together with a ribbon;[89] they were estimated to be worth only 3,328 *livres* by the merchant of luxury goods Simon-Philippe Poirier (ca. 1720–1785) on April 9, 1777, when the princess had her furniture valued.[90] Whatever the case, on June 12, 1777, Gouthière received 4,647 *livres* (including interest) in payment for his work. The princess wanted a third pair made, identical to the earlier ones, but on July 20, 1780, she approached not Gouthière but another caster-chaser-gilder, Nicolas Henry (act. 1771–after 1806). Henry executed the gilding for 1,900 *livres*.[91] The princess entrusted her marble cutter, Louis-François Leprince, with providing new chimneypieces, ornamented with gilt bronzes, for her boudoir and bathroom; it seems, however, that Leprince thwarted her plans by subcontracting the execution of the bronzes to Gouthière.[92]

The Marquis of Thoix, Louis-Guillaume-Angélique Gouffier (b. 1738), father-in-law of the Marquis of Choiseul-Gouffier, who lived on Rue de Richelieu, had commissioned the decoration of a new *hôtel particulier* on Rue de Monceau. He overspent, however, and fell prey to his creditors, including Gouthière, for 2,066 *livres*.[93]

Abel-François Poisson, Marquis of Marigny (1727-1781), brother of the Marquise of Pompadour and head of the Bâtiments du Roi, was also a client of Gouthière's: he owned at least two of his chandeliers in gilt bronze. In March 1779, he ordered that "a chandelier gilded by Gouthière" be transferred from the Château de Ménars to Paris, for the library of his residence on the Place des Victoires. This chandelier had been made before August 29, 1775, and on that date Marigny had it taken to Ménars by the packer Martin Pailliard, known as Delorme (1718-1799).[94] The 1779 carrier's invoice listed "two chandeliers by Gouthière with 8 arms in gilt bronze that had come from the dining room and winter salon at Ménars."[95] Neither the inventory drawn up after the marquis's death nor the catalogue of the sale of his collections allow the model to be identified; all we know, thanks to the first of these two documents, is that in Paris he had "another chandelier in chased and gilded bronze, valued with a smaller chandelier, also in gilt bronze, in the shape of a lyre, at 720 *livres*."[96]

The brothers Charles-Claude-Alexandre Taillepied de La Garenne (d. 1803) and Jean-Baptiste-Déodat Taillepied de Bondy (1741-1822) lived on Rue de Richelieu, at the corner of Boulevard Poissonnière, in two adjoining *hôtels* designed by Alexandre-Théodore Brongniart (1770-1847). Construction of Bondy's house began in 1771;[97] La Garenne's went up in 1773 on a plot of land given to him by his brother.[98] The sculptor Jean-Baptiste Julia had been entrusted in 1774 with all the decorative sculptural work and the gilt bronzes for a total of 25,000 *livres*. Once the project was underway, in 1776, Julia found himself unable to cover the advance costs and asked Gouthière to execute the work instead, without informing La Garenne of the arrangement. The bills came to 69,844 *livres*, of which 34,579 *livres* were for the bronzes alone. This led to a double dispute, between La Garenne and Julia on the one hand and Julia and Gouthière on the other.[99] The total additional cost was judged at 38,392 *livres*, 17,130 *livres* of which was for Gouthière's work, though he actually received 15,892 *livres*, all expenses paid.[100] The exact nature of his work on this occasion is not known, but it may have involved ornamentation for chimneypieces and several elaborate espagnolettes that are mentioned in a 1791 valuation following damage caused by a tenant, the notorious Lady Seymour Worsley (1757-1818).[101]

It was the architect Claude-Nicolas Ledoux who, in 1776, commissioned Gouthière to make a Montalembert-type stove-chimneypiece for François Fontaine de Cramayel (1714-1779) for his residence on Rue du Sentier. Gouthière's invoice (sold at auction) details the design of the four stove doors commissioned from a joiner, their execution, their decoration with mosaics of rosettes and interlacing motifs, and their gilding on a purple-colored background. Gouthière asked for 3,022 *livres* for them, a fee Ledoux reduced to 2,300 *livres*.[102]

In the 1770s, Antoine of Quelen, Duke of La Vauguyon (1706-1772) and governor of the royal children, was also a client of Gouthière's,[103] as was the farmer-general Pierre-Louis-Paul Randon de Boisset (1708-1776). The sale that took place after the death of the latter, totaling

Fig. 16
Eugène Atget, *Hôtel Gouthière, Rue
Pierre Bullet,* 1900–27. Gelatin-silver
print, 8⅞ × 6⅞ in. (22.4 × 17.5 cm). École
Nationale Supérieure des Beaux-Arts,
Paris (Ph 7369)

more than 1,300,000 *livres* in 1777, was one of the great auction sales that caused a stir among collectors.[104] Under lot 850, the catalogue describes "a medium pair of two-armed wall lights . . . matte-gilded by Gouthière."[105]

THE BUILDING OF THE HÔTEL GOUTHIÈRE AND THE FALL OF GOUTHIÈRE'S WORKSHOP

On April 29, 1772, confident in the success of his business, Gouthière purchased a large piece of land on Rue du Faubourg Saint-Martin (now numbers 72–76) for 17,050 *livres*.[106] Today, only the detached building and wings at the far end of the plot, at 6 rue Pierre Bullet—now considered a masterpiece of the day's taste—remain (fig. 16).[107] On August 18, 1772, Gouthière borrowed 1,800 *livres* from Simon-Charles Boutin to pay taxes owed to the clergy of the parish of Sainte-Opportune, who owned the land.[108] The purchase price itself had to be paid with 708 *livres* of interest, on April 3, 1773.[109] Two loans taken out on the same day made it possible for Gouthière to make this payment: 8,000 *livres* from the Duke of Aumont, as prepayment for works in progress, and 9,000 *livres* from Louis Lhuillier, assessor of parliamentary decrees (*contrôleur des Arrêtés du Parlement*).[110] On October 28, 1773, Gouthière borrowed 9,000 *livres* from Jacques-Nicolas-René Delorme (d. 1797), flower merchant to the king, to reimburse Lhuillier.[111] A week later, on November 4, he signed two promissory notes for 1,200 *livres* each for the jeweler Georges-Frédéric Stras (d. 1774). It is difficult to determine whether the notes stemmed from the normal course of his professional activities or are linked to his real-estate plans.[112] At the same time, Gouthière did not refrain from helping several good friends, acting as guarantor and even lending money, in January 1775, to Madeleine-Sophie Arnould (1740–1802), a singer at the Paris Opéra who was going through a difficult time.[113] On May 30, 1775, he nonetheless borrowed 7,000 *livres* from Charles-Philippe-Gaspard Fichon, otherwise known as Étienne-François, Marquis of Aligre (1727–1798), to pay back Delorme. Thus developed a dangerous pattern that eventually put Gouthière in the hands of speculators and rapidly escalated when he embarked on his building project.

Construction of the boundary walls of Gouthière's project was already underway on July 11, 1775, when he engaged the architect and entrepreneur Jean-Pierre Ango to visit the site.[114] Ango's first design shows a very long, rather narrow but widening parcel of land between the plots belonging to Pierre-Abraham Guerne (1742–1796), carpenter to the City of Paris, and Jean-Baptiste Reynard, the king's specially appointed mechanical engineer (*mécanicien privilégié*) and a member of the Académie des Sciences in Clermont-Ferrand. The buildings combined attractiveness with profitability. Via a long path, a porte cochère on the right led to a detached pavilion between courtyard and garden. It is unlikely that Gouthière ever intended to live in this house and more probable that he planned to rent it out for the income. To the left of the porte cochère and in the middle of two boutiques, a more modest entrance led to two courtyards that separated two independent buildings, each with a staircase, kitchen, stables, and sheds. Gouthière moved into the only completed building during the winter of 1776–77.

While ambitious, the program was not unreasonable. However, Gouthière had overextended himself, which left him unable to pay his contractors. On April 13, 1776, the king had to grant him a suspension of payment (*arrêt de surséance*). Forced on March 7 of the following year to take out more loans, Gouthière commissioned the architect Pierre Taboureur to produce a report on the buildings already completed, for which the paid bills already amounted to 68,562 *livres*.[115] In order to settle the accounts with his contractors (master mason, tiler, glazier, etc.), he borrowed 80,000 *livres* from Henri Armengau (d. 1787), a Parisian businessman and investor, on October 29, 1778.[116]

With a growing reputation as an unreliable payer, Gouthière was compelled to scale down his building projects and call in new master masons: Jean-Baptiste-Élisabeth Bimont and then Pierre Lemerle signed agreements with him, on April 7 and May 29, 1778, respectively, establishing a schedule and payment installments for the new work. The project was to be carried out according to the plans and under the direction of Joseph Métivier (d. April 1795), a talented sculptor but unexceptional architect Gouthière had known since their work at Louveciennes.[117] The reason Bimont dropped out on May 30, 1778, and Lemerle on July 10, is unknown. The work nonetheless continued, as is shown by the report dated May 2, 1780 (fig. 17), as well as by a rental offer of April 12, 1779,[118] and indeed the reprieve granted by Jean-Baptiste Lebeau, master gardener.[119] Other contractors, such as Guerne, who himself went bankrupt and was owed 45,000 *livres,* proved less accommodating.[120] Jean-Étienne Masson de Maisonrouge (1752–after 1785) was clearly wary of Gouthière: the document he made him sign on December 22, 1780, forbade him any recourse "to suspension judgments, pardons from the Prince, safe-conducts [*sauf-conduits*], stays of payment [*arrêts de defense*] and generally anything that could adversely affect or delay the payment."[121]

Despite this alarming situation, Gouthière was determined to complete the project: on February 17, 1781, he borrowed another 80,000 *livres* to continue construction.[122] Eventually, he approached his close friends. The opera singer Madeleine-Augustine Courtois, the mother of his illegitimate daughter, Marie-Louise, born on November 3 of the previous year "to an unknown father and mother" and baptized the following day at Saint-Germain l'Auxerrois,[123] lent him a further 12,000 *livres*. Little is known of their relationship. Courtois died in 1810, and the absence of any inventory made after her death prevents us from knowing whether she had kept a portrait of her craftsman lover.[124]

Neither the loans nor even a new suspension of payment granted by the king for six months as of December 21, 1783, could stop Gouthière's downward spiral; on October 16, 1784, the buildings, which had been repossessed on November 24, 1781,[125] were rented out by the creditors, as demanded by law,[126] and Gouthière and his wife were evicted. The most virulent creditors were neither the contractors nor the subcontractors but rather the bankers and their assignees with whom Gouthière had been associated in risky schemes such as refining Spanish copper[127] and the exploitation of the Guadalcanal salt mines in Estremadura.[128]

The inventory drawn up in 1784, on the occasion of the foreclosure and with a view to possible division of the property, shows that the construction was far from finished;[129] only the part occupied by Gouthière and his wife and some workshops situated in the facing wing had been given doors and windows, and most of the buildings were roofless, including the main pavilion that was intended for rental. The cost of the remaining work was estimated at 171,278 *livres*.

Fig. 17
*Plan for Gouthière's Parisian
hôtel by Joseph Métivier
showing a portion of the ground
floor opening onto the Grande
Rue du faubourg Saint Martin,*
1780. Ink on paper. Archives
Nationales, Paris (AN, Z¹J
1060, June 2, 1780)

A new phase in Gouthière's life had begun. Evicted from his home, he briefly rented a place on Rue Sainte-Apolline from a Jean Branchard for which he was unable to pay the rent of 600 *livres* for the year 1785.[130] His furniture, which had been auctioned off on November 11, 1784, at the behest of the locksmith Étienne-Henri Dumas, had only raised 1,714 *livres*; the 999 *livres* that remained were not enough to pay back small creditors, such as the butcher and the baker, or cover the servant's wages.

While staying with the sculptor Rousseau de la Rottière, for whom he was then subcontracting,[131] Gouthière had an estimate prepared for the additional work on his buildings, such as roofing over some of them.[132] Unable to cover the new expenses, he was obliged, on April 28, 1787, to attend the sale of the detached house and its vast garden at the far end of the plot, which were awarded at 32,000 *livres* to Nicolas-Hercule Arnoult (1745–1821), his former notary and creditor, who then rented the pavilion to the Marquis of Fleury, in 1788, at 700 *livres* per year.[133] Gouthière would later complain that the failure to roof the building had caused it to deteriorate.[134] The only ray of hope during this harsh period was when, on January 6, 1787, Gouthière obtained a new suspension of payment (*surséance*) for one year that again offered him physical protection from his creditors. It was his last: on December 10, 1787, he and his wife were forced to surrender all their assets to their creditors,[135] who, on April 12 of the following year, sold the remaining houses on the street and on the courtyard, for 124,000 *livres*, to Charles-Paul-Jean-Baptiste Bourgevin de Vialart de Saint-Morys (1743–1795), a member of the Parlement of Paris. According to Gouthière, the value of their assets then amounted to 504,343 *livres* and that of their debts to 345,935 *livres*.[136] Thereafter, it was the creditors who received any payments due to Gouthière.[137] Among them, in addition to the businessmen already mentioned, were the tradesmen he employed in the construction of his buildings and the bronze-makers he employed in his own business.

The disarray of Gouthière's accounting system is certainly one cause of his financial woes. There is often a noticeable absence of his invoices in the official files where they should normally be found. The fault was entirely Gouthière's, as he did not send them out, much to the displeasure of the accounting services of the Bâtiments du Roi and later of those of the Count of Artois. The four years Gouthière worked at the Château de Fontainebleau (1771, 1772, 1774, and 1777) are instructive. Each year, he should have submitted a statement detailing the work carried out, but he neglected to do so and therefore was not paid: in 1773, we know only that he received a down payment of 500 *livres* for ironwork for the new wing of the chateau.[138] Also, on August 10, 1784, to pay off a debt of 30,000 *livres* to Arnoult, he transferred to him the unpaid 27,398 *livres* on the work at Fontainebleau. At this point, we learn that Gouthière had only received 4,300 of the 21,714 *livres* due to him for 1771 and 1,500 of the 2,604 *livres* due for 1772; he had received nothing of the 755 *livres* due for 1774 nor any of the 8,124 *livres* for 1777.[139] However, it was not until June 6, 1785, that Gouthière submitted his invoices to the royal administration,[140] and he waited until March 1, 1786, to inquire about their payment.[141] In his letter, he took the opportunity to ask to be involved in work that he knew was planned at Fontainebleau. The response from the director general of the Bâtiments du Roi, dated March 7, 1786, clearly reflects his irritation. Charles-Claude Flahaut de la Billarderie, Count of Angiviller (1730–1809), fully acknowledged the quality of Gouthière's work but bemoaned its excessive cost; he lamented the chaos of the craftsman's accounting and refused new commissions until he straightened out his affairs.[142]

NEW ROYAL COMMISSIONS

In 1781, Gouthière received another order for the stables of the Countess of Artois, this time for "mourning pieces," probably on the occasion of the death of the Austrian empress Maria Theresa (1717-1780), Marie Antoinette's mother.[143] As usual, Gouthière was late in submitting his invoices; in 1785, the inspector of the stables noted that he had not produced a single bill for three years: "M. the First Equerry has never been able to get one out of him."[144] When, in December 1787, Gouthière had to surrender his assets to his creditors, he estimated the total of these as yet unissued invoices at 15,000 *livres*.[145]

According to the rules of precedence of the royal court, in 1770 Marie Antoinette inherited the carriages of the late queen of France, Marie Leczinska (1703-1768). Later, Marie Antoinette commissioned new ones, which involved Gouthière. His name appeared twice in relation to the queen's carriages in archival documents: in 1779, when his debts to Henri Armengau were transferred[146] and, more importantly, in 1786 in regard to a transfer of 43,925 *livres* for carriages supplied for the queen during the first half of 1784. When he himself went bankrupt in 1787, Gouthière still owed 618 *livres* to Pierre-Joseph Chandon, who was a farrier, and 1,500 *livres* to François Lepine, the queen's appointed saddler and coachmaker.

In 1777, Gouthière worked again for Marie Antoinette, this time on the chimneypiece of her Cabinet Turc at Fontainebleau (cat. 31), a small room decorated by the sculptors Jules-Hugues Rousseau (1710-1782) and Jean-Siméon Rousseau de la Rottière (1747-1820). Pierre-

Charles Bonnefoy du Plan (1732-1824), head of the Garde-Meuble de la Reine, also commissioned Gouthière to produce furnishing bronzes (*bronzes d'ameublement*)—probably the firedogs (cat. 25), the tongs and shovels adorned with African heads, a chandelier, wall lights in the form of horns of plenty held by four children,[147] and other candelabra.[148]

Gouthière was granted the title of chaser-gilder to the Count of Artois in January 1775, but, in the absence of any invoices or statements, the work he carried out for this aristocrat is difficult to identify. Here again, it had been commissioned by the count's office of works (or Bâtiments) under the authority of François-Joseph Bélanger, his architect, and by his Garde-Meuble, under the directorship of Pierre-Thomas Jubault (1742-1837), his valet, interior decorator, and upholsterer.[149]

Something of the nature and amount of work that Gouthière carried out for the Count of Artois can be learned from the sums he was paid. Between November 29, 1778, and February 30, 1780, Gouthière received 18,000 *livres*, spread across five payments, which seem to have come from the Bâtiments (whose responsibilities included the execution of chimneypieces).[150] On December 18, 1787, when Gouthière was forced to surrender his assets to his creditors, he had received no more than these 18,000 *livres* and was due to receive as much again, bringing the total due for work carried out for the Count of Artois's Bâtiments to 36,000 *livres*. On January 20, 1793, the creditors enlisted an attorney to attempt to recover this debt from Artois, who had emigrated.[151]

Around 1777, Gouthière worked mainly at Bagatelle, the Count of Artois's pleasure palace, built that year by Bélanger in the Bois de Boulogne (fig. 18). Gouthière's involvement is confirmed by an invoice for work completed between 1776 and 1778 by the carpenter Denis-Nicolas Carbillet (before 1747-1795), who gave him three pilasters "to model the wall lights for the salon."[152] Gouthière would later invoice the Duchess of Mazarin for a design for a firedog with a three-footed brazier, snake, and sphinx "like that of the salon at the Château de Bagatelle."[153] Finally, the large sum he received from the Count of Artois's Bâtiments suggests that he had executed the ornamentation in gilt bronze for the chimneypieces of Bagatelle (cats. 32-34).

It cannot, however, be assumed that Gouthière executed all the gilt bronzes at Bagatelle. One of his colleagues, and also his successor, François Rémond, is known to have supplied and repaired the Count of Artois's bronzes. In 1780, Rémond supplied three pairs of firedogs for 1,150 *livres*,[154] and in 1782 he cleaned four pairs of matte-gilded wall lights in the shape of hunting horns,[155] which may have been those executed by Gouthière for the salon.[156] In August 1786, Rémond again cleaned the gilt bronze on the chimneypiece at Bagatelle, even replacing an oak wreath with trumpets on the salon chimneypiece.[157] The uncertainly also applies to the model of firedogs with two cupids terminating in rinceaux and placed on either side of a tripod-based incense burner that an inscription indicates as having belonged to the boudoir at Bagatelle (fig. 19), although no firedogs of this type appeared in the sale or production of François Rémond and may therefore predate the work he supplied and instead be from the time when Gouthière was active.

Nor can Gouthière be credited with the gilt bronzes of the clocks sold to the Count of Artois for Bagatelle and elsewhere. In eighteenth-century France, clocks were more often than not supplied by clockmakers, who rarely mentioned who had made their cases. For Artois, they were supplied directly by the Lepautes, clockmakers to the king, who seem to have worked more regularly

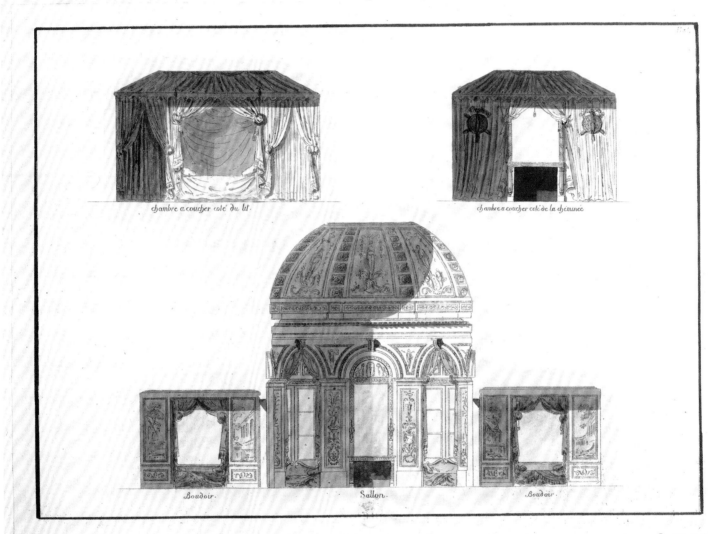

chambre a coucher coté du lit.

chambre a coucher coté de la cheminée

Boudoir.

Sallon.

Boudoir.

Fig. 18
Armand-Parfait Prieur, *Elevation of the Salon,
Bedroom, and Two Boudoirs of the Count
of Artois at Bagatelle*, ca. 1790. Pencil and
watercolor on paper. Bibliothèque Nationale
de France, Paris (Département des Estampes
et de la Photographie, VA-92-FOL)

with the bronze-maker Pierre-Philippe Thomire (1751–1843). While some of the clocks were made after designs by the architect Antoine-François Peyre (1739–1823) (for the Count of Artois's Cabinet Turc at the Palais du Temple)[158] or after designs by Bélanger (for the salon at Bagatelle, fig. 20)[159] and others "specially made by the best master" (for the bedchamber at Bagatelle), the names of the craftsmen who produced them are rarely revealed: all that is known is that the wooden model for the latter was sculpted by Louis Auger, who received 600 *livres* for "making a clock representing a trophy, comprising a shield surmounted by a helmet, standards and other military attributes."[160]

Gouthière's name does, however, appear in relation to some maintenance work: on June 21, 1781, he was enlisted to clean the bronzes of a recently acquired chimneypiece—destined for the Salon de Stuc (Stucco Room) at the Château de Maisons, which was designed in the previous century by François Mansart (1598–1666)[161] and had served as the Count of Artois's residence since 1777.

Gouthière received only one official commission from the Garde-Meuble de la Couronne: in 1785–86, he was asked to give thirteen bronzes from Louis XIV's collections a "smoke-colored"

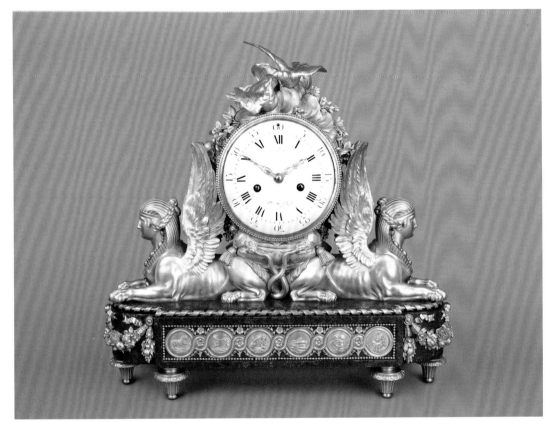

Fig. 20
Jean-Baptiste Lepaute, *Clock*, 1781.
Gilt bronze, stone, enamel, and glass,
20⅞ × 22 × 7⅛ in. (53 × 56 × 18 cm).
The Wallace Collection, London
(F269)

finish.[162] However, he continued to work for the Bâtiments du Roi through the intermediary of the Rousseau brothers. Indeed, in a letter to the Count of Angiviller, head of the Bâtiments du Roi, dated March 1, 1786, Gouthière boasted of having made "jointly with the brothers Messrs Rousseau sculptors to the King, the bronzes for the chimneypiece of the King's bath chamber at Versailles [cat. 36], for that of the Salle des Nobles in the Queen's apartment [cat. 37], and for that of the Queen's foyer at the Paris Opéra."[163] His work for Marie Antoinette's foyer at the Opéra may have been commissioned by the Garde-Meuble de la Reine or the Bâtiments du Roi. Of the three boxes at the queen's disposal in Paris—at the Comédie-Italienne, the Comédie-Française, and the Paris Opéra—the one at the Opéra was the most sumptuous, its foyer in the form of a tent made of blue silk taffeta, punctuated by mahogany and gilded wood posts that supported a cornice in the shape of a wicker basket. Gouthière's contributions probably included the following:

> two little side tables with white marble tops, 15 inches long by 8 inches deep, supported
> by two legs and ram's heads, the tops of semicircular form and in the shape of tailpieces,
> baskets filled with grapes, ornamented with 4 little chains forming garlands; open baluster

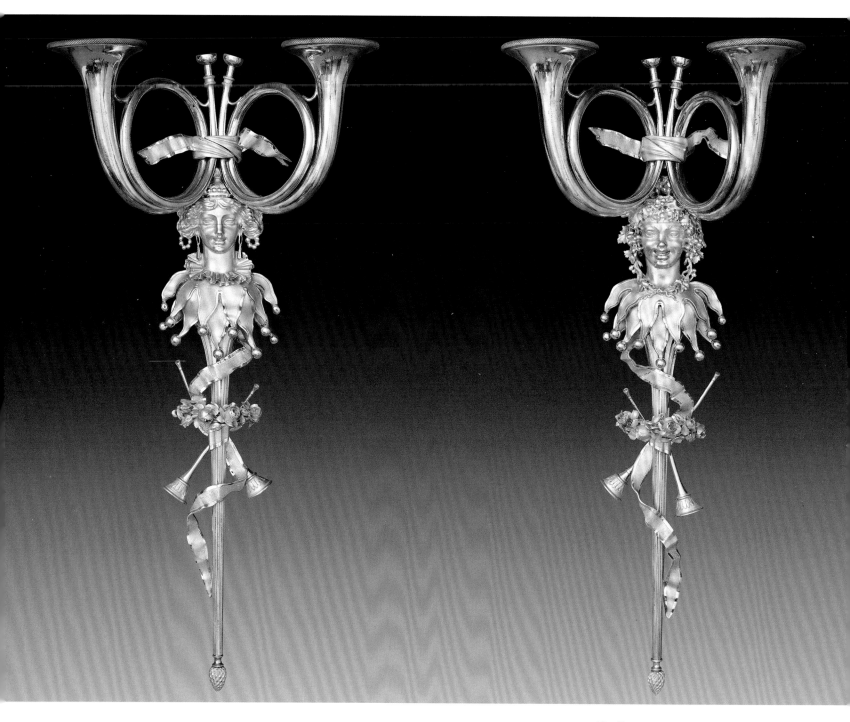

Fig. 21
Pair of Wall Lights, ca. 1785. Gilt
bronze, 20⅝ × 10 in. (52.4 × 25.5 cm).
Private collection

around the top; on this surface is a wall light with two arms in the form of hunting horns; the stand represents folly, and at its base is a cymbal and two seated children holding various instruments. All these bronzes are finely chased and matte gilded.[164]

When the wall light and side tables were cleaned in 1788 by the gilder Jean-Baptiste Godegrand-Mellet (1750–after 1825), the wall light was said to have a hunting horn, a female fool's head (*marotte*), and satyrs.[165] A similar wall light, however, without "two seated children holding various instruments" would feature in the Jean Lanchère *père* sale in 1806 (fig. 21).[166]

The response from Angiviller to Gouthière's letter not only confirms the relationship between Gouthière and the Rousseau brothers[167] but may allow us to attribute to Gouthière the earlier works listed in the Rousseaus' bills of 1783:

Arabesques in matte-gilded bronze for the white mirrors in the queen's boudoir (fig. 22)	9,000 *livres*
(plus decoration of the queen's private room)	18,000 *livres*
The matte-gilded chimneypiece for the same room (fig. 23)	7,200 *livres*
We currently have in hand … a bronze chimneypiece of approximately	3,000 *livres*[168]

During the same years, Gouthière may have also been responsible for the mounts for a pair of ewers in Marie Antoinette's collection. Made of Chinese porcelain with aubergine glaze, they are mounted with gilt-bronze ornaments that include female heads with grapevines and leaves in their hair, cymbals, bells, trumpets, and castanets (figs. 24, 25).[169] While Gouthière's authorship of these objects is likely, no document has confirmed the attribution. Nor is it known when the queen took possession of them—whether she purchased them from a merchant of luxury goods or received them as a gift from a close family member. Either way, a merchant of luxury goods certainly acted as an intermediary between Gouthière and the queen, but here again there are gaps in the archival documentation concerning the relationship between Gouthière and the merchants of exotic and luxury objects.

It is likely that other members of the royal family commissioned work from Gouthière. Among the objets d'art confiscated in 1794 from Louis-Joseph de Condé, Duke of Bourbon (1738–1818), in Chantilly, were a pair of wall lights with two arms in the form of child caryatids and a pair of firedogs, "all matte gilded by Gouthière,"[170] which were used shortly afterward to furnish the Palais du Luxembourg under the Directoire.

NEW PRIVATE COMMISSIONS

Gouthière started working for the Duchess of Mazarin in December 1777, when she was living in the former Hôtel de La Roche-sur-Yon on Quai Malaquais, recently restored and redecorated by François-Joseph Bélanger.[171] Some of Bélanger's designs for this project are preserved in the Print Department of the Bibliothèque Nationale de France, the Victoria and Albert Museum in London (fig. 26), the Metropolitan Museum of Art in New York, and in private hands (fig. 27).[172] Gouthière was entrusted with putting the finishing touches on these sumptuously decorated

Fig. 22
Ornaments decorating
the glass door of Marie
Antoinette's Cabinet de la
Méridienne (detail), 1781. Gilt
bronze. Musée National des
Châteaux de Versailles et de
Trianon

spaces, but what should have been a godsend for him became a nightmare because the Duchess of Mazarin was not timely in paying her bills.[173] On August 11, 1779, with the work far advanced, the duchess wrote in her will that the gilt bronzes executed by Gouthière for the gallery-salon were to be left to her very dear friend Claude-Pierre-Maximilien Radix de Sainte-Foy (1736-1810), who, according to reports at the time, was "one of the kingdom's greatest pleasure-seekers" and, like her, well known in fashionable circles.[174] The duchess was more concerned about the future of her possessions than she was about the remuneration of her craftsmen: on June 10, 1780, she had paid no more than 7,200 *livres* for work valued at 36,000 *livres*.[175] Her death, on March 17, 1781, placed Gouthière in a difficult situation that led him to ask the king for a moratorium on payments to his contractors, to whom he owed 53,798 *livres*. At that point, he assessed the two outstanding invoices due to be paid by Mazarin's estate at 101,000 *livres*,[176] an enormous sum considering that the *hôtel particulier* itself, with some of the bronzes, was sold for 420,000 *livres*.[177] Six years later, when Gouthière had to surrender his assets to his creditors, he estimated the total of his invoices for work supplied but not yet paid for at 97,243 *livres*, of which he had only received 12,000 *livres* from the duchess or her estate.[178] These two invoices were settled, respectively, by the bronze-maker Étienne Martincourt (1727-1796) on behalf of Mazarin's heirs and by the gilder François Rémond on behalf of Gouthière. One of the invoices, amounting to 18,359 *livres*, was reduced to 13,359 *livres*; the second, amounting to 82,235 *livres*, was reduced to 66,291 *livres*.[179] Only

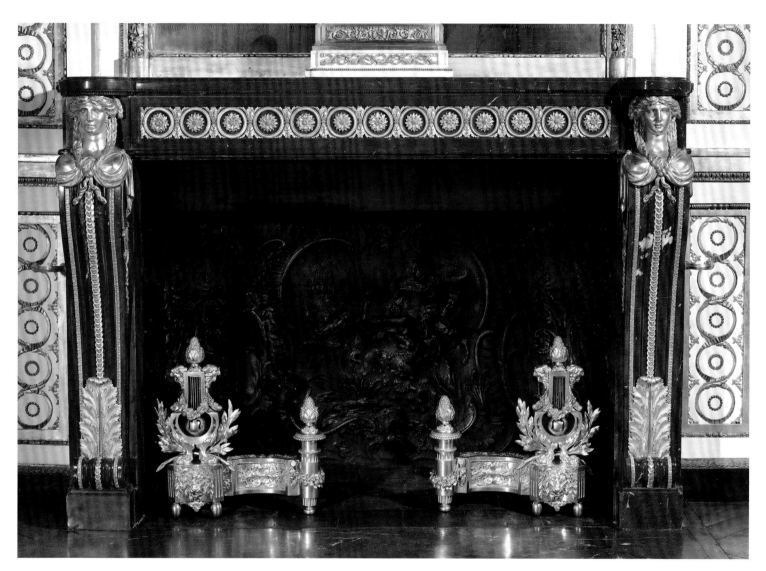

Fig. 23
Jean-François Dropsy (marble
cutter), *Chimneypiece from the
Grand Cabinet Intérieur de la
Reine also known as the Cabinet
Doré*, 1784. Griotte marble and
gilt bronze. Musée National des
Châteaux de Versailles et de
Trianon

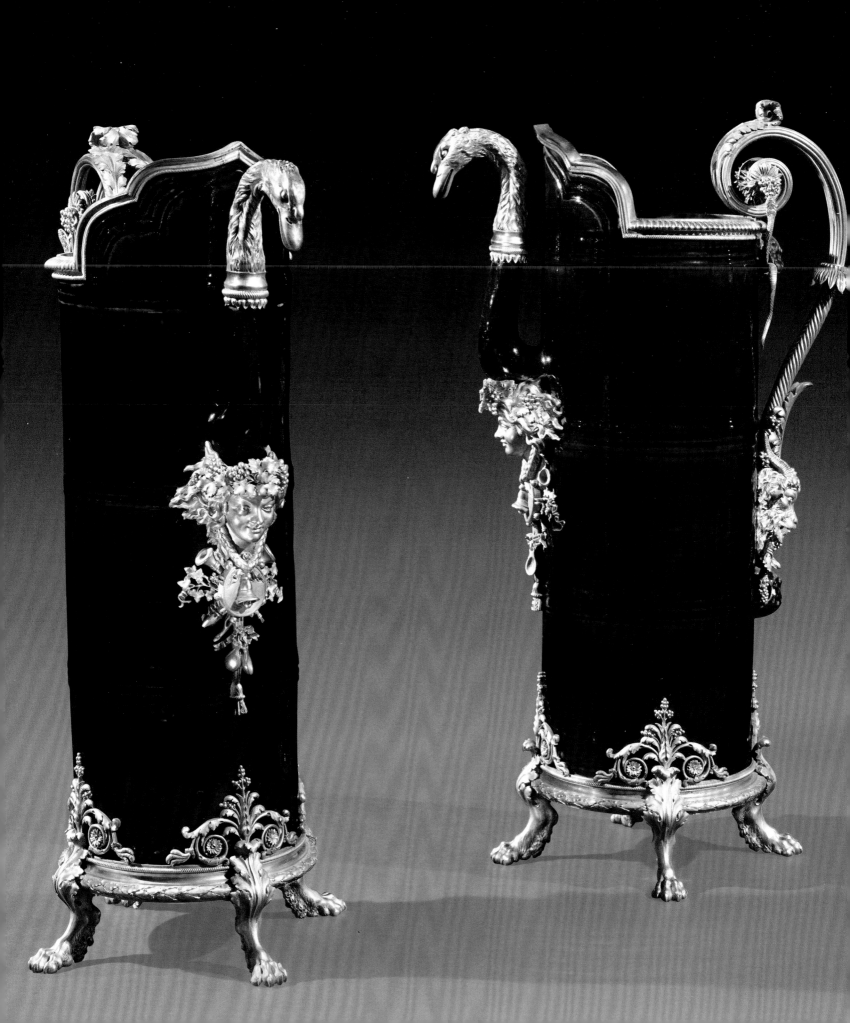

this second invoice survives today,[180] but the inventory produced after the Duchess of Mazarin's death[181] and the catalogues of the two sales of her collections—on December 10, 1781, and July 27, 1784, respectively—give some idea of the work supplied by Gouthière.

For the Duchess of Mazarin's gallery-salon, Gouthière produced gilt bronzes for the chimneypiece with bacchantes from models by the sculptor Jean-Joseph Foucou (1739–1815). Originally planned to be of granite, the chimneypiece was made in blue turquin marble, delivered by Jacques Adan, sculptor and marble cutter to the king (cat. 35). It was furnished with the famed pair of firedogs with eagles and salamanders made after a model by the sculptor Philippe-Laurent Roland (cat. 26). After drawings by Bélanger, Gouthière executed the gilt bronzes for the two pedestals that were to be placed between the windows, on the courtyard and garden sides (cat. 49). And after drawings by Bélanger and the architect Jean-François-Thérèse Chalgrin (1739–1811), Gouthière produced the gilt bronzes for a sumptuous table, again in blue turquin marble (cat. 39), to be placed opposite the chimneypiece; this commission was in the final phase of completion when the duchess died. Also among the unfinished works for the gallery-salon were two female groups modeled by Foucou and probably intended for the two pedestals made by Gouthière. The figures were designed to hold bronze tripods bearing nine lights, with a Sèvres porcelain vase containing a clock movement by Lepaute.

Gouthière's invoice also lists the bronzes for the duchess's Salon Arabesque, which was lit by three windows looking onto the garden. The white veined-marble chimneypiece had two columns of green Campan marble; these and the other marble pieces had been carved by Adan.[182] The gilt-bronze ornamentation, which was included in the 1781 sale, was not sold.[183] As in the gallery-salon, the two interlinked window piers of the Salon Arabesque had each been given a pedestal, in this case made of white marble with spiral fluting and gilt-bronze ornaments mounted on the marble; only the latter were put through the 1781 sale (lot 7). These pedestals were probably also intended to carry marble female figures serving as torches that were never executed.[184] Gouthière was also responsible for the wall lights in this salon, though there seems to have been some hesitation over the design. The chosen model, in the form of a lyre with the head of Apollo and olive-leaf branches, went under the hammer at 800 *livres* in the 1781 sale, acquired by the Duchess of Mazarin's daughter, Louise-Félicité-Victoire d'Aumont, Duchess of Valentinois.[185] It was a successful model that was often reproduced over the years[186] (fig. 28), but the Duchess of Mazarin's wall lights have not yet been identified. They were notable for their size (26 *pouces* high—approximately 25½ in.) and for the mass of ribbon above the mask of Apollo. Most of the other known wall lights do not have this additional fabric element and are therefore shorter (about 20½ in.); they also lack the blued background behind the lyre's strings that is mentioned in Gouthière's invoice.

The 1781 sale included two further lots by Gouthière, now both lost. The first was a serpentine vase the duchess had recently acquired at the sale of the Abbé Leblanc's collections.[187] She was barely able to enjoy it, however, for at the time of her death it was found in the possession of the gilder Charles Léveillé, who had probably been commissioned to clean it.[188] The second unlocated item is "a pair of firedogs with vases, or tripod, ornamented with heads to the front."[189]

Fig. 24
Pair of Ewers. Chinese porcelain from the Kangxi period (1662–1722), gilt-bronze mounts ca. 1785, 19⅛ × 11 × 11 in. (48.5 × 28 × 28 cm). Private collection

Fig. 25
Detail of ewer (fig. 24)

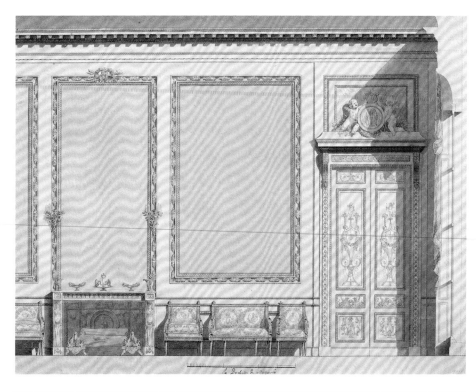

Fig. 26
Jean-Démosthène Dugourc (François-Joseph Bélanger's architectural firm), *Project for the gallery-salon of the Duchess of Mazarin's* hôtel particulier *showing the wall with the chimneypiece and the location of two of the four panels of Gobelins tapestry commissioned in 1771 but not installed until 1776 (the chimneypiece does not correspond to the model commissioned in 1780),* ca. 1777. Ink and watercolor on paper, 16⅜ × 20⅞ in. (41.5 × 53 cm). Victoria and Albert Museum, London (9078)

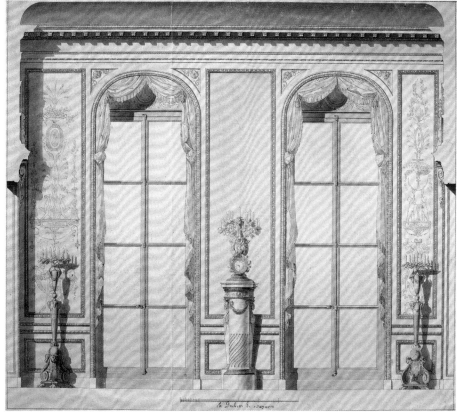

Fig. 27
Jean-Démosthène Dugourc, *Project for the gallery-salon of the Duchess of Mazarin's* hôtel particulier *showing the wall between the windows with two candelabra and a clock on a pedestal (the pedestal does not correspond to the model commissioned in 1780),* 1777. Ink and watercolor on paper, 16⅜ × 18½ in. (41.5 × 47 cm). Private collection

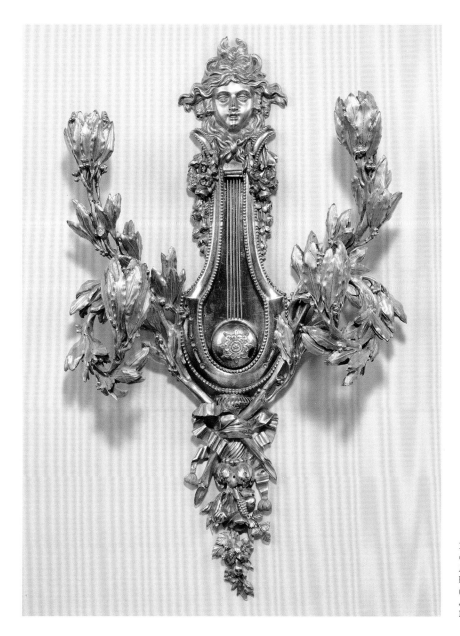

Fig. 28
One of a Pair of Wall Lights, ca. 1781. Gilt bronze, 20⅛ × 11 × 7 in. (51.2 × 27.8 × 17.8 cm). The J. Paul Getty Museum, Los Angeles (74.DF.5)

A similar example was better described in 1784 in the sale of Christophe-François-Nicolau de Montribloud (1733–1786), the city of Lyon's receiver of donations and grants, but with no mention of Gouthière's name[190] though Montribloud had been in contact with him since at least 1779,[191] particularly regarding a bond of 13,793 *livres* that the bronze-maker still owed him in 1787. A similar pair of firedogs is preserved at the J. Paul Getty Museum (fig. 29).

The orders the court banker Claude Baudart de Saint-James (1738–1787) placed with Gouthière are reflected in a document that transferred funds from Gouthière to goldsmith and gold merchant Charles Spire (master in 1736), dated March 1, 1780. On that day, Gouthière transferred 2,734 *livres* to him—as an advance on a greater sum—"to be paid by Mr. de Saint-James, on sums due to Gouthière for the supply of bronzes and gilding done by Gouthière for Mr. de Saint-James."[192] Here again, it is difficult to establish the nature of the works supplied, though they must have been substantial, considering the notorious reply of the munificent banker who gave the architect Bélanger carte blanche "as long as it was expensive."[193] Given the date of this commission, it must have been for the *hôtel particulier* in the Place Vendôme which Saint-James had acquired in 1777[194] and which Bélanger was asked to renovate in 1779. It is possible that Gouthière

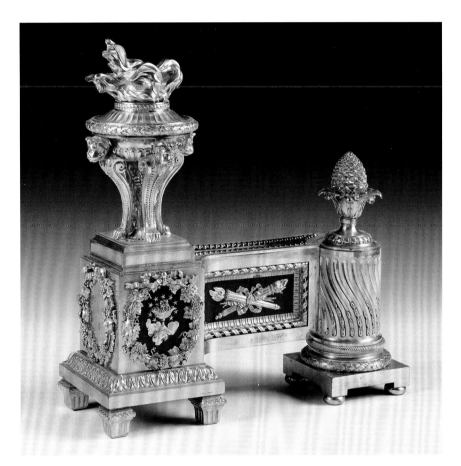

created the bronzes of the two clocks[195] for Saint-James's wife's apartments: one by Lepaute in the large study, representing "Neptune and a naiad" in white marble (figs. 30, 31),[196] and the other by Robert Robin (1741–1799), clockmaker to the king and queen, in the adjacent boudoir, representing two sphinxes in white marble (fig. 32).[197] Two candelabra with infant tritons, possibly by Gouthière, had originally been created to go with the Lepaute clock.[198]

Gouthière or Pierre-Philippe Thomire may have supplied the gilt bronzes for the chimneypieces. The one for Mme de Saint-James's large study was "a richly decorated mantelpiece of white-veined marble with friezes, shrub motifs, and foliage embellished with gilt bronze together with the moldings, two consoles with sheathed figures enriched with foliage, shrub motifs, and beading in a canted arrangement. The one for Mr. de Saint-James's bedchamber was of blue turquin marble, its pilasters embellished with bronze sheaths.[199]

Gouthière was not listed among Saint-James's creditors following his bankruptcy in 1787, which suggests that he had been paid for his work for the Place Vendôme *hôtel particulier* in Paris and did not participate in the works at Neuilly. For the architectural bronzes, he had commissioned the locksmiths Pierre-Antoine Deumier (ca. 1742–1812), Étienne-Henri Dumas, and Isaac-Louis Thibault. Deumier was still owed

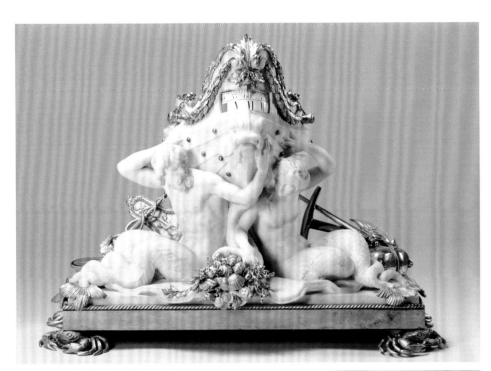

Fig. 30
Jean-André Lepaute (clockmaker),
Annual Dial Clock, ca. 1770. Gilt
bronze, marble, and enamel,
21¼ × 26⅜ × 12⅝ in. (54 × 67 × 32 cm).
Musée des Arts et Métiers, Paris
(06582)

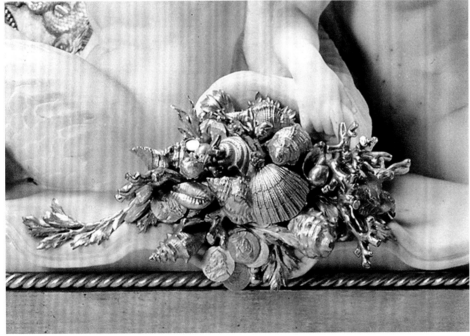

Fig. 31
Detail of *Annual Dial Clock* (fig. 30)

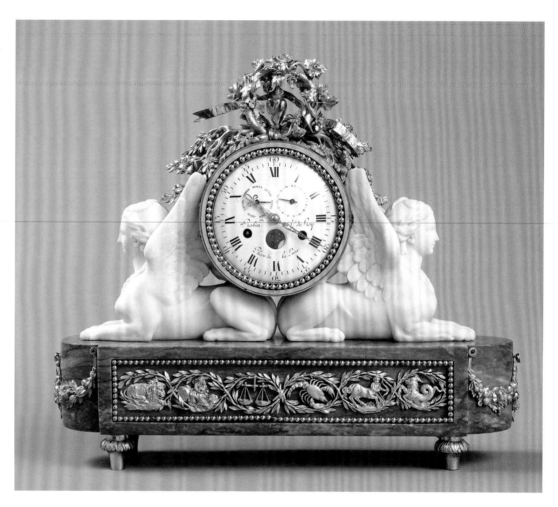

money by Gouthière, for a first invoice dated April 19, 1780, and a second for Mme Du Barry's apartments at Fontainebleau. These invoices were on hold because "it may be that Mr. Gouthière is owed a greater amount than he owes."[200]

The construction in 1779 of an *hôtel particulier* designed by Ledoux for Marie-Jeanne Girardot de Vermenoux (1740–1781), the widow of Georges-Tobie Thélusson, allowed Gouthière to create other masterpieces,[201] but he seems to have had some trouble fulfilling the commission. The interior decoration was almost finished on May 25, 1784, when Henriette-Louise von Waldner, Baroness Oberkirch (1754–1803), visited for the second time.[202] Five of the chimneypieces were due to be richly decorated in bronze, but Gouthière had only completed four of them; the fifth, for the main salon, was delivered by François Rémond. The decision to have them made dates to 1781, with the supply of the marble split between Bocciardi and Leprince.[203] Gouthière does not

seem to have begun work on them until 1784, after Ledoux's drawings (which were brought up to full scale by Métivier) and after some waxes made by the sculptor modeler Jean Martin. The payment of the invoices for these four mantelpieces gave rise to drawn-out dealings further complicated by the death of Mme Thélusson in 1781 and Gouthière's bankruptcy in 1787. The dénouement did not take place until July 5, 1787: Gouthière's invoice, which amounted to 11,665 *livres* and which Ledoux had settled at 6,840 *livres*, was finally revised to 7,720 *livres*. Since Gouthière had already received 1,800 *livres* in advance payment, that left 5,920 *livres* to be shared among his creditors. Métivier received 120 *livres* for his models.

As for the fifth chimneypiece—the one for the large Salon Ovale—Gouthière had only been able to offer models for it: a first with fluted columns; a second with sheathed infants; and a third with a "bacchante adorned with drapery of vine branches, a belt of ivy and a tambourine." The last model, the one ultimately chosen, repeated the design of one in the Duchess of Mazarin's gallery-salon (cat. 35): its execution was entrusted to Rémond, who asked for 5,304 *livres*, a sum reduced by Ledoux to 3,600 *livres* and finally raised again to 4,200 *livres*, which the gilder received on July 11, 1787, and which included 500 *livres* for the price of the model owed to Gouthière.[204]

In the mid-1780s, Mme Du Barry commissioned new work from Gouthière, for Louveciennes and Paris (probably for the home of her lover, the captain of the king's guards, Louis-Hercule-Timoléon de Cossé, Duke of Brissac [1734-1792]): eight receipts were signed by Gouthière between July 31, 1786, and May 27, 1788, for payments of 3,444 *livres*.[205] Several of these receipts can be linked to an invoice from the marble cutter Jean-Baptiste-François Corbel *fils* (before 1759–after 1811), who, in 1788, took down the Louveciennes chimneypieces and transported them to Gouthière's workshop in Paris where the latter altered their bronzes while Corbel restored their marble.[206] On October 1, 1789, Gouthière was enlisted by Mme Du Barry for several minor tasks along similar lines and even for some harness buckles, which he subcontracted to the chaser Charles Jacot.[207]

Notable among these commissions were ornaments in gilt bronze for four pedestals to hold torchères for the dining room at Louveciennes. Made of white marble and commissioned in 1771 from the sculptors Augustin Pajou (1730-1809), Félix Lecomte[208] (1737-1813), and Martin-Claude Monnot (1733-1803), the torchères represented female figures carrying horns of plenty from which emerged bronze candleholders made by Gouthière. Three heavily damaged fragments of these figures were identified in 2009 in the stores of the Château de Versailles.[209] Their fluted bases had previously received only temporary decorative treatment, executed by the sculptors Jean-Baptiste Feuillet and Joseph Métivier and composed of garlands of flowers with cascading garlands in the background; the foreground was ornamented with the countess's monogram surmounted by a crown.[210] Gouthière was entrusted with executing the ornamentation of these bases in gilt bronze but only completed one of them because of the death of Mme Du Barry in 1793. This base was confiscated during the revolution along with the marble of the three others and the four torchères, all of which were valued at about 12,000 *livres*, on February 11, 1794.[211] Given the relatively modest nature of such commissions, it is surprising that, on June 9, 1798, Gouthière filed an invoice for 756,786 francs for work delivered between 1788 and 1793; he agreed to reduce this sum to 642,000 francs, but the Ministry of Public Finances settled it at 235,866 francs.[212]

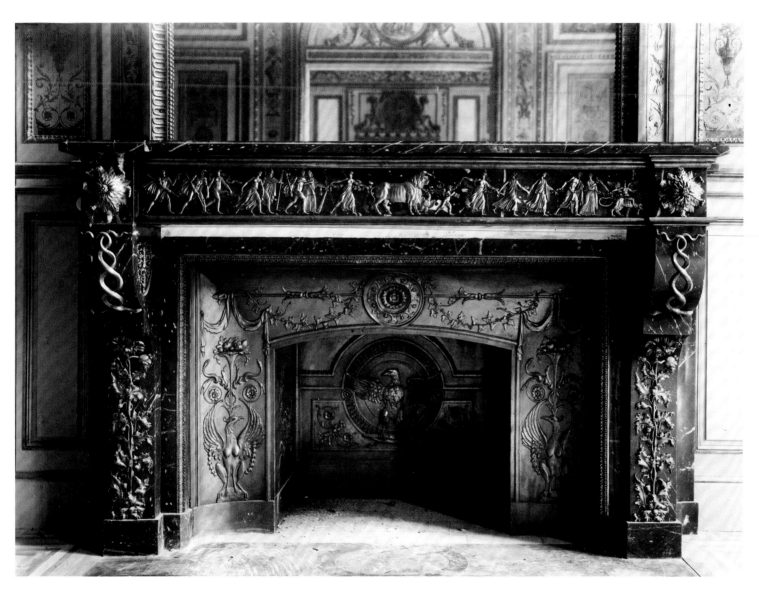

Fig. 33
Chimneypiece from the
bedroom of the Hôtel Hosten.
Whereabouts unknown

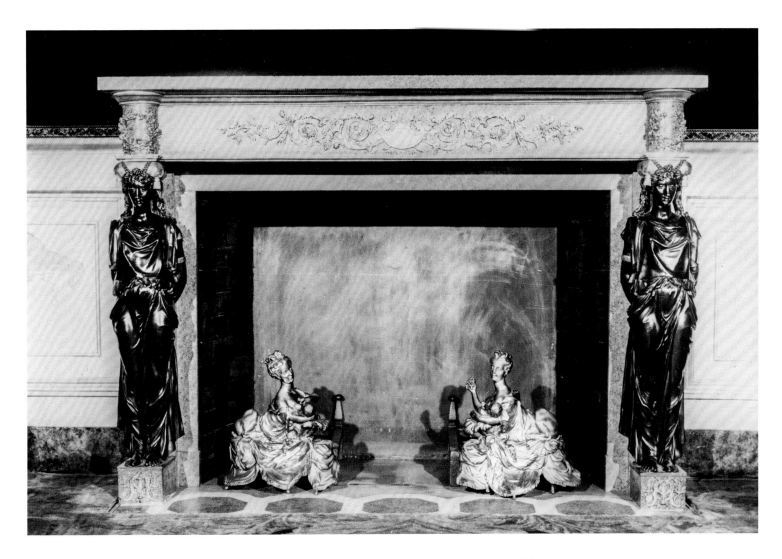

Fig. 34
Chimneypiece from the salon of the Hôtel Hosten. Private collection

Gouthière's name appears again in relation to construction work commissioned from Ledoux by Jean-Baptiste Hosten (1741–1802). Undertaken between 1788 and 1795, the project included a lavish *hôtel particulier* on Rue Saint-Georges for the patron and fifteen houses intended for rental, only six of which were built. Hosten, a wealthy businessman from Bordeaux, was a major landowner in Santo Domingo (where he died in 1802 during an uprising). He also had a military career as captain of the dragoons and then lieutenant-colonel in the Guyenne regiment, which earned him the Saint-Louis cross and explains the military allusions scattered throughout the symbols of trade and mythological allegories in the decoration of his Rue Saint-Georges residence.[213] Many of these motifs were carved by the sculptor Jean-Guillaume Moitte (1746–1810), and sever-

al were executed in gilt bronze, as evidenced by engravings made by Nicolas-François-Joseph Masquelier (1760–1809) in 1793.[214] No inventory was made after Hosten's death, but a summary of his papers provides the names of some of the craftsmen and artists involved in his construction projects and their decoration.[215] Here, alongside the main painters, sculptors, and bronze-makers employed on the construction sites,[216] is mention of a "chaser-gilder" who may well have been Gouthière since his name is listed as fifty-first among the craftsmen involved in legal proceedings, rulings, and judgments.[217] Thus, it seems that he participated in the decoration of the *hôtel particulier*, but nothing is known about the nature of his work. It is possible that two chimneypieces ornamented with gilt bronzes are by his hand: one for the salon, with its two caryatids attributed to Moitte and its gilt-bronze frieze of pelta shields and arabesques (fig. 34),[218] and the one presumed to be for the bedchamber, with poppy-stem pedestals (undoubtedly based on those in the bedchamber at the Thélusson residence) and a frieze based on a theme of ancient sacrifice, which was probably also after Moitte (fig. 33).[219]

It is difficult to identify Gouthière's other clients and even more so to establish any details concerning the work he carried out for them. More often than not, it is Gouthière's financial quarrels that shed light on his work and clientele. The name Polignac appears on April 10, 1782, when Gouthière assigned to the surgeon Pierre Colson, who was one of his creditors, a sum of 2,800 *livres* that was to be received from the Polignacs as an advance payment for his work: the duke, Armand-Jules-François (1746–1817), and his wife, Yolande-Gabrielle-Martine de Polastron (1749–1793), paid the sum directly to Colson on the thirtieth day of the same month.[220] Similarly, part of the money due to him for work on the Thélusson residence would serve to repay loans totaling 10,000 *livres*, which he had obtained from his notary, Nicolas-Hercule Arnoult. Gouthière was planning to pay off the rest of the sum through "works of gilding and bronze by himself made for other individuals such as the Duke and Duchess of Polignac and others."[221]

Also among his clients were Gaspard Grimod de La Reynière (ca. 1737–ca. 1790),[222] for whom he had made roses in gilt bronze, as well as Marie-Madeleine-Mélanie Fyot de La Marche, Marquise of Courteille (d. 1804),[223] and Charles-Louis Testu, Count of Balincourt (1729–1796).[224]

Two other clients appear in Gouthière's list of debtors, when, on December 18, 1787, he had to surrender his property to his creditors: the Prince of Nassau (probably Charles-Henri-Othon of Orange and Nassau-Siegen [1745–1805]), for 400 *livres*, and Papillon de La Ferté, for 1,200 *livres*. From the home of the latter—who, like Gouthière, had connections in the Champagne region, was perhaps one of his first patrons, and had held the prestigious post of chief commissioner to the king's household in the Menus-Plaisirs department—"an ivory vase with flowering branches under a glass case and a small stand with 3 caryatids in gilt bronze" was confiscated on November 24, 1794.[225] Although Gouthière's name is not mentioned, this stand may have had some connection to the small antique monument bought from Gouthière by Mme Geoffrin (cat. 6). However, Gouthière's name does appear on the occasion of the confiscation of a pair of vases from Jean-Baptiste-Charles-François, the Marquis of Clermont d'Amboise (1728–1792) on August 9, 1795 (cat. 7).

GOUTHIÈRE'S LATE YEARS, 1793–1813

The revolutionary years of 1793–94 were terrible for many artists and craftsmen who, despite pledging allegiance to the new ideas and the authorities of the day, struggled to be forgiven for their former aristocratic clientele or to convince others of the sincerity of their republican convictions. François-Joseph Bélanger, among those incarcerated, sent out numerous pleas from his successive prisons. He was in good company there, as he wrote from the Saint-Lazare prison on March 5, 1794, to Jules-François Paré (1755–1819), interior minister:

> Come to our aid, for we have here men who have twenty fingers on each hand and are forgotten, Robert [Hubert, painter], Pâquier [Pierre-Denis, lawyer], Le Monier [Guillaume-Antoine, writer], Audran [Jean, former director of the Gobelins tapestry workshops], Gouthière, all artists etc.[226]

In accordance with a decree issued on January 13, 1794, Gouthière was locked up three days later. On May 23 of that year, following a new law concerning artists, his wife passed on a request for liberation, which she signed "henriet wife Gouthière" (*henriet femme Gouthière*) in clumsy handwriting. Gouthière's self-defense has been preserved:

> Allow an old, sick man to submit to your view his response to the various questions that have been put to him:
>
> 1. My name is Pierre Gouthière, residing in Paris, no. 2 rue du Faubourg [Saint-]Martin, I am 64 years of age [in fact he was 61], I am married, I have one son aged 27 years; he lives with me and his mother.
>
> 2. I have been detained at Saint Lazare since Pluviôse 5 [January 24]; prior to which I was at the Madelonettes from Nivôse 27 [January 16]; I know only from my committal, by what order and for what reason I am incarcerated; here is the text of it: Brought herein as a suspect, on the basis of a ruling made on a decree by the National Convention's general security committee.
>
> 3. Before and since the revolution, I have been an artist, sculptor, chaser, engraver on metals.
>
> 4. My life is focused on my family and my workshops; I have never had any relationships other than those that are fitting to my work.
>
> 5. I possess neither property nor private income; I live off the profit of my work.
>
> 6. My political opinion at all times of the revolution has always been that of the true *sans-culotte*.[227]
>
> 7. I have never signed any petitions or decrees against freedom, and I have no fear of being criticized for any conduct that is against the public spirit. Although 64 years of age, I have always done my military duty, and if I have not done so in person, this is because, having the misfortune of being deaf, it has been acknowledged by my military superiors that I am unfit for service.
>
> I did not appear very diligent at my section's sessions; but I beg those who might draw from this any conclusion against my public-spiritedness to take into consideration the fact that the accident that caused me to lose my hearing 40 years ago deprived me from that time onward of al-

most all pleasures of society and condemned me to a solitary and withdrawn life; I therefore beg them not to lose sight of the fact that I was represented in the section by my son who remains with me and who might not have displayed the public-spiritedness that is known of him, if he had not found an example and encouragement of such in the bosom of his family. Citizens, my solitary and hard working life has caused me to acquire certain useful knowledge in working metals; if my talents can still be useful for the Republic, I will be delighted to dedicate them to it. Signed Gouthière.

Gouthière was set free on August 9, 1794, two weeks before the fall of Maximilien de Robespierre (1758–1794).[228] Intended to tug at the heartstrings, his plea probably exaggerates his deafness and isolation. The accident that befell him in 1754, when he was twenty-two, did not prevent him from going to the Opéra, and everything about his career testifies to his having been in frequent contact with members of high society, successfully engaging with them and not for professional reasons alone. Although nothing is known of his level of culture or education, it can be observed that, despite his terrible spelling—as revealed in the 1772 invoice for the Duchess of Mazarin—his handwriting and signature were always very elegant (fig. 35), unlike his wife's.

Gouthière remained on good terms with Arnoult, his former notary, one of the trustees of his bankruptcy, and the winning bidder for the handsome pavilion he had been forced to sell on April 28, 1787. Arnoult, who was still living on Rue de Chabanais in the building where his office had been, had even managed to sublease the ground floor of the building between courtyard and garden, by private deed, from the *fermier judiciaire*, from January 1, 1787; and the contract includes "another small adjacent building, serving as a workshop for Mr. Gouthière, distrained party." The use of the latter suggests that, thanks to Arnoult, Gouthière was able to return to his workplace, even though it was reduced in size.[229] The former notary even turned to Gouthière when, at the age of fifty, he resolved to legally recognize an old love affair that had produced a daughter: Gouthière appears as a witness on the affidavit (*acte de notoriété*).[230]

The next we know of Gouthière is that, on December 8, 1795, he again had an address in the Faubourg Saint-Martin. That day, he received a payment for 393 *livres* from the man temporarily in charge of the liquidation of public debt for his valuation of a tabernacle that had been left unfinished by the chaser Jean-François Laitié (master in 1753)[231] for the Carthusian monastery of Valdieu in the Orne department of northwestern France.[232] That this sum was given directly to him, and not to his creditors, suggests that Gouthière had reestablished some financial autonomy.[233]

Very little is known of Gouthière's professional activity at that point beyond the fact that in 1799 he gilded the inscription *Ministère de la Police* (Ministry of Police) on the pediment of the former residence of the Duchess of Mazarin, indicating the building's new use.[234] Widowed sometime around 1803, when he recognized his adulterine daughter,[235] Gouthière took a second wife, Marguerite-Antoinette d'Hautancourt, with whom he also had a daughter, Marie-Joséphine-Désirée (b. June 7, 1806).[236] Remarrying at this age and experiencing afresh the joys of fatherhood, he was clearly not a defeated man, and it is likely he retained some solid supporters. There is no other explanation for his work for the Palais Bourbon, the headquarters of the Corps Législatif: in

Gouthière
1200"

Memoire des Bronze et dorure faite
Par Gouthiere et fourni a Madame la
du chaise de Mazarin.

Savoire

Pour avoir fourny trois vaze en
cristale de coré detaite de bouque et
girlande prix convenue a La Somme
de 288." piece fait pour les trois cela 864...
Pour une paire de peti flanbau a
ligne doré et argenté 432...
Pour avoir nitoyé la toilaite de M. 48...

Totale ... 1344...

Jai recu de madame la duchaise de mazarin
par les mains de m. Duren La Somme de
douze cens Livre pour Sol de leur compte
jusaci jour ce 20 may 1772 Gouthière

Fig. 35
Extract from Pierre Gouthière's invoice for bronzes and gilding he made and delivered to the Duchess of Mazarin, 1772. Archives du Palais de Monaco, Monaco (S 432)

1800–1801, 1804–5, and 1810, at seventy-eight years of age, Gouthière—now called "chaser-gilder to the Corps Législatif"—was still working.[237] For example, in 1801, he produced a surround for a clock by Lepaute and bronzes for the Autel de la Patrie (Altar of the Homeland), after drawings by Alexandre-Jean-Baptiste-Guy Gisors (1762–1835); and in 1810, he executed rich ornamentation for five new mahogany doors for the emperor's entrances to the salon at the Palais Bourbon, after designs by Bernard Poyet (1742–1824).[238]

A chaser by the name of Gadan liked to recall how he often met Gouthière at his employers', the Jeannest family of bronze-makers, to whom the gilder had sold his workshop and models[239] and who in turn developed a famous bronze manufactory.[240] As an old man, Gouthière often came to Sunday dinner, and during the week, he liked to call in at the workshops. Gadan remembered him as a tall, thin man, who still wore the old style of short breeches, with grey woolen stockings and jeweled shoes. "Passionate about his art . . . lively and original in the extreme," the old master took an interest in the young apprentice's progress, offered him advice, and gave him some of his models.[241] Archival sources do not allow Gadan to be identified with any certainty: for chronological reasons, he cannot have been the Didier-Hippolyte Gadan who was described as a bronze assembler on his death on June 4, 1837, at 18 rue Sainte-Anastase; however, it may have been the latter's father, Pierre Gadan, of unknown profession, who was the beneficiary of the elderly Gouthière's advice.

If Gouthière did cease all professional activity, it cannot have been until shortly before his death[242] because, in a mandate dated November 15, 1811, he was still described as a chaser-gilder and still based at 88 rue du Faubourg Saint-Martin. He died on June 8, 1813, at 99 rue du Faubourg Saint-Honoré, in an annex of the Hôtel de La Vaupalière—a sort of retirement home owned by Count Pierre-Louis Roederer (1754–1835), an economist and politician. His wife and daughter were living nearby, at 3 rue des Saussaies. His estate, declared on December 7, 1813, comprised small furniture items that were valued at 41 francs.[243]

One of Gouthière's final sources of pride would have been reading the *Journal de Paris* of March 17, 1810, in which the architect Jean-Baptiste Boulland (1739–1813) delivered a veritable pre-funerary eulogy on the occasion of his recent works at the Palais Bourbon:

> The bronzes of a fine composition, especially those adorning the inner face of the door to the great hall of the Corps Législatif, are worthy of note. They consist of a harmonious composition of oak wreaths, thunderbolts, bees and other mixed ornaments, gilded *au mat*, by Gouthière, the inventor of this gilding. This octogenarian artist [he was seventy-eight at the time], who has passed on his strong organization and workforce to his son, has not declined in the slightest since his former reputation that he acquired in the final years of the reign of King Louis XV, at both Versailles and Fontainebleau, under Gabriel, architect and, latterly, Bagatelle, after the designs of Mr. Bélanger. One of the great showcases of this sculptor, chaser, and gilder's masterpieces was the residence of the Duke of Aumont, where a multitude of all types of precious bronzes could be seen, the majority of which, after the death of this zealous protector of the Arts, were acquired by Empress Catherine II,[244] and the rest by the Court of France. Contemporaries still recall all the pomp of refined oriental luxury with which Gouthière bedecked the chateau and above all the pavilion of

Luciennes [Louveciennes], designed by Ledoux, that giant of architecture, whose tragic death deprived us just at the moment when he was preparing to reproduce all of his monuments in a single one.[245]

Notes

1. Robiquet 1912 and 1920-21.
2. *Journal de Paris*, Monday, September 9, 1782, no. 252, 1029.
3. Bibliothèque Centrale, Versailles, MS 300 F. The court reduced the demand to 80,000 francs and then, on February 27, 1836, after an appeal from her heirs in 1836, to 32,000 francs. See Davillier 1870, xxx-xxxii; Robiquet 1912 and 1920-21, 71, 136-40 (a few documents are reproduced including an objection to the estate of Mme Du Barry by Gouthière's son and the judgment of the First Chamber of the Royal Court of Justice of Paris).
4. Robiquet 1912 and 1920-21, 8, 91 (transcribed).
5. Ibid., 8-9.
6. Ibid., 12.
7. Claeys 2009, vol. 2, 605.
8. The building at number 18 in the *Atlas de la censive de l'archevêché*. See Brette 1906, pl. XLI, and La Monneraye 2001, 402, n. 4849.
9. AN, M.C.N., CXIX 319, inventory of Marguerite Vast, July 18, 1754: XXXIX 439, February 10, 1757, abandonment by François Ceriset's widow (Marguerite Vast) due to their community of property, which was "more costly than beneficial."
10. AN, M.C.N., CXIX 320, contract dated October 2, 1754.
11. AN, M.C.N., LXXIII, 810, contract dated April 10, 1758.
12. Ibid.
13. AN, Y 9329, fol. 129. On April 14, 1758, "Pierre Gouthière has been admitted as a master gilder, chaser, and inlayer in Paris on all metals, in application of the ruling of the Conseil d'État of 1745." The Conseil d'État's 1745 ruling had ordered those working in the art and craft professions to be taxed in order to fund the War of the Austrian Succession, through the creation, at considerable expense, of agencies with inspectors. To pay for one of these, the corporation of master gilders, which had to borrow money, obtained permission on September 21, 1745, to supplement this 8,000-*livre* tax by creating twelve supernumerary master titles (AN, E 1224B, November 21, 1745, no. 3). See also Robiquet 1912 and 1920-21, 19.
14. Roland-Michel 1984, 20. The building's main tenant was then the silversmith Jacques Loir: see Brette 1906, pl. XLI (no. 17, n. 4848).
15. Bapst 1886, 514; and 1887, 132. See also Robiquet 1912 and 1920-21, 96 (transcribed).
16. Bapst 1886, 514; and 1887, 140-41.
17. *Annonces, affiches et avis divers*, no. 43, 1755, 177.
18. *Connaissance des arts* 1959, 86-88.
19. Châteaux de Versailles et de Trianon, currently on long-term loan to the Musée du Louvre (Vmb 1036). Ciancioni 1950-57, 184-86; Durand, Bimbenet-Privat, and Dassas 2014, 280. This clock was still on Gouthière's premises in October 1767 (AN, M.C.N., XXIII 702).
20. The J. Paul Getty Museum, Los Angeles, acc. 81.DF.96.

21. Musée du Louvre, Paris, inv. OA 8278–79. Verlet 1935; Durand, Bimbenet-Privat, and Dassas 2014, 290–91.

22. Alcouffe 1974, 336, no. 438; Alcouffe, Dion-Tenenbaum, and Mabille 2004, 112–14. This hypothesis is no longer considered valid: see Durand, Bimbenet-Privat, and Dassas 2014, 290.

23. Bapst 1887, 170–72.

24. Lorentz 1958, 9, n. 1. Note that the stucco worker does not say that Germain was involved in the gilding.

25. Archiwum Główne Akt Dawnych, Warsaw, Zbiór Popielów 230, 159 (see also Saratowicz-Dudyńska, p. 158 in this publication).

26. AN, Y 10886A, July 5 and 30, 1763.

27. AN, M.C.N., II 568, estate inventory of Anne-Louise Canut, wife of Jean Rameau, dated June 30, 1758.

28. Appendix 1: 1767, November 13 and 17.

29. Lorentz 1958, 10–11.

30. Ibid., 14.

31. Wildenstein 1962, 365–77.

32. BnF (Bibliothèque de l'Arsenal), Fonds de la Bastille, MS 12309 (Vial 1908, 334–35). Robiquet 1912, 23, 97. Mlle Courtois lent Gouthière 12,000 *livres* during his first period of financial difficulty (AN, M.C.N., XIV 473, April 26, 1781) in exchange for an annuity for herself and Marie-Louise, their illegitimate daughter (AN, M.C.N., XIV 476, October 5, 1781).

33. AN, O¹ 826.

34. AD 75, D⁴ B⁶, box 33 (sculptors' bankruptcies), file 1753.

35. AN, M.C.N., LXXVII 347, estate inventory of Henri Lebrun, July 18, 1769. The sculptor and marble cutter Gaspard-Élisabeth Jonniaux and the merchant of luxury goods Claude-François Julliot went to Guillemain's workshop on Rue de Vendôme to draw up an inventory of items belonging to the estate of Henri Lebrun.

36. Mosser and Rabreau 1979, 44. In 1783, Gouthière may have worked again with Charles De Wailly for the foyer chimneypiece of the new Comédie-Française (the Théâtre de l'Odéon) (Mosser and Rabreau 1979, 51, 53).

37. Leclair 2002, 273, 288, 306.

38. *Cheminée-Poêle* (chimney stove) or *Poêle-français* (French stove), *Mémoire lu à la rentrée publique de l'Académie royale des sciences, le 12 novembre 1763*, Paris, 1766. The invention met with immediate success. Louis-Joseph-Charles-Amable d'Albert de Luynes, Duke of Chevreuse (1748–1807), quickly adapted it to two of the fireplaces in his family's Château de Dampierre (ibid., 14); and he was soon followed by the Polish king Stanislas-August Poniatowski with designs by Jean-Louis Prieur (1732–1795?) for the fireplace of the Portraits Room at the Royal Castle in Warsaw (Lorentz 1958, pl. 10); and by Michel-Ferdinand d'Albert d'Ailly, Duke of Chaulnes (1714–1769), after plans by the architect Charles-Axel Guillaumot (1730–1807) for the entrance hall of his sumptuous residence on Rue de Varenne (Baulez 1981).

39. Information supplied by Monique Mosser, drawn from the correspondence of the Marquis of Voyer that is held at the University of Poitiers.

40. Appendix 1: 1769, September 27.

41. AN, M.C.N., XCIX 612, creditors' agreement of the Marquis of Brunoy, July 17, 1775. Sale catalogue, August 28, 1776, lot 4.

42. Bellaigue 1974, 114–17

43. Pradère 1993, 94–95.

44. Ibid.

45. Vial 1901, 136–37.

46. AN, R¹ 519, fol. 48.

47. AN, M.C.N., XXXI 193, company founded October 4, 1770.

48. Lemmonier 1911–29, vol. 8, 97.

49. *Livre d'ornements à l'usage des artistes dessiné par l'Huilier et gravés par Doublet et Romae*, undated, published in Paris by "Jean," 32 rue Jean de Beauvais, Bibliothèque des Arts Décoratifs, Paris, Collection Maciet, ORN.9.1–18, 26.

50. AN, M.C.N., XXII 8, company founded November 14, 1774.

51. Bibliothèque des Arts Décoratifs, Paris, Collection Maciet, *Graveurs et ornemanistes XVIIᵉ et XVIIIᵉ siècle* (seventeenth- and eighteenth-century engravers and ornament designers), under the name Lhuillier.

52. Robiquet 1912 and 1920–21, 24–26, 97–98; Stern 1930, vol. 1, 9–12.

53. Robiquet 1912 and 1920–21, 31, 101–2 (transcribed).

54. These candelabra-vases were taken to Versailles in 1775, where they were placed in Louis XVI's game room. At that time, they were restored by the gilder and silverer (*argenteur*) Claude-Jean Pitoin (AN, O¹ 3624, invoice dated July 14, 1775). Their whereabouts are unknown.

55. Appendix 1: 1773.

56. Loiseau n.d.; Stern 1930, 112–14.

57. AN, K 1715, file 8, item 6. Wackernagel 1966; Baulez 1986, 613–20.

58. AN, M.C.N., CXVII 886, inventory of March 8, 1779. Gouthière had also borrowed money from Auber, who still owed him 600 *livres* at the time of his bankruptcy in 1782. In 1786, it was Vincent who owed Gouthière 432 *livres* (AN, CXVII 924, guardianship account, January 23, 1786).

59. See p. 96 in this publication.

60. On September 13, 1776, Gouthière also assigned 8,000 *livres* to Jean-Auguste-Frédéric Bottenotte, the king's official doctor, "to be taken from the same sum that is to be received for items supplied for the establishment of the stables of Madame the Countess of Artois." Bottenotte took it upon himself to pay the sum to Vincent Guilliard, a chaser to whom Gouthière owed 19,214 *livres*. The same procedure would be repeated with the master casters Georges-Alexandre Moreau (AN, M.C.N., XIV 456, January 23, 1777), Jean-Baptiste Allenet (AN, M.C.N., XIV 456, March 18, 1777; Robiquet 1912, 62), Jacques-Marie Desouches (AN, M.C.N., XIV 467, September 2, 1779), and with the master gilder François-Magnus Harlau (AN, M.C.N., XIV 456, January 27, 1777). Gouthière transferred to the master sculptor Pierre-Jean-Baptiste Delaplanche part of the sum assigned to Vincent Guilliard (AN, M.C.N., XIV 457, April 3, 1777) and, more significantly, to Louis-Simon Boizot, 1,200 *livres* (AN, M.C.N., XIV 457, May 14, 1777). The expected remuneration by the Marquis of Chabrillan allowed Gouthière's suppliers to be paid: the merchant of luxury goods Jean-Jacques Sané (AN, M.C.N., XIV 455, December 14, 1776), the master joiner Jacques-Charles Boulogne (AN, M.C.N., XIV 474, August 4, 1781), and the wood merchant Jean-Baptiste-Louis Rampan (AN, M.C.N., XIV 476, September 10,

1781). Lastly, it allowed him to borrow 7,000 *livres* from Jacques-François-Isidore Dècle, valet, interior decorator, and upholsterer to the king and to the Duke of Aumont, who lived at the latter's residence on Place Louis XV (AN, M.C.N., XIV 467, September 18, 1779).

61. BnF Richelieu, Département des Manuscrits, MS 8158, 136 (Robiquet 1912 and 1920-21, 37-38).

62. BnF Richelieu, Département des Manuscrits, MS 8158, 138.

63. Appendix 1: 1773, December 31 (1).

64. See p. 332-38 in this publication.

65. La Beraudière sale, May 1885, lot 1733. Josse sale, May 28-29, 1894, lots 145-46.

66. Appendix 1: 1773, December 31 (2).

67. AN, M.C.N., XXIII 801, January 19, 1786, fols. 223-24.

68. AN, O¹ 3044 (Stern 1930, vol. 1, 46, with some inaccuracies).

69. Davillier 1870, xix-xxi; Baulez 1990, 11-41, 101-2.

70. On the Duke of Aumont's cabinet of curiosities, see, in particular, Davillier 1870; Du Colombier 1961; Castelluccio 2011. See also Vriz 2011 and 2013.

71. Castelluccio 2011, 75.

72. AN, Y 15393 (Guiffrey 1877, 158-63).

73. Appendix 1: 1782, May 1.

74. AN, M.C.N., XIV 478, June 22, 1782; 479, July 17 and August 20, 1782.

75. AN, Y 1905 (Wildenstein 1921, cols. 121-30). A small fragment of his report is preserved among Rémond's papers in the Archives du Monde du Travail in Roubaix.

76. AN, Y 5100 (Guiffrey 1877, 163-65).

77. One of these is preserved at the library of the Institut d'Art et d'Archéologie, Paris (VP Res 1782/14), and the other came up for sale in London at Sotheby's on February 13, 1951. A colored example is held in the Bibliothèque Nationale de France (Res. V 2856). My thanks to Sylvia Vriz for directing me to this document.

78. AN, R¹ 281. Purchase by Jubault for 19 *livres*, during the second half of 1785, "of a book containing the description and drawings of the precious objects sold after the death of the Duke of Aumont; the drawings are by M. de Saint Aubin."

79. Verlet 1980, 200-10.

80. Davillier 1870, pls. VII-VIII.

81. AN, M.C.N., VII 457, January 30, 1783. Robiquet 1912 and 1920-21, 54-55, 118-20.

82. In the (incomplete) certificate of Pâris's settlement of building expenses for the Aumont residence, dated June 25, 1779, there is also reference to an invoice to Mr. Guyart for "the two porcelain cups and serpent and the three-footed one at 1,800 livres." Bibliothèque Municipale, Besançon, Fonds Pâris, MS 7, fols. 30v and 31r. I would like to thank Marc-Henri Jordan for bringing this document to my attention.

83. Walpole 1965, vol. 32: 261.

84. AN, T 208 6 and 8.

85. Library of the Institut d'Art et d'Archéologie, Paris, MSS, box 29 ("Artisans, Gouthière"), note from Gouthière to Boutin dated August 18, 1772: "Friday morning, I will bring back the first pair of firedogs with a pair of wall lights, if the ironworker returns its grille today as he has promised to do; I should be able to give you back the

second pair of firedogs during the day on Saturday."

86. AN, Z¹ J 971, July 26, 1773.

87. AN, T 220 1-2; T 1685, item 165.

88. AN, M.C.N., CVIII 665, March 9, 1775.

89. AN, T 220 1-2; T 1685, item 165.

90. AN, M.C.N., CVIII 675, April 9, 1777.

91. AN, T 220, 3-4, estimate from Nicolas Henry, July-September 1780.

92. AN, M.C.N., XIV 474, August 15, 1781. Baulez 1984 and 1991b.

93. AN, M.C.N., LXII 559, creditors' agreement, March 28, 1775. See also AN, M.C.N., XIV 457, June 3, 1777.

94. Bibliothèque Historique de la Ville de Paris, Fonds Marigny, MSS N.A. 105, fols. 350, 353, 365, 385. Baulez 2009.

95. Bibliothèque Historique de la Ville de Paris, Fonds Marigny, MSS N.A. 100-105. Baulez 2009.

96. AN, M.C.N., XCIX 657, June 1, 1781, lot 996.

97. Silvestre de Sacy 1940, 24-26.

98. AN, M.C.N., LXXIII 944, April 20, 1773; 948, September 17, 1773.

99. AN, M.C.N., XXIII 973, May 25, 1776; XIV 454, June 26, 1776; Z¹ J 1002, May 2, 1776. La Garenne chose François-Joseph Duret (1729-1816) to value the sculptures and Jacques-Marie Desouches the works in bronze. Julia and Gouthière put their trust in their expertise, without asking for intervention from their own experts (the sculptor to the Bâtiments du Roi, Joseph Guibert [1747-after 1795] for the sculptures, and Jean-Louis Prieur for the bronzes); nor were third-party experts needed (Gilles-Paul Cauvet [1731-1788] and Jean-Guillaume [?] Leroy).

100. Almost all the amount received by Julia was handed over to his creditors: the sculptor Joseph Deschamps (1743-1788); the Italian moldmaker Dominique Lena; the casters Marie-Agathe Benoist (widow of Claude-Bernard Heban), Paul Henriet, Georges-Alexandre Moreau, and Jean-Baptiste Morel; the chaser Jean-Baptiste Gallois; and the gilder Nicolas Boullez. Gouthière had to deal with his own creditors, including the gilder Louis-Pierre Morant (AN, M.C.N., XIV 455, July 24, 1776).

101. AN, Z¹ J 1216, July 22, 1791.

102. Hôtel Drouot, Paris, June 15, 1984. See also Appendix 1: 1776, August 13.

103. AN, M.C.N., XIV 455, December 18, 1776. The Duke of La Vauguyon had been charged with ordering large wall clocks on the occasion of the dauphin's marriage in 1770. There may be a link between the production of these clocks and Gouthière because in 1778 Jean-Louis Prieur (1731-1795) owed Gouthière 1,500 *livres* (AD 75, D⁴ B⁶, 68, item 4505, bankruptcy of Prieur of September 22, 1778).

104. Freyberger 1980.

105. Appendix 1: 1777, February 27-March 25.

106. AD 75, reg. 117, fol. 95 (Vial 1901, 138).

107. Vial 1901.

108. Robiquet 1912 and 1920-21, 61, 125.

109. AN, M.C.N., XLVII 274, April 3, 1773.

110. AN, M.C.N., VII 407, April 3, 1773.

111. AN, M.C.N., XLVII 277, October 28, 1773.

112. AN, M.C.N., XXIV 875, inventory of January 25, 1774.

113. AN, M.C.N., LII 514, fund transfers of January 27, 1775, and November 23, 1775.

114. AN, Z¹ J 994, July 11, 1775.

115. AN, Z¹ J 1013, March 7, 1777; M.C.N., XIV 497, January 25, 1788, chap. 4, article 1 (Robiquet 1912 and 1920-21, 65 and 132-34 [transcribed]).

116. AN, M.C.N., XIV 464, October 29, 1778. This sum was also to allow him to pay the 17,000-livres price for the land, which was still unpaid despite loans taken out for the purpose on April 3, 1773. See also Robiquet 1912 and 1920-21, 63.

117. AN, M.C.N., XIV 462, April 7 and May 29, 1778.

118. *Annonces, affiches et avis divers*, no. 112, April 12, 1779, 811.

119. AN, M.C.N., XIV 467, August 16, 1779.

120. AN, M.C.N., XIV 472, January 21, 1781.

121. AN, Y 15393, fol. 102.

122. AN, M.C.N., CXVI 526, yielded liability (*obligation rapportée*), March 27, 1781.

123. On May 24, 1789, the singer from the Académie Royale de Musique gave birth to Henri-François, whose father was François de Raymond, a captain of dragoons.

124. AN, M.C.N., V 947, affidavit (*acte de notoriété*) of June 28, 1810, and appended documents. This 12,000 *livres* constituted the capital of a life annuity for Marie-Louise, their illegitimate daughter (AN, M.C.N., XIV 476, October 3, 1781).

125. AN, Y 3823, fol. 110 (Vial 1901, 139, transcribed). AN, ZZ² 868.

126. Robiquet 1912 and 1920-21, 64-65, 134-36. When creditors seized a dwelling during the ancien régime, the lease would be handed over to a *fermier judiciaire*. The term *fermier judiciaire* in French ancien regime legal terms refers to the person to whom the lease of a particular dwelling was legally handed over if the dwelling was seized by a creditor. The *fermier judiciaire* would handle the lease of the property until the creditor obtained permission to sell it.

127. In association with the businessman Pierre-Guillaume-Gabriel Lapotaire de Bellaunay, replaced by the silversmith Jacques-Nicolas Roëttiers de La Tour (1736-1788) and then by the engraver and medallion maker Alexandre-Louis Roëttiers de Montaleau (1748-1808), his brother, before Jean-François Lemore and Nicolas-Hercule Arnoult (AN, M.C.N., XXXVIII 612, October 23, 1778; XXI 490, May 28, 1779; XIV 480, December 16, 1782; VII 457, January 29, 1783; XIV 482, June 20, 1783; VII 469, June 5,1785).

128. In association with Henri Armengau and then with Jean-François Lemore (AN, M.C.N., XIV 464, October 29, 1778; XIV 469, April 17, 1780; XIV 470, July 17, 1780; XIV 473, March 29, 1781).

129. AN, Z¹ J 1126, November 9, 1784.

130. AN, M.C.N., XIV 490, January 17, 1786.

131. AN, Z¹ J 1147, March 3, 1786.

132. AN, Z¹ J 1150, June 1, 1786; M.C.N., XIV 492, July 10, 1786; XIV 493, October 3, 1786.

133. AN, M.C.N., XIV 496, December 18, 1787. Note that both Vial and Robiquet gave the wrong date of sale to Arnoult. According to Vial, Nicolas-Hercule Arnoult remained the owner of the former Hôtel Gouthière until his death in 1821. It was then inherited by Arnoult's daughter, Adelaïde-Louise-Rose (married name Petit), who died in 1858. In 1901, it was still owned by the Petit family (Vial 1901, 141). See also Robiquet 1912 and 1920-21, 65-66. The former Hôtel Gouthière is now home to the music school of Paris's tenth arrondissement.

134. On January 27, 1787, the architect-surveyor Jean-Pierre Ange had made a further visit to the buildings to split them into lots; a plan was attached (Z¹ J 1159). The *fermier judiciaire* also ordered a survey to be carried out on the work done and yet to do, on May 25, 1787 (Z¹ J 1165).

135. Robiquet 1912 and 1920-21, 64-65, 126-32 (transcribed).

136. Ibid.

137. For example, the total payments for the Duchess of Mazarin's orders amounted to 79,650 *livres*; taking into account the down payments that had been made, the sum that Gouthière should have received was 47,720 *livres*, but this was paid directly to his creditors from March 1, 1790 (AN, M.C.N., XIV 497, agreement of creditors of March 25, 1788, deliberation continued until August 7, 1790).

138. AN, O¹ 2277, fol. 305, down payment of November 27, 1773.

139. AN, M.C.N., XIV 486, August 10, 1784.

140. AN, O¹ 1922A.

141. AN, O¹ 1437, item 86 (Robiquet 1912, 102).

142. AN, O¹ 1179, fol. 131 (Baulez 1986, 568-70).

143. AN, M.C.N., XIV 480, fund transfer and liability (*délégation et obligation*) to Jean-François-Isidore Dècle dated December 19, 1782.

144. AN, R¹ 280.

145. AN, M.C.N., XIV 496, December 18, 1787, Gouthière's surrender of his assets to his creditors; AN, M.C.N., XIV 464, liability (*obligation*) of 80,000 *livres*, October 29, 1778.

146. AN, M.C.N., XIV 464, liability of 8,000 *livres*, March 31, 1779.

147. Cochet and Lebeurre 2015, 55, 116-17.

148. Without waiting for the payment of 19,711 *livres* for items he provided for the Cabinet Turc, Gouthière assigned the full amount to Joseph-Edme Goujon, his mason, as a down payment for work on his properties (AN, M.C.N., XIV 461, March 19, 1778). Gouthière had even taken the precaution of warning Bonnefoy du Plan about it through a court officer's writ on April 28, 1778 (AN, M.C.N., XIV 465, March 7, 1779. Baulez 1987, 34-45; Salmon and Cochet 2012, 12-27). On the death of his first wife, Bonnefoy declared that he owed Gouthière 19,000 *livres* (AN, M.C.N., XXXV 846, inventory of December 4, 1779).

149. Baulez 1997.

150. AN, R¹ 309. On July 5, 1779, Gouthière had already assigned 3,000 *livres* of this to Antoine Lejeune, master caster, for items supplied (2,267 *livres*) and to be supplied (732 *livres*); this sum was not actually paid until February 13, 1780 (AN, M.C.N., XIV 467, July 5, 1779). On February 9, 1782, 2,400 *livres* from the same source were assigned to Claude-Nicolas Bonfion, a master mason whom Gouthière employed on his own building projects (AN, M.C.N., XIV 477, February 9, 1782).

151. AN, M.C.N., XIV 497, January 1788, register of the proceedings of Gouthière's creditors. Gouthière, who seems to have begun to get his finances in order, received a receipt from Claude-Nicolas Bonfion for a sum of 1,500 *livres* for which the master mason had reduced his

demands, so that the account could be settled; thus the assignment of 2,400 *livres* to be received from the Duke of Artois was cancelled (AN, M.C.N., XIV 539, 12 Nivôse in the year IV [January 2, 1796], 26 Pluviôse in the year IV [February 15, 1796]).

152. AN, R¹ 280. On February 28, 1780, Gouthière handed over 3,000 *livres* to Jean-Martin Andras, taxpayer and resident of Paris, for bronze items supplied and work for Bagatelle (AN, M.C.N., XIV 469).

153. Baulez 1986, 635.

154. AN, R¹ 116.

155. AN, R¹ 118. He would clean them again in May 1786.

156. AN 183 AQ 1, fol. 190, September 1782. See also Baulez 1988, 153.

157. Baulez 1997.

158. Baulez 1987, 35-46.

159. AN, R¹ 324: "bronze has never been repaired with so much care as the ornamentation of this case has been." Lepaute mentions in his statement that the Count of Provence owned a similar one. Three almost identical clocks exist: one in the Wallace Collection, London (F 269), which is probably the Bagatelle one since the dial carries the inscription *movement placed in / this Case for lack of time / to make one that is / worthy of it August 1781*; one in the Mobilier National, Paris (GML 10109); and one at the Metropolitan Museum of Art, New York (1972.284.16). I thank Helen Jacobsen for sharing with me her research on the Wallace Collection's clock.

160. AN, R¹ 149.

161. AN, R¹ 59.

162. AN, O¹ 3277, file 5. Lefebure et al. 1999. In 1977, similar maintenance work on ancient bronzes was commissioned by Jean-Claude Pitoin. (AN, O¹ 3626, file 1).

163. AN, O¹ 1437, item 86 (Robiquet 1912 and 1920-21, 31, 102-4 [transcribed]).

164. AN, O¹ 3359: "Inventory of small pieces of furniture at the Garde-Meuble [furniture depository] of the Crown of France in Paris . . . Furniture placed by order of His Majesty and that of the Superindentence of the Queen's House in the hands of Monsieur Thierry, steward of the Garde-Meuble of the King by Monsieur Bonnefoy, steward of the interiors and Château of Trianon, February 1792: (Inventaire des Petits-Meubles au Garde-Meuble de la Couronne à Paris, Meubles . . . remis de l'ordre de Sa Majesté et de celui de la Surintendance de la Maison de la Reine à M. Thierry Intendant du Garde-Meuble du Roi par M. Bonnefoy Garde Meuble Ordinaire des Intérieurs et Château de Trianon, février 1792).

165. Archives of Bonnefoy du Plan, private collection.

166. Lanchère sale, April 16, 1806, lot 71: "a pair of wall lights depicting folly and hunting horn in matte-gilded bronze." Then collections of Lord Hertford (1777-1842), Sir Richard Wallace (1818-1890), Lady Wallace (1818-1897), and Sir John E. A. Murray Scott (1847-1912).

167. AN, O¹ 1179, fol. 131: "I have no reason to contradict what you tell me of your association with Messrs. Rousseau, sculptors, for the works that are assigned to them at Versailles. They are indeed free, as are all the king's tradesmen, to choose collaborators, but this does not make my department accountable in relation to the latter."

168. AN, O¹ 1922B.

169. Sold at Christie's, London, June 9, 1994, lot 35. Schwartz 2008, 202-3; Rochebrune, Sourisseau, and Bastien 2014, 206-7.

170. Appendix 1: 1794, January 15 (26 Nivôse in the year II).

171. Bélanger is listed among the Duchess of Mazarin's creditors for 32,000 *livres* (AN, M.C.N., XL VIII 267, June 31, 1781).

172. Bélanger sought assistance from the sculptor and ornamentist Gilles-Paul Cauvet, who is credited for another decorative design. Champeaux 1890-91, pl. 257. Among the papers found at Cauvet's home was a receipt of September 1, 1777, and a promise of 5,000 *livres* from the Duchess of Mazarin, dated April 24, 1779 (AN, M.C.N., XXVII 486).

173. On November 14, 1777, he delegated to Joseph-Edme Goujon, his master mason, six banknotes totaling 12,000 *livres* that the duchess had signed on September 18 of that year, but the payment of which was to be spread out between April 1778 and October 1780 (AN, M.C.N., XIV 460, November 14, 1777).

174. On Radix de Sainte-Foy, see Baulez 1997, 89.

175. AN, M.C.N., XXIII 771, June 10, 1780.

176. AN, M.C.N., VII 457, December 21, 1783.

177. AN, M.C.N., XXIII 802, November 16, 1784.

178. AN, M.C.N., XXIII 812, May 1, 1786; AN, T 172519, item 55. See also Vial 1901, 134-36.

179. The first invoice is mentioned in the inventory of papers following the death of Mme de Mazarin. For the second invoice, see Appendix 1: 1781.

180. Appendix 1: 1781.

181. AN, M.C.N., XXIII 778, May 15, 1781 (Robiquet 1912 and 1920-21, 57, 120-21).

182. Archives of the Palais de Monaco, A.M.C.: S43; Faraggi 1995, 72-98.

183. Appendix 1: 1781, December 10-15 (lot 282).

184. Foucou had produced the plaster model for them, which was exhibited at the Salon of 1779 (no. 244) and also sold at the Mazarin sale in 1781 (no. 327). The marbles may have been executed for another client and for a bedchamber because the only known pair in marble features two large bouquets of poppies in gilt bronze intended to hold candles (Sotheby's, Monaco, November 25, 1979, and December 9, 1984). A pair in terracotta was sold in Paris, Hôtel George V, on March 18, 1981. See also Alcouffe, Dion-Tenenbaum, and Mabille 2004, 170-71.

185. Appendix 1: 1781, p. 349 and 1781: December 10-15. An example that seems to have these characteristics is reproduced in Frégnac 1977, 253.

186. The J. Paul Getty Museum, Los Angeles, 74.DF.5 and Museu Calouste Gulbenkian, Lisbon (599A/B). A pair was also sold at Christie's, Monaco, on April 28-29, 2000, lot 44b.

187. Appendix 1: 1781, February 14 (lot 77); 1781, December 10-15 (lot 2); and 1783, April 8 (lot 169). The vase may have continued on its way to the residence of the Marshal Duke of Noailles (1713-1793) (see Appendix 1: 1794, January 15). Thiéry 1787, vol. 1, 154, already indicated a fine serpentine vase at the Hôtel de Noailles.

188. AN, M.C.N., XXIII 778, May 15, 1781, no. 277, valued at 500 *livres*.

189. Appendix 1: 1781, December 10-15 (lot 285).
190. Sale of February 9, 1784, lot 167: "Un feu à cassolette surmonté d'une flamme soutenue par quatre consoles à têtes d'enfant, terminées à pieds de biche, placé sur un piédestal carré, à corniche et socle à feuilles d'eau, à panneaux couleur d'eau, relevés de cadre, ovale, à nœud de ruban, raisins, feuilles de vignes, formant médaillon orné d'une coupe avec fruits, portée sur un nuage, et son recouvrement à frises, aussi couleur d'eau à trophée; rinceaux d'arabesque encadrés de moulures ouvragées, terminé par un fut de colonne, enrichi de différents accessoires et supportant une pomme de pin; avec garniture de pelle, pincette et tenailles. Ce feu est riche et d'un goût recherché [sold for 1,350 livres to Hervie]." The reason for the Montribloud sale was the collector's bankruptcy. Among the major private buyers were the Count of Artois and, more significantly, the Count of Angiviller, who spent 27,600 livres on behalf of the king for items destined for the future Musée du Louvre (AN, O¹ 1934b, item 80).
191. AN, M.C.N., XIV 467, August 11, 1779.
192. AN, M.C.N., XIV 469, March 1, 1780.
193. Baulez 1986, 586.
194. AN, M.C.N., XX 685, April 18, 1777. On Baudart de Saint-James, Ozanam 1969; Claeys 2009, vol. 1, 137-46.
195. The sculptor of these small marble pieces may have been the Belgian artist Maximilian van Lede (1759-1834), who was in Paris between 1781 and 1789 and who produced similar items for Saint-James.
196. Bibliothèque Marmottan, Boulogne-sur-Seine, MS, Réserve 03020, "Procès-verbal des Scellés et Inventaire des meubles et effets de M. Baudart de Sainte James Trésorier Général de la Marine et des Colonies." Sold after Baudart's bankruptcy, this clock became the property of Xavier de Saxe, Count of Lusace, from whom it was confiscated on June 17, 1794 (AN, F¹⁷ 1191). It may be the wall clock by the clockmaker Robert Robin that was sold at the Lelièvre de La Grange sale (see Appendix 1: 1808, December 21).
197. Alcouffe, Dion-Tenenbaum, and Mabille 2004, 208.
198. The same provenance as the Lepaute clock; then sent on November 23, 1796 to the Ministry of Justice, where they no longer seem to be (AN, F¹⁷ 1192B, item 175).
199. AN, Z¹ J 1171, October 11, 1787; Z¹ J 1177, April 15, 1788. On its third floor, the house had a fine blue turquin marble chimneypiece decorated with garlands and vine branches, which seems to have been reused for this location and is worthy of Gouthière (Vacquier 1923, pls. 52, 54, 55).
200. AN, M.C.N., CXVII 915, inventory of June 2, 1784.
201. Gallet 1980, 195-202.
202. Oberkirch 1970, 306. Her first visit was on March 31, 1782 (ibid., 179).
203. AN, AB XIX 214-15.
204. Baulez 2007a, 9-19. Rémond's invoice, kept in the Thélusson papers in the Archives Nationales, Paris, is also recorded in his accounting records of October 22, 1785, which must correspond to the period when this mantelpiece was completed. Thanks to the description attached to the lifetime lease of the house by the Thélusson estate to Count Emmanuel-Louis-Auguste

de Pons Saint-Maurice (1712-1791), it is known that this chimneypiece had still not been put in place by December 1784. It appears that it was never placed in the Thélusson hôtel particulier but was instead sent directly to the Champs-Élysées hôtel that Denis-Philibert Thiroux de Montsauge (1715-1786) and his architect Jean-Baptiste-Louis-Élisabeth Leboursier (act. ca. 1760-after 1793) rented on January 23, 1785, from Paul-Louis Thélusson (AN, M.C.N., CXVIII 624, January 23, 1785). A chimneypiece of this type and with a provenance from the latter residence is now in the collection of the Metropolitan Museum of Art in New York (1976.227; Watson 1966, 518-21; Kisluk Grosheide and Munger 2010, 156-57). This model was much reproduced, but this example is the only one known to have "the crossbeam all in bronze" mentioned in one of François Rémond's ledgers. In 1788, Rémond delivered two mantelpieces on this model for the Prince of Wales at Carlton House.
205. Bibliothèque Centrale, Versailles, MS 260 F.
206. Ibid., new acquisitions, no. 23299.
207. Ibid., MS 260 F.
208. Lecomte charged Mme Du Barry 800 livres for "a small candelabrum model composed of two female figures . . . carrying branches of flowers for holding candles" (BnF, Département des Manuscrits, 8158, fol. 26). The June 1774 inventory of the pavilion at Louveciennes indicated they were still on Gouthière's premises. The best description we have of them dates to 1795, when they were sent to a deposit at the Hôtel de l'Infantado, in Paris. (AN, O² 474; Baulez 1992, 69 and 83, n. 137).
209. Morisseau 2009, 51-60.
210. AN, Z¹ J 977, March 14, 1774, items 149-55 (Gallet 1978, 87).
211. Archives of the Musée du Louvre, Z 3 E, record of appraisal (procès-verbal d'estimation) of February 11, 1794 (Molinier 1902a, 177-79).
212. Davillier 1870, xxxi.
213. Gallet 1980, 209-13.
214. Gallet 1990, 9-28; Gallet 1991, pls. 10, 12.
215. AN, M.C.N. XX 806, register of April 3, 1805, items 35, 36, 38, 39.
216. The casters mentioned are Jean-François Vitelle (or Vitel) (master in 1778), Eustache Bourry (master in 1746), and Jacques-Maurice Rachel (or Rachelle) (1745-?). Bourry and Rachelle do not seem to have played a part in the most elegant work. Vittel was a fondeur-fontainier, a caster who specialized in fountains.
217. AN, M.C.N., XX 806, register of assets and liabilities, April 6, 1805.
218. Pons 1995, 399-400.
219. This frieze is also found on wall clocks (such as the one in the Salon des Amiraux in the Ministère de la Marine, Place de la Concorde, from the furnishing of the Château de Groussay by Carlos de Beistegui [1863-1953] [Gady 2011, 187]), and on a chest of drawers and a secretaire ordered in 1797 by the merchant of luxury goods Jean-Louis Collignon (act. ca. 1770-1801) from the cabinetmaker François-Joseph Dehm (1761-1843) and from Lucien-François Feuchère (act. 1780-1828); he sold them to the Liège-based clockmaker Laguesse (whose first name is unknown) for Russia.
220. AN, M.C.N., XIV 478, April 10, 1782.

221. AN, M.C.N., XIV 485, April 8, 1784.

222. AN, O¹ 2060¹.

223. AN, M.C.N., XIV 481, January 2, 1783. The debt was from December 23, 1780. Madeleine Mélanie Fyot de La Marche, widow of Dominique Barberie, Marquis of Courteille (1696-1767), superintendent of finances, had just completed the construction by Mathurin Cherpitel (1736-1809) of her new house at 110 rue de Grenelle.

224. AN, M.C.N., XIV 478, April 27, 1782.

225. AN, F¹⁷ 1268.

226. AN, F⁷ 4592, partially cited in Stern 1930, vol. 2, 63.

227. Literally "without breeches." The *culotte*, or breeches, which stopped at the knees, was an elegant item of clothing worn by the upper classes in society. The lower classes wore trousers, which went down to their ankles, avoiding the need to wear stockings. For this reason, the partisans of the revolution were called the *sans-culottes*.

228. AN, F⁷ 4731.

229. AN, M.C.N., XIV 495, agreement of May 2, 1787.

230. AN, M.C.N., XIV 538, December 8, 1795.

231. From 1791, Laitié described himself as a sculptor and chaser (AN, M.C.N., XXVII 506, January 31, 1791).

232. Robiquet 1912, xxix, 69, 71. See also Davillier 1870, xxix, xxx).

233. Two receipts support this hypothesis: one for 1,500 *livres* that Gouthière received from his former mason on January 2, 1796, and one for 6,500 *livres* received from his former gold-beater on February 15, 1796 (AN, M.C.N., XIV 539, receipts of 12 Nivôse and 26 Pluviôse in the year IV (January 2-February 15, 1796).

234. Waresquiel 2014, 244.

235. AN, M.C.N., CX 588, 2 Pluviôse in the year XI (January 22, 1803).

236. Vial 1901, 133. According to Vial, in 1867 Gouthière's daughter lived in the Villa Montmorency, the *garde-concierge* of which she married that same year.

237. Appendix 1: 1808, February 25. For his bills sent in 1808, he only received the first payment in April 1810 (AN, M.C.N., XXXII 180, procuration of April 10, 1810).

238. AN, F¹³ 1071.

239. Champeaux 1885-1902, 71.

240. Metman 1989, 198-99.

241. These models were given by Gadan's widow to the historian Auguste Dupont-Auberville (1830-1890), who lent them in 1880 to the Musée Rétrospectif du Métal at the exhibition of the Union Centrale des Beaux-Arts, which was held in the Palais de l'Industrie in Paris: they consisted of three friezes, one of which had a central mascaron and a "vase handle, figure of a woman terminating in mermaid fashion with acanthus leaves." Bibliothèque des Arts Décoratifs, Paris, Papiers Champeaux, *Dictionnaire des Bronziers*, X 54, vol. 1 (various letters from Dupont-Auberville to Champeaux).

242. Gouthière may be the author of the chimneypieces belonging to Nicolas Grandin on Place Vendôme (now the Ritz hotel) and to Étienne, Marquis of Drée, a knowledgeable mineralogist, which was described in the catalogue of the sale of his collections in 1817, as "a complete chimneypiece with solid tapering elements [*gaines massives*] in the finest of pink Egyptian granite, busts on these, and ornamentation in gilt bronze . . . This chimneypiece, originally made for the capital's most elegant boudoir, does justice to its destination through the beauty of its granite and through that of its bronzes made by the late Gouthière." It sold for 1,800 francs to André Coquille, a dealer in curios). It was illustrated in *Catalogue des huit collections qui composent le musée minéralogique de E. Drée*, Paris, chez Potey, rue du Bac, 1811, pl. XI, fig. B.

243. AD 75, DQ⁸ 401, fol. 88; DQ⁷ 2994, fol. 82.

244. This is probably an error. No annotated catalogue of the sale of the Duke of Aumont's collection mentions Catherine II's purchases, either in her own name or via an intermediary. The few objects said to be by Gouthière in Russian collections were acquired in 1798 for Tsar Paul I (Zek 1994, 152, 158, 161).

245. *Journal de Paris*, no. 81, 1510.

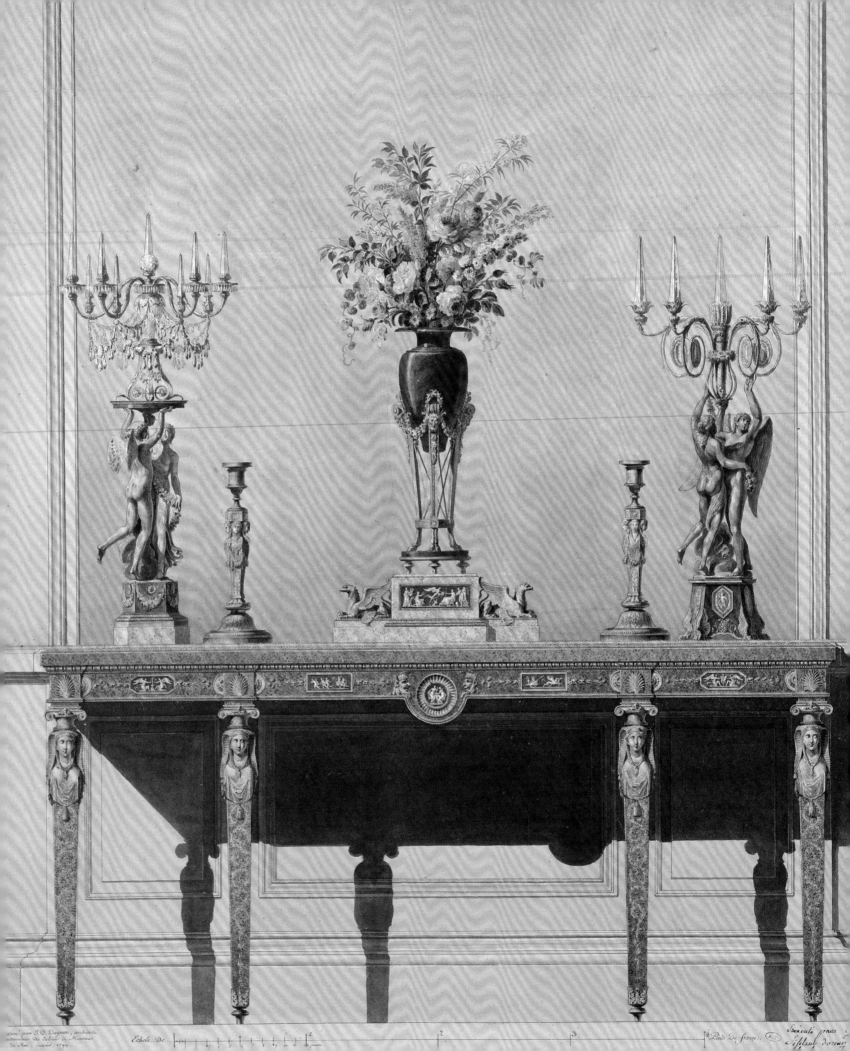

Gouthière's Network of Architects and Designers

ANNE FORRAY-CARLIER

The Musée des Arts Décoratifs holds in its drawings collection a sheet familiar to those interested in the decorative arts, particularly those of the last third of the eighteenth century (fig. 36). At the lower left-hand side of the drawing is a handwritten note in black ink similar to the ink used for the framing lines and identical to that of the scale at the base of the sheet. The note states: "Drawn by J. D. Dugourc, architect / and Draftsman to the Collection of Mr. / brother of the King [Count of Artois]. Paris. 1790." At lower right is another handwritten note, in brown ink: "Executed by Gouthiere / Chaser gilder to the King / Faubourg St Martin." Various authors have noted these inscriptions, but each has interpreted them in accordance with his or her specialty.[1] The present publication presents a full context in which to review these inscriptions and explore the links between Gouthière and Jean-Démosthène Dugourc, as well as, through the latter, the group of designers active in the last years of the century and the architects with whom Gouthière worked.

Both of these inscriptions are related to Dugourc's work via his brother-in-law, the architect François-Joseph Bélanger, and the merchant of luxury goods Dominique Daguerre. However, the date of 1790 gives pause since the model of the illustrated candlestick dates to 1783,[2] and the console table is not only comparable to those produced by Gouthière in the 1770s for the Duke of Aumont (cats. 38, 40) but also close in spirit to one he made in 1781, after designs by Bélanger and Jean-François Chalgrin, for the Duchess of Mazarin (cat. 39). Also noteworthy is a sketch by Dugourc of a very similar console table, which shows that Dugourc was aware of this design (fig. 37). This would seem to suggest that the Musée des Arts Décoratifs work is a presentation drawing, produced by an anonymous draftsman and specifying, at bottom left, the source of the design. Indeed, if Dugourc himself had drawn this image, he probably would have contented himself with the "Dugourc inv." or "Dugourc del." that appears on many drawings by his hand. The date 1790 would then be that of the execution of this presentation drawing. As for the inscription on the right, its nature leaves no doubt that it was a later addition, and, as Christian Baulez has noted, it is not possible to identify the hand responsible for this information.[3] However, it is sig-

Fig. 36
Jean-Démosthène Dugourc, *Project for a Console Table, Candelabra, Candlesticks, and Vase*, ca. 1790. Black ink and watercolor on paper, 26 × 21¾ in. (66.2 × 55.2 cm). Musée des Arts Décoratifs, Paris (CD 2703)

nificant that the address indicated for Gouthière is the one he occupied after 1788, where he was still listed in 1811.[4] Furthermore, the mention of the "chaser gilder to the King" makes it possible that this note was added between 1790 and 1792 since such a reference to the king would have been unthinkable after this date. Finally, it is worth noting that the scale placed at the bottom of the sheet states that it represents "*pieds de France*" *(French feet)*, which supports the hypothesis that this was a presentation drawing intended for a foreign court. It is tempting to suggest the Spanish court, with which Dugourc was in contact at this date.

In 1990, Baulez confirmed the role played by Dugourc on the Parisian decorative arts scene between 1770 and 1790—during which he progressed from subordinate to designer—as well as his partnership with his brother-in-law, Bélanger.[5] Their mutually beneficial relationship demonstrates the interconnectedness of the network in which Gouthière operated, and the appearance of Gouthière's name on the aforementioned drawing indicates his proximity and involvement. Scholars have struggled, however, to elaborate his personal and professional relationships. Because of the lack of surviving private papers, log books, or correspondence, any quest for information yields no more than hypotheses. We must content ourselves with bringing together data revealed by various authors and extrapolating from the records of his contemporaries and collaborators.[6]

Fig. 38
Augustin Pajou, *Charles De Wailly*, 1789. Plaster, h. 15¾ in. (40 cm). Musée des Beaux-Arts, Lille (2001.2.1)

The first architect Gouthière worked for was Charles De Wailly (fig. 38) around 1767. This was in the context of the remodeling of the Parisian *hôtel particulier* of Marc-René de Voyer de Paulmy, Marquis of Voyer.[7] It is difficult to explain how Gouthière came to work under him, given the architect's own abilities where interior decoration was concerned. One unconfirmed lead begins with Gouthière's relationship with the silversmith Jacques Rondot (1730–1808), who was from Troyes. The two men were contemporaries and almost certainly met during their initial training; also, as Natalis Rondot (1821–1900) informs us, in an article on the gold- and silversmiths around Troyes,[8] there was a family link between Jacques Rondot and De Wailly, with whom Rondot went to Rome in 1752. Rondot may have had a role in introducing Gouthiere to the architect, or the Marquis of Voyer himself may have imposed upon Gouthière, having had the chance to admire the "little antique monument" belonging to Mme Geoffrin, whose salon he frequented (cat. 6). While De Wailly and Gouthière had no further professional contact, a short time later, while working at Louveciennes, Gouthière met up again with some of the artists who had contributed to the decor of d'Argenson's residence.

The Louveciennes site marked the beginning of Gouthière's work with the architect Claude-Nicolas Ledoux (fig. 39). Following advice from her entourage, Mme Du Barry had called upon De Wailly and Ledoux, who submitted designs to her.[9] Her preference was for Ledoux, no doubt because of the work the architect was completing at that time in the *hôtel particulier* of the Duke of Montmorency, whose wife was a friend. Ledoux further benefited from the backing of the Marshal Prince of Soubise, who was also close to Du Barry and at the time the lover of the ballerina Marie-Madeleine Guimard. Newly arrived on Ledoux's team, Gouthière would work again for him on the Paris *hôtels* of Fontaine de Cramayel and the Geneva financier Georges-Tobie de Thélusson, as well as the residences of Jean-Baptiste Hosten.[10]

Luckily, some of the archival documents relating to these Ledoux projects have been preserved, and they indicate the role of each individual in the implementation of the work. Ledoux is revealed to have been attentive to the smallest details of the interior schemes entrusted to him, typically presenting actual-size drawings. This was notably the case for Louveciennes: Gouthière had access to drawings that allowed him to carry out the architect's wishes with the greatest of

accuracy, as is further confirmed by the latter's own records.[11] On the invoice that relates to his involvement in the work at the Thélusson residence, the creative process is apparent.[12] Gouthière began by modeling the chimney-pieces in clay, after Ledoux's drawings. These models were then produced in wood, at full scale, by a joiner from a full-size drawing requested, in this case, from Joseph Métivier, the architect and sculptor who was working on several of Ledoux's projects and who oversaw the construction of Gouthière's own house. From these, Gouthière produced wax models that were used to create plaster molds from which impressions in wax were made that were handed to the caster; then, on the cast bronzes, he carried out the chasing and gilding.[13]

Although the terms used in the invoices are not always consistent, they indicate that Ledoux supervised the work very closely and, where needed, made corrections. But Ledoux did not intervene on gilt-bronze furnishings. For example, for the firedogs with incense burners that Gouthière supplied for the fireplace in the Salon Ovale of the pavilion at Louveciennes, he specified that he had only executed them after presenting several drawings and clay models to the building's owner.[14] Contrary to other invoices, he did not name the creator of the drawings or the maker of the models, perhaps allowing it to be supposed that he himself had produced them. There is no denying that Gouthière worked from architects' designs and that, in the case of these major architectural projects, he was needed because he was an excellent practitioner, but it is not known whether his chasing and gilding work was at all influenced by architects. Logic suggests that Ledoux's corrections led to a dialogue between the two men, but this is no more than a supposition.

Gouthière's rising reputation may have been the reason Ledoux asked him to produce the Louveciennes gilt bronzes. We do not know who orchestrated the meeting between the two, but it was probably someone in the circle of actresses and their patrons, of which both men were a part. Exactly when Gouthière started to frequent the theater is not known, but it is certain that in 1769 he had a relationship with the actress Madeleine-Augustine Courtois that, as Jacques Robiquet has written, gives rise to suspicions about his marital fidelity.[15] Despite the absence of a name or a fortune, Gouthière had youth on his side and seems to have had a handsome face, which secured him women's favors and also allowed him to meet men he could not otherwise have approached. Rivalries and friendships then brought about opportunities for support that Gouthière most often knew how to use.

It may be in this milieu that Gouthière made the acquaintance of Bélanger (fig. 40), who was successively the lover of Sophie Arnould and of Marie-Madeleine Dujon, before succumbing to the charms of Anne-Victoire Dervieux and making her his wife. The two men entered the service of the Menus-Plaisirs in the same year, Bélanger as a designer, Gouthière as a chaser-gilder. There, they worked together on Marie Antoinette's jewelry cabinet (cat. 41) and on supplying mounts for

Fig. 40
Henri-Victor Roguier,
François-Joseph Bélanger.
Carved roundel on Bélanger's
gravestone, ca. 1818. Stone,
diam. 14⅛ in. (36 cm). Père-
Lachaise cemetery, Paris

Fig. 41
François-André Vincent, *Pierre-Adrien Pâris*, 1774. Oil on canvas, 24¼ × 18¾ in. (61.6 × 47.7 cm). Musée des Beaux-Arts, Besançon (2009.1.1)

the hardstone and porcelain pieces belonging to the Duke of Aumont, one of the king's Premiers Gentilshommes de la Chambre who had been in charge of the Menus-Plaisirs' accounting since 1763 (cats. 8-17, 21, 38-40, 42-48).[16] The archival documents are explicit. Gouthière produced the mounts after Bélanger's designs.[17] When, in 1773, the latter, through his mistress Sophie Arnould (who was simultaneously the mistress of the Prince of Hénin, captain of the Count of Artois's guards), was introduced to the Artois circle and then, in 1777, purchased the title of architect to the king's younger brother, he entrusted several pieces of work to Gouthière. The two men had shared interests, both professional and personal, and no doubt enjoyed each other's company.

In the Menus-Plaisirs, Gouthière also rubbed shoulders with Pierre-Adrien Pâris (fig. 41) who, in 1778, took over from Michel-Ange Challe (1718-1778) as the designer to the Cabinet du Roi. While Gouthière does not seem to have worked from Pâris's drawings, Pâris left the exceptional testimony of a tracing of several chased mounts by the bronze-maker and the *versions au net* to illustrate the catalogue for the sale that followed the Duke of Aumont's death (cats. 8-13, 16-17, 23, 40, 42, 46-48). His belonging to the Menus-Plaisirs' circle and, more particularly, the works carried out privately for the Duke of Aumont mark a critical point in Gouthière's career. These years were his heyday, as he worked in turn on private commissions and projects for the king both through the Menus-Plaisirs and the Bâtiments (the department responsible for the administration of the royal residences), encountering people who found him to be unrivaled in realizing their decorative fantasies. His patrons' desire to emulate and outdo one another led to the creation of several masterpieces. When Pâris joined the Menus-Plaisirs, he had just returned from a stay in Rome, whence he brought back numerous drawings. It is impossible to ignore the similarities between the tracing the architect made of the roses on the temple of Jupiter Stator and the Arch of Titus (fig. 42) and the rosettes used by Gouthière on these chimneypiece bronzes (fig. 43).

Dugourc preceded Pâris in Rome and was indirectly linked to the Menus-Plaisirs through his brother-in-law. Many of his drawings have survived, but it is difficult to judge whether they are translations of ideas from Bélanger or someone else, or indeed his own. Dugourc was in contact with architects and a private clientele thanks to his brother-in-law, but he also had links with joiners, ornamental sculptors, interior decorators, upholsterers, and bronze-makers, whom he met while working on different architectural projects. In one of his autobiographies, Dugourc goes so far as to mention that he supervised the execution of Gouthière's bronzes or at least those associated with his brother-in-law Bélanger's projects. Dugourc could not have been a stranger to the world of gilt bronze—from 1781 to 1785 he lived on Rue Meslay in a house belonging to Métivier and Charles Lachenait (ca. 1740–1836) that was also home to the Caille & Cie firm of casters and

Fig. 44
*Livre d'ornements à l'usage des
artistes dessiné par l'Huilier et
gravé par Doublet*, pl. 13 [n.d.],
in folio. Bibliothèque des Arts
Décoratifs, Paris (Collection
Maciet, ORN.9.14)

chasers, working under the direction of the sculptor Jean Hauré,[18] who was to join the Garde-Meuble at the same time as Dugourc, in 1784. Gouthière must have known this place.

Dugourc had an undeniable influence on Gouthière's style, as evidenced by a comparison of the first mounts made by Gouthière for the Duke of Aumont (cats. 9–12) with those found in his workshop on the duke's death (cats. 15, 16, 17, 21, 40). It is also pertinent to mention that the Rousseau brothers—Jules-Hugues and Jean-Siméon (known as Rousseau de la Rottière), decorative painters and sculptors—are recorded as having been frequently associated with Gouthière, who seems to have received some commissions from them.[19] They first worked together at Fontainebleau, for Marie Antoinette's Cabinet Turc (cats. 25, 31), under the direction of Richard Mique, though in truth they were overseen by the architect Nicolas-Marie Potain (1723-1790).[20] The quest for harmony among the various elements of French interior decoration—for which rules had been laid down by theorists such as Jacques-François Blondel—and the matching ornamentation within a given room that resulted from it required constant interaction among the various craftsmen. Whether sculpted in wood or cast in bronze, these elements of ornamentation demanded the understanding of volume and detail that both the Rousseaus and Gouthière shared. In addition to their mutual appreciation of each other's work, they were also relatively close. Indeed, when Gouthière was expelled from his workshop and forced to surrender his assets to his creditors, it was under Jean-Siméon's roof that he found refuge.[21] It was also during these years, 1785–89, that he produced the bronzes for several chimneypieces for the king's and queen's apartments at Versailles, on the Rousseaus' request.[22] In 1786, Gouthière attempted to secure new commissions from the Count of Angiviller by putting forward the latter pieces, but his efforts were in vain. Gossip was rife at the court, and Gouthière's prestige had been damaged by his carelessness in managing his finances, as well as by his prices, which were deemed excessive.[23]

While architectural bronzes produced on architects' orders occupy an important position within Gouthière's production and also brought him work with sculptors such as Louis-Simon Boizot, Philippe-Laurent Roland, and Jean-Joseph Foucou, they do not constitute his entire oeuvre. Furnishing bronzes comprise a significant portion of his work. In addition to the commissioned pieces, there were also more everyday items. For Mme Du Barry at Louveciennes, Gouthière carried out some more modest work in the antechambers and supplied candlesticks and fireplace implements from models he had at hand and that must have constituted the bread-and-butter of his business.[24] He had no hesitation in copying models (for example, cats. 4, 5, 26), and for this part of his production he forewent architects' designs in favor of those by ornament designers that were disseminated through engravings. Gouthière must have been aware of the anthology of ornaments that Gilles-Paul Cauvet published in 1777[25] and of the less famous one by Nicolas-François-Daniel Lhuillier[26] (fig. 44); he had certainly encountered the drawings of Jean-Louis Prieur, a fellow chaser and gilder, and those of Jean-François Forty, whose work displays shared traits (fig. 45).[27]

Gouthière was an interpreter extraordinaire who translated into gilt bronze an ornamental language that rose to glory because of a handful of architects, sculptors, decorative craftsmen, and clients who did not shrink from spending money. His bankruptcy impacted his dazzling production but did not completely destroy it, and he worked again after the revolution under the

Fig. 45
Jean-François Forty, *Project for
a Candlestick*, ca. 1780. Pencil,
black ink, and wash on paper,
17⅛ × 10¼ in. (43.5 × 26 cm)
Musée des Arts Décoratifs,
Paris (4494)

A. N: 4494.

A.D.

architects Alexandre-Jean-Baptiste-Guy Gisors and Bernard Poyet. Gouthière managed to retain support within his professional entourage: the letter Bélanger wrote from the Saint-Lazare prison to the interior minister Jules-François Paré, on 15 Ventôse in the year II (March 5, 1794), shows the esteem in which he held Gouthière, who was also incarcerated at that time: "Come to our aid, for we have here men who have twenty fingers on each hand and are forgotten, Robert, Pâquier, Le Monier, Audran, Gouthière, all artists."[28] Although the phrase may sound odd, the multiplication of the number of fingers was indeed intentional, to indicate the soundness of their talent.

Notes

1. Baulez 1986, 600; Ottomeyer and Pröschel 1986, vol. 1, 287; Verlet 1987, 294; Hughes 1996, vol. 3, 1249; Billon 2001, 203; Fuhring 2005, 318-19.
2. Hughes 1996, vol. 3, 1249.
3. Baulez 1990, 600.
4. Archival documents from after 1792 give his address as 2, then 88, rue du Faubourg Saint-Martin; Gouthière died at 99 rue du Faubourg Saint-Honoré.
5. Baulez 1997, 11-43.
6. This approach to Gouthière's oeuvre is the result of numerous questions that currently remain unanswered.
7. Rabreau 1979, 44; Baulez 1986, 575; Scherf 1997, 85-86.
8. Rondot 1891, 389. To date, it has not proved possible to verify the family link between Jacques Rondot and Charles De Wailly. Also Baulez 1986, 164-65.
9. Gallet 1980, 90 et seq.; Gallet 1992, 11-23; Rabreau 2005, 114.
10. Gallet 1980, 195 et seq.
11. Gallet 1974-75, 142-43, n. 53.
12. Appendix 1: 1787, June 26.
13. Ibid.
14. Appendix 1: 1773, December 31 (1).
15. Robiquet 1912, 23; and pp. 32, 49 in this publication.
16. See pp. 39–43 in this publication.
17. AN, O¹ 3044, item 362, cited by Stern 1930, vol. 1, 46-47. See also p. 41 in this publication.
18. Baulez 1990, 20-21.
19. See pp. 35, 50–51, 55–57 in this publication.
20. Raïssac 2011, 207.
21. See p. 50 in this publication.
22. See cats. 36, 37 in this publication.
23. See p. 51 in this publication.
24. Appendix 1: 1773, December 31 (1 and 2).
25. *Recueil d'ornemens à l'usage des jeunes artistes qui se destinent à la décoration des bâtimens, dédié à Monsieur par G.P. Cauvet sculpteur de S.A.R*, 1777, published in Paris by the author, Rue de Sève.
26. *Livre d'ornements à l'usage des artistes dessiné par l'Huilier et gravés par Doublet et Romae*, undated, published in Paris by "Jean," 32 rue Jean de Beauvais (Bibliothèque des Arts Décoratifs, Paris, Collection Maciet, ORN.9.1-18, 26).
27. Forty published several of his drawings between 1770 and 1790 in the form of notebooks offering numerous models of domestic and religious objects. They display a whole vocabulary that was shared by this generation of artists and that Gouthière employed: bodies terminating in fish tails, terminal figures, sphinxes, etc. Motifs for stair handrails and windowsills can be compared to those on friezes used by Gouthière on some of his chimneypieces.
28. AN, F⁷ 4592, cited in Stern 1930, vol. 2, 62-63. See p. 71 in this publication.

Gouthière's Network of Craftsmen

CHRISTIAN BAULEZ

The guilds that governed the economy under the ancien régime imposed extreme specialization on every trade, so each of Gouthière's commissions necessitated a network of independent workshops, artists, and craftsmen. A reconstruction of this professional network facilitates a better understanding of Gouthière's work and the production techniques it required.

Records related to Gouthière's bankruptcy filing in 1787 provide a snapshot of his many creditors, contacts, and subcontractors.[1] The documents, though sometimes vague and lacking in detail, are an indispensable tool for tracing craftsmen whose names were often lost to history. Additional information can be gleaned from marriage contracts, bankruptcies, creditors' agreements, estate inventories made after death, and various notarial deeds. Archival documents reveal the names of some of the metal craftsmen, casters, chasers, assemblers, gold-beaters, and gilders who collaborated with and subcontracted for Gouthière. It is difficult, however, to find out more about most of them, as they were little known masters or humble journeymen.

CASTERS

Under the ancien régime, casters were the only craftsmen who had the right to mold and sand-cast copper, brass, and tin. They could also chase their works to a certain level of finish. Often, they only conducted the initial stages of cleaning up the pieces that emerged from their molds; this was sometimes sufficient for lower quality works or those not intended to be gilded. Alongside these caster-founders (*fondeurs-fondants*) were a significant number of caster-chasers (*fondeurs-ciseleurs*), who had specialist colleagues carry out the molding or casting so they could focus on the chasing. Thus, François Rémond, who was a shrewd businessman, would have his work cast elsewhere—for example, by the three sons of Étienne Forestier (1712-1768), Étienne, Jean, and François—but would also have pieces from other casters on his premises, which he chased and

gilded. As a result, casters were among the craftsmen with whom Gouthière had the most frequent and direct contact. Numerous written sources testify to such collaborations, but the dates they indicate are often unreliable; references to longstanding debts (repaid or otherwise) appear more often than production dates.

The bankruptcy records of Pierre-Étienne Caron in 1780 (which had a strong impact on the entire profession due to the importance of their business) reveal that he had owed Gouthière money since 1770 for the provision of casting.[2]

In 1774, an inventory made after the death of the *fondeur-fondant* Claude-Bernard Heban (master in 1775) revealed that three dozen of his fellow Parisian casters owed him money, as did several gilders, including Gouthière at 500 *livres* and Luc-Philippe Thomire (1737–1783) at 238 *livres*.[3] Clearly a considerable number of Parisian *fondeurs-ciseleurs* used Heban, who also had his own models, as a *fondeur-fondant*. Gouthière also collaborated in the early 1770s with Guillaume Fleyssac, who delivered to him on December 20, 1775 "a Gouthière chandelier," but no information is given about its appearance.[4]

Today, some of the craftsmen in Gouthière's professional circle would be described as subcontractors rather than collaborators: this is the case, for example, for Jean-Claude-Thomas Chambellan Duplessis (Duplessis *fils*), judging by a transfer of funds to him from Gouthière dated October 5, 1776:

> To discharge himself of the 13,339 *livres* he owes in capital, interest, and fees to Jean-Claude-Thomas Chambellan Duplessis, master *fondeur-ciseleur* in Paris, where he resides on Rue du Four in the parish of Saint-Sulpice, in accordance with the account drawn up between the parties (credit of 560 *livres*) . . . for the bronzes that Duplessis has promised to supply ... for a four-seat carriage for the Countess of Artois; these two sums making 13,899 *livres* . . . the aforementioned Gouthière authorizes and transfers to the aforementioned Duplessis ... the same sum . . . to be received from the treasurer of the Household of the aforementioned Countess of Artois, for the items he has supplied for the establishment of the princess's stables.[5]

The name Duplessis *fils* comes up again in 1781, when he was described as an expert called upon to appraise the gilt bronzes not yet finished by Gouthière at the time of the settlement of the Duke of Aumont's estate.[6] Upon his own death in 1783, Duplessis was owed money by Gouthière for a pair of candlesticks valued at 36 *livres*.[7]

Georges-Alexandre Moreau was described on September 13, 1776 by the chaser Vincent Guilliard (also spelt Guillard) as "Mr. Gouthière's caster."[8] Moreau was also one of Jean-Baptiste Julia's creditors at the time of his bankruptcy in 1775;[9] in 1778, Gouthière paid Moreau 1,551 *livres*, both for signed notes (918 *livres*) and work supplied in 1776 (481 *livres*) and 1777 (248 *livres*).[10]

Two documents dating from 1776 give the name of another caster connected with Gouthière—Louis-Pierre Morant—although exactly what type of work he did for Gouthière is not known. On May 25, 1776, Morant lodged an objection to the sum that Gouthière was to receive from Taillepied de La Garenne; having obtained satisfaction, he withdrew his objection on July 24 of the same year.[11]

In 1779, a number of estate inventories hint at some of Gouthière's other collaborators, such as Jean-Baptiste Morel, who, when he died, was owed money by Gouthière for "a model for a supporting bar," the buckle for the straps that secured the body of a carriage.[12] The papers of Louis-Barthélémy Hervieu (1719-1779), who collaborated with the cabinetmakers Jean-François Oeben (1721-1763) and Jean-Henri Riesener (1734-1806) on Louis XV's roll-top desk at Versailles, include the following:

> a statement of the work done and supplied by the late Mr. Hervieu for Mr. Gouthière, chaser-gilder to the King, which, after deduction of the gilding supplied by the aforementioned Mr. Gouthière to Mr. Hervieu, totals 2,700 *livres*, and was fixed at the latter sum by the aforementioned Mr. Gouthière on August 15, 1779. Of which sum Hervieu's widow declares that 72 *livres* were paid on account to the late Mr. Hervieu.[13]

During the same period, Gouthière was working with three other casters: Jacques-Marie Desouches, Antoine Lejeune, and another named Fouet. On September 2, 1779, Gouthière assigned 2,400 *livres* to Desouches, to pay for the work Desouches was "just about to do for him."[14] In 1779, Antoine Lejeune put himself up as a creditor of Gouthière's for a sum of 781 *livres*, which had been previously established by a judge's ruling. A payment of 3,000 *livres* that Gouthière made to Lejeune on July 5, 1779 was broken down into "2,267 *livres* for foundry works already supplied, etc." and "732 *livres* for those that remain to be supplied." Lejeune's inventory drawn up after his death records a note of 1,000 *livres* payable to Louis-Simon Boizot, endorsed by the sculptor, as well as a list of the works that the deceased was supplying to Gouthière, which implies a regular collaboration between them.[15] The caster Fouet was Gouthière's creditor for 800 *livres* in the year 1779.[16] He and his partner Pierre Collin (also spelled Colin), who himself was a creditor of Gouthière's, were then working for Rémond, who, on May 16, 1779, debited 432 *livres* from Gouthière "for the casting, chasing, and gilding of a pair of a wall lights with 3 branches, model by Colin and Fouet."[17] In 1780, there is mention of Jean-Baptiste Allenet, to whom Gouthière assigned 60 *livres*, the remainder of a debt of 650 *livres* for the production of a wall light in gilt bronze.[18]

The document of Gouthière's surrender of his assets to his creditors in 1787 provides the names of other casters although without any indication of the date or of the precise nature of their collaboration with Gouthière: François-Aimé Damerat, who achieved some renown; a certain Raitel, perhaps Vincent-Camille Raitel (master in 1788), who was owed 1,640 *livres* by Gouthière; and Tirel, who may have been Pierre-François Tirel. Finally, among Gouthière's creditors was a man named Turpin, probably Joseph-Noël Turpin, whose business seems to have been more extensive, even though Gouthière owed him only 94 *livres*.

A judge's ruling noted by Jacques Robiquet further indicates that on March 19, 1783 Rémond was the arbiter in a dispute between Gouthière and a certain Boivin, the latter of whom was claiming the cost of unpaid invoices in the amount of 257 *livres*.[19]

CHASER-GILDERS

Although Parisian gilders were officially allowed by the guild to gild only on iron, cast iron, copper, and brass, "master chaser-gilders" occasionally gilded and chased works in silver as well. The regulations of the guild of the Parisian master chaser-gilders do not seem to have forbidden this, and those of the goldsmiths and silversmiths did not demand that these prerogatives be strictly the preserve of the latter professions.[20] Furthermore, Pierre Gouthière was received on April 13, 1758, as a master "gilder, chaser, and inlayer on all metals." Thus the silversmith to the king, François-Thomas Germain, called upon him to chase and gild certain objects in both gilt bronze (cat. 3) and silver (cats. 1, 2), which he sold to his wealthy clients. Only those few gilt pieces for Germain included here have been identified, but Gouthière may have carried out other tasks of gilding on silver, both for Germain and other silversmiths. For example, in the early 1770s, Gouthière was responsible for gilding several silver pieces for Mme Du Barry.[21] The identity of the silversmith who worked with Gouthière is not known—it may have been an artisan in Germain's workshop—but it was Gouthière who delivered the finished pieces to the king's mistress. Her specially appointed gold and silversmith (*orfèvre*) at that time was Jacques-Nicolas Roettiers, which may be why Alfred de Champeaux was told that Gouthière "had modeled items for a golden toilet for the king's favorite that she had ordered from the *orfèvre* Roettiers."[22]

According to the statutes of the gilders' guild, master gilders could both gild and chase their work; this privilege was also granted to some extent to the master casters, which led to numerous legal disputes between the two guilds.[23] In 1776, Louis XVI put an end to this ambiguous and antagonistic situation by bringing casters and gilders together under a single guild; however, the craftsmen remained highly specialized in their areas of training and skill. Some gilders would only practice gilding, a concentration that allowed them to perfect their art, while others chose to specialize as chasers. The latter were the ones who, depending on their know-how and the strictness of their client's demands, would transform standard models into unique works. Gouthière, who himself was a gilder and chaser, often delegated chasing and gilding work to colleagues so he could maintain a good pace of production.

It is impossible to distinguish each craftsman's work as independent artisans typically worked for multiple employers: Rémond employed chasers and gilders by the day, dividing the work among them. Since each chaser had his own specialty—ornaments, flowers, animals or human faces—he might work in turn for Gouthière, Rémond, Thomire, and several others. This interchangeability among workshops is illustrated by the career of Vincent Guilliard (1750–after 1797). Having entered into apprenticeship in 1763, under the master caster Antoine Dincre (1714–after 1769), he worked in Gouthière's workshop in 1776 and from 1779 at Rémond's, who also provided him with lodgings in his home.[24] It is just as impossible to assess the comparative extent of these craftsmen's work for Gouthière: sources often mention only the paid installments.

Among the chasers who have been identified, Jean-Nicolas Lebeau and Vincent Guilliard are the only ones whose work for Gouthière can be defined. In the late 1760s, Gouthière was subcontracting chasing work to Lebeau, whose bankruptcy in 1769 lists chasing works carried out for

Gouthière since 1765.[25] As for Guilliard, who described himself as a "chaser of coaches, presently residing at the Arsenal in Paris," his name appears for the first time on August 27, 1775, in relation to a note for 1,200 *livres* signed by Gouthière, which, between transfers and authorizations, was paid to Pierre Colson from the Duke of Aumont's funds. Guilliard's name crops up again on September 23, 1776, in relation to the accounts of Gouthière's transfer of funds to Jean-Auguste-François Bottenotte, *bourgeois* of Paris. This informs us that, up to that time, the chaser had partially made and supplied 19,214 *livres*' worth of work "after the models that the aforementioned Mr. Gouthière gave to the said Guilliard," which it then lists in detail:

> A pair of wall lights with quivers, of which one side of the light and the plate of the other side have already been delivered, so that all that remains to be delivered is one complete pair of wall lights and the arms of the ones for which the said Gouthière has the plate. All the complete models of all the small poppy wall lights mentioned in the invoice, each of which has a copy. All the models of wall lights with figures also noted in the said statement. Two pairs of wall lights with figures. All the models for the candelabrum surmounted by two infants. Plus *pieds de chaine*, some of the models for the large poppy wall lights. The surplus presently being in the hands of Mr. Moreau, caster of the said Mr. Gouthière, and all mentioned in the said invoice. The said works thus supplied and to be supplied by Mr. Guilliard to the said Mr. Gouthière being thus noted and their value established and finalized, the said Mr. Gouthière desiring to pay off . . . [26]

Of the chasers employed by Gouthière, only one appears on the list of his creditors in 1787: Frary *fils*, who was living on Rue Sainte-Apolline and awaited a payment that had been established by a ruling at 88 *livres*. The names of other chasers appear in the documents relating to the bankruptcy:[27] on May 1, 1786, Gouthière paid Pierre Philippet, his journeyman chaser, who lived on the Grande Rue du Faubourg Saint-Denis, perhaps at his employer's home, a sum of 920 *livres* for salaries due as a worker in the year 1785. Hilaire Masson, a chaser and assembler who lived on Rue Neuve-Saint-Nicolas, received 790 *livres* on April 12, 1786 for days spent working at Gouthière's during the same year, 1785; he would receive a further 150 *livres* on October 15, 1787 for days spent working since January 1786. Charles Jacot received 436 *livres* on June 8, 1786, to be deducted from the sums owed to him for days worked in 1785; the remainder of 60 *livres* was paid on June 8, 1786. Jacot worked for Gouthière again in 1789, spending "12 ¾ days" dismantling, cleaning, and reassembling the bronzes from Mme Du Barry's chimneypieces; this earned him 138 *livres*, including 6 *livres* for soldering two harness buckles, at least one of which may have been gilded on August 22, 1789, by François Rémond.[28]

The gilders subcontracted by Gouthière were likewise of varied reputation, but most were little known craftsmen. On January 27, 1777, Gouthière owed 3,204 *livres* to the gilder François-Magnus Harlau (1704–1778) for merchandise received.[29] He further owed 838 *livres* to the gilder François Dufour, pursuant to a ruling by the consuls on June 23, 1783, which he still had not carried out; added to this was a debt of 588 *livres* for works supplied to Gouthière since this date.[30]

When Gouthière filed for bankruptcy in 1787, he owed the gilder Jean-Baptiste-François Duval 1,039 *livres*. Among his largest debts was that owed to the gilder Pierre-François Feuchère:

this debt of 4,153 *livres* had been established in two rulings from the consuls, who had ordered Gouthière to pay it. Nicolas-Joseph Aimé was in his credit for 200 *livres* after an account that was difficult to settle because the two parties had to receive equal payments, "having mutually supplied merchandise to one another." In 1787, Gouthière also owed money to the gilders Nicolas-Pierre Delaporte (2,570 *livres*), Jean-Barthélémy Ligois (1,075 *livres*), and Adrien Dartois. The record of deliberations specifies that "there was an arrangement between him [Dartois] and Mr. Gouthière, by which the latter remained in debt for a sum of 678 *livres*; he has since been supplied with a pair of wall lights, not yet included in the balance."[31]

GOLD-BEATERS

Gold was of course the largest item of expenditure for gilders. Beaters (*batteurs*), who supplied it, reduced the precious metal into very fine leaves or powder, which they delivered to metal gilders and painter-gilders. Their fellow artisans, called *tireurs d'or* (gold-wire drawers) would draw out the gold into fine strands, the resulting spools of which were provided to brocade makers and master embroiderers. One of the gold merchants and beaters who worked with Gouthière was Jean-Bernard Bachellé, based on Rue de La Coutellerie. His name appears in relation to the legal dispute that pitted Gouthière and the sculptor Jean-Baptiste Julia against Taillepied de La Garenne. Besides their professional relationship, Bachellé had lent Gouthière 4,000 *livres* in exchange for 200 *livres* of annuities,[32] which he demanded back on December 18, 1787, during Gouthière's surrender of his assets. Gouthière was not able to pay him until February 15, 1796, when he reimbursed not only the 4,000 *livres* but also 2,500 *livres* due for other reasons. A certain Becht, a gold merchant, seems to have been owed 600 *livres* by Gouthière by promissory note (*transfert de billet*) alone. On the other hand, Jean-Guillaume Goix had supplied Gouthière with gold; at the time of Gouthière's bankruptcy, he still owed him the 744 *livres* he had been sentenced to pay him on December 6, 1782. Gouthière owed more money to the wife of another gold-beater, Mr. Jacob—probably Gaspard Jacob of Cul-de-sac Saint-Laurent—whose assets were legally separated from her husband's. However, Gouthière's main supplier seems to have been Charles Spire, who was also a goldsmith. On March 1, 1789, he delegated 3,734 *livres* to him on account of a larger sum that was to be taken from payments due from Baudart de Saint-James.[33] Ultimately, Gouthière still owed him almost 11,000 *livres*, which he had delegated from payments due for work done for the Duchess of Mazarin.[34]

GOUTHIÈRE AND FRANÇOIS RÉMOND

The name of the bronze-maker François Rémond—chaser, gilder, then caster—appears repeatedly in regard to appraisals of Gouthière's bronzes, to the chimneypieces he completed for the Thélusson *hôtel*, and to the craftsmen he employed concurrently with Gouthière.

Fig. 47
François Rémond,
Candelabrum with Ostriches
(detail), 1782. Gilt bronze,
30¾ × 17¾ in. (78 × 45 cm).
Musée National des Châteaux
de Versailles et de Trianon
(OA 5315)

Born between 1745 and 1747, Rémond commenced his apprenticeship on March 13, 1763, under Pierre-Antoine Vial (master in 1758), a gilder on Rue Saint-Martin,[35] and was admitted as a master on December 14, 1774. Twelve years later, his business had expanded so much that he was ranked in the second class for tax purposes, like Forestier's widow and Charles-Louis Berta (master in 1773).[36] In the first class was Michel Philippe Desprez (master in 1749), whose family business was mainly involved in heavy casting work for buildings and even bells. Rémond was clearly one of the most important Parisian gilders and casters. As for Thomire, he was taxed in the sixth class in 1785 and in the fifth in 1786 and 1787. By that time, Gouthière was ranked in the fifteenth class, which reveals a drop in his business after the deaths of his main clients. Added to this misfortune was his eviction from his workshops, which made it impossible to work.[37] Rémond died rich on April 14, 1812, after several years' retirement, and his only daughter's offspring enjoyed a dazzling rise in aristocratic circles.[38] Gouthière's demise greatly enhanced Rémond's business, and Thomire was able to develop professionally only after Rémond's retirement.

Many of Rémond's accounting records have survived, making it possible to attribute—or restore—to him a whole body of work that has traditionally been credited to Gouthière.[39] This author was led into a fruitless search for a connection between the two workshops that would have allowed Rémond to continue Gouthière's business, but it seems there was no such connection and that their collaboration was in fact episodic. It is possible, however, that after his apprenticeship under Vial, Rémond served as a journeyman under Gouthière. Juliette Niclausse has put forward the same argument in relation to Thomire,[40] but in both cases it may just reflect a wish to detect a line of descent linking the best craftsmen in each generation.

Nevertheless, their interactions were frequent and predate the writing of the surviving parts of Rémond's accounting records, since there is a mention in the latter, dated May 16, 1779, of the existence of a detailed bill of 1,063 *livres* for work carried out in September and October 1777.[41] As already stated, on this same May 16, 1779, Rémond billed Gouthière 432 *livres* for a supply of rough casting, the chasing, and the gilding of a pair of wall lights with three branches, after a model by Colin and Fouet. This account was settled in its entirety (1,615 *livres*) on July 19, 1783, the same day he handed over a remounted "Bacchus group, for having soldered in various places, supplied several screws, supplied the thyrsus, rods, copper, and fashioned the rods, and given the whole of the said group an antique green finish, 120 *livres*."[42]

On March 6, 1784, Rémond executed "various elements of chasing, assembling and matte gilding of a chimneypiece" for Gouthière.[43] On April 10, he invoiced him for "8 knobs and locks for Mr. Deumier" for 36 *livres;* on April 19, he drew up an invoice for 120 *livres* for "fashioning a mount, supplying beading and matte gilding a mantelpiece frieze."[44] Rémond's accounts for May 1, 1784 mention that he made a loan of 6 *livres*, which may indicate the beginning of Gouthière's descent into deep financial difficulties. Indeed, on July 17 of that year, Rémond noted, without stating the price, that he had supplied two chimneypieces and a third with consoles for Thélusson and Gouthière. On the verge of being evicted from his home, Gouthière seems to have been incapable of carrying out a project of this scope by himself. On August 9, it was Rémond, rather than Gouthière, whom the Count of Artois's architects asked to clean the bronzes of the five chimney-

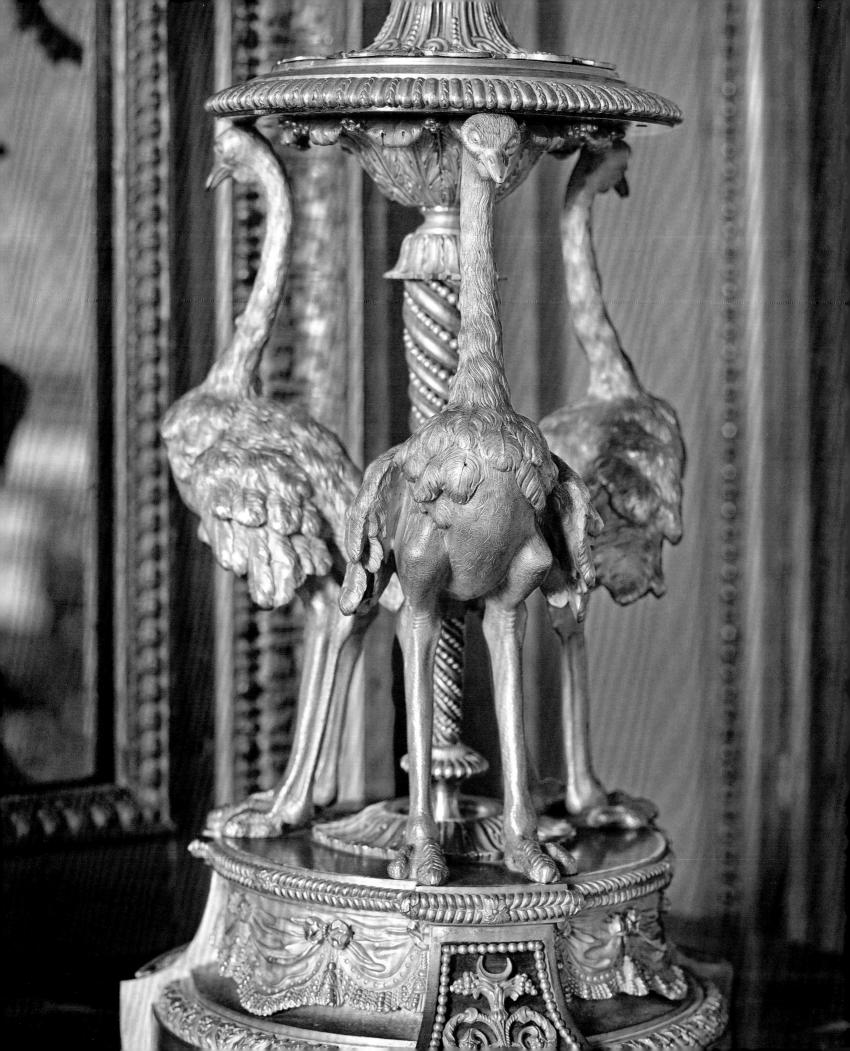

pieces at Bagatelle and to supply "the oak wreath and trumpets that have disappeared from the salon chimneypiece, as well as the fleurons and palmettes for the one in the bath chamber." On December 22, 1784, Rémond gave him an advance of 15 *livres* for paperwork and lent him 24 *livres*. Unable to repay his creditors, Gouthière had already transferred 6,000 *livres* to Rémond that his own clients owed him, and, on May 25, he borrowed 3,900 *livres* toward the sums due him for his gilt-bronze work for the Thélusson residence.[45]

On February 25, 1785, Gouthière must still have been working on a commission, as Rémond billed him 120 *livres* for "the matte coloring and burnishing of a mantelpiece ornament" and 2 *livres* 10 *sols* for gilding ten large iron screws for the Thélusson residence. Other work is recorded for June that year, such as regilding *au mat* a pair of candlesticks (48 *livres*), restoring nine pieces for a table (9 *livres*), and supplying and gilding eight feet of beading (9 *livres*). Comparable to these is the work ordered by Rémond from his own employees, the "two Gouthière friezes" requested from the chaser Villemet, and the "two Gouthière friezes" for which Pierre Bavelier paid 10 *livres*.

Rémond waited until January 16, 1787 to transfer Gouthière's debts to Nicolas-Hercule Arnoult, his former notary, specifying that he had "personally made these works for Messrs. Thélusson, for which he had received 2,400 *livres* that he does not want to deduct from the 3,900 *livres*."[46] Four days later, Rémond recorded 2,400 *livres* "in credit from Mr. Gouthière, for the remainder of all accounts between us and mutually clearing all debt; 2,740 *livres* were owed to me, which he paid off with models and gilding and partially in cash, for the remainder, 2,400 *livres*." Relieved of his debt, Gouthière soon asked Rémond to supply two crescents or hooks in gilt bronze for a fireplace's shovel and tongs (72 *livres*).[47] Rémond, for his part, paid Jean-Benoît Laplatte, one of his employees, 24 *livres* for "a sphinx frieze of Mr. Gouthière's" on July 21, 1787.[48]

Rémond continued to supply Gouthière until 1789, additionally selling him a significant amount of copper. In that year several deliveries were noted in more detail, such as, on January 30, 1 *livre* for 7 *onces* of brass fluting for a chimneypiece; on March 27, 380 *livres*-worth of matte gilding for a mantelpiece ornament; on August 22, 6 *livres* for matte gilding a square buckle;[49] on July 23, 180 *livres* for two lions, the casting and fashioning of which were billed by Rémond to Arnoult and Gouthière at a "price agreed with Mr. Gouthière, an installment for what he has."[50] Subsequent transactions must have been entered in a third ledger that has not survived.

Gouthière worked for Rémond again at an unspecified date, probably in 1796–97. Rémond then noted a "sum given to Mr. Gouthière for two chimeras" (perhaps for chimneypieces or firedogs):

casting, 80 pounds (weight) at 2 *livres* 10 *sols* per pound	200
manufacturing of both and of baskets	200
assembly	36
metal turning [*tournure*]	2
gilding of both, approximately	150
Total	588

Notes

1. AN, M.C.N., XIV 496, December 10, 1787, and T 1725-19, folder 55.
2. AD 75, D⁵ B⁶, reg. 739.
3. AN, M.C.N., CI 597, inventory of March 14, 1774.
4. AD 75, D⁵ B⁶, 4677, bankruptcy of June 3, 1777.
5. AN, M.C.N., XIV 454, October 5, 1776. The sum was to be subtracted from the revenue obtained from Gouthière's work for the Countess of Artois's stables.
6. AN, Y 1905 (Wildenstein 1921, cols. 121-30).
7. AN, M.C.N., CII 520, inventory of August 18, 1783.
8. AN, M.C.N., XIV 453, fund transfer (délégation).
9. AN, M.C.N., XIV 447, August 3, 1775.
10. AN, M.C.N., XIV 456, January 23 and 27, 1777.
11. AN, M.C.N., XIV 453.
12. AN, M.C.N., CX 474, August 7, 1779.
13. AN, M.C.N., XXVII 407, December 9, 1779.
14. AN, M.C.N., XIV 467. This sum was to be subtracted from the revenue obtained from Gouthière's work for the Countess of Artois's stables.
15. AN, M.C.N., XXII 33, March 6, 1782.
16. AN, M.C.N., XIV 496, December 18, 1787.
17. AN, 183 AQ 1-9, archival documents relating to Rémond preserved at the Archives Nationales du Monde du Travail in Roubaix.
18. AN, M.C.N., XXVI 691, November 16, 1780. This sum was to be subtracted from the revenue obtained from Gouthière's work for the Countess of Artois's stables.
19. Robiquet 1912 and 1920-21, 62.
20. Verlet 1987, 153, 160.
21. Appendix 1: 1773, December 31 (2).
22. Champeaux 1885-1902, 70. It is possible that Champeaux obtained this information from the historian Auguste Dupont-Auberville (see Champeaux 1885-1902, 71, and p. 20 in this publication).
23. Verlet 1987, 152-55.
24. AN, M.C.N., CVI 391, June 12, 1763, apprenticeship with Dincre; M.C.N., XIV, 453, September 13, 1776, accounting records and fund transfer. AN, 183 AQ 2 and 4, living with Rémond in 1784.
25. Appendix 1: 1769, September 27; see also p. 34.
26. AN, M.C.N., XIV 457, May 23, 1777.
27. AN, M.C.N., XIV 490, January 17, 1786.
28. Bibliothèque Centrale, Versailles, MS 260 F.
29. AN, M.C.N., XIV, 456, fund transfer.
30. AN, VII 457.
31. AN, M.C.N., XIV, 456, December 10, 1787.

32. AN, M.C.N., XIV 467, February 15, 1778. Bachellé did not discharge him entirely until February 15, 1796 (AN, M.C.N., XIV 539).
33. AN, M.C.N., XIV 469, fund transfer of March 1, 1790.
34. AN, M.C.N., XIV 496, and AD 75, D⁵ B⁶, box 100, file 7061. See also Vial 1901, 135-36.
35. AN, M.C.N., X 533, March 13, 1763.
36. AN, H 2118. In 1786, the guild of fondeurs-ciseleurs-doreurs was divided into seventeen classes, in diminishing order of their taxation; see also Verlet 1950, 156; Verlet 1987, 450-53.
37. Baulez 1995b, 77-109.
38. AD 75, DQ⁸ 672. "Épitaphes d'artistes français," Bulletin de la Société de l'histoire de l'art français, 1876, 11.
39. See note 17.
40. Niclausse 1947, 21-22. It is hard to imagine a future caster spending his time as a journeyman under a master gilder.
41. AN, 183 AQ 1.
42. Perhaps the Autumn that was one of the Four Seasons attributed to Jacques (?) Desjardins (1671-1737), acquired for Pierre-Gaspar-Marie Grimod, Count of Orsay (1748-1809) at the Gaignat sale, mounted in candelabra by Philippe Caffieri and now at Windsor Castle (Baulez 1984, 67, pl. 1. Bresc-Bautier and Scherf 2008, 400-403).
43. AN, 183 AQ 2, fol. 41, Rémond's accounting book.
44. Ibid.
45. AN, M.C.N., XIV 484, March 20, 1784; XIV 485, May 25, 1784.
46. AN, XIV 494, January 16, 1787.
47. AN, 183 AQ 2.
48. AN, 183 AQ 6.
49. These pieces seem to be related to the payments that Gouthière made at this time to Jacot, for work for Mme Du Barry.
50. AN, 183 AQ 3.

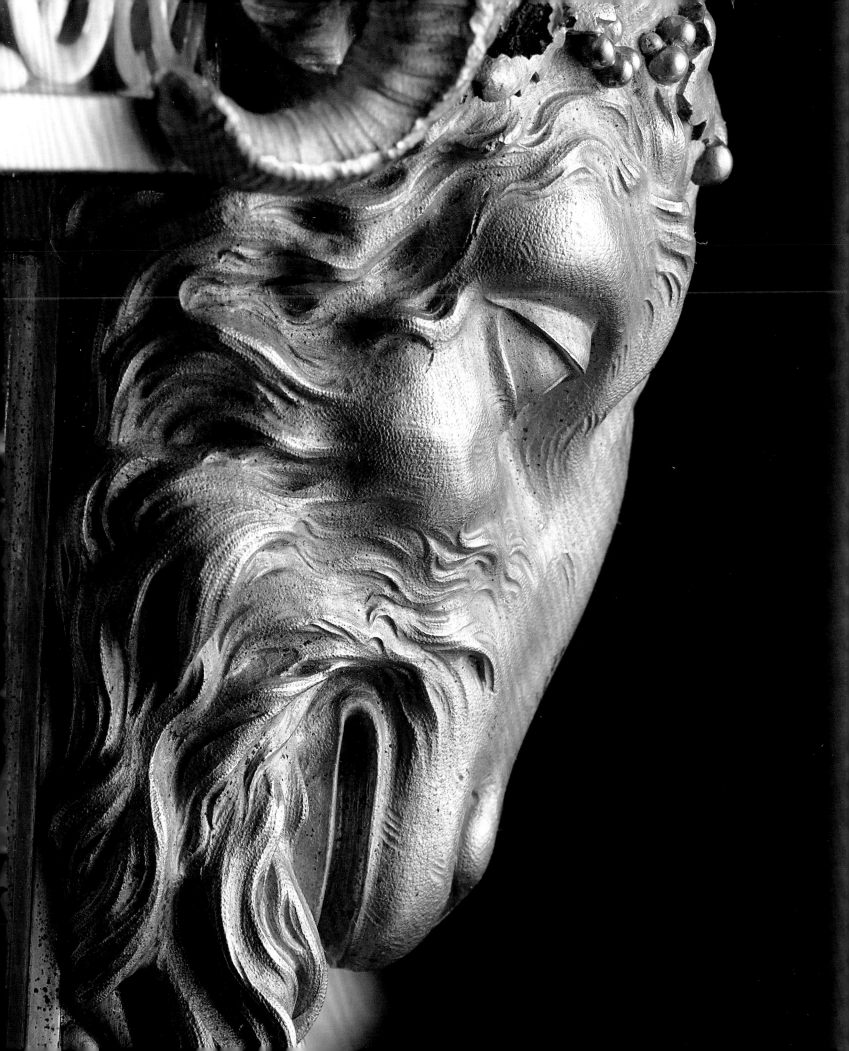

"Twenty Fingers on Each Hand": Pierre Gouthière's Chasing and Gilding Techniques

JOSEPH GODLA

When the architect François-Joseph Bélanger was incarcerated in the prison of Saint-Lazare in 1794, he wrote to the interior minister Jules-François Paré, suggesting that his talents and those of Pierre Gouthière and the other artists in whose company he found himself entitled them to special treatment. Praising the skills of his fellow captives, he referred to them as men with twenty fingers on each hand.[1] Nothing could have been more true of Gouthière, a master of the many stages of gilt-brass production,[2] an elaborate process involving an architect or designer, sculptor, modeler, mold maker, caster, turner, chaser, and gilder. Pierre Gouthière was admitted to the guild as a master chaser and gilder in 1758, and the system that governed the economy of eighteenth-century France dictated that he only be able to work as such. However, the challenging and very different techniques of chasing and gilding also involved the specialties of model making, soldering the cast elements, chemically manipulating the gilding, and mounting the completed gilt brasses; evidence shows that Gouthière and his workshop performed all of these tasks. Indeed, a man with many fingers. Using archival documents (primarily Gouthière's invoices), contemporary treatises, scientific analysis, and careful observation of the objects under study, this essay outlines and discusses Gouthière's multi-step gilt-brass production process.

ORIGINAL MODELS IN WAX OR WOOD

From nothing more than a loose drawing or a rough three-dimensional design model in clay from a designer or architect, Gouthière would create a clearly defined model, usually in wax[3]—the first step toward casting the object in brass—while anticipating the complex steps entailed in its production and mounting.[4] It was a role he seemed to relish. By 1794, he would drop the reference to gilding from his title and refer to himself as *sculpteur et ciseleur*.[5]

Fig. 48
X-radiograph of table capital
(cat. 39), showing two halves
soldered together

The wax—no doubt beeswax with the possible addition of olive oil, tallow, or turpentine to make it usable at room temperature[6]—was carefully worked with knives and spatulas to create the form of the object or ornament to cast, with some of the details probably added or refined at a later stage. Modeling in wax was a labor-intensive undertaking, something Gouthière pointed out to his clients on occasion.[7] There seems to have been a frugality in his approach to modeling. For example, for the symmetrical volutes atop the Ionic capitals of the Duchess of Mazarin's table (cat. 39), a wax model was made for just one side and subsequently used to produce a single foundry model. The foundry model was then used to cast two final brass versions that were soldered together to create the complete element (fig. 48). Occasionally, models for turned elements and long moldings—as well as fragile elements such as a fine trellis, ribbons, and cords—were made in wood, which was valued for its rigidity. Wood was also sometimes used as a support onto which wax was applied and modeled.[8]

FOUNDRY MODELS IN PEWTER OR BRASS

The wax (or wooden) model was then transformed into a foundry model made of a more durable metal that would ultimately be molded in sand for casting the final object. Gouthière's foundry models were made of pewter or brass.[9] He seems to have preferred brass foundry models, which were hard enough for repeated use in sand molds, with pewter reserved for one-time or limited use.

The first step in Gouthière's approach to making a foundry model in either metal was to create a plaster mold of the original wax (or wooden) model. He made his plaster molds in small pieces. For the plaster mold of the eagle of the Duchess of Mazarin's firedogs (cat. 26), he specifically states that he made a mold *à bon creux*, a period term for a piece mold.[10] A mold of this type could be disassembled, which was necessary so that the model could be removed without destroying the mold. Gouthière's models had many recesses into which the liquid plaster flowed prior to hardening. Once the plaster set, it would have been impossible to remove the original wax or elements eventually cast from the mold if it were made as a single piece.

Plaster molds had two functions in Gouthière's workshop. The first was to create the foundry model by pouring molten pewter into the mold.[11] Gouthière repeatedly notes in his invoices that he used *étain* (tin or pewter[12]) and, in one case, lead;[13] however, it was more likely a type of pewter, consisting of tin and lead, a more commonly used alloy for foundry models.[14] Either way, the melting point was quite low and was easily reached in a gilder's forge, so the model could be cast without the need of a foundry (fig. 49). The foundry model was next chased and pierced as necessary to provide a well-developed positive to be used in the sand casting of the final brass element.[15]

Pewter models are pliable; for this reason, Gouthière occasionally used them to adjust the shape to the hardstone or porcelain substrate onto which the final brass element would be mounted. For instance, for the Duchess of Mazarin's table (cat. 39), Gouthière made pewter models for the arabesque section of the frieze, which were bent to the shape of the marble. Here, the pewter served as an intermediate model. After being bent to the proper shape, it would be molded in sand from which a brass foundry model would be made.[16]

The second way Gouthière used plaster molds was for casting an intermediate wax model, a step toward producing a brass foundry model. The wax mixture used was probably harder than that used for the original model and may have included a resin-like burgundy pitch to provide the hardness necessary to withstand being molded in sand.[17] Molten wax was poured into the plaster mold; after cooling, the wax positive was removed by disassembling the piece mold. Details were sharpened on this intermediate wax in preparation for being molded in sand for the production of a brass foundry model. These wax models were refined in Gouthière's workshop; in some

cases, the chasing of the finished brass was done *d'après les cires* (after the waxes).[18] Gouthière often mentions in his invoices that he had recut (*réparé*) and in one instance that he had chased (*ciselé*)[19] the wax models. This step—the last before sending the wax models to the foundry where specialists molded them in sand—included refining the details and adding some of the profuse undercutting characteristic of his work.

Although wax is not generally thought of as being robust enough to use as a model for sand casting, it is clear from Gouthière's invoices that he used wax models. His listing for branches of roses and myrtle made for the Salon Ovale at Louveciennes included a charge for having "molded in plaster all said models, having cast a thickness of wax, repaired, and placed each piece on a plaster core for molding in sand…"[20] Mounting the wax on a plaster core may have provided the necessary rigidity for the model to withstand the forceful compression of the sand that was a necessary part of the mold-making process. A 1766 decree from the French parliament regarding the safeguarding of bronze models lists a sequence of steps for the production of foundry models that similarly calls for drawing a wax impression from the plaster to be subsequently molded in sand, which suggests this may have been routine practice in the second half of the eighteenth century in France.[21]

Gouthière's technique for sand casting from wax models is not yet fully understood. He refers to placing the wax on a plaster core but does not provide additional details on the preparation of the mold. Given the complexity of the forms and degree of undercutting, the molds were likely piece molds that could be disassembled (*à bon creux*) so the wax intermediate model could be removed (the process of making a piece mold in sand is described below in relation to molding the metal foundry model).

SAND CASTING

Once the foundry models were cast in brass, they were sent back to Gouthière's workshop to be chased and pierced (*évidé à jour* or *percé à jour*),[22] after which they made a return trip to the caster, along with any pewter models, to be molded in sand for casting the final products in brass.[23]

In their *Encyclopédie*, Diderot and d'Alembert include five plates that describe the technique of sand casting,[24] a process also reviewed in modern literature.[25] The *Encyclopédie* describes using a relatively simple piece mold made of sand for casting a pulley with an undercut hollow, a technique used for Gouthière's more complex foundry models. The variety of shapes, small details, and undercut recesses in Gouthière's elements would have presented difficult challenges for the foundry's mold-maker. Like that for the wax intermediary model, these sand molds were made in many pieces so they could be disassembled to remove the foundry model and reassembled for the pouring of the molten brass. Perhaps it was for this reason that Jean-Baptiste Launay, the caster of the column in the Place Vendôme, wrote in 1827 that casters of candelabra, figures, clocks, as well as novelty and luxury items employed only the most famous molders for this work.[26] He went so far as to say that only their genius saved the casters from embarrass-

ment. Gouthière's invoices cite the skill and care required for making sand molds and also their fragility, noting in one case that a sand mold was impossible to transport.[27] In another instance, Gouthière states that making a sand mold was difficult and therefore took a lot of time.[28]

 We tend to think of sand as a coarse material that lacks the cohesive properties required for making numerous small, removable piece molds, but the sand the Parisian casters worked with had a clay component that held it intact. Several period books mention the sand from Fontenay-aux-Roses as the choice of casters in Paris.[29] Launay describes that sand as silky and ideal for delicate parts, fine enough to form an impression for medals.[30] We cannot be sure this was the sand used by casters working for Gouthière; however, the mold-making material found inside a capital on the Duchess of Mazarin's table (cat. 39) is quite fine, predominantly comprising grains of sand averaging 100 microns in size in a matrix of clay (fig. 50).[31]

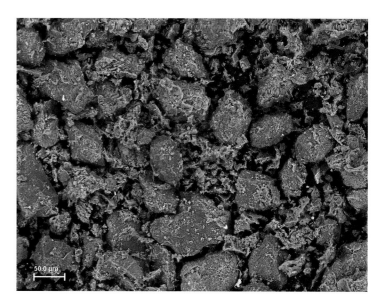

Fig. 50
SEM photomicrograph of mold-making material from inside table capital (cat. 39)

 Careful study of the model was required to plan the sequencing for the small molds to be made out of the somewhat friable sand. Simply described, the molding process for an element with an unadorned back would begin with placing the foundry model face up on a bed of sand in the lower chassis.[32] Next, small separate molds—sometimes called false cores or drawbacks—were made, one by one, by pressing sand into recessed undercuts (fig. 51). Each was keyed into both the bed and the adjacent false core. When all the cores were set, the upper chassis was put in place, filled with sand, and compacted. The completed mold was then disassembled and the foundry model removed. Launay describes similar steps for creating a piece mold in sand.[33] Gouthière's work shows evidence of this technique, most notably the Avignon clock (cat. 19), where small raised lines of brass on their inner surfaces, areas that were not subsequently chased, mark the location of the joins in the false cores (fig. 52).[34]

CASTING ALLOY

The extensive, refined detail in the chasing of objects made by Gouthière suggests that he preferred a particular alloy for the base metal from which they were cast. Exploring this possibility was one of the goals of this technical study. The alloys used in thirty gilt-brass elements from fifteen objects documented to be his work were analyzed with X-ray fluorescence spectroscopy (XRF), and all proved to be brass, an alloy consisting primarily of copper and zinc.[35] The copper component of the alloys examined ranges from 71 to 80 percent, and the zinc ranges from 16 to 26 percent; however, the vast majority of Gouthière's pieces fall within narrower parameters, averaging 75.5 percent copper, 20.75 percent zinc, 1.25 percent lead, and 1 percent tin and lesser amounts of several other ele-

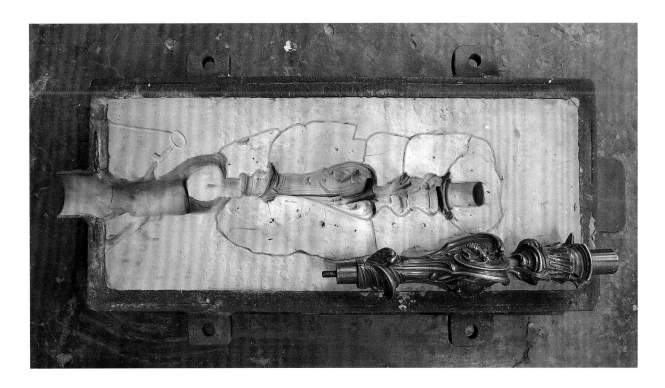

Fig. 51
Sand mold for a candlestick
showing the sections (or false
cores) of the piece mold

ments (see table on p. 134).[36] Brass of this kind fits neatly within the range of alloys used in France in the last quarter of the eighteenth century and would have satisfied Gouthière's needs for chasing, soldering, and gilding.[37] Gouthière's work with several foundries during his career[38] may account for some of the variation in the makeup of the brass; however, given the occasional practice in the eighteenth century of using recycled brass and scrap tinned copper, it would not be unusual to see a range within a single foundry.[39] Moreover, the complexity of Gouthière's pieces required casting elements in small sections. For example, each of the legs on the Duchess of Mazarin's table (cat. 39) includes sixty individually cast elements. With such a large number of pieces, it is not surprising to find some variation in the alloys on a single object. The capital from the Duke of Aumont's column (cat. 42) was assembled from approximately twenty-seven separate pieces likely cast in at least three distinct batches with a varied zinc content of 20, 23, and 26 percent.

CHASING

Once the rough castings (*fontes brutes*) were delivered to his workshop,[40] Gouthière began the process of enriching and embellishing the cast elements, the chasing that brought the metal to life. With files, chasing tools (*ciselets*), and a hammer, Gouthière could produce a vast range of

Fig. 52
Interior of the Avignon
clock (cat. 19), with arrows
indicating raised beads of
brass resulting from joins
in the piece mold

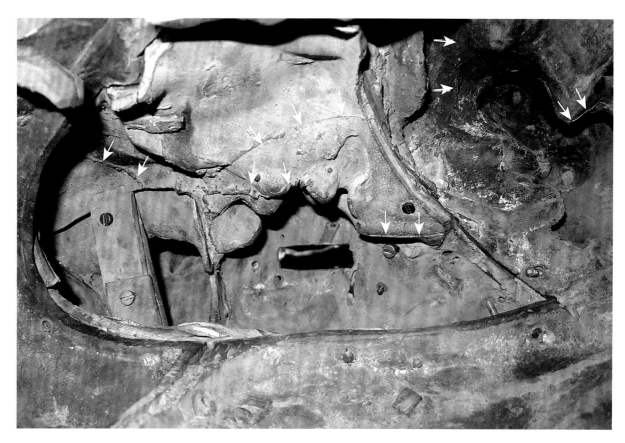

surfaces—the soft skin of a face, a goat's rippled fur or the alternating textures of its horns, the fine veins of a leaf.

Filing was probably the first step in his chasing process.[41] Files were used to deburr the coarse edges of the rough casting, as well as to smooth the raised lines in the brass caused by seams in the sand mold and refine the contour of a piece. Small, shaped files called rifflers (*rifloirs*) were used on difficult-to-reach areas (fig. 53: nos. 33–36). Gouthière also used files to bevel the receding edges of a piece (*dégraisser*), which gave an impression of lightness to the metal (fig. 54). He may have learned this technique—used by silversmiths to lighten their pieces and reduce the amount of silver needed—in the workshop of François-Thomas Germain, with whom he worked in the 1760s. Areas that were to be brilliantly burnished after the gilding were also leveled with files and further smoothed with scrapers and burnishers (see fig. 53: no. 32).

Working the surface of the brass with hammer and chasing tools was done on a pitch bowl filled with mastic-like material onto which the cast element adhered.[42] The backsides of pieces were often punched with a sharp tool to add texture that allowed for better grip on the pitch (fig. 55). The cast-iron bowl filled with pitch rested on a leather pad or a ring of rope or other material,

allowing it to be tilted to the appropriate angle for working the entire surface of the piece (see fig. 53, second worker from the right).

Like most chasers, Gouthière had hundreds of chasing tools. These fall into six categories, each with a specific purpose and in various sizes. Tracers (fig. 53: nos. 1–3) are for outlining a form or creating linear ornamentation (fig. 56). Planishers (fig. 53: nos. 9–14), the heads of which come in many different shapes, are flat, highly polished tools used to smooth metal (fig. 57). Pearling tools (fig. 53: no. 15) are concave half spheres used, as the name suggests, for shaping pearls (fig. 58). The counterpart to a pearling tool is a *bouterolle*, a rounded punch (fig. 61). Matting tools (fig. 53: nos. 21–23) come in many shapes and sizes and have patterned heads for creating textures in the brass (fig. 59). Some matting tools have geometric patterns filed into the head, some with irregular punched patterns, and others fine random patterns such as the *mat à la pointe*. The term *godronnoir* (fig. 53: no. 5) refers to modeling tools with heads in a variety of subtle shapes, both concave and convex (fig. 60). Finally, burins (fig. 53: no. 27), like the engraver's tool, are for cutting away rather than compressing the brass.

Some variations in Gouthière's chasing relate to the date of the specific piece, but an equally important factor seems to be whether it was a private commission or a more common workshop production. Indeed, the art of chasing depended not only on the talent of the chaser but also on the time involved. The most sophisticated pieces made by Gouthière were commissioned by a few wealthy clients whose budgets allowed him to spend unlimited time chasing a single piece.[43] In his earliest works—like the vase made in 1764, now at the Royal Castle in Warsaw (cat. 3 and fig. 65)—Gouthière produces remarkably crisp chasing with heavy reliance on a single matting tool, with nearly every unburnished surface treated in this manner. His workshop's surviving production from the late 1760s was chased to a lesser degree, probably because of the speculative nature of the work (cats. 4–6, 18). By the time of the commission for the Avignon clock (cat. 19) in 1771, Gouthière was fully exploring the medium, and his mastery of techniques led to a great variety of textures and smooth transitions between them. The chasing on this clock is reminiscent of silver pieces made in the workshop of François-Thomas Germain. A comparison of the Avignon clock with a table centerpiece made in 1766 by Germain illustrates Gouthière's application of many of the same textures achieved in silver to a harder material, brass. The similarities include the burnish used for running water, the matting of the rock surfaces, the near perfection of the skin, and the realistic treatment of the vegetation (figs. 62, 63).

With time, Gouthière's touch became lighter, his surfaces more subtle. His naturalistic chasing, combined with the chemical matting treatment, endowed his forms, particularly flowers and leaves, with a softness that belied the hard brass from which they were made. The edges of Gouthière's undulating leaves turn sharply to their smooth front surfaces, which rise to a crisply rendered mid-rib, and then transition into the rough bark of the attached branch. The edges of the leaves were treated with various files, the surface with planishers and *godronnoirs*. Tracers were used to better define the mid-rib, and a variety of tools was used to texture the bark (fig. 64). The hair and fur represented on his mature work were obtained by alternating several matting tools of different textures and by adding deep punches with a *bouterolle* while leaving other areas with a smooth surface.

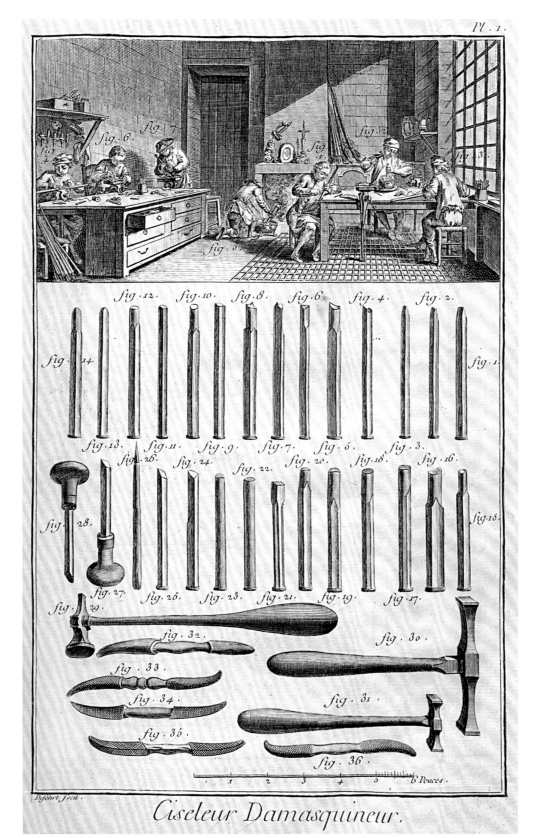

Fig. 53
Plate 1 ("Ciseleur Damasquineur"), showing a chaser's workshop and tools. From *Encyclopédie, ou Dictionnaire raisonné des sciences, des arts et des métiers, etc.*, edited by Denis Diderot and Jean le Rond d'Alembert, pls. vol. 3 (Paris, 1763).

Gouthière mastered a range of effects with matting tools. Beginning with linear patterns like those on the Warsaw mask, likely created with a *mat sablé* chasing tool hammered in straight rows (fig. 65), he evolved over time to more homogenous texture as on the faces of the goats on the chimneypiece for the Salon Ovale at Louveciennes (fig. 67). He also developed the use of matting tools for draftsman-like contoured hatching to accentuate shapes such as those on Marie Antoinette's firedogs (fig. 66). Gouthière's varied textures blend together seamlessly, and the chemicals of the matting treatment further integrate the surfaces with a sublime result. His finest works, like the mask on the Duchess of Mazarin's table (cat. 39), have an effortless grace in striking contrast to the hundreds of hours of concentrated work required for their production.

Fig. 55
Backside of a sunflower from the leg of table (cat. 39), with punch marks. Two threaded nails screw into the two small holes.

Fig. 56
Detail of chimneypiece
(cat. 28). Tracers were
used to depict the veins
of the oak leaves.

Fig. 57
Detail of chimneypiece
(cat. 29). The scales on the
snake were likely flattened
with a planisher.

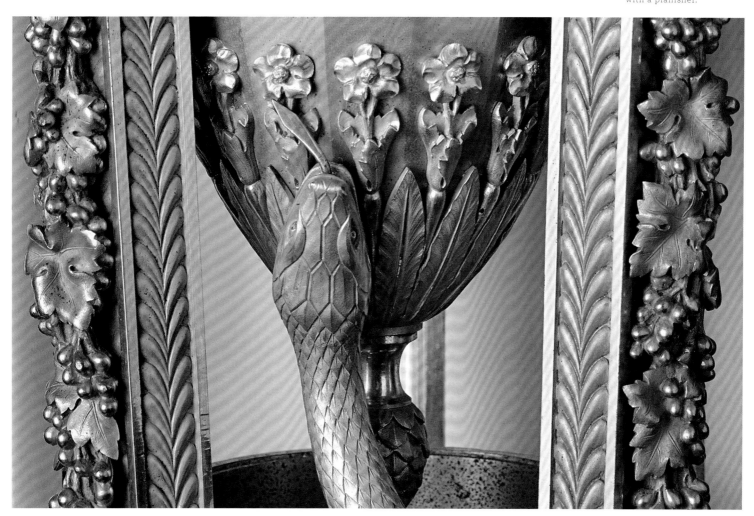

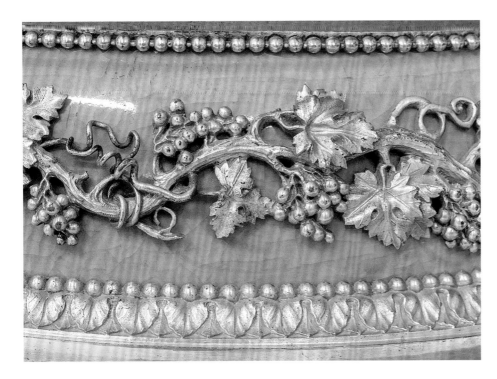

Fig. 58
Detail of vases (cat. 15). A
pearling tool was used to
chase each grape.

ASSEMBLY OF CAST ELEMENTS

The elements whose complexity required that they be cast in sections were chased separately and then assembled. Soldering—joining two metal elements by melting a metal alloy (solder) capable of fusing them together—was the artist's preferred method for joining separately cast elements. Surfaces to be joined were carefully filed to expose clean metal. Next, when small elements were to be soldered, they would be placed on a wooden timber hollowed out in such a way as to allow the pieces to rest with the faces to be joined in contact.[44] A simple butt solder join or possibly an overlapping join would be used (fig. 68). When the piece was large enough to accommodate the holes, the adjoining elements were drilled for the insertion of iron alignment pins (fig. 69). Two sizes of pins have been observed in Gouthière's work: iron pins with a smooth surface of approximately 1.5 mm in diameter were sometimes used on small elements, and threaded rods of roughly 3 mm have been observed on larger pieces.

It was essential that the alloy of the solder melt at a temperature sufficiently below that required by the cast-brass parts to assure their not being damaged during the heating process. It was understood in the eighteenth century that the mix of metals in the solder could be varied to suit the material and situation.[45] The *Encyclopédie* advised taking two parts of copper and one of zinc to formulate solder for brass.[46] A sample taken from a solder join on one of the leg capitals of the Duchess of Mazarin's table was analyzed and found to be close to that ratio, at 66 percent

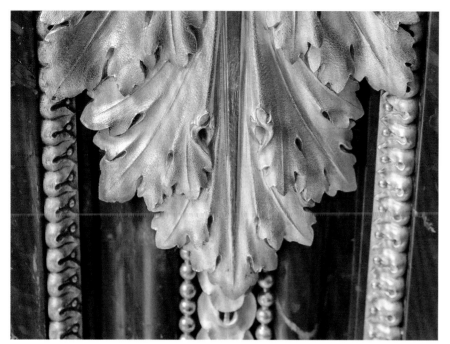

Fig. 59
Detail of chimneypiece (cat. 36), showing the fine texture obtained with a matting tool used on the surface of a large acanthus leaf

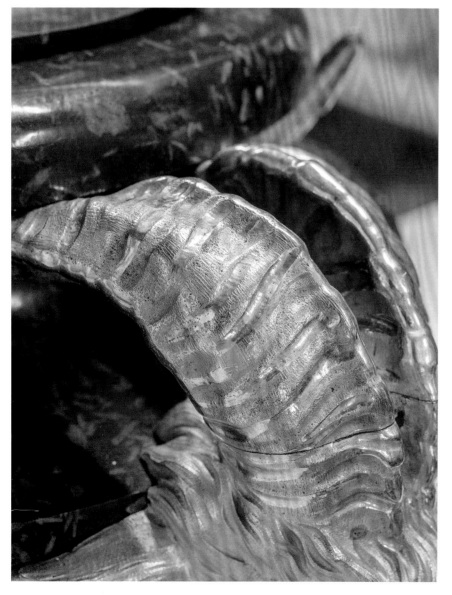

Fig. 60
Detail of vase (cat. 12). The indentations of the ram's-head horns were likely chased with a *godronnoir* before being burnished.

Fig. 61
Detail of pot-pourri vases
(cat. 7), showing indentations
from a *bouterolle* on the neck
of the swan

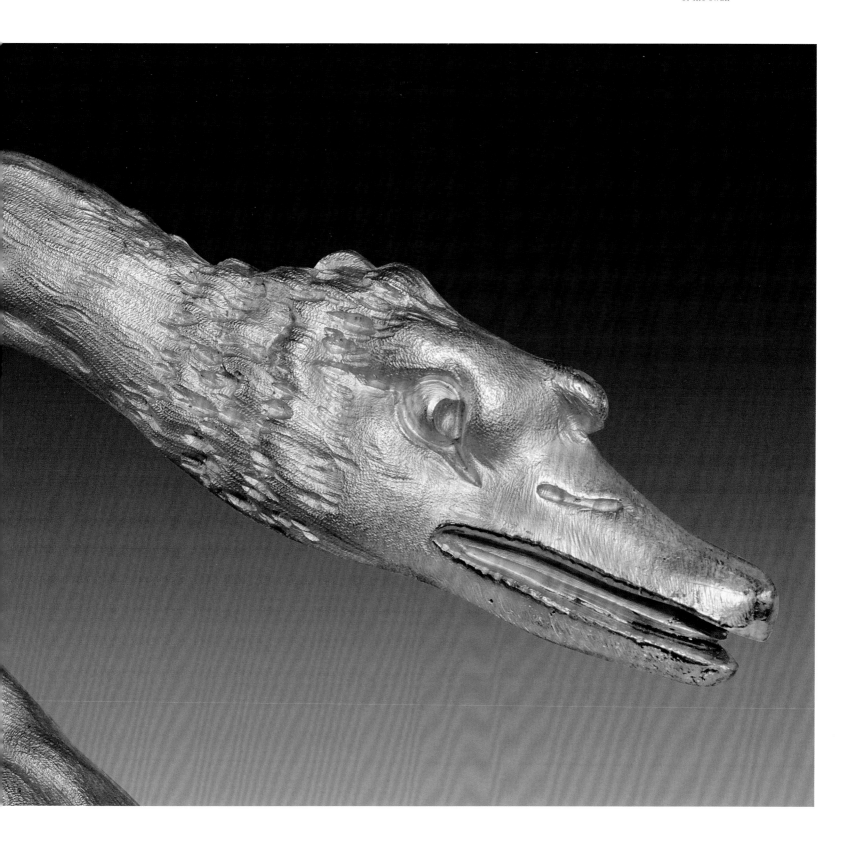

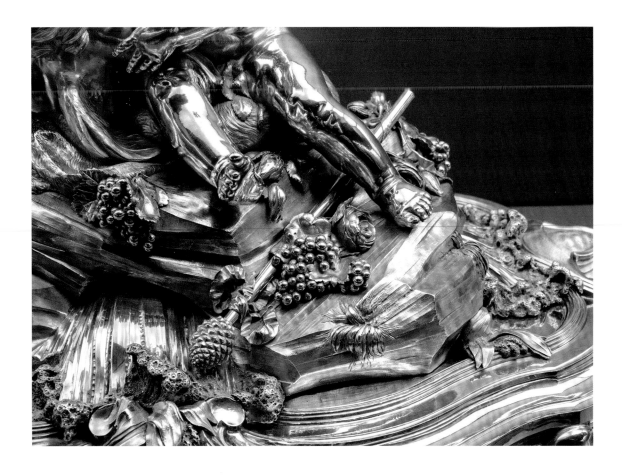

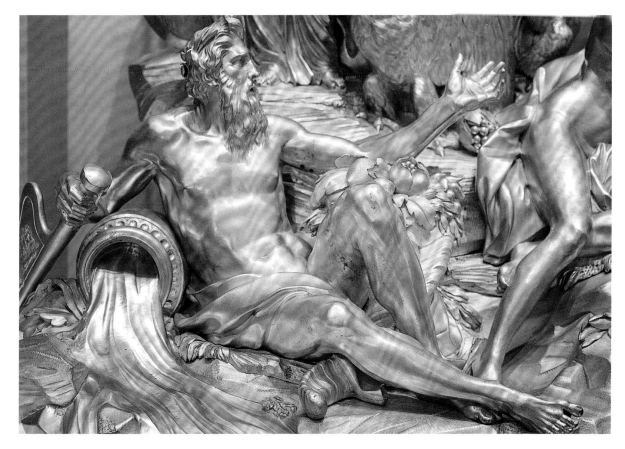

Fig. 63
Detail of mantel clock
(cat. 19)

copper, 31 percent zinc, and 1.3 percent tin.[47] Solder with a similar composition has been found on other eighteenth-century gilt brass and may have been available commercially.[48] Such an alloy melts at a temperature approximately 60 degrees centigrade lower than that required by the parts being joined. This solder was called "hard solder" or "strong solder," terms that differentiate it from soft solders (with a lead base). A well-executed hard solder join had roughly the strength of the adjacent metal. Gouthière recognized its attribute and mentions its use in joining the arms of a sconce (*demi-lustre*) for Mme Du Barry that supported crystals.[49]

Gouthière may have followed the standard methods for the actual soldering process. Therefore he probably used a lamp with a wick as a heat source for soldering smaller objects, with the flame directed by the use of a blowpipe (fig. 70).[50] The parts to be joined were covered with a small piece of coal, and the worker blew until the solder melted, uniting the two pieces, at which point the blowing stopped and the pieces were left to cool. The final step in the assembly process was chasing the area around the completed joins.

Fig. 64
Detail of chimneypiece (cat. 28)

Fig. 65
Detail of vase (cat. 3)

Fig. 66
Detail of firedog (cat. 25)

Fig. 68
Detail of spiraling ivy frieze on
table (cat. 39) and radiograph
showing the location of a
solder joint

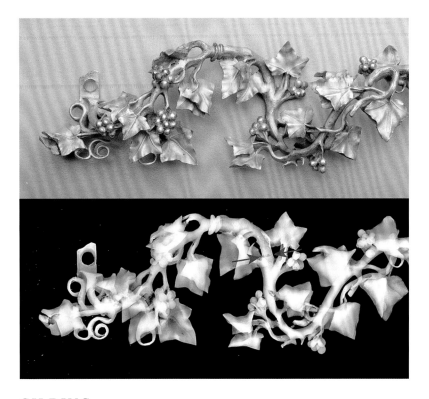

GILDING

With the completion of the chasing, the elements were ready for gilding (fig. 71). Like his contemporary gilders, Gouthière used mercury gilding with *or moulu* (ground gold), a complex technique thoroughly studied by Jean-Pierre-Joseph d'Arcet in his *Mémoire sur l'art de dorer le bronze* published in 1818, just five years after Gouthière's death. As it is likely that Gouthière applied gold in a manner similar to d'Arcet, his text is used to explain the technique.

The process began with annealing the brass by placing it on a bed of lit charcoal and surrounding it with hot coal to create even heat. The piece was heated to cherry red before being removed from the fire to slowly cool (fig. 71, worker on the far right). The primary purpose of annealing was to soften the work-hardened brass to make it less brittle. D'Arcet notes that pieces that had been soldered were not annealed, no doubt to prevent the joins from failing in the heat.[51] This leaves one to wonder if Gouthière's work was annealed, as soldering was so common in his work.[52]

The piece was next pickled in acid (either sulfuric or dilute nitric) to remove the layer of oxides from the surface. D'Arcet states that the cleaned metal had a beautiful pale yellow color that was grainy or slightly frosted, noting that if the brass was too smooth gold would not adhere well and if too heavily etched it would require too much gold.[53] The pickled piece was carefully washed with water and rolled in tanbark, bran, or sawdust until completely dry.

Fig. 69
X-radiograph of a foot from table (cat. 39),
removed and shot from directly above and
showing solder joints connecting the four
quadrants, as well as two small triangular
pieces to compensate for casting flaws

Fig. 70
Plate 7 ("Orfèvre Bijoutier, Outils"),
showing an oil lamp and blowpipe, from
*Encyclopédie, ou Dictionnaire raisonné
des sciences, des arts et des métiers, etc.*,
edited by Denis Diderot and Jean le Rond
d'Alembert, pls. vol. 8 (Paris, 1771).

The surface of the piece was next brushed with dilute nitric acid (or a nitric acid-mercury solution) just before the application of the gold-mercury amalgam. The amalgam itself consisted of eight parts mercury and one part gold (in powder form or slivers of gold leaf) when it was mixed in a red-hot crucible. When well mixed, the amalgam was washed in water and then filtered through chamois, smooth leather made from the hide of a small mountain goat of the same name, which reduced the ratio of mercury to gold to about three to one.[54] The amalgam was applied to the surface with a stiff brass-bristle brush called a *gratte-bosse*, which was used to spread it as desired across the surface of the piece (fig. 71, third worker from the left). More gold was applied to areas destined to be matte, while burnished sections received less. The greater thickness for the surfaces intended to be matte was probably required so the gold layer could withstand the subsequent chemical treatment. The cost of gold made gilding the most expensive step in the production of gilt brass. On an invoice to Mme Du Barry of May 1772, Gouthière included the cost of fine gold at the rate of 101 *livres* per ounce.[55]

Once the part was well covered with amalgam, it was exposed to lit coals and heated carefully and then withdrawn from the fire with long tongs and placed in the other hand, which was covered with a thickly padded leather glove. The gilder then turned it in every direction while rubbing it and lightly tapping it with a long-haired brush to distribute the amalgam layer. The

Fig. 71
Plate 1 ("Doreur, sur
Métaux"), showing
a gilder's workshop,
from *Encyclopédie, ou
Dictionnaire raisonné des
sciences, des arts et des
métiers, etc.*, edited by
Denis Diderot and Jean le
Rond d'Alembert, pls. vol. 3
(Paris, 1763).

gilder closely examined and repaired any unevenness or defect by charging it again with the amalgam, sometimes covering the entire element anew. The whole process was repeated up to four times, depending on the amount of gold desired on the surface. The piece was then placed in the fire again until the mercury vaporized and, when the layer of gold was deemed perfect, carefully brushed with the *gratte-bosse* and washed with water acidulated with vinegar and finally dried.[56]

Gouthière often mentioned in his invoices that he had *surdoré* his pieces, meaning he had applied several layers of gold, a necessary step for matte-gilded surfaces. Microscopic sections of matte surfaces from the Duchess of Mazarin's table show a gilded layer of about 25 microns (fig. 72), with burnished areas of approximately 5 microns (fig. 73). The thinness of the burnished gold results from less gold being applied, as well as the compression of the burnishing process.

Applying the amalgam was a dangerous operation. D'Arcet does not mince words when setting out the health issues related to breathing "carbonic acid, nitrogen, mercury, mercury oxide, nitric acid, and nitrous gas vapors," going so far as to describe a workshop with a poorly functioning forge chimney as a tomb.[57] D'Arcet, who offers some suggestions for improving the level of safety in the gilder's workshop, was not the first to recognize health issues related to gilding. More than a century earlier, the Italian Bernardino Ramazzini warned of the hazards of the gilder's work, noting, "Very few of the gilders reach old age, and even when they do not die young their health is so terribly undermined that they pray for death."[58]

Fig. 72
SEM photomicrograph of metallographic
section of a matte-gilded portion on swag
of the capital on proper right front leg of
table (cat. 39)

Fig. 73
SEM photomicrograph of metallographic
section of a burnished portion on volute
of capital on proper left front leg of table
(cat. 39)

COLORING AND MATTING THE GOLD

After the piece was gilded, it received its final finish, which in late eighteenth-century France typ-
ically included burnishing, as well as applying coloring and matting agents to the gold (*mise en
couleur de l'or* and *mise au mat*).[59] Burnishing was the first step following the application of the
gold. These brilliant surfaces were created by rubbing the gold with a burnisher of hematite or
bloodstone affixed to a wooden handle. The burnisher was dipped in water acidulated with vinegar
and then rubbed on the surface, compacting the grains of the gold to increase its reflectance (see
fig. 71, worker on far left). If other sections of the same element were to receive a matte finish, as
was usually the case in Gouthière's work, the burnished areas were isolated with a masking mate-
rial that protected the surface from the chemical action of the matting solution. D'Arcet describes
applying a mixture of Spanish whiting, unrefined sugar, and gum as the mask.[60] The piece was
then dried and ready for the matting treatment.

 Parisian gilders working before Gouthière's time produced gilt elements that paired matte
and burnished surfaces; however, the matte areas were achieved by texturing the brass with chas-
ing tools before the gilding process. The matting process that Gouthière used in the last third
of the eighteenth century resulted in a much more subtle finish that gave a soft luster to the sur-

Fig. 74
SEM photomicrograph of gilded surface on the swag
of the capital on the proper left front leg of table
(cat. 39), showing matte gilding on the left and
burnished gilding on the right

Fig. 75
SEM photomicrograph of NaCl crystals on the surface
of the matte-gilded section of the swag on the capital
of proper left front leg of table (cat. 39)

face of the gold. This was achieved with a chemical treatment following the gilding that would
come to be known as *dorure au mat*. Because of its high price, *dorure au mat*—a technique fre-
quently mentioned in contemporary auction catalogues, invoices, and inventories—was initially
reserved for the royal family and a few elite clients. In d'Arcet's description, the process began
with the application to the surface of a mixture of saltpeter (mineral form of potassium nitrate),
sea salt (primarily sodium chloride), and alum (aluminum potassium sulfate) in water. The piece
was returned to the fire, heated until the mixture became homogenous, almost transparent, and
immediately plunged into clear water, which removed the layer of salt and masking material pro-
tecting the burnished section. To complete the treatment, the piece was dipped in weak nitric
acid, washed in water, and dried.[61] The mixture d'Arcet describes would form aqua regia (nitric
acid hydrochloride), which is capable of dissolving gold.[62] Momentarily exposing the gilding to
the mixture preferentially dissolved any copper alloy (flaws in the gilding layer) while creating a
more consistent layer of gold with a microscopically spongy texture, which produced the matte
appearance (fig. 74). Sodium chloride crystals found in the surface of the gold on matte sections
of the table of the Duchess of Mazarin suggest that Gouthière was using a mixture with a recipe
similar to that described by d'Arcet (fig. 75).

Called the "inventor of *dorure au mat*" in 1810[63] and again in 1836, Gouthière has been
credited with inventing the process of matte gilding since the nineteenth century by art histo-

rians, dealers, and collectors.[64] He had certainly mastered the process as early as 1784, while working for François-Thomas Germain (see cat. 3).[65] However, a recipe similar to d'Arcet's appeared in a Dutch gold-smith treatise as early as 1721, discussing its use in creating the color white on solid gold objects.[66] In this case, the mixture is applied as a powder by sprinkling it onto a pre-moistened surface. Another recipe for *couleur blanche pour l'or* containing the same ingredients in pow-der form appeared in France in 1762.[67] As Gouthière was working with-in a circle of silversmiths and goldsmiths during his formative years, he may have known of such a powder. Germain's workshop was clear-ly experimenting with gilding techniques, as evidenced by his adver-tisements and correspondence, though there is no specific reference to *dorure au mat*.[68] Gouthière's "invention" may have been in determin-ing a practical way to apply it to gilded brass rather than solid gold objects, which included using it in a liquid form that would allow for a partial treatment of a small object.

Famous for the matte technique, Gouthière rarely used other coloring techniques for gold. References to violet (probably blue)[69] and gray (*couleur de fumée*) on his invoices[70] typically refer to the col-oring of steel elements, including the back plate of the french-window knob for Mme Du Barry (cat. 27), rather than gilded brass.[71]

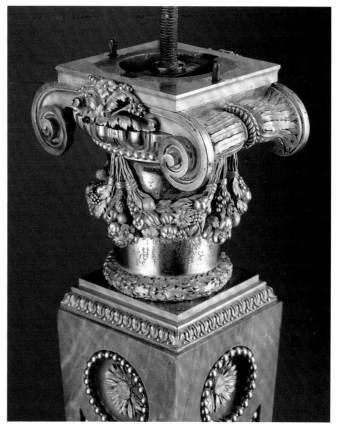

Fig. 76
Detail of proper left front leg (removed) of table (cat. 39)

MOUNTING

While Gouthière produced objects made entirely of metal, such as fire-dogs, clocks, and wall lights (cats. 19, 20, 22, 24-26), the vast majority of his oeuvre consisted of gilt-brass mounts applied to materials such as ivory, porcelain, and hardstones. He seems to have taken great pride in preserving the cleanliness and elegance of the overall object by affixing the gilt brass without visible means of attachment,[72] another trick he borrowed from silversmiths. Superlative descriptions, such as "mounting done with the greatest mastery," were included in his invoices.[73]

The practical work of boring holes in the substrate material, making and fitting screws, and adjusting mounts required a great deal of time and could be among the most expensive steps in the creation of a piece.[74] Therefore, many of the refinements Gouthière brought to mounting were resolved much earlier, during the planning and modeling stages, when it was determined how elements would be attached.

Gouthière used screws or threaded rods extensively in mounting gilt elements. Single central threaded rods, which could compress layers of mounts, were used to assemble footed ves-sels or table legs with capitals (fig. 76). The walls of hardstone vessels were sometimes drilled so

Fig. 77
Detail showing interior of
capital (cat. 42)

that threaded rods attached to the backside of gilt-brass mounts passed through their thickness and could be secured with a nut. Such fasteners on the interior of these vessels were often hidden from view by a gilt-brass liner.

For porcelains, like the Duke of Aumont's celadon vases (cat. 15), Gouthière attached gilt brass without drilling the ceramic. This greatly increased the difficulty and required considerable ingenuity on his part. One solution was to create a complex network of gilt-brass elements that would hug the entire piece, a technique he fully mastered on the pair of candelabra also made for the Duke of Aumont (cat. 21). On occasion, Gouthière used plaster to secure gilt brass elements, such as the rims of vases, to the porcelain.

Gilt brasses were typically attached to marble furniture and chimneypieces with nails. The stones were drilled (and Gouthière counted every hole).[75] A wooden dowel was inserted into the hole to receive the nail fastened to the backside of the gilt-brass element. Attaching the nail to the mounts involved drilling a shallow hole in the backside of the element and tapping it to receive corresponding screw threads on the nail (see fig. 55). It appears that Gouthière used lead solder to secure the nail to the brass.

Gouthière's most generous use of mechanical fasteners was for mounting one gilt-brass element to another. He sometimes used dozens in a single object, as, for example, in the Corinthian capital for an ancient porphyry column belonging to the Duke of Aumont, where he used forty-eight threaded rods to secure the individually cast acanthus leaves (cat. 42 and fig. 77).

An example of the lengths to which Gouthière went to ensure properly fitting elements can be seen on the upper section of the incense burners made for the Duke of Aumont (cat. 14). Rather than casting a continuous run of pearls to be bent into shape, each pearl was made separately with a round tenon extending from one side and a hole in the other so they could be pieced together to simulate a string. The pearls were sandwiched between two gilt-brass moldings with a screw passing through every fourth one (fig. 78).

Fig 78
Detail of inside rim of incense
burner (cat. 14)

CONCLUSION

Pierre Gouthière's incomparable hand skills and innovative approach to chasing and gilding pushed the medium of gilt brass to new heights and, together with the artistry he brought to model making, resulted in some of the most celebrated examples of eighteenth-century French gilt brass. It is likely that his collaboration with silversmiths early in his working life helped to give his work its unique character. Despite the absence of signature, it is now possible to differentiate his work from that of other talented, contemporary bronze-makers like François Rémond and Étienne Martincourt. A great modeler, an exceptional chaser, and an excellent and innovative gilder, Gouthière created pieces that, at their best, are beautifully sculpted, full of life and expression, and richly textured and gilded. If the legend were true that Marie Antoinette took for gold a rose made by Gouthière in gilt brass, we would not be surprised.

XRF results for the surface alloy
compositions of ungilded sections
of documented Gouthière pieces.
Compositions are given as the average
weight percentage for each element.

Cat.	Object	Sample Location	Spots Analyzed	Fe	Ni	Cu	Zn	As	Ag	Cd	Sn	Sb	Pb	Bi	Total	
3	two incense burners	base: 2037.1	3	0.50	0.08	72.49	23.38	<0.15	<0.09	<0.03	0.35	<0.05	2.01	<0.06	99.0	
		leaf mount at bottom: 2007.1	3	1.09	0.10	75.96	19.96	0.15	0.09	<0.03	1.10	0.07	0.65	<0.06	99.3	
		base: 2037.2	3	0.39	0.08	71.27	24.77	<0.15	<0.09	<0.03	0.31	<0.05	1.94	<0.06	99.0	
		leaf mount at bottom: 2037.2	2	0.61	0.09	79.95	15.52	<0.15	<0.09	<0.03	1.38	0.10	1.40	<0.06	99.2	
7	pot-pourri vases	under base	4	0.50	0.08	75.46	20.77	<0.15	<0.09	<0.03	0.85	<0.05	1.33	<0.06	99.2	
8	vase	side panel	4	1.01	0.07	71.82	23.01	0.15	<0.09	<0.03	0.83	<0.05	2.43	<0.06	99.5	
11	vase	back of proper left fauness	1	0.50	0.06	74.67	22.11	0.16	0.09	<0.03	1.01	<0.05	0.46	<0.06	99.3	
19	mantel clock	base section: proper left side	2	0.52	0.09	79.86	17.12	0.19	0.12	<0.03	0.84	0.09	0.54	<0.06	99.4	
		base section: proper right side	2	0.59	0.08	78.57	17.82	<0.15	0.12	<0.03	0.96	0.10	0.98	<0.06	99.4	
		"rock" under clock: bottom surface	2	0.47	0.08	73.35	23.66	0.16	<0.09	<0.03	0.38	<0.05	0.85	<0.06	99.2	
		"rock" under clock: top surface	2	0.49	0.08	70.78	26.35	<0.15	<0.09	<0.03	0.42	<0.05	0.80	<0.06	99.3	
		standing female figure: proper left side	2	0.55	0.09	75.95	20.08	0.22	<0.09	<0.03	0.72	0.07	1.32	<0.06	99.3	
21	candelabrum	foot bottom: vase A	4	0.50	0.12	75.86	20.30	<0.15	0.10	<0.03	0.78	0.08	1.65	<0.06	99.6	
		top: vase A	3	0.57	0.08	75.80	20.60	<0.15	0.11	<0.03	0.81	0.06	1.25	<0.06	99.6	
		candle cup: vase A	2	1.06	0.08	76.72	20.07	<0.15	<0.09	<0.03	0.75	<0.05	0.55	<0.06	99.5	
24	pair of firedogs	long section: proper left firedog	2	0.60	0.09	76.68	19.85	0.19	<0.09	<0.03	0.64	0.07	1.19	<0.06	99.4	
		long section: proper right firedog	2	0.85	0.08	77.41	17.71	0.26	0.10	<0.03	1.16	0.10	1.64	<0.06	99.3	
		top of round section: proper right firedog	1	0.61	0.10	76.06	20.57	<0.15	<0.09	<0.03	0.87	0.10	0.74	<0.06	99.3	
25	pair of firedogs	under base: proper right firedog	3	0.52	0.06	76.50	20.42	<0.15	<0.09	<0.03	0.66	0.06	0.88	<0.06	99.3	
		under base: proper left firedog	3	0.65	0.06	76.54	20.42	0.15	0.09	<0.03	0.72	<0.05	0.67	<0.06	99.4	
27	french-window knob	sunflower	2	0.71	0.10	79.36	16.22	0.25	0.15	<0.03	1.13	0.10	0.72	<0.06	99.0	
39	side table	capital volute: proper left front leg	3	0.68	0.08	73.35	22.69	0.16	0.10	<0.03	0.99	<0.05	1.17	<0.06	99.4	
		egg and dart: proper left front leg	4	0.78	0.08	76.78	18.27	0.22	0.18	<0.03	1.62	0.16	1.18	<0.06	99.3	
		capital top flat: proper left front leg	5	0.65	0.10	76.36	17.21	0.18	0.13	<0.03	1.99	0.28	2.18	<0.06	99.1	
		foot bottom: proper left front foot	2	0.61	0.09	75.54	18.45	<0.15	0.12	<0.03	1.70	0.10	2.80	<0.06	99.8	
		ogee at base of capital: proper left leg	1	0.77	0.08	74.63	21.84	<0.15	0.09	<0.03	0.86	0.06	0.80	<0.06	99.2	
		foot bottom: proper right front foot	5	0.82	0.07	71.64	24.70	<0.15	<0.09	<0.03	0.75	0.07	0.95	<0.06	99.3	
42	capital	back of small acanthus leaf	3	0.58	0.08	74.58	22.69	0.24	0.09	<0.03	0.44	<0.05	0.61	<0.06	99.5	
		back of large acanthus leaf	2	0.49	0.09	71.26	25.58	0.20	<0.09	<0.03	0.47	0.06	0.99	<0.06	99.4	
		main cylinder	4	0.55	0.10	77.30	19.93	<0.15	<0.09	<0.03	0.62	<0.05	0.64	<0.06	99.4	
44	capital	inside capital: MR1248	3	0.72	0.06	75.57	20.50	0.17	0.12	<0.03	0.95	0.11	0.94	<0.06	99.2	
		inside capital: MR1248B	3	0.54	0.08	75.82	20.69	0.15	<0.09	<0.03	0.81	0.10	0.89	<0.06	99.2	
		critical value*		0.04	0.04	n/a	0.22	0.15	0.09	0.03	0.40	0.05	0.24	0.06		
	total number of spots analyzed and average percentage by weight for each element				0.08	75.43	20.73					0.87		1.16		99.3

*The critical value is derived from the instrumental calibration and represents the calibrated result below which the method delivers less
than a 95% confidence that the element is actually present in the sample.

Notes

The technical study aspect of this project benefited from the generous assistance of many individuals and institutions. First and foremost, I would like to thank Charlotte Vignon for giving me the opportunity to work on this project. Marco Leona and Federico Carò from the Department of Scientific Research at the Metropolitan Museum of Art deserve special thanks for their analytical work. Linda Borsch from the Department of Objects Conservation at the Metropolitan generously radiographed elements from the Gouthière table in the Frick. I am indebted to Julia Day for assuring that best practices were used in collecting X-ray fluorescence (XRF) data and to Arlen Heginbotham for providing direction in calibrating the results using methods he developed. Both read early versions of the essay and made helpful comments. I am grateful to those who allowed for Gouthière pieces to be disassembled to facilitate XRF analysis: Pierre Costerg, Frédéric Dassas, Anne Forray-Carlier, Jürgen Huber, Helen Jacobsen, Alexis Kugel, Anna Saratowicz-Dudyńska, and Maria Szczypek. Frick colleagues Michaelyn Mitchell, Patrick King, Adrian Anderson, and Brittany Luberda have provided important assistance with many aspects of this study for which I am grateful. Interns Elizabeth Peirce and Jessica Walthew, and Blanca del Castillo were also helpful. I am very thankful to Richard Stone, David Scott, Arie Pappot, Martin Grubman, and Yannick Chastang for their insightful consultation.

1. See p. 71 in this publication.
2. The traditional term is "gilt bronze," but the material used was not, in fact, bronze—an alloy consisting primarily of copper and tin—but rather brass, which is made of copper and zinc.
3. The use of wax for model making is mentioned more than fifty times in the archival material related to Gouthière (Appendix 1: 1773, December 31 [1] and [2]; 1781; and 1787, June 26). For example, in his invoice for the chimneypiece made for the Salon Ovale at Louveciennes (cat. 29), he refers to all models having been "made in wax and each finished with the greatest assiduity . . ." (see p. 329 in this publication).
4. For a discussion of Gouthière's role in wax model making, see Robiquet 1912 and 1920-21, 37-39.
5. Davillier 1870, XXIX. Also see *Journal de Paris*, no. 81, 1510.
6. For a period recipe for modeling wax, see Panckoucke and Lacombe 1788, 251.
7. Appendix 1: 1781 (p. 347).
8. Appendix 1: 1773, December 31 (1) (p. 332).
9. Gouthière repeatedly refers to the foundry models as being made of *cuivre* (Appendix 1: 1773, December 31 [1]; 1781; and 1787, June 26, pp. 330, 347-48, 365-66), but he seems to be describing a copper alloy as he sometimes writes *bronze*. Both terms were broadly used in the eighteenth century to describe various copper alloys. The foundry models were likely brass consisting primarily of copper and zinc.
10. Appendix 1: 1781 (p. 348).
11. Gouthière repeatedly mentions going directly from plaster mold to pouring pewter. For some of the models for the chimneypiece made for the Salon Ovale at Louveciennes (cat. 29), he charged "for molding the wax in plaster, [and] to have them cast in pewter . . ." (Appendix 1: 1773, December 31 (1) [p. 330]). See also ibid. (pp. 332, 334-38) and 1781 (pp. 347-48).
12. The term *étain* translates as tin but also pewter, a varying alloy that was primarily tin combined with other metals, including copper, antimony, bismuth, and lead. The pewter used for purposes not related to food or drink was a mixture of tin and lead. That used for foundry models contained approximately 25 percent lead. See Guettier 1844, 214.
13. Appendix 1: 1773, December 31 (1) (p. 341).
14. Guettier 1844, 200, 214.
15. Appendix 1: 1773, December 31 (1) (for example, p. 333).
16. Appendix 1: 1781 (pp. 347-48).
17. Fiquet 1780, 577.
18. Appendix 1: 1781 (pp. 350, 352); Baulez 1986, 613, 614, 617.
19. Appendix 1: 1773, December 31 (1) (p. 330).
20. Ibid., p. 329.
21. Eriksen 1974, 271-75. Another period source states that "all that one must cast in bronze is cast in wax before the caster makes his mold in sand" (Fiquet 1780, 577).
22. Appendix 1: 1773, December 31 (1) (pp. 333, 337, 339) and 1787, June 26 (p. 365).
23. There is little doubt Gouthière used sand casting to create his final brasses as it is specifically mentioned in many of his invoices. Regarding the mounts for chimneypieces for Mme Du Barry's Salon Carré, he states they "have molded in sand and cast in bronze all the ornaments and moldings that decorate the chimney" (Appendix 1: 1773, December 31 (1) [p. 335]. See also ibid., pp. 330-35, 337-41.
24. Diderot and d'Alembert 1751-72, pls. vol. 5 (1767), pl. 6 ("Fondeur en Sable").
25. Considine and Jamet 2000, 283-95.
26. Launay 1827, vol. 1, 43.
27. Appendix 1: 1773, December 31 (2) (p. 344).
28. Appendix 1: 1773, December 31 (1) (p. 338).
29. Panckoucke and Lacombe 1784, vol. 3, 18. Another source states that copper casters use a yellow sand found in the Paris area (Bertrand 1780, 196).
30. Launay 1827, vol. 1, 18-19, 47.
31. "The sample of the core material from the mount of the Mazarin table (cat. 39) consists of well sorted, very fine, round sand grains ranging from about 70 to 300 microns, with an average size of about 100 microns. The grains are predominantly quartz, with subordinate K-feldspar, micas, and rare rutile and Fe-oxide grains. This framework is set into a very fine clay matrix (possibly illitic and/or smectitic). Qualitatively, the matrix is about 6 to 8 percent of the entire core material, the rest being the quartz sand." Email communication from Federico Carò, Associate Research Scientist, Department of Scientific Research, The Metropolitan Museum of Art, New York, July 21, 2015.
32. For a discussion of the French false core sand casting

technique, see Suverkrop 1912, 923–28.

33. Launay 1827, vol. 1, 22–23.

34. Jane Bassett and Francesca Bewer have suggested another casting method that would result in the raised lines seen inside French bronze sculpture. However, Gouthière consistently refers to sand casting in his invoices. This archival material, combined with sand found inside a capital of the Duchess of Mazarin's table (cat. 39), suggests that piece molds of sand was the technique used on his work. It should be noted that remnants of yellow core material are present inside the Avignon clock, but it was not sampled (Bassett and Bewer 2014, 205–14).

35. The thirty sampled elements come from fifteen individual objects of eleven object groups (some were pairs). All samples were taken on ungilded surfaces. Multiple readings were taken from each sampled spot. Some readings were disqualified because of low counts or a high concentration of gold resulting in eighty-seven statistically valid samples. The author thanks Julia Day and Arlen Heginbotham for their guidance and support related to the gathering and processing of the XRF data for this project.

36. Methodology: *Acquisition*: Spectra were acquired with a Bruker Tracer S1 hand-held XRF. The live acquisition time for each spectrum was typically 60 seconds or 300 seconds when possible; voltage was 40 KeV; amperage was 15μA; beam filtration with .027 mm Al and .0026 mm Ti. This configuration resulted in count rates of approximately 9,000 cps and a dead time of approximately 30 percent. *Quantification*: Initial quantification was done by processing the spectra using PyMca fundamental parameters (FP) software. Background stripping was done using a channel width of 2 using 2,000 iterations and a Savitsky-Golay smoothing width of 6. A Mca Hypermet fit function was applied, with no continuum, 50 iterations and a minimum $\chi2$ difference of 0.001 percent. Fitting included accommodation for stripping, escape peaks, and pile-up (sum) peaks. A step-tailing algorithm was used. X-ray tube modeling used values of 0.0125 cm for the thickness of the Be window, an α electron angle of 52°, and an α X-ray angle of 63°. K line groups were modeled for Cr, Mn, Fe, Co, Ni, Cu, Zn, Rh, Ag, Cd, Sn, and Sb. Kα and Kβ were modeled separately for As, and L line groups were modeled for Sn, Au, Pb, and Bi. Attenuators were modeled using values of 0.5 cm air, 0.0013 cm Be detector window, 0.0392 cm Al tube filter, 0.0033 cm Ti tube filter, 0.045 cm detector thickness, and a copper matrix of infinite thickness. Based on measured, rectified images of the unit, the incoming X-ray angle was modeled as 50° and the outgoing angle was modeled at 65°. Initial estimations of concentrations were calculated from fundamental parameters based on a flux of 3.6e9 and an active area of 30 mm2. Initial concentration estimates based on the standardless FP procedure outlined above were refined through a calibration using 14 reference standards manufactured by MBH Analytical (see Heginbotham et al. 2015).

37. For a broader discussion of alloys, see Heginbotham 2014, 158–59.

38. See pp. 95–97 in this publication.

39. D'Arcet 1818, 9.

40. More than 2,800 pounds (1,370 kilograms) of *fonte brute* were delivered to Gouthière for the carriages ordered by the Count of Artois in 1773 (Baulez 1986, 615, 616). These were produced at a rate of 3 *livres*/pound. Approximately 80 pounds (39 kilograms) of more refined castings made for Mme Du Barry's chimneypieces were done at the higher rate of 5 *livres*/pound (Appendix 1: 1773, December 31 (1) (pp. 332, 333).

41. Appendix 1: 1781 (pp. 350, 352).

42. The pitch or *ciment* typically consists of wax, resin, and finely pulverized and sifted brick dust; see Courtin 1825, 151. This is very close to the recipe that Benvenuto Cellini included in his *Treatise on Goldsmithing* in 1568; see Bois 1999, 22.

43. Gouthière noted that the "garlands and drops consumed much time for roughing out, filing, and chasing" (Appendix 1: 1781 [p. 352]).

44. Diderot and d'Alembert 1751–72, vol. 15 (1765), 391.

45. Macquer 1789, vol. 3, 470.

46. Diderot and d'Alembert 1751–72, vol. 15 (1765), 392.

47. The solder was analyzed with scanning electron microscopy with energy dispersive X-ray spectroscopy (SEM-EDS) by Federico Carò, Associate Research Scientist, Department of Scientific Research, The Metropolitan Museum of Art, New York, July 13, 2015.

48. See Heginbotham 2014, 159.

49. Gouthière was quite specific in his description, noting that "all the crystal supports [were] soldered with strong solder and tapped to screw on nuts" (Appendix 1: 1773, December 31 (1) [p. 342]).

50. Diderot and d'Alembert 1751–72, vol. 15 (1765), 392; Macquer 1789, vol. 3, 470.

51. D'Arcet 1818, 40–44.

52. During the course of this study, the author observed many broken sections on the fine details, perhaps an indication that the brittle work-hardened sections were not annealed. However, it is possible that the smaller sections were annealed prior to being joined by soldering, and the breakage is simply the result of excessive handling of the fragile elements.

53. D'Arcet 1818, 46.

54. Ibid., 30.

55. Baulez 1986, 632. One *once* during the ancien régime was equivalent to 30.59 grams.

56. D'Arcet 1818, 57–59.

57. Ibid., 60–63.

58. Ramazzini 1940, 33. Originally published in 1700, the 1713 edition was expanded. The original edition was translated into English in 1705. The first French version was published in 1777.

59. For an overview of coloring methods and materials, see Pappot forthcoming.

60. D'Arcet 1818, 59.

61. Ibid., 64–68.

62. Pappot includes the mechanism as described by Wagner 1858, 357: the heated alum decomposes forming sulfuric acid, which releases hydrochloric acid from the salt and nitric acid from the saltpeter.

63. *Journal de Paris*, no. 81, 1510 (see p. 74 in this publication).

64. Davillier 1870, xxxi. Also see Vial 1901, 141. This is related to the trial Gouthière's son brought against the heirs of Mme Du Barry for payment of his father's claims.

65. In a letter written in about 1764 by Gouthière and silversmith Jean Ratneau to the king of Poland, Gouthière is mentioned as "being the only one to possess the color in which Your Majesty's works are gilded." Matte gilding is consistently referred to as a color in period documents. The vase and cassolettes (cat. 3) Gouthière made for the king were, in fact, done with matte gilding.

66. Laer 1721, 98. The author thanks Arie Pappot for translating this section.

67. *Dictionnaire portatif de commerce*, vol. 3, 135–36. This recipe, which is also in powder form, does not include plunging the piece in water after the mixture reacts with the gold. Instead it is left to cool in the air. Therefore, it does not seem practical for a thin layer of gold on gilded work.

68. See pp. 29–32 in this publication.

69. In describing the the steel components of the espagnolettes he made for the Grand Salon Carré at the pavilion at Louveciennes, Gouthière refers to the color as *violet* (Appendix 1: 1773, December 31 (1) [p. 341]); yet for repair work done on the espagnolettes in 1772, the color is recorded as *couleur d'eau* (ibid., p. 345).

70. Appendix 1: 1773, December 31 (1) (p. 334).

71. Gouthière was commissioned by the Garde-Meuble de la Couronne in 1785 to give thirteen preexisting bronze sculptures a smoke-colored finished. However, we see only one reference to a similar finish being used on his own work in gilt brass (see pp. 54–55 in this publication).

72. On his invoice for the chimneypiece for the Duchess of Mazarin's large salon (cat. 35), Gouthière states that screws were used in a few places, but "all other bronzes are placed on the marbles without visible screws" (Appendix 1: 1781, p. 350). See also ibid., 1773, December 31 (1) (pp. 331, 337).

73. Appendix 1: 1781, p. 350.

74. In an extreme example, such as the Louvre's complex celadon vases (cat. 15), the expense of mounting the bronzes rivaled that of the gilding. See Wildenstein 1921, 127.

75. "For mounting the frieze, the two vine wreaths and the two uprights: drilled 44 holes in the marble, made 44 threaded pins and made all the solders" (Appendix 1: 1787, June 26, pp. 365–68). There are two references to attaching elements to chimneypieces with screws that pass through the entire thickness of the marble to be secured with nuts, making their removal impossible once the chimneypiece is installed in the architecture.

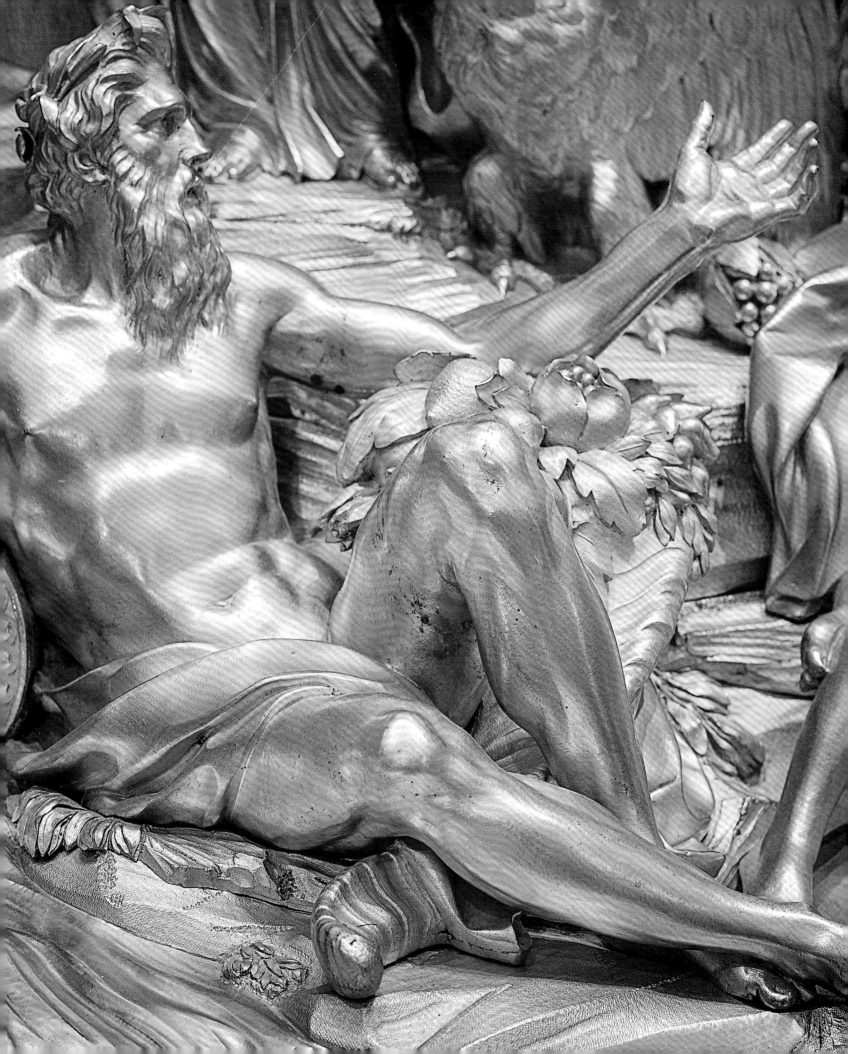

Gouthière's Legacy: Nineteenth-Century Collectors in Britain

HELEN JACOBSEN

In Jacques Robiquet's 1912 monograph on the life and work of Pierre Gouthière, the Wallace Collection stands out as having the world's second largest collection (after that in the Louvre) of works by Gouthière, with twenty-two pieces attributed to him. This figure has fluctuated ever since, as only two definitive eighteenth-century attributions are known (cats. 13, 19). Reattribution is a familiar theme in art history and a reminder that fashion, no less than connoisseurship, can play an important role in the rise and fall of artistic reputations. However, the roller-coaster of Gouthière's legacy has been exacerbated by the paucity of signed works, the lack of information about him and his contemporary bronze-makers, and the nature of the medium, from which over-casts could be taken and original models reused. His connection to some of the most colorful and romantic figures of the ancien régime has proved a compelling lure for collectors and dealers alike, with consequent effects on the value of his works.

We know of no contemporary British patrons of Gouthière, which may be a function of the tight circle of architects, designers, and clients with whom he worked, as well as the exorbitant cost of his pieces. While furnishing the new Carlton House in the late 1780s, the dealer Dominique Daguerre supplied George, Prince of Wales (1762–1830), with a pair of firedogs of the same model as those Gouthière had made for the Duchess of Mazarin a few years earlier (cat. 26), but we do not know whether Gouthière worked on them: several layers of regilding make connoisseurial attribution all but impossible.[1] The prince's taste, which he shared with a number of friends—among them, Francis Seymour-Conway, third Marquess of Hertford (1777–1842)—was for lavish and sumptuously gilded interiors, but there is no evidence that he sought specifically to acquire works by Gouthière in the manner of the pre-revolutionary French court. The third marquess owned a garniture of blue oriental porcelain vases "on richly Chased ormolu Bases and ornamented with festoons of flowers. Niaad [sic] Handles," which he displayed in the salon of St. Dunstan's Villa, his *maison de plaisance* in London; the three vases were later attributed

to Gouthière.[2] Catalogues from the sales of other early British collectors of French ancien régime decorative art—such as William Beckford (1760–1844), William Pole Tylney Long Wellesley, fourth Earl of Mornington (1788–1857), and George Watson Taylor (1771–1841)—contain no mention of Gouthière's name, which makes it difficult to know to what extent his work was appreciated by their generation. Objects were described as "sumptuously" decorated or mounted with bronze "highly gilt in or-mat" and given provenances such as "from the Garde Meuble at Paris" or various royal residences, but only the names of the cabinetmakers André-Charles Boulle and Jean-Henri Riesener had common currency.

The absence of attributed Gouthière works in these early British collections may be for reasons of taste or, more likely, scarcity, since much of his oeuvre remained in France. With their connections to the Paris market, however, some British dealers were familiar with the chaser and gilder's name and reputation. In 1830, Squibb & Son advertised "a very extensive recent IMPORTATION from the Continent," including furniture, Sèvres porcelain, and two "large oriental tea-green enamelled bottles, sumptuously mounted in or-molu à la gouthière," evoking a recognizable style or manner of gilding bronze.[3] Since the revolution, French sale catalogues in which Gouthière pieces were occasionally highlighted had been distributed in London, and although British buyers may have had little visual recognition of his work, there was evidently an increasing awareness of his reputation. In 1835, Foster's advertised a new shipment from France at their gallery in fashionable Pall Mall. Ranked alongside soft-paste Sèvres porcelain reputedly once owned by Marie Antoinette, the headline billing offered "the Or-moulu Locks, Bolts and Fittings of the Private Apartments of Louis XVI manufactured by the celebrated GOUTHIÈRE."[4] Important for linking Gouthière with the royal family, this claim has credence because he did supply gilt-bronze decoration for doors and windows.

By specifically evoking connoisseurship, Foster's advertisement marked a significant development in the British market. Gilt bronze was no longer seen as merely an expensive and rich adornment of the furnishing of a room but as art to be assessed and admired. Nonetheless, judging Gouthière exclusively on technical grounds was, and remains, highly problematic since the gilding and chasing of some of his contemporaries, such as François Rémond, the Feuchère family, and Pierre-Philippe Thomire, also reached extraordinary heights of refinement. The number of attributions grew, however, in line with the mythology surrounding him, assisted perhaps in the 1830s by the high-profile court case between his legatees and those of Mme Du Barry. Gouthière's name became associated with the great British collecting passions of Sèvres porcelain, lacquer, and Marie Antoinette, but the link that proved the hardest to shift, and still remains so, was the association of Gouthière with furniture mounts.[5]

By the early 1850s, Gouthière's reputation in Britain had eclipsed even that of Marie Antoinette's favorite cabinetmaker, Jean-Henri Riesener. The most admired piece of furniture at the influential loan exhibition *Specimens of Cabinet Work* at Gore House, Kensington, was a cabinet lent by Queen Victoria and made by Riesener in the late 1780s but described as "a noble work of the celebrated French cabinet-maker, Gouthier [sic]. This magnificent piece is, perhaps, one of the most perfect examples of finished workmanship ever executed" (fig. 79).[6] The author,

J. C. Robinson, was Keeper of Art at the Museum of Manufactures at Marlborough House (a precursor of the South Kensington and Victoria and Albert museums) and a noted connoisseur; his attribution to Gouthière added an authoritative and independent voice to dealers' subsequent claims, confirming Gouthière's reputation and ensuring that his name would be associated, inaccurately, with furniture mounts of the Louis XVI period for the next hundred years. Only twenty-five years previously, George IV had acquired the cabinet as "a chef d'oeuvre of the ingenious Riesner [sic]."[7]

The subsequent generation of British collectors actively pursued the name of Gouthière. Richard Seymour-Conway, fourth Marquess of Hertford (1800–1870), brought up in Paris and London, inherited a vast fortune from his father and started collecting during the 1840s. It was well known that Hertford would pay high prices for any work of art he wanted, and he was criticized in the press for overpaying.[8] His expertise was, however, admired by contemporaries, and his connoisseurship is evidenced by the quality of the gilt-bronze mounts on the copies of eighteenth-century furniture he commissioned in the 1850s and of the *bronzes d'ameublement* in the Wallace Collection today. He can be considered the first serious British collector of Gouthière, owning two of his masterpieces (cats. 13, 19) and at least fifteen attributed pieces, in marked contrast to contemporary British collectors of his class like William Lowther, second Earl of Lonsdale (1787–1872), Robert Herbert, twelfth Earl of Pembroke (1791–1862), or Richard Grenville, second Duke of Buckingham and Chandos (1797–1861), whose collections show no evidence of attributed Gouthière works. Hertford may have had deeper pockets, but it also seems that his taste had been influenced by his Parisian surroundings.[9] His half-brother, Lord Henry Seymour (1805–1859), also raised in Paris, shared his admiration for Gouthière and owned a column clock with mounts attributed to the gilder, as well as a model of a firedog sometimes associated with him.[10]

The British fascination with furniture overshadowed Gouthière's association with *bronzes d'ameublement*, and although he was grouped with cabinetmakers Riesener, Roentgen, and Chippendale at the *Special Exhibition of Works of Art* at the South Kensington Museum in 1862, none of the gilt-bronze candelabra, mounted hardstone vases, or other "miscellaneous objects" were attributed to him despite being of the quality and style that were later to be so, such as the openwork ivory vases lent by George Field (fig. 80).[11] This changed after the *Musée rétrospectif: la Renaissance et les temps modernes*, an 1865 exhibition in Paris that was covered by both the French and British press. The catalogue detailed twenty-nine objects with gilt-bronze mounts by Gouthière, including candelabra, wall lights, mounted Sèvres vases, and clocks, as well as fur-

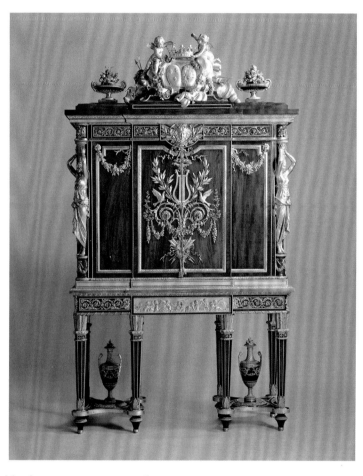

Fig. 79
Jean-Henri Riesener, *Jewel Cabinet*, ca. 1787, exhibited at Gore House in 1853 and attributed at the time to Gouthière. Oak, mahogany, and gilt bronze, 96⅞ × 57⅞ × 21½ in. (246 × 147 × 54.6 cm). Royal Collection Trust (RCIN 31207)

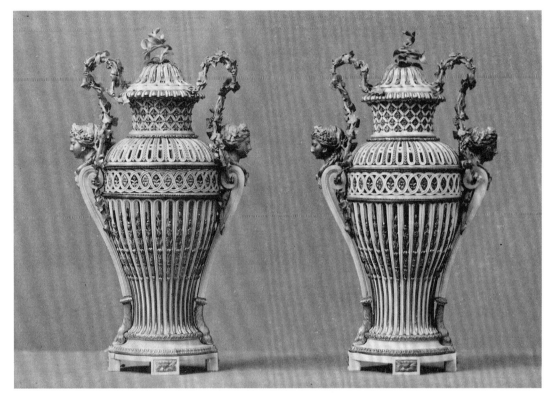

niture. Eleven of these items, the largest collection, belonged to Lord Hertford, and two (cats. 13, 19), with their rock-solid provenances and in one case a signature, fueled the appetite for knowledge about the elusive Gouthière, which dealers and sales catalogues readily exploited (fig. 81).[12]

By the mid-1860s, aristocratic collectors like Hertford were no longer the norm in London, and as the economic wealth of Victorian Britain grew, so did new buyers of decorative art: the second half of the nineteenth century was characterized by merchant, banker, and industrialist collectors with newly acquired wealth, as well as by heightened connoisseurship. Connoisseurship in French decorative arts, however, progressed slowly. The collection of the barrister, member of parliament, and antiquarian Ralph Bernal (1783–1854), "distinguished . . . by the perfection of his taste, as well as the extent of his knowledge," included furniture attributed to Boulle with mounts by Gouthière, a reflection of the widespread lack of understanding of the distinct styles and artistic techniques employed in eighteenth-century France.[13] Charles Drury Edward Fortnum (1820–1899), a different type of gentleman connoisseur, was much more focused in his approach. A scientist by training, he married his cousin, an heir to the Fortnum & Mason grocery business, whose fortune allowed him to live as a scholar and collector, particularly of sculpture, bronzes, maiolica, and jewelry. He had widely acknowledged expertise, acting as an advisor to the Victoria and Albert and the Ashmolean museums, and kept meticulous notebooks cataloguing his collection, which he lat-

er gifted to the Ashmolean. It may have been his passion for bronzes rather than a love of French eighteenth-century decorative art that drove him to buy works he considered to be by Gouthière: a pair of candelabra (fig. 82) and two gilt-bronze-mounted marble vases (see fig. 93).[14]

From the middle of the nineteenth century, spurious attributions to Gouthière vastly outnumbered authentic works on the London market. Hertford claimed to disregard such attributions, complaining that "bronzes, clocks, and furniture, all is by Riessner [sic] or Boule [sic] or Gouthière and all belonged to Marie Antoinette, Madame Du Barry or Madame de Pompadour."[15] Clock attributions proliferated, no doubt encouraged by the awareness of Hertford's signed clock. Philip Salomons (1796–1867), a successful financier, may not have had the expertise to assess whether his clock in the form of a bust of an African woman really was "a very beautiful clock by Gouthière," but there is no doubting the quality of the model.[16] Another wealthy collector, Charles Spencer Ricketts (1788–1867), may also have been mistaken, but the quality of at least two of his five "Gouthière" pieces is still regarded as outstanding even if they are now considered to be the work of François Rémond (fig. 83).[17] These plaques were originally intended for mounting on fur-

Fig. 81
Some of the 4th Marquess of Hertford's loans on display at the *Musée rétrospectif* of 1865, including the Avignon clock (cat. 19) and incense burner (cat. 13). Wallace Collection Archives

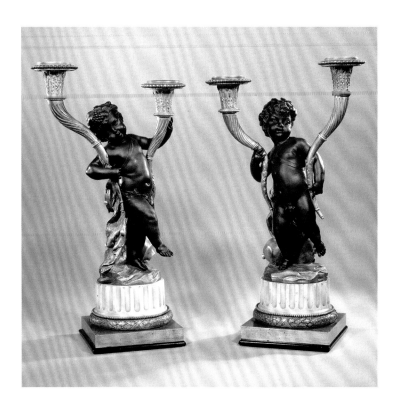

Fig. 82
Pair of candelabra considered
by C. D. E. Fortnum to be "in
all likelihood" the work of
Gouthière. Patinated and gilt
bronze and marble, 16⅞ x 5½ in.
(42.9 x 14.2 cm) Ashmolean
Museum, Oxford (WA1899.
CDEF.B1036–37)

niture, but their display in ebony-framed glazed cases implicitly reinforced Gouthière's status as an artist.

Richard Wallace (1818–1890), the illegitimate son of Lord Hertford and founder of the Wallace Collection, bought the two plaques from the Ricketts sale of 1867, acting as agent for his father, but his own early art collection, formed in Paris in the 1840s and 1850s, also included works attributed to Gouthière and his peers, among them, two vase candelabra and mounted hardstone vases.[18] As prices later escalated, the financial wherewithal to afford the very best in gilt bronze eluded Wallace until he inherited Hertford's vast fortune in 1870. Becoming one of the richest men in Britain allowed Wallace to make spectacular acquisitions in the art market and to compete against collectors as wealthy as the Rothschild family, traditional buyers of Gouthière.[19] In 1871, he purchased two hardstone tables with gilt-bronze mounts attributed to Gouthière from Durlacher, the London dealer, for the massive sum of £3,150 (fig. 84).[20] A spectacular "find" of the collector-dealer Frédéric Spitzer, they had purportedly been shipped back from St. Petersburg to Paris and were authenticated in glowing prose by Charles Davillier, a sometime dealer and leading expert on Gouthière.[21] Davillier's comments underline just how difficult it was, and still is, to attribute work to this most elusive of artists. Similar in concept to tables made by Gouthière for the Duke of Aumont (cats. 38, 40) and then known thanks to the illustrations in the duke's sale catalogue, which had been republished in 1870 by Davillier—the Wallace Collection model is likely to have been made in the workshop of François Rémond, although the authorship of the female busts supporting the hardstone top remains a matter of debate. More tellingly, however, only one of the tables is eighteenth-century; either Spitzer, or Davillier, or both, and certainly Richard Wallace, were duped by a first-class copy.

Gouthière was a headline attraction for British and international buyers at the Demidoff San Donato sales of 1870 and 1880. At the first sale, Hertford paid 49,000 francs for a garniture of a clock and two candelabra (figs. 85, 86).[22] Charles Mannheim, a Parisian dealer and expert who sometimes bought on behalf of Hertford and the Rothschilds, paid the huge sum of 105,500 francs for the stellar furniture of the sale, a four-piece set of black lacquer-mounted commode, secretaire, and two *encoignures* "garnis de bronzes dorés au mat, ciselés par GOUTHIÈRE," which later appeared in the Alphonse de Rothschild collection.[23] The same set had been in the 1824 sale after the death of the dealer Philippe-Claude Maëlrondt. Not only had there been no mention then of Gouthière, but one of the *encoignures* had been acknowledged as new.[24] Similarly, the Riesener furniture sold at the Hamilton Palace sale in London in 1882—originally acquired by the tenth Duke of Hamilton in the 1820s and 1830s without any connection to Gouthière—had by 1882 become

Fig. 83
Plaque (one of a pair), ca. 1783,
attributed to Gouthière in the sale
catalogue of Charles Spencer Ricketts
(June 13, 1867, lot 657). Gilt bronze,
11⅜ × 8½ in. (28.8 × 21.5 cm). The
Wallace Collection, London (F296)

Gouthière's work and comprised the premium lots in a celebrated sale where a heady mix of royal and aristocratic provenance, a headline marketing campaign, and fabulously wealthy buyers from North America newly introduced to ancien régime furnishings fueled interest and prices. The British dealers William Boore, Samson Wertheimer, and Frederick Davis dominated the buying of these lots, often securing them at exorbitant prices for American buyers (fig. 87).[25] Few British collectors could compete at this level, but Wertheimer acquired a Riesener writing table that had once belonged to Marie Antoinette, with mounts attributed in the sale catalogue to Gouthière, for Ferdinand de Rothschild (1839–1898), for £6,000.[26] The scale of expenditure shocked the British establishment. Referencing Juvenal's illustration of profligacy, the *Times* railed: "If Juvenal had been present at the auction rooms in King-street yesterday, he would have seen the man who gave six thousand sesterces for a mullet outdone by another who gave six thousand pounds sterling for a writing table."[27] Sir Dudley Coutts Marjoribanks (1820–1894), a banker, embodied the newly moneyed London collectors who sought to fill their homes with the ancien régime furnishings that

Fig. 84
One of two tables, ca. 1785, attributed to Gouthière by Baron Davillier in 1870 and bought by Sir Richard Wallace in 1871. Hardstone and gilt bronze, 32¼ × 44⅝ × 20⅜ in. (82 × 113.2 × 51.7 cm). The Wallace Collection, London (F317)

had become a symbol of status, wealth, and good taste. Hertford, pursuing Gouthière to the end of his days, bought a pair of *encoignures* with "Gouthière" mounts from the Marjoribanks sale through the London dealer Frederick Davis just three months before he died.[28] As illustrated at the Hamilton Palace sale, auction buyers were increasingly dealers, sometimes buying on their own account, sometimes for clients; either way, Charles and Frederick Davis, Charles Mannheim, Samson Wertheimer, Edward Joseph, William King, and others dominated the market and were relied upon for their knowledge and connoisseurship. The relationship between dealers and makers was often close, with French dealer-cabinetmakers such as Alfred Beurdeley and Henri Dasson and English dealer-decorators such as White Allom supplying copies and reproductions of French eighteenth-century furniture and *bronzes d'ameublement*, as well as eighteenth-century originals.[29] Samson Wertheimer had started his career as a bronze-maker, advertising himself as an "ormolu dealer" and "manufacturer of ornamental mounts for cabinets, tables, vases etc., in Bronze and Ormoulu."[30] Although copies were increasingly lauded—Dasson exhibited his copy of the Gouthière incense burner made for the Duke of Aumont at the 1878 Exposition Universelle— the extent to which dealers hoodwinked buyers remains an open question; the tradition of metal-workers handing down models from one generation to another extended through the nineteenth

century, as the sales of the French *bronziers* Feuchère and Beurdeley show. Samson Wertheimer's stock sale in London in 1892 included various "complete patterns" for Louis XVI wall lights and candelabra, and the celebrated firm of J. Hatfield & Son, "Bronze & Ormolu manufacturer," bought several, including a model "for a Louis XVI wall-light with a piping boy."[31] Whether these were used to make honest reproductions or with an intent to deceive is impossible to say, but the dating of one of a pair of Louis XVI "piping boy" wall lights bequeathed to the Victoria and Albert Museum in 1882 by John Jones (1798/99–1882) has been questioned (fig. 88). Jones may have been sadly misled: of the thirteen pieces attributed to Gouthière that he bequeathed to the museum, none is recognized as such today.[32]

In the early 1890s, Asher Wertheimer bought the spectacular Gouthière table made for the Duchess of Mazarin (cat. 39) from Alfred Morrison (1821–1897), and in so doing confirmed the direction of twentieth-century collecting. It is unclear from inventories whether Morrison or his father James (1789–1857), described as Britain's richest commoner, had acquired the table, although it seems less in keeping with Alfred's collecting habits; the hardstone, gilt bronze, and superb workmanship of the table are more typical of James's taste.[33] Wertheimer acquired the table for Paul Ernest Boniface ("Boni") de Castellane (1867–1932), a French aristocrat whose American wife brought him the inherited fortune of the Gould railroad family. By then, the United States had overtaken Britain as the world's greatest economic powerhouse, and Gouthière masterpieces were sold to discerning collectors with American wealth, like John Pierpont Morgan and Alfred

Chester Beatty. Just as they had been in the 1830s and 1840s, British dealers were at the forefront of this shift, educating a new clientele and prizing Gouthière works of art from private collections to sell to the new collectors. Spurious attributions continued to appear, increasing in number as collectors on both sides of the Atlantic chased fashionable *bronzes d'ameublement* and publications on public and private collections illustrated work attributed to Gouthière, mistakenly or otherwise. Items of varying quality were displayed in countless "Louis Seize" drawing rooms in London and New York, but authenticity had given way to fashion, and, just as in Gouthière's lifetime, only a very few, very wealthy collectors could claim that they owned pieces that had actually passed through the hands of the most famous chaser and gilder of the eighteenth century.

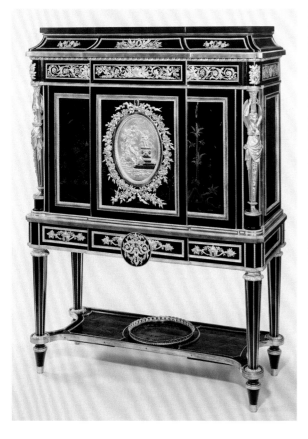

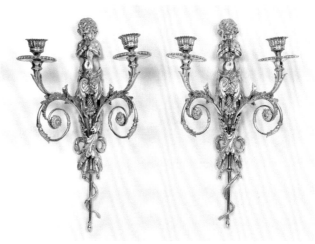

Fig. 87
Jean-Henri Riesener, *Secretaire*, ca. 1785, acquired by Samson Wertheimer at the Hamilton Palace Sale in 1882 and subsequently sold to Cornelius Vanderbilt II with an attribution to Gouthière. Oak, amaranth, and ebony, panels of Japanese lacquer, gilt bronze, and marble, 61 × 44¼ × 18½ in. (155 × 112.5 × 47 cm). The J. Paul Getty Museum, Los Angeles (71.DA.104)

Fig. 88
Two wall lights bequeathed to the Victoria and Albert Museum by John Jones, ca. 1780 or 19th century. Gilt bronze, 17¾ × 10⅞ × 5½ in. (45 × 27.5 × 14 cm). The lights do not form a pair and are different in decorative details and in quality of execution. Victoria and Albert Museum, London (975-1882)

Notes

I would like to express my thanks to my colleagues, past and present, at the Wallace Collection who have supported my work on this essay, including Christoph Vogtherr, Jeremy Warren, Suzanne Higgott, Jürgen Huber, Cassandra Parsons and Samantha Beeston. I am also grateful to Anne Forray-Carlier, Anna Saratowicz-Dudyńska, and the other curators who have been so quick to share their knowledge and time, to Joe Godla for his technical expertise, and to Christopher Payne for his invaluable advice and experienced eye. Finally, my sincere thanks to Charlotte Vignon, whose enthusiasm and commitment made this publication possible.

1. The same model, but with patinated bronze eagles, was in the Countess of Blessington's collection (her sale, May 7, 1849, lot 27), where they were described as coming from Malmaison, bought by the 4th Marquess of Hertford, and inventoried in the salon at Bagatelle on the death of Sir Richard Wallace (AD 75, inventory, August 14, 1890, no. D48 E³ 76). Now in the Philadelphia Museum of Art (1939-41-25a,b). François Rémond supplied "un feu à aigle" to Baron de Staël on December 9, 1787 (AN, 183 AQ 5). See also cat. 26 in this publication.
2. St. Dunstan's Villa inventory, May 1842 (Wallace Collection Archives, HWF/1/2/7, fols. 28, 29). He bequeathed the house and contents to his mistress; the sale after her death described the garniture as "Oriental China vases, gros-bleu, mounted in the finest taste by GOUTIÈRE [sic] . . . the centre with striking clock" (St. Dunstan's Villa, London, July 9, 1855, lot 85).
3. *The Times*, May 18, 1830.
4. Foster's, London, June 16, 1835, lots 24–25.
5. There is no evidence of Gouthière ever having mounted Sèvres porcelain or lacquer and very few documented instances of him working on furniture mounts, apart from the hardstone tables he mounted for the Duke of Aumont and the Duchess of Mazarin, although his name had been linked to furniture as early as 1797 in the Hôtel Bullion sale (Baulez 1986, n. 282). Accounts show that Rémond had connections to the Hôtel Bullion (AN 183 AQ 5, fol. 80).
6. Exhibition catalogue. The exhibition was arranged by the Board of Trade and intended "for the information of students of Schools of Art, and the public at large."
7. Watson Taylor sale, May 28, 1825, lot 76.
8. *Cabinet de l'amateur* 1845–46, 429.
9. Hertford's friendship with Napoleon III gave him access to what was and remains the largest single collection of documented works by Gouthière, which Empress Eugénie had included in the furnishing of her apartments in the palace of the Tuileries. Much of this remains in the Louvre.
10. This is a model with winged female figures terminating in *rinceaux*, warming their hands at a flame. February 23, 1860, lots 118, 144.
11. A pair of similar ivory vases "ciselés par gouttières [sic]" was in the Cheronnet sale, November 30, 1840, lot 330.
12. The so-called Avignon clock was clearly signed by Gouthière, and the provenance of the perfume burner that had been acquired for Marie Antoinette at the Duke of Aumont's sale had been clearly established in the Prince of Beauvau sale earlier in 1865.
13. Introduction to sale catalogue, March 5, 1855, lot 4138.
14. Penny 1992, nos. 264/5 and 281/2. I am also grateful to Jeremy Warren for sharing his knowledge of the Fortnum archive with me.
15. Wallace Collection Archives, AR2/16.
16. Philip Salomons, May 14, 1867, lot 524. A clock of the same model is in the Royal Collection (RCIN 30390), probably acquired by George, Prince of Wales, in 1790.
17. Captain Charles Spencer Ricketts, RN, June 13, 1867, lot 657. Rémond was one of Riesener's suppliers and also made plaques and mounts for Roentgen and Frost. AN 183 AQ 1–9.
18. *Provenant du cabinet d'un amateur*, February 26, 1857, lots 109, 260.
19. The privately printed inventory of Mentmore Towers (1884) showed that the highlights of the Earl of Rosebery's collection, much of it inherited from his father-in-law, Baron Mayer de Rothschild, were two pieces of furniture and two vases with mounts attributed to Gouthière.
20. Wallace Collection Archives, AR2/25T.
21. Davillier 1867.
22. Demidoff San Donato sale, March 24, 1870, lots 255, 256.
23. Ibid., lots 280–82.
24. Cordier 2007.
25. Hamilton Palace sale, June 17–July 20, 1882, lots 1296–98.
26. Ibid., lot 303.
27. Quoted in Bellaigue 1974, 525.
28. *Property of a Gentleman* sale, May 27, 1870, lot 51. Wallace Collection, F275 and F276.
29. Lord Revelstoke sale, June 28, 1893. The collection asssembled by Lord Revelstoke (1828–1897), another banker who chose to furnish his London house in the Louis XVI taste, showed a conscious mix of old, new, and pastiche.
30. Westgarth 2009.
31. Samson Wertheimer's stock sale, London, March 15, 1892, lots 1–19, the "piping boy" lot 9. John Ayres Hatfield, a bronze-maker, started the family firm by 1844 and seems to have specialized in high-quality reproductions made both for the trade and private clients. His nephew continued the business after his death in 1881.
32. *Handbook of the Jones Collection*, 74. Object nos. 1882-1082, 1882-1113:8, 1882-1106, 1882-1078, 1882-1071, 1882-1061, 1882-1137/1137a, 1882-1144, 1882-1141, 1882-971, 1882-970, 1882-976.
33. Dakers 2011. I am grateful to Caroline Dakers and John D'Arcy for their help. James Morrison acquired what was left of William Beckford's Fonthill in 1830, but no evidence has been found to show that Beckford owned the table.

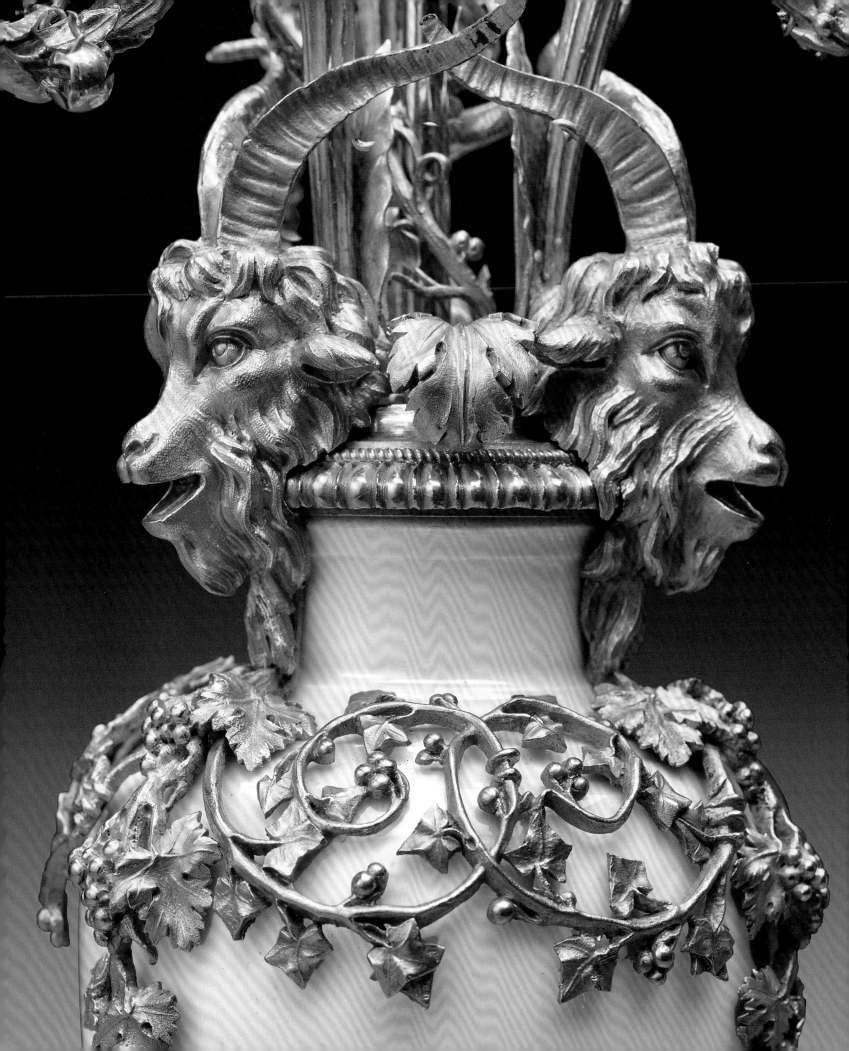

CATALOGUE RAISONNÉ

SILVER GILT

1

Dessert Service

Silver by François-Thomas Germain, 1760–65 (cutlery) and 1764–65 (dishes) Silver gilt by Pierre Gouthière, 1767 Dishes: Diam. 10 in. (25.4 cm); spoons (95; MNAA 1949–53 Our/PNA 5414–503): H. 7⅝ in. (19.3 cm); knives (93; MNAA 1959–63 Our/PNA 5590–677); H, 8⅜ in, (21.4 cm); forks (91; MNAA 1954–58 Our/PNA5504–589): H. 7½ in. (19 cm) Museu Nacional de Arte Antiga, Lisbon, and Palácio Nacional de Ajuda, Lisbon

Provenance:
Commissioned by Joseph I for the Portuguese royal court, 1756; Palácio das Necessidades; Museu Nacional de Arte Antiga, Lisbon.

Literature:
Bapst 1886, 513–14; Bapst 1892, 16–17; Foz 1926; Cunha Saraiva 1934; *Trésors de l'orfèvrerie* 1954, 20; *Exposição de ourivesaria* 1955, 16; Levenson 1993, 167–72; Orey 1991, 126–37; *Triomphe du baroque* 1991, 103–10; Orey 1993, 165–69; Perrin 1993, 25, 115–18, 140–200; *Royal French Silver* 1996, 74–81; Orey 1999, 148–65; Monteiro 2002.

The Lisbon earthquake of November 1, 1755 had profound repercussions not only for the capital of the Portuguese empire but for all of Europe. In the decades before the disaster, King John V of Portugal, sustained by ever greater remittances of gold and diamonds from Brazil, had imported magnificent paintings, sumptuous textiles, extraordinary sculptures, and the finest silverware from Italy and France. Churches and palaces were filled with beautiful objects that were the pride of the Portuguese capital and its court.[1] The Frenchman Thomas Germain, silversmith to Louis XIV, had been commissioned to produce the first great Portuguese royal silver service. Although nothing from this set survived the cataclysm, documentary descriptions convey its magnificence, as well as the difficult negotiations between the workshop of the famous silversmith and the Portuguese court. Correspondence between the keeper of the Portuguese crown jewels and the ambassador to Portugal in Paris refers to the types of pieces that were commissioned and some of the technical aspects of their finishing.[2] Although the relationship was tense, the quality of Germain's work justified the continuous flow of commissions; when he died, the royal preference was transferred to his son, François-Thomas.

The destruction of the city triggered a great need for rebuilding and for replacing luxury objects, and Lisbon and the Portuguese royal household thus became a major market for works of art. In 1756, Joseph I commissioned a new silver service from François-Thomas.[3] One of the artist's great masterpieces—comprising four sets and consisting of more than a thousand items, including a variety of essentially utilitarian objects—this service has survived largely intact and displays both sophisticated design and great technical expertise.

Imitating the custom of the French court, the Portuguese royals served dessert in a separate room; hence the decoration of this set differed from that of the dinner service. In this case, vermeil (silver gilt) was used. Designed in an elegant, sometimes rather bold, baroque style, the dessert dishes are adorned with a gently shaped border of ribbons and flowers, enhanced by the light engraving and chasing of a vegetal motif. In the center is the Portuguese royal coat of arms. The dessert cutlery also displays great

sobriety and elegance, with the ribbons that decorate the handles of the spoons and forks enhanced with vermeil. The knives used for cutting fruit were entirely gilded in order to protect them against the acids in the fruit.

At least eight dozen dessert dishes and seventy-two complete fruit knife, fork, and spoon sets were ordered for the royal service,[4] all of these latter pieces in silver gilt.[5] However, bankruptcy proceedings brought against Germain complicated their manufacture.[6] Part of the order had already been sent to Lisbon in 1765, when, on October 18, 1765, the French foreign minister, the Duke of Choiseul, wrote to the Portuguese ambassador Sousa Coutinho as follows:

> The disagreements among the partners [of Germain's workshop] did not prevent them from working on the service destined for the King of Portugal. They shipped Mr. Gouthiers [*sic*] a part of the order that required gilding, but Mr. Delorme had the pieces seized. He had also requested that the company deliver to the same worker [Gouthière] a few other pieces that needed to be gilded—a considerable part of the service had already been delivered to this gilder.[7]

According to the testimony of the silversmith Pierre-Louis Régnard (appointed to inventory his colleague's workshops after the bankruptcy decree), dozens of these pieces were still in the hands of Gouthière in 1767, waiting to be gilded.[8] And it was at this gilder's workshop—despite the opposition of the partners involved in the Germain bankruptcy process—that the pieces were temporarily seized on the orders of Martin Delorme, the representative in Paris of Louis Beaumont, a Lisbon trader and the custodian of the models of the never-finished fourth silver service.[9] There was considerable dispute between the partners and the king's representatives in Portugal,[10] not only about the ownership of the pieces but also whether or not Gouthière should finish his gilding and who should pay him.[11] The work eventually continued, with those pieces that still needed gilding sent to Gouthière for completion. A note dated August 1765 explained:

> Concerning the works belonging to the Court of Portugal that will be sent to Mr. Gouthière for

gilding. It is granted by Delorme that the works belonging to the Court of Portugal first seized . . . from Mr. Germain, silversmith to the king, at the house of Mr. Gouthière, gilder, will be moved from the latter and brought to the house or workshop of Mr. Germain with the understanding that the value of the works will be the same as if they had not been brought to the gilder. Mr. Germain and his partners consent to transport to Mr. Gouthiere those works belonging to the Court of Portugal that still require gilding.[12]

L.P.

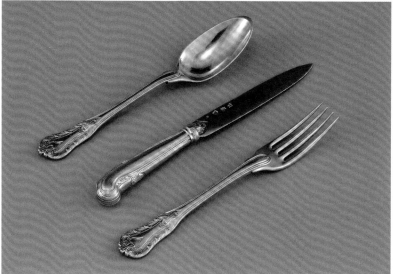

Toilette Set

Silver by François-Thomas Germain,
1764–65
Silver gilt by Pierre Gouthière, 1767
Mirror: 27⅛ × 16½ in. (69 × 42 cm); ewer: H.
10⅛ in. (25.8 cm); basin: 3⅛ × 12¾ × 8⅜ in.
(7.9 × 32.3 × 21.4 cm); candlesticks: each 8⅜
× 7⅛ in. (21.2 × 18 cm); foot bath: H. 2⅛ in.
(5.5 cm), Diam. 3 in. (7.7 cm); hairbrushes:
each H. 3¾ in. (9.6 cm); clothes brushes:
each 7¾ × 3 in. (19.7 × 7.7 cm); large
rectangular boxes: each 3⅞ × 9⅛ × 6¼ in.
(9.8 × 23.2 × 15.8 cm); powder boxes: each
H. 3½ in. (8.8 cm), Diam. 5⅛ in. (13.1 cm);
beakers with lids: each H. 4⅛ in. (10.6 cm);
salvers: each 1⅜ × 8¼ × 6⅛ in. (3.6 × 21 ×
15.4 cm); glove box: 2½ × 5⅛ × 2⅞ in. (6.3
× 13.1 × 7.2 cm); bell: H. 5⅜ in. (13.7 cm);
funnel: H. 2 in. (5.1 cm); spittoon: H. 3⅝ in.
(9.1 cm), Diam. 7⅛ in. (18 cm)
Museu Nacional de Arte Antiga, Lisbon
(MNAA 1751 Our; MNAA 1759–60 Our;
MNAA 1762–65 Our; MNAA 1768–83 Our)

Provenance:
Commissioned by Joseph I for the
Portuguese royal court, 1756; Palácio das
Necessidades; Museu Nacional de Arte
Antiga, Lisbon.

Literature:
Bapst 1886, 513–14; Bapst 1887, 132–33, 140–
41, 169–70, 214; Bapst 1892, 16–17, 22–24,
32; Foz 1926, 31–32, 61–63; Cunha Saraiva
1934, 23–26, 30, 78, 80, 83, 94, 98; *Triomphe
du baroque* 1991, 110; Levenson 1993, 172;
Perrin 1993, 25, 113–14, 140–200.

Throughout the eighteenth century, the Portuguese royal family commissioned silver sets from French silversmiths,[13] among them, two silver-gilt toilette sets from Thomas Germain. Delivered in 1726, the first toilette set was accompanied by a detailed description of the contents of the "court toilette boxes," including the names (in both Portuguese and French) of each of the pieces, explanations of their use, and instructions on where they could be found in the magnificent boxes in which they were packed. Contemporary documents, showing a preference for maintaining the French names, reflect the rigorous customs and rituals of the French court and the prevailing desire to emulate them.

With the destruction of most of the property of the Portuguese court in Lisbon's devastating earthquake of November 1, 1755, new toilette sets were ordered from Thomas Germain's son, the French silversmith François-Thomas Germain, from whom a large dinner service had been commissioned in 1756 (cat. 1). Ten years later, in 1766, this commission—

described as including a mirror topped by "Love on the verge of crowning Beauty"—was advertised as follows in the *Avant-Coureur*:

The work of this toilette set is, in general, unified and relatively simple but with all the grace and merit of those qualities. One thing we should mention is the extreme realism of the gilding. It can be compared with gold itself, something that could not be said of the gilding from Germany. We cannot be more grateful to M. Germain for having renewed and perfected this technique too neglected in France and crucial to revive.[14]

In the same year, a vermeil *toilette de campagne* (toilette set for the country) made for the princess of Portugal was said to be on view in Germain's workshop for all to admire.[15] Another twelve years would elapse before the first of the pieces of this toilette set reached Lisbon. Arriving around 1778, they were itemized as follows: "a large vermeil mirror, frame and plaque. One is said to be a hand mirror, two small

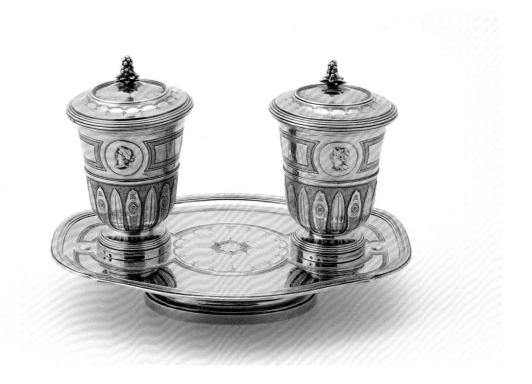

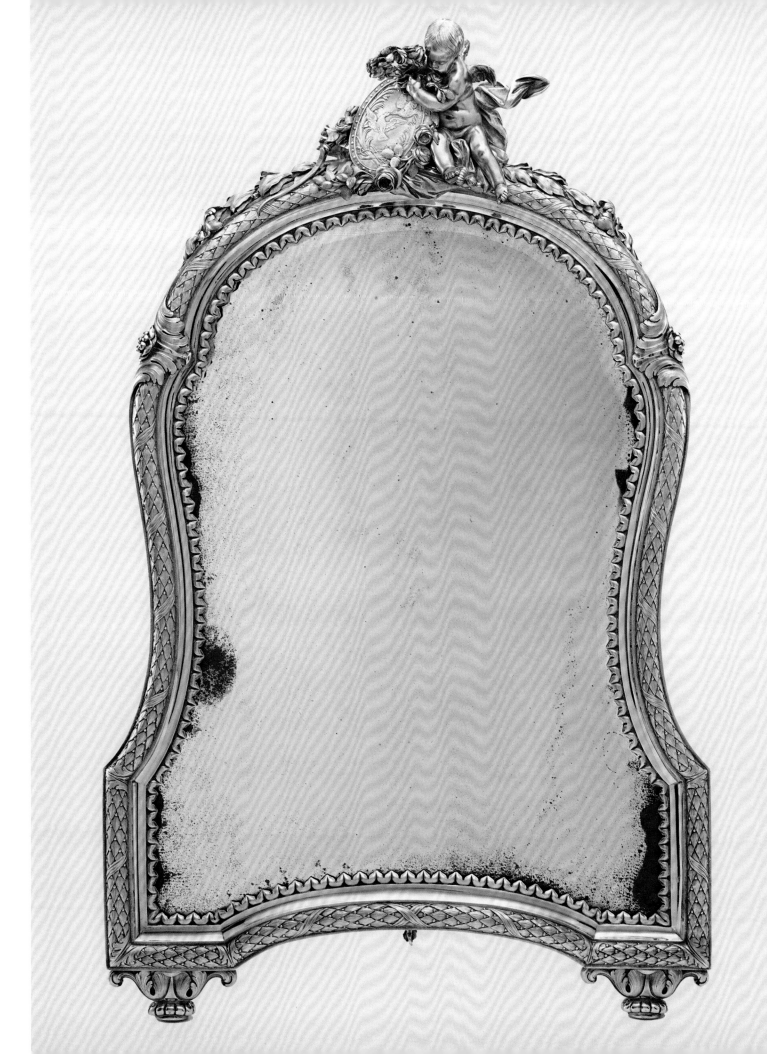

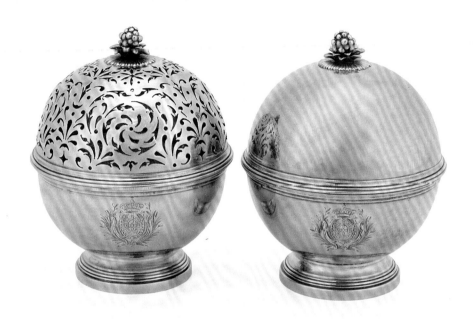

square boxes, two powder boxes, two patch boxes (*boîtes à mouches*), a root box, two clothes brushes, a saucer, two covered beakers and their cases, two hairbrushes, a spittoon, a small bell, a basin, and a ewer for water, a glove box, two candlesticks, and two girandoles with two branches, a sponge box."[16] Germain had engraved his signature on one of the small square boxes (the one marked with the date of 1765) and on the frame of the largest mirror (dated 1766).[17] The extraordinarily long period of time between the placement of the order and its delivery—no doubt due in large part to bankruptcy proceedings Germain was embroiled in—and the attendant changes in taste that had occurred in the interim help explain the Portuguese ambassador's disappointment with the pieces, which he described as "ordinary."[18] On the other hand, Pierre-Louis Régnard, one of the silversmiths involved in the partnership, is said to have considered them to be "d'une belle forme" (of beautiful shape).[19] The set's large mirror recalls the rocaille style of Germain's Portuguese dinner service

but contrasts with the other pieces, which have purer, more classical lines and are decorated with medallions, a motif that was fashionable at the beginning of the century and highly popular by the second half of the 1770s.

Bankruptcy proceedings had been filed against Germain in 1765, and related documents list the other artists and workshops involved in the manufacturing process, specifically in the gilding of the pieces. At the time of the filing, the following objects of the toilette set were documented at the home of Gouthière (though whether or not they had already been gilded remains unknown): the square boxes, the basin, the ewer, the powder boxes and the patch boxes, the root box, the clothes brushes, the covered beakers, the glove box, the saucers, and the spittoon.[20] These pieces had been sent to Gouthiere for gilding, following the same procedure as the dessert dishes and cutlery of the large dinner service also made by Germain. Hence it was Gouthière's work that was described in the *Avant-Coureur* in 1766, and credit should proba-

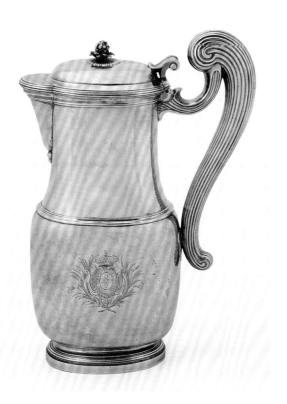

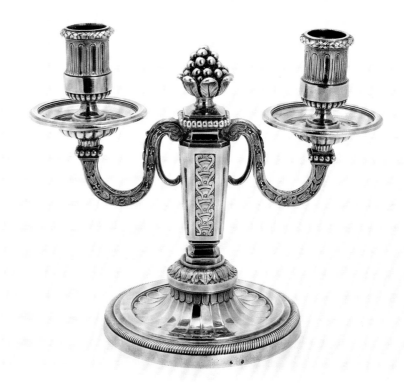

bly be given to him, rather than Germain, for "having renewed and perfected this technique [gilding] too neglected in France and crucial to revive."[21]

In the accounting records for these works, dated 1757 to 1765, signed by Germain himself, and sent to Louis Beaumont on June 17, 1765,[22] there are payments recorded of 4,446 *reais* for the gilding of the silver pieces, 8,500 *reais* for the making of all the vermeil pieces, 36 *reais* for the glass and the large mirror, and, among others, a reference to the amount of 4,000 *reais* for the bronze-maker and gilder in ormolu for a case and a *nécessaire* (toilette set). These payments cannot be attributed conclusively, but it is possible that this latter piece, the whereabouts of which are unknown, may also have been the work of Gouthière.

L.P.

3

Vase and Two Incense Burners

Faux porphyry carved by Jean-François
Hermand
Gilt bronze by Pierre Gouthière
1764
Stucco imitating porphyry and gilt bronze
Vase: 17½ × 8¼ × 7¾ in. (44.6 × 21 × 19.6 cm)
Incense burners: 8⅛ × 10¼ × 9¼ in. (20.6 ×
26 × 23.5 cm); 7⅞ × 10⅛ × 9⅛ in. (20.1 × 25.6
× 23.1 cm)
Royal Castle, Warsaw (ZKW/2036,
ZKW/2037/1-2)

Provenance:
Purchased by Casimir Czempinski for
Stanislas-August Poniatowski, later King of
Poland, before August 10, 1764; remained
at the Royal Castle in Warsaw after the
partition of Poland in 1795 and during
the nineteenth century when the castle
became the Russian tsar's palace; taken to
St. Petersburg, 1915; returned to Warsaw,
1922; moved to the National Museum in
Warsaw after the bombing of the Royal
Castle, 1939; taken by the Germans during
World War II; claimed by the National
Museum in Warsaw, 1946; 1960-71, the
incense burners, and 1968-71, the vase,
were displayed at the Łazienki Palace in
Warsaw; since 1984, at the reconstructed
Royal Castle in Warsaw (New Audience
Chamber).

Literature:
Iskierski 1929, 27; Pariset 1962, 152-53;
Eriksen 1974, 363; Baulez 1986, 563-64;
Przewoźna 1986, 549; Perrin 1993, 236-38;
Priore 1996, 34-35; Ładyka and Saratowicz
1997, 27-32.

In July 1764, several months before he became king of Poland on November 25, Stanislas-August Poniatowski, a connoisseur and aficionado of the fine arts, sent his agent, the merchant Casimir Czempinski, to Paris to expedite purchases for the Royal Castle in Warsaw and establish contact with Parisian artists.[23] Charged with acquiring items in the *goût grec*, Czempinski stated, "For all the acquisitions that I have made, I gave preference to the severe Greek over the beautiful style from antiquity."[24]

Czempinski selected three vases in this new style from the workshop of François-Thomas Germain. Made of a stucco imitating porphyry and mounted in gilt bronze, the vases were sent to Warsaw,[25] where they were accepted by the king.[26] Although the slender, ovoid vase and two low-sided incense burners were probably purchased as a set, they have different ornamentation.[27] The handles of the vase are in the shape of a Greek key, whereas those of the incense burners are scrolled; the base of the vase is decorated with delicate laurel wreaths, whereas the bases of the incense burners have flat meanders; and lastly, the body of the vase is decorated with a mask of Apollo and swags of drapery, and the incense burners have laurel wreaths tied with ribbons. Moreover, the beige-gray hue of the vase and one of the incense burners differs from the reddish tone of the other incense burner.[28] It may be these differences that caused the set to be split—the inventory of 1769 records a vase in the furniture storage and two incense burners in the king's study.[29] The 1795 inventory describes them as a set of fireplace vases but records them all as being in storage.[30] In the nineteenth century, the incense burners were on display in various rooms, and the vase is again recorded as being in storage.[31] The pieces were probably not displayed as a complete set until after World War I.[32]

Based on references in a letter to the king from the stucco worker Jean-François Hermand,[33] who made the bodies of the vases, they were ascribed to François-Thomas Germain,[34] but the gilt-bronze mounts were made by Gouthière,[35] as confirmed in a letter to the king from Gouthière and the silversmith Jean Rameau: "Having had the honor of working for Your Majesty, they have been fortunate enough for their works to have been appreciated by

Yourself, and they dare to assert that Germain, who appeared to be their author, was absolutely incapable of making them, or indeed of bringing them to perfection."[36]

The finely crafted chasing and meticulously executed gilding are indisputably the work of Gouthière, but the designer of the vases is not known. Svend Eriksen suggested that the vase on the title page of Joseph-Marie Vien's *Suite de vases composée dans le goût de l'Antique* of 1760 might have been the inspiration for the design of the incense burners (fig. 89).[37] According to Christiane Perrin, silver and bronze pieces with anthropomorphic motifs—masks of Apollo, Midas, and female figures—made in Germain's workshop in the years 1764-66 demonstrate the silversmith's "originality in interpreting neoclassicism,"[38] whereas Alicia Priore considers François Boucher to be the designer of a set of vases today in the Neues Palais in Potsdam (fig. 91)—bearing strong resemblance to the Warsaw vases.[39] Boucher's designs may have been the inspiration for the vases, but there is no evidence of the artist's direct involvement, and the rather "architectural" design of these vases seems closer to the vase designs of Vien or Jean-François de Neufforge, another designer working in the severe Greek style. All that can be said with certainty is that the designs and models were commissioned by Germain—indeed, in 1766, he put similar items up for sale that he described as having made himself[40]—and in 1767, similar vases are recorded among the items belonging to him in Gouthière's workshop.[41]

Poniatowski's collection of drawings includes three unsigned designs for gueridons (small tables),[42] one of which is decorated with a mask of Apollo, much like the one ornamenting the body of the vase from this set (fig. 90). Natalia Ładyka and I related the drawings of the gueridons to a fragment of a letter from Czempinski dated February 22, 1765: "the designs from the hand of Mr. Germain of the Gueridons received the approbation of Your Majesty."[43] The drawings were therefore probably sent by Germain in 1764 to show the versatility of his workshop with the hope of securing a commission from the king. In fact, the design for the reconstruction of the Royal Castle was commissioned from the French architect Victor

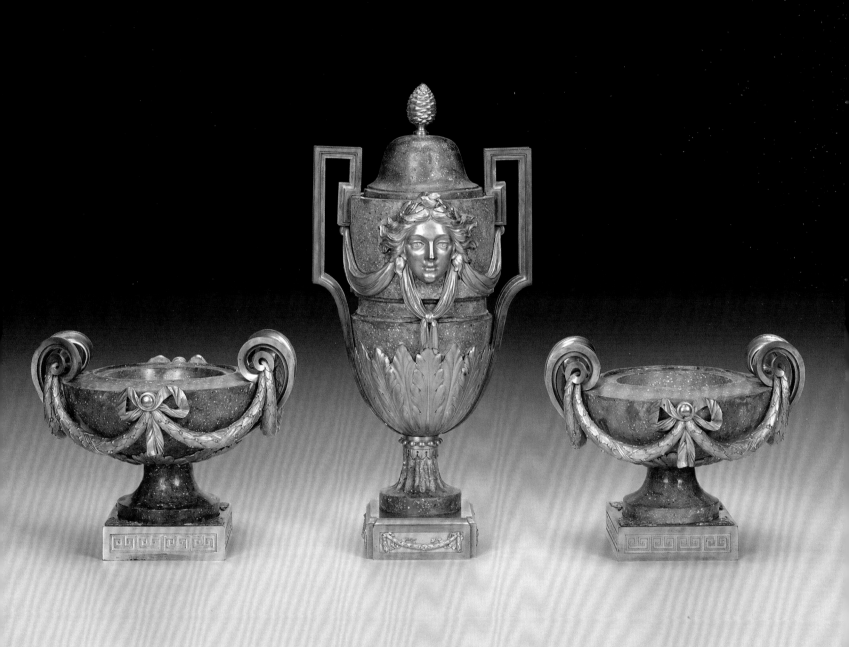

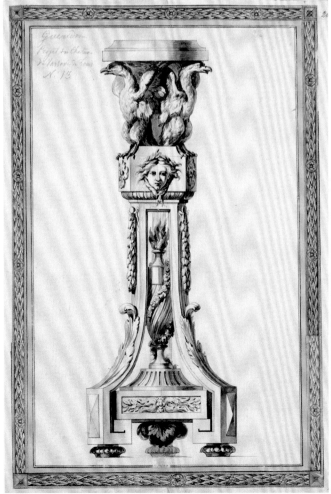

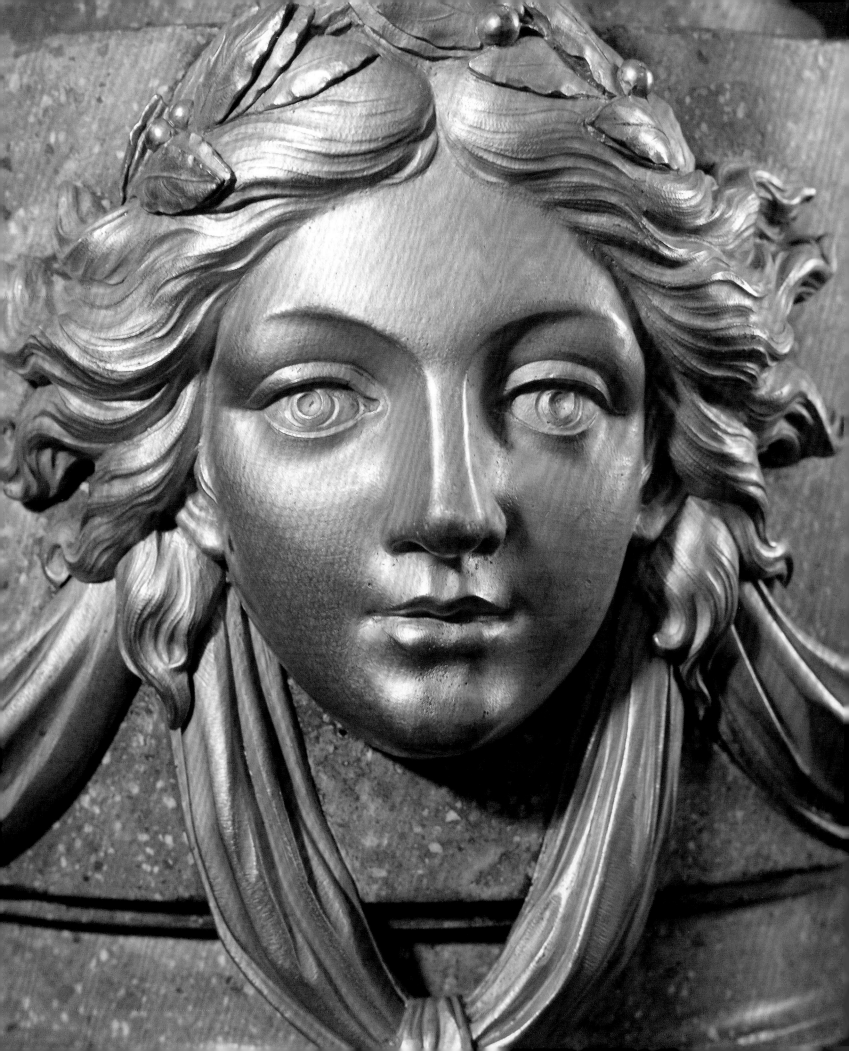

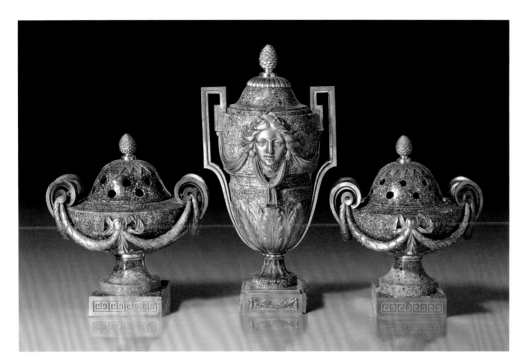

Fig. 91
Vase and Two Incense Burners, ca.
1765. Stucco imitating porphyry or
granite, gilt bronze. Neues Palais,
Potsdam (3651-3643)

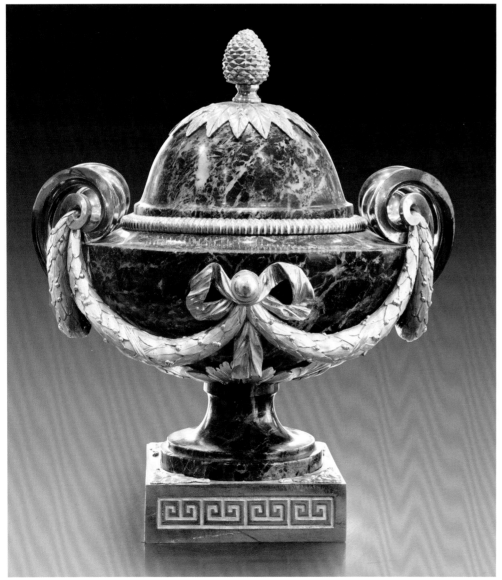

Fig. 92
Incense Burner, ca. 1765.
Verde antico marble and
gilt bronze, 11 × 10¼ × 9 in.
(28 × 26 × 23 cm). Private
collection

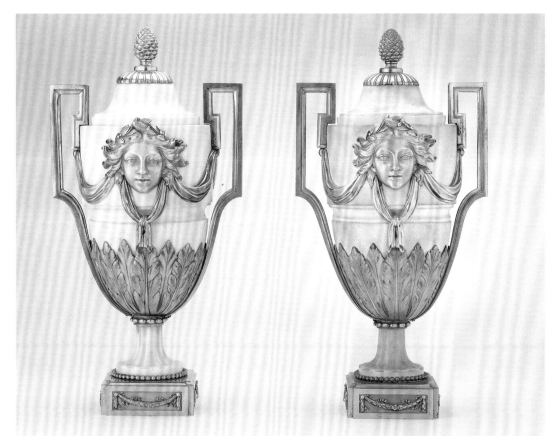

Fig. 93
Pair of Vases, ca. 1765. White
Carrara marble and gilt
bronze, h. 17½ in. (44.5 cm).
Ashmolean Museum, Oxford;
gift of C. D. E. Fortnum
(WA1899.CDEF.B1128-B129)

Louis (1731–1800), who had likely collaborated earlier with Germain[44] and had been introduced by him to Czempinski.[45] Among the wide-ranging designs from 1765–66 connected with this reconstruction project are not only a repertoire of forms and motifs related to the drawings for the gueridons but also direct references to them.[46] Thus Louis may be the only individual we can associate with the designs dating from the period of the rebuilding of the castle, as well as those for the gueridons and should perhaps be considered the designer of this vase and pair of incense burners.[47]

A.S-D.

In November 1767, Gouthière stored in his workshop around twenty vases and some ten incense burners in hardstone or imitation stone that he had chased and gilded for François-Thomas Germain. Some of these resemble the vase and incense burners bought in Germain's workshop in 1764 by Casimir Czempinski for his prestigious patron, the king of Poland (cat. 3).[48] Three vases and three incense burners are clearly linked to the ones mentioned in Gouthière's workshop in 1767 and to those now in Warsaw: a set comprising a vase and two incense burners in faux granite (or faux porphyry) today at the Neues Palais in Potsdam[49] (fig. 91), two vases in white marble at the Ashmolean Museum in Oxford[50] (fig. 93), and an incense burner in *verde antico* marble belonging to a private collector (fig. 92). From a detailed examination of these objects, it seems that they were all made in the eighteenth century from the same mold, but differences in the quality of their chasing and gilding make it difficult to attribute them to Gouthière with certainty, all the more so since there are no archival documents that link these objects to him.

C.V.

4

Pair of Ewers

Pierre Gouthière
1767
Gilded and patinated bronze
11¼ × 4½ in. (28.6 × 11.4 cm)
Inscription on the base of the ewer with
a handle in the form of a siren: *FAIT PAR
GOUTHIERE CISELEUR DOREUR / DU
ROY QUAY PELLETIER 1767* (Made by
Gouthiere Chaser Gilder / to the King
Quay Pelletier 1767)
Frick Art and Historical Center, Pittsburgh
(1988.143.1-2)

Provenance:
Lord Hastings; John Pierpont Morgan;
Duveen Brothers; purchased by Henry Clay
Frick (1849-1919), 1916; inherited by Helen
Clay Frick (1888-1984); donated to the
Frick Art and Historical Center, Pittsburgh,
1988.

Literature:
Verlet 1987, 205, no. 235.

These ewers are similar to those in the drawing Gouthière may have given to Jacques Rondot, an engraver at the Mint of Troyes and one of the four founders of the École Royale de Dessin de Troyes, a free design school that opened in Troyes on November 2, 1779.[51] Three designs were exhibited at the school's salon on September 30, 1784: "No. 15—an altar in relief carrying a vase by Gouthière, gilder and chaser to the King. Nos. 16 and 17—two vases by the same."[52]

Natalis Rondot, Jacques Rondot's great-grandson, still owned six drawings in the nineteenth century, notably two signed *Gouthière, siseleur, doreur du roy* (Gouthière, chaser, gilder to the king), which represented marble ewers, the handles of which were formed by a faun in one case and a siren in the other (figs. 94, 95).[53] Two other drawings for vases carried Gouthière's name added by an unknown hand, while another was signed *Le Barbier delineavit 1766* with the (possibly modern) handwritten *exécuté par Gouthière*.[54] These designs, which Gouthière would have given to Rondot in the 1780s,[55] were not necessarily all from the same period—that is, 1766, as indicated on the design by Jean-Jacques-François Le Barbier. However, the two drawings signed *Gouthière, siseleur, doreur du roy* probably were since the date 1767 is engraved on the base of one of these two ewers, which is represented in one of the designs. The companion to this ewer has a handle in the form of a faun, as shown on the other drawing. Thus one ewer symbolizes water or springtime with a siren as a handle and ornamentation in the form of acanthus garlands and a dolphin's head; and the other represents wine, earth, or fall, with its decoration comprising a satyr, a ram's head, and a garland of vines.

Gouthière had been a master chaser-gilder for nearly ten years, when, on November 7, 1767, he received from the Duke of Aumont the title of *doreur seul ordinaire des Menus-Plaisirs*, "on the basis of testimony we possess as to the intelligence, ability and integrity of Mr. Gouthière, merchant gilder in Paris."[56] Over the next two months, Gouthière completed these two ewers in gilt bronze, engraving his new title in capital letters on the rectangular base of the siren-handled ewer. Bronze-makers rarely signed their works, but it was standard practice for goldsmiths and silversmiths to do so.

This model was a great success. Several examples are known in different materials: porphyry (cat. 5), white marble,[57] *verde antico*,[58] and boxwood root.[59] They are probably by Gouthière, but only an examination of their chasing and gilding and study of their provenance and history could confirm this. In the case of the Pittsburgh ewers, the authentic signature on one of them allows both pieces to be attributed to Gouthière, even though their chasing is rather coarse and their gilding quite simple. The rather average quality of these two pieces can be explained by their execution relatively early in the master's career, at a time when he was trying to develop a model he could adapt to various clients' tastes and budgets by altering the material of the vases and the finish of the gilt bronzes. This was a business technique he had learned from Germain.

These two ewers were probably not made for a king, a prince, a powerful financier, or for their wives and mistresses; this explains not only their quality but also the fact that their history is only known from the nineteenth century on. After they had been part of the collections of Lord Hastings and John Pierpont Morgan, the art dealer Joseph Duveen sold them to Henry Clay Frick in 1916 for what was then the relatively large sum of $25,000.[60] Frick placed them in the lounge of his summer residence, Eagle Rock, at Prides Crossing in Massachusetts. They were inherited by his daughter, Helen Clay Frick, who in 1970 founded the Frick Art and Historical Center in Pittsburgh in the family home of Clayton to display her growing collection.

C.V.

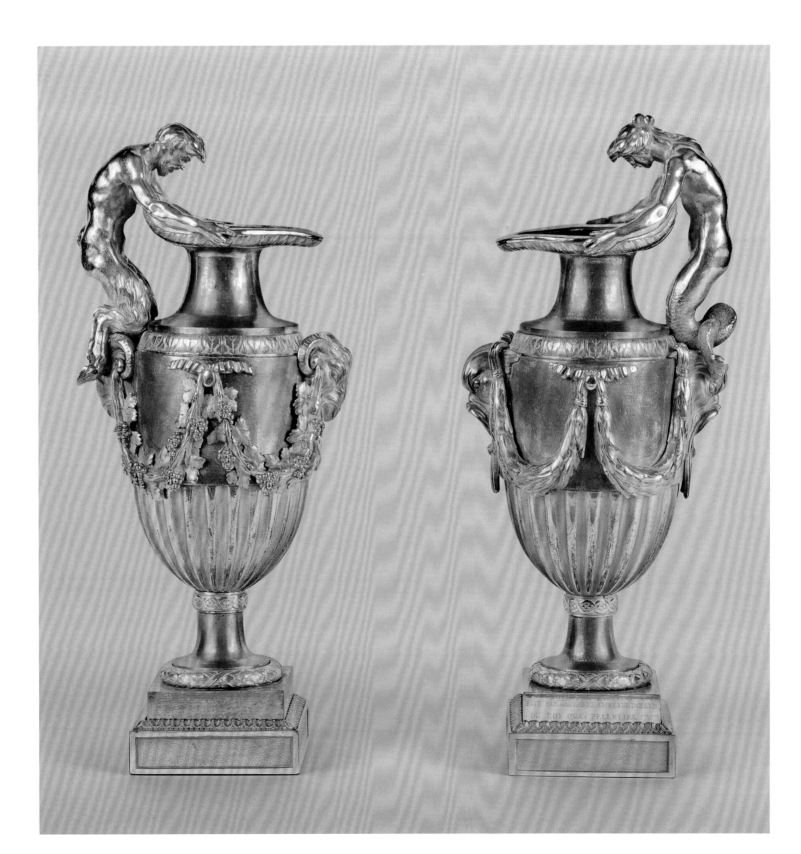

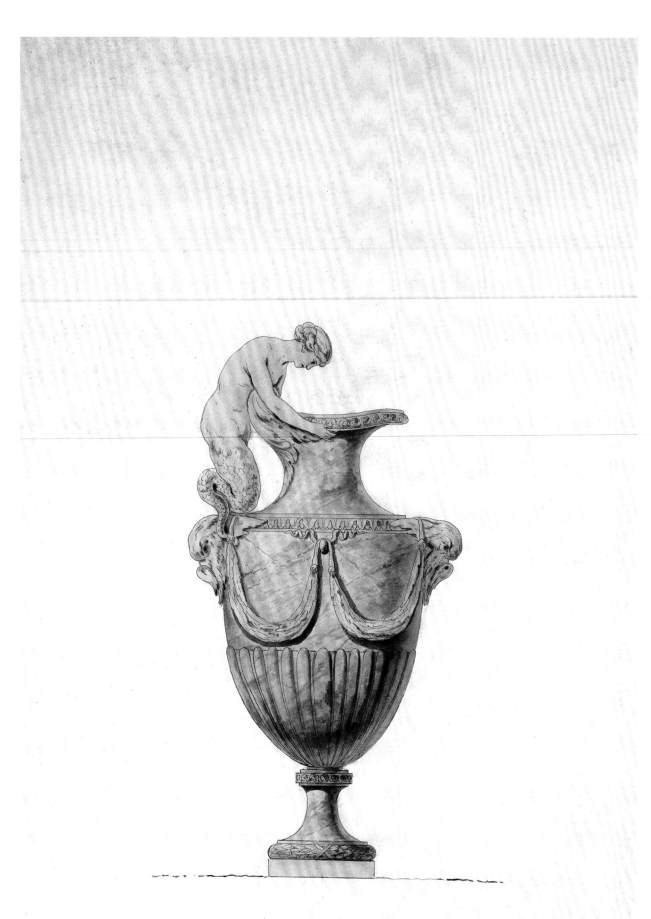

Fig. 94
Drawing representing a ewer with handles formed by a siren, signed *Gouthière, siseleur, doreur du roy*, ca. 1767. Pencil and ink with colored washes on paper. Private collection

Fig. 95
Drawing representing a
ewer with handles formed
by a faun, signed *Gouthière,
siseleur, doreur du roy*,
ca. 1767. Pencil and ink with
colored washes on paper.
Private collection

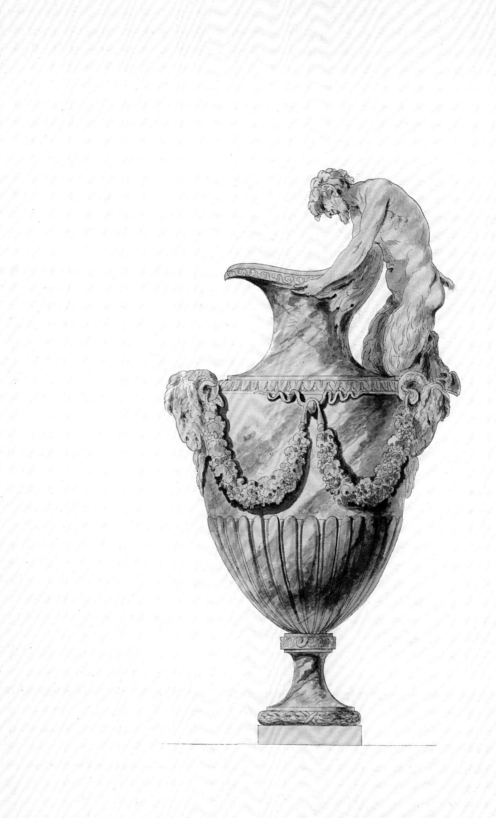

Pair of Ewers

Gilt bronze by Pierre Gouthière
Ca. 1767-70
Porphyry and gilt bronze
Each, 10½ × 4⅞ × 3⅞ in.
(27.7 × 12.4 × 9.8 cm)
Inscriptions in Cyrillic on the undersides
of the square bases; *N15* (painted in white)
and *896* (painted in red)
Private collection

Provenance:
Acquired in Paris by Tsar Paul I, 1799;
in the Russian imperial collections by
descent until 1932; then sold by the Soviet
government; sold at Sotheby Parke Bernet,
Monaco, October 5, 1980, lot 444; acquired
by Galerie J. Kugel, Paris; acquired by
Barbara Piasecka Johnson, New York; sold
at Christie's, New York, October 26, 1994,
lot 142; sold at Christie's, Paris, December
19, 2007, lot 802; private collection.

Literature:
Benois 1902, 166; Zek 1994, 152 and 164.

These ewers were purchased in Paris by Tsar Paul 1 for St. Michael's castle in St. Petersburg. When they were delivered, on October 8, 1799, they were accompanied by a small pot-pourri vase in porphyry decorated with two female figures similar to Madame Geoffrin's "petit monument antique" (cat. 6).[61] The set was displayed in the tsar's bedroom, where they witnessed his assassination on March 23, 1801. They were kept at the Imperial Hermitage until October 6, 1823, when Tsar Alexander I had them transferred to the Peterhof Palace outside the city, known as the Russian Versailles.[62] They were still there in 1902, when they were published in *Les Trésors d'art en Russie* (The Art Treasures in Russia).[63] They left the Peterhof Palace thirty years later, in 1932, to be sold by the new Soviet government. They were attributed to Gouthière throughout this period, as can be seen in an inventory drawn up under the Soviet regime.[64] Their peregrinations thereafter are unknown until their appearance at Christie's, New York, in 1994. They were probably sold in the 1930s by the Antikvaria, an organization led by Nikolas Iljin (or Il'in) that was responsible for finding foreign buyers—important art dealers and wealthy collectors—for the treasures amassed over the centuries by the Russian tsars.

These two ewers resemble a design and a model in gilt bronze, which carries Gouthière's signature (cat. 4), but this, along with their attribution to Gouthière in the nineteenth-century Russian inventories, is not sufficient for confirmation. The most convincing evidence is provided by the gilt bronzes: as on many of Gouthière's pieces, the veins of the leaves are chased and raised in a naturalistic way, and the human and animal figures are highly expressive, with the textures of the bodies and faces obtained by extremely fine stippling. Also noteworthy is the matte gilding of most of the bronzes, with the exception of details such as the dolphins' eyes, the bows of ribbon, and the draperies, which are burnished. Many of these features occur regularly in Gouthière's work.

C.V.

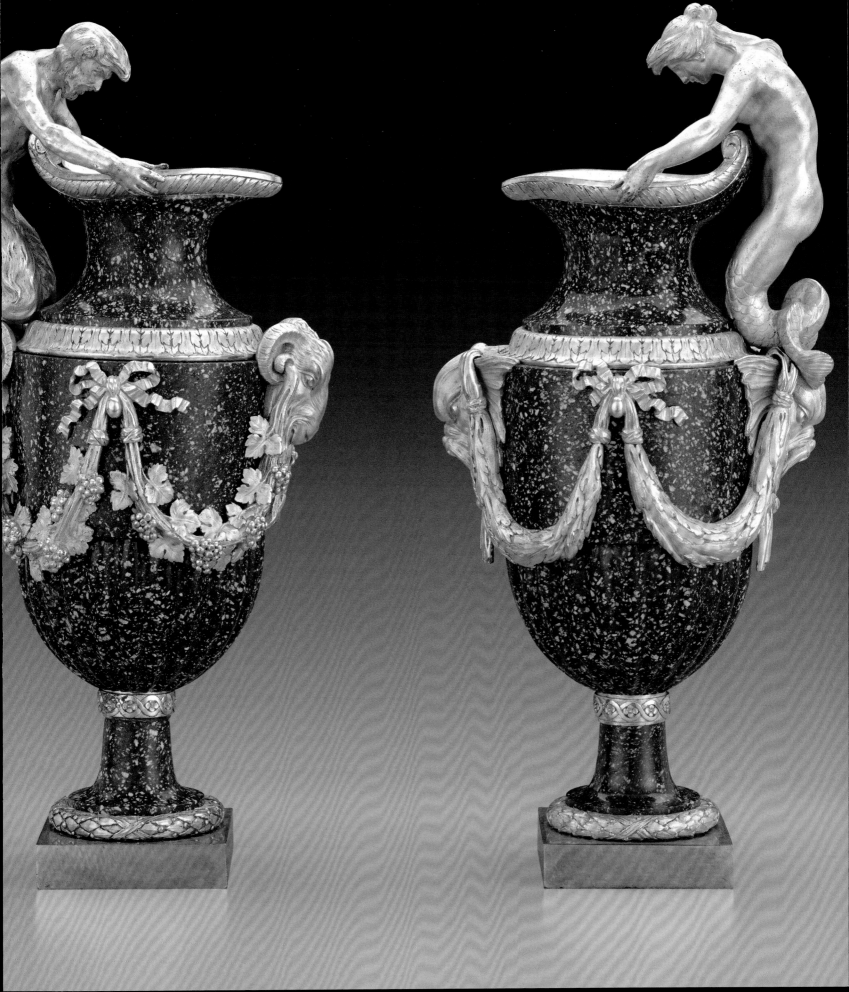

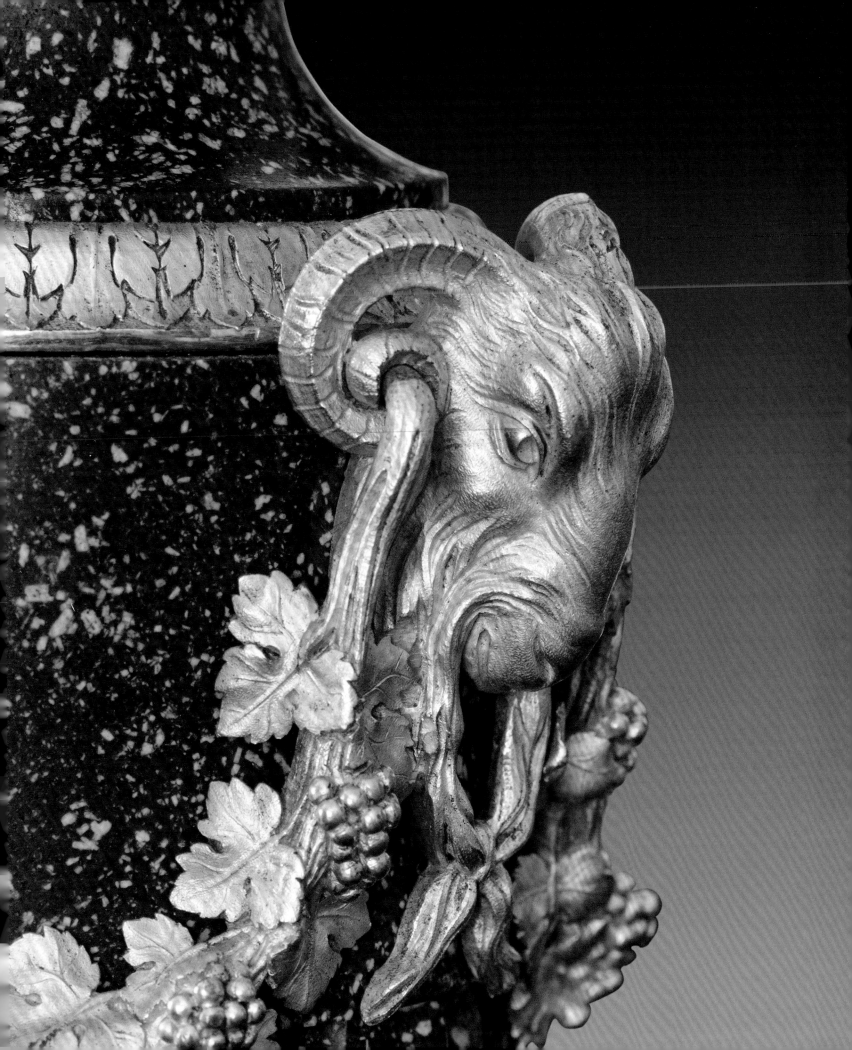

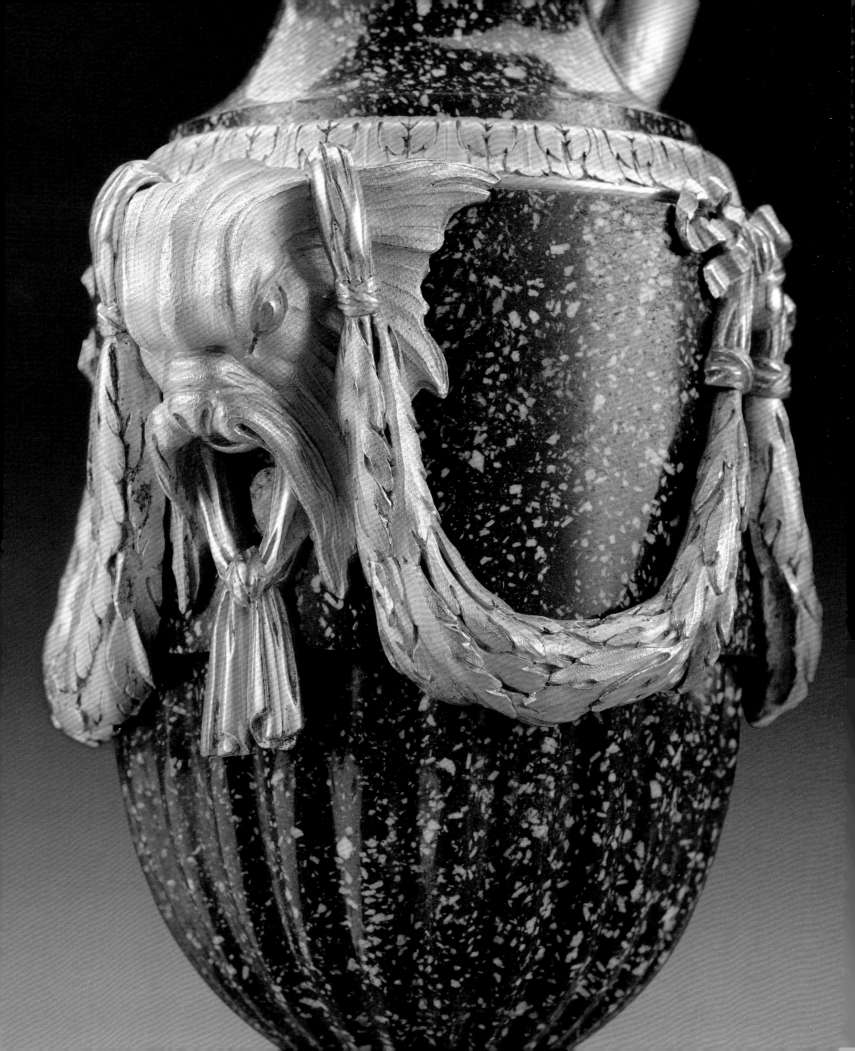

6

Small Pot-Pourri Vase

Gilt bronze by Pierre Gouthière
Ca. 1770
Ivory, white marble, and gilt bronze
11¾ × 7⅛ in. (29 × 18 cm)
Inscription: *40322/3* (engraved under the cover)
Private collection

Provenance:
Marie-Thérèse Rodet Geoffrin, known as Mme Geoffrin, until her death in 1777; by descent.

Literature:
Boucher 1927; *Grands salons littéraires* 1927, no. 154; Baulez 1986, 564.

The illustrious Marie-Thérèse Rodet Geoffrin was a client of Gouthière's, as is shown by this statement from one of her notebooks: "Price of various items that I want to remember: a small antique monument in ivory, marble, and gilt bronze made by Gouthière, 600 *livres*."[65] Unfortunately, the note is not dated, and, in the absence of an invoice from Gouthière, it is difficult to know when Geoffrin ordered this little altar. It remained in the family and was mentioned in 1832 in the inventory of the Marquise of Estampes's property made after her death. It was then in the living room of the former *hôtel particulier* of this popular hostess on Rue Saint-Honoré.[66] From 1749 until her death in 1777, Geoffrin held a renowned literary salon there, which earned her the epithet of "queen of the Rue Saint-Honoré." Twice a month, on Mondays, she received artists, intellectuals, literary figures, and philosophers; Diderot, Voltaire, and d'Alembert were regulars there. As a wealthy and cultivated bourgeois woman, Geoffrin had her home furnished and decorated tastefully and with distinction, as is suggested by a portrait painted after her death (fig. 96).[67]

This altar can be compared to a drawing (number 15) exhibited at the salon of the École Royale de Dessin in Troyes on September 30, 1784, and described in the booklet as "an altar in relief, carrying a vase, by Gouthierre, gilder, chaser to the King."[68] While the drawing then belonged to Jacques Rondot, who would have received it directly from Gouthière, by 1865 it was no longer in the family.[69] Its current location is not known.

This altar had also been compared to three red-chalk drawings preserved at the Musée du Louvre: two by Edmé Bouchardon and a third recently attributed to Jean-Francois Guyard (1723-1788).[70] However, the source of inspiration for Gouthière was probably an engraving by Gabriel Huquier after one of the two drawings by Bouchardon. The frequently repeated theme of Graces circling a column is inspired by the ancient Roman fountain in the Borghese collection,[71] also a source for biscuit socles made by the Sèvres porcelain manufactory.[72]

Other examples of the "small antique monument" were made in different materials; however, none of them are attributed to Gouthière in documents from the period, notably the catalogues for the auctions at which they were sold. One example in ivory similar to the one belonging to Geoffrin was described in the Radix de Sainte-Foy sale in 1782,[73] while another, in white marble, was sold in the dispersal of François-Michel Harenc de Presle's collections in 1795.[74] The richest and largest of all was in black and white granite with steps in green granite and a large vase of red porphyry from Alsace embellished with four satyr heads. It was purchased in April 1783 for 1,881 *livres* by Louis-Guillaume Baillet, Baron of Saint-Julien, at the Jean-Louis Lebeuf sale.[75] It reappeared at the first Saint-Julien sale, in June 1784, where it was specified that the model for it was by the sculptor Jean-Baptiste Feuillet; unsold there, it then went through the second Saint-Julien sale, in February 1785.[76] Feuillet had sold one that was similar to Lebeuf's and Saint-Julien and described identically in the catalogue, although it may have been the same one that appeared in the sale he organized under the name Mr. Du Pereux in March 1784.[77]

Gouthière's little altar seems to have been designed to be flanked by a pair of vases, one of which had a faun and the other a siren handle (cats. 4, 5). A similar set, particularly precious since it was made of silver gilt, belonged to Mme Du Barry, who commissioned it from Gouthière in the early 1770s.[78] It was probably for the king's mistress that Gouthière had created the first example. Du Barry's set seems to have disappeared. It is, however, possible to imagine it thanks to the example in *verde antico* marble from the former Falize collection (fig. 97).[79] Ewers in porphyry (cat. 5) and in boxwood root (mentioned in the entry for cat. 4) also previously accompanied a small altar.[80]

C.B. and C.V.

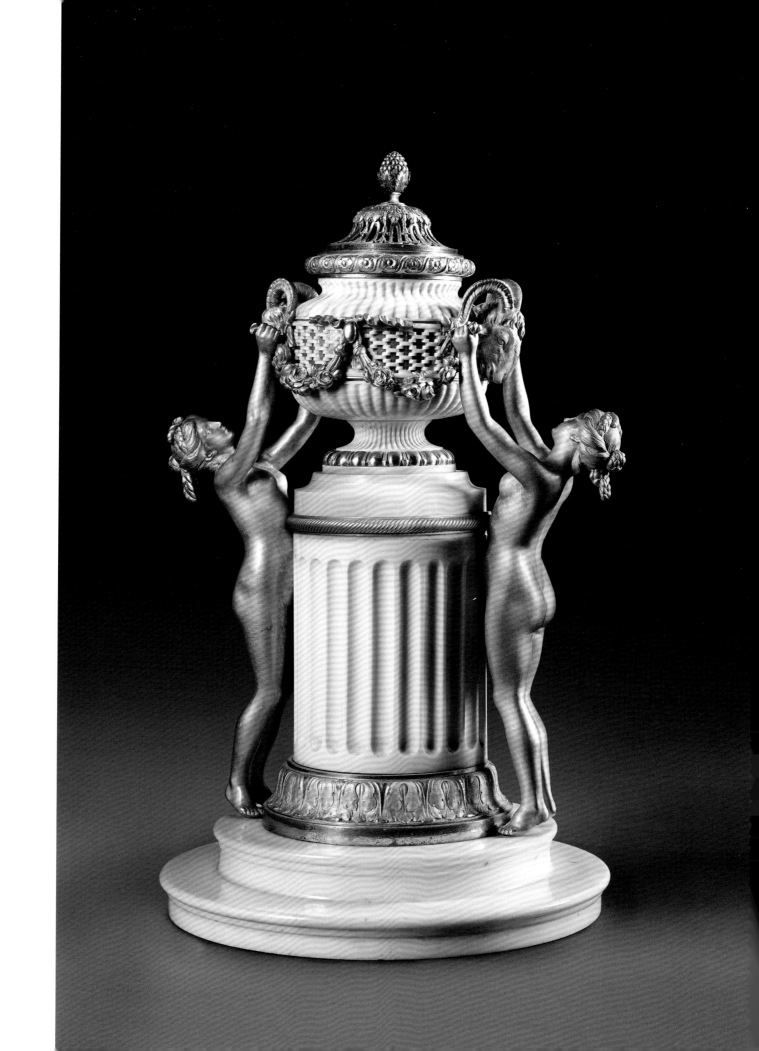

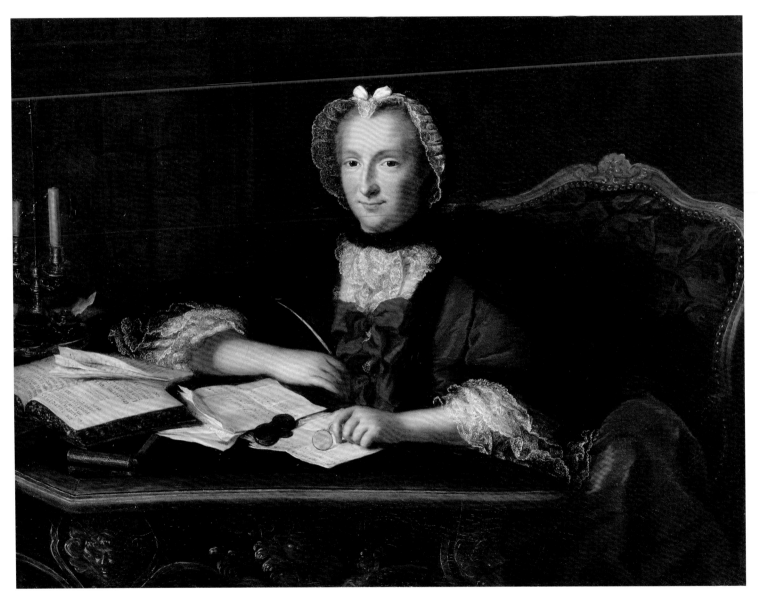

Fig. 96
Unknown French artist,
Madame Geoffrin, probably
after 1777. Oil on canvas,
34⅝ x 46½ in. (87.9 x 117.3 cm).
Private collection

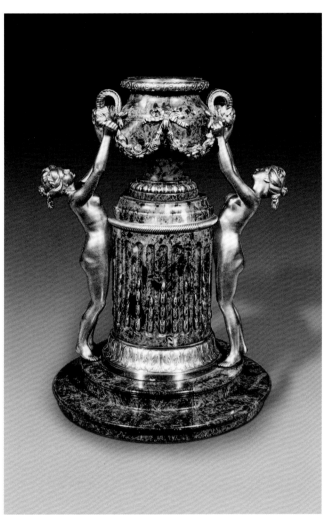

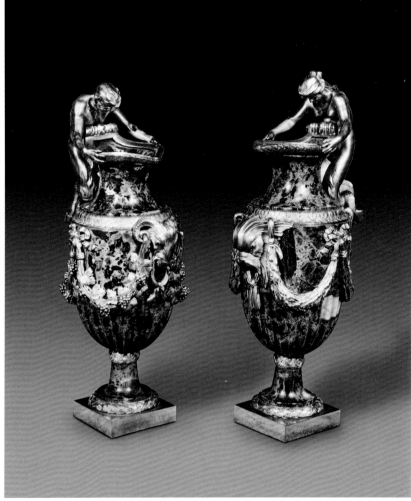

Fig. 97
Attributed to Pierre Gouthière,
Pot-Pourri Vase and Two Ewers, ca.
1770. *Verde antico* marble and gilt
bronze. Private collection

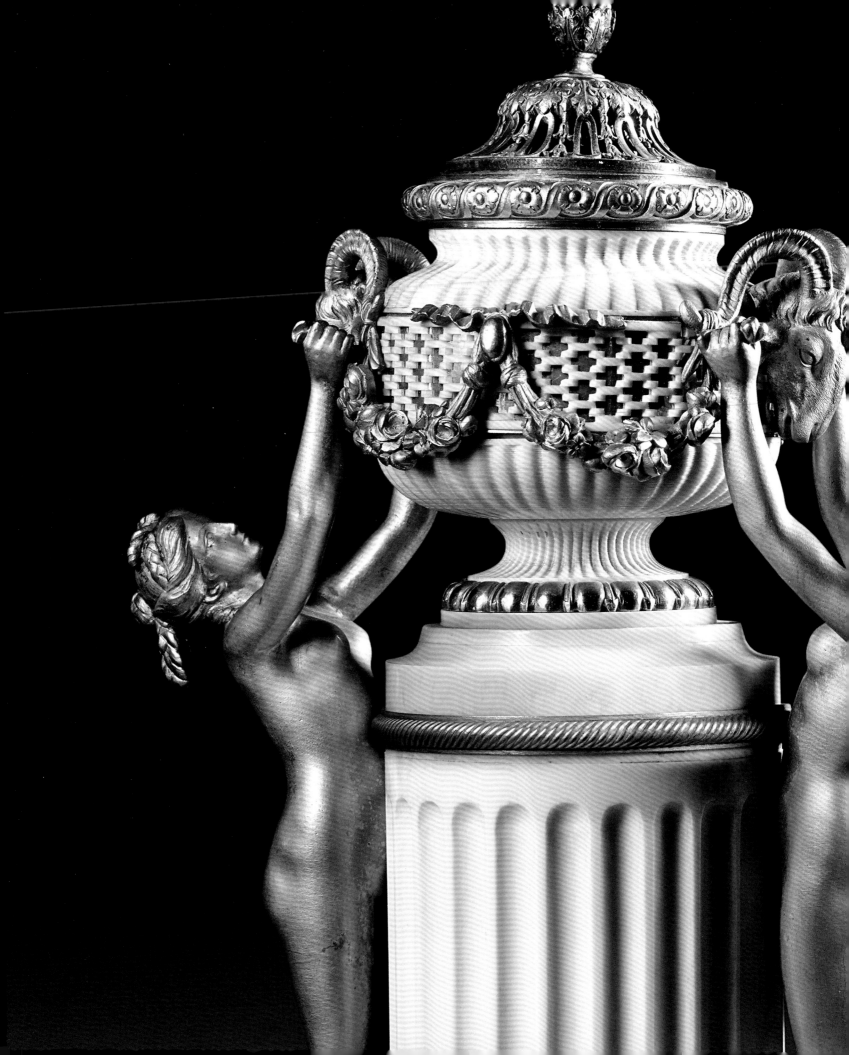

Two Pot-Pourri Vases

Chinese porcelain, eighteenth century
Gilt bronze by Pierre Gouthière, ca. 1770-75
Chinese porcelain and gilt bronze
Each, 11 × 12⅝ × 7½ in. (28 × 32 × 19 cm)
Musée du Louvre; transfer from the
Mobilier National, 1901 (OA 5182)

Provenance:
Seized from the home of the late Jean-
Baptiste-Charles-François, Marquis of
Clermont d'Amboise, and sent to the
Muséum du Louvre, 1794; in the study of
the Duke of Orléans's apartment at the
Palais des Tuileries, 1833; transferred from
the Mobilier National to the Musée du
Louvre, 1901.

Literature:
Williamson 1883a, 29, no. 228; Williamson
1897, 39, no. 228; *Exposition universelle*
1900, no. 2961, pl. 223; Furcy-Raynaud
1912, 276; Dreyfus 1913, 71, no. 389; Dreyfus
1922, 87, no. 432; Dreyfus 1923, vol. 2, 11,
pl. 27; Lunsingh Scheurleer 1980, fig. 289;
Verlet 1987, fig. 61; Kjellberg 2000, 114;
Alcouffe, Dion-Tenenbaum, and Mabille
2004, 216-17.

Gouthière's name appears in 1794 on the occasion of
the confiscation of these two vases from the estate of
the late Jean-Baptiste-Charles-François, Marquis of
Clermont d'Amboise.[81] He may have commissioned
them from Gouthière in the early 1770s before he left
for the court of Naples, where he was ambassador
from 1775 to 1784. The rarity of such a reference in an
eighteenth-century inventory—particularly one from
Gouthière's lifetime—makes it reasonable to take se-
riously the attribution, which has been confirmed by
meticulous examination.

The bearded male figure, probably a sea or riv-
er god, has a face similar to that of the river god on
the Avignon clock dated 1771 (cat. 19); both are very
expressive with deeply marked features, notably pro-
truding cheekbones and animated eyebrows. In the
case of these pot-pourri vases, the face has slightly
open lips that are fleshy and well defined. This could
reflect the influence of the sculptor Louis-Simon
Boizot, who supplied the model for Gouthière's
Avignon clock. Also noteworthy is the lively treat-
ment of the hair and beard, with thick curls molded
and chased with stippling, the recessed parts matte
gilded so as to enhance the visual effects on these
particularly visible sections of the gilt bronze.

The swans emerging from large shells are equal-
ly impressive in their expressiveness and naturalism,
achieved through a range of treatments of the bronze.
The feathers on the large birds' necks and breasts are
created by chased stippling of various sizes, along
small irregular grooves probably cast in the mold;
they contrast with the upper part of the shell, which
is a slightly bulging fan shape with alternating matte
and burnished ribs. The lower part displays an origi-
nal motif of small regular waves chased in little dash-
es and stippling.

From their beaks, these birds are clearly identi-
fiable as mute swans, a common species in Europe.
Their eyes express fury: about to attack, they unfold
their wings on either side of the porcelain pots. Their
mood is also indicated by their slightly open beaks,
which are edged with a burnished line.

Two more particularities are the frieze of gadroons
and pearls framing the porcelain lids, which are in a
different shade of gold than the swans and bearded
figures, and the openwork frieze that is simply carved
into a metal band and gilded, without being chased
or beveled (*dégraissé*), which may suggest a later
date of fabrication.

It is not known who supplied Gouthière with
the design that transforms two rare Chinese porce-
lain pieces from the first half of the eighteenth cen-
tury—turquoise-colored lidded bowls in the shape of
shells[82]—into extraordinary pot-pourri vases. Louis-
Simon Boizot was mentioned above on the basis of
similarities with certain elements of the Avignon
clock, as well as the frequency of the collaborations
between the sculptor and Gouthière (cats. 19, 28).
If Boizot was not the originator of the model, it was
probably another sculptor, given the sculptural ap-
pearance of these gilt bronzes.

C.V.

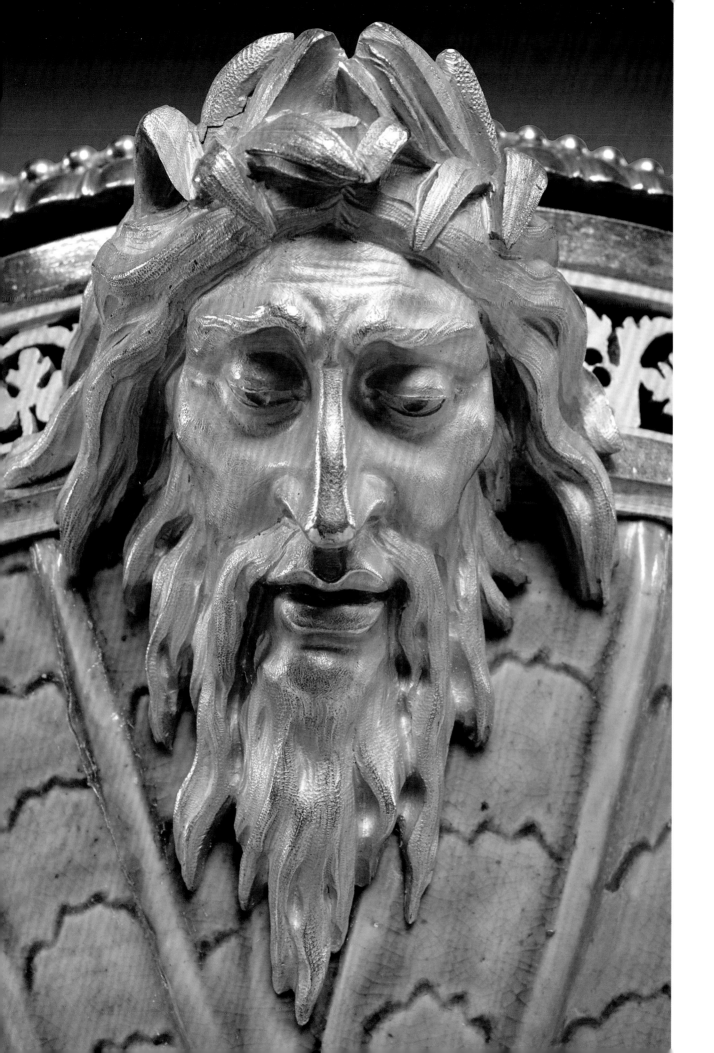

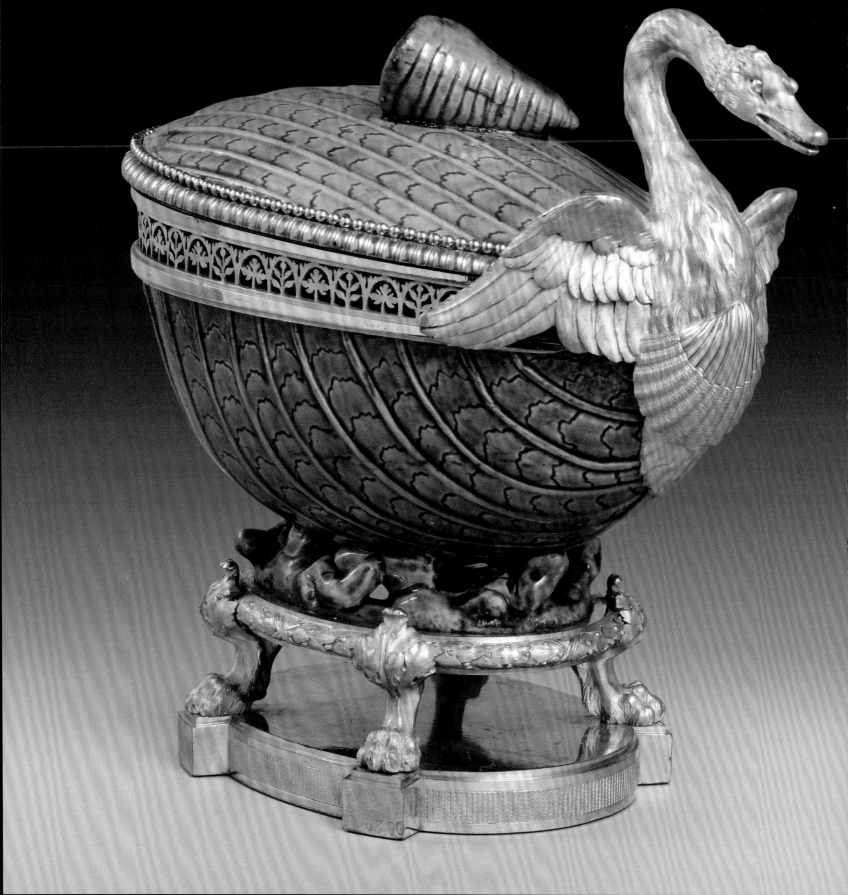

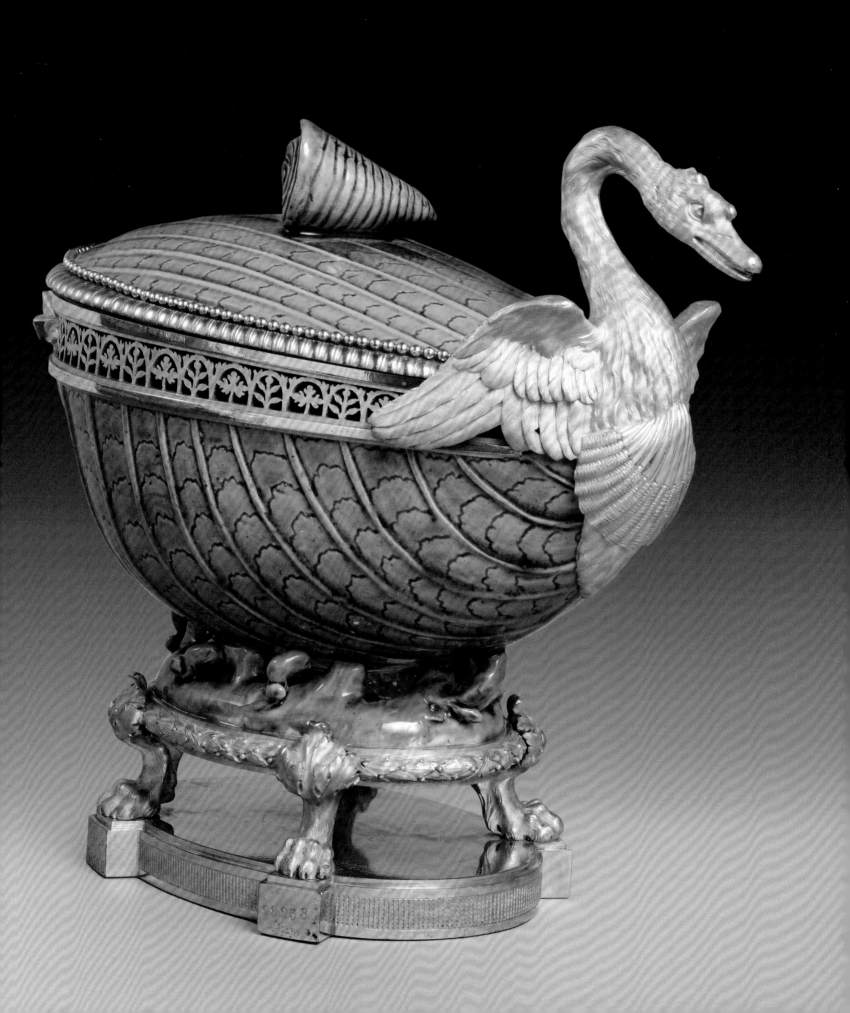

Two Vases

Porphyry carved in Rome in the eighteenth century
Gilt bronze by Pierre Gouthière after a design by François-Joseph Bélanger, ca. 1770-75
Red porphyry and gilt bronze
Each, 13⅜ × 6¾ in. (34 × 17 cm)
Musée du Louvre (OA 2825-26)

Provenance:
Commissioned by Louis-Marie-Augustin, Duke of Aumont, ca. 1770-75; in the sale of his collections, December 12-21, 1782, lot 3; purchased for Louis XVI; transferred to the Muséum du Louvre, 1793; under the Second Empire, in the apartments of the director general of the "imperial museums," at the Musée du Louvre.

Literature:
Davillier 1870, 11-13; Robiquet 1912, 205; Dreyfus 1913, 72, no. 394; Robiquet 1920–21, 205; Dreyfus 1922, 88, no. 439; Dreyfus 1923, 12, pl. 32; Verlet 1980, 207; Baulez 1986, 606; Malgouyres 2003, 175-76.

"No pictures; but columns, tables, chandeliers, marbles, porphyries, granites, jaspers at wild prices, this is what the Duke of Aumont's luxury consisted of."[83] This is how Baron Charles Davillier summed up the contents of the Duke of Aumont's collections, to which he dedicated an 1870 book still considered to be a key reference work. The duke was indeed one of the greatest hardstone collectors of his era. He was particularly fond of marble, granite, porphyry, serpentine, jasper, and agate, which the prevailing neoclassicism had brought back into fashion. When possible, he obtained these in Italy—which is where these vases came from[84]—because it was generally agreed that the finest stones were Italian.

In the catalogue of the sale of his collections, which took place in Paris in December 1782, the authors Philippe-François Julliot and Alexandre-Joseph Paillet emphasized the importance of this prestigious origin in their introduction: "The Duke of Aumont, eager to give his study the greatest of character, carried out the greatest of research to obtain the rarest marbles in Rome and throughout Italy, and to have them fashioned by men of the highest merit, who perfectly fulfilled his vision." Vivant Denon, who was passing through Corneto in November 1777, noted the size of the ancient site, as well as the scantiness of the remains: "The remains of these marbles are sold every day, and latterly the Duke of Aumont had most of the still-remaining precious pieces purchased and sent to France."[85]

For these vases, which had been carved and polished in Italy, Gouthière was commissioned to produce gilt-bronze mounts after designs by François-Joseph Bélanger,[86] whose brother-in-law, Jean-Démosthène Dugourc, directed and oversaw the work, as he did with other pieces executed by Gouthière for the Duke of Aumont.[87] Their intervention was very minimal, with extremely simple socles finely chased with friezes of interlacing motifs and strings of pearls.

Gouthière worked for Aumont for about ten years, beginning in about 1770. In 1774, he was very busy with work for him, although we do not know what was in progress, already delivered, or not yet commissioned or begun. In April 1782, when Aumont died, nine unfinished objects were still to be found in Gouthière's workshop. Since the objects belonging to Aumont that were not in Gouthière's workshop in 1782 are difficult to date, they are presented here, in each section,

according to their appearance in the catalogue of the sale of the duke's collections. Julliot and Paillet followed the hierarchy by which stones were classified throughout the eighteenth century, starting with the pieces in "top-quality" porphyry,[88] including these two vases (see fig. 12),[89] followed by the objects in green porphyry, *verde antico* marble, serpentine antique marble, African marble, gray granite, *jaune antique* marble, *bleu grec* marble, *vert d'Égypte* marble, red oriental jasper, *jaspe fleuri*, and jasper. These two vases were bought by Louis XVI through Julliot, who attended auctions on the king's behalf. Their high price of 3,134 *livres*—three times the estimate given in the inventory drawn up after the duke's death[90]—was justified by the quality of what the catalogue identified as their Italian workmanship. Julliot and Paillet mentioned in the catalogue that the two vases were similar to those of Randon de Boisset that were sold in 1777; but the latter were placed on different socles—decorated with Bacchus heads—that may not have been made by Gouthière.[91]

There are several porphyry vases that are almost identical to Aumont's but in slightly different sizes and with a number of gilt-bronze pearls that varies between twelve and fifteen on each side;[92] one pair is in the J. Paul Getty Museum,[93] another was sold in Paris in 1977 and probably again in Monaco in 1983,[94] and a third was sold in London in 2002 with a large dish.[95]

The Italian workshop from which these vases came may have produced similar ones that were given mounts in Paris. It is also possible that the workshop of the Menus-Plaisirs, set up at Aumont's request to carve hardstones and mount them in gilt bronze, made copies of the duke's vases or of another vase and gave them similar mounts.[96] In any case, not all the bases of these vases can be attributed to Gouthière.

C.V.

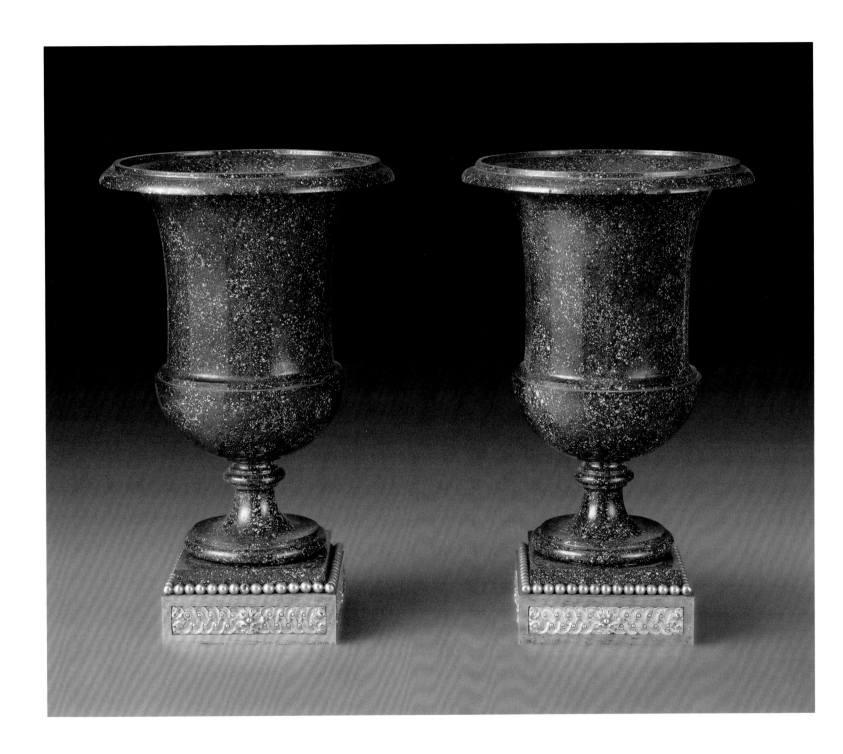

9

Pair of Vases

Green granite (known as "green granite
from the cathedra of San Lorenzo")
probably carved by Augustin Bocciardi or
Pierre-Jean-Baptiste Delaplanche
Gilt bronze by Pierre Gouthière
After a design by François-Joseph Bélanger
Ca. 1770-75
Green granite, bardiglio, and gilt bronze
Each, 13¾ × 10⅞ in. (35 × 27.75 cm)
Private collection

Provenance:
Commissioned by Louis-Marie-Augustin,
Duke of Aumont, ca. 1770-75; in the sale of
his collections, December 12-21, 1782, lot 6;
purchased for Marie Antoinette; transferred
to the Muséum du Louvre, 1793; possibly
sold with other objects from the Muséum,
1797; acquired by Mr. Fierard after the
revolution; in the sale of his collections,
January 25, 1837, lot 181; purchased
by Marie-Jean-Pierre Hubert, Duke of
Cambacérès; inherited by his widow, Louise
Alexandrine Thibon, 1881; sold at Galerie
Charpentier, Paris, June 25, 1957, lot 94;
purchased by Ernest Gutzwiller; sold at
Christie's, London, December 2, 1997, lot
10; private collection.

Literature:
Davillier 1870, 14; Robiquet 1912 and
1920-21, 115; Du Colombier 1961, 29; Verlet
1980, 207; Baulez 1986, 578.

The catalogue for the sale of the Duke of Aumont's collections does not mention the origin of these vases, as is the case with the red porphyry vases (cat. 8), but provides only this description in the caption to the engraving: "Two vases in green Porphyry." They were described as being in "black porphyry" in the inventory drawn up in May 1782 following the duke's death.[97] In fact, they are in an antique marble described as "green granite from the cathedra of San Lorenzo," the quarries for which are in the Egyptian desert. The name comes from the roundels on the back of the cathedra at the basilica of San Lorenzo outside the Aurelian Wall in Rome.

The description in the Aumont catalogue focuses more on their particular appearance, the bottoms being not flat but in the form of a *cul-de-lampe,* echoing the knob forms on the tops of the lids.[98] Unable to stand, they had to be supported by a mount, which in this case was created by Gouthière after designs by François-Joseph Bélanger.

It was probably an artisan working in Paris under Bélanger who carved these rare and original vases: perhaps the Genoese-born sculptor Augustin Bocciardi, who carved and polished numerous hardstones for the Duke of Aumont, although some were entrusted around 1774 to the sculptor and marble cutter Pierre Jean-Baptiste Delaplanche.[99]

At the sale of the duke's collections, these two vases were sold for 3,001 *livres* to Marie Antoinette through Alexandre-Joseph Paillet, who attended auctions on her behalf. We do not know the full details of their royal journey—in which chateau and in which rooms they were placed—except that by 1789 they were not in Marie Antoinette's quarters at Versailles.[100] They reappear in 1793 at the Muséum du Louvre.[101] We know neither when nor how they left the royal collections, which had become national collections of the republic. They may have been sold in 1797 during the auctions of public collections organized by the Directory or gifted or exchanged under the First Empire.[102] They reappear in Paris, on January 25, 1837, at the sale of a Mr. Fierard's collections and were subsequently bought for 1,805 francs by the Duke of Cambacérès, Peer of France and future grand master of ceremonies to Napoleon III, before going through several private collections in France and the United States.

C.V.

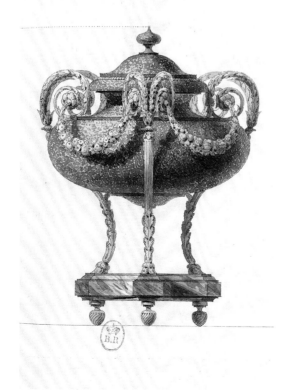

Fig. 98
Pierre-Adrien Pâris, *Preparatory
Drawing for the Engraving,
Representing a Vase from the
Duke of Aumont,* 1782. Pencil,
ink, and watercolor on paper,
7⅞ × 5⅛ in. (20 × 13 cm).
Bibliothèque Nationale de
France, Paris (RES V 2586, pl. 6)

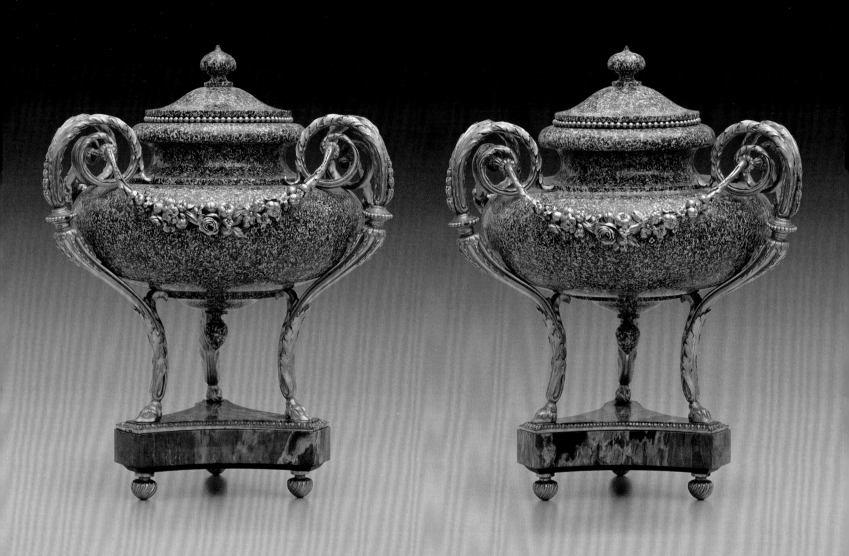

Pair of Vases

Alabaster probably carved by Augustin
Bocciardi or Pierre-Jean-Baptiste
Delaplanche
Gilt bronze by Pierre Gouthière
After a design by François-Joseph Bélanger
Ca. 1770–75
Alabaster, green marble, and gilt bronze
Each, 16⅛ × 16½ in. (41 × 42 cm)
Private collection

Provenance:
Commissioned by Louis-Marie-Augustin,
Duke of Aumont, ca. 1770–75; in the sale
of his collections, December 12–21, 1782,
lot 7; purchased for Louis XVI; transferred
to the Muséum du Louvre, 1793; sold
with other objects from the Muséum du
Louvre, 1797; purchased probably in Paris
by the Count and Countess of Flahaut de
la Billarderie, ca. 1830; in their London
residence, Coventry House, in June 1863;
in 1870, upon the death of the Count of
Flahaut (countess died in 1867), inherited
by their eldest daughter, Emilie Jane
Mercer Elphinstone de Flahaut, wife of the
Marquess of Lansdowne; at the home of
Lady Lansdowne at 15a Grosvenor Square,
London, in 1875; sent to Meikleour, in
Perthshire, Scotland, a property belonging
to the Lansdowne family, at an unknown
date; sold by the Trustees of the Meikleour
Estate Trust, Christie's, London, June 11,
1992, lot 60; French & Company; Christie's,
New York, November 24, 1998, lot 15;
private collection.

Literature:
Davillier 1870, 14–15; Verlet 1980, 207;
Wannenes and Wannenes 2004, 347.

The seventh entry in the catalogue of the sale of
the Duke of Aumont's collections consisted of two
large, handsome columns of *verde antico* marble dis-
covered in 1766 near the Temple of Vesta in Rome
(cat. 43). On top, each had an alabaster vase that
the catalogue authors Philippe-François Julliot and
Alexandre-Joseph Paillet judged "interesting" and
with ornamentation "of an excellent type . . . perfectly
carried out."[103]

Paillet acquired the full set of items for 13,801
livres on behalf of Louis XVI. While the columns were
stored in the Salle des Antiques at the Louvre, the vas-
es were left at Julliot's premises for more than twenty
years.[104] In 1793, they were transferred to the Muséum
du Louvre, but they clearly fell out of favor: in October
1797—on orders from the Ministry of Finance and to
cover the costs of establishing the new museum—
these "two vases in oriental alabaster, of mediocre
quality, or vases, on *verde antico* socle, ornamented
with laurel foliage in chased and matte-gilded bronze"
were put up for sale, estimated at 120 *livres*, and sold
for 180 *livres*.[105] This judgment clearly applied essen-
tially to the alabasters, which were defective, and not
to Gouthière's mounts, the originality and execution
of which are almost without equal.

These vases subsequently reappear in the London
residence of Auguste-Charles-Joseph, Count of Flahaut
de la Billarderie, and his wife, Margaret, Baroness Keith
and Nairne.[106] The Countess of Flahaut thus noted, in
June 1863, in her "List of Things at Coventry House,"
in the small drawing room, "2 very fine vases, Oriental
alabaster, mounted 'or mat.'" There is no reference to
Gouthière, but matte gilding, which was his specialty, is
specifically mentioned by the countess, who in all other
instances describes her gilt bronzes with the anglicized
term "ormolu."

The count and countess's eldest daughter, Emilie
Jane Mercer Elphinstone de Flahaut, who probably in-
herited the vases upon her father's death in 1870 (her
mother died in 1867), mentions them in an undated
list: "2 Algerian Onyx Vases with lids, ormolu mount-
ed *verde antiquo* [*sic*] bases." They are described again
around 1867, at Coventry House, as a pair of "Algerian
onyx vases with lids, ormolu mounted."

Believed to have been made of oriental alabas-
ter in the Duke of Aumont catalogue and by the
Countess of Flahaut, these vases were henceforth said
to be of Algerian onyx. Both these designations re-

fer to calcite alabaster, also known as oriental alabas-
ter, since many objects fashioned from this material
came from the East. In fact, they are most likely not
antique stones but rather gypsum alabaster, which
is more fragile than calcite alabaster, possibly from
Tuscany in Italy. It is difficult to know whether it was
François-Joseph Bélanger, Augustin Bocciardi, or
Pierre-Jean-Baptiste Delaplanche—all three worked
for the Duke of Aumont—who gave them their form
or whether they were designed and carved elsewhere,
possibly in Italy.

In 1875, the vases were in London at 15a Grosvenor
Square, the residence of Emilie Jane, who, in 1843,
married Henry Petty-Fitzmaurice, Earl of Shelburne
(who became Marquess of Lansdowne in 1863). They
were then sent to Meikleour, in Perthshire, Scotland,
which was a Lansdowne family property.

When the vases reappeared at an auction in 1992,
they were standing on gilt-bronze feet of a very dif-
ferent type from the example reproduced in the cata-
logue of the Duke of Aumont sale (fig. 99). The orig-
inal feet, which were probably of alabaster (although
the catalogue description says nothing on this sub-
ject), must have been damaged or broken sometime
after the sale and replaced by these, which are of fine
quality but difficult to date. There are several other
differences between these vases and the ones repro-
duced in the Aumont catalogue. The *verde antico*
marble plinth mentioned in the catalogue descrip-
tion does not appear in the reproduction, perhaps
because it was considered an integral part of the
column, which was also reproduced (cat. 43). The
greatest difference, however, lies in the treatment of
the laurel leaves that form the vases' handles; those
in the catalogue are rigid and uninspired, lacking the
brio of Gouthière's mounts in which each leaf seems
to have been cast from nature, so realistically do they
capture the density and variety of a branch of blos-
soming laurel.

C.V.

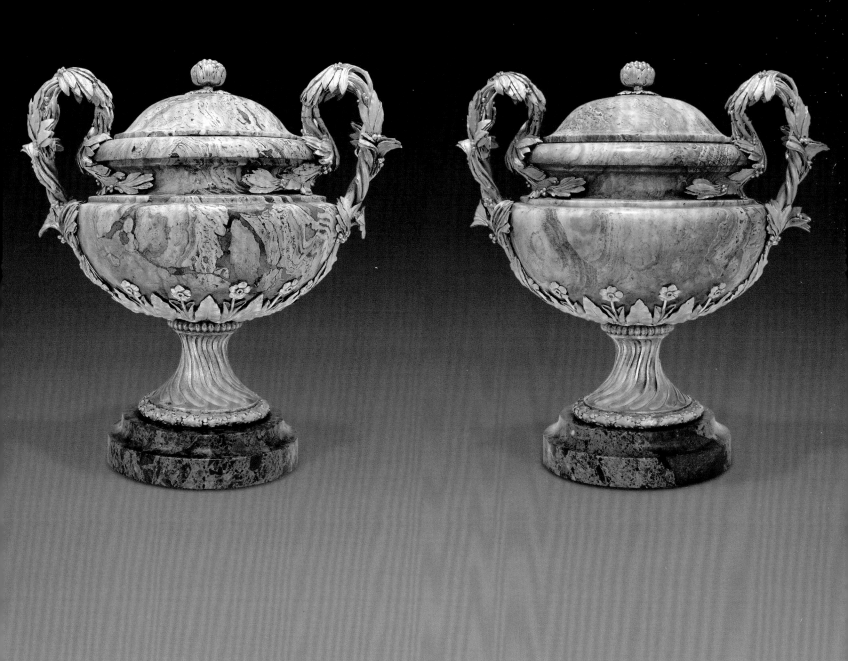

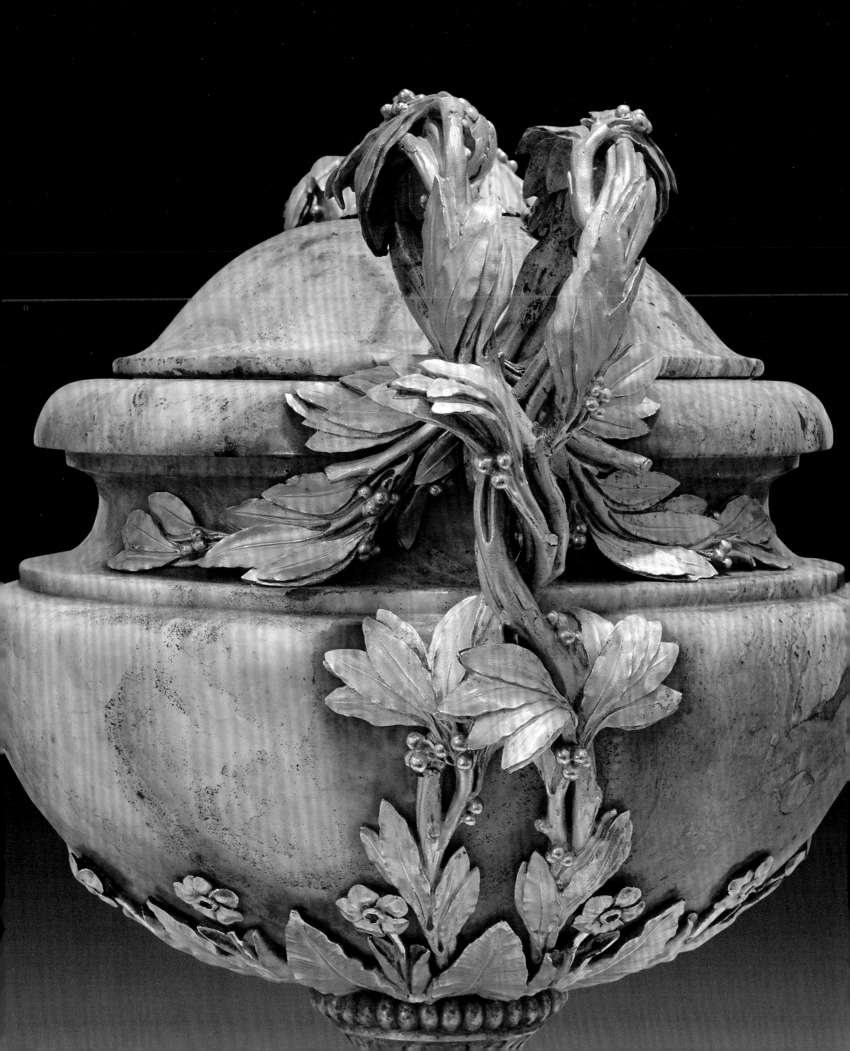

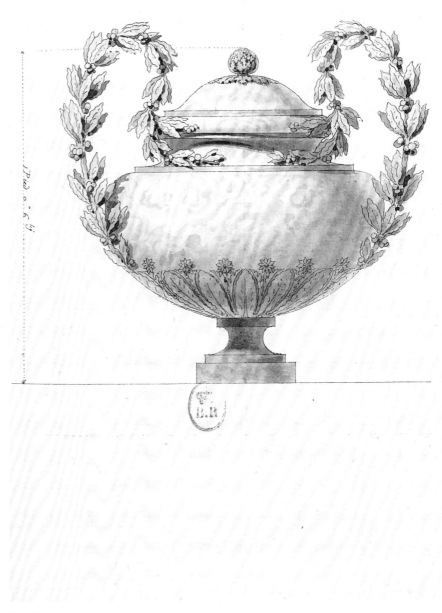

Fig. 99
Pierre-Adrien Pâris, *Drawing for the
Engraving, Representing a Vase from
the Duke of Aumont*, 1782. Pencil, ink,
and watercolor on paper, 7⅞ × 5⅛ in.
(20 × 13 cm). Bibliothèque Nationale de
France, Paris (RES V 2586, pl. 7)

Vase

Green Greek porphyry (known as serpentine antique), possibly carved by Augustin Bocciardi or Pierre-Jean-Baptiste Delaplanche after a design by François-Joseph Bélanger, or carved at an earlier period
Gilt bronze by Pierre Gouthière after a design by François-Joseph Bélanger
Ca. 1775-80
Green Greek porphyry and gilt bronze
15 × 15 × 11¾ in. (38 × 38 × 30 cm)
Musée du Louvre; transfer from the Mobilier National, 1901 (OA 5178)

Provenance:
Louise-Jeanne de Durfort de Duras, Duchess of Mazarin (?); Louis-Marie-Augustin, Duke of Aumont, ca. 1775-80; in the sale of his collections, December 12-21, 1782, lot 11; purchased for Louis XVI; transferred to the Muséum du Louvre, 1793; in the first salon of the Grands Appartements du Roi at the Palais des Tuileries, 1826; transferred from the Mobilier National to the Musée du Louvre, 1901.

Literature:
Davillier 1870, 18-19; Williamson 1883a, 28, no. 224; Williamson 1883b, vol. 2, pl. 58; Williamson 1892, 38, no. 224; Molinier 1902a, pl. XXXVII; Robiquet 1912, 148; Dreyfus 1913, 69, no. 430; Robiquet 1920-21, 148, 205; Dreyfus 1922, 85, no. 420; Dreyfus 1923, vol. 1, 11, pl. 20; Du Colombier 1961, 28, fig. 7; Verlet 1980, 207; Baulez 1986, 237; Verlet 1987, 42-43; Lemonnier 1991, 42; Kjellberg 2000, 151, 154; Alcouffe, Dion-Tenenbaum, and Mabille 2004, 241.

Valued at only 1,000 *livres* in the inventory drawn up in May 1782 after the Duke of Aumont's death,[107] this vase, which the specialists of the auction sale described as "commendable for its high quality and shape" and "interesting for its tastefully chosen ornamentation,"[108] was acquired by Louis XVI, through his intermediary Philippe-François Julliot, for the considerable sum of 5,000 *livres*.

According to a note written by Germain de Saint-Aubin, who attended the sale (as attested to by three catalogues bearing annotations and illustrations by his hand), this vase was "a gift [to the Duke of Aumont] from the Duchess of Mazarin who had paid 2,400 / item at Boissette's, 2,400 *livres*."[109] No other document has been found to confirm this provenance or throw any light on the nature of this present. One wonders whether the duchess, who was also a client (cats. 22, 26, 35, 39, 49), gave the duke the vase with mounts by Gouthière or, more probably, gave him the vase unmounted or with different mounts, leaving the duke to commission the mount from Gouthière. Either way, Gouthière certainly worked from a design by François-Joseph Bélanger, whose clients included the duke and the duchess. A watercolor design attributed to Bélanger, probably a preparatory drawing, represents this vase with most of the gilt bronzes made by Gouthière but with some differences, notably in the choice and size of the motifs in the friezes.[110] Pierre-Adrien Pâris's preparatory drawing for the plate in the Aumont sale catalogue shows the two female figures looking in opposite directions (fig. 100). However, this is not the case in the preparatory design attributed to Bélanger or on the bronzes Gouthière made.

In 1826, this vase is recorded as being at the Palais des Tuileries, in the first salon of the Grands Appartements du Roi, erroneously displayed as a pair with another vase (cat. 12).[111]

Several copies made in the nineteenth century, notably by Alfred Beurdeley (1847-1919), appear from time to time at auctions,[112] but no other example from the eighteenth century is known.

C.V.

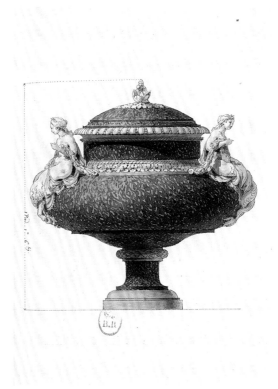

Fig. 100
Pierre-Adrien Paris, *Drawing for the Engraving, Representing a Vase from the Duke of Aumont*, 1782. Pencil, ink, and watercolor on paper, 7⅞ × 5⅛ in. (20 × 13 cm). Bibliotheque Nationale de France, Paris (RES V 2586, pl. 11)

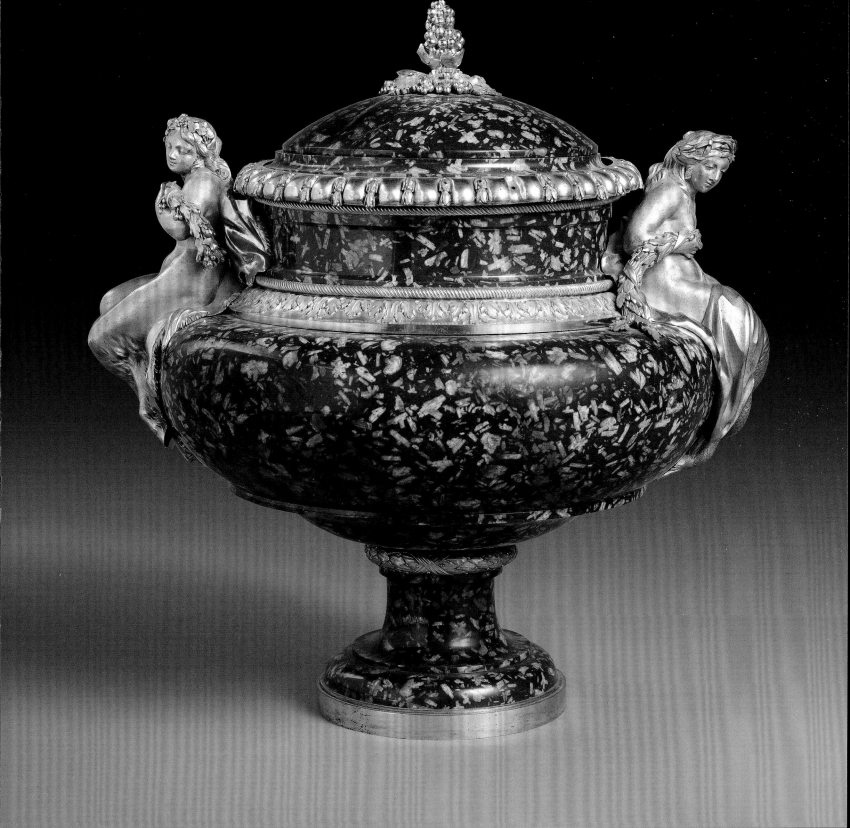

Vase

Green Greek porphyry (known as
serpentine antique), possibly carved by
Augustin Bocciardi or Pierre-Jean-Baptiste
Delaplanche after a design by François-
Joseph Bélanger, or carved at an earlier
period
Gilt bronze by Pierre Gouthière after a
design by François-Joseph Bélanger
Ca. 1775-80
Green Greek porphyry and gilt bronze
15 × 13⅜ × 11 in. (38 × 34 × 28 cm)
Musée du Louvre, Paris; transfer from the
Mobilier National, 1901 (OA 5179)

Provenance:
Commissioned by Louis-Marie-Augustin,
Duke of Aumont, ca. 1775-80; in the sale of
his collections, December 12-21, 1782, lot
12; purchased for Louis XVI; transferred to
the Muséum du Louvre, 1793; in the first
salon of the Grands Appartements du Roi
at the Palais des Tuileries, 1826;[113] in the
fifth salon of the Grands Appartements du
Roi, garden side, at the Palais des Tuileries,
1851; transferred from the Mobilier National
to the Musée du Louvre, 1901.

Literature:
Davillier 1870, 19; Williamson 1883a, 28,
no. 225; Williamson 1883b, vol. 2, pl. 58;
Williamson 1897, 38, no. 225; Molinier
1902a, pl. XXVII; Robiquet 1912, 148-49;
Dreyfus 1913, 68, no. 376; Robiquet
1920-21, 148-49, 205; Dreyfus 1922, 85,
no. 419; Dreyfus 1923, vol. 1, 11, pl. 20; Du
Colombier 1961, 28, fig. 5; Winokur 1977,
160; Verlet 1980, 207; Baulez 1986, 236;
Verlet 1987, 351; Müntz de Raïssac 1990,
389; Lemonnier 1991, 42-43; Kjellberg
2000, 151; Alcouffe, Dion-Tenenbaum,
and Mabille 2004, 242-43; McCormick,
Ottomeyer, and Walker 2004, 23-24.

This vase, similar in shape and material to the pre-
vious one (cat. 11), was, however, valued at a lower
price in the inventory drawn up following the Duke
of Aumont's death (650 *livres* compared to 1,000
livres).[114] It fetched a relatively weak 1,511 *livres* at the
sale of the duke's collection in December 1782. It was
sold to Philippe-François Julliot for Louis XVI, while
the king was prepared to spend 5,000 *livres* for the
previous lot. Clearly, Julliot and Alexandre-Joseph
Paillet, the specialists for the sale, thought this vase
was of inferior quality to the one with female figures
since their description was shorter and their assess-
ment less laudatory.[115] The vase is not described, like
the previous lot, as a vase of "high quality" (probably
a reference to the stone and the way it was carved),
and the gilt-bronze ornamentation is simply judged
to be "correct." Indeed, the absence of chasing on the
arabesque frieze is surprising, but the rams' heads are
particularly expressive and impressively naturalistic.
We may even recognize the Pyrenean goats that the
painter Jean-Baptiste Huet (1745-1811), a contempo-
rary of Gouthière's, often reproduced in his oeuvre.[116]

On this vase, the goats' hair is exceptionally live-
ly. It is simply chased on the noses and ears, in con-
trast to the tight tufts elsewhere on the heads; the lat-
ter were cast in the mold and subsequently chased,
gilded, and partially burnished. The extraordinary
horns, alternately burnished and matte gilded to imi-
tate nature more closely, lend an element of sophisti-
cation and luxury.

Rams are often found on Gouthière's pieces.
Already in the second half of the 1760s, he gilded
rams' heads for Germain's vase mounts,[117] and the
chaser Jean-Nicolas Lebeau produced ram's-head
handles for him.[118] The same decorative motif ap-
peared on two other objects in the Duke of Aumont
sale (cats. 17, 21) and served as handles for two pink
granite vases auctioned at the sale of the collections
of the farmer-general Randon de Boisset organized
after his death.[119]

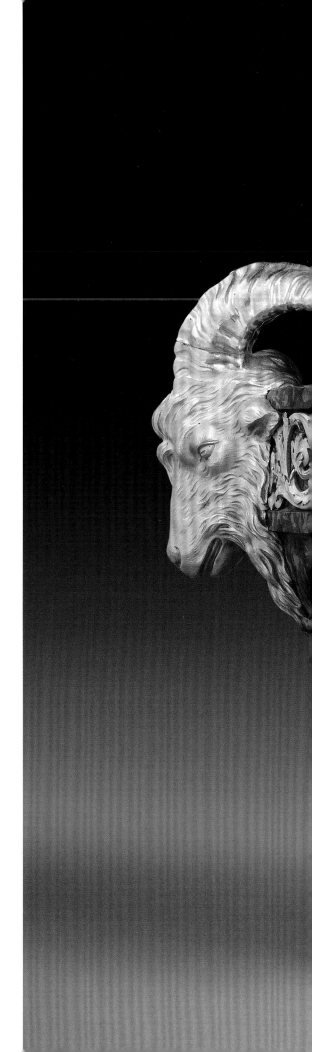

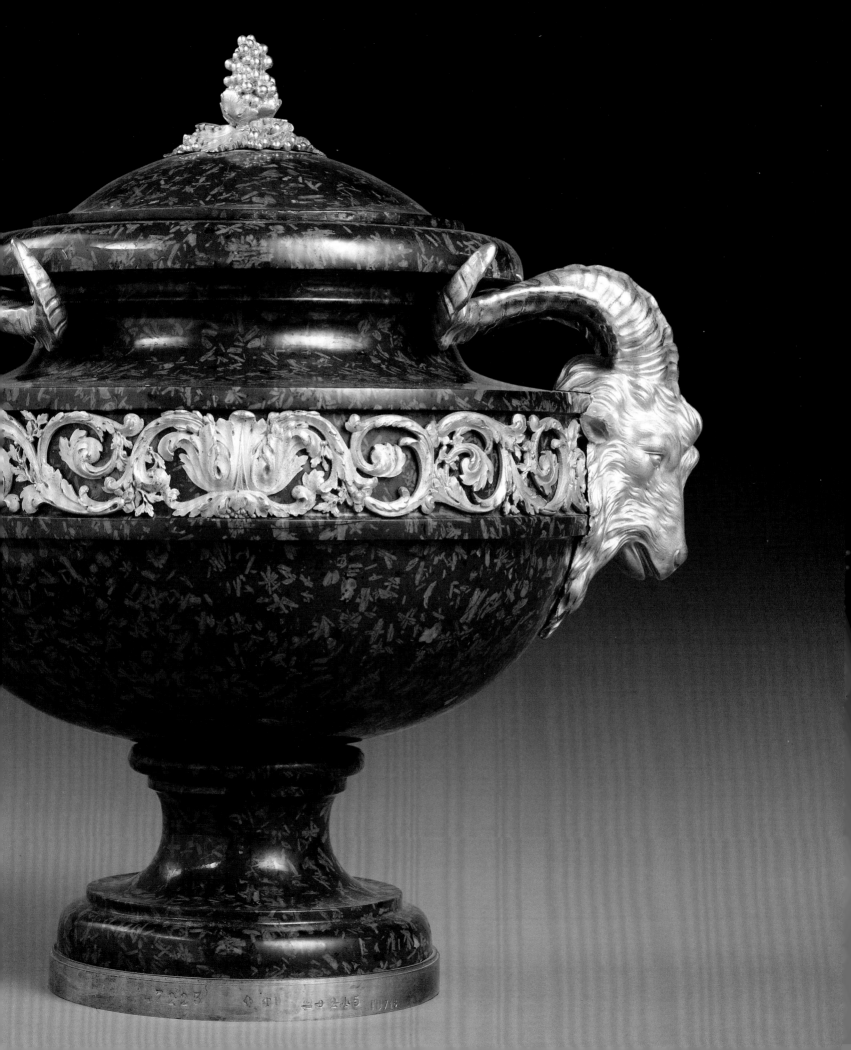

On Pierre-Adrien Pâris's drawing, which served as a model for the plate in the sale catalogue (fig. 101), as well as on the catalogue plate itself, this vase is reproduced with a small ball on the lid, the ornamentation of which is different from what is there today. This decoration may have been changed at a later stage, replaced by a copy of that on the vase with female figures (cat. 11) in order, perhaps, to display these two pieces as a pair. However, the description in the 1782 catalogue mentions that this vase was topped by a "rosette [*rosasse*] on the lid." This is the same term used to describe the decoration on the lid of the vase with female figures, which was this time accurately reproduced with ornamentation that more closely resembles that found today on both pieces. Therefore, it may be that the engraving does not correctly represent the ornamentation that appeared then, and still appears now, on this vase. In 1826, both pieces were described as having "knobs in the form of bunches of grapes" and, in 1851, this one was topped with simply a "knob."

In 1826, this vase was in the first salon of the Grands Appartements du Roi, along with the one with female figures.[120] But in 1851 they were separated, and this one was found in the fifth salon of the Grands Appartements du Roi, on the garden side, still at the Palais des Tuileries.[121]

Copies of this vase, as of the previous one, were made in the nineteenth century,[122] but no other eighteenth-century example is known.

C.V.

Fig. 101
Pierre-Adrien Pâris, *Drawing
for the Engraving, Representing
a Vase from the Duke of
Aumont*, 1782. Pencil, ink, and
watercolor on paper, 7⅞ × 5⅛ in.
(20 × 13 cm). Bibliothèque
nationale de France, Paris (RES
V 2586, pl. 12)

Incense Burner

Jasper probably carved by Augustin
Bocciardi or Pierre-Jean-Baptiste
Delaplanche
Gilt bronze by Pierre Gouthière
After a design by François-Joseph Bélanger
1770–75
Red jasper and gilt bronze
19 × 8½ in. (48.3 × 21.7 cm)
The Wallace Collection, London (F292)

Provenance:
Commissioned by Louis-Marie-Augustin,
Duke of Aumont, 1774-75; in the sale of
his collections, December 12-21, 1782,
lot 25; purchased for Marie Antoinette;
Mr. Fournier sale, May 31, 1831, lot 26; in
the sale of the Prince of Beauvau, April
21, 1865, lot 19; purchased for Richard
Seymour Conway, 4th Marquess of
Hertford.

Literature:
Molinier n.d., pl. 55; Mantz 1865, 480–81;
Davillier 1870, 27; Ephrussi 1879, 398, pl.
55; Dilke 1901, 181; Robiquet 1912 and
1920–21, 50, 169–70; Watson 1956, 143–45;
Eriksen 1974, 105, 363, pl. 243; Ottomeyer
and Pröschel 1986, vol. 1, no. 4.3.3; Baulez
1986, 578; Verlet 1987, 61, fig. 57 and 393;
Hughes 1996, 1340–45; Baulez 2001b, 38;
Hans 2008, 154; Durand, Bimbenet-Privat,
and Dassas 2014, 451.

Like vases and columns, incense burners represented a quintessential leitmotif of the classical past, and from the 1760s artists and architects such as Joseph-Marie Vien and Jean-Charles Delafosse sought to depict them in paintings and designs. The creativity of the architect and designer François-Joseph Bélanger is displayed in this hardstone incense burner made for the Duke of Aumont and cut in the workshop of the Hôtel des Menus-Plaisirs, probably by Augustin Bocciardi or Pierre-Jean-Baptiste Delaplanche. Made of very fine quality jasper, the rounded bowl is juxtaposed with perfectly proportioned gilt-bronze legs, their verticality offset by the twisting snake and garlands of vine branches, and softened by the animal forms of the satyr masks and hooves, all richly chased and gilded in *or mat* by Gouthière. A gilt-bronze liner allowed for the burning of perfumed pastilles, although the first consideration of a refined collector like the Duke of Aumont would have been for display rather than function; he kept it alongside the rest of his precious collection of artworks in his *hôtel particulier* on the Place Louis XV (today the Place de la Concorde).

In many respects, this incense burner evokes the chimneypiece with gilt-bronze mounts by Gouthière made for Mme Du Barry's Salon Ovale at Louveciennes in 1771 (cat. 29), with its serpent-entwined legs supporting a hardstone vase mounted with similar palm leaves and forget-me-nots. The exact date of the incense burner is unknown, but it was probably one of the works made for Aumont in the first half of the 1770s. Considered a masterpiece of gilt-bronze work when it was auctioned after Aumont's death in 1782, it was admired in the sale catalogue for its rarity, "the pleasing brilliancy of the colors," the ingenuity of its design, and "the perfection of the craftsmanship." [123]

The incense burner had been valued at 1,500 *livres* in Aumont's inventory in April 1782,[124] but at the auction in December it was sold for 12,000 *livres*, the highest price paid for a single object. It was bought by Jean-Baptiste-Pierre Le Brun, the noted art dealer and husband of the queen's favorite artist, Élisabeth Vigée Le Brun, on behalf of Marie Antoinette, who also acquired eight other works by Gouthière from the sale.

Marie Antoinette shared Aumont's love of mounted hardstone objects and personally owned works of precious minerals such as agate, porphyry, jade, and rock crystal finely mounted in gold or gilt bronze.[125] She displayed the incense burner in her boudoir, or Cabinet de la Méridienne, one of the small, exquisite rooms in her private quarters at Versailles, where she was surrounded by her most precious possessions. The boudoir had been redecorated in 1781 by her favorite architect, Richard Mique, to coincide with the birth of the dauphin and included door fixtures and mirrors richly mounted with gilt bronze: everything was of the outstanding refinement that Marie Antoinette demanded. The incense burner took pride of place in the center of the chimneypiece, flanked by more hardstones and a pair of Chinese porcelain ewers, also mounted in gilt bronze by Gouthière (see fig. 24).[126]

Following her forced departure from the chateau of Versailles in October 1789, the queen deposited much of her collection of small objects of precious materials, lacquer, and hardstones, including the incense burner, with the dealers Martin-Eloi Lignereux and Dominique Daguerre for safekeeping.[127] Handed over to the republican Commission des Arts after her death in 1793,[128] the incense burner was among the objects sold on the orders of the French state, beginning on July 10, 1798, to raise funds for the establishment of the Louvre museum.[129] Passing through the hands of notable collectors, it was finally bought in 1865 by the fourth Marquess of Hertford who displayed it at the *Musée rétrospectif* exhibition in Paris, where it garnered international attention and helped promote Gouthière's reputation (see fig. 81).

H.J.

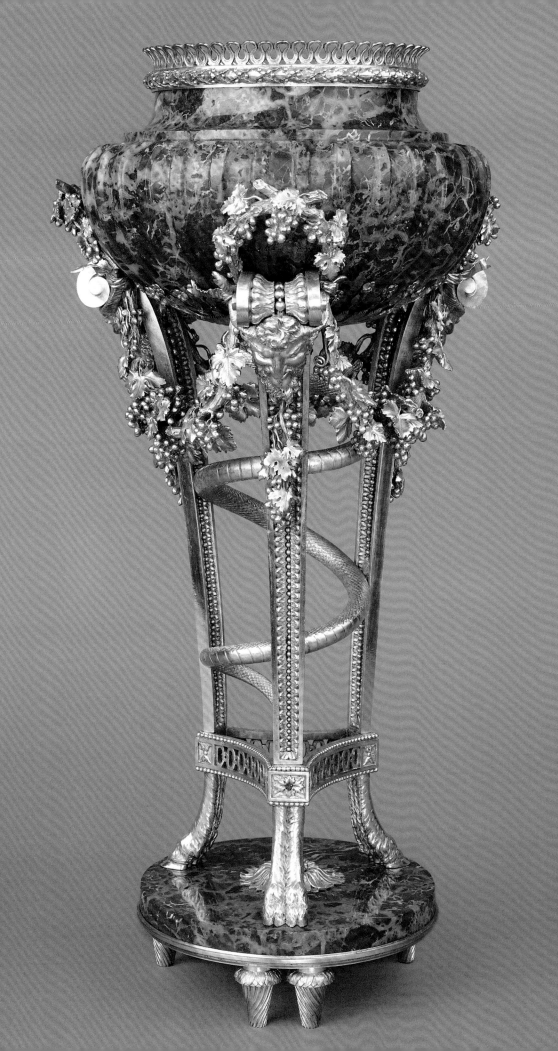

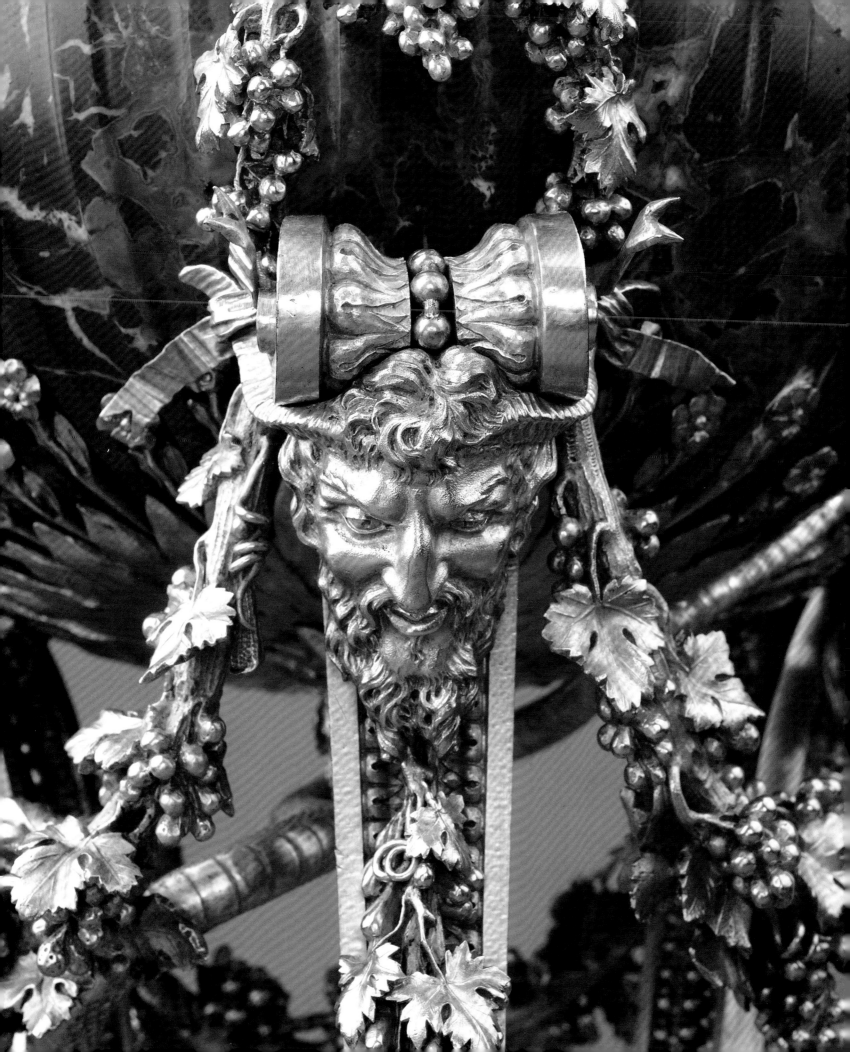

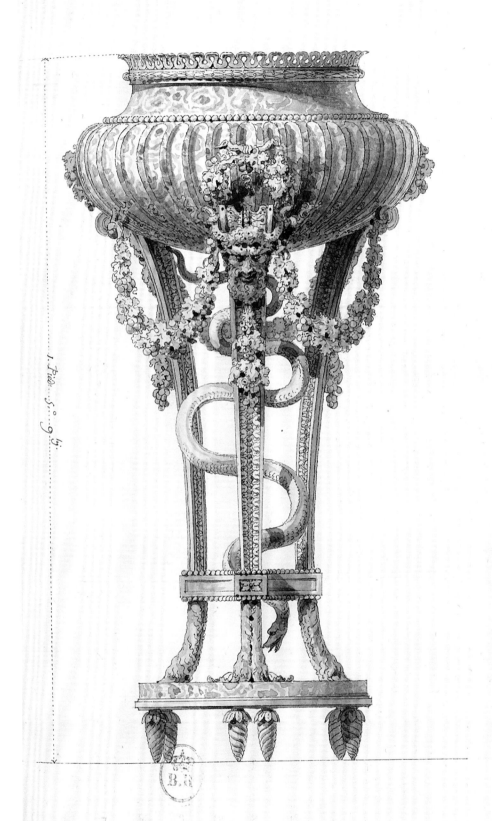

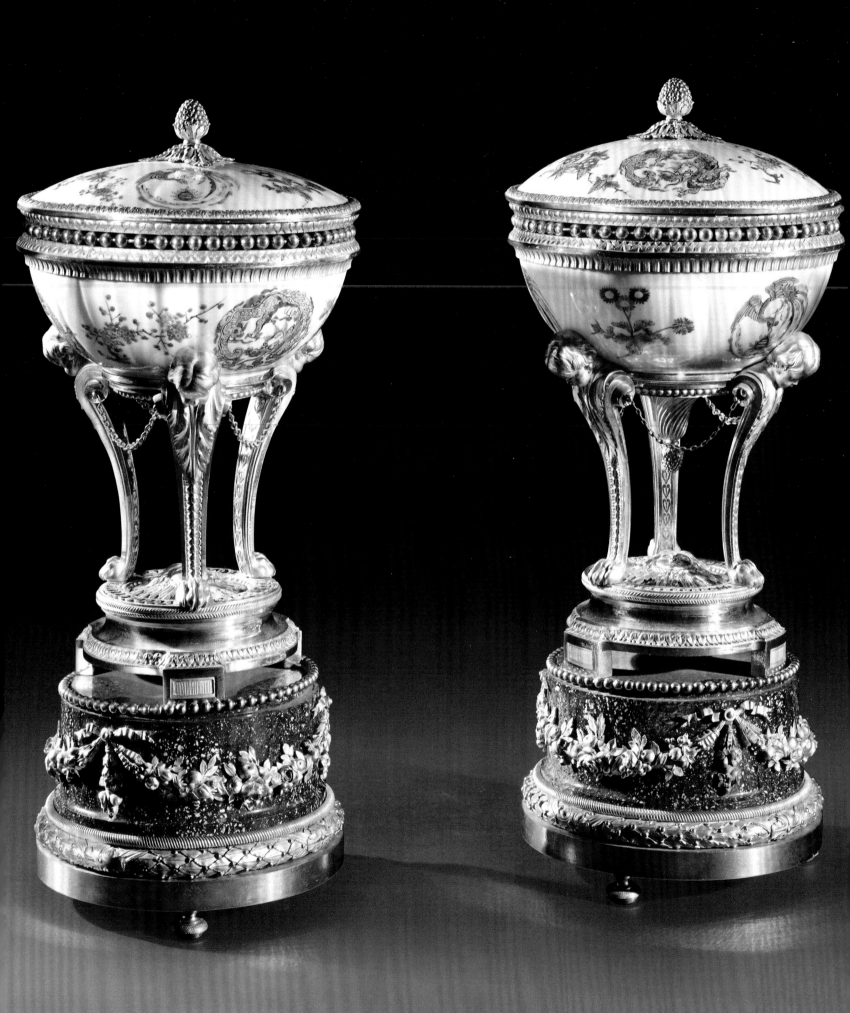

Pair of Incense Burners

Japanese porcelain, eighteenth century
Gilt bronze by Pierre Gouthière after a
design by François-Joseph Bélanger, ca.
1775
Kakiemon porcelain, porphyry, and gilt
bronze
14 × 6 in. (35.5 × 15.3 cm)
Private collection

Provenance:
Commissioned by Louis-Marie-Augustin,
Duke of Aumont, ca. 1775; in the sale of
his collections, December 12–21, 1782, lot
43; purchased for Louis XVI; Marguerite-
Suzanne Denoor from 1793; in the sale of
her collections, March 14, 1797, lot 155;
Sir Alfred Chester Beatty, until his death
in 1968; by descent to the Countess of
Aubigny; in the sale of her collections,
Christie's, London, July 1, 1976, lot 82;
Sotheby's, London, April 28, 2015, lot 112;
private collection.

Literature:
Verlet 1980, 207; Baulez 1986, 577; Vriz
2013, 90.

At the time of his death in April 1782, the Duke of Aumont owned more than four hundred pieces of oriental porcelain, which, along with his hardstone pieces, were the pride of his collection.[130] Almost half had received mounts in gilt bronze, silver gilt, silver, or even gold, often commissioned by their previous owners. However, the duke himself had ordered new mounts for eight of the items. By directly approaching Gouthière, he circumvented the merchants of luxury goods, whose specialty since the early eighteenth century had been to supply mounts for precious objects, including oriental porcelain pieces. As for the duke's collection of mounted hardstones, Gouthière worked from designs by François-Joseph Bélanger, whose brother-in-law, Jean-Démosthène Dugourc, oversaw the work.

Among the porcelain pieces were these two incense burners, lot 43 in the catalogue of the sale of the duke's collections.[131] They were not reproduced in the catalogue, but Germain de Saint-Aubin made a small pencil sketch of them[132] before they were acquired by the king for his new museum. Valued at only 900 *livres* in the inventory drawn up after the duke's death,[133] they finally sold for 2,703 *livres* to the king through Philippe-François Julliot, who still owned them on November 12, 1793.[134] In January 1795, they were among the objects belonging to the state that Julliot left in the "dépôt de Nesle," the national storehouse on Rue de Beaune.[135] Initially not

included among the disposable items, they were eventually given to Marguerite-Suzanne Denoor in exchange for the natural history collection of her late husband, François Levaillant, which she had sold to the government.[136] They later passed through three auctions: in 1797, at the first Denoor sale; in 1976; and lastly in 2015.

Here, as elsewhere, Gouthière's gilt bronzes enhanced and transformed already highly prized objects. In 1767, the Duke of Aumont acquired a bowl painted with a bird, for 610 *livres*, at the sale of the famous collector Jean de Julienne (1686–1766), director of the Gobelins tapestry manufactory.[137] We do not know where or when he bought the second bowl, decorated with dragons and pomegranates, but it was probably this purchase that justified replacing the "well-composed" mount of Jean de Julienne's bowl and ordering a new one by Gouthière that would better suit the taste of the day and of their new owner. The gilt-bronze mounts by Gouthière also allowed Aumont to create a pair using similar objects that had been bought at different times.

C.V.

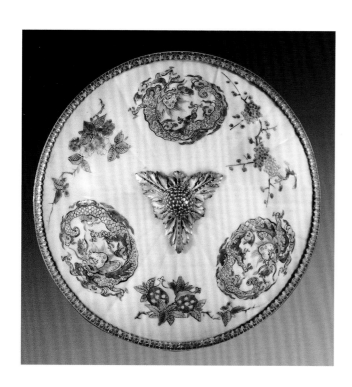

Pair of Vases

Chinese porcelain, eighteenth century
Gilt bronze by Pierre Gouthière after a
design by François-Joseph Bélanger
1782
Celadon porcelain, porphyry, and gilt
bronze
Each, 23 × 15 × 11⅞ in. (58.5 × 38 × 30 cm)
Musée du Louvre; transfer from the
Mobilier National, 1870 (OA 5514-5514 bis)

Provenance:
Commissioned by Louis-Marie-Augustin,
Duke of Aumont, 1782; in the sale of his
collections, December 12-21, 1782, lot 110;
purchased for Louis XVI; transferred to the
Muséum du Louvre, 1793; in the Galerie de
Diane at the Palais des Tuileries, 1833;[138]
transferred from the Mobilier National to
the Musée du Louvre, 1870.

Literature:
Williamson 1883b, vol. 2, pl. 67; Champeaux
1896-97, pl. 835; Molinier 1902a, 34;
Robiquet 1912, 153; Dreyfus 1913, 72,
no. 393; Robiquet 1920-21, 153, 205;
Wildenstein 1921, 126-27; Dreyfus 1922,
88, no. 438; Dreyfus 1923, vol. 2, 12, pl.
31; Du Colombier 1961, 24-25; Lunsingh
Scheurleer 1980, 345, fig. 342; Verlet 1980,
42, fig. 35, 211, fig. 240, 289; Verlet 1982,
208; Baulez 1986, 237; Kjellberg 2000,
106-7; Slitine 2002, 172-73; Alcouffe, Dion-
Tenenbaum, and Mabille 2004, 245-46.

At the time of the Duke of Aumont's death, on April 15, 1782, Gouthière still had nine items in his workshop that had not yet been delivered to his greatest client and patron.[139] In order to settle the duke's estate, François Rémond and Jean-Baptiste Guyart were asked to go to Gouthière's workshop, accompanied by the architect Pierre-Adrien Pâris, to examine and determine the value of these pieces, which they did on September 8, 12, and 15, 1782.[140] Among "the aforementioned works, some of which were not mounted," were two large pots "in the form of barrels, of green celadon porcelain,"[141] for which Gouthière had been asked to make gilt-bronze mounts after a design by François-Joseph Bélanger, with his brother-in-law, Jean Démosthène Dugourc, overseeing the work. Bélanger had created a composition of arabesques, rinceaux, snakes, and harpies—the height of fashion in the 1780s. The original ornamentation on both sides

creates a sumptuous ornament for the oriental masks in the porcelain. Bélanger also used the pots' lids as bases for harpies and placed them on porphyry socles, which were found elsewhere in the Duke of Aumont's collection (notably cat. 14).

Gouthière's interpretation of the architect's complex design demonstrates his mastery of the medium of gilt bronze. For example, the tops of the snakes are chased to create little scales, while the undersides are chased with larger scales to imitate nature more faithfully; the snakes are ingeniously designed to wind around in a spiral. Gouthière's naturalism is just as remarkable on the harpies, whose numerous feathers are pared back (*dégraissés*) to give them lightness; then chased to make them look as natural as possible.

Gouthière managed to complete his task before the sale of the duke's collections in December 1782, when the two vases were auctioned as lot 110.[142] The

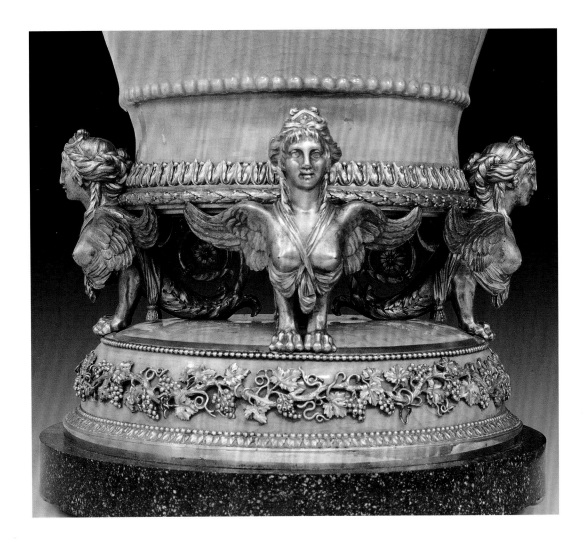

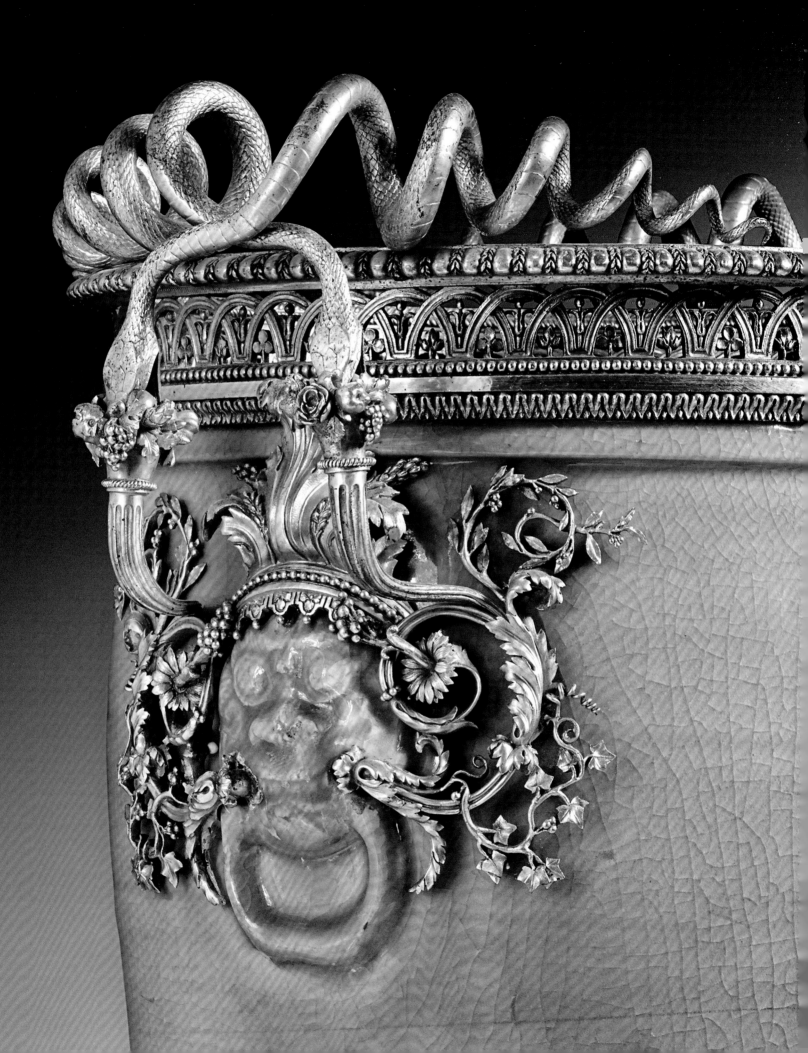

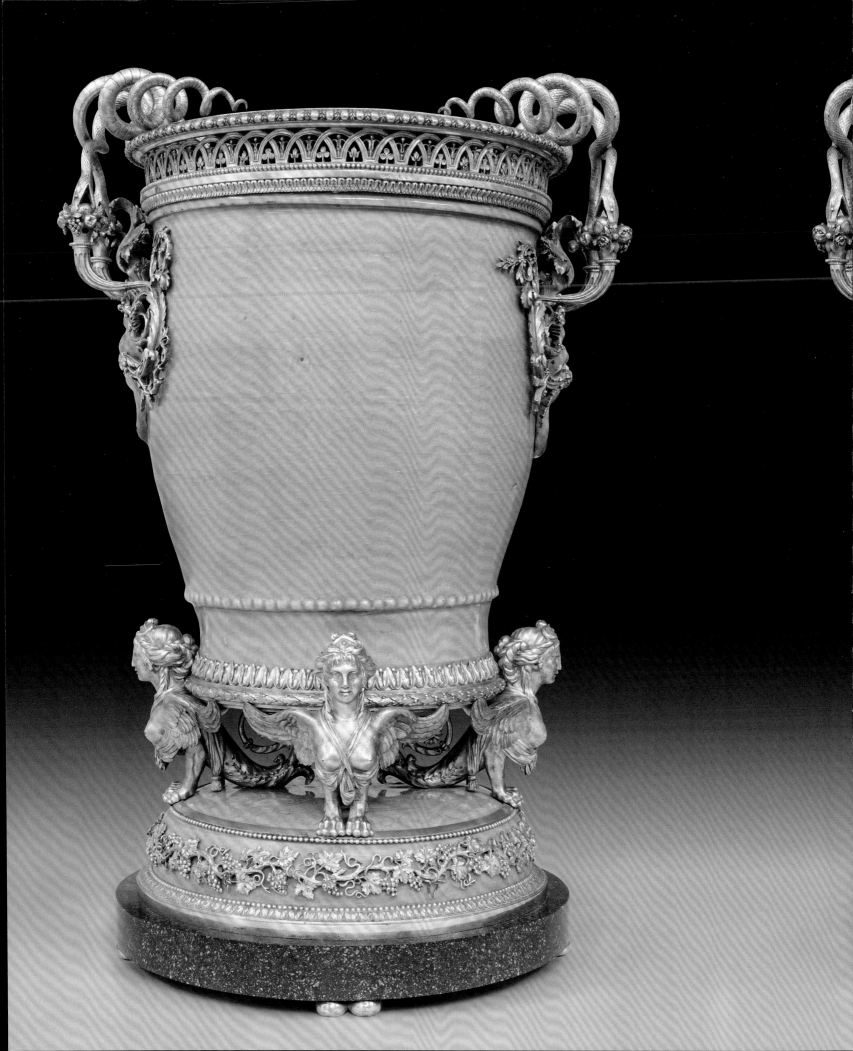

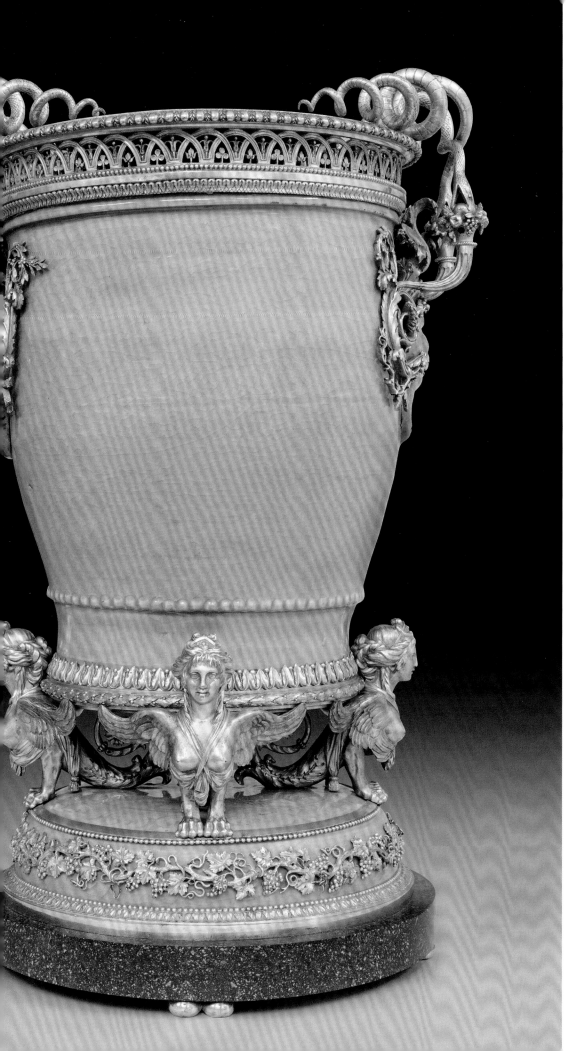

catalogue included them under the category of "old Japanese celadon" porcelain, although the vases (originally garden seats) came from China and were likely made in the town of Longquan or Jingdezhen.[143] Either way, Louis XVI bought them, again with Julliot acting as intermediary, for 7,501 *livres*, well below the 13,076 *livres* at which Rémond had valued Gouthière's gilt bronzes. The caster Jean-Claude Duplessis, who replaced Guyart as valuer of Aumont's gilt bronzes, himself estimated these two pieces at 9,328 *livres*.[144] The silversmith Jean-Baptiste-François Chéret, who was called in when Rémond and Duplessis were not in agreement, quoted 10,710 *livres* "for the bronze, chasing, mounting, gilding, and models."[145] All these sums were higher than the price fetched at auction.

With these vases, Gouthière demonstrated his virtuosity by creating gilt bronzes from a complex model while avoiding any piercing of the vases. They were successfully copied in the nineteenth century, in Chinese porcelain and Sèvres porcelain, notably by Samson.[146]

C.V.

Pair of Ewers

Gilt bronze by Pierre Gouthière after a
design by François Joseph Bélanger
1782
Chinese porcelain and gilt bronze
Each, H. 17 *pouces*, according to the
catalogue description for the sale of the
Duke of Aumont's collections (approx.
18⅛ in.; 46 cm)
Whereabouts unknown

Provenance:
Commissioned by Louis-Marie-Augustin,
Duke of Aumont, 1782; in the sale of his
collections, December 12–21, 1782, lot 114;
purchased by Abraham; in the sale of his
collections, November 29, 1784, lot 46;
since lost.

Literature:
Baulez 1986, 579; Vriz 2013, 93.

Two celadon porcelain ewers from China with gilt-
bronze mounts by Gouthière were featured in the sale
of the Duke of Aumont's collections in December
1782, alongside cat. 15. Here again, they were errone-
ously listed under the category of "old Japanese ce-
ladon" porcelain. The catalogue's authors specified
that "these two pieces merit as much attention for
the tastefulness of their type as they do for the se-
ductive taste of their ornamentation and the perfec-
tion of its finish."[147]

Sold for 2,600 *livres* to an individual named
Abraham, the ewers were probably the same ones
that were auctioned two years later, in November
1784.[148] Since then, there has been no trace of them;
they are known today solely through three drawings,
two of which are shown here. One, in pencil, is a pre-
paratory sketch by Pierre-Adrien Pâris for the plate of
the catalogue from the Aumont sale (fig. 103); the sec-
ond, in watercolor, is the final drawing for the same
plate (fig. 104);[149] and the third, again in watercolor,
shows the second ewer, or the other side of the first.[150]

Pierre-Adrien Pâris, who in the 1770s decorated
Aumont's *hôtel particulier* on Place Louis XV, was
summoned upon the duke's death to participate in
the appraisal of the unfinished gilt bronzes still on
Gouthière's premises.[151] These ewers were among
those items, which meant that Pâris, accompanied
by the bronze-makers François Rémond and Jean-
Baptiste Guyart, had the opportunity to see them on
September 8, 12, and 15, 1782.[152] He probably made
the pencil sketch at this time, which helped him to
produce the watercolor. This image was not, however,
used in the catalogue, which does not reproduce lot
114 from the sale.

The report on Rémond's appraisal is a valuable
source of information on these two ewers, which he
estimated at 1,800 *livres*.[153] The appraisal of the cast-
er Jean-Claude Duplessis, who replaced Guyart, was
slightly lower, at 1,720 *livres*.[154] The silversmith Jean-
Baptiste-François Chéret, who was called in when
the two bronze-makers were in disagreement, valued
them at 1,768 *livres*.[155]

The same faun's head with vine branches and
grapes is found on a pair of ewers in the former col-
lection of the Duke of Talleyrand, sold at Christie's in
Paris in 2005.[156]

C.V.

Fig. 103
Pierre-Adrien Pâris, *Sketch
Representing a Ewer from the
Duke of Aumont*, 1782. Pencil on
paper, 6½ × 4⅝ in. (16.5 × 11. 6 cm).
Bibliothèque Municipale, Besançon
(Fonds Pâris, vol. 453, no. 166)

Fig. 104
Pierre-Adrien Pâris, *Preparatory
Drawing for the Engraving,
Representing a Ewer from the
Duke of Aumont*, 1782. Pencil,
ink, and watercolor on paper,
7⅞ × 5⅛ in. (20 × 13 cm).
Bibliothèque Nationale de
France, Paris (RES V 2586,
pl. 114)

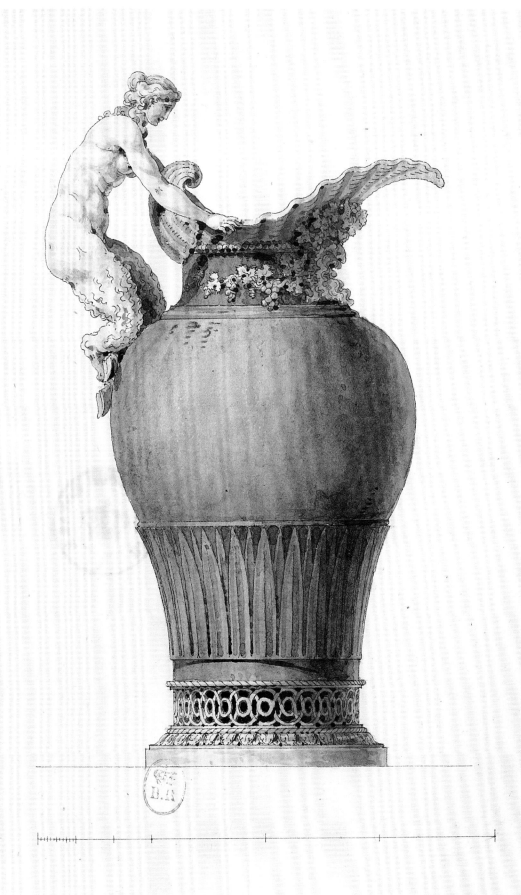

Two Urns

Gilt bronze by Pierre Gouthière after a design by François-Joseph Bélanger
1782
Chinese porcelain, porphyry, and gilt bronze
Each, H. 15 *pouces* (approx. 16 in.; 40.6 cm), according to the catalogue description for the sale of the Duke of Aumont's collections
Whereabouts unknown

Provenance:
Commissioned by Louis-Marie-Augustin, Duke of Aumont, 1782; in the sale of his collections, December 12–21, 1782, lot 163; purchased for Marie Antoinette; transferred to the Muséum du Louvre, 1793; at the end of the eighteenth century, probably sold with other objects from the Muséum du Louvre.

Literature:
Verlet 1980, 207.

At the Duke of Aumont sale in December 1782, Queen Marie Antoinette bought two urns said to be in "lapis-colored old porcelain from China" and ornamented with a gilt-bronze mount by Gouthière. They are known today solely through a pencil sketch (fig. 105) and a watercolor drawing (fig. 106).[157] These drawings were probably made by Pierre-Adrien Pâris when he examined the urns in Gouthière's workshop in September 1782, accompanied by the gilder François Rémond, who noted in his valuation report: "After careful and detailed examination of the ornamentation of the ribbed blue pots, I found that these two objects should not be subject to any decrease and that they are worth the sum of three thousand *livres* for which they are noted in the invoice [of Gouthière, now lost] … 3,000 *livres*."[158] In this atypical case, Jean-Claude Duplessis gave a more generous estimate than Rémond, or indeed Gouthière, at 3,200 *livres*.[159] The silversmith Jean-Baptiste-François Chéret valued them at 3,000 *livres*.[160]

These exceptional items are described in detail in the catalogue of the sale of Aumont's collections;[161] its authors concluded that "they are as precious for the perfection of their form and their color as they are for the ingenious taste of their ornamentation and the merit of their finish." Unsurprisingly, these refined objects were acquired for the queen, for the high price of 4,320 *livres*. Now lost, they probably left the royal collections at the end of the eighteenth century with other objects that belonged to the new Muséum du Louvre.

C.V.

Fig. 105
Pierre-Adrien Pâris, *Sketch Representing an Urn from the Duke of Aumont*, 1782. Pencil on paper, 8 × 5⅜ in. (20.4 × 13.7 cm). Bibliothèque Municipale, Besançon (Fonds Pâris, vol. 453, no. 168)

Fig. 106
Pierre-Adrien Pâris, *Preparatory Drawing for the Engraving, Representing an Urn from the Duke of Aumont*, 1782. Pencil, ink, and watercolor on paper, 7⅞ × 5⅛ in. (20 × 13 cm). Bibliothèque Nationale de France, Paris (RES V 2586, pl. 163)

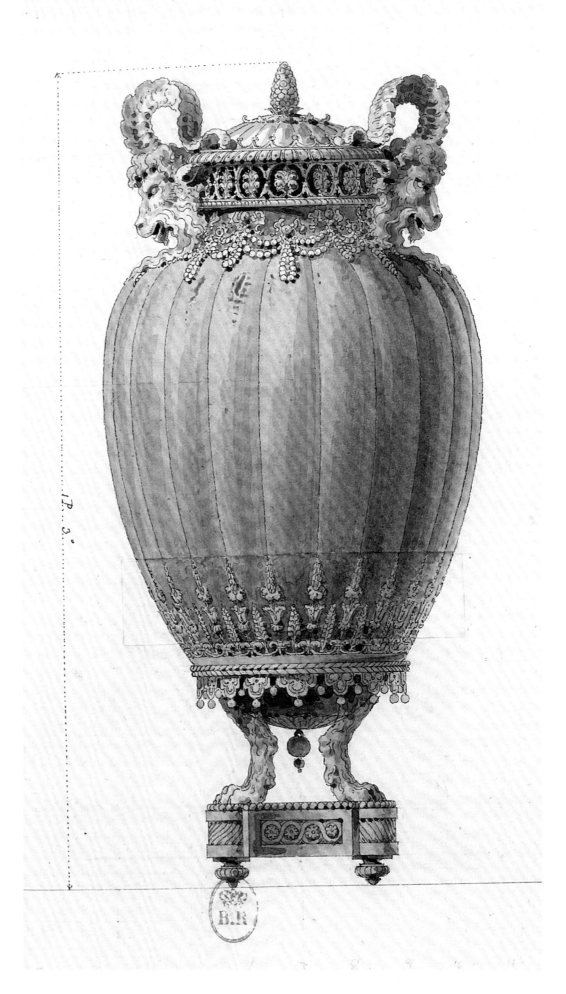

P. 3.°

18

Small Clock with Horizontal Rotating Face

Gilt bronze by Pierre Gouthière
1767
Painted yew, gilt bronze, and enamel
11¾ × 4⅜ × 4⅜ in. (29.5 × 11 × 11 cm)
Inscription on the collar: *FAIT PAR
GOUTHIERE CISELEUR DOREUR / DU
ROY QUAY PELLETIER 1767* (Made by
Gouthiere Chaser Gilder / to the King
Quay Pelletier 1767)
Musée Cognacq-Jay, Paris (J 315)

Provenance:
Bequeathed by Ernest Cognacq to the City
of Paris, 1928.

Literature:
Rondot 1865, 315–16.

This small clock with a horizontal rotating face is a variant of Mme Geoffrin's "small antique monument" (cat. 6), without the nude female figurines. Several examples are known, all signed and dated on their circular bases, under the frieze of acanthus leaves, with an engraved inscription similar to the one found on the Pittsburgh ewer (cat. 4). The attribution of this clock to Gouthière is based mainly on the authenticity of the signature and the similarity of the chasing to that on other Gouthière pieces, notably on the rams' heads on Mme Geoffrin's piece.

This clock originally stood on a column painted in imitation of lapis lazuli, now covered by a thick layer of blue paint,[162] and was therefore related to the piece sold in 1893 at the sale of the collection of Lord Revelstoke, who was probably Edward Charles Baring, first Baron Revelstoke : "397 A CLOCK, with horizontal enameled dial, showing the hour and minute, and with twisted serpent pointer, in case of agate, formed as a vase and cover, mounted with goat's head handles, and a festoon of flowers of chased or-molu, on fluted pedestal of lapis-lazuli and or-molu base, inscribed 'Fait par Gouthière ciseleur doreur du Roy Quai Pelletier, 1767'—12½ *pouces* high."[163] This description matches the Cognacq-Jay clock with the exception of the "case of agate," or most likely in imitation of agate, that is not to be found under the current blue paint.[164]

Other examples are known solely from descriptions in sale catalogues: one is said to be "of black-and-yellow-lacquered wood in imitation of Portor marble" in a sale catalogue from 1989 and again in 1996;[165] another one, in white marble, was sold in 1978 and again in 1981.[166]

Alfred de Champeaux, who saw Natalis Rondot's six drawings in the nineteenth century, maintained that they included one of a small clock signed at the base: *Gouthière ciseleur doreur du Roi*.[167] This may have been a drawing of this model of vase clock with a rotating face.

These small clocks should also be compared to two objects mentioned by Baron Davillier that have not been identified to date.[168] The first is "a lidded vase ornamented with garlands" that stands on a "base of a fluted column . . . the whole in matte-gilded bronze, with burnished areas in silver-gilt tone." This item, which was probably related to Geoffrin's small altar (cat. 6), carried on its base the inscription *Gouthière, Doreur, quai Pelletier*. Davillier described this object as being "rather mediocre, both in terms of the chasing and of the gilding." The second object, similar to the first, is a small gilt-bronze clock signed *Gouthière*, which, according to Davillier, was "unworthy of his reputation." Davillier then added: "We can conclude from this that, while [Gouthière] was an artist, he was also a merchant,[169] and that sometimes he had to have second-rate objects made in his workshops for those who wished to spend little."

C.V.

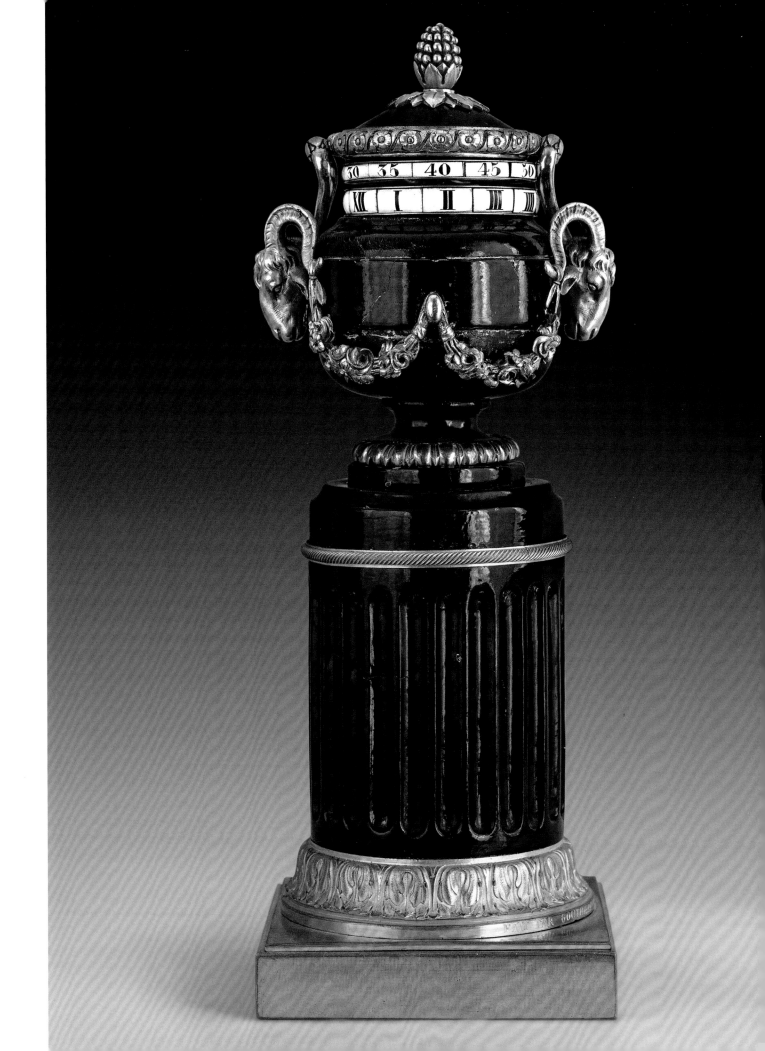

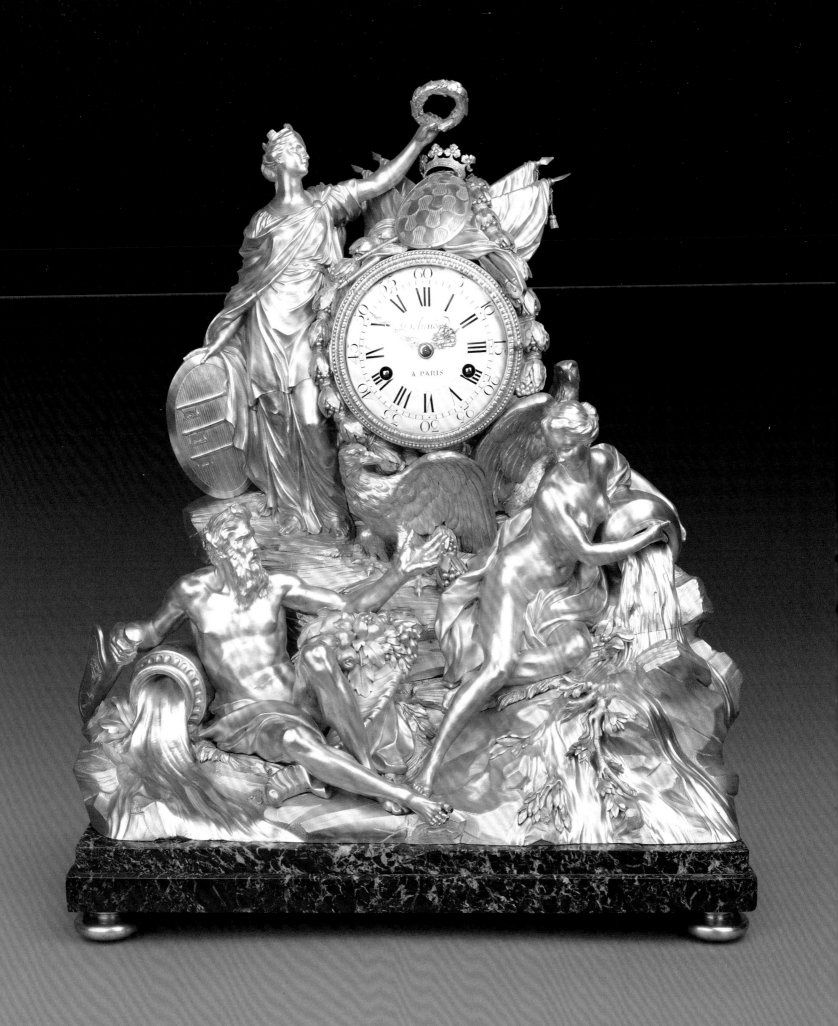

19

Mantel Clock

Movement by Nicolas-Pierre Guichon Delunésy
Gilt bronze by Pierre Gouthière after a design by Louis-Simon Boizot
Enameled dial by Joseph Coteau
Striking spring by Pierre Masson
1771
Gilt bronze, Levanto rosso marble, glass, brass, and enamel
27 × 23 ¼ × 13 ¼ in. (68.5 × 59 × 33.8 cm)
Inscription on the medallion: *BOIZOT FILS / SCULPSIT / ET / EXÉCUTÉ / PAR GOUTHIERE / CIZELEUR ET DOREUR / DU ROY / A PARIS / QUAY PELLETIER / À LA / BOUCLE D'OR / 1771* (Boizot fils / Sculptor / and / executed / by Gouthiere / chaser and gilder / to the king / at Paris / quai Pelletier / at the Golden Buckle / 1771)
The Wallace Collection, London (F258)

Provenance:
Commissioned by Ange-Joseph Aubert on behalf of the consular assembly of the city of Avignon, 1771; presented to the Marquis of Rochechouart, December 1771; in the family by descent; sold De Cayeux sale, Paris, May 25, 1847, from the Château de Courteilles, lot 40; by 1865, acquired by Richard Seymour-Conway, 4th Marquess of Hertford, probably from the dealer Frederick Davis.

Literature:
Molinier n.d., pl. 36; Mantz 1865, 472–73; Davillier 1870, xxi; Vissac 1910, 245–76; Robiquet 1912, 35–36, 171–72, pl. XIII; Marcel 1919, 93–98; Robiquet 1920–21, 35–36, 171–72, pl. XIII; MacColl 1922; Watson 1956, 121–24; Eriksen 1974, 100; Baulez 1986, 580–81; Ottomeyer and Pröschel 1986, vol. 1, 234–35; Verlet 1987, 173, 264–65, figs. 213, 298; Hughes 1996, 463–69; Baulez 2001a, 275–76; Picquenard 2001, 67–69.

On April 13, 1771, the consular assembly of Avignon authorized the commissioning of a gift for the city's governor, Jean-Louis-Roger, Marquis of Rochechouart, to express the high esteem in which he was held and to show gratitude for the role he had played in the transfer of control over Avignon from the Holy See to France. Avignon's first consul, who had personally benefited from Rochechouart's patronage, secured agreement for an ornamental clock "whose pendulum would symbolize the beating of the Heart of the City and whose hands would tell no time that had not been marked by his good deeds."[170] The project was entrusted to the Avignon-born goldsmith-jeweler Ange-Joseph Aubert, who was part of the circle of artists working for the Menus-Plaisirs and who had a fashionable clientele in Paris. Aubert commissioned a design from the sculptor Louis-Simon Boizot, just returned from Rome, and gave the execution of the gilt-bronze case to Gouthière, who was by this time the official gilder of the Menus-Plaisirs and recognized as one of the best chasers and gilders in Paris.

The Avignon clock is one of Gouthière's best-documented works.[171] Boizot's initial design was slightly altered at the request of the consular assembly, and a terracotta model was delivered in July.[172] A drawing in the Musée Calvet in Avignon (fig. 107) has in the past been considered to be the final design, but its soft and rather clumsy treatment makes a Boizot attribution unlikely; and the way in which it copies the clock and its base so precisely suggests it is a later sketch of the finished object, perhaps done as a record for the assembly.[173] Boizot was paid 1,500 *livres* for the modeling, while Gouthière was paid 9,200 *livres* for his work—"bronze, chasing and gilding in the richest manner." Gouthière and Boizot were to work together again after this successful collaboration, on, among other things, a chimneypiece for Mme Du Barry at Fontainebleau (cat. 28).[174]

Boizot's classical composition shows the influence of his time in Italy as a pensionnaire of the Académie de France in Rome. It includes the personification of Avignon, dressed in classical clothing and wearing the battlemented *corona muralis*, holding in one hand a shield emblazoned with the city's heraldry while with the other crowning the Marquis of Rochechouart's coat of arms with a wreath of oak leaves. She stands high on a rocky outcrop, representing that on which the cathedral of Avignon, Notre-Dame-des-Doms, stands. The two finely modeled river gods below represent the Rhône and its lesser tributary, the Durance, from which much of Avignon's prosperity flowed. Supported by two eagles, the clock itself is worthy of its magnificent case, with a movement of exceptional quality and an early example of a half-deadbeat escapement. Nevertheless, in contrast to the high cost of employing Gouthière, Delunésy was paid only 360 *livres* for the clock.

The case is a masterpiece of metalwork, with outstanding chasing. Despite possible regilding in the nineteenth century,[175] the figures are imbued with a life and character worthy of the best sculptors, and the handling of the eagles' wings displays Gouthière's characteristic attention to detail. His treatment of the rocks, vegetation, and fast-flowing water recalls the work of the silversmith François-Thomas Germain (see fig. 63), for whom he gilded objects in the 1760s. The engraved signature on the back of Avignon's shield may denote Gouthière's pride in this work but would also have added luster to the city's gift and is certainly one of the reasons why his reputation flowered in the nineteenth century.

H.J.

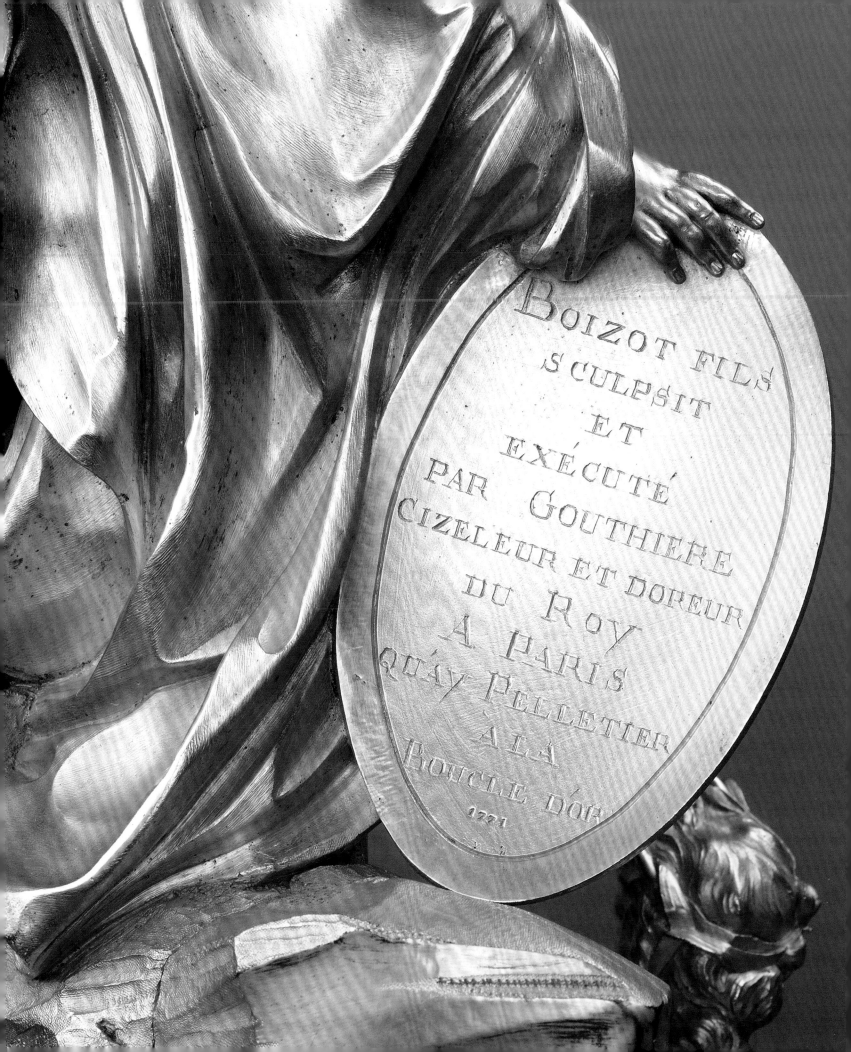

BOIZOT FILS
SCULPSIT
ET
EXÉCUTÉ GOUTHIERE
PAR
CIZELEUR ET DOREUR
DU ROY
A PARIS
QUÁY PELLETIER
À LA
BOUCLE D'OR
1771

Fig. 107
Drawing representing the
Avignon clock, probably
18th century. Pencil on
paper. Musée Calvet,
Avignon (21357)

20

Candlesticks

Pierre Gouthière
Ca. 1765-67
Gilt bronze
13⅞ × 6⅜ in. (35 × 16.5 cm)
Inscription: *GOUTIER, CIZELEUR
DOREUR, QUAI PELTIER* (Goutier, chaser
gilder, quai Peltier)
Private collection

Provenance:
Paris, Hôtel Drouot, June 11, 1986; private
collection.

Literature:
Verlet 1987, 198.

Several candlesticks of this type are known. Engraved on the socle of the one shown is *Goutier, cizeleur doreur* [chaser gilder], *quai Peltier*, and on another one *Gouttier, siseleur, doreur du Roy* [chaser, gilder to the King]. *Quay Peltier*.[176] The latter must have been made after 1767, the year Gouthière received the title of gilder (*doreur seul ordinaire*) to the Menus-Plaisirs, while he probably made the former a few years earlier, around 1765. They reflect the *goût grec*, as seen notably in the compositions of ornament designers such as Jean-François de Neufforge (1714-1791). Futhermore, all known examples of this model are decorated with a Greek key-pattern frieze around the socket,[177] except one pair that is ornamented with an interlacing motif and rosettes,[178] motifs that also appear on the bases of several ewers by Gouthière, including one dated 1767 (cat. 4).

Four candlesticks of this model, attributed to Gouthière in the eighteenth century, were sold at auction in 1778 to a buyer named Léger (or Légère) for 720 *livres* at the sale of Mme de Langeac's collections after her death.[179] Four similar candlesticks, possibly the same ones, were found the following year at the home of her lover, Louis Phélypeaux de la Vrillière, Count of Saint-Florentin, minister to Louis XV. The description in the inventory drawn up following the death of the count places them in the salon on the second floor of his *hôtel particulier* on the Place Louis XV (now the Consulate of the United States of America, Place de la Concorde).[180] They may have been commissioned from Gouthière between 1767 and 1769, during construction of the Saint-Florentin *hôtel particulier*, which was designed by the architect Jean-François-Thérèse Chalgrin, who also built the *hôtel* of

Mme de Langeac in 1773 on the corner of the Avenue des Champs-Élysées and Rue de Berry. These four, or eight, pieces were probably not signed; if they had been, the Langeac sale catalogue and the Vrillière inventory would surely have mentioned this rare feature.

Other examples, possibly the Vrillière and Langeac ones, appeared at auctions in Paris in the late eighteenth and early nineteenth century, notably at the sales of the collections of Mme Légère, on December 15, 1784 (lots 215 and 216); François-Michel Harenc de Presle, on April 16, 1792 (lot 456); and Baron Hoorn van Vlooswyck, on November 22, 1809 (lot 95). They were all 13 *pouces* tall (about 13⅞ in., 35 cm) and 6 *pouces* in diameter (about 6⅜ in., 16.5 cm). Aside from the Harenc de Presle pieces, the catalogues specify that they were matte gilded, which was Gouthière's specialty; however, his name is not mentioned.

It is difficult to know how many pieces were made by Gouthière, all the more so since the model very quickly made its way across the Channel, where it enjoyed considerable success thanks to the firm Boulton & Fothergill, which made copies mainly in silver but also in gilt bronze, both with and without branches.[181] Matthew Boulton may have discovered this model during his visit to Paris in 1765, given that Gouthière was already making them at this time, or else a few years later through engravings or gilt-bronze copies that had reached England.

C.V.

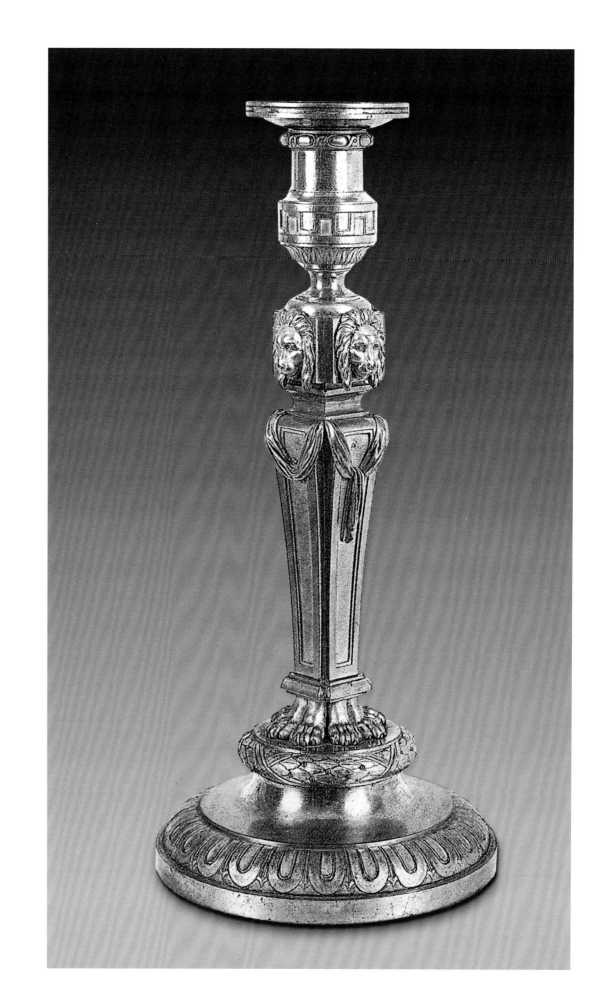

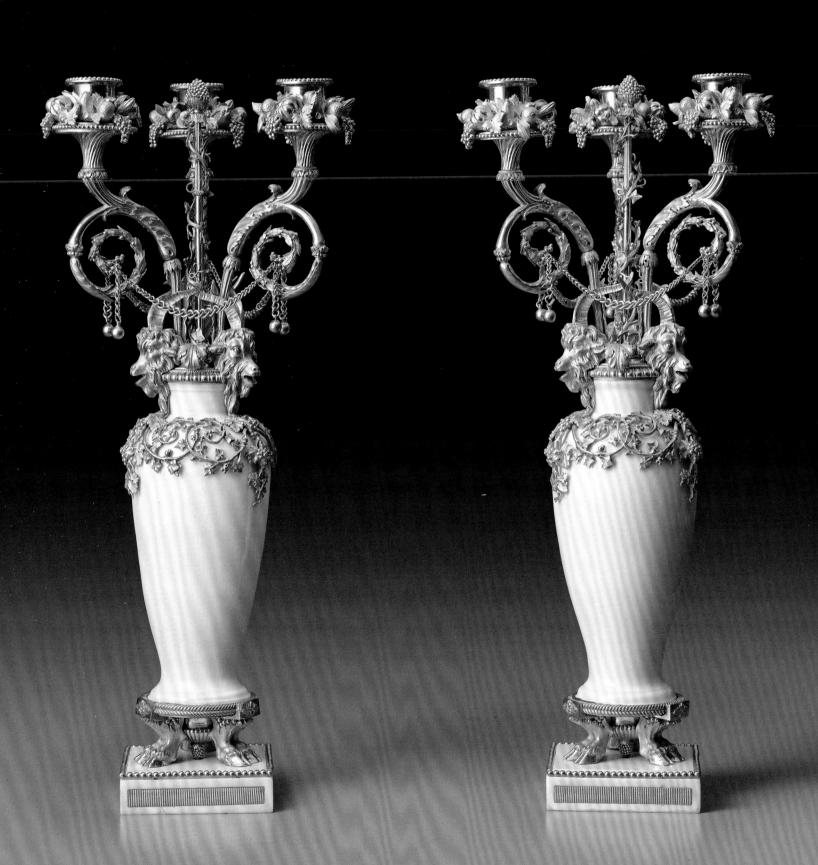

Pair of Candelabra

One vase, hard-paste porcelain,
Meissen factory, ca. 1720; the other,
a later replacement
Gilt bronze by Pierre Gouthière
after a design by François-Joseph
Bélanger, 1782
Hard-paste porcelain and gilt bronze
17⅛ × 6⅞ × 6⅞ in. (43.5 × 17.5 × 17.5 cm)
The Frick Collection, New York;
Gift of Sidney R. Knafel, 2016
(2016.6.01[1-2])

Provenance:
Commissioned by Louis-Marie-
Augustin, Duke of Aumont, 1782; in
the sale of his collections, December
12-21, 1782; purchased by the Duke
of Aumont's son, Louis-Alexandre-
Céleste d'Aumont (1736-1814), Duke
of Villequier, later Duke of Aumont;
sold in Paris, June 7, 1974, lot 68;
Christie's, London, July 10, 2008, lot
92; private collection; acquired by
The Frick Collection, 2016.

Literature:
Davillier 1870, 87-88; Wildenstein
1921, 127, 130.

This unique pair of candelabra was not illustrated in the sale catalogue of the auction of the Duke of Aumont's collections and until recently was known only through the descriptive text in the catalogue.[182] The catalogue authors Philippe-François Julliot and Alexandre-Joseph Paillet, considered them to have an "attractive form," adding that they "brought together a composite set of ornamentation in studied taste." Surprisingly, these two pieces, sprung from the fertile imagination of François-Joseph Bélanger, seduced neither the queen nor the king nor indeed any other knowledgeable collector. It was Aumont's heir, the Duke of Villequier, who bought them for 1,180 *livres*.

Gouthière had finished them just in time for the sale. Incomplete at the time of the duke's death in April 1782, they were subject to a valuation by the casters François Rémond, who estimated them at 1,800 *livres*, and Jean-Claude Duplessis, who put a price of 1,540 *livres* on them.[183]

What distinguishes these candelabra are Gouthière's bronzes, the craftsmanship of which is comparable to that of a goldsmith, contrasted with the simplicity of the white vases. These were considered in the Aumont sale catalogue to be of Meissen porcelain (*ancien blanc de Saxe*), although they appear in the section titled "old white Japanese porcelain" (*porcelaines d'ancien blanc du Japon*). Rémond and Duplessis are vaguer in their description, simply mentioning "old white." Regardless of what Aumont knew about the porcelain, he clearly valued these vases highly to have commissioned such exquisite mounts for them.

C.V.

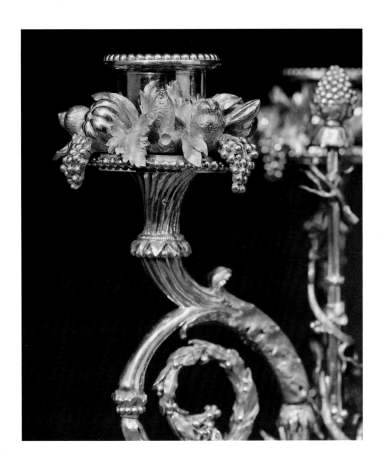

Pair of Wall Lights

Pierre Gouthière after a design by François-Joseph Bélanger
Ca. 1780
Gilded and patinated
28 × 11⅜ × 22 in. (71 × 55 × 29 cm)
Musée du Louvre; gift of the Société des Amis du Louvre, 2002 (OA 11995-96)

Provenance:
Commissioned by Louise-Jeanne de Durfort de Duras, Duchess of Mazarin, ca. 1780; in her former *hôtel particulier* until 1845; probably, Baron James de Rothschild; in the family by descent; acquired by the Musée du Louvre, 2002.

Literature:
Baulez 1986, 583, 634, 636; Faraggi 1995, 81; Mabille 2003a; Mabille 2003b; Alcouffe, Dion-Tenenbaum, and Mabille 2004, 247-51; Duclos 2009, 74-79.

Several of Gouthière's masterpieces were made for Louise-Jeanne de Durfort, Duchess of Mazarin, an enthusiastic and faithful client (see also cats. 26, 35, 39, 49) who was the daughter-in-law of the Duke of Aumont and heiress to the vast Mazarin fortune. Most of the objects made for her, including these wall lights, were intended for the large salon of her *hôtel particulier* (since destroyed and now the site of the École des Beaux-Arts) on the Quai Malaquais in Paris.[184] In a project finished in 1776, this salon, or gallery-salon, was redecorated with wood paneling by the sculptor and ornament designer Gilles-Paul Cauvet and the painter Jean-Baptiste Huet (1745-1811). In 1778, the duchess initiated a further renovation, but her death in 1781 prevented its completion. The project had been entrusted to François-Joseph Bélanger, who had been working since 1774 on the interior decoration of other rooms in the Mazarin residence. It was probably Bélanger who produced the model for these large wall lights with poppy decoration, the design and execution of which are described in meticulous detail on Gouthière's 1781 invoice.[185]

From at least the mid-1770s, Gouthière had been proposing two sizes ("small" and "large") of poppy wall lights to his clients.[186] The modeling and chasing of flowers—especially poppies, the flower of sleep and dreams—seem to have been a particular talent of Gouthière's; in 1818, at the Detaille sale, the editor of the catalogue praised one such pair of wall lights. A splendid design by [187]Jean-François Forty was circulated through prints.[188] However, the most lavish model (after the one for the Duke of Aumont, now lost) was the Duchess of Mazarin's. These wall lights differ from the other models by their size, as well as the extreme richness of the poppy branches with numerous flowers, almost every one different from the others, all features that increased both the time and cost of making the lights. Some of the flowers are buds while others are fully opened to form the candle holders. Because the lights were intended to be hung relatively high, the undersides of the flowers were burnished so they would sparkle with reflected light. To appeal to a client eager for symbolic objects, a quiver of love completed the design of the Duchess of Mazarin's wall lights.

In her will, dated August 11, 1779, the duchess provided for "all the bronzes gilded by Gouthière that are in my large salon" to be left to her lover Radix de Sainte-Foy.[189] The two poppy wall lights were installed in the large salon, where they appear in the inventory drawn up on May 15, 1781, after the duchess's death, valued at only 500 *livres*.[190] They were subsequently included in the two auctions of her collections but were not sold at either.[191] They continued to adorn the Mazarin *hôtel particulier*, which was itself sold in March 1785 to the Marquis of Juigné "with all its ornaments, embellishments, decorations, mirrors, marbles, pictures above doors and chimneypieces, bronzes and caryatids gilded by Gouthière that have remained in the large salon, which were bequeathed to Mr. de Sainte-Foy by Madame the Duchess of Mazarin according to her testament."[192] Faced with the enormous debts his late mistress had left him, Radix de Sainte-Foy gave up his bequest in exchange for 10,000 *livres*,[193] though it had previously been inventoried and valued at 15,000 *livres*.[194]

Meanwhile, Gouthière, who had not been paid by the duchess, battled against her heirs to recover at least some of what was owed to him; this lengthy legal dispute also involved other gilt bronzes ordered from Gouthière by the duchess just before her death (cats. 26, 35, 39, 49). It was not until December 1789 that the bronze-makers François Rémond and Étienne Martincourt handed in their report on the valuation of the Gouthière bronzes.[195]

In 1810, the poppy wall lights were still in the large salon at the Mazarin *hôtel*, which had become the headquarters of the Ministry of General Police.[196] In 1820, the *hôtel* was bought by Vincent Caillard—an entrepreneur who had made his fortune in stagecoaches—with "the paneling, mirrors, mantelpieces, stoves, and other objects that are furnishings in nature but have become immovable fixtures due to their relationship to the decoration of the aforementioned *hôtel*."[197] The wall lights must have been among these immovable fixtures and probably remained there until 1845, when the heirs of Caillard (d. 1843) decided to sell the various elements of the interior before demolishing the *hôtel*. "Mr. de Rothschild," probably James de Rothschild, founder of the French branch of the dynasty, acquired "a door for 10,000 francs" and perhaps also these wall lights, the chimneypiece, and the two pedestals that previously belonged to the duchess (cats. 35, 49), which appear in

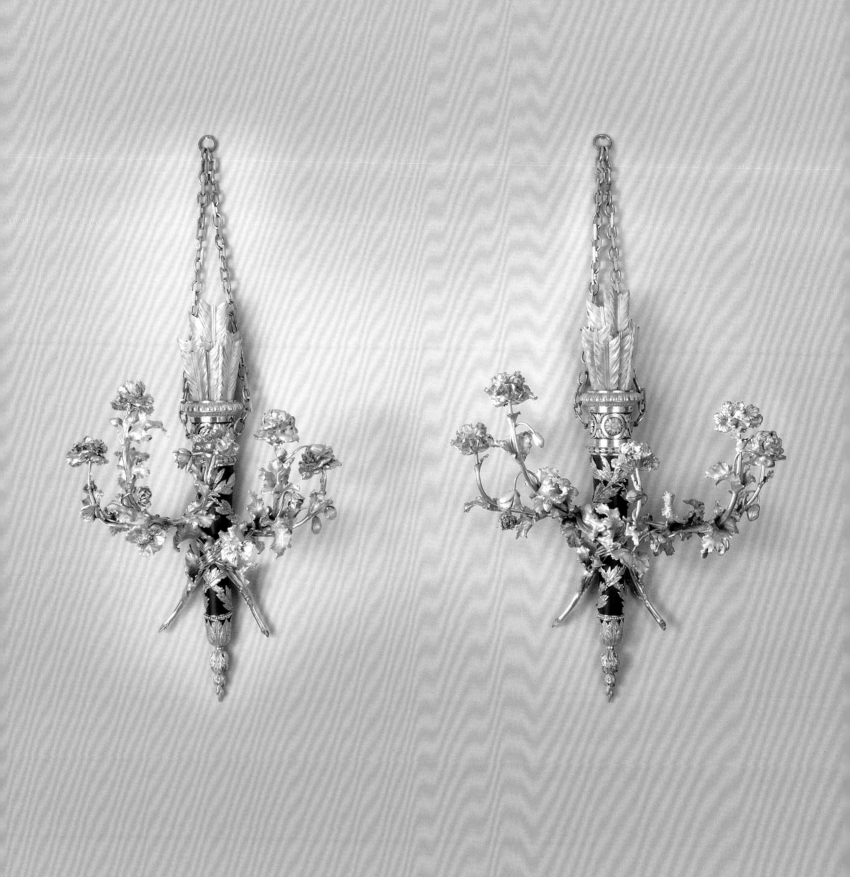

a watercolor by Eugène Lami (see fig. 127) that depicts the large salon at the Château de Ferrières, built between 1855 and 1859 by James de Rothschild.[198]

Gouthière soon made two other pairs of large wall lights with poppy decoration that were identical to the Duchess of Mazarin's.[199] They appear for the first time at the Count of Vaudreuil sale, on November 26, 1787, where they were sold to the luxury goods merchant Mala (probably Charles-Louis Mala[200]) for 1,380 livres and 1,200 livres, respectively.[201] The Count of Vaudreuil may have commissioned them from Gouthière after the sale of the duchess's collections, from which he had acquired the eagle-and-salamander firedogs made by Gouthière (cat. 26). In January 1788, Mala sold them, along with the Vaudreuil firedogs and 290 aunes of taffeta, to the Garde-Meuble de la Couronne for 8,500 livres.[202] A pair of Vaudreuil wall lights was used by the royal family at the Château de Saint-Cloud, probably from around 1788, in Louis XVI's bedchamber, where it is mentioned in the chateau's inventories of 1789, 1790, and 1794; at this time, it was valued at only 720 livres, which may explain why it was sold in the turmoil of the revolution.[203] In any case, all traces of it disappear after 1794. The

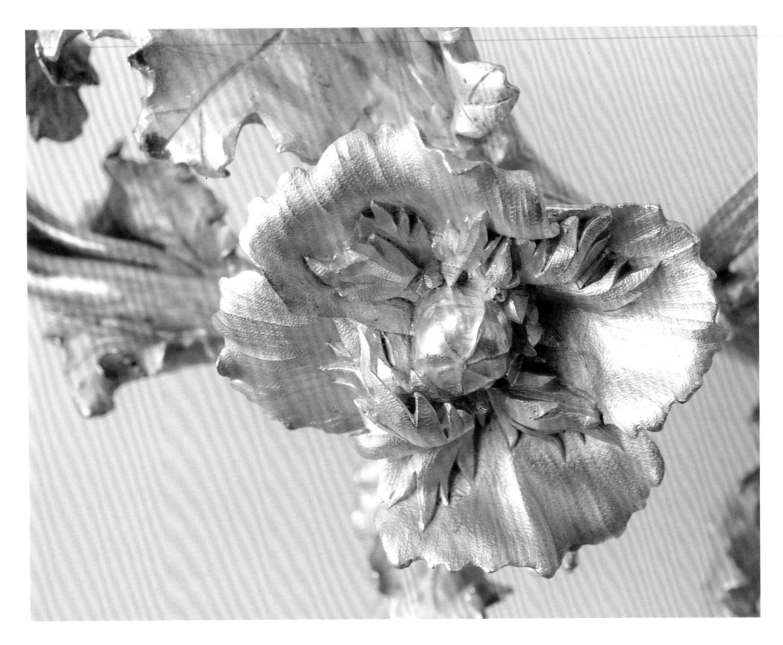

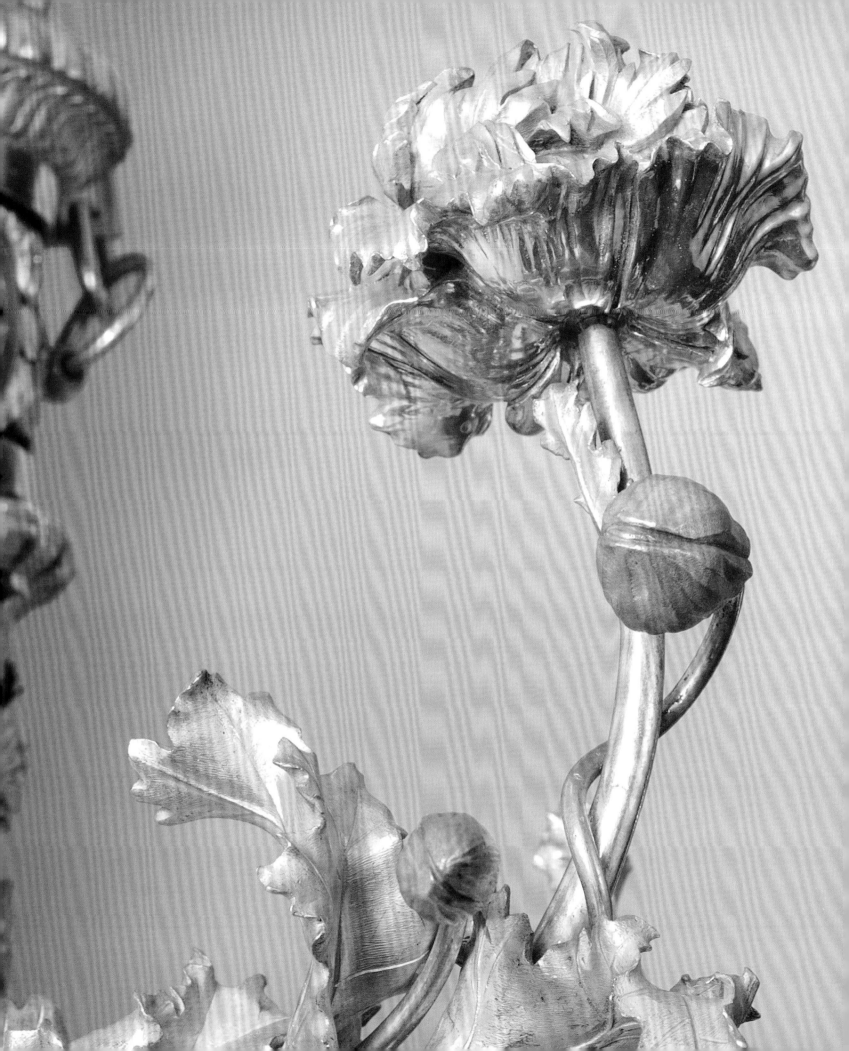

Fig. 109
*Interior of the Residence of
Consuelo Vanderbilt Balsan.*
Plate 78 from L. H. Prost,
*Collection de Madame et du
Colonel Balsan* (1936).

second pair of Vaudreuil wall lights was placed in
the large salon at the Château de Montreuil, then the
property of Madame Élisabeth, Louis XVI's youngest
sister, after being entirely regilded by Pierre-Philippe
Thomire.[204] Lucien-François Feuchère secured it in
1793—at one of the sales held during the revolution
that dispersed the royal collections—for 1,051 *livres*.[205]
This was probably the pair in the collection of the
American Consuelo Vanderbilt Balsan (figs. 108, 109),
in the 1930s and sold in New York in 1995.[206]

This model of poppy wall lights was used in the
nineteenth century to make a fifteen-light chandelier
for Sir Richard Wallace, which was wrongly attribut-
ed to Gouthière.[207]

C.V.

Fig. 108
One of a Pair of Wall Lights.
Plate 91 from L. H. Prost,
*Collection de Madame et du
Colonel Balsan* (1936).

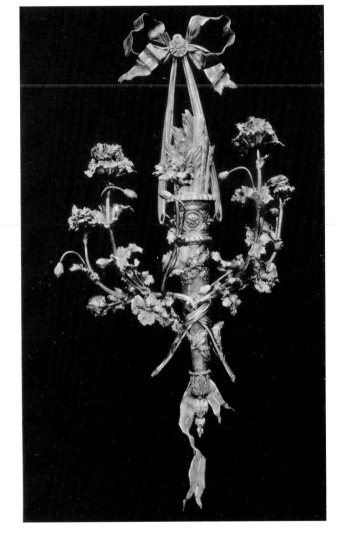

Chandelier

Pierre Gouthière after a design by François-Joseph Bélanger
Ca. 1775–80
Gilt bronze
H. 27 *pouces* 6 *lignes* "including the ornamental cord" (approx. 29¼ in.; 74.4 cm), D. 20 *pouces* (approx. 21¼ in.; 54.1 cm), according to the catalogue description for the sale of the Duke of Aumont's collections
Whereabouts unknown

Provenance:
Commissioned by Louis-Marie-Augustin, Duke of Aumont; in the sale of his collections, December 12–21, 1782, lot 351; purchased for Louis XVI; since lost.

Literature:
Ottomeyer and Pröschel 1986, vol. 1, 238.

One of the few chandeliers made by Gouthière was owned by the Duke of Aumont; it hung in the boudoir that overlooked the Champs-Élysées in the duke's *hôtel particulier* on the Place Louis XV.[208] The chandelier is also the only one known today from the engraving shown, which was in the catalogue of the sale of the duke's collections, and from the preparatory drawing for the engraving, which was by Pierre-Adrien Pâris (fig. 110). The catalogue note written by Philippe-François Julliot and Alexandre-Joseph Paillet indicates ornaments "with arabesque rinceaux" and an upper section "in Chinese taste"[209] and describes the chandelier as "appealing for the grace of its form and the exquisite taste of its ornaments." The "Chinese" inspiration is very discreet on this relatively simple model in comparison with those conceived in the same period by Jean-Démosthène Dugourc (fig. 112), brother-in-law of François-Joseph Bélanger, who probably also designed the one for the Duke of Aumont.[210]

This chandelier was bought by Louis XVI at the sale of Aumont's collections in December 1782, with Paillet as intermediary, for 2,500 *livres*. Despite this high price, it was not included on the list of "precious and intriguing furnishings [*meubles précieux et de curiosité*] acquired for the King at the estate sale after the death of Mr. the Duke of Aumont";[211] so it effectively disappeared. If it did survive the turmoils of France's history, its whereabouts today are not known.

The Duchess of Mazarin liked the model, and, for her Salon Arabesque, Gouthière invoiced 96 *livres* for a model for a chandelier described as "large, like that of the late Monseignour the Duke of Aumont."[212] This was not the first time that Gouthière billed his clients for models that were believed to have been specially made but in fact had already been used.

A model similar to Aumont's chandelier was known from a preparatory drawing for an engraving by Richard de Lalonde (fig. 111). Several copies made in the nineteenth century repeat or are inspired by this model known only through the engraving.[213]

C.V.

Fig. 110
Pierre-Adrien Pâris, *Preparatory Drawing for the Engraving, Representing a Chandelier*, 1782. Pencil, ink, and watercolor on paper, 7⅞ × 5⅛ in. (20 × 13 cm). Bibliothèque Nationale de France, Paris (RES V 2586, pl. 351)

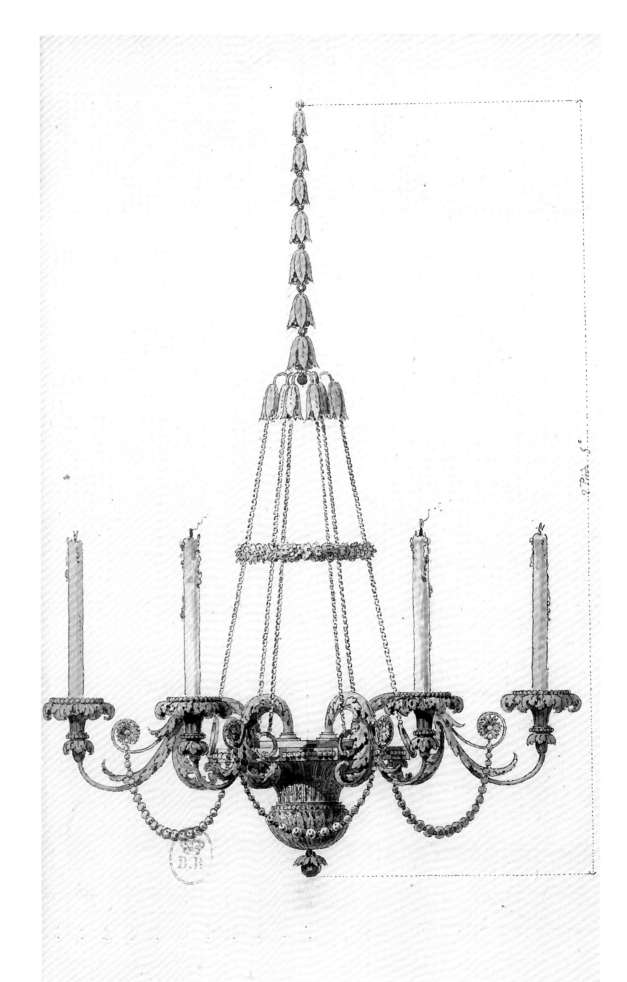

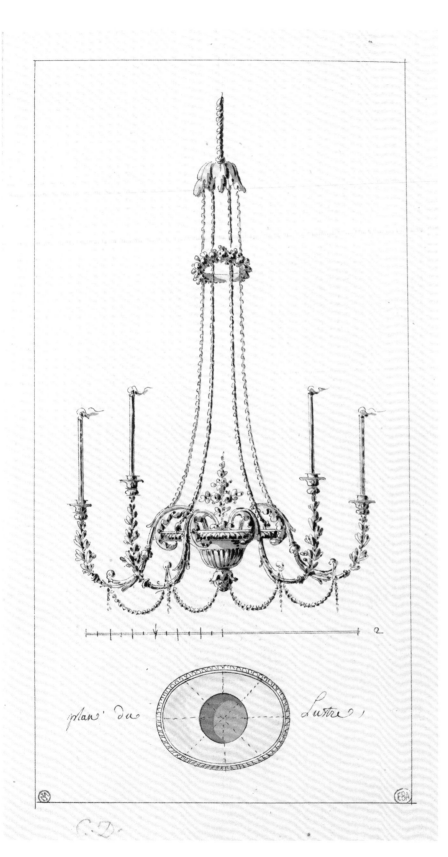

Fig. 111
Richard de Lalonde, *Model for a Chandelier*, ca. 1780. Pencil, ink, and wash on paper, 10½ × 5⅞ in. (26.6 × 14.9 cm). École Nationale Supérieure des Beaux-Arts, Paris (O560)

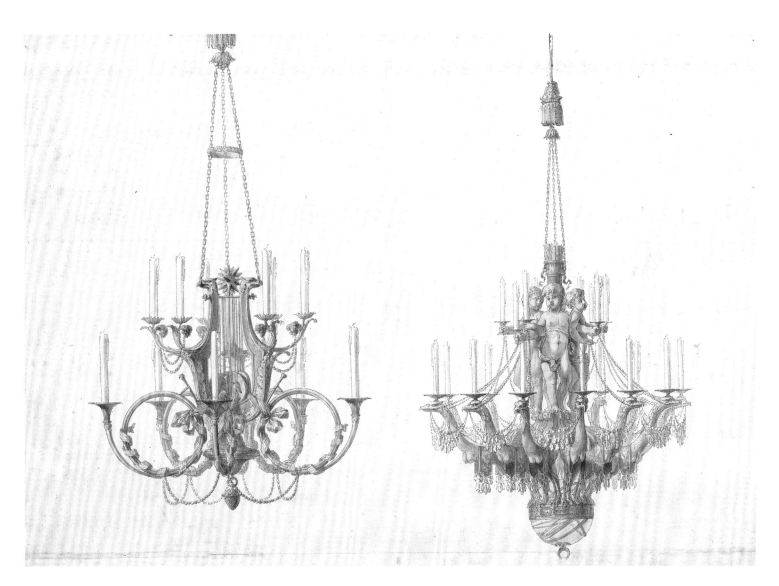

Fig. 112
Jean-Démosthène Dugourc, *Two Chandeliers*,
1777. Pencil, ink, brush, and watercolor on
paper, 8⅛ × 11½ in. (20.5 × 29.3 cm). Cooper
Hewitt, Smithsonian Design Museum, New
York (1921-6-61)

FIREDOGS

Pair of Firedogs

Pierre Gouthière
1771
Gilt bronze
19½ × 18½ × 6½ in. (49.5 × 47 × 16.5 cm)
Private collection

Provenance:
Probably for Mme Du Barry's Grand Salon
Carré at Louveciennes; Galerie Philippe
Delpierre, Paris; private collection

For Mme Du Barry's Grand Salon Carré in her new pavilion at Louveciennes, Gouthière supplied two pairs of firedogs to be placed in the two chimneypieces of white marble and gilt bronze that heated the room. According to Gouthière's invoice, he presented several drawings and models of firedogs to Du Barry "one of which was found to be to Madame's taste,"[214] and this one was used to make the pieces. Gouthière noted that these firedogs were "very rich and are decorated with low-reliefs." They were accompanied by a "shovel and small and large tongs, well chased and matte gilded," for a sum of 7,000 *livres* per pair.[215] The inventory of the pavilion, drawn up in June 1774, describes the ornamentation as being "very rich and in low-relief depicting children's games, surmounted by a three-footed incense burner at one extremity and a vase at the other."[216] The low-relief featuring a child leading a goat to sacrifice—directly inspired by the *Bacchanal of Children with a Goat* sculpted in Rome in 1626 by François Duquesnoy (1597–1643)[217]—evokes a purification by sacrifice, which is, together with smoldering vases and tripods, and Jupiter thunderbolts, the most favored motif for firedogs in the second half of the eighteenth century. Its presence refers to the first element, fire, and is well suited to the purpose of these gilt-bronze objects in fireplaces and their position next to the flames.

This pair of firedogs is identical to one at the Detroit Institute of Arts;[218] they slightly differ from a third pair at the Château de Compiègne[219] in the frieze that decorates the circular bases of the tripods. On this model (and on the one at Detroit), we find a myrtle branch decoration, while the bases of the one at Compiègne are given an interlacing openwork motif. These two examples can be identified as the firedogs supplied for the two fireplaces in Du Barry's Grand Salon Carré at Louveciennes. For the bronze works for the countess's pavilion, Gouthière had used the Venus-related motif of myrtle leaves several times, notably on the chimneypieces (cats. 29, 30); it is therefore highly likely that he repeated the motif on the firedogs. After Du Barry was condemned to death in 1793 and her property seized, the two pairs of firedogs from the Grand Salon Carré were taken to Versailles, where they must have been dispersed during auctions held during the revolution.

The pair of firedogs at the Château de Compiègne is probably from the large salon of the Paris *hôtel particulier* of Princess Kinsky, specifically from the fireplace for which Gouthière had supplied "a large pair of firedogs with incense burners," similar to the two Louveciennes examples, between 1773 and 1775.[220] It was confiscated in 1794 and taken to the national storehouse on Rue de Beaune before being relocated in 1796 to enhance the furnishings of the Palais du Luxembourg, which at that time had become the Palais du Directoire. At this point, the firedogs were described succinctly as "a set of fireplace ornaments comprising a gallery with an antique frieze, and small bas-reliefs depicting bacchanals, carrying incense burners, the whole gilded [*doré d'or moulu*]."[221] Princess Kinsky's firedogs, now part of the national collections, were likely sent to the Château de Compiègne during the First Empire period.

In any case, the versions of the firedogs with incense burners and bacchanals in low-relief that were supplied for Louveciennes and for Princess Kinsky are a reminder that Gouthière did not hesitate to reuse a model. Other examples of this pair of firedogs belonged to the Galerie Étienne Lévy in 1970. Another, with its wrought-iron support missing, was sold on June 17, 1989 (lot 864), at Sotheby's in Monaco.

E.S.

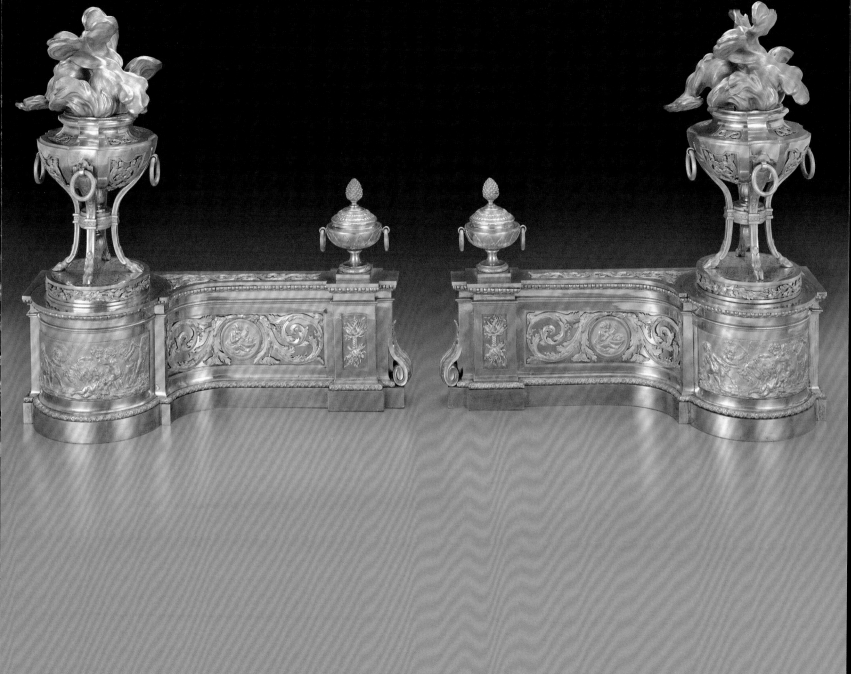

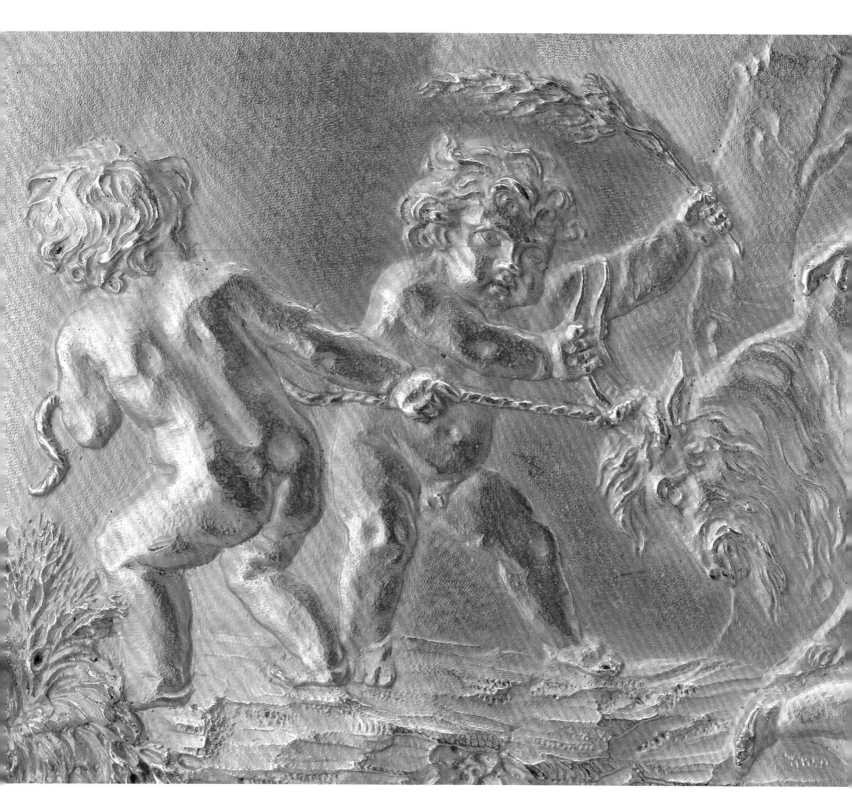

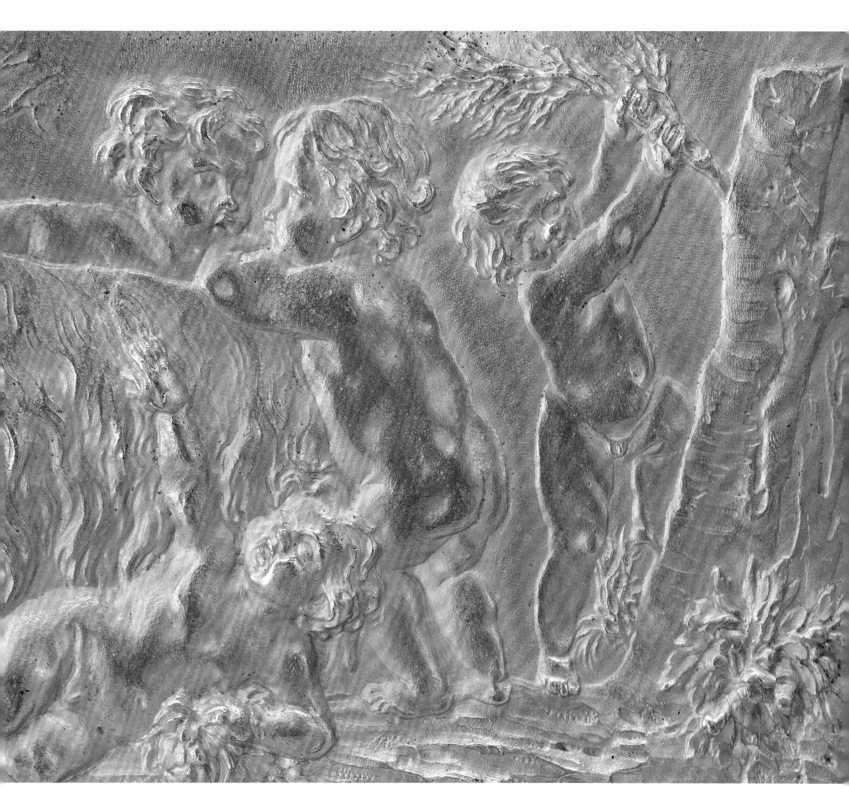

Pair of Firedogs

Pierre Gouthière
1777
Gilt bronze and blued steel
12¾ × 8⅞ × 4⅜ in. (32.5 × 22.5 × 11 cm)
Musée du Louvre; transfer from the
Mobilier National, 1901 (OA 5260)

Provenance:
Commissioned for Marie Antoinette for
the Cabinet Turc at Fontainebleau, 1777;
Lazare Carnot's office in the Palais du
Luxembourg in March 1796; Empress
Josephine's library at the Palais des
Tuileries in 1807; Pavillon de la Muette
in 1808; at the Château Neuf de Meudon
until 1871; entered the Mobilier National,
1874; transferred from the Mobilier
National to the Musée du Louvre, 1901.

Literature:
Baulez 1986, 568; Alcouffe, Dion-
Tenenbaum, and Mabille 2004, 190–91, no.
96; Rondot 2008, 209–10, no. 148; Durand,
Bimbenet-Privat, and Dassas 2014, 466.

In addition to being commissioned by the Bâtiments du Roi in 1777 to produce the gilt-bronze ornamentation for the chimneypiece for Marie Antoinette's Cabinet Turc (cat. 31), Gouthière was also engaged by the head of the Garde-Meuble de la Reine, Pierre-Charles Bonnefoy du Plan, to supply the gilt bronze furnishings (*bronzes d'ameublement*) for the room, which had recently been fitted out in the inner rooms of her apartment at the Château de Fontainebleau. This commission, for which Gouthière was to receive the considerable sum of 19,711 *livres*,[222] included a chandelier, wall lights that were to be brandished by cupids sculpted in the room's wall panels (*boiseries*), and a pair of firedogs for the hearth. The loss of both Gouthière's invoices for his Fontainebleau commission and the archives of the Garde-Meuble de la Reine unfortunately prevents us from knowing the details of this commission.

Of this group of items, only the firedogs, identified as coming from the queen's Cabinet Turc at Fontainebleau, have survived. Small in relation to the mantelpiece, they have an original design featuring two symmetrically arranged seated dromedaries. Each animal rests on a rectangular socle originally set on four feet in the form of inverted pinecones, which must have been lost in the nineteenth century.[223] The fronts of the socles are decorated with a fine, elegant arabesque frieze that matches the ones adorning the central part of the chimneypiece's architrave.

To accompany the firedogs, Gouthière supplied a shovel and tongs, the handles of which feature African heads, echoing the ones that ornamented the painted arabesques by the Rousseau brothers on the room's doors (pp. 258–59). Like the decoration of the shovel and tongs, the dromedary motif contributes to the oriental references essential to the Cabinet Turc, which was meant to transport the queen into a world of fantasy, sensuality, and refinement.

Several versions of these firedogs are known. Two pairs on feet with spiral fluting were sold in Paris: the first in 1978 at the Palais d'Orsay,[224] and the second in 1992 at the Hôtel George V.[225] Two other examples passed through the hands of the Islamic art dealer Oliver Hoare and the antiquarian Frank Partridge in London. They are identical to those in the Cabinet Turc at Fontainebleau, even in the absence of feet, confirming that they are fine copies from the nineteenth century, as were produced by the Beurdeley firm. Indeed, in 1897, a pair of dromedary firedogs was included in the sale of this firm's collection of models, among the "art bronzes with reproduction rights."[226]

E.S.

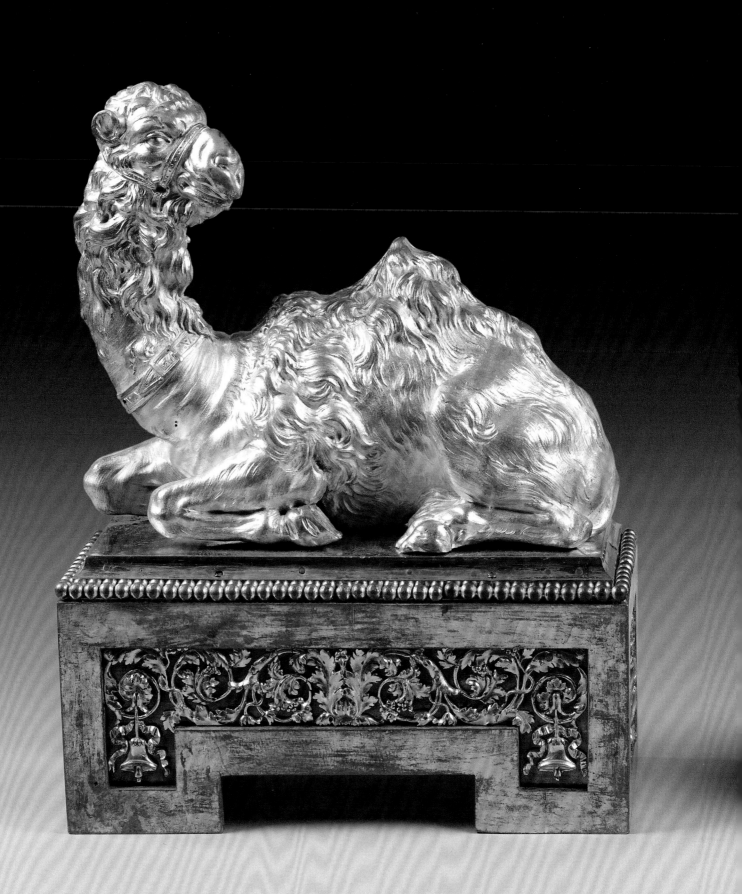

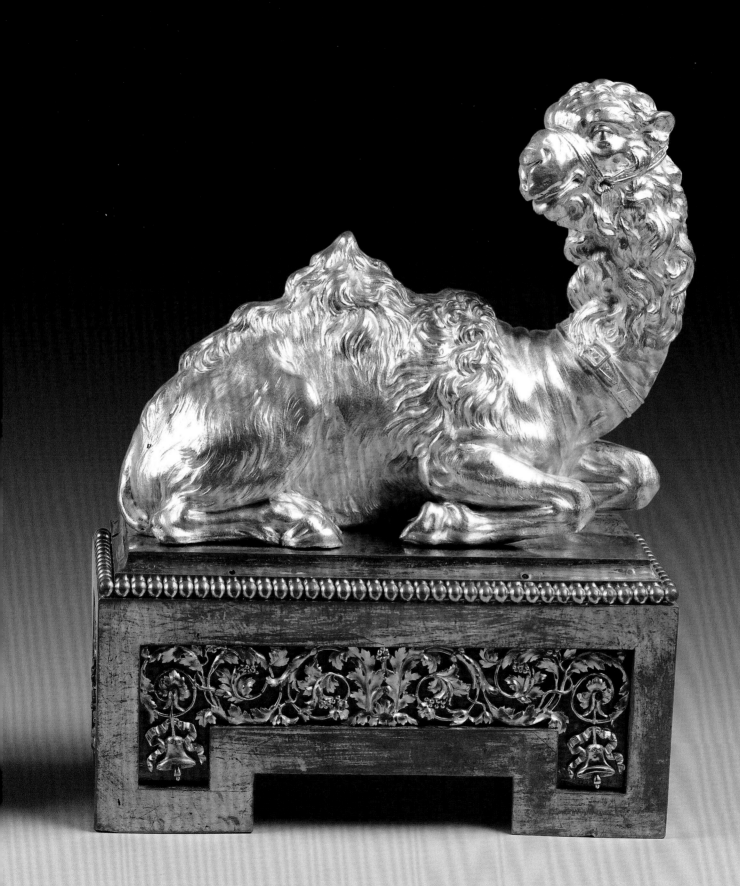

Pair of Firedogs

Pierre Gouthière
Modeled by Philippe-Laurent Roland
After a design by François-Joseph Bélanger
1781
Gilt bronze
18½ × 17⅜ × 7⅞ in. (47 × 44 × 20 cm)
Mobilier National, Paris (GML 3600)

Provenance:
Commissioned by Louise-Jeanne de Durfort de Duras, Duchess of Mazarin, 1781; in the sale of her collection, December 10-15, 1781, lot 284; in the second sale of her collections, July 27, 1784, lot 9; purchased by the Count of Vaudreuil; in the sale of his collections, November 26, 1787, lot 372; purchased by Charles-Louis Mala; sold to the Garde-Meuble de la Couronne, 1788; in the game room at the Château de Saint-Cloud, 1789; reserved to be exchanged, 1793; entered the collections of the Mobilier National; in the large salon of the *hôtel particulier* of the Ministry of General Police (former Hôtel Mazarin), perhaps in 1810; at the Palais Royal until 1875.

Literature:
Véron 1884, 39; Baulez 1986, 583, 634, 636; Gautier 2007, 20-21, no. 6; Duclos 2009, 74-78.

All the gilt bronze in the renovation carried out from 1777 on in the large salon of the Duchess of Mazarin's Paris residence was done by Gouthière. An invoice shows that he was engaged, under the directorship and according to the drawings of François-Joseph Bélanger, to supply two pairs of espagnolettes, a pair of wall lights (cat. 22), gilt-bronze ornaments for the two pedestals between the windows (cat. 49), four torchères, the large blue turquin marble table (cat. 39), and the facing chimneypiece (cat. 35), as well as this pair of gilt-bronze firedogs ornamented with eagles of Jupiter, modeled by the sculptor Philippe-Laurent Roland (1746-1816).[227] The eagles mirror each other, with their wings outspread and each holding a Jupiter thunderbolt and a "salamander" in their claws.

In the inventory drawn up on May 15, 1781, almost two years after the duchess's death, the "pair of firedogs representing eagles, the large and small tongs, and the shovel, made by Gouthière" were valued at 1,000 *livres*.[228]

The catalogue published on the occasion of the sale of the duchess's property on December 10, 1781, and the following days in the *hôtel particulier* on the Quai Malaquais, included a description of the firedogs that differs somewhat from the comments on Gouthière's invoice, which suggests that some undocumented changes had been made to the initial design. This description also allows for a better assessment of the richness of the pieces.[229] Having failed to secure a buyer, the firedogs were auctioned in a second sale held in 1784,[230] at which the pair was acquired by the Count of Vaudreuil. In his *Guide des amateurs et des étrangers voyageurs à Paris*, Luc-Vincent Thiéry describes a white marble chimneypiece in the salon of the Vaudreuil *hôtel* that had gilt-bronze ornaments: "There is to be seen a superb pair of firedogs that has come from the late Madame the Duchess of Mazarin: they are eagles and salamanders."[231] The reference to the firedogs' provenance suggests that Gouthière's work already enjoyed renown.

At the Vaudreuil sale (November 26–December 3, 1787), the firedogs were acquired for 2,000 *livres* by the interior decorator and luxury goods merchant Charles-Louis Mala,[232] who sold them the following year to the Garde-Meuble de la Couronne, along with 290 *aunes* of taffeta and the Duchess of Mazarin's wall lights (cat.

22), for the considerable sum of 8,500 *livres*.[233] The firedogs were then sent to the Château de Saint-Cloud, where, according to the 1789 inventory, they were in the game room, before being incorporated into the national collections at the fall of the ancien régime.[234]

The Duchess of Mazarin's firedogs are the pair preserved today in the Mobilier National. Fully gilded, they have lost the blued background of the socle, against which Gouthière's gilt openwork rinceaux stood out along with the duchess's monogram. These modifications may, however, have been carried out when the firedogs were acquired by the Garde-Meuble de la Couronne in 1788, in order to adapt them to their new royal purpose.

After their time in the collections of the Mobilier National, during the revolutionary period, the Gouthière firedogs were returned to their original function in the First Empire. Indeed, in October 1810, a pair of eagle firedogs was inventoried as being in the large second-floor salon of the *hôtel particulier* occupied by the Ministry of General Police, which had been none other than the Duchess of Mazarin's *hôtel*.[235]

Other examples of eagle firedogs serve as a reminder that the Bélanger and Gouthière model has been copied since the late eighteenth century, as was the satyresses chimneypiece for which it was originally intended (cat. 35). A pair made by François Rémond, now at Windsor Castle (fig. 113), was initially one of two pairs sent in 1787 by the Parisian merchant of luxury goods Dominique Daguerre to adorn the two fireplaces at Carlton House, the London residence of the then Prince of Wales, later to become George IV (1762-1830).[236] There is also a pair of eagle firedogs from the collection of Richard Wallace in the Philadelphia Museum of Art; it is notable for its eagles in patinated bronze (fig. 114).[237] A nineteenth-century version is now in the Malmaison collections.[238]

E.S

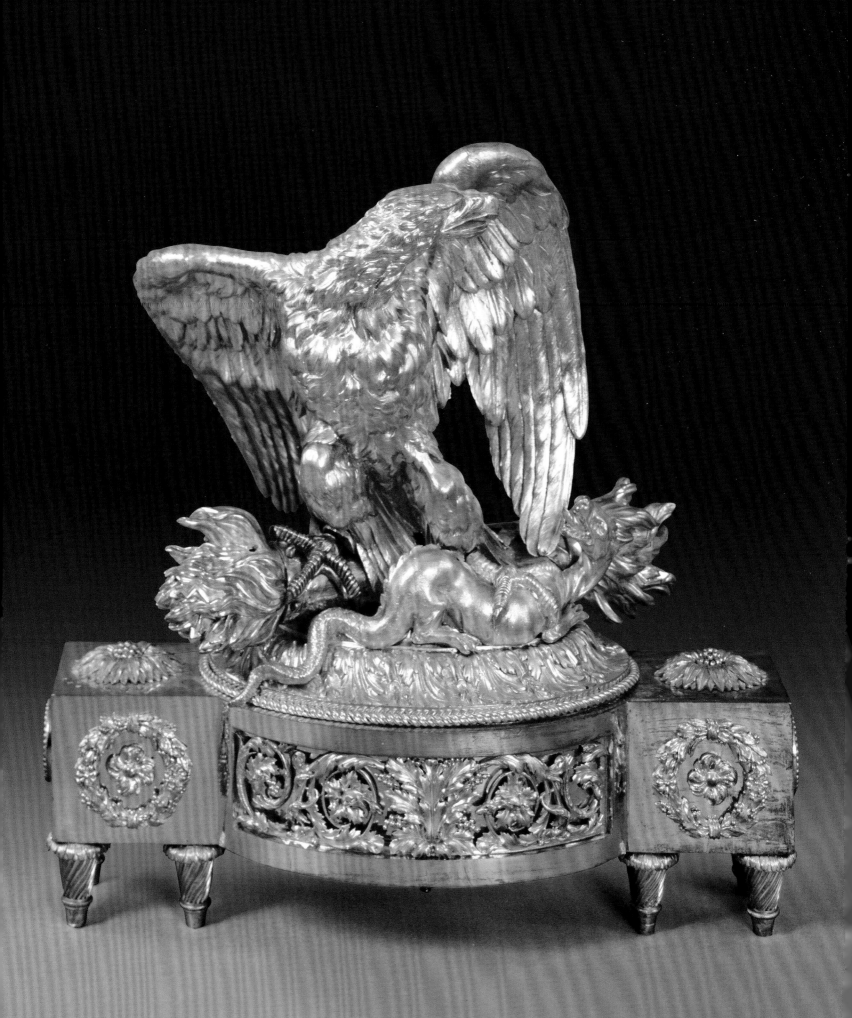

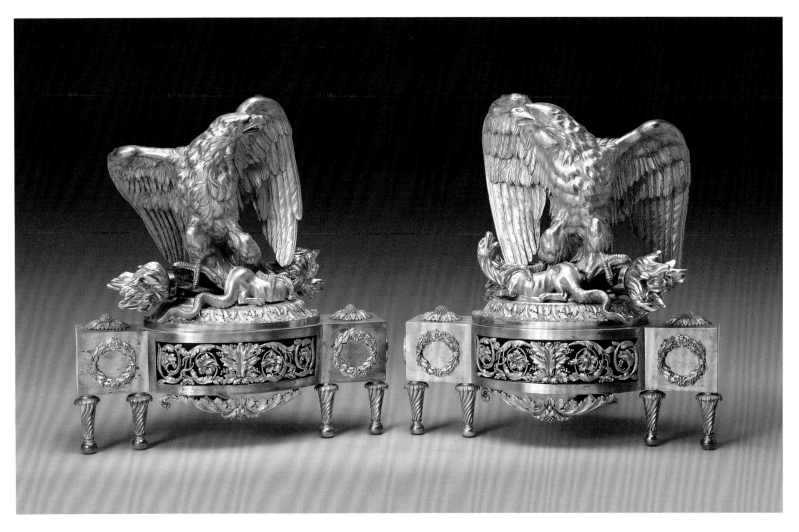

Fig. 113
François Rémond, *Pair of Firedogs*, ca.
1781. Gilt bronze, 17⅞ × 17⅜ × 15⅛ in.
(45.5 × 44 × 38.4 cm). Royal Collection
Trust (RCIN 21664)

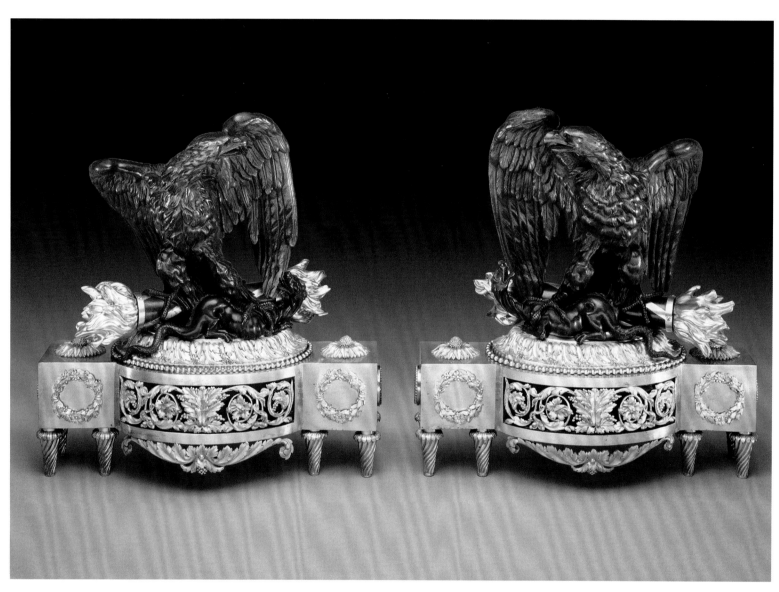

Fig. 114
Pair of Firedogs, ca. 1781. Gilt and
patinated bronze, 17½ × 16½ × 8½ in.
(44.4 × 41.9 × 21.6 cm). Philadelphia
Museum of Art; Bequest of Eleanore
Elkins Rice, 1939 (1939-41-25 a, b)

ARCHITECTURAL ELEMENTS

27

French-window Knob

Pierre Gouthière
After a design by Claude Nicolas Ledoux
Ca. 1770
Chased and gilt bronze
2 × 2¼ in. (5 × 5.8 cm); back plate:
2¾ × ⅜ in. (6.9 × .9 cm)
Musée des Arts Décoratifs, Paris (1002)

Provenance:
Commissioned for the Salon en
Cul-de-Four of Mme Du Barry's pavilion at
Louveciennes, ca. 1770; purchased by the
Musée des Arts Décoratifs at the auction
following the death of the Count of La
Béraudière, Paris, 12 rue de Poitiers, May
27, 1885, lot 732.

Literature:
Hessling and Hessling n.d., 59; Bouilhet
1908, 201; Robiquet 1912 and 1920, 156;
Baulez 1986, 623; Baulez 1992, 19; Mabille
1992, 172.

The Louveciennes pavilion can no longer be viewed in its original splendor, but archival documents, contemporary accounts, and various decorative elements bear witness to the refinement Claude-Nicolas Ledoux sought when conceiving interior decorative schemes for the woman who played such a major role in his success. A rare survivor of a sumptuousness that extended to every little detail, this knob confirms the recollections of Élisabeth Vigée Le Brun, who wrote that "the locks could be admired as masterpieces of the goldsmith's art,"[239] and those of the Count of Hézecques, who reported that "every profession had excelled itself there; not one thing was not a model of taste and delicacy, even down to the hinges."[240] Gouthière's invoice mentions several knobs for both doors and espagnolettes and reveals both their technical complexity and diverse ornamentation.[241] Each is more elaborate than the one before, featuring sunflower petals, garlands of roses and myrtle, some trimmed with swirling ribbons in delicate openwork that enclose the initials of the mistress of the building. This one is the "type of knob made for the tilting casement window" in the Salon en Cul-de-Four, the various stages and cost of the creation of which are described in Gouthière's invoice.[242]

What the invoice does not specify is the original design from which Gouthière worked—a design no doubt supplied by Ledoux, who kept a keen eye on every detail.[243] Gouthière then made a model sculpted in wood. This allowed him to produce a wax model that in turn enabled the creation of the plaster mold for the casting process. Gouthière's considerable talent was brought to bear on the small, rounded surface. Each myrtle leaf is rendered in detail, both similar to and different from its neighbors, forming an extraordinary lacework of leaves that contrasts with the smooth surface of the interlinked *D* and *B* of the royal mistress's initials. Indeed, nothing was too lavish for this woman who, like Mme de Pompadour, was determined to reign over the arts. The artists who contributed to the creation of the pavilion's decor understood this. The choice of myrtle leaves is not insignificant, as these were guarantees of eternal youth. Mme du Barry's enjoyment of this magnificent production was short-lived, however, for, on December 8, 1793, she was guillotined. Her furnishings and property were seized and the pavilion was sold in 1795; if the author of *Paris et ses curiosités* is to be believed, "foreigners bought everything that was movable."[244]

It is not known who acquired the knobs and espagnolettes, and it was not until the sale, on May 27, 1885, of the collections of Jacques Victor, Count of La Béraudière, following his death on January 2 of that year, that four objects described as furniture knobs bearing the monogram of Mme Du Barry reappeared, as lots 732 and 733, one of which had been mounted on a pink oriental granite plaque to form a paperweight. The Musée des Arts Décoratifs was the buyer, for 278 francs. The three others, chased with roses, were the types made for the Salon Ovale,[245] two of them appearing in the Josse collection sale.[246] No espagnolettes or door furniture seems to have reappeared since, or at least none has been identified as coming from the Louveciennes pavilion.

The use of the knob as the basis for a paperweight can be safely credited to the Count of La Béraudière. According to one of his friends, Baron Pichon, he had impeccable taste and a great knowledge of antiques and curios, regularly frequenting collectors and merchants. Perhaps it was from one of these that he bought these knobs, at a time when the Parisian dealers had access to objects testifying to the opulence of the eighteenth century that had eluded foreigners' purchasing power.

Although he knew he owned objects linked to Mme Du Barry, the count was unaware of their primary function since they were described as furniture knobs in the catalogue of the May 27, 1885 sale. One of these he had mounted on a piece of granite. Its dismantling revealed that a screw thread and threaded rod had been added to transform the knob into a paperweight. This modification damaged the small leaves at the center of the back plate, where the knob proper was fixed. There is still some doubt over this back plate, which does not correspond exactly to the description in the invoice. However, this in no way lessens the impressiveness of the chasing, which is worthy of a goldsmith's work, or the quality of the assembly of various ornaments that are as finely designed as a piece of jewelry.

A.F-C.

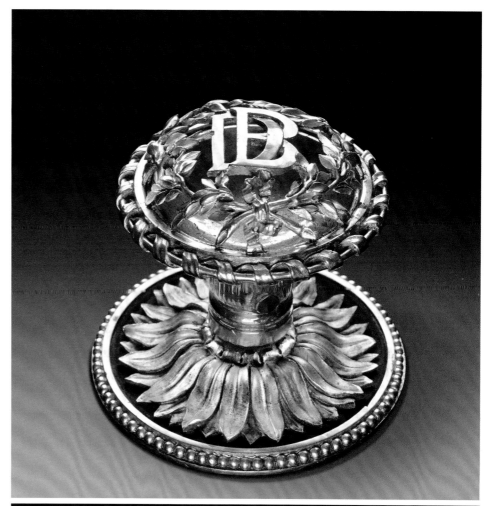

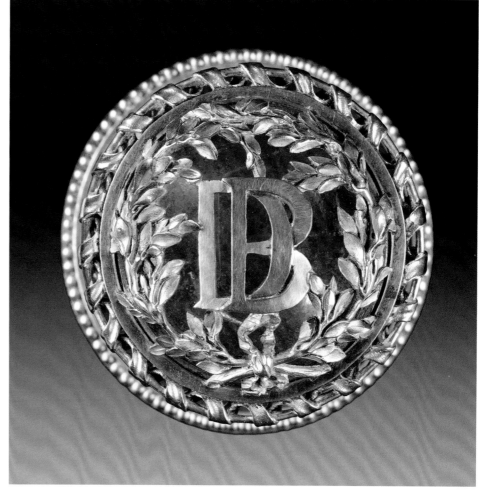

28

Chimneypiece

Marble carved by Louis-Simon Boizot
Gilt bronze by Pierre Gouthière
After a model by Ange-Jacques Gabriel
1772
White Carrara marble and gilt bronze
47⅝ × 75¼ × 18⅛ in. (121 × 191 × 46 cm)
Musée National des Châteaux de Versailles
et de Trianon

Provenance:
Commissioned for Mme Du Barry's salon at
Fontainebleau, 1772; in the Bibliothèque du
Roi at the Château de Versailles since 1774.

Literature:
Baulez 1986, 567-68; Samoyault 1992,
88-92.

During the court's visit to the Château de Fontaineb-leau in autumn 1771, Mme Du Barry obtained permis-sion from Louis XV, her lover, to have a pavilion built in the Jardin de Diane to house a salon. Ange-Jacques Gabriel, the king's principal architect, was entrusted with the planning and construction, as well as the in-terior decoration, of this octagonal room. The sculp-ture on the paneling was executed by the workshop of Honoré Guibert (1720–1791), and the chimneypiece was put in the hands of Du Barry's protégé Louis-Si-mon Boizot, who sculpted two half-figures of infants in white Carrara marble enveloped in gilt-bronze dra-pery on the front of the jambs. These figures are rep-resented in different poses. On the left, the little girl modestly crosses her arms to cover her chest, while on the right the little boy holds the drapery at his waist with one hand, using the other to loosen the bronze fabric that covers his head. As the 1772 invoice reveals, Boizot was also in charge of modeling the bronze ornaments:

> For having made the two marble chimneypiece jambs, consisting of two infants in the form of shafts . . . 1,200 *livres* / For the hollow and plaster models necessary for the execution of the said jambs . . . 400 *livres* / For having reworked [*réparé*] the wax forming the drapery to give them to the chaser to be executed, the full amount for transport costs of the work to various workshops such as those of the marble cutter, the chaser, etc. . . . 200 *livres*. Total 1,800 *livres*.[247]

Two documents attest to the chasing and gilding of the bronzes having been entrusted to Gouthière. The first is a notarial deed of 1784 that records the re-payment to his creditor from sums received, includ-ing 4,300 *livres* out of the 21,714 *livres* of the 1772 in-voice for work carried out at Fontainebleau.[248] The second is Gouthière's petition of March 1, 1786, ad-dressed to the Count of Angiviller, in which he at-tempted to retain the privilege of producing works for the Bâtiments du Roi. In it, Gouthière reminds him that "he made the bronzes and did the gilding of the chimneypiece in the Salon de Diane that has now

been taken to the Bibliothèque du Roi at Versailles, as well as all the other parts of this salon, after the afore-mentioned models that the sculptor of the Académie Mr. Boizot was tasked to make."[249]

The bronze fabric wrapped around the waists and heads of the infants crowned with oak wreaths fol-lows the forms of Boizot's marble with admirable pre-cision. Gouthière knew how to translate the softness of elegantly draped fabric into bronze. Elsewhere, a wreath of roses and branches of rose and myrtle, two symbols of Venus, celebrate Mme Du Barry's charms.

The last royal mistress barely enjoyed her en-chanting new salon and beautiful chimneypiece: she was dismissed from the court upon the death of Louis XV on May 10, 1774, and the room was demol-ished the following month. The decor was put into storage, while the chimneypiece was transported in September 1774, on Gabriel's orders, to the Château de Versailles, to be reused in Louis XVI's new library on the second floor of the chateau, where it can still be admired today (fig. 115).[250]

This chimneypiece model with infants, one of the most charming ever made in the second half of the eighteenth century, is a perfect example of the bal-ance reached between the masculine strictness of straight line, the feminine charm of Gouthière's fine-ly chased floral ornaments, and Boizot's classically calm and beautiful little children.

E.S.

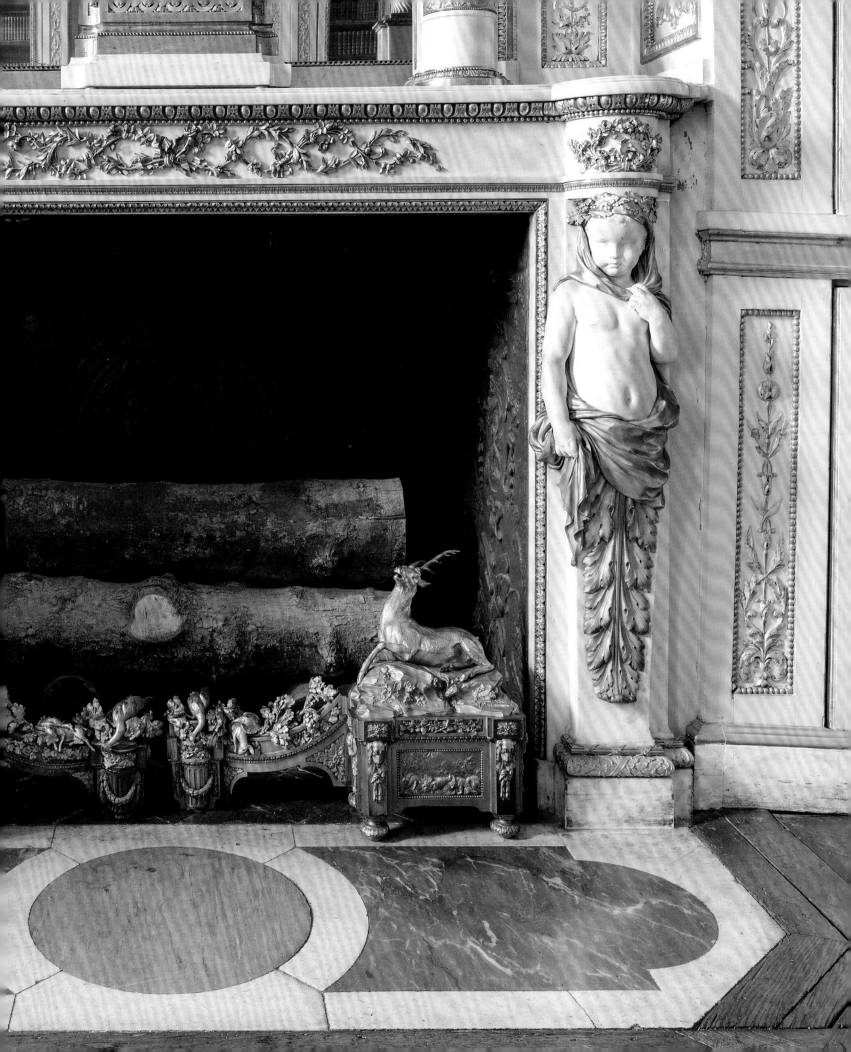

Versailles

Bibliothèque du Roy aux Petits Pié[...]
face de la Cheminée
fait à Versailles ce 18 Juin 1774.

Grands Appartemens.

Gabriel

Fig. 115
Ange-Jacques Gabriel, *Second Design for the New Library of Louis XVI in the King's Private Apartment on the Second Floor of the Château de Versailles, Elevation on the Chimney Side,* June 1774. Pencil and ink with watercolor highlights on paper, 12¼ × 18½ in. (31 × 47 cm). Inscribed *Versailles—Bibliothèque du Roy aux Pleins Pieds des Grands Appartements—face de la cheminée—fait à Versailles le 18 juin 1774.* Signed *Gabriel.* Musée National des Châteaux de Versailles et de Trianon (DESS. 249)

Chimneypiece

Marble carved by Jacques Adan
Gilt bronze by Pierre Gouthière
After a design by Claude-Nicolas Ledoux
1771–73
46 × 72 × 26¾ in. (117 × 183 × 68 cm)
White statuary marble, blue turquin marble,
gilt bronze, and steel
Private collection

Provenance:
Commissioned for Mme Du Barry's Salon
Ovale at Louveciennes, ca. 1770; sold at the
Hôtel George V in Paris, December 5, 1989,
lot 60; private collection.

Literature:
Gallet 1980, 91–93; Baulez 1986, 376–77;
Baulez 1992, 38–40.

In 1769, Louis XV offered his new mistress, Mme Du Barry, the use of the Louveciennes estate. The following year, she had a very expensive pleasure pavilion built there in the fashionable "antique-style" by her architect, Claude-Nicolas Ledoux. The pavilion afforded a magnificent view of the Seine Valley. For the interior decor, Ledoux called upon the most gifted artists of the time: Jean-Baptiste Boiston (1734–1814), Jean-Baptiste Feuillet, and Joseph Métivier for the ornamental sculpture; Augustin Pajou, Félix Lecomte (admitted to the Académie in 1771), and Martin-Claude Monnot (1733–1803) for the sculpture; Jean-Honoré Fragonard, François-Hubert Drouais (1727–1775), Gabriel Briard (1729–1777), Jean-Bernard Restout (1732–1797), and Joseph-Marie Vien for the painting; Jean-François Forty for the decorative painting; and Louis Delanois (1731–1792) and Joseph-Nicolas Guichard (admitted to the Académie in 1765) for the furniture.

As confirmed by invoices, it was Gouthière whom Ledoux engaged, in 1770, for the chasing and gilding of the items destined to adorn the pavilion's interior.[251] Following the architect's designs, Gouthière supplied all the knobs, lock covers, and espagnolettes for the doors and windows, as well as chandeliers, wall lights, firedogs, sets of shovels and tongs, hooks, and the bronze ornamentation for the four white marble chimneypieces. One of these chimneypieces was for the Salon en Cul-de-Four (cat. 30); two other mantelpieces of an identical model (now lost) were to heat the "Grand Salon Quarré" at the center of the pavilion; and the one shown here, the fourth chimneypiece, was for the adjacent Salon Ovale. On May 14, 1771, the Marquis of Marigny instructed a certain Darcy, steward of the king's marbles in Paris, to deliver to the marble cutter Jacques Adan the blocks of white statuary marble needed for the making of the countess's chimneypieces.[252]

The most original and remarkable mantelpiece in the pavilion was that of the Salon Ovale, the jambs of which are made of antique-style tripods in gilt bronze. When designing this model, Ledoux seems to have found inspiration in the engraved inventions of the ornament designer Jean-Charles Delafosse, who published—in his *Nouvelle iconologie historique* (Paris, 1768)—an example of a monument in which

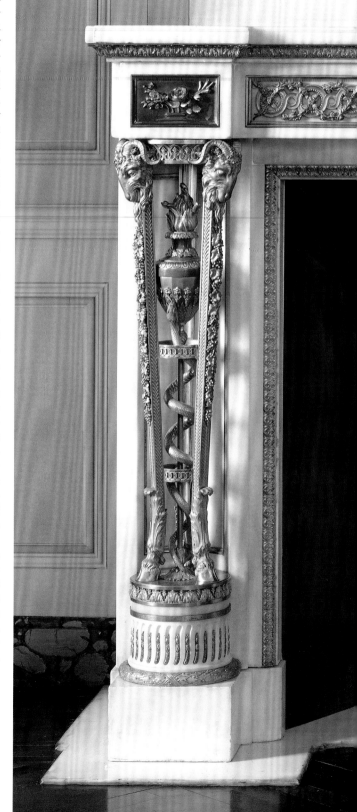

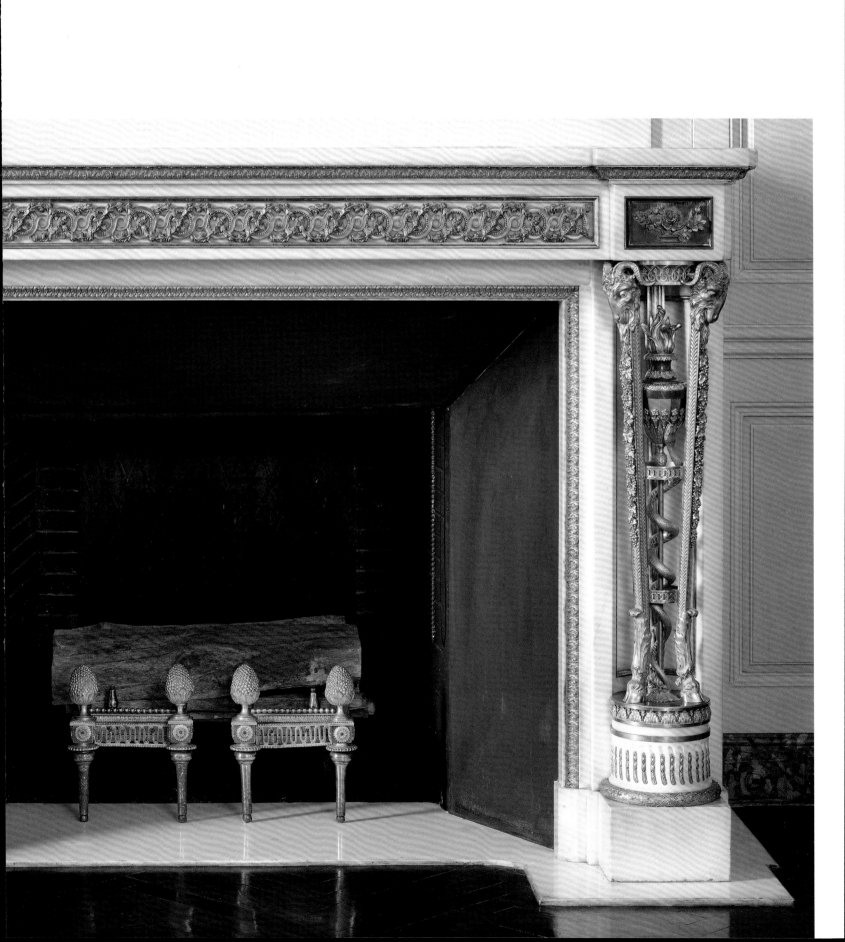

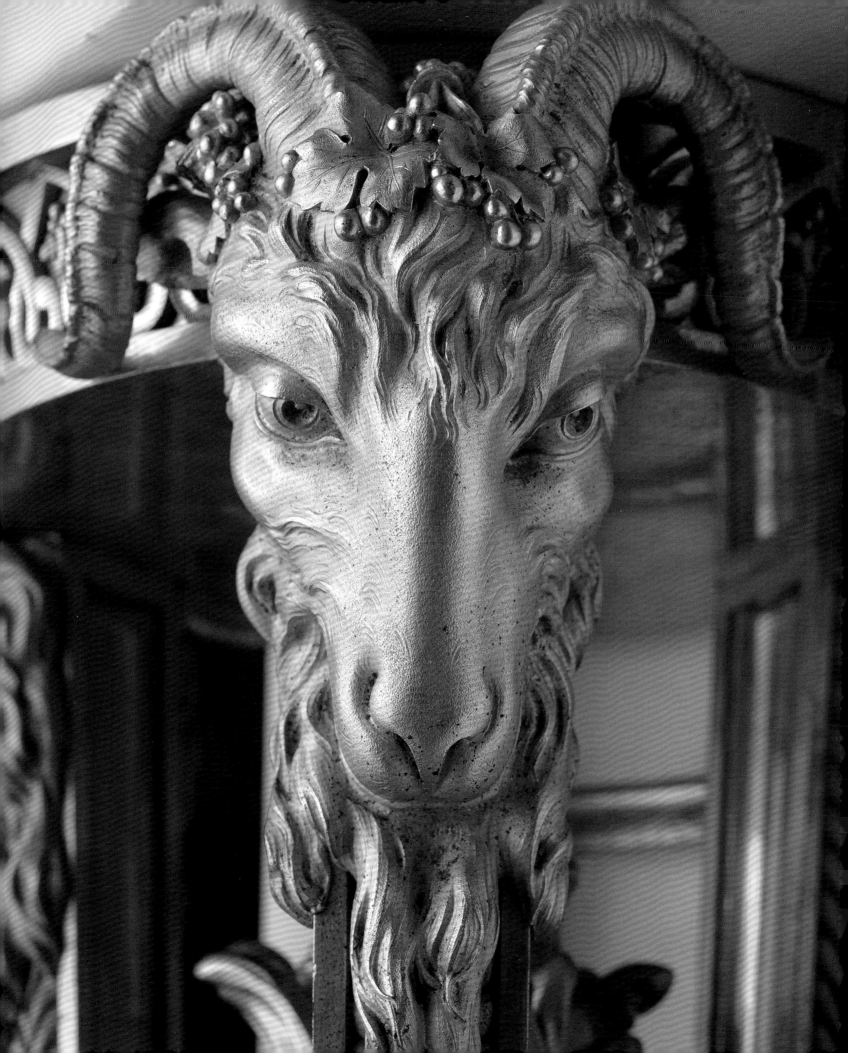

the columns were replaced by tripods (fig. 116). The steps involved in the making of the gilt-bronze ornamentations are meticulously recorded in Gouthière's invoice, which amounted to 10,133 *livres*.[253]

One of the most original features of this chimneypiece are the flaming vases, mentioned in Gouthière's invoice as being made of steel;[254] in reality, they are of blue turquin marble. This contradiction may be explained by a change to the chimneypiece's ornamentation that occurred after the invoice was drawn up. No doubt marble was chosen over steel to enhance the preciousness of the piece.

The tripods on the chimneypiece place the Salon Ovale under Apollo's authority and within the much-fantasized world of antiquity and its train of moral and intellectual virtues. However, the serious character of the tripod motif is counterbalanced by Gouthière's delicate floral decoration, which serves as a reminder that Mme Du Barry's pavilion was viewed as a Temple of Love. The quest for balance, between the antique motifs and the gentler ornamentation inherited from rocaille, became one of the main characteristics of interior decoration in the second half of the eighteenth century in France. This chimneypiece is a masterful demonstration of that.

E.S.

Fig. 116
Jean-Charles Delafosse, *The Four Parts of the Day and the Five Senses of Nature*. Plate 8 from *Nouvelle iconologie historique* (Paris, 1768).

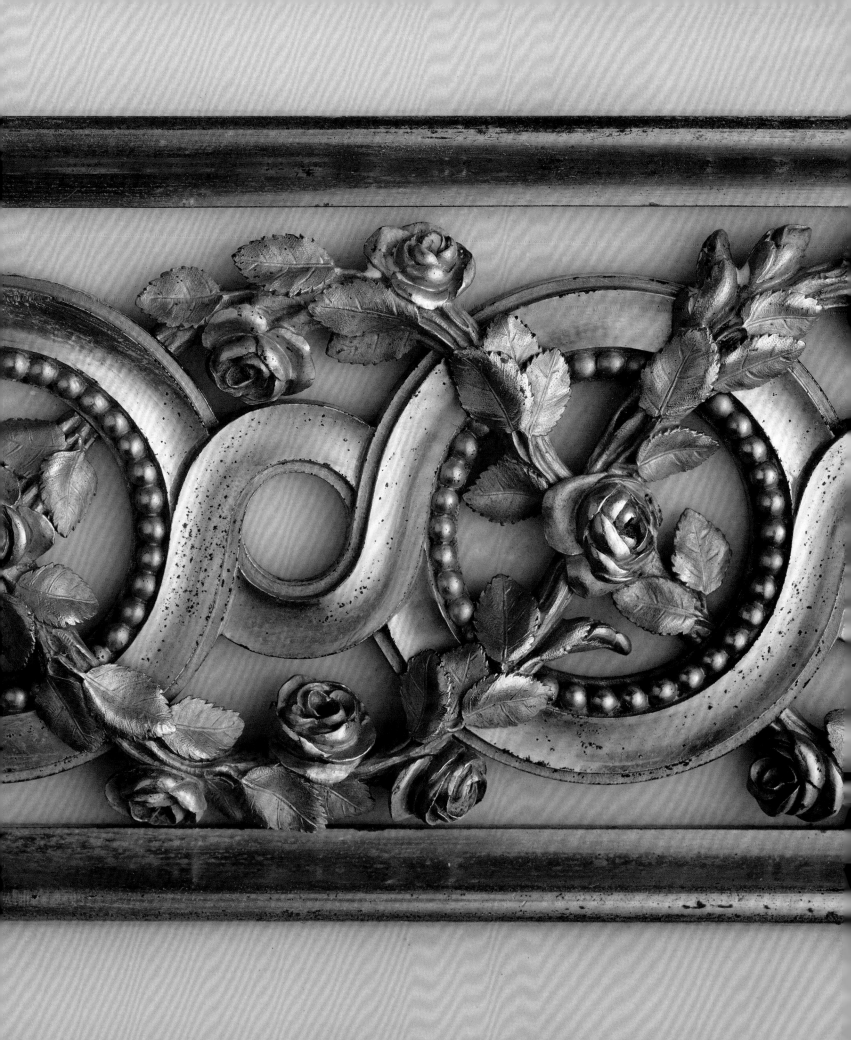

Chimneypiece

Marble carved by Jacques Adan
Gilt bronze by Pierre Gouthière
After a design by Claude-Nicolas Ledoux
1771/1-73
White statuary marble and gilt bronze
44⅛ × 63¾ × 18⅛ in. (112 × 162 × 46 cm)
Private collection

Provenance:
Commissioned for the Salon en Cul-de-Four of Mme Du Barry's pavilion at Louveciennes, ca. 1770; sold at Sotheby's, London, June 14, 1997, lot 56; sold at Sotheby's, New York, January 27, 2012, lot 6; private collection

Literature:
Baulez 1986, 576.

Although not comparable to the tripod chimney-piece of the Salon Ovale (cat. 29) in either originality or luxuriousness, this chimneypiece made for Mme du Barry's Salon en Cul-de-Four at Louveciennes is no less elegant. Having reappeared on the market in 1997 at a sale at Sotheby's in London, it serves as rare evidence of the refinement of the pavilion at Louveciennes's interior decoration, which was dismantled in the nineteenth century and dispersed in private collections.

For this model, Ledoux revived the classical tradition of a decor of solitary columns in front of the jambs, which had been forgotten in chimneypieces of Louis XIV's reign and those sculpted during the rocaille period. The mantelpiece was carved by the marble cutter Jacques Adan in white statuary marble that was delivered in 1771 by the Magasins du Roi in Paris.[255]

The severe character of the straight forms and architectural orders is tempered by delicate bronze ornamentation chased and gilded by Gouthière after designs supplied by Ledoux. Gouthière's invoice, dating from 1773, reveals the various steps for making these bronze decorations—from the preparation of the models and their casting to their chasing and gilding—and how they were fixed to the mantelpiece.[256] It also informs us of the changes that took place. Indeed, the lions' heads on the forward-breaking ends of the architrave were made more recently. Originally, Gouthière had chased a decoration of two rose branches enclosed in a plain ogee molding on each of them.[257] This lost motif must have had a similar composition to the one on the projecting ends of the architrave of the tripod chimneypiece (cat. 29).

The refinement of Gouthière's bronzes can be seen even on the surround of the fireplace opening, with its pierced molding made up of a ribbon spiraling around a stem, which he states that he "made with great mastery."[258] Finally, Gouthière himself fitted the bronzes to the marble mantelpiece. For this last stage, he notes that he "made all the mounts for the bronzes on the marble, did the soldering, filed it back, and made all the iron screws mounted with nuts through the marble, and drilled all the holes with the greatest of mastery."[259] He valued all this work at a little more than 5,752 *livres*.

The Venus-related symbols of rose and myrtle were the common ornaments of the Salon Ovale and Salon en Cul-de-Four chimneypieces, but for the large salon that lay between these two rooms at the center of the pavilion, intertwining vine branches in gilt bonze were chosen to adorn the white marble console chimneypieces. To date, these two mantelpieces have not been located.[260] However, Gouthière's invoice gives us a sense of their beauty, which was already celebrated by his contemporaries, among them, Antoine-Nicolas Dezallier d'Argenville (1723–1796), who wrote of the pavilion's interior decoration: "The most famous artists have pushed themselves to the limit in decorating the living room so deliciously: they seem to have surpassed themselves in the ornaments of the details, such as the locks, the espagnolettes, the cornices, the chandeliers, the firedogs, the wall lights, and the mantelpieces. All these creations are models of the finest and most perfect of what art can beget."[261]

E.S.

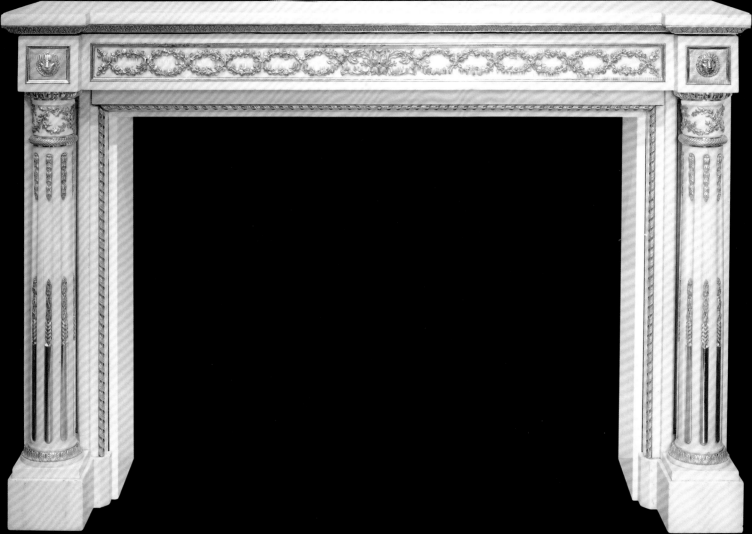

Chimneypiece

Marble carved by Augustin Bocciardi
Gilt bronze by Pierre Gouthière
After a design by Nicolas-Marie Potain
1777
White marble and gilt bronze
40½ × 48⅜ × 11 in. (103 × 123 × 28 cm)
Château de Fontainebleau

Provenance:
Commissioned for the Cabinet Turc of
Marie Antoinette at Fontainebleau, 1777;
in the same room ever since.

Literature:
Baulez 1986, 568-69; Barbier 2005, vol. 3,
608-10; Raïssac 2011, 205-11; Salmon and
Cochet 2012, 13-26; Cochet and Lebeurre
2015, 54-57.

Marie Antoinette's Cabinet Turc at Fontainebleau is the last surviving well-preserved remnant of the extraordinary late eighteenth-century craze for Turkish-style decor, which was particularly favored for small withdrawing rooms. In August 1776, the queen ordered one of her small private rooms, situated on the mezzanine level of her quarters in the Château de Fontainebleau, to be redecorated in the Turkish taste. In February of the following year, Richard Mique drew up the plans and elevations for this new space devoted to royal delectation. It was to be lit from the north by a single window—which could be blacked out, if desired, by a retractable mirror—that overlooked the Jardin de Diane. However, since the room's transformation was funded by Louis XVI, it was ultimately the Bâtiments du Roi administration (represented at Fontainebleau by the architect and surveyor Nicolas-Marie Potain) that oversaw the work. Taking up Mique's designs and completing them with his own, Potain supervised the installation of the room's decor.

The room's pre-existing chimneypiece was to be retained, until a visit from the director of the Garde-Meuble de la Reine, Pierre-Charles Bonnefoy du Plan, who recommended that it be replaced. Potain then informed the Count of Angiviller of his intention to

> change the mantelpieces of the chimneys in the 2nd and 3rd rooms [Cabinet Turc and its anteroom] to make them in a good style and in the taste that the Queen calls Italian, in white marble. He [Bonnefoy du Plan] affirms that the Queen will have them removed if they are not renewed, as she has in other similar cases. It is certain that, in view of the richness and elegance that is proposed to be given to the furniture, the mantelpieces are in too poor a taste for them to be left there. You will be so kind, Sir, as to give me your orders on this subject so that, if you approve of this alteration, I shall not lose any time in preparing designs for it . . .[262]

Having received a favorable response from Angiviller, Potain again set out the design of the chimneypiece for the Cabinet Turc. On June 7, 1777, the architect wrote:

> Here are two drawings that I have the honor of sending you, one is a design for a chimneypiece for the Queen's two rooms. If it meets with your

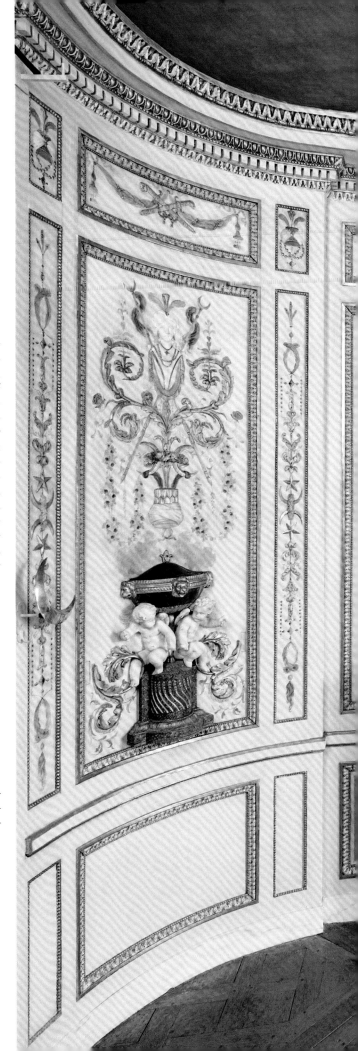

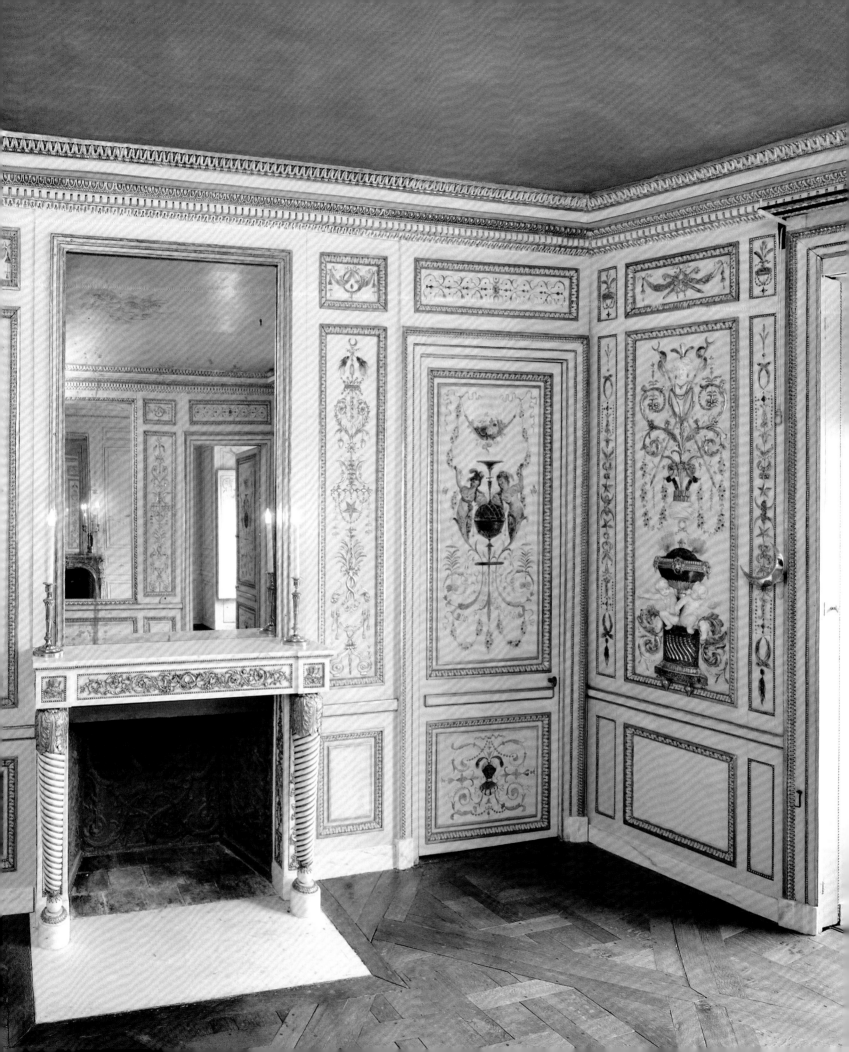

approval, you will be so good as to order half of it only to be made up at full size, by Mr. de Robsy [Dropsy], marble cutter, asking him to inform me when the model is ready so that I can assess its effect and make small corrections to it so that the execution corresponds to the idea. This model will also serve to mold all the parts that will be in bronze, which are generally all the ornamental parts.[263]

Marie Antoinette approved the design of her new chimneypiece, while Potain, in a missive dated July 16, 1777, insisted on the importance of the bronze decor for the harmony of the room:

> I have just received the Queen's acceptance relating to the gilding indicated by the model. Mr. de Bonnefoy brought me the statement of acceptance that Her Majesty signed herself. This decoration imperatively requires the ornamentation of the chimneypiece to be made in bronze to be gilded, and thus to retain the harmony that must reign in this room. I will arrange them in such a way that they will be very light and will afford great repose to the eye.[264]

Although the king's marble cutter, Jacques-François Dropsy (1719–1790), was commissioned to make the preparatory model, it was the sculptor and marble cutter Augustin Bocciardi who carved the white marble mantelpiece on which Gouthière's bronzes were to be fixed. Gouthière had had the monopoly on the supply of gilt bronze to the Château de Fontainebleau since 1772, a privilege he lost in 1777. In his 1786 petition, addressed to the Count of Angiviller, Gouthière reminds him that "he chased and gilded all the bronzes that were ordered in the years 1772, 1773, 1774 and 1777, for the Château de Fontainebleau," before underscoring that the Bâtiments du Roi owed him more than 27,301 *livres*, 8,124 *livres* of which were for his work supplied in 1777 alone. The chimneypiece bronzes for the Cabinet Turc were thus the last pieces Gouthière produced for Fontainebleau.

The bronzes chased and gilded by Gouthière are truly worthy of a goldsmith's hand. The bronze arabesques, stars, and crescents are a match for the sculpted and painted wall paneling by the workshop of the Rousseau brothers. Such interior decorations were intended to pique curiosity and distract the queen by transporting her into a voluptuous fantasy of the Orient. A further reference to the oriental imagination was contributed by the exceptional firedogs ornamented with dromedaries, which were supplied by Gouthière in 1777 for this fireplace (cat. 25).

E.S.

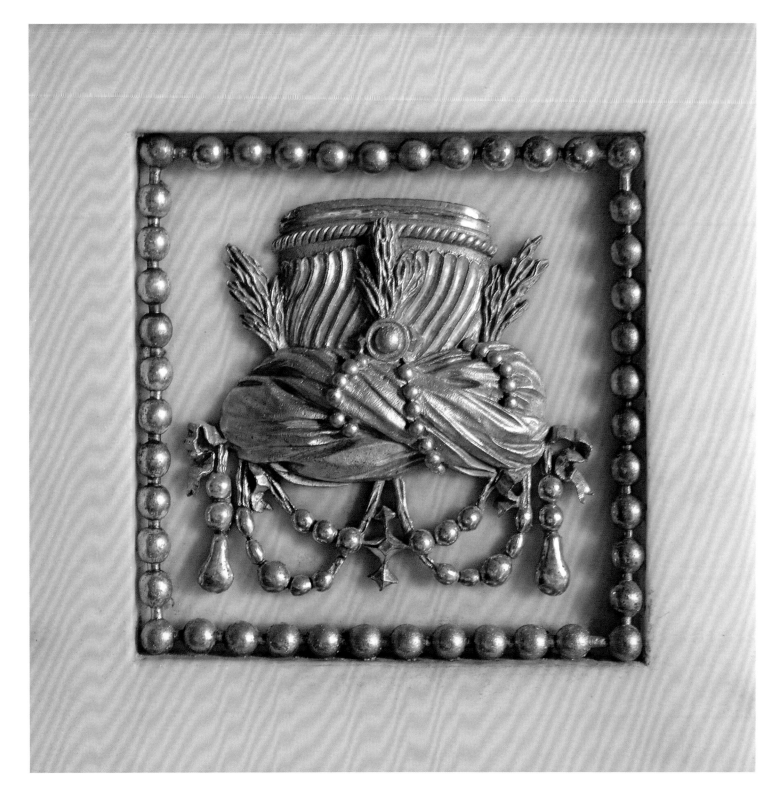

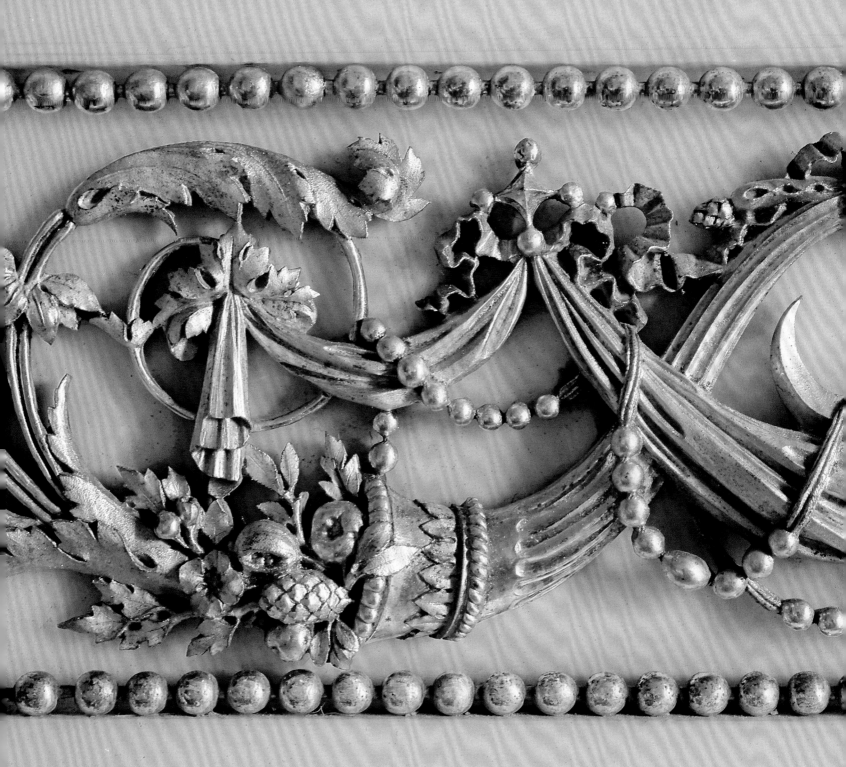

Chimneypiece

Marble carved by Augustin Bocciardi
Gilt bronze by Pierre Gouthière
After a design by François-Joseph Bélanger
1777–78
White veined marble and gilt bronze
52 × 74⅜ × 20⅞ in. (132 × 189 × 53 cm)
Whereabouts unknown

Provenance:
Commissioned for the ground-floor salon
of the pavilion at Bagatelle, ca. 1777; stolen
in the 1980s.

Literature:
Baulez 1986, 572-74; Baulez 1988, 143-45.

In 1777, as the result of a wager between the Count of Artois and his sister-in-law, Marie Antoinette—in which she challenged him to have the pavilion at Bagatelle restored in 100 days or less—the count engaged his architect, François-Joseph Bélanger, to direct the necessary work. Bélanger entrusted the carving of all the marble chimneypieces to Augustin Bocciardi.[265] Five of them were given gilt-bronze ornamentation[266] by Gouthière, who had been chaser-gilder to Artois since January 6, 1775. Gouthière's involvement at Bagatelle is attested to by the invoice of works of the joiner Denis-Nicolas Carbillet, in which he notes that he had "supplied three pilaster pieces in pine to Mr. Gouthière for him to model the chimneypiece wall lights for the salon."[267] On December 18, 1787, when Gouthière was forced to surrender his assets to his creditors, he had received only 18,000 of the 36,000 *livres* that Artois's Bâtiments administration owed him for work carried out at the king's youngest brother's various residences. This considerable sum must have included payment for the gilt-bronze ornaments of the five chimneypieces at Bagatelle.[268]

Covered by a coffered dome and lined with eight arches with arabesque decoration in stucco, the circular ground-floor salon was the most lavish room in the new princely pavilion. In early October 1778, Bocciardi delivered the salon's white veined marble mantelpiece, which was installed in the embrasure of the south arcade, facing the three arched windows that opened onto the gardens.[269] Although the chimneypiece was stolen in the 1980s, its form and gilt-bronze ornaments are known from Bocciardi's invoice and rare photographs of the salon (figs. 117–119).[270]

Carved after Bélanger's designs, the imposing chimneypiece was made up of two console jambs that supported the architrave with cubic projecting ends topped with an overhanging shelf. For this piece, Bélanger proposed a modern reinterpretation of Italian Renaissance chimneypiece forms, in particular those of the architect Sebastiano Serlio (1475–1554).[271] The chimneypiece's originality and richness were accentuated by Gouthière's gilt-bronze ornaments, notably a complex openwork frieze on the architrave, the delicacy and elegance of which softened the strict classicism of the marble mantelpiece.

Two gilt-bronze hooks in the shape of crescents and ornamented with snakes, intended to support the accompanying shovel and large and small tongs, were fixed to the center of the marble lining of Bocciardi's chimneypiece. This pair of hooks had been supplied in 1787 by François Rémond, who gradually took over from Gouthière from the early 1780s on in the maintenance and supply of gilt-bronze pieces to the Count of Artois.

E.S.

Fig. 117
Chimneypiece from the salon
of Bagatelle. Plate 3 from
*Monographie du château de
Bagatelle: intérieurs et extérieurs*
(Paris, n.d.).

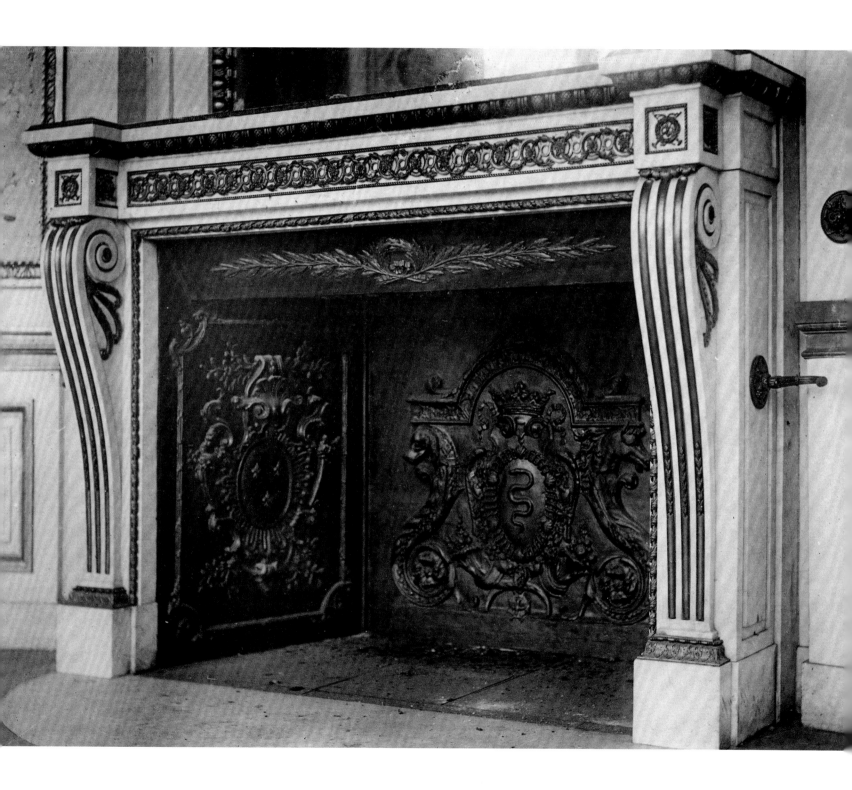

Fig. 118
Details of the chimneypiece from
the salon of Bagatelle. Plate 2
from Jules Vacquier, *Les anciens
châteaux de France, L'Île-de-
France, Bagatelle, Chantilly,
Saint-James* (Paris, 1920).

Fig. 119
Charles Marville, *Grand Salon.*
Plate 37 from *Bagatelle jusqu'à
1870*, ca. 1870. Bibliothèque
Nationale de France, Paris

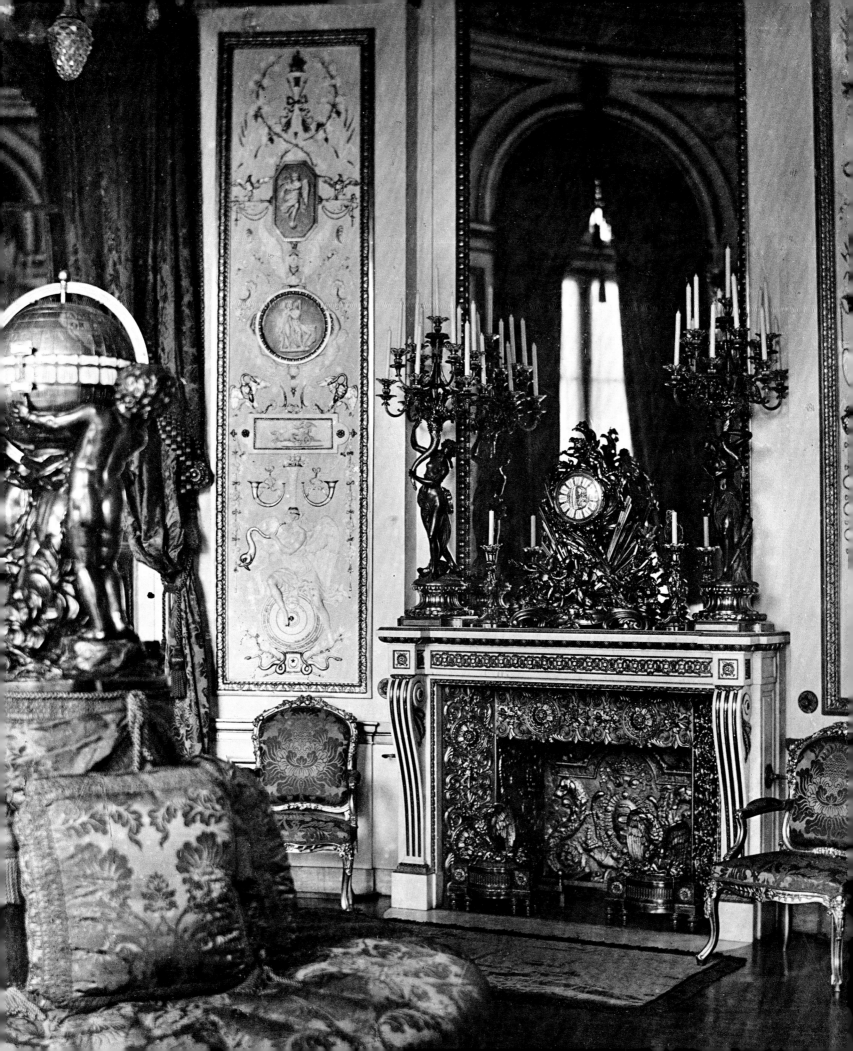

Chimneypiece

Marble carved by Augustin Bocciardi
Gilt bronze by Pierre Gouthière
After a design by François Joseph Bélanger
1777–78
Blue turquin marble and gilt bronze
38¼ × 48⅜ × 12¼ in. (97 × 123 × 31 cm)
Whereabouts unknown

Provenance:
Commissioned for the ground-floor boudoir
of the pavilion at Bagatelle, ca. 1777; stolen
in the 1980s.

Literature:
Baulez 1986, 574; Baulez 1988, 143–44.

For each side of the circular ground-floor salon of the pavilion at Bagatelle, Bélanger furnished two small rectangular alcove rooms, each lit by a north-facing window overlooking the gardens (see fig. 18). Used as a bath chamber, the room to the west of the salon was remarkable for six large Italianate Hubert Robert landscapes set into the upper parts of the wall paneling.[272] The room to the east of the salon served as a boudoir and was decorated with six erotic mythological scenes by the painter Antoine-François Callet (1741–1823).[273]

It was for the latter room that, between December 8 and 12, 1778, Augustin Bocciardi supplied a chimneypiece in blue turquin marble.[274] Both the rather high opening of the fireplace and the columns of the jambs recall the architectonic form and composition of classical English chimneypieces that Bélanger, the most Anglophile of French architects, had studied during his stays across the Channel in the 1770s.[275]

The relatively even gray-blue color of the marble of the chimneypiece enhanced the sober but elegant ornaments in gilt bronze, which were executed by Gouthière. They notably included, on the architrave, a frieze of alternating seed fleurons and palmettes, which seems to have been borrowed from Piranesi's *Diverse maniere*.[276] A similar model of frieze was chosen by Bélanger at the same period to adorn the architrave of the chimneypiece in the large salon of the Duchess of Mazarin's *hôtel particulier* in Paris (cat. 35). As Bocciardi's invoice reveals, the marble sides of the chimneypiece were also given gilt-bronze ornaments; indeed, the Count of Artois's marble cutter noted that he had pierced six holes on "the chimney surface for the cascading flowers and fruits."[277]

In early December 1778, Bocciardi supplied a chimneypiece for the bath chamber that was identical to that of the boudoir. The only difference was in the type of the marble, since the bath chamber chimneypiece was in *vert d'Égypte* (fig. 120).[278]

E.S.

Fig. 120
Detail of the chimneypiece from
the bath chamber of the Count
of Artois at Bagatelle. Plate 55
from *Monographie du château de
Bagatelle: intérieurs et extérieurs*
(Paris, n.d.).

Fig. 121
Chimneypiece from the
boudoir of Bagatelle. Plate 31
from *Monographie du château
de Bagatelle: intérieurs et
extérieurs* (Paris, n.d.).

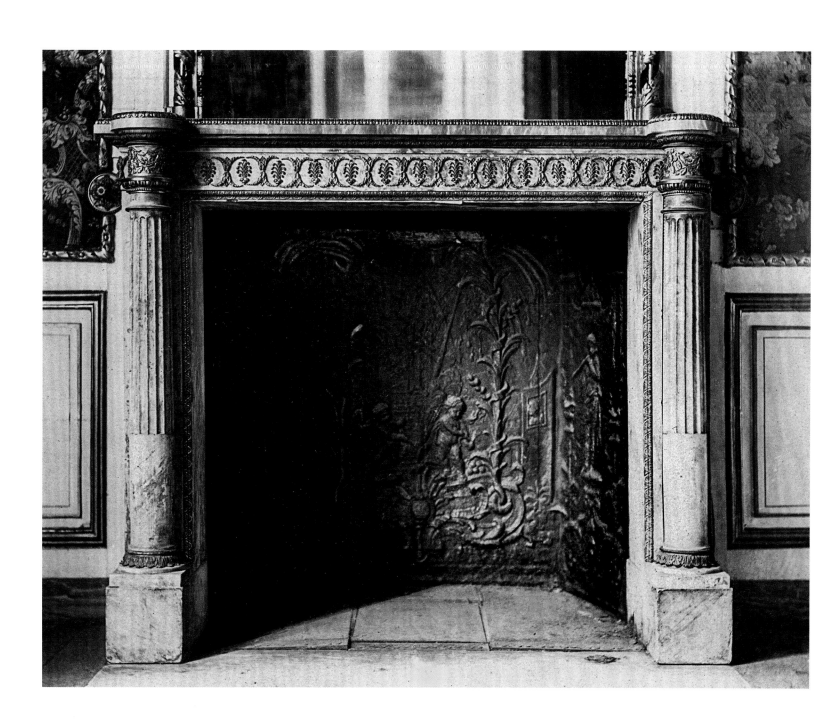

Chimneypiece

Marble carved by Augustin Bocciardi
Gilt bronze by Pierre Gouthière
After a design by François-Joseph Bélanger
1777-78
White veined Italian marble, blue turquin
marble, and gilt bronze
36¼ × 47¼ × 13¾ in. (92 × 120 × 35 cm)
Whereabouts unknown

Provenance:
Commissioned for the Count of Artois's
bedchamber at Bagatelle, ca. 1777; stolen in
the 1980s.

Literature:
Baulez 1986, 574-75; Baulez 1988, 144-51;
Leribault 2010, 384-87.

The most original room in the pavilion at Bagatelle was the Count of Artois's bedroom, the decor of which is well known from several watercolors signed *Bélanger* (see fig. 125). The architect had proposed covering the walls with and suspending from the ceiling a blue-and-white-striped silk fabric with lambrequin motifs, an arrangement that simulated a Tartar tent.

The chimneypiece was equally original and entirely appropriate to the martial theme of the room, which was intended to celebrate Louis XVI's youngest brother's status as colonel-general of the Suisses et Grisons regiment. The jambs of the mantelpiece thus took the form of two cannons sculpted in the round in blue turquin marble by Augustin Bocciardi.[279] This idea of giving both a structural and a decorative function to a faithful reproduction of an artillery object seems to have been borrowed by Bélanger from the designs of the architect and ornament designer Jean-Charles Delafosse: in his *Nouvelle iconologie historique* (1768), Delafosse presented an example of a monument in which the classical orders of architecture were substituted by upright cannons (fig. 123).

As the watercolor by Bélanger shows, the architect's intention was to adorn the chimneypiece with gilt-bronze cannons. In the end, the use of bronze chased by Gouthière was limited to representing the structural elements of the two artillery pieces, such as the breech button, the laurel torus surmounted by a touch hole, the handles of the breech chased with foliage, Artois's monogram,[280] and the muzzle band chased with alternating leaves and thunderbolts.

The center part of the architrave was adorned with Jupiter's thunderbolt. The angles of the chimneypiece break forward and are ornamented with flaming bombs, while "a string of large bronze balls"[281] runs around the fireplace opening. In front of the hearth, Bélanger's watercolor depicts a pair of gilt-bronze firedogs ornamented with a flaming cannonball on a pedestal, attached to which are two additional bombs. As accounts written by two contemporaries confirm, an original model for firedogs with warlike ornaments seems to have been made and installed in the cannon fireplace. The anonymous author of the *Mémoires secrets*, known as Bachaumont, gave a brief description of the bedroom, which he visited on May 26, 1780: "The prince's bedchamber, which he has never inhabited, is truly remarkable; it is in the form of a tent, and everything in it indicates a military apartment. The pilasters are designed as stacks of arms, surmounted by a helmet; the jambs of the chimneypiece are two cannons on breeches; the firedogs are in the form of cannonballs, bombs, and grenades; the wall lights in the form of hunting horns, etc."[282] A few years later, Luc-Vincent Thiéry (1734–after 1811) appears to have seen a different model, since he wrote that "mortars served as firedogs"[283] in the prince's bedchamber.

A pair of firedogs with warlike ornaments was probably supplied by Gouthière around 1779, perhaps even when the chimneypiece was installed in the bedchamber, between December 8 and 12, 1778.[284] The making of the firedogs for Bagatelle is confirmed by Gouthière in his invoice of works

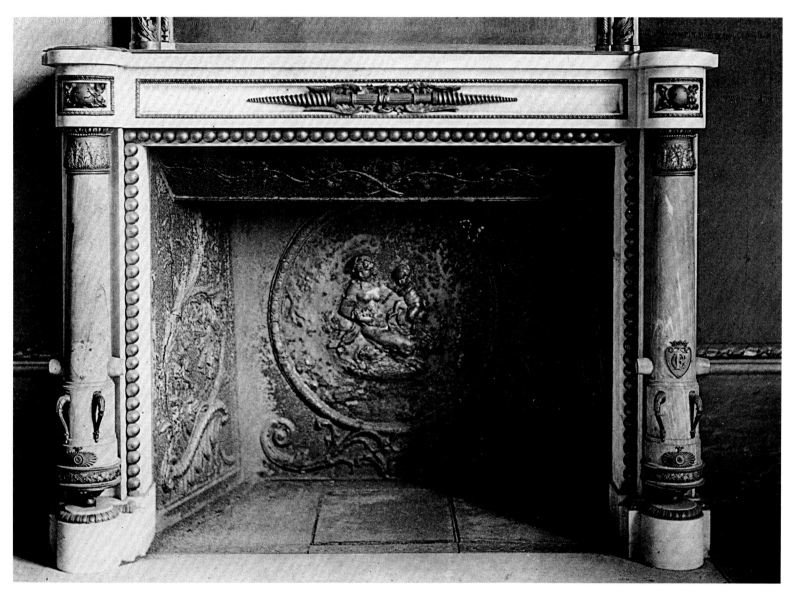

Fig. 122
Chimneypiece from the
bedroom of the Count of
Artois at Bagatelle. Plate 19
from *Monographie du château
de Bagatelle: intérieurs et
extérieurs* (Paris, n.d.).

for the Duchess of Mazarin, in which he provides quotes for the design of a pair of firedogs featuring a three-footed incense burner and two sphinxes, which he notes are "the same as those for the salon at the Château de Bagatelle" (cat. 26). A small pair of firedogs decorated with flaming cannonballs may well be the set from the bedchamber at Bagatelle (fig. 124). Indeed, aside from a few details, this model reflects Bélanger's drawing while the thunderbolts on the sides and the bombs in gilt bronze quote Artois's chimneypiece. If Gouthière made the pair of firedogs for Artois's bedchamber, he was soon to lose the privilege to François Rémond, who in March 1780 supplied a pair of firedogs featuring lovebirds for the count's Boudoir Rose on the upper story,[285] followed in 1787 by two other pairs of firedogs for the boudoir and the bath chamber on the ground floor.[286]

E.S.

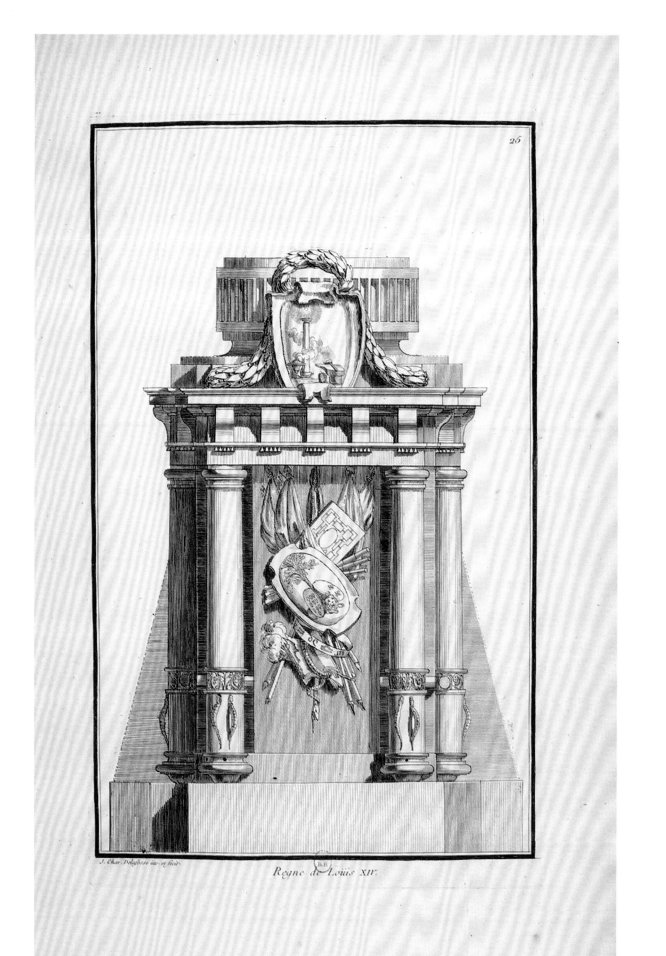

J. Char: Delafosse inv: et fecit.

Regne de Louis XIV.

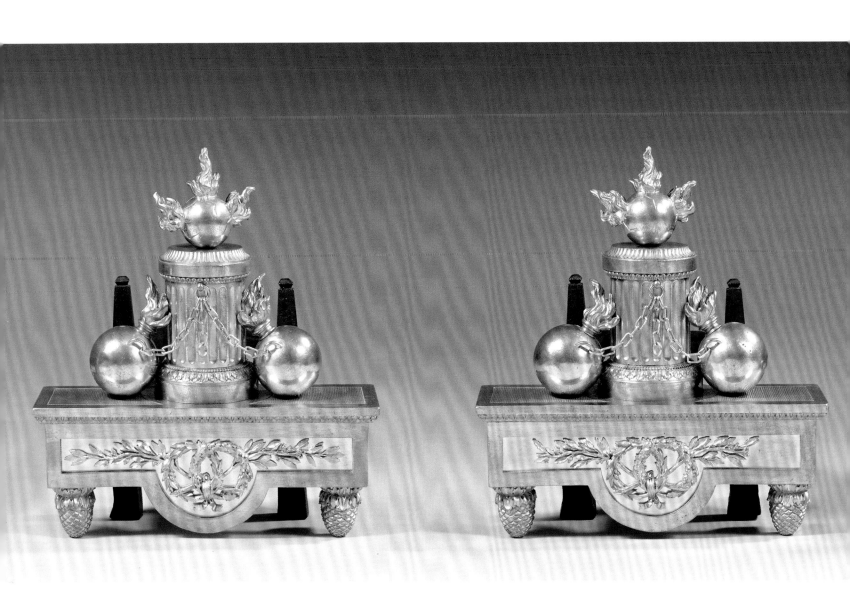

Fig. 124
Attributed to Pierre Gouthière,
Pair of Firedogs, ca. 1778–79. Gilt
bronze, 9⅞ × 10⅝ in. (25 × 27 cm).
Private collection

Chambre à Coucher de Monseigneur Comte D'Artois à Bagatelle Côté de La Cheminée

Fig. 125
François-Joseph Bélanger, *Bedchamber of Monseigneur the Count of Artois at Bagatelle, Chimneypiece Side*, ca. 1777. Pencil and watercolor on paper, 14⅞ × 19 in. (37.8 × 48.3 cm). Signed *Belanger*. Bibliothèque Nationale de France, Paris (Département des Estampes et de la Photographie, VA-418)

Chimneypiece

Marble carved by Jacques Adan
Bronzes modeled by Jean-Joseph Foucou
Gilt bronze by Pierre Gouthière
After a design by François-Joseph Bélanger
1777-80
Blue turquin marble and gilt bronze
Dimensions unknown
Whereabouts unknown

Provenance:
Commissioned by Louise-Jeanne de Durfort de Duras, Duchess of Mazarin, for the gallery-salon at the Hôtel Mazarin, Paris, ca. 1777; remained in the Duchess of Mazarin's former *hôtel* until 1845; acquired by James de Rothschild; until 1980 at the Château de Ferrières.

Literature:
Baulez 1986, 582-86, 633, 635-36; Faraggi 1995, 72-98.

Beginning in 1767, the Duchess of Mazarin undertook a costly renovation of her *hôtel particulier*, on Quai Malaquais, overlooking the Seine. Probably on the recommendation of her former father-in-law, the Duke of Aumont, she engaged, in 1774, François-Joseph Bélanger to furnish an apartment for her daughter on the ground floor of the *hôtel* and to refurbish the interiors of her reception rooms and private rooms on the second floor. Around 1777, Bélanger proposed designs for the redecoration of the large gallery-salon, which spanned the full depth of the building and was lit by four windows that opened onto the inner courtyard to the north and the garden to the south.

The renovations made to this salon included the replacement of the chimneypiece. One watercolor design by Bélanger reveals that he had initially envisioned a white marble chimneypiece with caryatids (see fig. 24). In the end, what was chosen was completely different: an innovative design that featured gilt-bronze figures of satyresses on the fronts of its jambs. In designing these mythological creatures, Bélanger may have been inspired by the example of a chimneypiece illustrated in an engraving by Jacques Androuet du Cerceau (1511–1586) in his *Second livre d'architecture*.[287] He may have proposed this chimneypiece as a modern, feminized interpretation, adapted to the limited dimensions of the mantelpiece, of famous models that were disseminated through engravings and copies, such as the antique so-called "della Valle" satyrs,[288] as well as more recent and accessible works such as the satyresses in stucco by Rosso Fiorentino that decorate the Galerie François Ier at Fontainebleau.

Gouthière's invoice lists the bronze works he produced for the Duchess of Mazarin's *hôtel* and the names of various people involved in the creation of the satyresses chimneypiece, as well as the different stages of its production.[289] Above all, the invoice, the last date on which is 1781, gives a glimpse of the bronze ornamentation of the chimneypiece, which is unfortunately lost. Gouthière states that the chimneypiece was originally intended to be in granite. However, following a setback with the supplier of the material, Bélanger opted for blue turquin marble, which was brought to the workshop of Jacques Adan, who had been employed to carve the mantelpiece.

Still following Bélanger's designs, Gouthière produced the clay and wax models of the chimneypiece and its numerous decorative adornments at full size, while the sculptor Jean-Joseph Foucou was entrusted with the trickiest part prior to casting: the modeling of the satyresses. Standing on semicircular bases, these figures lean against the chimneypiece jambs, their crossed hooves circled with little bells and their arms raised above their ivy-wreathed heads. Two braids knotted at each of their throats, a piece of fabric draped down each of their backs, and a belt of ivy at each of their waists lend a little modesty to these Bacchic creatures. The satyress on the right has a tambourine suspended from her shoulder by a ribbon, and the one on the left, cymbals. They were "well chased" and fully gilded. Gouthière emphasizes that, in terms of gilding, "the figures became very costly, as I was obliged to overgild [*surdorer*] them in order to give them a proper color, whether red or matte-gilded [*bien mettre en couleur tant en rouge qu'au mat*]."[290]

The refinement of the other gilt-bronze ornaments matched the elegance of the satyresses, including the frieze with fleurons and palmettes on the architrave of the chimneypiece. This matched one of the same type that decorated the waists of the two pedestals in blue turquin marble and gilt bronze that were made by Adan and Gouthière for the same room (cat. 49). As for the projecting ends of the architrave, these were adorned with a wreath of interlacing vine branches with bunches of grapes, while the sides of the architrave were given arabesque decoration comprising arrows and ivy branches tied with ribbons, "all done in openwork on the marble."

The Bacchic theme was also developed on the marble facings of the chimneypiece, which were each carved with a panel covered with a rich arabesque motif of ivy-wreathed satyr heads above interwoven ivy branches, in the middle of which was a trophy of musical instruments tied together with a sash, including "trumpets and flutes, tambourines trimmed with bells and disks, cymbals, Pan pipes and a cylinder."

For this exceptional work, which was installed in the gallery-salon on June 17, 1780, Gouthière emphasized on his invoice that "everything was done with the greatest mastery and finished to a superior standard, to the satisfaction and under the supervision of Mr. Bélanger." The chimneypiece was quoted at 16,369 *livres*, 11,000 of which was for the bronzes. The total price was brought down to 12,521 *livres*.[291]

Fig. 126
Salon of the Château de Ferrières.
From *Plaisir de France* (December
1969), page 69.

Fig. 127
Eugène Lami, *Salon Louis XVI
at the Château de Ferrières*, ca.
1865. Watercolor, 33½ × 27½ in.
(85 × 70 cm). Private collection

Finally, Gouthière supplied a pair of eagle fire-dogs (cat. 26) for this fireplace; the proud and stern portrayal of the two birds contrasted with the feminine character of the bronze decoration on the chimneypiece.

The satyresses chimneypiece was one of the most copied models at the end of the eighteenth century. Several versions are known, including one that adorned the large Salon Rond at Mme Thélusson's Paris *hôtel*, which was built and decorated between 1778 and 1781 under the direction of Claude-Nicolas Ledoux. Ledoux had engaged Gouthière to produce bronze ornamentation for five chimneypieces, among which was a version with satyresses that was similar to the Duchess of Mazarin's chimneypiece.[292]

Hobbled by financial difficulties, Gouthière was to deliver only four chimneypieces, around 1784. The fifth, decorated with satyresses, was made a few months later by François Rémond. As an inventory of fixtures dating from December 1784 confirms, the satyresses chimneypiece was not in the Hôtel Thélusson's salon.[293] It was probably placed in the salon of the house that Paul-Louis Thélusson, Mme Thélusson's son, was renting on the Champs-Élysées.[294] When this residence was demolished in 1929 in order to be rebuilt in the Jardin de l'Observatoire in Paris, the chimneypiece was taken down and eventually purchased by the collector Charles Wrightsman, who bequeathed it to the Metropolitan Museum of Art in New York in 1976.[295]

E.S.

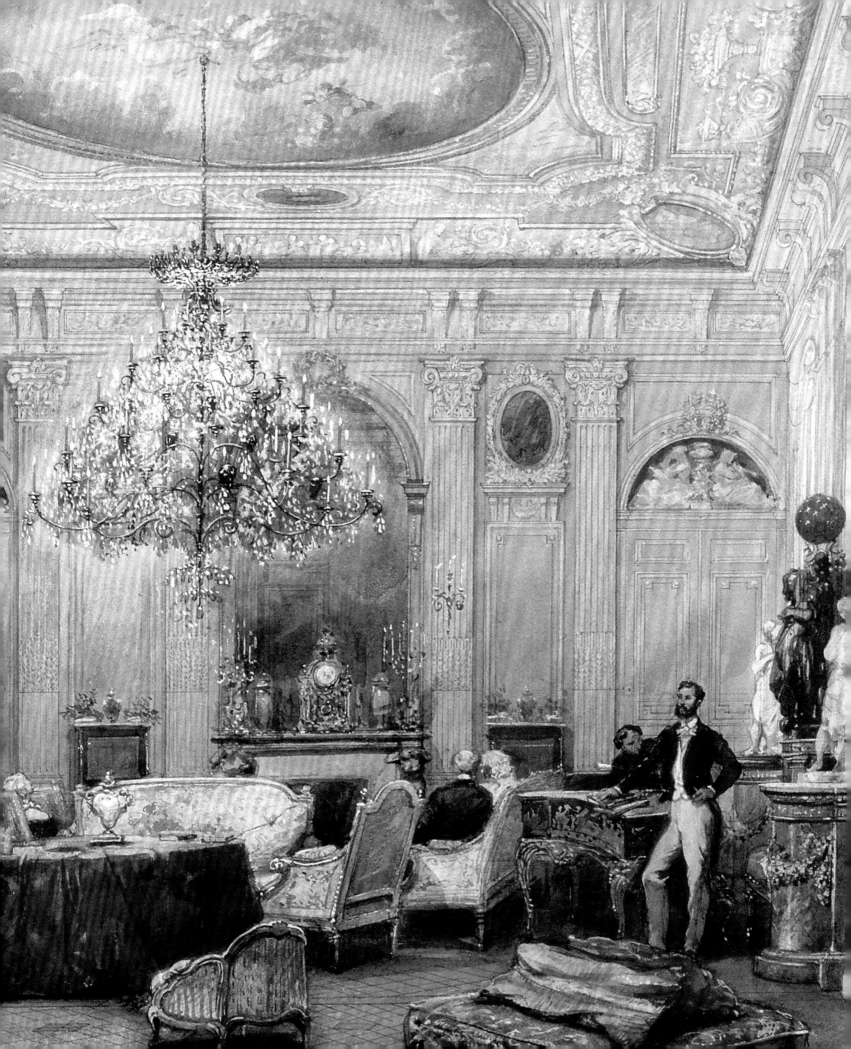

Chimneypiece

Marble carved by Jacques-Antoine Dropsy (?)
Gilt bronze by Pierre Gouthière
After a model by Jules-Hugues Rousseau
and Jean-Siméon Rousseau de la Rottière
1785
Red Griotte marble and gilt bronze
42⅛ × 53½ × 10⅝ in. (107 × 136 × 27 cm)
Musee National des Chateaux de Versailles
et de Trianon

Provenance:
Commissioned for Louis XVI's Cabinet de
la Cassette at the Château de Versailles,
1785; in the same room ever since.

Literature:
Baulez 1986, 569-70; Baulez 2005, 24-41.

Fig. 128
*Side and Front Elevations of the
Chimneypiece for Louis XVI's so-called
"Cabinet de la Cassette,"* 1785. Pencil,
Indian ink, wash, and watercolor
on paper. Archives Communales,
Versailles (Cartes, Plans et Dessins
d'Architecture, 7 Fi 231)

Shortly before 1780, Louis XVI had Louis XV's bath chamber at Versailles converted into a private office. This room was in the king's private apartment on the second floor of the central part of the chateau, which had been decorated between 1770 and 1772 under the direction of Ange-Jacques Gabriel. The alcove was removed in order to make the room square in plan, and the stove was replaced by a blue turquin marble chimneypiece, set against the south wall and facing the single window that overlooked the inner courtyard known as the "Cour de la cave du Roi" to the north. The wall panels were adapted to the new dimensions of the room. Evoking the room's initial function, these panels had been carved with bathing scenes, lakeside landscapes, and various aquatic motifs by the workshop of Jules-Antoine Rousseau, in which his sons, Jules-Hugues and Jean-Siméon, were both employed.

In 1784, when a corridor was fitted to the west, the room's floor area was reduced. This alteration required that the chimneypiece be moved to the middle of the east wall, followed by intervention from the gilder Louis-Joseph Dutems, who applied three-color gilding to the sculptures and moldings of the former bath chamber's paneling. Along with these decorative improvements, the blue turquin marble chimneypiece was replaced by a mantelpiece with consoles in red Griotte marble, which was probably sculpted by Jacques-Antoine Dropsy, then sculptor and marble cutter to the Bâtiments du Roi, from designs by the Rousseau brothers, Jules-Hugues and Jean-Siméon.

Although there is some uncertainty as to who sculpted the marble chimneypiece, the gilt bronzes can be indisputably credited to Gouthière. In his petition of March 1, 1786, to the Count of Angiviller, director of the Bâtiments du Roi, Gouthière notes that he "has the honor of remarking to My Lord the Count, that he has just made the chimneypiece for the King's bath chamber [the so-called Cabinet de la Cassette] at Versailles, in collaboration with the aforementioned Rousseau brothers."[296] The Rousseau brothers had thus supplied Gouthière with the drawn designs for the bronzes. Two watercolor drawings may be identifiable with these models, since one shows the bronze ornamentation of the console sides and the second details that are on the fronts of the jambs and architrave (fig. 132).

Gouthière's gilt bronzes derive their forms from the repertoire of classical architecture: a large matte-gilded acanthus leaf with a burnished central vein, disks, *rais-de-coeur* motifs, rosettes, waterleaves, roses, and pearls. The refinement of the chasing, together with the contrast between the matte and burnished surfaces, provide depth to Gouthière's bronzes, lending the rigorously straight forms of the chimneypiece a luxurious finish worthy of royal living quarters.

E.S.

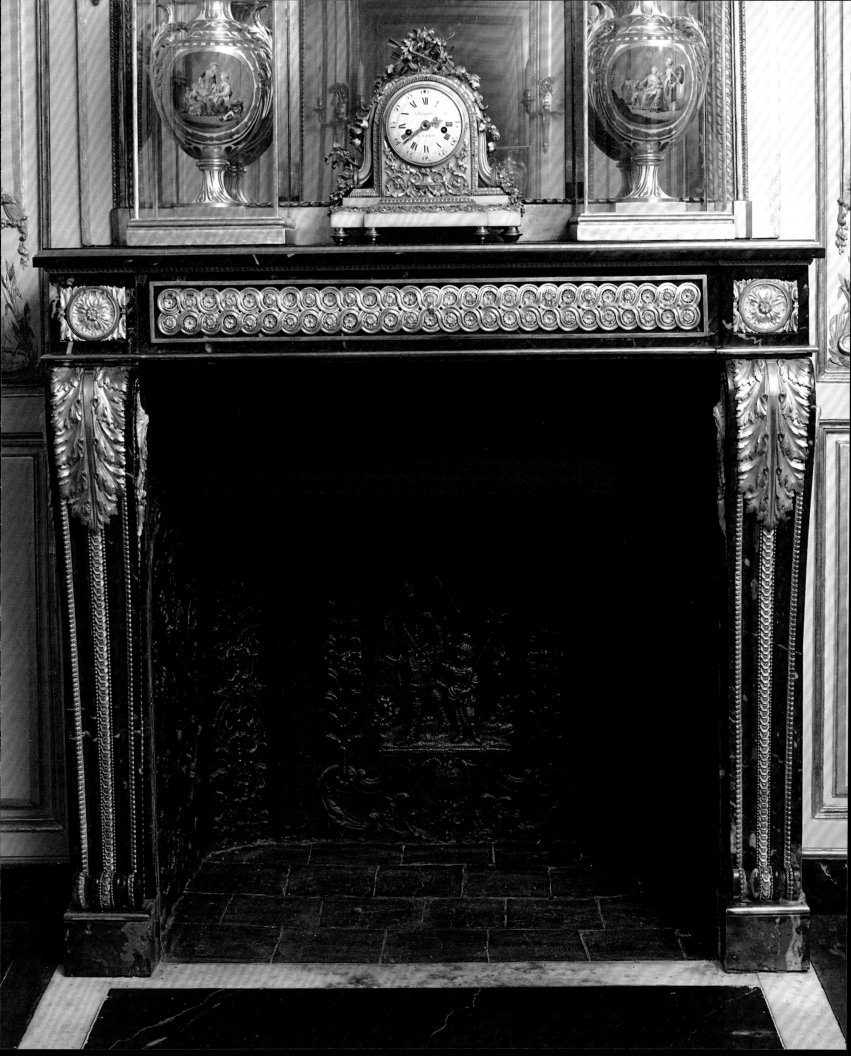

Chimneypiece

Marble carved by Jacques-Antoine Dropsy
Gilt bronze by Pierre Gouthière after a
model by Jules-Hugues Rousseau and
Jean-Siméon Rousseau de la Rottière,
After a design by Richard Mique
1785
Blue turquin marble and gilt bronze
49⅝ × 82⅝ × 17⅜ in. (126 × 210 × 44 cm)
Musée National des Châteaux de Versailles
et de Trianon

Provenance:
Commissioned for the Salon des Nobles de
la Reine at the Château de Versailles, 1785;
in the same room ever since.

Literature:
Verlet 1945, 32-33; Baulez 1986, 569-70;
Raïssac 2011, 194-99.

In 1785, Marie Antoinette wanted the Salon des Nobles in her apartment at the Château de Versailles redone in the latest taste. This room adjoining her main bedchamber to the east, with Gobelins tapestries stretched over its walls above a marble wainscot, had remained fixed in the century of Louis XIV. The project was initially entrusted to Jean-François Heurtier (1739–1822), inspector general of the Bâtiments du Roi at the chateau; when Heurtier withdrew, the job went to Richard Mique, the queen's favorite architect.[297] Mique presented two proposals to the sovereign. The first, which was very costly, consisted of covering all the walls with a geometric inlay of various marbles; Mique said of it that "this is how the decoration of this room should be." The second, which was more modest, involved stretching silks over the walls, "without great expenditure," above white and gold wood-paneled wainscoting with moldings.[298] Marie Antoinette opted for the second proposal, merely stating a requirement that the work be carried out during the court's visit to the Château de Fontainebleau, in the fall of 1785.[299]

The modernization of the Salon des Nobles included the replacement of the chimneypiece. Two drawings reveal the architect's hesitation over the ornament that the new mantelpiece should receive.[300] One shows an elaborate chimneypiece with winged, sheathed caryatids, with nemes on their heads, while the second is more restrained, with facing console jambs. In the end, elegant simplicity prevailed: Mique chose a mantelpiece with straight forms in blue turquin marble, with consoles and ornaments in gilt bronze.

The Rousseau brothers were responsible for realizing the decorative scheme for the salon's fixtures and for modeling the bronze ornamentation for the chimneypiece. However, since they had no qualification as chaser-gilders, they subcontracted this delicate work to Gouthière, as testified in the petition of 1786 addressed to the Count of Angiviller, in which Gouthière writes that "in collaboration with the Rousseau brothers, he has just made the bronzes for the chimneypiece . . . of the Salle des Nobles in the Queen's apartment."[301] The task of carving and polishing the blue turquin marble mantelpiece fell to Jacques-Antoine Dropsy, marble cutter to the

Bâtiments du Roi; consoles support the architrave that breaks forward at each end and is topped by an overhanging shelf. It must have been a change or adjustment of the bronze ornamentation that forced Dropsy to go "to the premises of Messrs. Rousseau to bore two holes to secure [Gouthière's] bronzes" before he installed the chimneypiece in the room on November 12, 1785.[302]

Remarkably precise and classically elegant, Gouthière's gilt bronzes not only highlighted the architectonic forms of the mantelpiece but also were a match for the measured sumptuousness of the room, which, in accordance with the principle of majestic progression, was required not to overshadow in any way the decorative climax of the adjacent Grande Chambre de la Reine. Ultimately, Gouthière's ornamentation would determine that of the furniture supplied by Jean-Henri Riesener in 1786 (fig. 129). Indeed, similar festoons and the Vitruvian scroll frieze, both of which are emblematic of the classical revival of the second half of the eighteenth century, were repeated on the borders and uprights of the three chests of drawers and two *encoignures* in the salon, for a harmonious overall effect.

E.S.

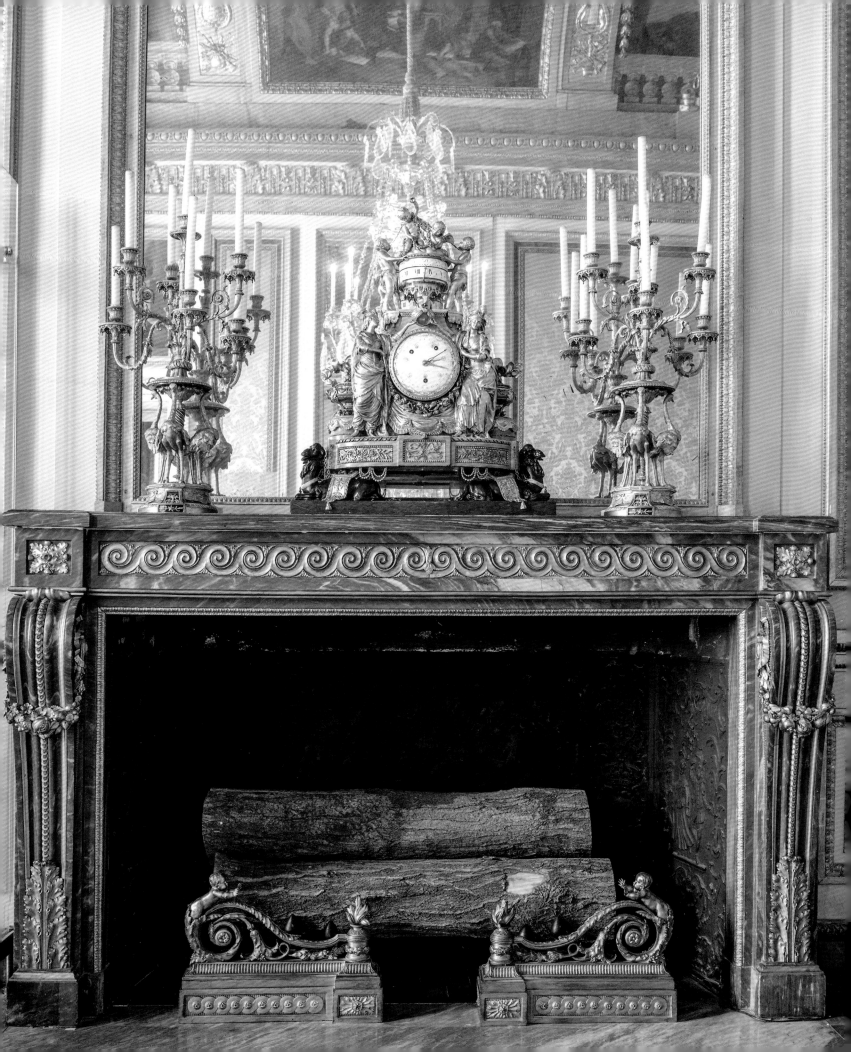

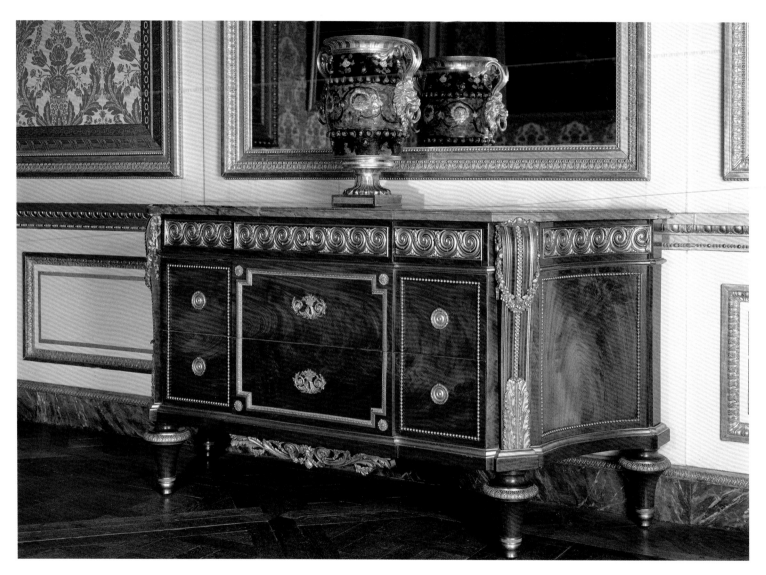

Fig. 129
Jean-Henri Riesener, *Chest of Drawers*
(from a set of three), 1786. Oak, flame
mahogany, gilt bonze, blue turquin marble,
40½ × 79½ × 27¾ in. (103 × 202 × 70.5 cm).
Musée National des Châteaux de Versailles
et de Trianon (OA 5229)

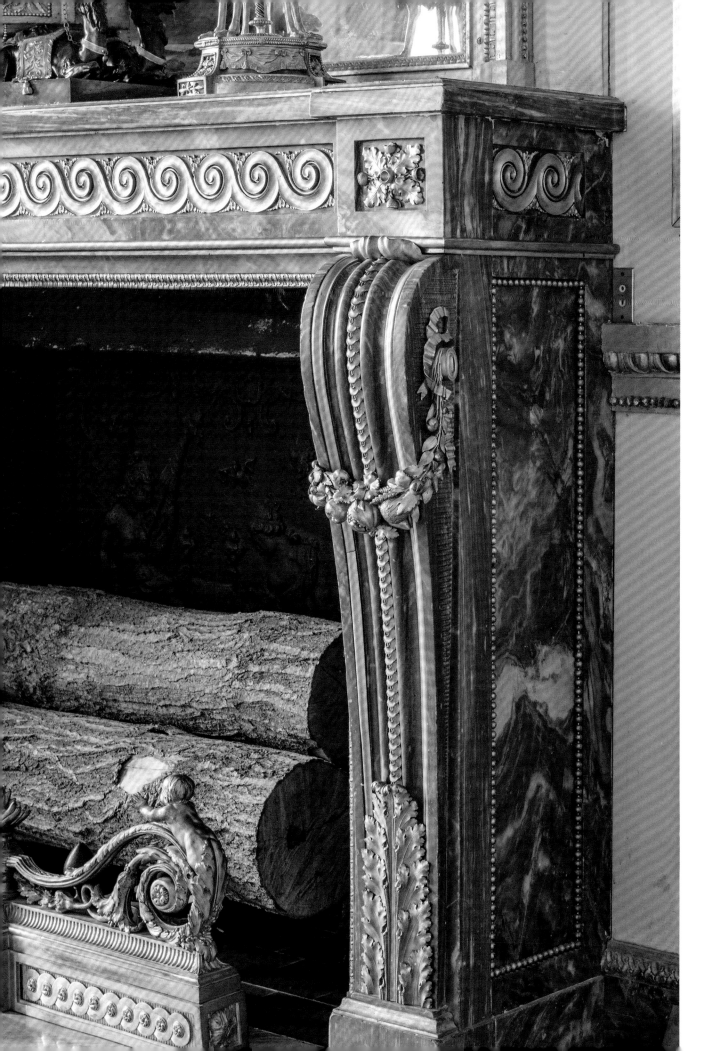

Two Tables

Gilt bronze by Pierre Gouthière after a
design by François-Joseph Bélanger
Ca. 1773
Red porphyry and gilt bronze
36 *pouces* long and 21 *pouces* 6 *lignes* deep,
according to the catalogue description for
the sale of the Duke of Aumont's collections
(approx. 38⅜ × 22⅞ in.; 97.5 × 58 cm)
Whereabouts unknown

Provenance:
Commissioned by Louis-Marie-Augustin,
Duke of Aumont, ca. 1773; in the sale of his
collections, December 12–21, 1782, lot 318;
purchased for Marie Antoinette; Muséum
du Louvre, 1793–1802; Palais des Tuileries
or Château de la Malmaison, 1802–7; Palais
des Tuileries, 1807–38; Château de Saint-
Cloud, 1838–70; since lost.

Literature:
Guiffrey 1877, 156; Du Colombier 1961, 27,
fig. 3; Watson 1966, 129–30; Baulez 1986,
579; Castelluccio 2011, 75.

On September 9, 1782, the *Journal de Paris* encouraged its readers to visit Gouthière's workshop: "This week there are to be seen at the premises of Mr. Gouthière, chaser and gilder to the King, Rue du Faubourg St Martin, near the guard house, tables, vases, and candelabra, in the form of relief arabesques, and gilded [*dorés d'or moulu*], the execution of which is a great credit to this artist and should stimulate collectors' curiosity."[303] The tables mentioned were probably those belonging to the Duke of Aumont, which were in a fashionable style after a design by François-Joseph Bélanger. Today they are known only through drawings (figs. 130, 131), engravings, and archival documents. Aumont must have been particularly proud of them because he asked to exhibit them at the annual Salon organized by the Académie Royale de Peinture et de Sculpture, in the Salon Carré of the Louvre. Jean-Baptiste-Marie Pierre, chief painter to the king and director of the Académie, and Abbot Terray, director general of the Bâtiments du Roi, consented on the condition that Gouthière display his two tables in "the ground-floor room that leads to the Garden of the Infanta," rather than in the Salon itself. Pierre explained to Abbot Terray in a letter dated August 28, 1773:

> The Duke of Aumont prays the Controller General
> [Abbot Terray] to allow Mr. Gouthière, gilder and
> chaser to the King and to the Menus[-Plaisirs], to
> display two porphyry tables at the Salon, for which
> he has supplied mounts that are a credit to his talent.
>
> Only members of the Académie have the right to
> exhibit works at the Salon. This is a rule that it is
> most essential to uphold; the numerous requests
> made by people who take advantage of their
> patrons' goodwill, and who have little awareness of
> His Majesty's orders on this subject, have always
> been rejected. However, Monseigneur may allow Mr.
> Gouthière to place his tables on the ground floor, in
> the entrance of the rooms that serve as a passage
> from the court to the Garden of the Infanta.[304]

The two porphyry tables enjoyed a second moment of glory at the sale of Aumont's collections, when they were purchased for Marie Antoinette (with the painter and picture dealer Vincent Donjeux acting as intermediary) for the astronomical sum of 23,999

livres—making them by far the most expensive item in the sale.[305] Marie Antoinette was so proud of her acquisition that she had herself painted arranging roses placed on one of the two Gouthière tables in a portrait by Élisabeth Vigée Le Brun (fig. 132). In 1793, it was decided that the two tables would be exhibited in the new Muséum du Louvre, which had just opened to the public.[306]

In 1802, the architects Charles Percier (1764–1838) and Pierre Fontaine (1762–1853) used the tables to furnish either the Palais des Tuileries or the Château de la Malmaison, then the two residences of the first consul, Napoleon Bonaparte, and his wife Josephine.[307] At this point, Gouthière was recognized as the creator of the gilt bronzes, the model for which had previously been misattributed to Pierre-Adrien Pâris, probably because of his role in the production of the plates for the catalogue of Aumont's collections and of the drawing known to be by his hand that represents a table leg.[308] In 1807, they were at the Palais des Tuileries, which had become the emperor's official residence: one was placed in the empress's bedchamber, while the other was installed in her "second salon"; in 1809, they were reunited in her boudoir.[309]

After Napoleon and Josephine's divorce in December 1809, the tables remained in Marie-Louise's boudoir, where they were still to be found in 1818.[310] In 1826, they were in the dauphine's powder room (*cabinet de toilette*)[311] before being sent to storage, where they were still recorded as having been in 1833.[312] They were finally sent to the Château de Saint-Cloud on March 13, 1838;[313] it was probably during the bombing and the fire at the chateau during the Franco-Prussian War in 1870 that they disappeared.

C.V.

Fig. 130
Pierre-Adrien Pâris, *Preparatory Drawing for the Engraving, Representing the Duke of Aumont's Table*, 1782. Pencil, ink, and watercolor on paper, 7⅞ × 5⅛ in. (20 × 13 cm). Bibliothèque Nationale de France, Paris (RES V 2586, pl. 318)

Table de Porphire dont la Planche
Suivante indique les Details plus en grand.

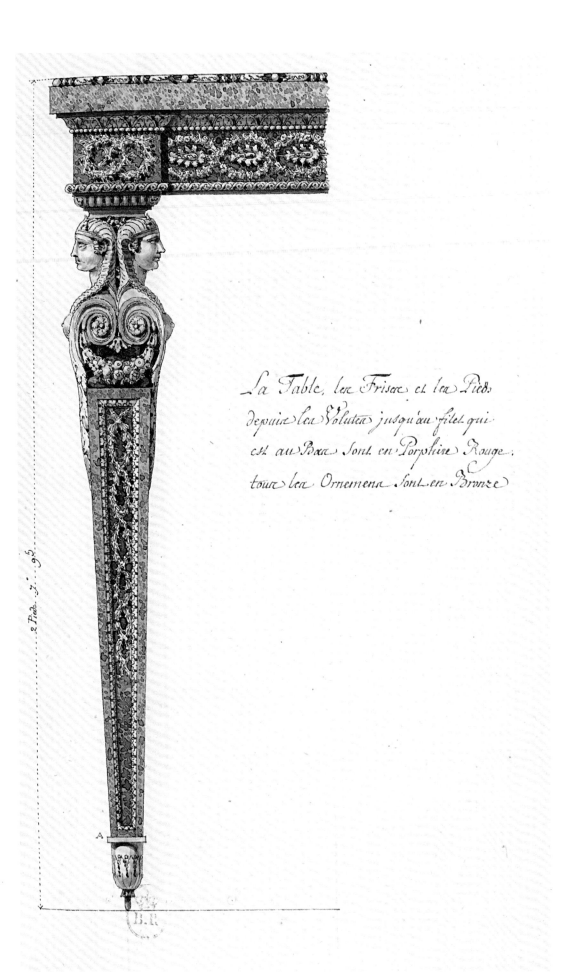

La Table, les Frises et les Pieds
depuis les Volutes jusqu'au filet qui
est au Bas sont en Porphire Rouge.
tous les Ornemens sont en Bronze

Fig. 131
Pierre-Adrien Pâris, *Sketch Representing a Leg of the Duke of Aumont's Table*, 1782. Pencil, ink, and watercolor on paper, 7⅞ × 5⅛ in. (20 × 13 cm). Bibliothèque Nationale de France, Paris (RES V 2586, pl. 318)

Fig. 132
Élisabeth Vigée Le Brun, *Marie Antoinette "en gaulle,"* 1783. Oil on canvas, 35⅜ × 28⅜ in. (89.8 × 72 cm). Princess of Hesse-Darmstadt Collection, Castle of Wolfsgarten

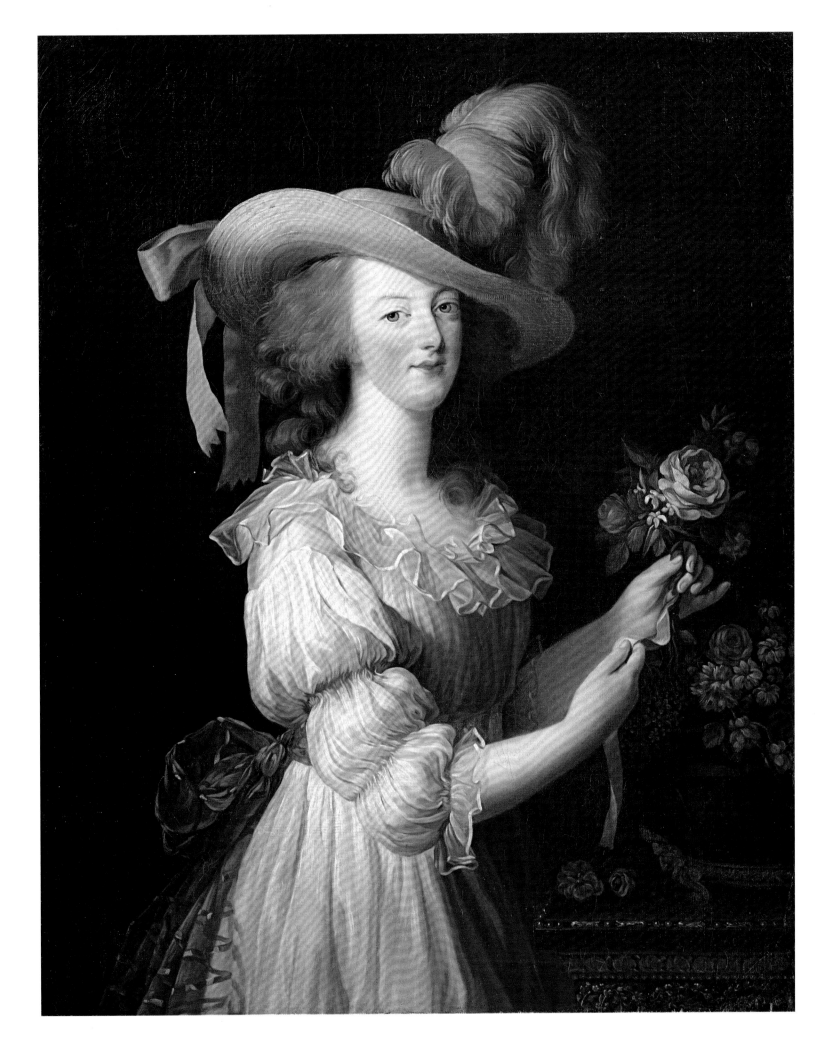

Side Table

Marble supplied and carved by Jacques
Adan
Gilt bronze by Pierre Gouthière
After a design by François-Joseph Bélanger
and Jean-François-Thérèse Chalgrin
1781
Blue turquin marble and gilt bronze
37½ × 81⅛ × 27 in. (95.2 × 206 × 68.6 cm)
Stamped on the iron beam added across
the back of the table: *TUDHOE* followed
by a stylized crown (probably the mark of a
foundry located in Tudhoe, County Durham,
west of Newcastle upon Tyne).
Stamped on a few replaced sections of gilt
bronze: *J.A. HATFIELD, LONDON.*
Inscribed in red wax crayon on the
underside of the top: *P.M.114*
The Frick Collection, New York; Henry Clay
Frick Bequest (1915.5.59)

Provenance:
Commissioned by Louise-Jeanne de
Durfort de Duras, Duchess of Mazarin,
1781; probably remained in her former *hôtel
particulier* until 1845; private collection,
Russia (?); Alfred Morrison, London (d.
1897); around 1893 or in 1897, Asher
Wertheimer, London; probably in 1896,
purchased by Count Boni de Castellane,
Paris; Charles Wertheimer, London;
purchased by John Pierpont Morgan,
1900; inherited by his son, Jack Morgan
1913; purchased by Joseph Duveen, 1914;
purchased by Henry Clay Frick, 1915.

Literature:
Véron 1884, 38; Molinier 1898, 187, pl. 21,
no. 2; Robiquet 1912, 124, nos. 31 and 185;
Robinson 1914, 113; Robiquet 1920-21, 185;
Castellane 1924, 139; Brière 1955, 9-14;
Hunter-Stiebel 1985, 454, 457, 459, 460;
Baulez 1986, 584-85, 634-37; Ottomeyer
and Pröschel 1986, vol. 1, 206; Verlet 1987,
48; Dell 1992, 104-23; Faraggi 1995, 80, 83;
Lapine 1999, 47; Mabille 2003a, 18.

This blue turquin marble table, Gouthière's master-piece, was made in 1781 for the Duchess of Mazarin's large salon in her *hôtel particulier* on the Quai Malaquais. The interior decoration had been assigned to François-Joseph Bélanger, but his role for the Count of Artois, for whom he became chief architect in 1777, led him to entrust oversight of the work to the architect Jean-François-Thérèse Chalgrin. It was Chalgrin who gave Gouthière the design for what would be the most spectacular piece of furniture in Mazarin's gallery-salon.

Extending across the building from courtyard to garden and lit by two windows on each side, this long salon was entered through a single doorway, accessed via the small salon (also known as the Salon Arabesque), although three other false doors had been created for the purpose of symmetry. A similar concern for symmetry had inspired the Gouthière commission. Each side of the salon was to have at its center an element made of blue turquin marble—supplied and carved by the marble cutter Jacques Adan and decorated with gilt bronzes by Gouthière—placed under a mirrored overmantel: the long side of this table faced a chimneypiece decorated with satyresses modeled by Jean-Joseph Foucou (cat. 35), and between the windows were two pedestals (cat. 49) on which a large candelabrum was to be placed. This table and the chimneypiece had each been designed to be flanked by Gobelins tapestries, four panels in total, drawn from the *Theatrical Scenes* wall hangings after cartoons by Charles Coypel.[314]

Gouthière's invoice, dated 1781, describes the blue turquin table in minute detail, stating that it was originally designed with its owner's initials on the sides, which have now been replaced.[315] Gouthière then explains that the gilding was not complete upon the duchess's death on March 17, 1781: "This is why I am permitted to request an indemnity for these works, which are very considerable, the marbles remaining on my account, and that I should be allocated for these a sum of 3,000 livres."[316]

The spectacular gilt-bronze ornamentation Gouthière made for the duchess's table features a mask at the center of the entablature that is one of the most beautiful faces to have been created in gilt bronze in the second half of the eighteenth century

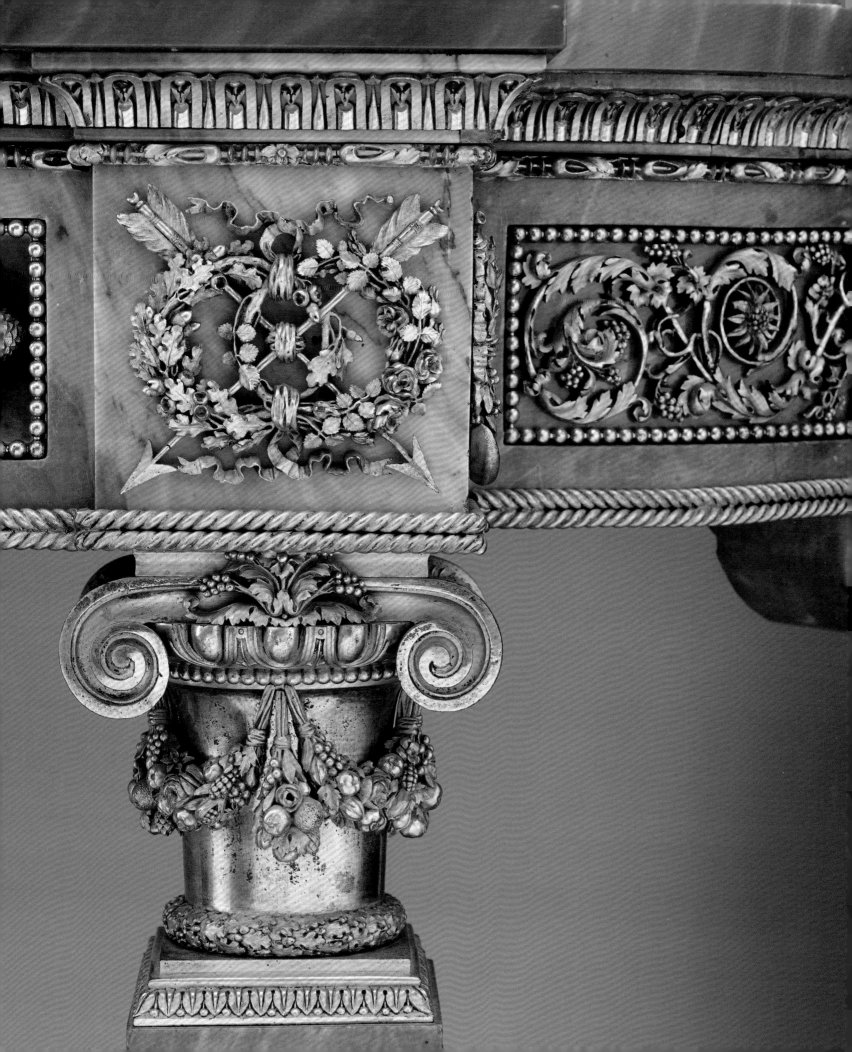

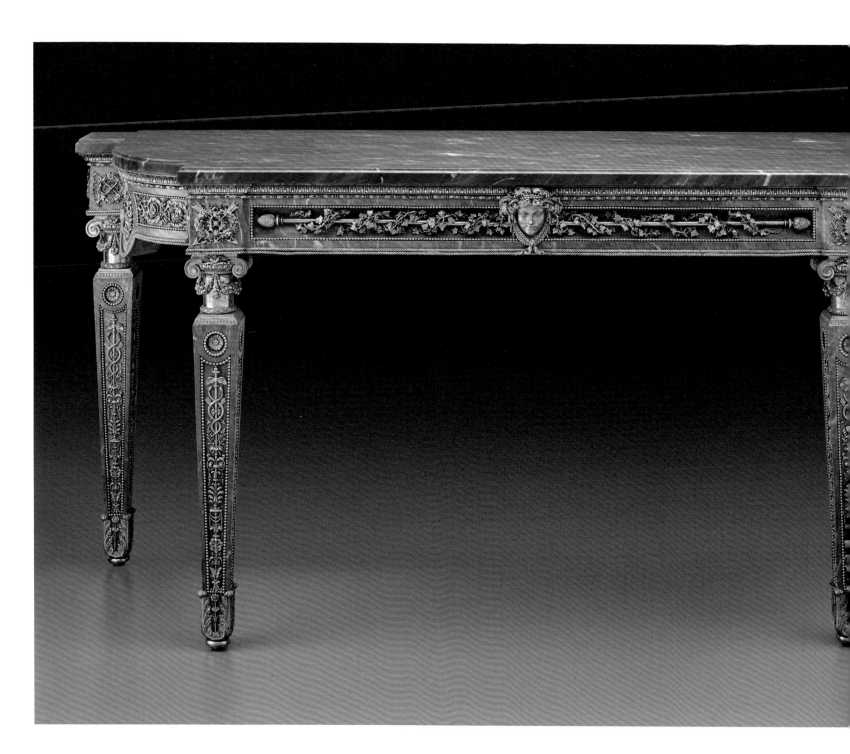

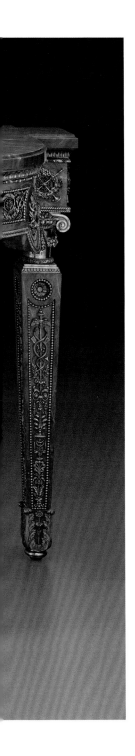

(see p. 2). Its fine and perfectly regular features follow the classical canon then in fashion, but without the rigidity or coldness of some faces inspired by Greco-Roman models. Quite the opposite: it is animated by a lively gaze, with eyes under slightly lowered eyelids that look to the right, and a mouth that expresses both self-confidence and pensiveness in equal measure. Is it a young man or a beautiful woman? Gouthière's statement merely refers to a "head."[317] Bacchus immediately springs to mind, here surrounded by ivy leaves, a living allegory of the Roman god's eternal youth, and placed between two thyrsi; however, the hair with its braids and pearls is more reminiscent of a female face; either way, he or she is deep in thought. A tour de force in itself, the hair is wavy, rolled into curls or plaited into braids that intermingle with a pearl necklace and two ivy branches; this variety of textures was created in the original clay model but was magnificently reworked during the chasing process.

The ivy leaves that curl around the two thyrsi terminate in pinecones so naturalistic that they seem to be real leaves dipped in gold. The refinement, the daring design, with some leaves overlaying others, and the lightness achieved through paring back (*dégraissage*) are all admirable. The veins of the leaves and branches are irregular so as to imitate nature more closely; and the whole is matte gilded, with the exception of the fruits, which are burnished to play on the contrast between matte and shiny effects.

The capitals are unique:[318] heavy and imposing, they are essentially structural elements on which rests the hardstone entablature with its rich gilt-bronze ornamentation. Of the Ionic order, their strict classicism is softened by a garland of flowers and fruits, hanging around the necking of the capital.

In 1789, the bronze-makers François Rémond and Étienne Martincourt were asked to appraise the gilt bronzes Gouthière had made for Mazarin, in order to determine the sum that the duchess's heirs still owed Gouthière. They reduced the value of the model of the table to 720 *livres* (down from the 1,000 *livres* mentioned in Gouthière's invoice) and that of its execution to 2,000 *livres* (down from 3,000 *livres*). As

for the marble cutter Jacques Adan, he received 1,642 *livres* for supplying and cutting the marble.

It is difficult to establish what subsequently happened to the table. It was bequeathed by the Duchess of Mazarin, along with the other gilt-bronze items by Gouthière in the large salon of the *hôtel particulier* on the Quai Malaquais, to Radix de Sainte-Foy, who gave them up for 10,000 *livres*.[319] However, was it for the duchess's heirs that Gouthière completed the table? And where was it in 1789 when it was examined by Rémond and Martincourt? In their report, they specified that they had carried out their valuation "both in the aforementioned *hôtel* that Mme the Duchess of Mazarin occupied at the time of her decease, situated on the Quai des Théatins, and in various places where those of the aforementioned works that had been sold during the sale following the Duchess of Mazarin's decease were to be found."[320] As the table was not included in either of the two auctions of the Duchess of Mazarin's collections (in 1781 and 1784), should it be assumed that in 1789 it was still in the duchess's former *hôtel*? If so, it may have shared the fate of the wall lights (cat. 22), chimneypiece (cat. 35), and pedestals (cat. 49) from the duchess's large salon, remaining in the *hôtel* on Quai Malaquais until 1845, when the building was destroyed and the decorative elements sold to numerous collections.[321]

The mystery of the blue turquin table continued throughout the nineteenth century. One of its owners, the snobbish and extravagant Count Boni de Castellane, wrote in his memoirs in 1924: "I returned to England, and, at Asher Wertheimer's, treated myself to the 'Morrison table,' in blue turquin marble, ornamented with bronzes by Gouthière and that had come from Russia."[322] Although Boni de Castellane does not give the date of this trip, it could be during his journey to London in 1896, the year following his marriage to the extremely wealthy American Anna Gould, who provided him with the financial means to pursue his dream of being a great collector. He would have thus bought the table during the lifetime of its previous owner, the English collector Alfred Morrison, who died in 1897. However, it is possible, and even probable, that Boni, who shows

little regard for chronology in his memoirs, bought it after Morrison's death. Either way, he soon got rid of it, for in 1900 the American financier John Pierpont Morgan acquired it in London from Asher Wertheimer's brother, Charles Wertheimer, who was also an art dealer.[323] The table appears in a black-and-white photograph of his apartment, which also served as his gallery (fig. 133). It graced Morgan's London residence, at 13–14 Princes Gate, until 1912, when the pictures, tapestries, sculptures, and the finest items of furniture and objets d'art bought by Morgan for this residence, or lent to the Victoria and Albert Museum, were sent to the Metropolitan Museum of Art in New York for a retrospective of the American financier's collections. After Morgan's death in 1913, his son Jack took up where his father had left off, and the exhibition opened its doors on February 17, 1914. However, a year later, while the Morgan collection was still on display at the Metropolitan Museum, Jack Morgan sold a large portion of the treasures his father had amassed to the art dealer Joseph Duveen. He parted with seventy-eight eighteenth-century French items of furniture and objets d'art in April 1915, for the then astronomical sum of $2,000,000.[324] The lot included the Gouthière table, which Duveen resold two months later, on June 4, 1915, to Henry Clay Frick for $132,000, along with sixteen other eighteenth-century French pieces of furniture and objects from the Morgan collection.[325]

In accordance with the fashion for reproducing eighteenth-century royal furniture, a copy of the Duchess of Mazarin's side table was made around 1850, probably in Paris, by a bronze-maker and for a client whose name is unknown, but who certainly knew the original.[326]

C.V.

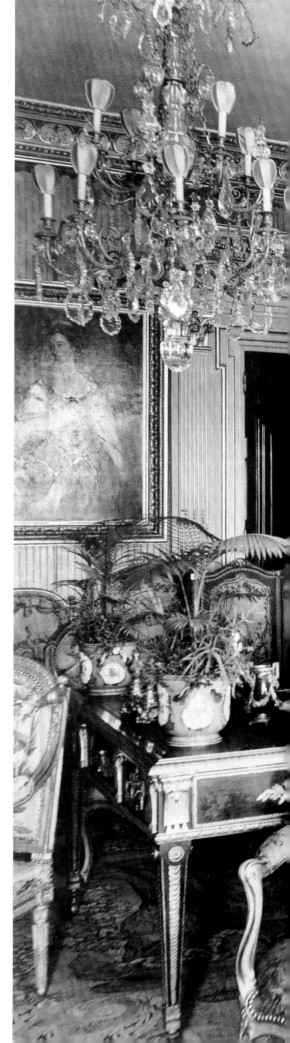

Fig. 133
Interior view of the London gallery and home of Charles Wertheimer, ca. 1900. The Getty Research Institute, Los Angeles (Duveen Archives, 960015)

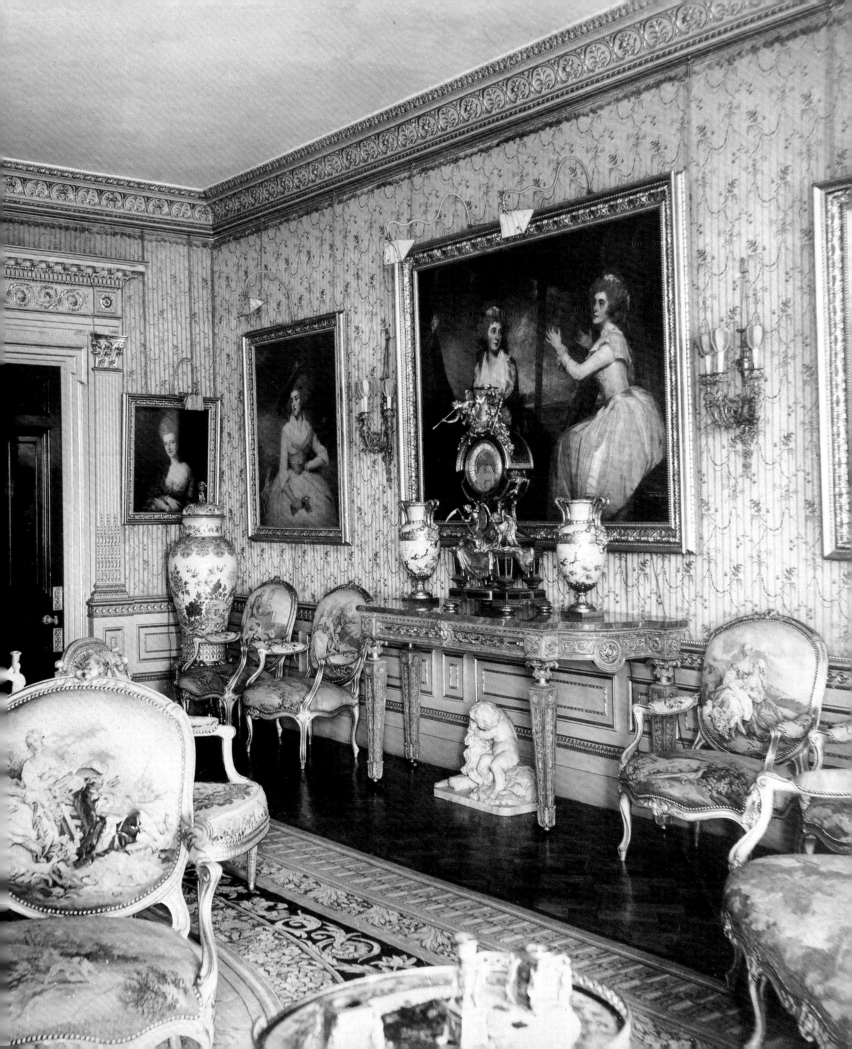

Two Tables

Gilt bronze by Pierre Gouthière
Probably after a design by François-Joseph
Bélanger
1782
Green jasper and gilt bronze
36 *pouces* long by 21 *pouces* 6 *lignes* deep,
according to the catalogue description for
the sale of the Duke of Aumont's collections
(approx. 38⅜ × 22⅞ in.; 97.5 × 58 cm)
Whereabouts unknown

Provenance:
Commissioned by Louis-Marie-Augustin,
Duke of Aumont; in the sale of his
collections, December 12-21, 1782, lot 319;
purchased for Louis XVI; placed in Marie
Antoinette's quarters at Versailles, January
1783; at the Château de Saint-Cloud,
1789-1870; since lost.

Literature:
Davillier 1870, 142-43, no. 319; Dutilleux
1886, 31; Huisman and Jallut 1970, 104;
Samoyault 1971, 170; Verlet 1980, 20.
Baulez 1986, 579–80.

About ten years after commissioning Gouthière to supply the gilt-bronze decoration for two sumptuous red porphyry tables (cat. 38), the Duke of Aumont turned again to him, this time to make the bronzes for these two green jasper tables. According to drawings, probably by François-Joseph Bélanger in collaboration with his brother-in-law Jean-Démosthène Dugourc, Gouthière's bronzes reflected the style of the early 1780s, notably featuring a broad frieze of arabesques in the Pompeiian taste at the level of the entablature instead of a frieze of floral wreaths like those found on the red porphyry tables. Like the red porphyry ones, however, they were supported on Egyptian heads, though of a simpler and perhaps less original design. Bélanger also quoted the decoration of the table legs, with a caduceus motif and arabesques, created by Jean-François-Thérèse Chalgrin (working under his supervision), for the Duchess of Mazarin's blue turquin table (cat. 39).

The duke died before he had the chance to see these extraordinary green jasper tables, which at the time of his death in April 1782 were still in Gouthière's workshop, unfinished. They were the subject of a detailed assessment by the bronze-maker François Rémond, who valued them at the extravagant sum of 15,026 *livres* each, that is, more than 30,000 *livres* for the pair.[627] The *fondeur-ciseleur* Jean-Claude Duplessis was more succinct in his report and less generous in his valuation, giving the two tables a value of 21,096 *livres*.[328] The silversmith Jean-Baptiste-François Chéret valued them at 27,040 *livres* "for the chasing and mounting as well as for the value of the bronzes, chasing, gilding, and models."[329] The tables were ultimately sold for 19,580 *livres* at the Duke of Aumont sale in December 1782, where they were bought by Alexandre-Joseph Paillet on behalf of Louis XVI.[330]

Like the two red porphyry tables, the green jasper ones are known today purely from old descriptions and the catalogue plate from the sale of the duke's collections, which shows only the detail of one leg. The architect Pierre-Adrien Pâris provided the preparatory drawing for this plate (fig. 135), as well as a sketch showing a slightly different view, and the detail of an arabesque (fig. 134).

Following their purchase by the king, the green jasper tables were sent, in January 1783, to Versailles to be "immediately installed in the queen's quarters."[331] In 1785, they were restored by Philippe-François Julliot, the merchant and specialist who along with Paillet was responsible for the Aumont sale catalogue.[332] In 1789, they were sent to the Château de Saint-Cloud, where they furnished the queen's bedchamber.[333] The tables were returned to Paris in 1793 for the opening of the new Muséum du Louvre,[334] but they did not remain there for long, because in June 1794 they were sent back to Saint-Cloud, included on a "List of precious objects reserved for the Muséum," demonstrating the great interest of the managers of the Muséum.[335] They may have been exhibited between 1797 and 1799 at Versailles in the Musée Spécial de l'École Française before it was decided that they be sent again to the Muséum du Louvre, but their transfer was delayed or cancelled because "it was impossible to move them, without risk in view of their fragility in carriages."[336] In 1804, they were to be found again at the Château de Saint-Cloud but this time in Napoleon I's quarters.[337] In 1807, they furnished the same room, when the emperor decided to give up his quarters on the Cour d'Honneur in favor of the Empress Joséphine.[338] In 1818, the tables were in the Duchess of Angoulême's bedchamber[339] and probably in the Salon du Conseil in 1855.[340] In all likelihood, they were lost during the bombing and fire at the Château de Saint-Cloud in 1870.

C.V.

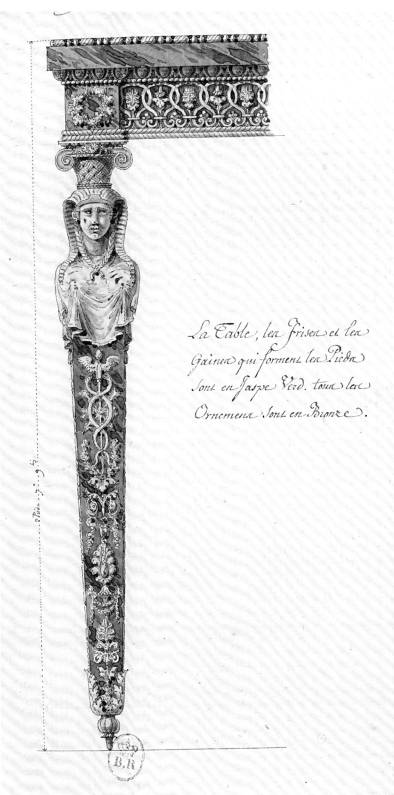

La Table, les Frises et les
Gaines qui forment les Pieds
sont en Jaspe Verd. tous les
Ornemens sont en Bronze.

Fig. 134
Pierre-Adrien Pâris, *Sketch Representing a Leg of the Duke of Aumont's Table*, 1782. Pencil on paper, 8 × 5⅜ in. (20.4 × 13.7 cm). Bibliothèque Municipale, Besançon (Fonds Pâris, vol. 453, no. 173)

Fig. 135
Pierre-Adrien Pâris, *Preparatory Drawing for the Engraving, Representing a Leg of the Duke of Aumont's Table*, 1782. Pencil, ink, and watercolor on paper, 7⅞ × 5⅛ in. (20 × 13 cm). Bibliothèque Nationale de France, Paris (RES V 2586, pl. 319)

41

Gilt-Bronze Ornaments

Pierre Gouthière after a design by François-Joseph Bélanger
1769-70
Gilt bronze
Dimensions unknown
Whereabouts unknown

Provenance:
Offered as a gift to the dauphine, Marie Antoinette, 1770.

Literature:
Maze-Sencier 1885, 101; Robiquet 1912 and 1920-21, 23-27; Salverte 1927, 144-45; Stern 1930, vol. 1, 9-12; Watson 1960, no. 9; Huisman and Jallut 1970, 99-101; Eriksen 1974, 79, 81, pl. 448; Baulez 1986, 593; Thornton 1998, pl. 339; Fuhring 2005, 246-48.

In 1745, at the time of the marriage of the dauphin, Louis XV's son, the Menus-Plaisirs, under the direction of the Duke of Richelieu, had already supplied a "superb cabinet in gold-embroidered crimson velvet," on a gilded and carved stand, at a price of 13,475 *livres*.[341] In 1770, for the marriage of the new dauphin, Louis XV's grandson, to Marie Antoinette, the tradition was continued with "a piece of furniture to hold jewelry" (again covered in gold-embroidered crimson velvet), the Bélanger design for which had been approved by the Duke of Aumont the previous year.[342] Several designs had been submitted to the duke, one of which is now in the Hermitage Museum,[343] but it was Bélanger's that was chosen. All the joinery and internal veneering, as well as the crowning features and base, were executed by Maurice Bernard Evalde (master in 1765). The sculpture of the eight tapered legs, the eagle brace between them, and the crown and surrounding dolphins were commissioned from Augustin Bocciardi for 5,540 *livres* (settled at 4,445 *livres*). The cabinet itself was covered in a crimson velvet richly embroidered in gold "in the manner of sculpture" that was supplied by the merchant of luxury goods Claude Delaroue (1707-1793) for 13,503 *livres* (settled at 13,000 *livres*). Gouthière supplied and gilded the main bronze moldings, the eight ball feet, the twenty-eight laurel ring handles for the drawers, and the round borders of the two medallions on the waist; for the central door, he also gilded a head of Apollo that replaced an embroidered head ordered and eventually rejected. His invoice shows that he asked the sculptor Jean-Antoine Houdon for the model for the head, at a price of 48 *livres*. He set out the stages of his work on the head as follows: "For fashioning the mold that was cast in tin and chasing the said tin; which mold was to serve as a model to make the same in copper, the whole estimated at 24 *livres*; for execution in copper, 36 *livres*; Plus, for matte gilding, 30 *livres*."[344] His invoice came to a total of 882 *livres* but was settled for 730 *livres*.

This jewelry cabinet was placed in Marie Antoinette's bedchamber, as is shown in a gouache by Jean-Baptiste-André Gautier-Dagoty (1740-1786) in which the cabinet still bears the ornamentation relating to the dauphine (fig. 137). The cabinet is still in the bedchamber in the Vigée Le Brun portrait of Marie Antoinette with her children (fig. 138), painted in 1787—not yet having been replaced by the "diamond chest" (*coffre aux diamants*) commissioned that same year from Jean-Ferdinand-Joseph Schwerdfeger (1734-1818)—but the symbols of the dauphine are gone and the crown has become a royal one. When Schwerdfeger's cabinet was finished, the one with gilt bronzes by Gouthière was sent to the Garde-Meuble's storehouse until it was auctioned on September 30, 1793, and sold for 6,120 *livres* to a certain Chauffour from Orléans. It was probably taken apart later on.

C.B.

Fig. 136
François-Joseph Bélanger, *Design for an Item of Furniture to house the Jewelry of Madame the Dauphine, made after drawings by Mr. Bélanger Architect, designer for the Menus-Plaisirs du Roy . . . approved for execution / the Duke of Aumont*, 1769. Black ink and gray wash, 25 × 30 in. (63.5 × 76.2 cm). Bibliothèque Nationale de France, Paris (Département des Estampes et de la Photographie, Ha 58, folio, fol. 32)

Projet d'un Meuble destiné a serrer les Bijoux de M.ᵐᵉ La Dauphine exécuté d'apres les dessins de M. Belanger architecte, Dessinateur des menus plaisirs du Roy.

approuvé pour estre exécuté
Le Duc d'aumont

Fig. 137
Jean Baptiste-André Gautier-Dagoty,
*Marie Antoinette Playing the Harp in
Her Room at Versailles*, ca. 1775.
Gouache on paper, 26½ × 21½ in.
(67,5 × 54,5 cm), Musée National des
Châteaux de Versailles et de Trianon
(MV 6278)

Fig. 138
Élisabeth Vigée Le Brun, *Marie
Antoinette with Her Children*, 1789.
Oil on canvas, 106¾ × 76¾ in.
(271 × 195 cm). Musée National des
Châteaux de Versailles et de Trianon
(MV 4520)

COLUMNS AND PEDESTALS

Column Capital and Base

Gilt bronze by Pierre Gouthière probably
after a design by François-Joseph Bélanger
Ca. 1775-80
Gilt bronze
Column, overall 97⅝ × 14⅝, diam. 8⅝ in.
(248 × 37, diam. 22 cm)
Musée du Louvre, Founding collection of
the museum (MR XI 1077)

Provenance:
Commissioned by Louis-Marie-Augustin,
Duke of Aumont, ca. 1775-80; in the sale of
his collections, December 12-21, 1782, lot 2;
purchased for Louis XVI; in the Musée du
Louvre since 1793.

Literature:
Robiquet 1912 and 1920-21, 48; Dreyfus
1922, 90, no. 453; Silvestre de Sacy 1953,
137; Verlet 1980, 205, 208; Cuzin, Caborit,
and Pasquier 2000, 174-75; Malgouyres
2003, 174-75; Alcouffe, Dion-Tenenbaum,
and Mabille 2004, 244.

Marble columns and vases were among the most precious objects in eighteenth-century French collections. In the sale catalogue for the Duke of Aumont's collection, Philippe-François Julliot and Alexandre-Joseph Paillet noted the following:

> There is little ornament more impressive or interesting in the arrangement of a collection than that which can be introduced by the well-judged placement of handsomely proportioned vases and columns. These elements essentially correspond to the ideas of the Ancients: it is to their refined taste, and their efforts to overcome, through hard work, the challenges due often to the extreme hardness of the most precious materials, that we owe these rare pieces that remain with us today.[345]

Among the fourteen columns the duke owned at the time of his death, many if not all of which dated back to antiquity, eleven were ornamented with bronze elements gilded and chased by Gouthière (cats. 42–48). The king bought six columns, including this one, for the future Muséum du Louvre, which opened in 1793. Since the date on which they were made is uncertain, they are presented here according to their appearance in the catalogue of the Duke of Aumont sale. The "Marble Columns and Vases" section was organized by type of material, starting with porphyry, including the column for this capital,[346] and moving on to *verde antico* marbles, serpentines, and so on.

Valued at 1,500 *livres* in the inventory drawn up after the duke's death,[347] this column went for 6,999 *livres* at the Aumont sale, where it was bought by Philippe-François Julliot on behalf of Louis XVI. The military ball described in the catalogue note and shown in the accompanying plate has disappeared. Only the preparatory drawing for the catalogue engraving gives us an idea of the superb contrast of colors between the gilt bronze and the various stones used (fig. 140).

Gouthière probably made the gilt-bronze elements after a design by François-Joseph Bélanger, who in this case was inspired by an ancient column that also belonged to the duke and was bought in 1782 by Louis XVI and is now at the Musée du Louvre (fig. 139).

C.V.

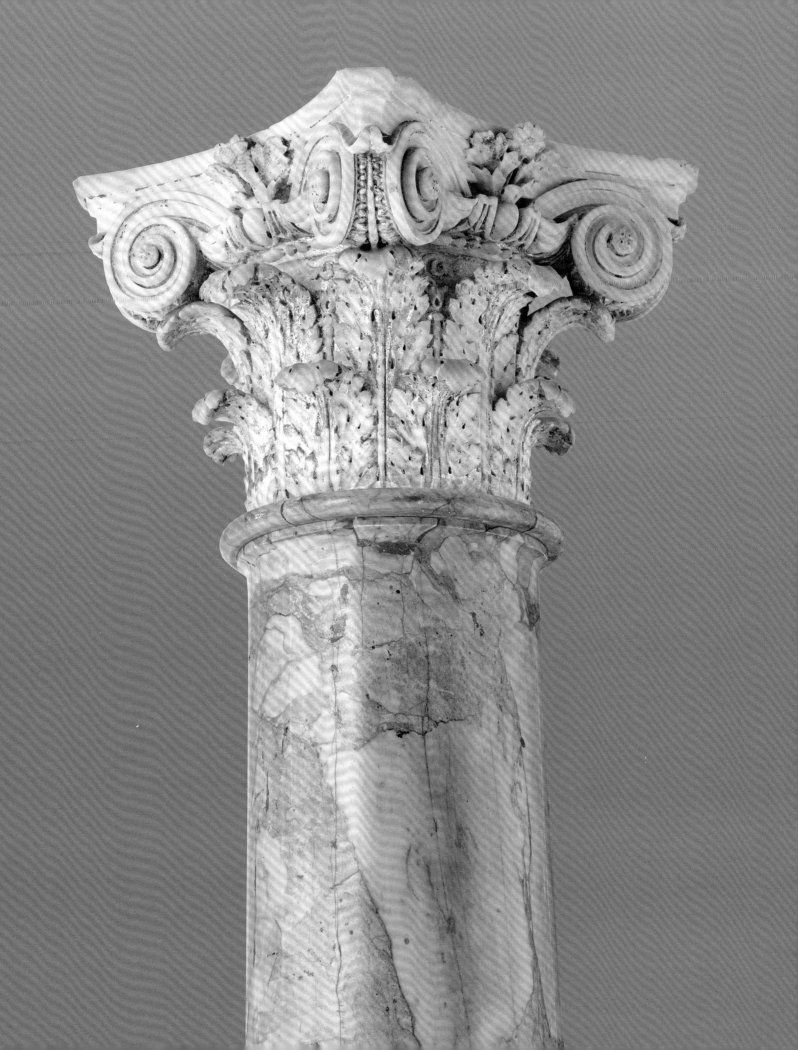

Fig. 139
Antique column from the
collections of the Duke of Aumont.
Antique yellow, white, and
Brocatelle d'Espagne marble with
traces of gilding on the capital.
Musée du Louvre, Paris (Ancien
fonds, MR 1252)

Fig. 140
Pierre-Adrien Pâris, *Preparatory
Drawing for the Engraving,
Representing a Column and a
Milliary Ball from the Duke of
Aumont*, 1782. Pencil, ink, and
watercolor on paper, 7⅞ × 5⅛ in.
(20 × 13 cm). Bibliothèque
Nationale de France, Paris (RES V
2586, pl. 319)

Two Column Bases

Gilt bronze by Pierre Gouthière probably
after a design by François-Joseph Bélanger
Ca. 1775–80
Gilt bronze
Each column, overall 102⅜ × 13, diam. 9 in.
(260 × 33, diam. 23 cm)
Musée du Louvre, Founding collection of
the museum (MR 1190–1191)

Provenance:
Commissioned by Louis-Marie-Augustin,
Duke of Aumont, ca. 1775–80; in the sale of
his collections, December 12–21, 1782, lot 7;
purchased for Louis XVI; in the Musée du
Louvre since 1793.

Literature:
Robiquet 1912 and 1920-21, 48; Dreyfus
1922, 91, no. 455.

Gouthière made the bases for two rare and precious "top-quality" *verde antico* marble columns that belonged to the Duke of Aumont. In the Aumont sale catalogue, Philippe-François Julliot and Alexandre-Joseph Paillet wrote: "These two Columns, of the greatest importance, perhaps unique in this capital, are striking for their handsome proportions and for the rich quality of their rare material. . . . They were found in Rome in an excavation carried out in 1766, close to the Temple of Vesta, near the Tiber, and it was after a considerable struggle, that the Artist engaged by Mr. the Duke of Aumont, obtained permission to bring these two pieces out of Rome."[348]

Gouthière's intervention on these columns was minimal: he merely added a base with an interlacing motif and waterleaves. His art is more fully on display in the two oriental alabaster vases intended to be placed atop the columns (cat. 10). The ensemble was purchased by Louis XVI, with Paillet as intermediary, for the astronomical sum of 13,800 *livres*. Although the king acquired them for the Muséum du Louvre, only the columns remain in the French public collections; the vases, which were sold in 1797, are now in a private collection.

C.V.

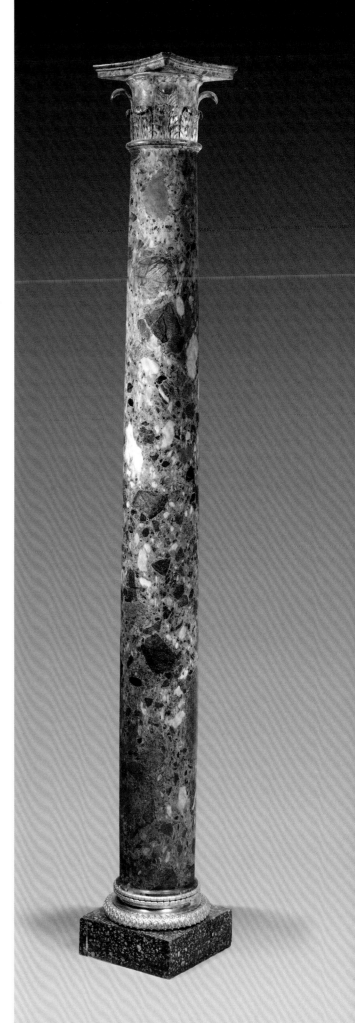

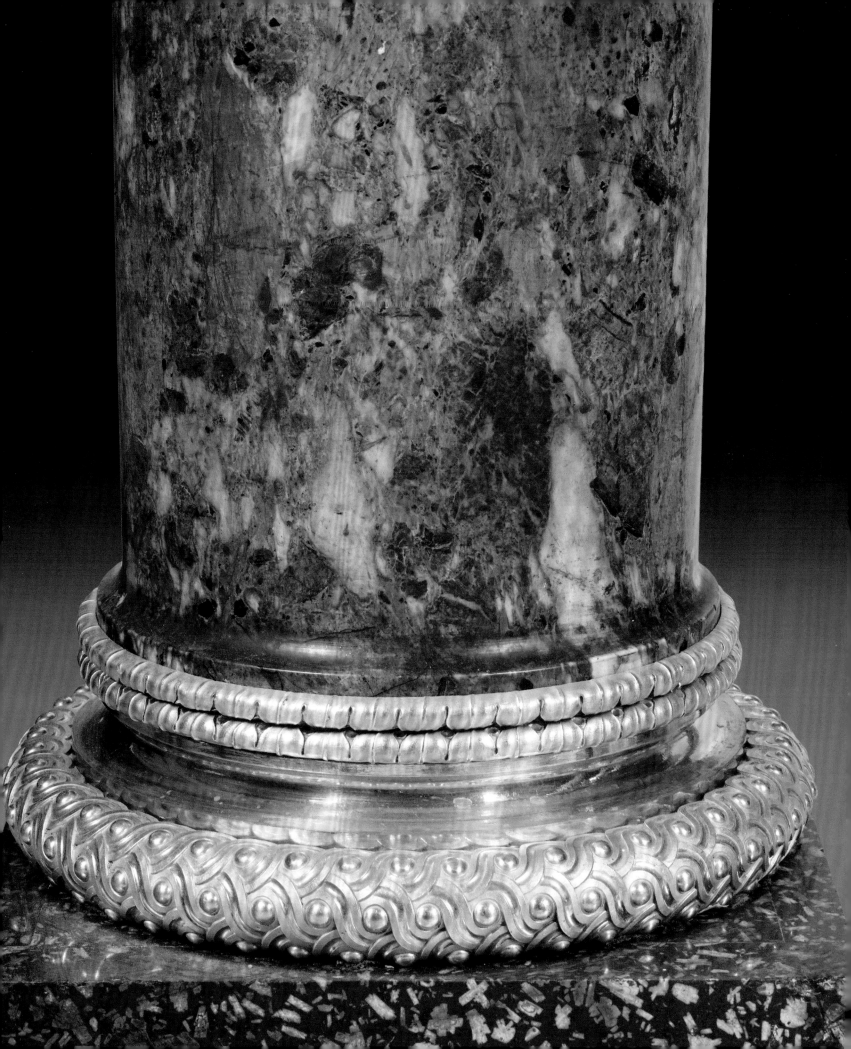

Column Capital and Base

Gilt bronze by Pierre Gouthière probably after a design by François-Joseph Bélanger
Ca. 1775-80
Gilt bronze
Column, overall 94⅛ × 16⅞, diam. 11 in. (239 × 43, diam. 28 cm)
Musée du Louvre, Founding collection of the museum (MR 1248)

Provenance:
Commissioned by Louis-Marie-Augustin, Duke of Aumont, ca. 1775-80; in the sale of his collections, December 12-21, 1782, lot 14; purchased for Louis XVI; in the Musée du Louvre since 1793.

Literature:
Robiquet 1912 and 1920-21, 49; Dreyfus 1922, 91, no. 456; Silvestre de Sacy 1953, 137.

On this *ancienne roche* (ancient rock) column, Gouthière added a wreath of acanthus leaves at the top of the shaft and, as a base, a wreath of laurel leaves. In the Aumont sale catalogue, Philippe-François Julliot and Alexandre-Joseph Paillet described it as "admirable, not only for its handsome and unusual proportions in this rare type but also for the rich quality with a variation of bright coloring, and its excellent harmony with the perfectly chased ornamentation."[349] Sold for 2,261 *livres* to Louis XVI for his museum's collections, the column is still at the Musée du Louvre.

C.V.

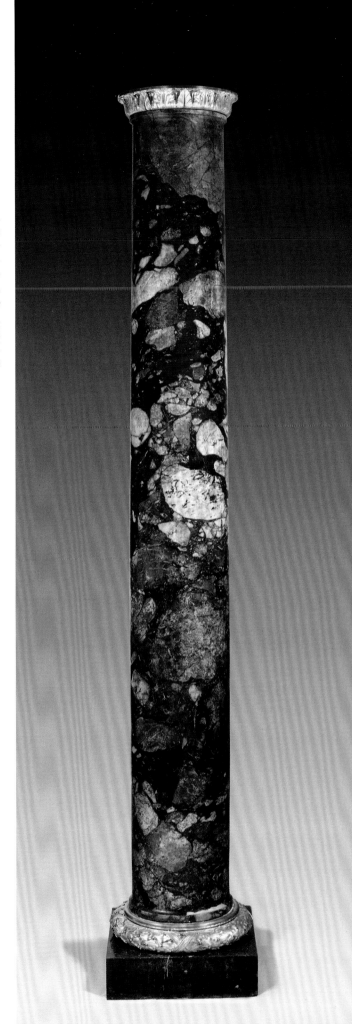

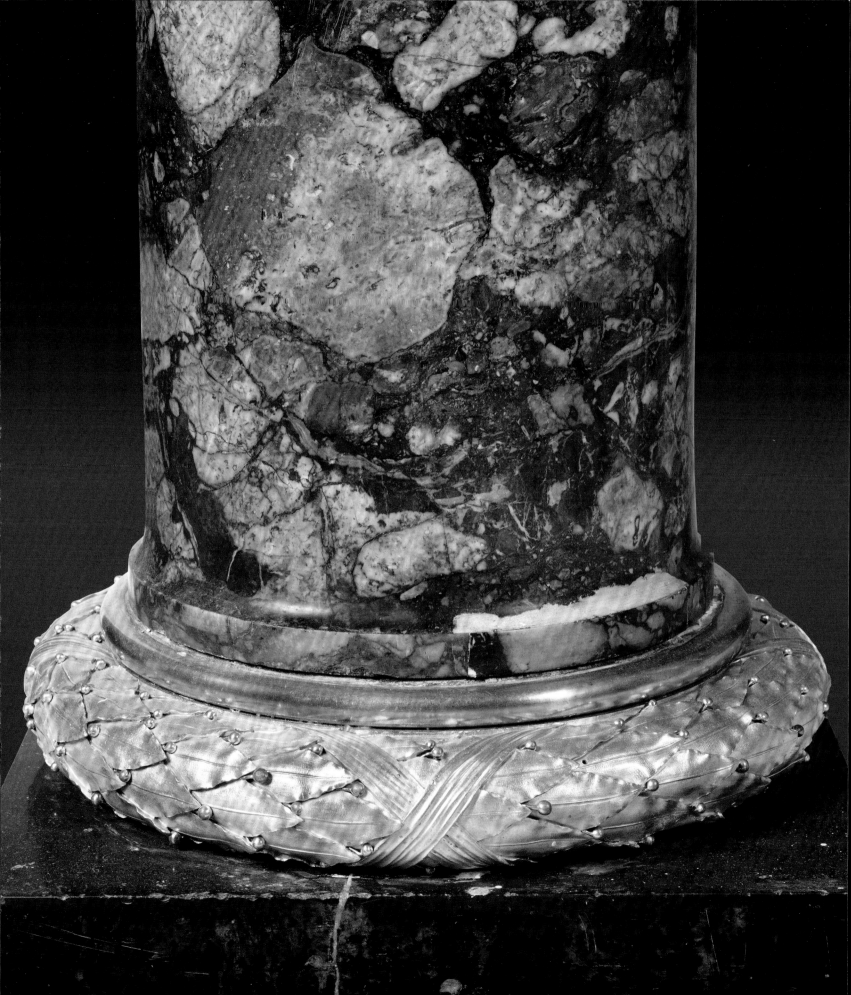

Column Capital and Base

Gilt bronze by Pierre Gouthière probably after a design by François-Joseph Bélanger
Ca. 1775-80
Gilt bronze
Column, overall 94⅛ × 16⅞, diam. 11 in. (239 × 43, diam. 28 cm)
Musée du Louvre, Founding collection of the museum (MR 1158)

Provenance:
Commissioned by the Duke of Richelieu (without the gilt bronzes), ca. 1775-80; Louis-Marie-Augustin, Duke of Aumont; in the sale of his collections, December 12-21, 1782, lot 15; purchased for Louis XVI; in the Musée du Louvre since 1793.

Literature:
Robiquet 1912 and 1920-21, 49; Dreyfus 1922, 91, no. 457; Silvestre de Sacy 1953, 137.

According to a penciled note in a copy of the catalogue for the sale of the Duke of Aumont's collections, Gouthière made the gilt-bronze ornamentation of the African marble column (cat. 44) for a gray granite column that had belonged to the Duke of Richelieu.[250] The column shown here was not reproduced in the catalogue, which instead referenced the plate of the African marble column as an illustration of Gouthière's gilt bronzes (cat. 44). Forming a false pair with the African marble column, it was likewise purchased by Louis XVI for the Muséum du Louvre. However, it achieved a higher price—3,320 *livres*—perhaps because of its provenance.

C.V.

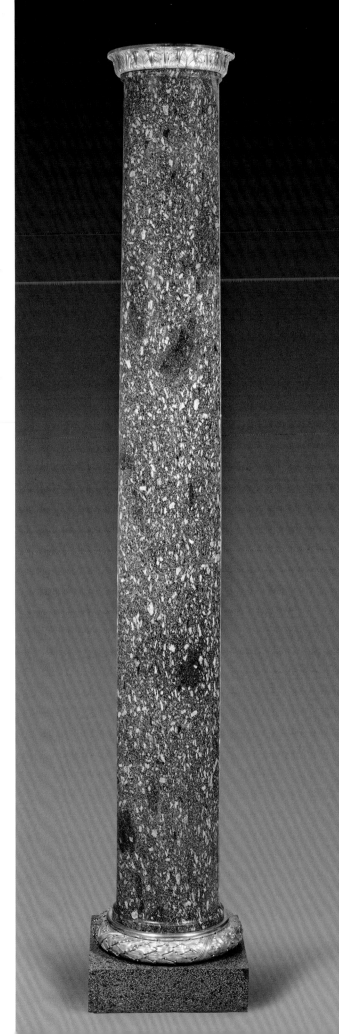

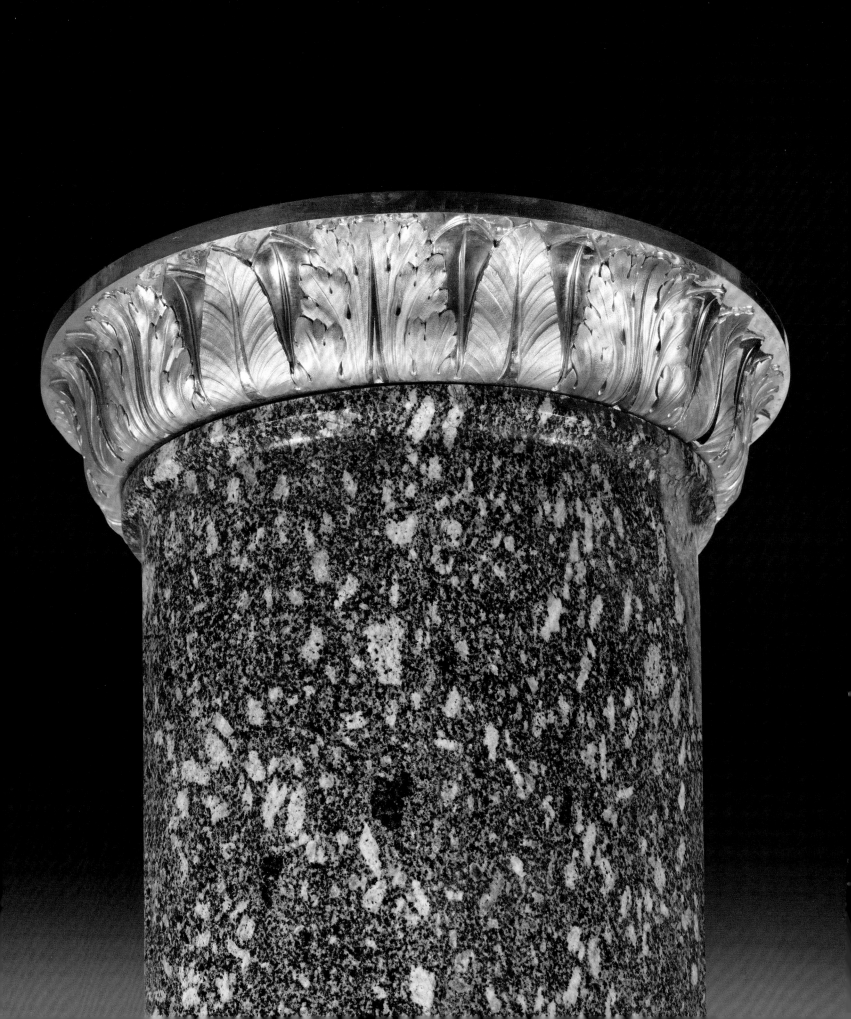

Bases for Two Column Shafts

Gilt bronze by Pierre Gouthière probably after a design by François-Joseph Bélanger
Ca. 1775-80
Gilt bronze
Each, 44 *pouces* 6 *lignes* (including the base) × 8 *pouces*, according to the catalogue description for the sale of the Duke of Aumont's collections (approx. 47 ½ × 8 ½ in.; 160.6 × 21.6 cm)
Whereabouts unknown

Provenance:
Commissioned by Louis-Marie-Augustin, Duke of Aumont, ca. 1775-80; in the sale of his collections, December 12-21, 1782, lot 17; purchased for Louis XVI; since lost.

At the sale of the Duke of Aumont's collections, Louis XVI bought, for 3,451 *livres*, two column shafts in gray granite with gilt bronze by Gouthière in an original design of dolphins and arabesques. The sale catalogue's authors, Philippe-François Julliot and Alexandre Joseph Paillet, said of them, "these two pieces are very agreeable for the lively speckle of their material, their proportions, and their elegant ornamentation."[351] Acquired by the king for the future Muséum du Louvre, where they were mentioned in 1793 as being stored in the Salle des Antiques,[352] the two shafts have since disappeared and are known today only through the plate from the Aumont sale catalogue and the plate's preparatory drawing by the architect Pierre-Adrien Pâris (fig. 141).

C.V.

Fig. 141
Pierre-Adrien Pâris, *Preparatory Drawing for the Engraving, Representing a Column Shaft from the Duke of Aumont*, 1782. Pencil, ink, and watercolor on paper, 7⅞ × 5⅛ in. (20 × 13 cm). Bibliothèque Nationale de France, Paris (RES V 2586, pl. 17)

3 Pieds. 8°. 6 lij.

Bases for Two Column Shafts

Gilt bronze by Pierre Gouthière probably
after a design by François-Joseph Bélanger
Ca. 1775–80
Gilt bronze
Each, 39 *pouces* (including the base) × 9
pouces 6 *lignes*, according to the catalogue
description for the sale of the Duke of
Aumont's collections (approx. 41½ × 10⅛ in.;
105.5 × 25.7 cm)
Whereabouts unknown

Provenance:
Commissioned by Louis-Marie-Augustin,
Duke of Aumont, ca. 1775–80; in the sale of
his collections, December 12–21, 1782, lot
22; purchased by Louis XVI; since lost.

At the 1782 sale of the Duke of Aumont's collections, Louis XVI acquired (for 1,720 *livres*) two fluted column shafts in *bleu grec* marble, each furnished with a gilt-bronze base of acanthus leaves and laurel torus interlaced with ribbon executed by Gouthière. Sale catalogue authors Philippe-François Julliot and Alexandre-Joseph Paillet described them as follows: "these two pieces are interesting for their quality, which is both rare and pleasant, their workmanship, and their tasteful ornamentation."[353] In 1793, the shafts were mentioned as being stored in the Salle des Antiques at the Louvre;[354] but thereafter they became untraceable and are known today only through the plate from the sale catalogue and the plate's preparatory drawing (fig. 142).

C.V.

Fig. 142
Pierre-Adrien Pâris,
*Preparatory Drawing for the
Engraving, Representing a
Column Shaft from the Duke
of Aumont*, 1782. Pencil, ink,
and watercolor on paper,
7⅞ × 5⅛ in. (20 × 13 cm).
Bibliothèque Nationale de
France, Paris (RES V 2586,
pl. 22)

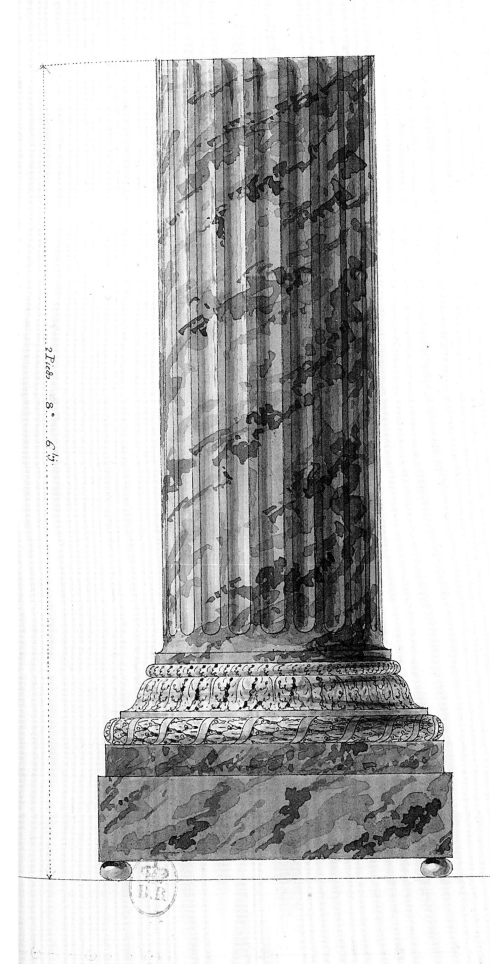

2 Pieds....8°....6¼

Two Column Shafts

Gilt bronze by Pierre Gouthière probably
after a design by François-Joseph Bélanger
Ca. 1775–80
Gilt bronze
Each, 44 *pouces* × 8 *pouces lignes*,
according to the catalogue description for
the sale of the Duke of Aumont's collections
(approx. 46⅞ × 8½ in.; 119 × 21.6 cm)
Whereabouts unknown

Provenance:
Commissioned by Louis-Marie-Augustin,
Duke of Aumont, ca. 1775–80; in the sale of
his collections, December 12–21, 1782, lot
23; purchased by Claude-Louis Châtelet;
Saint-Julien sale, June 21, 1784, lot 178;
since lost.

It was with a simple ribbon molding that Gouthière ornamented two columns in *vert d'Égypte* marble, which were sold at the auction of the Duke of Aumont's collections in December 1782 (fig. 143). The sale catalogue authors emphasized the importance of the marbles, which called for a base by the high-priced chaser-gilder to the king, adding: "These two shafts are of the most perfect quality, & from the most ancient rock of this material."[355] The shafts went for 800 *livres* to the painter Claude-Louis Châtelet (1753–1795), who was probably acting as an intermediary since lot 23 of the Aumont sale was to reappear as lot 178 in the Saint-Julien sale on June 21, 1784.

C.V.

Fig. 143
Pierre-Adrien Pâris, *Preparatory Drawing for the Engraving, Representing a Column Shaft from the Duke of Aumont*, 1782. Pencil, ink, and watercolor on paper, 7⅞ × 5⅛ in. (20 × 13 cm). Bibliothèque Nationale de France, Paris (RES V 2586, pl. 23)

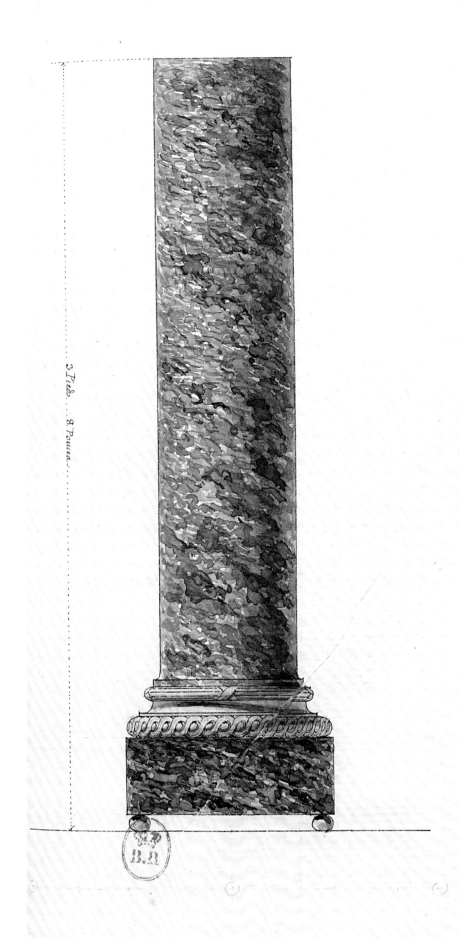

3 Pieds ... 9 Pouces

Two Pedestals

Marble carved by Jacques Adan
Gilt bronze by Pierre Gouthière
After a design by François-Joseph Bélanger
1781
Blue turquin marble and gilt bronze
Dimensions unknown
Private collection

Provenance:
Commissioned by Louise-Jeanne de
Durfort de Duras, Duchess of Mazarin, 1781;
in her former *hôtel particulier* until 1845;
Baron James de Rothschild at the Château
de Ferrières; private collection.

Literature:
Baulez 1986, 582-87, 634; Faraggi 1995, 82;
Duclos 2009, 74.

Two extraordinary pedestals were made in 1781 for the large salon of the Duchess of Mazarin's *hôtel particulier* on Quai Malaquais, where they were placed between windows overlooking the courtyard and garden. They had been designed to hold a group of female figures sculpted in white marble by Jean-Joseph Foucou, but the duchess's death precluded its making. Each group was intended to support a gilt-bronze tripod, which formed a nine-light candelabrum while also serving as a base for a Sèvres porcelain vase in which a Lepaute clock was to be incorporated.[356] The gilt-bronze elements had also been commissioned from Gouthière, who had only made the model by the time of the duchess's death.[357]

Gouthière received the pedestals on October 30, 1779 from Jacques Adan, who had been engaged to supply and carve the marble. It took Gouthière fifteen months to complete and assemble the gilt-bronze elements. The pedestals were installed in the large salon of the residence on Quai Malaquais on March 14, 1781—three days before the duchess's death.[358] In the subsequent inventory, the letter *L* for *légué* (bequeathed) was added alongside the description of the pedestals to indicate they had been given by the duchess to Radix de Sainte-Foy together with the other gilt-bronze objects by Gouthière from the large salon.[359]

Gouthière's invoice, dated 1781, provides valuable details of the design and making of these sumptuous pedestals.[360] He judged his work to be worth 29,734 *livres*, but, not having been paid before the duch-

ess's death, he only received 24,300 *livres* following the valuation by the bronze-makers François Rémond and Étienne Martincourt.[361]

At the request of the Duchess of Valentinois, the Duchess of Mazarin's daughter and heir, an attempt at selling the Quai Malaquais *hôtel* was made immediately after the duchess's death. For the 685,000 *livres* asked for it, the Baron of Castelet, a potential buyer, demanded that the two pedestals remain in place. Radix de Sainte-Foy, to whom they had been bequeathed, consented on the condition that he receive 10,000 *livres* in compensation.[362] Included in the 1781 sale,[363] they were bought and subsequently sold to the Marquis of Juigné in March 1785 with Mazarin's former residence. They probably remained there until the building's demolition, which was ordered in 1845 by the heirs of Vincent Caillard, who had acquired the *hôtel* in 1820.[364] The decorative elements were then scattered, the best of them serving to ornament the chateau of the Rothschilds. If a watercolor by Eugène Lami is to be believed, they were placed together with the Duchess of Mazarin's chimneypiece in the large "Louis XVI" salon at the Château de Ferrières (fig. 127). At some point, the two pedestals, which were of different sizes because of the difference between the window piers in Mazarin's salon, were altered so they would have equal dimensions.

C.V.

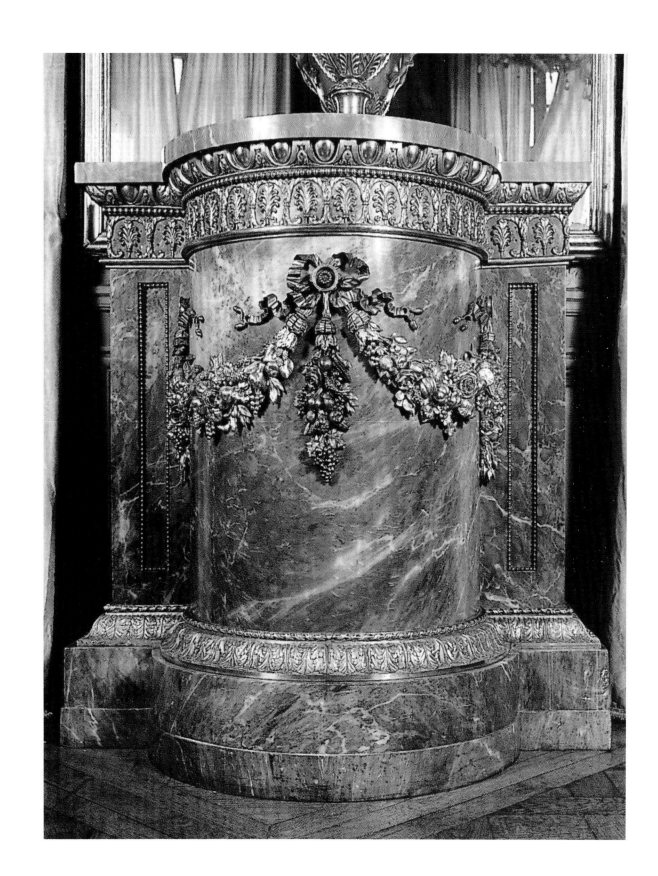

1. *A Encomenda Prodigiosa* 2013.
2. Note, for example, the letter from A. Azevedo Coutinho, dated May 20, 1724, in which he states, "Yesterday, I saw the work by Germain, and found another two salvers that are very green. The gilded parts are beginning to 'jeter le vif-argent,' so that we still have time. But I am beginning to worry, which is what I always do." *Boletim da Academia Nacional de Belas-Artes* (I). Doc V, Documentos, Lisbon, 1935, 3.
3. Orey 1991.
4. Several dessert spoons and knives were also chased by Nicolas Martin Langlois, one of the best cutlery manufacturers in Paris, and by Jacques Ballin. According to Christiane Perrin, this suggests that Germain entrusted this silversmith with the task of manufacturing or finishing some of these pieces, which were not yet completed at the time of their seizure, on December 15, 1767. Perrin 1993, 170.
5. Monteiro 2002, 58.
6. Note from Dom Vicente de Sousa Coutinho to the Duke of Choiseul about the pieces ordered from Germain, Paris, June 11, undated. Instituto dos Arquivos Nacionais Torre do Tombo, Ministério dos Negócios Estrangeiros, Lisbon (hereafter IANTT), cx. 927.
7. Ibid.
8. Perrin 1993, 160–70.
9. IANTT, L93, letter of June 25, 1765, signed by Dom Luis da Cunha, ambassador of the Portuguese court in Paris. On Delorme, see Baulez 2009.
10. Vera-Cruz Pinto and Alves 2002.
11. IANTT, cx. 927.
12. Ibid.
13. *Boletim da Academia Nacional de Belas-Artes* (I). Doc. V, Documentos, Lisbon, 1935, 16–18; *Mercure de France*, September 1748, 230.
14. *Avant-Coureur*, September 8, 1766.
15. Bapst 1886, 514; Bapst 1887, 140.
16. "Note des ouvrages comises au S. Germain pour la Cour du Portugal," sent by the ambassador Vicente de Sousa Coutinho to the Duke of Choiseul, Paris, June 11, undated. IANTT, cx. 92.
17. Still remaining from this set are a mirror, ewer and basin, two candlesticks, a candle snuffer and its tray, a root box, two red velvet cushions, two hairbrushes and two clothes brushes, two large boxes, two powder boxes, two patch boxes, two beakers with lids, two oval foot salvers, a glove box, a sponge box, a bell, a funnel, a spittoon, and four glass flasks with vermeil lids. Perrin 1993, 286, n. 152.
18. Letter from João Pinto da Silva to Ambassador Vicente de Sousa Coutinho, dated October 27, 1777. *Boletim da Academia Nacional de Belas-Artes* (I). Doc. V, Documentos, Lisbon, 1935, 87.
19. Perrin 1993, 192.
20. Letter from the police superintendent to the Count of Saint-Florentin, dated October 23, 1765. IANTT, cx. 95, quoted by Perrin 1993, 192.
21. See note 14 above.
22. *Compte de M. L. Baumons de Lisbonne du 1er août 1764*, IANTT, cx. 925.
23. Lorentz 1951, 41–45.
24. Archiwum Główne Akt Dawnych, Warsaw (hereafter AGAD), Zbiór Popielów 230, 146, letter from Czempinski dated July 28, 1764; quoted in Lorentz 1951, 45.
25. AGAD, Zbiór Popielów 230, 141, letter of August 10, 1764; quoted in Ładyka and Šaratowicz 1997, 27.
26. "I beg him at his departure to bring with him the vases with which Your Majesty seems to be so pleased." AGAD, Zbiór Popielów 230, 137, letter of February 25, 1765, from Germain to the king.
27. The 1765 inventory of Germain's workshop mentions "two sets of porphyry vases composed of two incent [*sic*] burners and a vase to be placed between them; in total 6 pieces at 733 *livres*, sale price: 6,600 *livres*." AN, M.C.N., LXXXIII 511, April 1765.
28. Research has indicated differences in the composition of the mass from which the bodies of the vases were made, which might explain the difference in colors between the vases.
29. AGAD, Archiwum Józefa Poniatowskiego 134, "Inwentarz Zamku Jego Królewskiej Mości . . . Warszawskiego . . . 1769 . . . spisany," 215.
30. "Generalny Inwentarz Mebli i innych ruchomości znajdujących się w Zamku Warszawskim sporządzony w marcu 1795 roku" (translated and edited in Ładyka 1997, 125, note 83).
31. AGAD, Zarząd Pałaców Cesarskich 3197, vol. 3, 16.
32. Iskierski 1929, 27.
33. AGAD, Zbiór Popielów 230, 168: "He also composed the material for the vases that the Sr. Germain has delivered to Your Majesty."
34. Przewoźna 1986, 549.
35. These vases were first attributed to Gouthière by Christian Baulez (1986, 563–64).
36. AGAD, Zbiór Popielów 230, fol. 159 (undated letter); quoted in Ładyka and Saratowicz 1997, 31; Taillard 2009, 69–70.
37. Eriksen 1974, 363.
38. Perrin 1993, 59.
39. Priore 1996, 34–35.
40. See p. 31 of this publication.
41. Appendix 1: 1767, November 13 and 17.
42. Biblioteka Uniwersytetu Warszawskiego (hereafter BUW), Gabinet Rycin, Zb. Król. P. 183, nos. 266, 267, 271; on no. 271 later inscribed in pencil: Giacomo Morot; see *Katalog rysunków z Gabinetu Rycin Biblioteki Uniwersyteckiej w Warszawie*, vol. 1, *Varsaviana* (Warsaw: Państwowe Wydawnictwo Naukowe, 1967), cats. 316–18.
43. AGAD, Zbiór Popielów 230, 133; quoted in Ładyka and Saratowicz 1997, 32.
44. Lorentz 1951, 46.
45. Lorentz 1958, 10.
46. Details of design of the gueridon beneath the candelabra, BUW, Gabinet Rycin, Zb. Król. P. 183, no. 267, and the design for the candlestick, Zb. Król. P. 183, no. 281.
47. This confirms Christian Taillard's opinion that "Louis provided models to Germain before receiving an important commission from the king of Poland where the decoration played an important role" (2009, 23).
48. Appendix 1: 1767, November 13 and 17.
49. Horbas 1996.
50. Penny 1992, vol. 2, 43–44 ; Penny 1993, 252–54; see also Perrin 1993, 238.
51. Rondot 1891, 389–91. See also Rondot 1865; Brault-Lerch 1986, 8, 252, 255; Robiquet 1912 and 1920–21, 14–15.
52. Rondot 1865.
53. Ibid.
54. The Metropolitan Museum of Art owns a drawing representing a candelabrum by Le Barbier with the inscription at the lower right: *No. 1*, below: *Gouthiere* (1986.1007.2).
55. Rondot 1865.
56. AN, O^1 826.
57. Sotheby's, London, May 18, 1967, lot 134, (h. 28 cm); bought by the art dealer Blaiman for £5,600; since the mount is said to have been in gilt bronze, it was probably not one of Mme Du Barry's silver gilt vases.
58. Former collection of the gold merchant and jeweler André Falize. *Connaissance des arts*, November 1960, 93; *Maison et Jardin*, December 1960, 116; Meuvret and Frégnac 1963, 297; Musée des Arts Décoratifs, Paris, Collection Maciet 480/2; Baulez 1986, 565, figs. 3, 4. Note that two vases described as being in *vert de mer* (sea green) marble, from the late nineteenth century, were sold at Christie's, London, on June 7, 2000, lot 499, and again in Paris, at the Hôtel Drouot, on May 25, 2005, lot 55.
59. Sale of April 6, 1789 (Mr. Lolliée), lot 117: "Two vases in boxwood root, in the shape of ewers, with figures of fauns and sirens in gilded copper, forming the handles." These may be the ewers that belonged to Mme Jacques Balsan, née Consuelo Vanderbilt, Duchess of Marlborough; Matthew Schutz; sale at Sotheby's, New York, December 9, 1994, lot 152; sale at Sotheby's, New York, May 23, 2012, lot 218; private collection. Note that the two ewers sold in 1994 and 2012 are similarly decorated with a dolphin's head and a garland of acanthus leaves, although their handles are formed differently, with a satyr and a siren.
60. The Frick Collection, New York, Frick Art Reference Library Archives, Eagle Rock Papers, Duveen Brothers invoices of July 6, 1915, May 27, 1916, and June 21, 1916, under the inventory number M77 (for Morgan 77). The Duveen invoices incorrectly state that the ewers are dated 1765. In April 1915, Joseph Duveen had bought, for two million dollars, the collection of eighteenth-century French objects and furniture amassed by John Pierpont Morgan. In the succeeding years, he sold many of these works to Henry Clay Frick for his New York residence, which is now The Frick Collection, and his summer residence, Eagle Rock, in Massachusetts (Vignon forthcoming).
61. Zek 1994, 152 and 164.

62. Christie's, New York, October 26, 1994, lot 142 (this information seems to have been communicated to Christie's by Nina Valentinovna Vernova, then director of the Peterhof Palace, and/or Elena Kalnit-skaya, then director of the Mikhailovsky Palace in St. Petersburg).
63. Benois 1902, 166.
64. See note 62.
65. Boucher 1927.
66. Inventory of the Marquise of Estampes, May 9, 1832 (private collection): "No. 87: A receptacle in white marble with two gilded female figures, two porcelain vases, valued at 75 *livres* (kept [in the family])."
67. *Grands salons littéraires* 1927, no. 154.
68. Rondot 1865.
69. Ibid.
70. Musée du Louvre, inv. 24278, 24677, and 24701. My thanks to Juliette Trey for providing information regarding these drawings. See also Boucher 1927; Guiffrey and Marcel 1908, nos. 798-800.
71. Duclaux 1973, no. 20, pl. VII.
72. Brunet and Préaud 1978, 185.
73. Sale of April 22, 1782, lot 139: "an ivory vase placed on an altar in the same material; two young nude female figures in gilt bronze decorating it with garlands of roses that they are attaching to rams' heads which are on either side of the vase embellished at the top with a bronze neck and at the bottom with a string of pearls. The base of the altar is in bronze with parsley leaves, and the whole is placed on two white marble steps; height 9 inches 6 *lignes*, diameter 9 inches." It sold for 281 *livres* to Charles-Joseph Lenoir Du Breuil, from whom it was confiscated during the revolution. Still not attributed to Gouthière, it was valued at 1,010 *livres* in 1793 (AN, F^{17} 1191, file 3, item 38, no. 25, inventory of objets d'art sequestered from Lenoir Du Breuil at the "dépôt de Nesle," the storehouse on Rue de Beaune, on 30 Prairial in the year II [June 18, 1793]). In 1795, it was proposed that it be given "to the citizen Grandcourt," one of the Republic's creditors; it was then valued at 240 *livres* (AN, F^{17} 1192b, item 105, 3 Thermidor in the year IV [July 21, 1795]). But it was decided to attribute it along with other objects to Marguerite-Suzanne Denoor, in exchange for the natural history collection of her former husband, François Levaillant, which she had sold to the government (AN, F^{17} 1192b, item 174, 20 or 26 Frimaire in the year V [October 12 or December 16, 1796]. Christie's, London, November 12, 2002, lot 133; private collection, Paris.
74. Sale of April 30, 1795, lot 185: "A vase standing on a fluted column shaft. This piece is embellished with two female figures, standing on either side, attaching garlands of flowers to two rams' heads placed on each side of the vase, and other matte-gilded bronze ornamentation. The whole ensemble standing on a double socle, in the shape of a step in white marble. Height: 10 *pouces*, width 7 and a half *pouces*."
75. Sale of April 8, 1783, lot 179: "A red porphyry vase of 10 *pouces* in height, embellished with four satyr heads terminating in tapered shafts with goats' hooves; the lower part adorned with a shrub motif of long leaves and ornamented with garlands of ivy. The piece standing on a base comprising an altar in black and white granite of 9 *pouces* in height and richly ornamented with bronze circles of laurel leaves, waterleaves, and parsley; the said base accompanied by two Bacchantes of 13 *pouces* in size attaching garlands to the satyrs' horns. The whole placed on a plinth of green granite forming two rimmed steps of 2 *pouces* 6 *lignes* in height. This item, which is prized for the beauty of the materials and the gilt-bronze work that has been done after a model that is both ingenious and in impeccable taste, cannot fail to please collectors. Total height: 24 *pouces*, diameter 16 *pouces*."
76. Sale of June 21, 1784 (Baron of Saint-Julien), lot 173. The description repeats the one used in the catalogue of the sale of April 8, 1783, lot 179 (note 74) with the following addition: "This item, which is prized for the beauty of the materials and the gilt-bronze work that has been done after a model by Mr Feuillet." The same description was used again in the catalogue for the sale on February 14, 1785 (lot 177).
77. Sale of March 23, 1784, lot 1; see also Baulez 2003, 161.
78. Appendix 1: 1773, December 31 (2).
79. See note 59.
80. Sale of April 6, 1789, lots 117 and 118. See also note 58.
81. Appendix 1: 1794, August 16. See also Baulez 2014, 89.
82. Three vases of the same shape and color, but with different bronze ornamentation, from the collection of the earls of Pembroke, are now in a private collection (Alcouffe, Dion-Tenenbaum, and Mabille 2004, 217). An unmounted pair of Chinese porcelain vases, Kangxi ca. 1720, was exhibited by Cohen & Cohen at TEFAF, Maastricht, in 2008.
83. Bachaumont 1783-89, vol. 21, 218. I thank Kristel Smentek for sharing this reference. See also Davillier 1870, iii.
84. Appendix 1: 1782, December 12-21, lot 3.
85. Vivant Denon, "Voyage pittoresque," unpublished manuscript, Collection Frits Lugt, Paris, 43.
86. See pp. 39-41 in this publication.
87. See pp. 87-91 in this publication.
88. On porphyry collectors in eighteenth-century Paris, see Baulez 2003, 152-62.
89. Appendix 1: 1782, December 12-21, lot 3.
90. Appendix 1: 1782, May 1, no. 584.
91. Sale of February 27, 1777, lot 437: "Two further vases, Medici form, perfectly carved and hollowed out, to a thickness that is almost as slight as a very strong board might be, placed on a square socle, refined in taste, with panels, fleurons, and masks of Bacchus, in gilt bronze; height of the porphyry, 11 inches 6 *lignes*, shafts 8 inches in diameter. These two vases made in Rome are sensational gems of great interest, for the beauty and polish of their material, as well as for the mastery of their art."
92. Malgouyres 2003, 176.
93. J. Paul Getty Museum, 74. DJ.24, purchased in June 1974 (35.6 × 22.9 cm). This pair was wrongly considered the one belonging to Randon de Boisset.
94. Palais d'Orsay, Paris, November 25, 1977, lot 94 (h. 36 cm). Palais d'Orsay, Paris, June 20, 1978, lot 48 (h. 36 cm). Sotheby's, June 25-26, 1983, lot 130 (h. 36 cm).
95. Christie's, London, December 12, 2002, lot 50 (34 × 23 cm). The dish has snakes for handles.
96. Malgouyres 2003, 176.
97. Appendix 1: 1782, May 1, no. 606.
98. Appendix 1: 1782, December 12-21, lot 6.
99. Baulez 2003, 160, and pp. 40-41, 377 in this publication.
100. They do not appear in the inventory of items taken by the luxury goods merchant Dominique Daguerre in 1789 from Marie Antionette's quarters (Tuetey 1914).
101. See Verlet 1980, 207, no. 61. "Two incense burners in gray porphyry with scrolled handles and standing on three gilt-bronze feet (h. 12 in.)." This succinct description was repeated in the first catalogue of the Musée du Louvre, which was published a few months later.
102. The information is given in the Christie's catalogue, London, December 2, 1997, lot 10.
103. Appendix 1: 1782, December 12-21, lot 7.
104. AN, O^1 1934, folder B, item 15; O^1 3280, folder 7.
105. Archives of the Musée du Louvre, M4, "Vente d'objets d'art du Museum," October 27-28, 1797 (6-7 Brumaire in the year VI), the museum's no. 59, no. 79 among the valuations.
106. The history of these vases in the nineteenth century is given in the catalogue of the sale at Christie's, New York, November 24, 1998, lot 15.
107. Appendix 1: 1782, May 1, no. 604.
108. Appendix 1: 1782, December 12-21, lot 11.
109. Catalogue of the Duke of Aumont sale, library of the Institut National d'Histoire de l'Art, Paris (see also Du Colombier 1961, 28). "Boissette" was probably a reference to Randon de Boisset, whose collection of hardstones and other curiosities was sold at auction in 1777. However, this vase does not appear in the sale catalogue, with or without Gouthière's mount.
110. Drouot, Paris, May 25, 1993, lot 90 (former collection of Eugène Becker).
111. AN, AJ19 155, no. 107 (formerly no. 103): "Two plump-shaped vases in green serpentine, one with a frieze at the neck and a ram's head, and the other with a female figure, with knobs in the form of bunches of grapes. Each valued at 800 francs."
112. For example: Sotheby's, April 9, 2008, lot 187 (h. 40 cm, w. 38 cm). For Beurdeley, see Dorival 1989, 192-241. On p. 207, the author reproduces a photograph of the Beurdeley stand at the Exposition Universelle in Paris in 1889, where an example of vases 11 and 12 (cat. 12) from the Aumont sale can be seen.
113. AN, AJ19 155, no. 107 (formerly no. 103).
114. Appendix 1: 1782, May 1, no. 603.

115. Appendix 1: 1782, December 12-21, lot 12.
116. Couilleaux 2016, 38.
117. Appendix 1: 1767, November 13 and 17.
118. Appendix 1: 1769, September 27.
119. Appendix 1: 1777, February 27; and 1810, March 20-25.
120. AN, AJ[19] 155, no. 107 (formerly no. 103).
121. AN, AJ[19] 155, no. 370 bis: "An urn-shaped vase in serpentine marble, handles in the form of rams' heads in gilt bronze, lid ditto, girdle ditto, surmounted by a knob, vine leaves, and bunches of grapes. H. 37 cm (no. 26714/Magasin)."
122. Dorival 1989, 207.
123. Appendix 1: 1782, December 12 and 21, no. 25. The description was accompanied by a laudatory commentary by Juillot and Paillet: "Ce morceau, précieux par la rareté de son espece, le vif agréable des couleurs et le net du travail, est relevé par une garniture du dessin le plus ingénieux et du goût le plus flatteur dont l'Artiste ait pu être animé pour donner à cette coupe une forme aussi heureuse que riche, qui répondît au mérite de la matiere par le plus parfait accord de l'excellent genre et du fini des ornemens; et en effet cette piece présente un chef-d'œuvre de l'art."
124. Appendix 1: May 1, 1782, no. 610.
125. Baulez 2001b, 36-38.
126. Ibid. and Hans 2008.
127. Ephrussi 1879, 389-408.
128. Ibid.
129. *Annonces, affiches et avis divers*, no. 292, 22 Messidor in the year VI (July 10, 1798), 5721.
130. On the Duke of Aumont's porcelain collection, see Castelluccio 2011 and Vriz 2013.
131. Appendix 1: 1782, December 12-21, lot 43.
132. The other known example of the catalogue of the Duke of Aumont sale, illustrated by Saint-Aubin and now in a private collection, also features a sketch of these incense burners (Verlet 1980, 207).
133. Appendix 1: 1782, May 1, no. 628.
134. Verlet 1980 and AN, O[1] 3280, no. 43 (cited in Vriz 2013, 90).
135. AN, F[17] 372, fol. 139; F[17] 1191, folder 6; F[17] 1192B, item 174.
136. Ibid.
137. Sale of March 30, 1767, lot 1362: "An incense burner, also in old porcelain, of excellent & rare quality with birds, variously colored bouquets, and slightly ribbed in form, which gives a double merit to this piece, embellished with carefully composed ornamentation in bronze. At Jean de Julienne's, this incense burner decorated his accommodation at the Gobelins" (AN, M.C.N., XXIX 529, cited in Vriz 2013, 90).
138. AN, AJ[19] 169, no. 1093.
139. Guiffrey 1877, 159-65; Wildenstein 1921.
140. Wildenstein 1921, 121-22. See also Guiffrey 1877, 161.
141. Appendix 1: 1782, November 16 (1) and (2).
142. Appendix 1: 1782, December 12-21, lot 110.
143. Vriz 2013, 92.

144. Appendix 1: 1782, November 16 (2).
145. Appendix 1: 1782, December 20.
146. Ledoux-Lebard 1975, 195; Ducrot 1993, 285, no. 225; Slitine 2002, 72-73; Christie's, London, May 9-17, 1895, lot 498; Christie's, New York, September 28, 1995, lot 219.
147. Appendix 1: 1782, December 12-21, lot 114.
148. Appendix 1: 1784, December 25.
149. Vriz 2013, 93.
150. Beurdeley 1988, 59. Although Beurdeley mentions that this drawing is at the Metropolitan Museum of Art (without accession number), it has not been found either there or at the Cooper Hewitt, Smithsonian Design Museum. I am grateful to Femke Speelberg and Caitlin Condell for their help in trying to locate this drawing.
151. Wildenstein 1921, 121-22.
152. Ibid.
153. Appendix 1: 1782, November 16 (1).
154. Appendix 1: 1782, November 16 (2).
155. Appendix 1: 1782, December 20.
156. Christie's, Paris, November 26, 2005, lot 307.
157. According to Verlet, Germain de Saint-Aubin made a sketch of these urns in the catalogue for the sale of Aumont's collections that is preserved in a private collection (Verlet 1980, 207).
158. See also Appendix 1: 1782, November 16 (1).
159. Appendix 1: 1782, November 16 (2).
160. Appendix 1: 1782, December 20.
161. Appendix 1: 1782, December 12-21, lot 163.
162. The clock is covered by several layers of paint, the earliest of which is clearly a faux lapis lazuli. It consists of a thin layer of natural ultramarine (ground lapis lazuli) topped with a plant resin varnish with flecks of gold simulating the pyrite found in lapis lazuli. I thank Susan Buck and Joseph Godla for the paint analysis.
163. Christie's, London, June 28, 1893, lot 397. The following lot was a pair of candelabra "each with an undraped female figure bearing a cornucopia, supporting poppy branches for three lights each . . . by Gouthiere."
164. The earliest paint on the clock case is the same faux lapis lazuli found elsewhere on the piece (see note 162); no trace of faux agate was found. I thank Susan Buck and Joseph Godla for the analysis of the paint on this piece.
165. Paris, June 21, 1989, lot 100, and Paris, May 29, 1996, lot 197.
166. Christie's, New York, April 19, 1978, lot 42, and Paris, June 16, 1981, lot 16.
167. Bibliothèque des Arts Décoratifs, Paris, Papiers Champeaux. See also Rondot 1865 and cat. 4.
168. Davillier 1870, xxii-xxiii.
169. On Gouthière's merchant side, see p. 23 note 9 and p. 33 in this publication.
170. Vissac 1910, 245-76.
171. Archives Départementales d'Avignon, BB86, AA156; CC art. 367; Vissac 1910; Marcel 1919, 89-120; Watson 1956, 121-24; Hughes 1996, 463-69.
172. A marginal note in one of the Avignon registers

claimed that the composition was that of Avignon's first consul, Mr. des Achards de la Baume; he may have suggested the alterations referred to in the assembly. Archives Départementales d'Avignon, AA 156, fol. 300.
173. Picquenard 2001, 67.
174. Baulez 2001a, 275-76.
175. The gilding appears more homogeneous, the difference between matte and burnished areas more blurred, than one might expect from eighteenth-century gilding.
176. *Cabinet de l'amateur* 1956, 70, no. 232 (a group of four candlesticks, only one of which is signed) (38.5 × 16.5 cm). Gouthière's signature also seems to appear on two candelabra of lapis lazuli mounted in bronze and with swan's-neck handles, the groups of lights being composed of branches of roses, one of which is inscribed *Gouthière 1780* (Paris sale, April 8, 1990, lot 45; and April 24, 2005, lot 238).
177. Aside from the object mentioned in note 175, it is worth mentioning those sold at Christie's, Monaco, April 28-29, 2000, lot 33 (pair of candlestick-candelabra, Lagerfeld collection); Christie's, London, June 11, 1992, lot 72; Drouot Richelieu, Paris, December 7, 2007, lot 138, and Artcurial, Paris, June 20, 2012, lot 450 (Georges Bemberg collection).
178. Christie's, London, June 11, 1992, lot 72.
179. Appendix 1: 1778, April 2. They were valued at 150 *livres* in 1777 in the inventory drawn up after Mme de Langeac's death (AN, M.C.N., LXXVI/465, October 27, 1777 [reference generously supplied by Patrick Leperlier]).
180. AN, M.C.N., XCVI 485, March 7, 1777: "Four tapering candlesticks with lions' heads and claws, drapery and moldings, the whole in matte-gilded bronze . . . 280 *livres*." These four candlesticks were sold at auction at Sotheby's, Monaco, on February 23, 1986, lot 905 (Duke of Talleyrand collection), and at Christie's, Monaco, on April 28-29, 2000, lot 32 (Lagerfeld collection).
181. Goodison 2002, 66-67, 187-89.
182. Appendix 1: 1782, December 12-21, lot 148.
183. Appendix 1: 1782, November 16 (1) and (2).
184. On the Duchess of Mazarin's *hôtel*, see Faraggi 1995, particularly pp. 80-87, for the decor of the large salon.
185. Appendix 1: 1781.
186. Thanks to Vincent Guilliard, who chased them, we know that they were cast by Georges-Alexandre Moreau.
187. Paris, February 16-17, 1818, lot 62: "a pair of three-armed wall lights: vases with rams' heads placed on large brackets of acanthus leaves, garland, and rosettes, and from which spring branches of roses, carnations, and poppies, which carry the candle holders. These pieces, chased with great care and matte gilded, were made by Gouthière, total height 38 inches."
188. Jean-François Forty, 5e cahier, pl. 3.
189. See p. 58 in this publication.
190. Appendix 1: 1781, May 15, no. 163; see also Duclos

2009, 74.

191. Appendix 1: 1781, December 10-15, lot 291; and 1784, July 27, lot 10.

192. Duclos 2009, 74; Mouton 1911, 145-47.

193. AN, M.C.N., XLVIII 264, Sainte-Foy's consent, January 10, 1782: "the Mazarin *hôtel* Quai Malaquais Saint-Sulpice parish, belonging to the heirs of Mme the Duchess of Mazarin, the bronze Pedestals and caryatids gilded by Gouthière, being in the large assembly room of the said *hôtel* and that were included and indicated in the report of the visit and valuation of the said *hôtel* by the expert Duboisterf on October 11, 1781, and the following days, in order for the said *hôtel* to be sold; which bronzes pedestals and caryatids were bequeathed, together with the other bronzes from the said Assembly room not indicated in the said report and which consequently will not be included in the sale of the said *hôtel* . . . the price of the said bronzes, pedestals, and caryatids that will be included in the sale of the said *hôtel*; which price is raised by the said report by Duboisterf to the sum of ten thousand *livres*." Document supplied by Sylvia Vriz, to whom I extend warm thanks.

194. Mouton 1911, 145-47.

195. Appendix 1: 1781, p. 353.

196. AN, AF IV 431*; Duclos 2009, 74.

197. AN, M.C.N., XLVI 767, August 21, 1820; Duclos 2009, 74.

198. Mouton 1911, 183; Duclos 2009, 76.

199. Duclos 2009, 76-77.

200. Ibid., 76.

201. Appendix 1: 1787, November 26, lots 373-74.

202. AN, O¹ 3290, fol. 52v, order 57 of January 7, 1788; see also AN, O¹ 3537, file 2, *dépenses extraordinaires* (extraordinary expenditure), January 4, 1788; AN, O¹ 3648, file 3, statement by Mala.

203. AN, O¹ 3428, fol. 119, inventory of the Château de Saint-Cloud, 1789: "A pair of chimneypiece wall lights with 5 candle holders each part composed of a quiver 25 inches in height with background in the color of water interlaced with laurel leaves, frieze with interlacing motif and rosettes [*rosaces*] neck with ornaments suspended from a chain with two arms fixed to a nail the round head of which ornamented with a row of pearls three inches in diameter the candle holders supported by two branches of poppies fixed in saltire to the belly of the quiver, the whole in gilt bronze [*doré d'or moulu*] 18 inches front view"; AN, O¹ 3430, inventory of the Château de Saint-Cloud, 1790, valued at 1,120 *livres*; Bibliothèque Centrale des Musées Nationaux, Paris, MS no. 37, fol. 119, inventory of the Château de Saint-Cloud, 1794: "A pair of five-armed chimneypiece wall lights each composed of a quiver twenty-five inches in height background azure color intertwined with laurel leaves friezes of interlacing motifs and rosettes (*rosaces*) neck with ornaments suspended from a chain with two arms. The candle holders surmounted by two branches of poppies fixed in saltire, on the slope of the quiver, the whole

in gilt bronze (*doré d'or moulu*) valued at . . . 720 *livres*" (Duclos 2009, 76).

204. AN, O¹ 3649, statement by Thomire, 1789: "Montreuil; Service of Madame Élisabeth; Salon; By interim order of Monsieur de Villeneuve dated April 27 of the current year 1789; For carrying out the restoration of a pair of five-armed poppy-flower wall lights with quiver plates and ribbons, and the necessary soldering to consolidate them for this . . . 36 *livres*. Supplied 2 copper nails, turned and decorated with rosettes, these to support the chains . . . 12 *livres*. Supplied a *bidet* . . . 1 *livre*. For entirely matte gilding this pair of wall lights . . . 347 *livres*"; AN, O¹ 3493, fol. 5, inventory of the Château de Montreuil, 1790: "1 pair of chimneypiece wall lights each with 5 candles in gilt bronze (*doré d'or moulu*) . . . 2500 *livres*" (Duclos 2009, 77).

205. AD 78, 2Q70: "4895 ditto, a large pair of matte-gilded wall lights, with five candle holders ornamented with flower chains and quivers of article 29" (sold for 1,051 *livres* to citizen Feuchère); Duclos 2009, 77.

206. Christie's sale, New York, May 23, 1995, lot 229; see also Prost 1936, pls. LXXVII, XCI.

207. Hughes 1996, 1537, 1548. The same chandelier can already be seen in photographs taken by Charles Marville of the dining room at Bagatelle, around 1857 (Thomine 1997, 123). A chandelier and wall lights of this design adorned Empress Eugénie's pavilion at the 1867 Exposition Universelle, which was set up by the Penon brothers (Starcky 2013, 58).

208. Appendix 1: 1782, May 1, lot 468.

209. Appendix 1: 1782, December 12-21, lot 351.

210. Baulez 1986, 238-39.

211. The Duke of Aumont's chandelier does not appear in the documents in the Archives Nationales (AN, O¹ 3280-87) that are studied in Verlet 1980.

212. Appendix 1: 1781, p. 349.

213. A chandelier of this design is reproduced in Ricci 1913, 34. An identical example, aside from the garlands of pearls, was in the possession of the antiques dealer Calvet, who specialized in fine copies made in the nineteenth century (Christie's, New York, September 27, 2007, lot 17).

214. Appendix 1: 1773, December 31 (1), p. 338.

215. Ibid.

216. Baulez 1992, 80, n. 122. The inventory drawn up in 1774 is preserved in a private collection.

217. Galleria Doria Pamphilj, Rome.

218. Detroit Institute of Arts (71.211-12); 19½ × 18¾ × 6½ in. (49.5 × 47.6 × 16.5 cm). Probably made for Mme Du Barry's Grand Salon Carré at Louveciennes; probably the Marquis of Foz, Lisbon; José Guedes de Queiroz; in the sale of his collections at Christie's, London, June 10, 1892, lot 57, then probably purchased by Jacques Seligmann; George Jay Gould, Lakewood, New Jersey; Duveen Brothers, 1923; Anna Thompson Dodge, 1932. See also *Dodge Collection* 1933 and *Dodge Collection* 1939; Winokur 1971, 49, 51; Darr 1996, 125-26.

219. Musées et domaine nationaux de Compiègne (C 473c). 20½ × 19¾ in. (52 × 50 cm). Provenance:

Probably for the large salon of the Kinsky *hôtel* in Paris; in 1796, in Paris, at the Dépôt National on Rue de Beaune; reserved for the Palais du Directoire (Palais du Luxembourg); since 1810, at the Château de Compiègne. See also: Baulez 1986, 576; Baulez 1992, 175, no. 21.

220. Baulez 1984, 120.

221. AN, F¹⁷ 1102A, file no. 7, item 1515. "State of the works of art kept in the national storehouse rue de Beaune, handed over by citizen Naigeon, curator of the storehouse . . . to citizen Chalgrin, manager in charge of works for the Palais du Directoire Exécutif, for the embellishment of the said palace . . . 5 Thermidor year 4 [July 23, 1796]." (État des objets d'art provenant du dépôt national de la rue de Beaune, remis par le citoyen Naigeon, conservateur du dépôt . . . au citoyen Chalgrin, chargé de la direction des travaux du Palais du Directoire exécutif pour l'embellissement dudit palais . . . , 5 thermidor an 4 [23 juillet 1796]), no. 34, fol. 1v.

222. Baulez 1986, 568.

223. The base of the firedogs is described in the inventory of furnishings at Fontainebleau, January 13, 1796. See Alcouffe, Dion-Tenenbaum, and Mabille 2004, 190.

224. Paris, Palais d'Orsay, June 13, 1978, lot 43.

225. Paris, Hôtel George V, December 12, 1992, lot 53.

226. Paris, Beurdeley firm sale, October 19-22, 1897, lot 204.

227. Appendix 1: 1781, p. 348. It was during the sale of the bronze-maker Pierre-François Feuchère's property on November 29, 1824, that the identity of the modeler of the eagle firedogs was revealed: lot 162, "a pair of eagle firedogs, modeled by Roland, executed by Gouthière for the Duchess of Mazarin, it is matte gilded."

228. Appendix 1: 1781, May 15, no. 161.

229. Appendix 1: 1781, December 10-15, lot 284.

230. Appendix 1: 1784, July 27, lot 9.

231. Thiéry 1787, vol. 2, 547.

232. Appendix 1: 1787, November 26, lot 372.

233. Baulez 1986, 583. Duclos 2009, 76.

234. AN, O¹ 3428, fol. 181, inventory of the Château de Saint-Cloud, 1789: "A pair of large firedogs with eagles, under the feet of which is a thunderbolt, the body of which is the same color as water; with a salamander on an oval-shaped socle complete with horizontal ormulu support (*recouvrement*) with ornamentation, rinceaux friezes, projections, and medallions, carried on six tapering feet with spiral fluting; a separate balustrade with a frieze of plain moldings and fifteen likewise plain balusters; also in gilt bronze."

235. AN, AF IV* 431, fol. 31, no. 214, inventory of the furniture in the *hôtel particulier* of the Ministry of General Police, November 1810: "A pair of iron firedogs with four arms and a horizontal support (*recouvrement*) in copper, chased and matte gilded, the base carried on eight feet, socle ornamented with a frieze of ornamental leaves, scrolls, on the sides wreaths of flowers and laurel, on the pilasters

rosettes chased with ornamental leaves; the center with a base, a well rope, leaves and flowers, thunderbolt and eagle clutching a lizard in its talons . . . 14 inches long; 16 inches high."

236. Baulez 2007a, 14. One of the two pairs of eagle firedogs supplied for Carlton House has not been located.

237. See p. 149, note 1, in this publication.

238. Châteaux de Malmaison et Bois-Préau, Rueil-Malmaison (MM65.3.22).

239. Vigée Le Brun 2015, 90–91.

240. Hézecques 1983, 104.

241. Appendix 1: 1773, December 31 (1).

242. Appendix 1: 1773, December 31 (1), p. 340.

243. See p. 86 in this publication.

244. *Paris et ses curiosités* 1804, 148–49.

245. Appendix 1: 1773, December 31 (1), p. 332.

246. Josse sale, Galerie Georges Petit, May 28–29, 1894, lots 145–46. Their description differs slightly from that in the catalogue of the La Béraudière sale, and one of them has a blue base. Are these two of the knobs from lot 733 of the La Béraudière sale, or are they instead other examples?

247. AN, O¹ 1443, item 163, fol. 1.

248. See Baulez 1986, 568.

249. AN, O¹ 1437, item 86, March 1, 1786, fol. 1v. Also Robiquet 1912 and 1920, 21, 102 (with incorrect archival reference).

250. AN, O¹ 1434, item 31, September 23, 1774, fol. 1.

251. See Appendix 1: 1773, December 31 (1) and (2).

252. AN, O¹ 2084.

253. Appendix 1: 1773, December 31 (1), p. 339.

254. Ibid.

255. AN, O¹ 2084.

256. Appendix 1: 1773, December 31 (1), p. 339.

257. Ibid.

258. Ibid.

259. Ibid.

260. Ibid.

261. Dezallier d'Argenville 1779, 180–81.

262. AN, O¹ 1435, item 319, letter from Potain, May 23, 1777.

263. AN, O¹ 1435, item 328, letter from Potain, June 7, 1777.

264. AN, O¹ 1435, item 324, letter from Potain, July 16, 1777.

265. AN, R¹ 81, "Mémoire des ouvrages de marbrerie par Bocciardi, années 1777 et 1778."

266. These were the chimneypieces of the salon, the boudoir, and the bath chamber on the ground floor and of the Count of Artois's bedchamber and his Boudoir Rose in the upper story.

267. AN, R¹ 82, "Mémoire des ouvrages de menuiserie par Carbillet, années 1776 à 1778," 193.

268. Baulez 1986, 574.

269. AN, R¹ 81, "Mémoire des ouvrages de marbrerie par Bocciardi, années 1777 et 1778," 105.

270. Ibid., 60–68.

271. See, for example, Sebastiano Serlio, *Règles générales de l'architecture*, Anvers, P. Coecke, 1542, Book 4, chap. 9, p. 62: "cheminée de la manière composite"

(chimneypiece in the composite manner).

272. Metropolitan Museum of Art, acc. no. 17.190.25 30.

273. Dulaure 1787, vol. 1, 21.

274. AN, R¹ 81, "Mémoire des ouvrages de marbrerie par Bocciardi, années 1777 et 1778," 105.

275. Gallet 1995, 52.

276. See Giovanni Battista Piranesi, *Diverse maniere d'adornare i cammini . . .* (Rome: Salomoni, 1769), pl. 39.

277. AN, R¹ 81, "Mémoire des ouvrages de marbrerie par Bocciardi, années 1777 et 1778," 75.

278. Ibid., 75–76.

279. AN, R¹ 81, "Mémoire des ouvrages de marbrerie par Bocciardi, années 1777 et 1778," 2–13.

280. The monogram of the Count of Artois was removed during the French Revolution. During the Restoration, the monogram *CF* of Charles-Ferdinand of Artois, the son of the Count of Artois, was added on the legs of the chimneypiece. See Baulez 1988, 146.

281. AN, R¹ 81, "Mémoire des ouvrages de marbrerie par Bocciardi, années 1777 et 1778," 12.

282. Bachaumont 1783–89, vol. 15 (1784), 168.

283. Thiéry 1787, vol. 1, 29. A pair of firedogs in the form of mortars is shown on a drawing by Jean-Démosthène Dugourc, featuring a decorative scheme with cannon chimneypiece for the Duke of Deux-Ponts's bedchamber (Musée des Arts Décoratifs, Lyon, inv. RF 41618).

284. AN, R¹ 81, "Mémoire des ouvrages de marbrerie par Bocciardi, années 1777 et 1778," 105.

285. AN, R¹ 264, "Mémoire d'ouvrages de bronze ciselés, et dorures mattes . . . par Rémond doreur rue des Petits-Champs Saint-Martin," 1780, fol. 1.

286. Baulez 2001a, 297.

287. Jacques Androuet du Cerceau, *Second livre d'architecture*, Paris, André Wechel, 1561, pl. 11: "Modèle de cheminée à cariatides et faunes."

288. See Haskell and Penny 1988, 331–32.

289. Appendix 1: 1781.

290. Ibid., pp. 349–50.

291. Faraggi 1995, 83.

292. Appendix 1: 1787, June 26.

293. AN, AB XIX 215, file 2, "État des lieux de l'hôtel de Thélusson," December 1784, 404–5.

294. Baulez 1986, 587. The *hôtel particulier* where Paul-Louis Thélusson lived was known as the Hôtel Thiroux de Montsauge, before being named the Hôtel de Massa in the nineteenth century.

295. The Metropolitan Museum of Art, acc. no. 1976.227.

296. AN, O¹ 1437, item 86, fol. 2.

297. AN, O¹ 1802, item 13. A design by Jean-François Heurtier for the redecoration of the salon is preserved in Paris, in the collections of Olivier Kraemer.

298. AN, O¹ 1802, item 14.

299. Ibid.

300. See AN, V.A. Box XXVII, no. 30; and AN, O¹ 1886¹, no. 13.

301. AN, O¹ 1437, item 86, fol. 2.

302. AN, O¹ 2087, file no. 3, "Mémoire des ouvrages de marbrerie par Dropsy," 1785, fols. 1v–6.

303. *Journal de Paris*, Monday, September 9, 1782, no. 252, 1029.

304. AN, O¹ 1927. See also Furcy-Raynaud 1905, 4–6.

305. Appendix 1: 1782, December 12–21, lot 318.

306. AN, F¹⁷A 1268, 12 Frimaire in the year II (December 2, 1793), no. 19. Verlet 1980, 209, no. 318.

307. AN, O³ 1430, "Report on the columns, statues, busts, tables, and vases given to citizens Percier and Fontaine for the decoration of the Palais Consulaire and of the Malmaison on the orders of the Minister of the Interior" (État des colonnes, statues, bustes, tables et vases remis aux citoyens Percier et Fontaine pour la décoration du Palais Consulaire et de la Malmaison d'après les ordres du ministre de l'intérieur), 1 Pluviôse in the year X (January 21, 1802), no. 32.

308. Pierre-Adrien Pâris, *Sketch Representing a Leg of the Duke of Aumont's Table*, 1782. Pencil on paper, 8 × 5 ⅜ in. (20.4 × 13.7 cm). Bibliothèque Municipale, Besançon (Fonds Pâris, vol. 453, no. 169).

309. AN, AJ¹⁹ 140, inventory of the Tuileries, 1807, nos. 613 and 643; AN, O² 680, inventory of the Tuileries, 1809, no. 1372.

310. AN, AJ¹⁹ 146, inventory of the Tuileries, 1818, no. 1678.

311. AN, AJ¹⁹ 155, inventory of the Tuileries, 1826, nos. 1678 and 1945.

312. AN, AJ¹⁹ 624, inventory of the Tuileries, 1833, no. 26.

313. Ibid.

314. Faraggi 1995, 80, 86.

315. Appendix 1: 1781, pp. 347, 348, 351.

316. Ibid.

317. Ibid.

318. There are similar but not identical capitals on a chimneypiece from the Hôtel Botterel-Quintin (now at the J. Kugel Gallery, Paris).

319. See pp. 220, 318 in this publication.

320. Appendix 1: 1781, p. 353.

321. See pp. 220–23 in this publication.

322. Castellane 1924, 159–60; Dell 1992, vol. 2, 120.

323. Dell 1992, vol. 2, 120 and 123, n. 44.

324. Duveen Archives, Getty Research Institute, Los Angeles, box 194.

325. Duveen Archives, box 452, file 1, invoice dated June 4, 1915. This document is also preserved in the Frick Collection Archives, Frick Art Reference Library, New York.

326. Sotheby's, New York, April 19, 2013, lot 222.

327. Appendix 1: 1782, November 16 (1). Germain de Saint-Aubin was aware of this 30,000-*livre* price, mentioning it in the margin of a sale catalogue of Aumont's collections that he annotated (Davillier 1870, 142–43, no. 319).

328. Appendix 1: 1782, November 16 (2).

329. Appendix 1: 1782, December 20.

330. Appendix 1: 1782, December 12–21, lot 319.

331. AN, O¹ 1176, fol. 1, January 5, 1783 and O¹ 1916, folder 4, piece 285. January 11, 1783.

332. AN, O¹ 1922ᴬ (folder Julliot).

333. AN, O¹ 3431, inventory of the Château de Saint-Cloud, 1789 (from this date on, the tables were sometimes mistakenly described as being of petrified wood); see also Samoyault 1971, 170.

334. AN, O¹ 3280, folder 7, 22 Brumaire in the year II (November 1793). See also Verlet 1980, 208.

335. AN, O² 489, folder 10, item 20 and 34, 22 Prairial in the year II (June 10, 1794), no. 2137.

336. AD 78, 1 LT 714, 5 Prairial and 9 Ventôse in the year VII (February 27 and May 24, 1799), no. 142. See also Dutilleux 1886, 125.

337. AN, O² 731, inventory of the Château de Saint-Cloud, year XIII (1804-5), fol. 24.

338. AN, O² 731, inventory of the Château de Saint-Cloud, 1807, fol. 72v. See also Samoyault 1971, 169-70.

339. AN, O³ 2071, inventory of the Château de Saint-Cloud, 1818, nos. 667 and 718.

340. AN, A5¹⁹, 1155, fol. 87, inventory of the Château de Saint-Cloud, 1855, no. 397.

341. AN, O¹ 3252 and 3253.

342. AN, O¹ 3113, documents 145, 152, and 153. Robiquet 1912 and 1920-21, 25, 97-98.

343. One of which is now in the Hermitage Museum, in the Beurdeley Collection.

344. AN, O¹ 3115, documents 195-99.

345. Davillier 1870, 7-8.

346. Appendix 1: 1782, December 12-21, lot 2.

347. Appendix 1: 1782, May 1, no. 594.

348. Appendix 1: 1782, December 12-21, lot 7. Davillier 1870, 15.

349. Appendix 1: 1782, December 12-21, lot 14. Davillier 1870, 20.

350. See pencil note on the 1782 sale catalogue of the collections of the Duke of Aumont at the library of the Institut National d'Histoire de l'Art (VP RES 1782-14).

351. Appendix 1: 1782, December 12-21, lot 17. Davillier 1870, 21.

352. Verlet 1980, 208.

353. Appendix 1: 1782, December 12-21, lot 22. Davillier 1870, 24.

354. Verlet 1980, 208.

355. Appendix 1: 1782, December 12-21, lot 23.

356. Appendix 1: 1781, p. 347.

357. Ibid.

358. Faraggi 1995, 82.

359. Appendix 1: 1781, May 15, no. 162.

360. Appendix 1: 1781, pp. 347, 350, 351.

361. Ibid.

362. See pp. 220-22 in this publication.

363. Appendix 1: 1781, December 10-15, lot 283.

364. See pp. 220-22 in this publication.

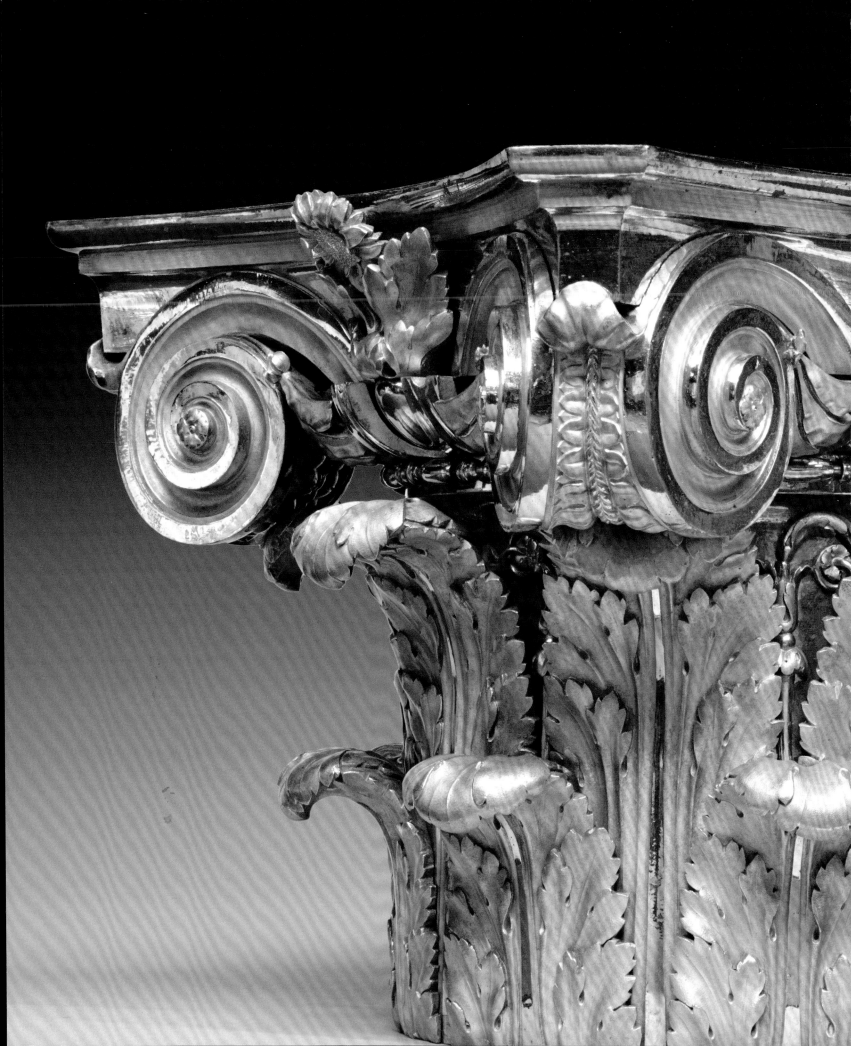

Appendix 1

This appendix includes Gouthière invoices that describe objects he made or delivered, as well as contemporaneous documents that mention works attributed to him, primarily estate inventories and sales catalogue entries. The attributions reflected in these documents are considered more reliable than those made after his death. The documents are presented in chronological order and in the original French.

1767, November 13. *Dépôt du procès verbal de la vaisselle d'argent du Sieur Germain, Orfèvre, dressé par Pierre-Louis Regnard, doreur* (AN, M.C.N., XXIII 702)

1 cassolette façon de porphyre décorée de guirlandes, feuilles, canaux, montée sur un pied doré d'or moulu, jugée à 800 livres.
1 vase de marbre blanc décoré de tête d'Apollon, feuilles, linge, godrons, différentes moulures, monté sur un pied doré d'or moulu, jugé à 1 050 livres.
1 cassolette de cristal décorée de têtes de bélier, guirlandes de feuilles de chêne, fruits, feuilles d'acanthe, godrons à dards, montée sur son pied doré d'or moulu, jugée à 850 livres.
1 cassolette façon d'agate, deux femmes pour anses qui tiennent des guirlandes de fleurs, têtes de lion, moulures à baguettes liées avec des rubans, guirlandes de laurier, montée sur un pied décoré de feuilles, le tout doré d'or moulu. 2 autres vases pour les côtés, aussi façon d'agate, décorés de deux enfants tritons pour anses, guirlandes de laurier, têtes de femmes, montés sur leur pied décoré de différents ornements, le tout doré d'or moulu, jugé à 2 448 livres.
2 vases, dont un façon de prime d'améthyste et l'améthyste et l'autre d'agate. Décorés de têtes de bouc, guirlandes de vignes, montés sur leur pied, orné de postes et feuilles de laurier, jugés à 1 400 livres.
2 petits vases, façon de prime d'améthyste, décorés de têtes de bouc, guirlandes de fleurs, différentes moulures, montés sur leur pied orné de différentes feuilles dorées d'or moulu, jugés à 340 livres pièces, les deux : 680 livres.
2 vases façon d'albâtre décorés de différentes feuilles, canaux, moulures, dorés d'or moulu, jugés à 540 livres.
8 vases de cristal décorés de têtes de Méduse, godron, canaux, différentes moulures, dorés d'or moulu, jugés à 200 livres pièce, les 8 : 1 760 livres.
151 pièces de cristaux, tant unis que façonnés et dorés, jugés à 900 livres.
4 serre-papiers formant une terrasse surmontée d'un taureau, 2 desdits serre-papiers dorés d'or moulu entier, jugés à 640 livres et les 2 autres les terrasses seulement d'or moulu et les taureau en couleur de fumée, jugés à 500 livres, le tout la somme de 1 140 livres.

1767, November 17. *Dépôt du procès verbal de la vaisselle d'argent du Sieur Germain, Orfèvre, dressé par Pierre-Louis Regnard, doreur* (AN, M.C.N., XXIII 702)

1 cassolette de porphyre décorée de guirlandes, feuilles, canaux, montée sur un pied doré d'or moulu, jugée à 800 livres.
1 vase façon de granit décoré de têtes d'Apollon, feuilles, linge, godrons, différentes moulures, dorés d'or moulu, jugé à 850 livres.
1 vase de marbre blanc, pareille décoration que le précédent, jugé à 1 050 livres.
1 cassolette de cristal décorée de têtes de bélier, guirlandes de feuilles de chêne et fruits, feuilles d'acanthe, godrons à dards, monté sur un pied doré d'or moulu, jugée à 850 livres.
2 cassolettes bleues factices, décorées comme les deux précédentes, les deux jugées à 1 800 livres.
1 vase prime d'améthyste violet et 1 (autre) façon d'albâtre, décorés de guirlandes de fleurs, têtes de femme, à pieds de biches montés sur un pied à rouleaux, les deux jugés à 780 livres.
1 garniture de vase en cristal dorée d'or moulu, jugée à 140 livres.
14 cristaux jugés à 6 livres pièce, ce qui fait 84 livres.

1769, September 27. *État des ouvrages de ciselure faits par moi Lebeau depuis le 10 mai 1765 jusqu'à ce jour pour M. Gouthière* (AD 75, D⁵ B⁶ 4542, bankruptcy of Jean-Nicolas Lebeau, chaser)

2 anses à tête d'aigle	12
2 cercles de laurier	14
4 rosettes	4
1 entrelacs	4
2 cercles de laurier	7
2 anses à tête d'Hercule	24
2 grands cercles à lacs d'amour ornés	36
2 entrelacs	8
2 anses à tête de bélier	12
1 idem	12
2 paires d'anses à tête d'Hercule	24
2 guirlandes de fleurs et fruits	28
2 nœuds de laurier	14
1 pomme de pin	8
1 ruban	3
1 cercle à feuilles de persil	10
1 idem	10
2 guirlandes de fleurs et fruits	28
1 nœud de laurier	7
1 idem	7
1 pomme de pin	8
3 pieds de vases	27

3 pieds à feuilles d'eau	14
3 pieds à nœuds de laurier et canaux	30
1 pomme de pin	8
1 guirlande	14
4 pieds de vases	36
1 guirlande	14
1 petit cercle	6
1 cercle à feuilles de persil	10
3 anses à tête d'aigle à 6 ≠ pièce	18
8 pieds de lion	16
2 guirlandes à fleurs et fruits	28
1 nœud de laurier	7
2 cercles à feuilles d'eau	6
1 nœud de pied à godrons	2
1 socle à feuilles d'eau	8
1 idem	8
1 idem	8
2 têtes de bouc	12
1 nœud de laurier	7
1 draperie	6
1 nœud de ruban	7
1 tête de bouc	6
4 cercles à 6 ≠ pièce	24
3 cercles à 2 ≠ 10 s	7
1 corde en lacs	6
1 anse tête d'aigle	6
1 idem	6
8 pieds de vermiculage	24
2 guirlandes à fleurs et fruits	28
1 pied de vase	7
4 cercles brettelés	6
Des modèles de rosettes	8
2 cercles	12
1 petit pied	7
1 corde en lacs	6
2 pieds de vases	16
Idem	16
1 pied pareil	8
1 petit pied orné	10
La ragréure	4
1 socle et pied	18
1 socle sans pied	10
1 guirlande de fleurs d'après les cires	36
1 idem	36
2 pieds de flambeaux	18
2 guirlandes de fleurs et fruits	28
4 têtes de boucs	24

4 têtes d'aigles	12
4 cercles à 6 ≠ pièce	24
2 socles à feuilles d'eau à 8 ≠ pièce	16
2 guirlandes de fleurs d'après les cires	72
4 pieds de vases à 8 ≠ pièce	32
2 cercles à feuilles de persil	20
2 pieds de vases	16
2 têtes de boucs	12
2 anses à tête d'aigle	12
2 cercles à feuilles de persil	20

1773. Extract from *Mémoire des Modèles, Bronzes, Ciselures, Montures et Dorure faits et fournis par Gouthière, Ciseleur et Doreur du Roi et de Son A. R. le Monseigneur le Comte d'Artois, pour l'établissement des voitures de Madame la Comtesse d'Artois, sous les ordres de M. le Marquis de Chabrillan, son Premier Ecuyer, pendant l'année 1773* (AN, K 1715, file 8, item 6 ; Baulez 1986, 613-20)

Première Voiture de Cérémonie

Modèles …	3 000 livres (réglé à 2 000 livres)
Fonte de bronzes …	6 300 livres (réglé à 4 000 livres)
Exécution des bronzes …	12 400 livres (réglé à 10 000 livres)
Dorure des bronzes …	18 000 livres (réglé à 16 000 livres)
Bronzes des attelages …	10 400 livres (réglé à 8 600 livres)
Bossettes …	1 520 livres (réglé à 1 400 livres)
Panaches …	600 livres (réglé à 516 livres)
Total : 52 220 livres (réglé à 42 516 livres)	

Deuxième Grande Voiture

Modèles …	1 200 livres (réglé à 1 000 livres)
Fonte de bronzes …	2 325 livres (réglé à 2 000 livres)
Exécution des bronzes …	8 000 livres (réglé à 7 000 livres)
Dorure des bronzes …	9 000 livres (réglé à 7 000 livres)
Panaches …	336 livres (réglé à 270 livres)
Bossettes …	720 livres (réglé à 600 livres)
Total : 21 581 livres (réglé à 17 870 livres)	

Troisième Grande Voiture

Modèles …	536 livres (réglé à 450 livres)
Fonte de bronzes …	1 285 livres (réglé à 1 140 livres)
Exécution des bronzes …	3 800 livres (réglé à 3 400 livres)
Dorure …	4 200 livres (réglé à 3 700 livres)
Panaches …	208 livres (réglé à 170 livres)
Bossettes …	480 livres (réglé à 310 livres)
Total : 10 509 livres (réglé à 9 170 livres)	

Première des petites Voitures

Modèles ...	1 560 livres (réglé à 1 300 livres)
Fonte de bronzes ...	1 134 livres (réglé à 1 200 livres)
Exécution des bronzes ...	8 600 livres (réglé à 7 600 livres)
Dorure ...	9 000 livres (réglé à 7 700 livres)
Bossettes ...	480 livres (réglé à 400 livres)
Total : 20 774 livres (réglé à 18 200 livres)	

Deuxième des petites Voitures

Modèles ...	800 livres (réglé à 600 livres)
Fonte de bronzes ...	792 livres (réglé à 640 livres)
Exécution des bronzes ...	4 600 livres (réglé à 4 100 livres)
Dorure ...	5 000 livres (réglé à 4 400 livres)
Bossettes ...	480 livres (réglé à 400 livres)
Total : 11 672 livres	

Troisième des petites Voitures

Modèles ...	450 livres (réglé à 380 livres)
Fonte de bronzes ...	684 livres (réglé à 550 livres)
Exécution des bronzes ...	3 600 livres (réglé à 3 200 livres)
Dorure ...	3 800 livres (réglé à 3 200 livres)
Bossettes ...	600 livres (réglé à 472 livres)
Total : 9 134 livres	

Voiture Allemande

Modèles ...	96 livres (réglé à 75 livres)
Fonte de bronzes ...	250 livres (réglé à 200 livres)
Exécution des bronzes ...	1 280 livres (réglé à 1 140 livres)
Dorure ...	1 160 livres (réglé à 1 095 livres)
Total : 2 786 livres	

Première Chaise à Porteurs

Modèles ...	1 000 livres (réglé à 900 livres)
Fonte de bronzes ...	348 livres (réglé à 295 livres)
Exécution des bronzes ...	3 800 livres (réglé à 3 200 livres)
Dorure ...	3 600 livres (réglé à 2 900 livres)
Total : 8 748 livres	

Deuxième Chaise à Porteurs

Modèles ...	60 livres (réglé à 50 livres)
Exécution des bronzes ...	1 000 livres (réglé à 800 livres)
Dorure ...	900 livres (réglé à 800 livres)
Total : 1 960 livres	

Deux autres Chaises à Porteurs ...	1 000 livres (réglé à 850 livres)
Dormeuse ...	1 853 livres (réglé à 1 700 livres)
Chaise à une place ...	392 livres
Diable ...	583 livres

Berline ...	2 130 livres (réglé à 1 820 livres)
Cabriolet ...	194 livres (réglé à 144 livres)
Diligence Fond Or faite chez Mr. Martin ...	2 037 livres (réglé à 2 000 livres)
Voiture de chasse de Madame La Comtesse ...	1 389 livres (réglé à 1 190 livres)
Cabriolet de Madame La Comtesse ...	702 livres (réglé à 648 livres)
Chaise à deux places ...	734 livres (réglé à 680 livres)
Autre chaise ...	372 livres (réglé à 320 livres)
Chaise de poste de Cour ...	1 171 livres (réglé à 1 066 livres)
Grande voiture de Ville ...	2 971 livres (réglé à 2 900 livres)
Autre voiture allemande à 8 places ...	2 589 livres (réglé à 2 000 livres)
Calèche à 6 places ...	2 892 livres (réglé à 2 218 livres)
Chaise de M. Daupoule (d'Hautpoul)	625 livres (réglé à 600 livres)
Diligence de M. Daupoule (d'Hautpoul)	2 554 livres (réglé à 2 243 livres)

Total : 168 501 livres (réglé à 141 344 livres)

1773, December 31 (1). *Divers Modèles et Exécution d'ouvrages de Bronze, Cizelure et dorure, d'après les ordres et pour le service de Madame La Comtesse du Bary. Par Gouthière, Cizeleur et Doreur des Menus Plaisirs du Roy. A Paris, Quai Pelletier, à la Boucle d'or* (Bibliothèque Centrale, Versailles, MS 240 F; Baulez 1986, 620-31).

<u>Salon oval.</u>
<u>Esquisses et Modèles des bras à roses.</u>

Pour une première Esquisse faite à 3. branches, modelée en Cire, Composée de branches de Roses et de Mirte, noüée avec un nœud de Rubans, estimée à la Somme de	170 livres

Pour un autre modèle en Cire, à 2. branches de Mirte et de Roses et à Rubans ; Lequel modèle n'a point été détruit par la facilité de la monture des 8 bras, estimé à Celle de	150 livres

Pour tous les divers modèles des Roses et boutons de Rose de différentes grosseurs et variétés, avec leurs feüilles et branchages, tant de Roses que de Mirte et de nœuds de Rubans ; tous lesquels modèles ont été faits en cire et finis chacun Séparément avec la plus grande sujétion ; estimés ensemble à la Somme de	300 livres

Pour avoir moulé en plâtre tous les dits modèles, en avoir coulé des cires d'épaisseur, reparé et posé chaque pièce Sur des noyaux de plâtre, pour ensuite les mouler en Sable ; pour ce, Celle de	96 livres

Pour les avoir moulés en Sable, les avoir fondus en étain et les avoir Cizelés, pour ce, celle de	220 livres

Pour les avoir moulés en Sable, ensuite fondus en bronze et les avoir Cizelés ; Chaque bras évalué à la Somme de 1 000 livres. Ce qui fait pour le huit Bras celle de 8 000 livres

Pour la monture et ragréure des soudures faittes avec grande sujétion ; chaque bras évalué 300 livres fait pour les 8 bras, la Somme de 2 400 livres

Pour les avoir dorés et surdorés d'or moulû et les avoir mis en Couleur matte ; La dorure de chaque bras portée à 1 200 livres fait pour les huit, Celle de 9 600 livres

Modèles de la Cheminée (**cat. 29**) :
Pour les modèles de la moulure du dessous de la tablette ; avoir poussé cette moulure en bois de 2. pieds de longueur, sur laquelle on a mod-elé en Cire de feüilles d'ornemens et feüilles d'eau ; Letout estimé à la Somme de 60 livres

Pour avoir assemblé d'onglets 2. bouts de la même moulure, sur lesquels on a modelé des feüilles pour les angles ; Ce qui fait avant-corps et ar-rière-corps ; pour ce, Celle de 30 livres

Pour avoir moulé en Sable les dittes moulures, les avoir fondües en Cuivre et les avoir bien cizelées, pour servir de modèles, pour ce, la Somme de 150 livres

Pour avoir fait tailler en bois un modèle d'Entrelacs pour la traverse, por-tant 14 pouces de longueur, Sur 2. pouces 2. lignes de hauteur, où il y a 5 grands Ronds et 5. Petits ; les dedans des grands Ronds décorés d'un Chapelet ; Le tout estimé à la Somme de 72 livres

Pour les modèles en Cire des Entrelas de branches de Roses Celle de 200 livres

Pour avoir moulé les entrelas en plâtre, avoir fondû des Etaims et les avoir Cizelés Celle de 320 livres

Pour le modèle en Cire de 2. branches de Roses entrelassées pour le pet-it panneau de la traverse, le dit modèle portant 5 pouces de longueur sur 2. pouces de hauteur, estimé a Celle de 40 livres

Pour moulage de la cire en plâtre, avoir ensuite fondû en Etaim et avoir cizelé, pour ce, la Somme de 60 livres

Pour le modèle en bois du Cadre qui entoure les branches de Roses : Ce cadre est une doucine unie portant 6. pouces de longueur, sur 2. pouces 4. lignes de hauteur, estimé à Celle de 6 livres

Pour une bout de moulure en doucine de 2 pieds de longueur, sur 7. lignes de largeur. Sur cette moulure qui est en bois on y a modelé en Cire des Rez de cœur ; Le dit bout de moulure évalué à celle de 24 livres

Pour avoir moulé en Sable et fondû en cire la ditte moulure ; pour l'avoir cizelé ensuite avoir évidé tous les fonds des Rez de cœur Celle de 72 livres

Pour le modèle du trépied décoré de 2. têtes de Bouc, d'une guirlande de vignes et 2. chûtes, d'un bandeau, avec des cœurs entrelassés, d'un vase isolé dans le trépied ; Le dit vase décoré d'une flamme et d'une moulure sur laquelle la flame est posée ; La ditte moulure taillée en Rez de cœur et graines.
Plus, une seconde moulure sur la gorge, taillée en oves et dards, une branche de vigne tournant dans la gorge du Vase, un Culot en feüilles d'eau et coque d'ornement, d'où sort une tige portant une fleur, un bou-ton à graines d'où sort le tyrse, une pomme de Pin, et au milieu un Serpent. Plus un montant du dit trépied fait en bois.
Tous lesquels modèles et moulures, estimes en totalité à la Somme de 500 livres

Pour avoir moulé en plâtre une partie des dits modèles, et fondû en étaim une autre partie des dits modèles en sable et avoir fondû en Cuivre le pied du Trépied, avoir pris de narcelles sur pièce du haut en bas sur une face et une patte de Bouc en bas dudit Trépied. Pour la Cizelure des dits modèles, tant en étaim qu'en Cuivre ; Letout estimé à la Somme de 500 livres

Pour le modèle du Soc Sur lequel porte le trépied, une petite Coque d'ornemens et une fleur avec un Soleil modelée en Cire, Celle de 30 livres

Pour avoir moulé ledit modèle, l'avoir fondû en Cuivre et l'avoir ciselé, celle de 30 livres

Pour avoir modelé en Cire des feüilles de laurier sur un tord de bois, por-tant 9. pouces de longueur sur onze lignes de tour. Plus une tigette pour mettre dans le Canelures ; Letout porté à la Somme de 24 livres
Pour avoir moulé en Sable, avoir fondû en Cuivre et avoir Cizelé, Celle de 55 livres

Total : 2 173 livres

Exécution des bronzes de la Cheminée (**cat. 29**) :
Pour 5. pieds 5. pouces de moulure en doucine, posée sous la tablette. Cette moulure décorée de feüilles d'ornemens et feuilles d'eau, faisant avant-corps et arrière-corps audessus des montans ; La ditte moulure es-

timée à raison de 60 livres par Chaque pied : ce qui revient pour le dits 5. pieds 5. pouces de moulure à la Somme de 325 livres

Pour avoir fait forger une lamme d'acier de la même longueur de la moulure ci dessus, l'avoir limée d'épaisseur et égale largeur, l'avoir ajustée et fraisée à vis dessous la ditte moulure . Cette lame bien ajustée avec sujettion est visible et apparente sous chaque feüille d'ornement et feüille d'eau. Pour l'avoir bien polie à vif toute prête à mettre au violet ; pour le tout la Somme de 60 livres

Pour avoir doré et surdoré le tout en or moulu et l'avoir mis en couleur matte Celle de 320 livres
Pour le panneau audessous de la moulure sur la traverse, pour lequel panneau j'ai fait une frise en entrelas doubles ; laquelle frise porte 3. pieds 10. pouces de longueur sur 2. pouces de hauteur, les Entrelas unis avec un chapelet à l'entour du grand Rond, le double Entrelas de branches de Roses ; Le tout bien cizelé et ajusté à vis fraisées sans qu'aucune vis soit apparente ; La ditte frise estimée en totalité à Celle de 1 500 livres

Pour 2. ornemens de branches de Roses entrelassées pour chacun des petits panneaux de la même traverse ; Chaque branche portant 5. pouces de longueur sur 2 pouces de hauteur ; Les dittes branches bien cizelées évaluée chacune à 150 livres fait pour les dittes 2. branches la Somme de 300 livres

Pour avoir doré en or moulu et couleur matte Celle de 1 600 livres

Pour le 2. cadres qui entourent les dits ornemens, lesquels sont d'une doucine unie et portent chacun 6. pouces de longueur, 2 pouces de hauteur ; Chaque Cadre estimé à la Somme de 20 livres fait pour les deux Celle de 40 livres

Pour avoir doré ces deux Cadres en moulu Celle de 48 livres
Pour 4 têtes de Bouc pour les 2. trépieds ; les dittes têtes bien Cizelées et estimées ensemble à Celle de 240 livres

Pour 6 montans pour les dits 2. Trépieds, décorés de narcelles tout le long et sur les faces et d'une gorge sur le derrière : au bas de chaque montant il y a un pied de Bouc avec des feüilles d'ornemens. Chaque montant porte 2. pied de hauteur et est évalué cizelure et limure comprises à 100 livres. Ce qui revient pour les 6. montans à la somme de 600 livres

Pour la Cizelure de deux pommes de Pin et 2. boutons à feüilles et graines : Ces quatre pièces estimées ensemble à Celle de 40 livres

Pour 2 Serpens sur lequels les Ecailles ont été prises sur pièce ; Le tout bien cizelé et chaque Serpent estimé à la Somme de 80 livres fait pour les deux Celle de 160 livres

Pour 2. Cercles d'un pied de tour sur 10. lignes de largeur ; pour renforçement d'une plattebande avec deux champs en Relief sous le fond et pour avoir pris sur pièce des Cœurs entrelassés avec des petites feuilles d'ornemens Cizelées et percées a jour ; Le tout estimé à la somme de 144 livres

Pour 4. autres Cercles avec des platte-bandes renfoncées et des Champs et avoir percé à jour des Ronds entrelassés sur les plattes-bandes ; Les dits 4. Cercles estimés ensemble à Celle de 96 livres

Pour 2. Cercles décorés d'oves dards et plattes-bandes ; Chaque Cercle portant un pied de tour, sur 9. lignes de pourtour ; Les dits 2. cercles bien cizelés et évalués à Celle de 144 livres

Pour 2. guirlandes de vignes de Ronde bosse et 4. Chûtes d'un pied de longueur ; Les dittes 6. pièces bien cizelées et estimées en totalité à Celle de 360 livres

Pour le Vase, 2. Culots à feüilles d'eau, avec des tigettes de fleurs. Plus une petite branche de vignes tournant à l'entour de la gorge du dit Vase ; ces 8 pièces bien cizelées et estimées ensemble à la Somme de 300 livres

Pour 2. cercles du dessus de la gorge, décorés de feüilles graines et d'une corde, estimés totalité à Celle de 120 livres

Pour 2. flammes étant Sur le dit Vase, portées à Celle de 60 livres

Pour les plattes-formes sur lesquelles les trépieds sont montés et pour avoir fait 2. bandeaux de feüilles d'ornemens, découpés à jour et entre chaque feüille une Coque d'où Sort une fleur et 2. soleils au milieu, Celle de 240 livres

Pour des Corps de vases en acier, avoir pris des facettes sur pièce, les avoir limées et bien polies à vif. Plus pour 2. tringles montans dans le trépied de 14 pouces de hauteur chacune bien polie. Plus pour les 2. plattes-formes sur lesquelles les trépieds sont montés ; tous ces aciers faits avec sujettion et bien finis estimés ensemble à la Somme de 300 livres

Pour avoir monté avec sujettion, les dits trépieds, sans qu'aucune vis soit apparente ; La ditte monture évaluée à Celle de 384 livres

Pour la dorure de tous les bronzes des 2 trépieds : Cette dorure bien surdorée et mise en couleur matte portée à celle de 1 000 livres

Pour le pied d'Estal en marbre qui porte le trépied, auquel j'ai fait 2. tords de laurier portant chacun 9. pouces de longueur sur onzes lignes de tour : La Cizelure de ces pièces estimée à Celle de 96 livres

Pour 35. tigettes de laurier pour mettre dans les Canelures torses, toutes bien cizelées et estimées à Celle de 87 livres

Pour 2. Bandes-lisses audessus des Canelures, portant 7. pouces de longueur sur 4. lignes de largeur. Plus 2. Cadres en doucine unie, faisant le tour des tours Creuses portant 10. pieds 9. pouces de longueur pour faire les 2. Cadres ; Le tout estimé à la somme de 72 livres

Pour avoir doré en or moulu la garniture entière de 2 piédestaux et 2 cadres, celle de 230 livres

Pour le Cadre du tour du Chambranle : Ce Cadre décoré d'une doucine sur laquelle j'ai fait des Rez de coeur, tous refendus à jour et bien cizelés. Le dit Cadre portant 11 pieds de tour et estimé en totalité, y compris la Cizelure à Celle de 264 livres

Pour avoir fait forger onze pieds de bandes d'acier, sur 6. lignes de largeur, pour mettre dessous les Cadres, avoir bien limé les dittes bandes, d'égales largeur et épaisseur ; les avoir polies à vif et montées a vis fraisées sur la ditte moulure ; Les ditets bandes évaluées en totalité à la somme de 132 livres

Pour avoir doré et surdoré le tout en or moulu et Couleur matte, Celle de 264 livres

Pour avoir moulé en Sable, et fondû en Cuivre toutes le dittes pièces de Bronzes, pezant ensemble 57. livres 6. onces à raison de 5 livres la livre ; Ce qui revient pour des dittes 57. Livres, 6. onces à Celle de 286 livres

Pour avoir monté tous les Bronzes sur les marbres, avec vis et écroux ; lesquelles vis passent à travers de toute l'épaisseur des marbres et avoir percé tous les trous à mes frais ; La ditte monture faitte avec beaucoup de Sujettion estimée en totalité à Celle de 300 livres

Plus, pour avoir fait mettre tous les aciers au violet, la Somme de 48 livres

Total : 12 354 livres

Modèle du bouton de la Croisée fermante à basses-cules [bascules].
Pour avoir fait un Bouton en bois, avoir modelé en Cire une Couronne de Roses ornée du Chiffre de Madame, d'un chapelet et d'une fleur de soleil,

qui sert de Rosette pour le bouton, une plaque et des graines sur quoi le soleil est posé ; Le tout estimé à la Somme de 48 livres

Pour le moulage et Cire tirée d'épaisseur, Celle de 15 livres

Pour avoir moulé en sable et fondû en Cuivre le dit Bouton, avec Sa plaque et soleil ; toute la Cizelure, Chiffre de Madame, et Couronne de Roses, percés à jour avec sujettion ; Le tout porté à Celle de 150 livres

Pour la monture, tournure et avoir ajusté des doublures en acier bien poli, et mis en Couleur violette, la Somme de 72 livres

Pour avoir doré le tout en or moulu, l'avoir bien surdoré et mis en couleur matte Celle de 120 livres

Total : 405 livres

Modèles de l'Espagnolette
Pour une poignée en Bois, évidée à jour en forme de Lyre, sur laquelle on à fait des graines de Chapelets des 2. côtés. Pour un autre modèle en bois pour le Bouton dela ditte Poignée, avoir modelé sur ledit Bouton une branche de Roses faisant tout le tour du dessus ; Lequel Bouton à été décoré du chiffre de Madame au milieu. Plus pour avoir modelé un branche de fleurs de Lys pour le milieu de la ditte Poignée. Pour 2. Rosettes dont l'une sert à arrêter le Bouton sur la Poignée, et l'autre à l'arrêter sur l'Espagnolette ; Tous lesquels modèles, tant en bois qu'en Cire sont estimés ensemble à la somme de 150 livres

Pour avoir moulé en plâtre les modèles ci dessus désignés, avoir tiré les cires d'épaisseur ; les avoir fondûs en étaim, les avoir Cizelés et percés à jour ; Le tout évalué en totalité à Celle de 150 livres

Pour le modèle du suport à charnières, avoir fait un Bois et modelé tous les ornemens en Cire avec un bouton à graines ; Ledit modèle porté à Celle de 48 livres

Pour avoir moulé le dit suport, avoir séparé tous les ornemens, les avoir moulés en étaim et les avoir cizelés, Celle de 60 livres

Pour avoir tourné un bois de la grosseur de l'Espagnolette, y avoir modelé en Cire 2. branches de Roses entrelassées, avec un Culot d'ornemens, d'où sortent les branches ; les dits ornemens portant en totalité 6. pouces de longueur sur 2. pouces 1/2 detour et évalués ensemble à la Somme de 86 livres

Pour les avoir moulés en Sable, fondûs en Cuivre, les avoir bien Cizelés, évidés àjour avec Sujettion et ajusté un noyau pour les fondre en Cuivre, Celle de 150 livres

Pour le modèle d'un autre ornement posé entre chaque branche des Roses, avoir tourné en bois d'égale grosseur au fer de l'Espagnolette, y avoir modelé en Cire le dit ornement décoré d'entrelas et Rosettes en feüilles tournantes : Ce morceau portant 4. pouces 3. lignes detour ,sur un pouce 1/2 de hauteur, estimé en totalité à Celle de 24 livres

Pour avoir moulé le dit ornement en Sable, l'avoir fondû en Cuivre ; Plus pour l'avoir tourné, cizelé, évidé à jour et avoir tourné les noyaux ; Letout estimé à la Somme de 48 livres

Pour le modèle du Lacet, fait d'abord en bois et ensuite fondû en Cuivre, avoir coupé le dit modèle en 2 parties pour l'ajuster avec Sujettion sur l'Espagnolette, avoir pris sur pièce les feüilles et les ornemens et sur la platte-bande des cœurs entrelassés ; Le dit modèle évalué à Celle de
96 livres

Total du modèle : 812 livres

Exécution des Bronzes de l'Espagnolette

Pour 10. montans de branches de Roses entrelassées et évidées à jour ; chaque montant portant 6. pouces de hauteur sur 2 pouces 1/2 de tour, estimé à raison de 120 livres Ce qui revient pour les dits 10. montans à la Somme de 1 200 livres

Pour un autre montant de 3. pouces de hauteur, sur 2. pouces 1/2 tour, la Somme de 150 livres

Pour 12. ornemens entrelassés avec plattes-bandes et Rosettes évidées à jour, portant un pouce et un quart de pouce de hauteur, sur 3. pouces de tour ; Chaque ornement estimé à la Somme de 24 livres Ce qui revient pour les 12. à Celle de 288 livres

Pour 6. Lacets décorés de feüilles sur les doucines et d'entrelas ; Chaque Lacet évalué à la Somme de 24 livres. C'est pour les 6. Lacets Celle de
144 livres

Total : 1 782 livres

Exécution de la Poignée de l'Espagnolette.

Pour Cizelure de 2. branches de Lys pour le dedans dela Poignée, pour l'avoir limée et fait des graines des 2. côtés avoir braité les Champs et doublé le milieu d'une plaque d'acier bien poli et violet ; Letout estimé à la somme de 150 livres

Pour le bouton dela ditte Poignée orné d'une Couronne de Roses et du chifre de Madame percé à jour, avec Chapelets doublés en acier et 2.

Rosettes Le dit Bouton estimé en totalité à Celle de 96 livres

Pour le suport de la Poignée, avoir cizelé 2 branches de Lys et 2 boutons à graines, avoir canelé le montant et avoir cizelé tous les ornemens dudit suport avec une plaque en violet ; le tout évalué à la Somme de 150 livres

Pour la monture de ditte Poignée et du suport, Celle de 114 livres

Pour avoir moulé en Sable et fondû en Cuivre tous les ornemens de la ditte Espagnolette ; Lesquels forment ensemble un poids de 11. Livres 5 onces, à raison de 5 livres la Livre ; ce qui revient pour les dittes 11 Livres 5. onces à la Somme de 56 livres

Pour l'ajustage et tournure de tous les bronzes posés sur l'Espagnolette ; ce qui a employé beaucoup de tems, eû égard à la délicatesse des Bronzes. Plus pour avoir fait tous les trous dans le fer pour y monter le vis ; La ditte monture estimée en totalité à Celle de 300 livres

Pour avoir mis en violet la ditte Espagnolette ; laquelle porte 12. pieds 8. pouces de hauteur à raison de 3 livres par chaque pied ; Ce qui revient pour les dits 12. pieds 8. pouces à la Somme de 38 livres

Pour avoir doré tous les bronzes de la dite espagnolette,
Sçavoir.
les 5 Lacets,
les 11 branches de Roses,
les 12 ornemens,
La Poignée, le bouton et le suport à charnières.
Toutes lesquelles pièces bien dorées d'or moulu et mises en couleur matte, sont estimées en totalité à la somme de 1 848 livres

Total : 2 782 livres

Modèle d'un troisième Bouton.

Pour avoir tourné en Bois et avoir modelé en Cire une Couronne de Roses décorée du chifre de Madame au milieu, avec une fleur de soleil qui sert de Rosette pour le bouton, une plaque et des graines, sur lesquels le soleil est posé ; le tout estimé à la somme de 36 livres

Pour avoir moulé en sable et fondû en Cuivre le modèle du dit troisième Bouton avec sa plaque et Soleil. Pour toute le Cizelure du Chiffre, Couronne de Roses, Chapelets et Soleils, dont partie est percée à jour avec Sujettion, la Somme de 96 livres

Pour avoir exécuté deux Boutons pour les grandes Portes qui rendent dans le Salon quarré, servant à ouvrir et fermer ces Portes. Pour les avoir moulés en Sable, fondûs en Cuivre avec leurs plaques et Soleils :

Cizelure, perles à l'entour de chaque Bouton comprises ; tous ces ornemens percés à jour avec sujettion ; chaque bouton évalué à 48 livres. Les deux reviennent à la Somme de 96 livres

Pour la tournure de ces 2. Boutons avec leurs plaques, monture, doublure d'acier dans les Boutons et plaques ajustées avec grande Sujettion et mises en couleur violette ; Chaque Bouton garni de sa Plaque et Rosette, estimé à 24 livres. Ce qui revient pour les 2. Boutons à la Somme de 48 livres

Pour les avoir bien dorés d'or moulu, surdorés et mis en couleur matte ; Chaque Bouton avec ses garnitures évalué à la somme de 48 livres Les 2. Boutons reviennent à Celle de 96 livres

Pour avoir fait 4. Boutons en ovals en Cuivre, avec leurs Rosettes, pour arrêter les volets ; Cuivre, Cizelure et tournure compris ; Chaque Bouton avec sa Rosette, estimé à 3 livres Les quatre reviennent à la Somme de 12 livres

Pour la dorure en or moulu de chaque Bouton la Somme de 3. livres C'est pour les 4. Celle de 12 livres

Pour un fort Bouton qui ouvre la Croisée à basses-cules, bronze, Cizelure et tournure compris, la Somme de 15 livres

Pour l'avoir doré en or moulu, Celle de 15 livres

Plus, pour avoir limé, poli et doré d'or de feuilles 6. Crochets de fer avec leurs pitons ; Chaque Crochet évalué à 40. sols. Les Six reviennent à la Somme de 12 livres

Pour avoir fait 4. fortes Poignées en Cuivre, avec leurs tiges en fer, pour ouvrir les Jalousies ; Chaque Poignée estimée à la Somme de 12 livres Les 4. reviennent à Celle de 48 livres

Plus, pour avoir fourni un feu à Cassolettes avec ses revêtemens et garnitures de Pelle et Pincettes ; Lequel feu a été composé exprès et n'a été exécuté qu'après plusieurs Desseins et modèles en terre présentés à Madame et d'après son choix, le dit feu a été exécuté et est porté en totalité, y compris Desseins, Modèles, Bronzes, Ciselure, Monture et dorure en couleur matte et violette,et les fers fournis par M. Thibault Serrurier de Madame, ont été, partie dorés et partie en Couleur d'eau, à la Somme de 6 000 livres

Plus, avoir fourni une paire de Girandoles, composée d'un Vase, Pied d'Estal et 4. branches de Lys, dont 3 servant de bobèches, évaluée, y compris la (sic) Bronze, Ciselure, monture, dorure en couleur matte et le Vase en couleur de fumée, en totalité à la Somme de 1 200 livres

Plus avoir fourni une paire de petits Flambeaux Cannelés, avec leurs pieds à Canneaux et ornemens, estimée pour Bronze Cizelure et dorure à la Somme de 400 livres

Total : 47 157 livres

Grand Salon quarré.
Modèles d'une Cheminée.
Pour avoir fait pousser 2. moulures, chacune de 2. pieds de longueur dont une est Ceintrée, avoir fait Sculpter des oves et feüilles d'ornemens ; Ces deux moulures estimées à la Somme de 96 livres

Pour un bout de trois pouces assemblé d'onglets, sur lequel on a modelé une feüille d'ornement sur l'angle, pour ce, Celle de 30 livres

Pour avoir fait modeler 4. branches de vignes, pour la frise de la traverse ; 3. morceaux portant un pied de longueur sur 2. pouces de hauteur, 2 morceaux faisant partie et contre partie du milieu ; Le 4e portant 2. pouces de longueur sur 2. pouces de hauteur et servant au bout la traverse dans le petit Panneau, pour ce, Celle de 144 livres

Pour les avoir moulés en plâtre, fondûs en étaim et les avoir cizelés Celle de 288 livres

Pour le montant d'une Cheminée, avoir modelé en Cire une feüille d'ornement sortant de dessous la traverse et couvrant sur la Console un bout de moulure en bois sur lequel on a modelé des narselles et taillé sur le bois des Chapelets de 2 côtés : Cette moulure porte 14. pouces de longueur sur un pouce de largeur et est estimée à la somme de 72 livres

Pour avoir modelé des feüilles d'ornemens sur les Rouleaux, aux bas de la volute, dela Console ; le milieu en Chapelets et narcelles, porté à Celle de 40 livres

Pour le panneau de dessous la Console, avoir modelé en Cire une plante d'où sort un pied de tournesol avec une fleur et à l'entour une branche de vignes : Cette tige portant 19. pouces de longueur, estimée à Celle de 72 livres

Pour avoir fait modeler 2. culots avec des feüilles et chapelets faisant partie et contrepartie et portant chacun 2. pouces de longueur évalués à Celle de 12 livres

Pour avoir moulé en plâtre tous les dits ornemens, les avoir fondus en Etaim et cizelés ; pour ce, la Somme de 300 livres

Exécution d'une des 2. Cheminées :
Pour le dessous de la tablette, avoir fait une moulure de 7. pieds 2. pouces de longueur, sur 14. lignes de tour : Cette moulure décorée d'oves, plattes-bandes, feüilles d' ornemens, Chapelets et feüilles sur les angles faisant avant-corps et arrière-corps ; La ditte moulure ceintrée sur la face et estimée à raison de 80 livres par chaque pied de moulure ; Ce qui revient pour les dits 7. pieds 2. pouces à la Somme de 573 livres

Pour avoir doré d'or moulu la ditte moulure, l'avoir surdorée et mise en Couleur matte, Celle de 645 livres

Pour 9 pieds 4 pouces de moulure unie pour le Cadre de la traverse de la Cheminée à 3 livres le pied, fait Celle de 28 livres

Pour 2. autres Cadres pour le bout de la traverse, portant un pied de la même moulure, la Somme de 6 livres

Pour la frise composée de branches de vignes entrelassées, bien cizelées et percées à jour : Cette frise porte 4. pieds 2. pouces de longueur sur 2. pouces de hauteur ; Chaque pied évalué à la Somme de 192 livres. Ce qui fait pour les dits 4 pieds deux pouces, celle de 800 livres

Pour 2. branches de vignes qui Sont dans les Panneaux des bouts de la traverse, Celle de 192 livres

Pour avoir doré d'or moulu et surdoré tous les Cadres et frises dela dite traverse, Celle de 1 100 livres

Pour avoir fait 2 feüilles d'ornemens posés sur le haut de la Console du montant dela ditte Cheminée, Cizelure comprise, Celle de 72 livres

Pour le milieu de la Console avoir fait 2. moulures d'un pied de longueur, sur un pouce de largeur, avoir cizelé sur la ditte moulure des narcelles et Chapelets des 2. côtés : Ces moulures ceintrées suivant le galbe des Consoles et estimées à la Somme de 72 livres

Pour les volutes dubas des Consoles, avoir cizelé 2. rouleaux de feüilles d'ornemens et feuilles d'eau et entre les dittes feüilles des narcelles et Chapelets, pour ce, Celle de 120 livres

Pour avoir orné d'une moulure unie les 2. côtés de chaque Console et Rouleau, faits avec beaucoup de Sujettion ; Letout évalué à Celle de 72 livres

Pour avoir doré d'or moulu et Surdoré tous les ornemenss et moulures des 2. Consoles et Rouleaux, Celle de 360 livres

Pour les panneaux de dessous les 2. Consoles, avoir cizelé deux plantes et 2. montans de tournesol de chacun un pied 10. pouces de longueur, avec deux fleurs épanoüies, portant dessous les Rouleaux et à l'entour des tiges montent des branches de vignes ; Letout estimé à la Somme de 384 livres

Pour les 2. cadres des 2. panneaux faits avec une doucine unie, Celle de 24 livres

Pour avoir doré d'or moulû et surdoré tous les ornemens et Cadres, Celle de 400 livres

Pour avoir cizelé 9. pieds 10. pouces de Culots avec des Chapelets enfilés ; Ce qui fait le Cadre du tour de toute la cheminée ; Ledit Cadre estimé avec ses ornemens à Celle de 413 livres

Pour avoir doré d'or moulu le dit Cadre et l'avoir surdoré, Celle de 474 livres

Pour avoir fait toute la monture de tous les Bronzes, Soudures, vis en fer montées à écroux, et pour avoir fait percer tous les trous à travers les marbres avec Sujettion toutes les dittes montures estimées en totalité à la Somme de 500 livres

Pour avoir moulé en Sable et fondu en bronze tous les ornemens et moulures qui décorent la Cheminée ; Lesquels ornemens pezent ensemble 26. livres 4. onces à raison de 5 livres la livre Ce qui revient en totalité pour les dittes 26. livres 4. onces, à la Somme de 131 livres

Total : 6 366 livres

Pour l'exécution de la seconde cheminée, tant pour les bronzes, ciselure, que monture et dorure, celle de 6 366 livres

Total : 12 732 livres

Modèle des ornemens posés sur la Serrure d'une Porte :
Pour avoir fait pousser un bout de moulure en bois d'un pied de longueur l'avoir moulé en Sable, fondû en Cuivre et limé un Rond entre deux quarrés, une doucine de chaque côté ; Sur les doucines, avoir pris sur pièce des Rez de cœur et sur le Rond des cœurs entrelassés, avec des petites feüilles Sur les plattes-bandes unies ; Le tout faits avec grande Sujettion et estimé à la Somme de 144 livres

Pour un autre modèle pour le veroüil posé au bout de la même moulure ; Ce morceau est de 5. pouces de hauteur sur 2. de largeur, avec un bout en saillie, ou se répètent les Rez de cœur et au bas, pour cacher le joint

des 2. moulures une bande avec des Canneaux et graines ; Ledit morceau porté à Celle de 96 livres

Pour le bas de la ditte moulure avoir fait un bout d'ornement qui pose sur la Serrure ; Lequel porte environ 2. pouces de longueur et est décoré d'une petite graine de Canneaux et le bas est orné des mêmes Rez de cœur que ceux qui sont sur la moulure ; tous les dits ornemens pris sur pièce sur un morceau de Cuivre évalués à la Somme de 36 livres

Pour avoir fait modeler en Cire, pour la Serrure, un arabesque décorée du Chiffre de Madame au milieu : Cet ornement portant 5. pouces 6. lignes de longueur, sur 2. pouces 6. lignes de hauteur, estimé à Celle de 72 livres

Pour avoir moulé en plâtre le dit ornement, l'avoir fondû en étaim et l'avoir bien Cizelé Celle de 72 livres

Pour avoir fait mouler un pareille Arabesque, décoré de semblables ornemens pour la Serrure posée à la Porte de la Salle à manger ; Ledit arabesque portant 3. pouces 6. lignes de longueur sur 2. pouces 6. lignes de hauteur, estimé en totalité à la Somme de 72 livres

Pour avoir moule en plâtre Cet Arabesque, l'avoir fondû en Etaim et l'avoir ciselé, Celle de 72 livres

Pour avoir fait pour la Serrure un Cadre en bois, ceintré des 2. bouts, les 4 angles quarrés,; pour l'avoir fait fondre en Cuivre, l'avoir bien limé et avoir pris la moulure des Rez de cœur et sur les angles des Chapelets avec une petite branche de Mirthe pour l'angle ; tous les dits ornemens pris sur pièce et estimés ensemble à Celle de 120 livres

Pour avoir tourné en bois un bouton sur lequel on a modelé en Cire un tête de Soleil avec des rayons, et à l'entour des narcelles ; Letout évalué à Celle de 60 livres

Pour avoir monté ledit bouton et avoir tiré les Cires d'épaisseur, la Somme de 15 livres

Pour un second modèle de petit Bouton pour ouvrir la Serrure : Ce modèle est à fleurs de Soleil et est estimé à Celle de 15 livres

Total : 774 livres

Exécution des Bronzes d'une Porte :
Pour avoir cizelé 23. pieds 4. pouces de moulure sur un pouce 1/4 de pouce de largeur ; Chaque côté dela moulure est décoré d'un Rez de cœur sur une doucine, le milieu orné d'un Rond entre 2. quarrés, sur lequel Rond

sont Cizelés des cœurs entrelassés avec des feüilles et plattes-bandes unies : Le tout percé à jour et estimé à raison de 48 livres par chaque pied : Ce qui revient pour les dits 23. pieds 4. pouces à la Somme de 1 120 livres

Pour 4. bouts de 5. pouces de longueur, Sur un pouce 1/2 de largeur chaqun ; lesquels bouts se mettent au haut et au bas des Basses-cules, les mêmes ornemens sont répétés de même que sur les moulures, les bouts sont terminés par les mêmes Rez de cœur que Ceux qui sont sur les côtés et au bas une platte-bande sur laquelle on a cizelé des Canneaux et fait des graines ; Cette platte-bande faitte pour couvrir l'assemblage des deux moulures ; Chaque bout évalué à 30 livres Ce qui revient pour les 4. bouts à la Somme de 120 livres

Pour avoir cizelé 4. autres ornemens qui se posent dessous et dessus les Serrures, la moulure sort de dessous lesdits ornemens : Chaque ornement porte un pouce 3/4. de hauteur et est porte à la Somme de 9 livres Ce qui fait pour les 4 ornemens, Celle de 36 livres

Pour 2. moyens boutons à fleurs de Soleil pour lever les Basses-cules, les avoir tournés avec un Chambranle à l'entour et bien cizelé la fleur et avoir ajusté dessous une plaque d'acier bien polie et mise au violet : Chaque bouton estimé à 30 livres fait les deux la Somme de 60 livres

Pour avoir doré d'or moulu et surdoré les 23. pieds, quatre pouces de moulure ; Chaque pied à raison de 48 livres Ce qui revient pour les dits 23. pieds 4 pouces à la Somme de 1 120 livres

Pour avoir également doré les 4. bouts qui couvrent les haut et le bas des Basses-cules ; Chaque bout porté à la Somme de 30 livres, fait pour les quatre celle de 120 livres

Pour avoir doré de même les 4. ornemens qui sont posés dessous et dessus les Serrures ; Chaque ornement évalué à raison de 9 livres fait pour les 4 ornemens la Somme de 36 livres

Pour avoir aussi également doré les 2. Boutons ; Chaque Bouton porté à la somme de 30 livres fait pour les deux, Celle de 60 livres

Pour avoir cizelé avec grand soin l'ornement en Arabesque décoré du Chiffre de Madame : Cet ornement percé àjour avec grande Sujettion estimé à Celle de 150 livres

Pour des Rez de cœur cizelés au Cadre qui entoure le dit ornement sur le Palastre de la serrure, pour ce Celle de 60 livres

Pour les 4 angles, avoir cizelé 4. petites branches de Mirthe, estimées ensemble à la Somme de 72 livres

Pour les 2. Boutons qui ouvrent la serrure, pour ciselure, tournure et plaque d'acier bien polie et mise au violet ; chaque bouton estimé à 15 livres, fait pour les 2, la somme de 30 livres

Pour avoir doré d'or moulu l'ornement en Arabesque, le Cadre, les 4. branches de Mirthe et les 2 boutons ; L'dorure de ces 8. ornements évaluée en totalité à Celle de 200 livres

Pour avoir cizelé 2. gros Boutons à têtes de Soleil et Rayons bien évidés à jour, 2. fleurs de Soleil doubles et leurs plaques avec des Chapelets : Chaque Bouton porté à la Somme de 120 livres, fait pour les 2. Celle de 240 livres

Pour la tournure et monture des 4. Plaques en acier bien polies à vif et mise en couleur violette, Celle de 144 livres

Pour avoir bien doré d'or moulu et surdoré les 2. Boutons ; Chaque Bouton estimé à raison de 96 livres fait pour les dits 2. boutons la Somme de 192 livres

Pour avoir moulé en Sable et fondû en Cuivre toutes les moulures et ornemens de Serrures et Boutons : Toutes ces pièces formant ensemble un poids de quinze Livres, Chaque Livre pezant estimée à raison de 5 livres eû égard à la grande Sujettion, fait pour les dittes 15. Livres péz.la Somme de 75 livres

Pour avoir monté tous les dits ornemens sur la Porte et Serrure : Cette monture étant de la plus grande Sujettion par la raison que les Cadres et ornemens sont coupés sur la Serrure, sans qu'aucune vis soit apparente, quoique très difficile à poser, en ce qu'elles se trouvent dans l'épaisseur de la cage dela serrure ; Laditte monture estimée en totalité à Celle de 350 livres

Pour montant d'une Porte et Exécution des Bronzes, Cizelure et Dorure la somme de 4 185 livres

La même Somme que celle accoladée ci-dessus, pour la Porte qui est en face et qui rend dans le Salon à cul-de-four 4 185 livres

Pour la Porte qui rend dans la Salle à manger le même prix que pour les précédentes 4185. Cy 4,185 livres

Modèles des Espagnolettes :
Pour avoir fait une Poignée en bois évidée à jour, en forme de Lyre, pour servir de modèle au Serrurier ; La ditte Poignée estimée en totalité à la somme de 6 livres

Pour avoir tourné en bois un Bouton sur lequel on a modelé en Cire un Soleil pour le milieu du dit Bouton et à l'entour des branches de la poignée des guirlandes de fleurs ; Lesquelles guirlandes font partie et contre partie ; un autre petit ornement d'où sortent les Cordes de la lyre, une Embaze ou elles sont censées [être] attachées ; tous les dits modèles estimés à la Somme de 120 livres

Pour les avoir moulés en plâtre, fondus en Etaim et Cizelés, Celle de 96 livres

Pour le modèle de l'Embaze, avoir fait tourner un bois et fait modeler en Cire des feüilles d'ornement de 2. pouces de longueur et sur les moulures au bas des feüilles avoir taillé sur le Bois des Rez de cœur, oves, dards et chapelets, Celle de 36 livres

Pour l'avoir moulé en Sable et fondû en Cuivre, l'avoir bien Cizelé et tire d'épaisseur sur letour, y avoir ajusté les noyaux prêts à être moulés, Celle de 72 livres

Pour le modèle du Lacet, fait d'abord en Bois de 2. pièces et ensuite fondû en Cuivre ; l'avoir ajusté avec Sujettion sur l'Espagnolette, avoir pris sur pièce tous les ornemens, qui consistent en Rez de cœur des deux côtés et des entrelas sur la Platte-bande ; Le dit modèle estimé en totalité à la Somme de 96 livres

Pour avoir tourné un Bois d'égale grosseur à Espagnolette et avoir modélé en Cire 2. branches de vignes entrelassées, portant 10. pouces de longueur, sur 3. pouces de tour ; l'avoir moulé en Sable, fondû en Cuivre, bien cizelé, évidé à jour sur le tour et avoir ajusté un noyau ; le tout évalué à Celle de 100 livres

Pour avoir fait modeler en Cire un Suport à charnières ; l'avoir moulé en Sable et fondû en Cuivre et l'avoir bien ciselé, Celle de 48 livres

Pour 2. branches de vignes tournant à l'entour de l'Espagnolette, portant chacune 9. pouces de hauteur, sur 3. pouces de tour ; la Cizelure de chaque branche faitte avec grande Sujettion et évidée à jour, estimée à 130 livres fait pour les 2. branches la Somme de 260 livres

Pour avoir doré d'or moulu ces 2. branches, les avoir surdorées et mises en couleur matte, la Somme de 130 livres par chacune des branche ; fait pour les deux, Celle de 260 livres

Pour 2. vases en feüilles d'ornemens, Rez de cœur, oves, dards et chapelets ; Chaque Vase portant 3. pouces de hauteur, sur environ 4. pouces de tour, bien cizelé et évidé en dedans sur le tour, estimé à 48 livres, fait pour les 2. Vases, la Somme de 96 livres

Pour les avoir dorés en or moulu et couleur matte, Celle de 120 livres

Pour avoir tourné et Cizelé les 6. Lacets, lesquels sont ornés de Rez de cœur et d'entrelas sur le milieu ; Chaque Lacet évalué à raison de 24 livres, fait pour les 6. Lacets la Somme de 144 livres

Pour la dorure en or moulu de chaque Lacet la Somme de 30 livres Ce qui revient pour les 6. à Celle de 180 livres

Pour l'ajustage et monture des Bronzes posés sur la ditte Espagnolette, Celle de 120 livres

Pour avoir ciselé les ornemens de la Poignée, qui consistent en 9. guirlandes des fleurs d'environ 2 pouces. Ces guirlandes ont été très difficiles à Cizeler et ont employé beaucoup de tems. Plus 2. petites Rosettes et 4. ornemens où sont attachées les cordes de la Lyre. Plus 2 autres Rosettes à Soleil ; La première pour arrêter la poignée sur l'Espagnolette ; La 2ème. pour arrêter le Bouton ; Letout bien cizelé et estimé à Celle de 168 livres

Pour avoir cizelé et tourné les boutons de la Poignée, avoir ajusté sous le Soleil dudit bouton, une plaque d'acier bien polie et avoir cizelé des narcelles à l'entour de ce même Bouton, la Somme de 72 livres

Pour avoir monté toutes les guirlandes à l'entour des branches de la poignée, avoir posé à vis tous les ornemens, avoir ajusté dans le milieu une plaque d'acier bien polie des 2. côtés et y avoir mis des cordes de laiton des 2 côtés : Cette moulure a employé beaucoup de tems eû égard à la grande difficulté et est estimée à Celle de 96 livres

Pour avoir doré d'or moulu tous les ornemens de Bronzes et boutons de la Poignée, pour ce, Celle de 50 livres

Pour avoir doré et surdoré en or de feüilles la Poignée en fer, Celle de 18 livres

Pour avoir fait le suport à charnières et l'avoir bien cizelé la Somme de 150 livres

Pour l'avoir doré en or moulu et couleur matte, Celle de 120 livres

Pour avoir moulé en sable et fondû en Cuivre tous les ornemens de l'Espagnolette ; avec Ceux de la Poignée, boutons et suport à charnières ; tous lesquels ornemens pezent ensemble 9. livres 3. onces à raison de 5 livres la livre ; Ce qui revient pour les dittes 9. livres 3. onces, à la somme de 45 livres

Pour avoir mis en violet la ditte Espagnolette ; Laquelle porte 12. pieds 8. pouces de hauteur, à raison de 3 livres par pied ; fait pour les dits 12. pieds 8. pouces la Somme de 38 livres

<u>Observation :</u>
Une seule Espagnolette revenante à la Somme ci accoladée de 1 937 livres

Les deux autres Espagnolettes portées au même prix, reviennent ensemble à Celle de 3 875 livres

Plus pour avoir limé, poli et doré d'or de feüilles 6. Crochets en fer avec leurs pitons ; Chaque Piton évalué à 40. sols, fait pour les six Crochets la Somme de 12 livres

Pour avoir fait 6. moyens Boutons en ovals, avec leurs plaques pour les veroüil des volets ; Chaque Bouton, avec sa Rosette, Cuivre, Cizelure et tournure compris, porté à la Somme de 3 livres Les dits 6. Boutons reviennent ensemble à Celle de 18 livres

Plus, pour avoir doré en or moulu 4. Ventouses, au coin des Cheminées ; Chaque ventouse portée à la Somme de 6. livres Ce qui revient pour les 4 à Celle de 24 livres

Plus pour avoir fait 6. fortes Poignées en Cuivre, avec leurs tiges en fer, pour ouvrir les Jalousies ; Chaque Poignée estimée à la Somme de 12. livres Les six reviennent à Celle de 72 livres

Plus, pour avoir fait faire plusieurs Desseins et Modèles pour les feux du Salon quarré, dont un Modèle s'étant trouvé du goût de Madame, a servi à l'exécution des 2. feux des 2. cheminées du dit Salon (**cat. 24**) ; Lesquels sont très riches et sont décorés de bas reliefs ; Chaque feu porté, y compris les Desseins, Modèles, Bronze, Cizelure, monture, dorure en couleur matte et les fers qui m'ont été fournis par M. Thibault Serrurier de Madame, partie en dorure d'or de feüilles et partie en couleur d'eau, avec les boutons de Pelle, Pincettes et tenailles bien cizelés et dorés en couleur matte, à la Somme de 7 000 livres, Ce qui revient pour les deux, à Celle de 14 000 livres

Plus pour les Desseins et Modèles qui ont servi à l'exécution des 2. paires de bras posés aux 2. cheminées du Salon quarré ; Lesquels sont évalués y compris Bronze, Cizelure, monture et dorure en couleur matte, à la Somme de 6 000 livres pour chaque Paire ; Ce qui revient pour les dittes 2. paires de bras, à Celle de 12 000 livres

Plus pour avoir fourni deux paires de Flambeaux Cannelés, avec leurs pieds à Canneaux et ornemens ; Chaque paire estimée, y compris Bronze Cizelure et dorure la Somme de 400 livres Les deux paires reviennent à Celle de 800 livres

Total : 60 447 livres

Salon à cul de four
Modèles dela Cheminée. (**cat. 30**)
Pour la moulure de dessous la tablette, avoir fait un Bois de 2. pieds de longueur sur 1. pouce de profile, avoir fait tailler sur la ditte moulure des trèfles et feüilles d'ornemens ; Le dit modèle estimé à la Somme de 60 livres

Pour l'avoir moulé en Sable, fondu en Cuivre, Cizele et avoir assemblé 2. bouts pour faire les avant-corps et arrière-corps, Celle de 30 livres

Pour avoir fait modeler 4. branches de Roses pour la frise de la traverse ; trois morceaux portant un pied de longueur et 2. pouces de hauteur ; deux morceaux faisant partie et contre-partie et un pour le milieu ; un autre portant 2. pouces et demi de longueur sur 2. pouces de hauteur ; lequel se met dans les panneaux des bouts de la traverse ; Le tout estimé à Celle de 150 livres

Pour avoir moulé en plâtre les quatre branches de Roses ci devant désignées ; les avoir fonduës en étain et les avoir Cizelées, la somme de 200 livres

Pour les ornemens qui décorent les colonnes qui sont dans les montants, avoir tourné en bois 3. Ronds ou Cercles

Sçavoir.
Le premier destiné pour le haut de la colonne, sur lequel on a taillé des oves, plattes-bandes et feüilles d'ornemens : Ce cercle portant 10. pouces de tour sur un pouce de dévelopement, évidé en dedans et tiré d'épaisseur estimé en totalité à celle de 24 livres

Le second Cercle est posé dessous et porte 8. pouces de tour, sur 9. lignes de dévelopement, l'avoir moulé en Sable, fondû en Cuivre, l'avoir tourné et avoir pris des Narcelles sur pièce, évalué à Celle de 48 livres

Le troisième Cercle porte un pied detour, sur onze lignes de dévelopement ; pour l'avoir moulé en Sable, fondû en Cuivre, l'avoir tourné et pris sur pièce des feüilles d'eau et graines entre chaque feuille ; Le dit modèle estimé à la Somme de 18 livres

Pour avoir modelé en Cire une branche de Mirthe, tournant à l'entour de la gorge dela Colonne, l'avoir moulée en plâtre et fondue en Etaim ; La ditte branche portée à Celle de 12 livres

Pour avoir modelé en Cire une tigette en Culot d'ornemens pour mettre dans le haut des Canelures ; laquelle porte 3. pouces 6. lignes de longueur. Plus une seconde tigette modelée en Cire pour le bas des Canelures, portant 5. pouces de longueur ; Cette tigette est en culot d'ornemens, avec des Perles enfilés. Plus une Canelure Ronde en bois

pour modèle. Toutes lesquelles pièces, après avoir été moulées en Sable et fonduës en Cuivre ont été ensuite Cizeléces et limées pour Servir de modèles et sont estimées en totalité à Celle de 36 livres

Pour avoir fait en Bois 2. bouts de baguettes à Rubans, faisant partie et contre-partie ; le Ruban évidé à jour avec une baquette au milieu et des feüilles sur les angles : Chaque bout portant un pied de longueur ; Les dits 2. bouts de baguettes à Rubans évalués ensemble à la Somme de
 24 livres

Exécution des bronzes de la Cheminée. (**cat. 30**)
Pour le dessous de la tablette, avoir fait une moulure en doucine, taillée en treffles, feüilles d'ornemens et feüilles d'eau : Cette moulure porte 9. lignes de développement sur 6. pieds 6. lignes de longueur et fait avant-corps et arrière-corps au dessus des montans avec des feüilles d'ornemens sur les angles et sur les arrière-corps ; La ditte moulure bien Cizelée, évaluée à raison de 60 livres par chaque pied : Ce qui revient pour les dits 6. pieds 6. lignes à la Somme de 362 livres

Pour avoir doré d'or moulu la ditte moulure, l'avoir surdorée et l'avoir mise en couleur matte, la Somme 362 livres

Pour le Cadre de la traverse de la ditte Cheminée, avec les deux petits bouts au dessus des montans, avoir employé 11. pieds 4. pouces de doucine unie, évaluées à la Somme de 3. livres par pied ; Ce qui revient pour les dits 11. pieds 4. pouces à Celle de 34 livres

Pour la frise composée de branches de Roses entrelassées bien Cizelées et évidées à jour ; laquelle porte 4. pieds 5. pouces de longueur sur 2 pouces de hauteur : Chaque pied estimé à la Somme de 192 livres fait pour les dits 4. pieds 5. pouces, Celle de 848 livres

Pour 2. branches de Roses qui sont dans les Panneaux des bouts de la traverse, au dessus des montans ; Chaque morceau portant 3. pouces 1/2. de hauteur ; Les dittes 2. branches de Roses estimées ensemble à la Somme de 240 livres

Pour avoir doré d'or moulu et mis en Couleur matte les trois Cadres dela ditte traverse et les frises, celle de 1 150 livres

Pour les 2. Cadres en doucine unie pour les 2. tours Creuses des montans de la ditte Cheminée, avoir employé 11. pieds 7. pouces de moulures, à raison de 3. livres chaque pied ; Ce qui revient pour les dits 11. pieds 7. pouces à Celle de 34 livres

Pour les ornemens qui décorent la Colonne, avoir fait 2. Ronds d'oves et feüilles d'ornemens, Chaque Rond portant 10. pouces de tour sur un

pouce de profile, estimé à la somme de 48 livres Revient pour les dits 2. Ronds à Celle de 96 livres

Pour 2. Cercles en narcelles de chacun 8. pouces detour, sur 9. lignes de dévelopement ; Chaque Cercle estimé à 18. livres Ce qui revient pour les dits deux Cercles à la Somme de 35 livres

Pour 2. autres Cercles décorés de feüilles d'eau et graines ; Chaque Cercle portant un pied de tour sur onze lignes de dévelopement porté à la Somme de 48. livres, fait pour les dits deux Cercles, Celle de 96 livres

Pour 6. branches de Mirthe, tournant à l'entour des gorges des Colonnes ; Chaque branche portant 4. pouces de longueur portée à la Somme de 10. livres , fait pour les dittes 6. branches de Mirthe, Celle de 60 livres

Pour avoir fait 14. Chûtes en Culots d'ornemens de chacune 3. pouces 4 lignes de longueur : Ces chûtes sont posées clans le haut des Canelures des Colonnes et sont évaluées à 6. livres chacune ; Ce qui revient pour les dittes 14. Chûtes à la Somme de 84 livres

Pour les 14. Chandelles unies montantes dans les mêmes Canelures et portant chacune 8. pouces de hauteur et au dessus de chaque Chandelle 3. culots d'ornemens, enfilés avec des Piastres ; Chaque bout portant 5. pouces de hauteur ; Ce qui forme avec chaque chandelle un pied un pouce de hauteur à raison de 12. livres chacune ; fait pour les 14. Chandelles, Celle de 168 livres

Pour 2 boutons unis pour placer dessous les bouts des dittes Canelures estimés ensemble à Celle de 8 livres

Pour avoir doré d'or moulu surdoré et mis en couleur matte tous les ornements des susdittes colonnes composant ensemble un nombre de 56. pièces, estimées en totalité à la Somme de 800 livres

Pour avoir fait avec grande Sujettion 9. pieds 10. pouces de moulures à Rubans et feüilles d'ornemens sur les angles du Cadre, formant tout le tour du dedans de la Cheminée ; Chaque pied dela ditte moulure porté à la somme de 40 livres fait pour les dits 9. pieds 10. pouces, Celle de
 393 livres

Pour avoir doré d'or moulu et surdoré les 9. pieds 10. pouces de moulures ci dessus ; Chaque pied de moulure porté à la somme de 48. livres Ce qui revient pour les dits 9. pieds 10. pouces à Celle de 472 livres

Pour avoir fait toutes les montures des Bronzes sur les marbres, soudures, ragréures et toutes les vis en fer montées à écroux, tout à travers les marbres et pour avoir fait percer tous les trous avec la plus grande sujet-

tion ; Laditte monture estimée en totalité à la Somme de 400 livres

Pour avoir moulé en sable et fondû en Cuivre tous les ornemens et moulures qui décorent la ditte Cheminée ; lesquels forment ensemble un poids de 21. livres 8. onces à raison de 5. livres la Livre ; Ce qui revient pour les dittes 21. Livres 8. onces, à 107 livres

Total pour la cheminée : 5 752 livres

Modèle du Bouton de la Croisée fermante à basses-cules. (cat. 27)

Pour avoir tourné un Bouton en bois, y avoir modelé en Cire une Couronne de branches de Mirthe, décorée du Chifre de Madame et ornée d'une moulure à Rubans percée à jour ; Le tout estimé, avec le moulage et Cire tirée d'épaisseur à la Somme de 48 livres

Pour l'avoir moulé en Sable et fondû en Cuivre avec sa plaque et Soleil. Pour la Cizelure du chifre de Madame, couronne de Mirthe, moulures à Rubans et Soleils, servant d'ornement sur la Plaque avec des Chapelets ; tous les dits ornements bien évidés et percés à jour, de même que le fond du bouton qui est aussi évidé, y compris, le Cuivre et Cizelure ; Le tout estimé à la Somme de 166 livres

Pour la tournure, monture et ajustage, Celle de 72 livres

Pour la dorure en or moulu, bien surdorée et mise en couleur matte, Celle de 120 livres

Plus, pour un fort Bouton en dehors de la ditte Croisée, estimé, Cuivre, Cizelure, monture, tournure et dorure compris, à Celle de 36 livres

Total du bouton : 442 livres

Modèle d'un Moyen Bouton.

Pour avoir tourne un Bois, y avoir modelé en Cire une Couronne de branches de Mirthe ornée du chifre de Madame, avec une moulure à Rubans à l'entour, l'avoir moulée et avoir tiré les Cires d'épaisseur ; pour ce, la Somme de 36 livres

Pour avoir moulé en Sable et fondu en Cuivre la Couronne de Mirthe, le chiffre de Madame, et avoir évidé àjour le Ruban ; Le tout bien cizelé et prêt à fondre, estimé à Celle de 84 livres

Total du moyen bouton : 120 livres

Exécution de 6. Boutons avec leurs plaques et Soleils.

Pour avoir fondû en Cuivre Six Boutons avec leurs plaques et Soleils. Pour Cizelure de chaque Bouton orné du chifre de Madame, Couronne

de Mirthe et baquettes à Rubans ; tous les dits ornemens évidés àjour avec Sujettion ; Le fond des Boutons évidé, avec chaque plaque à chapelets et leurs soleils ; Letout bien Cizelé : Chaque Bouton, avec les plaques évalué à 120 livres fait pour les 6. boutons la Somme de 720 livres

Pour la tournure et monture de Chaque Bouton, la Somme de 48 livres. Ce qui revient pour les 6 Boutons à 288 livres

Pour la dorure en or moulu et Couleur matte de Chaque Bouton la Somme de 72. livres fait pour les 6. Boutons, Celle de 432 livres

Total : 1 440 livres

Modèles de l'Espagnolette.
Pour une poignée en bois évidée à jour en forme de Lyre, sur laquelle on a fait des graines de Chapelets des 2. côtés. Pour un autre modèle en bois pour le Bouton deladitte Poignée et avoir modelé sur le dit Bouton une branche de Mirthe faisant tout le tour dudessus, décorée du Chifre de Madame au milieu. Plus une branche en fleurs de Mirthe modelée en Cire aussi pour le milieu. Plus 2. Rosettes, dont l'une sert à arrêter le Bouton sur la Poignée et l'autre à arrêter la poignée sur l'Espagnolette ; Tous lesquels modèles, tant en bois qu'en Cire sont estimés ensemble à la somme de 150 livres

Pour avoir moulé en plâtre les modèles ci dessus désignes, avoir tiré les Cires d'épaisseur, fondûs en plomb, les avoir cizelés et percés àjour, pour ce, Celle de 150 livres

Pour le modèle de la Baze, avoir tourné en bois, avoir fait modeler en Cire des feüilles d'eau et sur les moulures des feüilles de Laurier et un Ruban ; Ledit modèle estimé en totalité à Celle de 15 livres

Pour avoir moulé en Sable et fondû en Cuivre le dit modèle, l'avoir cizelé et tiré d'épaisseur sur letour et avoir ajusté les noyaux ; Ledit modèle estimé en totalité 48 livres

Pour le modèle du Lacet fait d'abord en Bois et ensuite fondû en Cuivre, avoir coupé le dit modèle en 2. parties pour l'ajuster avec Sujettion sur l'Espagnolette, avoir pris sur pièce les feüilles et les doucines et sur la platte-bande des cœurs entrelassés, Celle de 96 livres

Pour avoir modelé en Cire 2. branches de Mirthe entrelassées portant 9. pouces de longueur sur 3. pouces de tour ; les avoir moulées en Sable et fonduës en Cuivre, les avoir cizelées, bien évidées àjour et avoir ajusté un noyau, pour ce Celle de 150 livres

Total : 609 livres

Exécution des Bronzes de l'Espagnolette :
Pour 2. branches de Mirthe qui sont entrelassées et percées à jour, a l'entour de l'Espagnolette, Chaque branche portant 9. pouces de longueur, sur 3. pouces de tour, bien cizelée et estimée à 130. livres C'est pour les 2 branches la Somme de 260 livres

Pour 2. vases de 3. pouces de longueur chacun sur lesquels il y a des feüilles d'eau, un cordon à Ruban et un tord de Laurier ; Chaque vase porté à la Somme de 36. livres C'est pour les deux vases Celle de 72 livres

Pour 6. Lacets décorés de feüilles sur les doucines et de cœurs entrelassés ; Chaque Lacet évalué à la Somme de 24. livres C'est pour les 6. Celle de 144 livres

Exécution de la poignée de l'espagnolette.
Pour Cizelure d'une branche de Mirthe, pour le devant et derrière de la Poignée, pour l'avoir limée et fait les graines des 2. côtés, avoir braité les Champs et avoir doublé le milieu d'une plaque d'acier bien polie et violette ; Les dittes 2. branches de Lys estimées ensemble à la Somme de 150 livres

Pour le bouton de la ditte Poignée, tourné, cizelé, évidé à jour avec Chapelets à l'entour dudit Bouton et 2. Rosettes ; le dedans doublé en acier bien poli et mis au violet ; Le dit Bouton évalué 96 livres

Total : 246 livres

Pour avoir moulé en Sable et fondû en Cuivre tous les ornemens de l'Espagnolette ; lesquels pezent ensemble 7. livres 4. onces à raison de 5 livres la Livre ; ce qui revient pour les dittes 7. livres 4. onces à la Somme de 36 livres

Pour l'ajustage et monture des bronzes posés sur l'Espagnolette, Celle de 100 livres

Pour avoir mis en violet la ditte Espagnolette portant 12. pieds 8. pouces à raison de 3. Livres Ce qui revient pour les dits 12. pieds 8. pouces à la Somme de 38 livres

Pour avoir doré tous les bronzes de la dite Espagnolette.
Sçavoir.
Les 6. lacets	à 30 livres	180 livres
Les 2. Branches de Mirte,	à 130 livres	260 livres
Les 2. Vases	à 36 livres	72 livres
La Poignée et le Bouton		150 livres

Toutes lesquelles pièces qui ont été bien dorées d'or moulu et mises en couleur matte, sont estimées ensemble à la somme de 662 livres

Plus, pour avoir fait en Cuivre 4. Boutons ovals avec leurs Rosettes, pour arrêter les volets : Chaque Bouton, avec sa Rosette, Cuivre, Cizelure et tournure compris estimé à la Somme de 3. livres Ce qui revient pour les 4. à Celle de 12 livres

Pour la dorure en or moulu de Chaque Bouton, la somme de 3. livres C'est pour les 4. Celle de 12 livres

Plus, pour avoir fait 4. fortes Poignées en Cuivre, avec leurs tiges en fer pour ouvrir les Jalousies ; Chaque Poignée estimée à la Somme de 12. livres Les 4. Reviennet à Celle de 48 livres

Plus, pour Desseins et Modèles d'un feu pour le Salon à Cul de four ; Lequel est évalué, y compris la (sic) bronze, Cizelure, monture et dorure en couleur matte en totalité à la Somme de 5 000 livres

Plus, pour avoir limé poli et doré d'or de feüilles 6 Crochets en fer, avec leurs pitons ; Chaque Crochet porté à la Somme de 40. Sols Ce qui revient pour les 6. à Celle de 12 livres

Plus pour avoir fourni 3 paires de flambeaux Cannelés, avec leurs pieds à Canneaux et ornemens ; Chaque Paire estimée, y compris Bronze, Cizelure et dorure à la Somme de 400. livres. Les 3. paires reviennent à Celle de 1 200 livres

Total : 16 807

Passage qui rend dans l'Anti-chambre des Garde-robes en marbre.
[...]

Anti-chambre des Garde-robes en Marbre.
[...]

Garde-robe en marbre.
[...]

Total 820 livres

Salle à manger.

Pour avoir fait un modèle de demi-Lustre à 4. bobèches, en avoir exécuté 4. en Bronze sur le même Modèle, avec tous les suports de Cristaux soudés en soudure forte et tarodés à visses avec Ecroux ; toutes les Carcasses bien montées ; Chacun de ces 4. demi-lustres estimé, y compris Modèles, Bronze, Monture, Limure, argenture, fourniture de

Cristaux et tous les frais de Coupure des dits Cristaux pour les demi-vases, pendeloques, autres pièces bien repolies et posage des Cristaux à la Somme de 350. livres Ce qui revient pour les 4. demi-lustres à Celle de 1 400 livres

Pour la Porte qui rend sur le Jardin, avoir décoré une serrure et un Palastre d'un Cadre Ceintré des 2. Bouts ; Le Cadre orné de platte-bandes unies, gorge formant l'Equerre et d'une doucine décorée de rez de cœur sur le pourtour de l'intérieur et de filets et Chapelets sur les 4. Angles ; Letout estimé, Bronze, Cizelure et monture avec Sujettion compris, en observant que cette monture sans qu'aucune visse soit apparente, à la Somme de 96 livres

Pour les 4 angles avoir cizelé quatre petites Branches de Mirthe, estimées en totalité à la Somme de 24 livres

Pour les 2. Boutons qui ouvrent la Serrure, pour Cizelure, tournure et plaque d'acier bien polie et mise au violet ; Chaque Bouton évalué à la somme de 30 livres Ce qui fait pour les deux Celle de 60 livres

Pour avoir doré d'or moulu le Cadre, les 4. Branches de Mirthe, les 2. Boutons ; toute la dorure des dits ornemens portée ensemble à la Somme de 72 livres

Pour avoir fait 2. forts Boutons ronds, au dehors dela ditte Porte, Chaque Bouton, y compris Bronze, Cizelure et tournure estimé à la Somme de 15. livres 30 livres

Plus la dorure en or moulu de couleur ordinaire, Celle de 30 livres

Pour 2. moyens Boutons à fleurs de Soleil pour lever les Basses-cules, pour la tournure avec un Champ braité au tour et bien Cizelé, avoir ajusté dessous le Soleil une plaque d'acier bien polie et mise au Violet ; Chaque Bouton estimé à la Somme de 18. livres fait pour les deux Celle de 36 livres

Pour la dorure de Chaque Bouton en or moulu et couleur matte la Somme de 18. Livres Ce qui revient pour les deux à Celle de 36 livres

Pour quatorze nœuds de Rubans qui servent de coulisses aux Basses-cules ; Chaque nœud, y compris fonte, Cizelure et monture évalué à la Somme de 6. livres Les 14. reviennent à Celle de 84 livres

Pour la dorure en or moulu de couleur ordinaire de chaque nœud la Somme de 6. livres ce qui fait pour les 14. Celle de 84 livres

Pour la Porte du Salon, avoir fait 2. Boutons ronds avec leurs Rosettes, à fleurs de Soleil et Chapelets ; Lesquels sont à plattes-bandes braittées

et décorées d'ornemens ; Chaque Bouton estimé avec ses garnitures, Bronze, Cizelure, tournure et monture compris à la Somme de 36. Livres Ce qui fait pour ces 2. Boutons Celle de 72 livres

Pour avoir limé, poli et doré d'or de feüilles 2. Crochets en fer avec leurs pitons ; Chacun porte a la Somme de 3. livres. Les deux font Celle de 6 livres

Pour avoir fait 2. fortes Poignées ovales pour les deux fausses-portes ; Chaque Poignée estimée, Bronze, Cizelure, plaque et monture compris à la Somme de 15. livres Les deux reviennent à Celle de 30 livres

Pour la dorure en or moulu et couleur mate de chaque poignée, la somme de 15 livres, fait pour les deux celle de 30 livres

Plus pour avoir doré en or moulu deux Ventouses ; chacune à raison de 6. livres, C'est pour les deux la Somme de 12 livres

Pour avoir fourni 12 fortes Bobèches pour placer sur les Cornes d'abondance ; Chaque Bobèche évaluée, bronze et dorure compris à la Somme de 3. livres Ce qui revient pour les 12. à Celle de 36 livres

Total : 2 138 livres

<u>Vestibule qui rend dans la Salle à Manger.</u>
[...]
Total 869 livres

Suplement.

Pour les anciens appartemens du Château, avoir fourni une paire de bras composés de trois branches de Lys, autres fleurs et nœuds de Ruban ; deux des dittes branches de Lys servant de bobèches, estimée en totalité y compris bronze Cizelure, monture et dorure en or mat à la Somme de 2 500 livres

Pour la Salle à manger, avoir fourni un feu à enfans, estimé, y compris les fers à Celle de 600 livres

Pour 2. garnitures de fortes pelles, pincettes et tenailles, garnies de leurs boutons en bronze, Cizelées et dorées d'or moulu ; Chaque garniture évaluée à la Somme de 96. livres Les 2. Reviennet à Celle de 192 livres

Total : 3 292 livres

<u>Dépenses et frais extraordinaires.</u>
[...]
Total 2 160 livres

<u>Récapitulation Générale des objets contenus au Présent Mémoire.</u>
[...]
Montant du Présent Mémoire 134 218 livres (Réduit à 99 298 livres)

1773, December 31 (2). *Ouvrages de Modèles et Orfèvreries, que Gouthière Cizeleur et Doreur des menus Plaisirs du Roy, a fait faire pour le service de Madame la Comtesse du Barry* (Bibliothèque Centrale, Versailles, MS 240 F; Baulez 1986, 631-33).

Sçavoir.
Pour les modèles en bois pour la Bordure d'un Miroir, avoir fait des moulures ceintrées sur les 4. parties et décorées d'une doucine en dedans, faisant le tour de la Glace et sur l'angle au dehors une baguette tout à l'entour, payé au Menuisier pour les bois la somme de 50. Cy 50 livres

Pour avoir fait mouler en sable les dits modèles, les avoir fondus en Cuivre, ensuite les avoir réparés et mis d'épaisseur, avoir pris des Chapelets et fils apparens tout à l'entour de la Bordure ; laquelle porte 4. pieds et demi de tour, et sur la doucine 4. pieds de rez de cœur ; les dits Modèles estimés à celle de 260. livres Cy 260 livres

Pour les 2. Bordures pezant ensemble 8 marcs 3. onces 4. gros à 52. le Marc, fait 438. Cy 438 livres

Pour le Contrôle des 2. Cadres 35. livres Cy 35 livres

Façon pour le fondre à raison de 4. par marc ; C'est pour les dits 8. marcs, 3. onces 4. Gros 33 livres Cy 33 livres

Pour la Cizelure de Chaque Miroir à raison de 200. livres c'est pour les deux 400. livres Cy 400 livres

Pour façon de la monture et polissage évalué par chaque Cadre à 120. livres y compris les charnières et Rosettes ; Les deux reviennent à 240. Cy 240 livres

Payé 36. au Garnisseur pour les chevalets et plaques garnies de moire cy 36 livres

Pour la dorure des dits 8. marcs, 3. onces 4. gros, à 50. livres du marc fait 425. livres Cy 425 livres

Pour un Etui couvert en maroquin rouge doré et décoré des armes de Madame ; les garnitures en Cuivre sont doublées en chamois rouge, payé pour ce 60. livres cy 60 livres

Pour la dorure en or moulu 18 livres

Plus pour une garniture composée de 3. pièces en marbre blanc, garnie d'argent et dorée d'or moulu : L'une des pièces du milieu est un autel décoré d'un bout de colonne, de marches et d'un Vase ; Cet autel est orné de 2. figures de femmes, de 2. guirlandes de fleurs 2. têtes de Bouc, de tords en ornemens à l'entour du Vase au pied d'ouche est une Cuvette, à la colonne, une doucine en ornemens tigette et une corde. Les deux autres pièces sont 2. urnes dont l'une représente le vin et l'autre l'eau ; elles sont ornées de 2. figures, dont l'une est un Satire et l'autre une Nayade, décorées de guirlandes de vignes et d'huîtres et le bec orné de feüilles d'ornemens de deux têtes de Bouc, de deux gargoüilles, de 2. Cercles à feüilles d'acanthe, 2 tords ornés de laurier, 2. Cercles en entrelas, et 2. socs quarrés ; Les dittes 3. pièces, y compris argent, dorure, Cizelure et monture, évalués en totalité à la Somme de 5000. livres Cy 5 000 livres

Plus pour les frais de deux groupes pour les girandoles que j'ai fait modeler par M. Boisseau auquel j'ai payé pour ses modèles et esquisses en terre, la Somme de 1500. livres Cy 1 500 livres

Plus payé 150 livres au mouleur en plâtre pour avoir monté à bouts creux et durci les moules et avoir jetté 2. talques cy 150 livres

Plus payé 200. livres au dit Mouleur pour avoir jetté 4. groupes avec tous les accessoires en Cire tirée d'épaisseur, avec les noyaux et portées pour faire les moules en Sable, pour fondre les argents ; toutes ces pièces sont très Sujettes et demandent beaucoup d'attention et de tems, à raison de 50. livres par chaque groupe ; Les 4. reviennent à la Somme ci dessus de 200. livres cy 200 livres

Plus 20. Livres de Cire neuve à 40. sols la livre, fait 40. livres Cy 40 livres

Payé 300. livres à M. Boisseau pour le réparage [reparure] des Cires pour les 4. groupes, ce qui fait 8. figures sans les accessoires, à raison de 75. livres par chaque groupe ; Ce qui revient pour les quatre à la somme première de 300. livres Cy 300 livres

Payé à Mrs. Feuillet et Métivier, pour les 2. groupes que j'ai fait porter à Versailles. Ces Messieurs ont composé les 2. pieds d'estaux, taillé les ornemens et les fleurs qui sont sur les pieds et ont réparé les fleurs des 2. groupes ; ce qui leur a demandé beaucoup de soin et employé beaucoup de tems ; ils ont aussi Composé et modelé la Corbeille de fleurs, en totalité la Somme de 660. livres Cy 660 livres

Payé à M. Boisseau pour le montage et le réparage des dits 2. Groupes Celle de 72. livres 72 livres

Payé pour un moule et deux biscuits de Corbeille 24. livres Cy 24 livres

Payé à compte à M. Bairai fondeur 200. livres sur 315. livres qu'il demande, pour les moules en Sable qu'il a faits pour fondre les figures en argent : Ces moules ne sont point détruits, on peut les voir, en se transportant dans ses ateliers, parce qu'il n'est pas possible de les transporter cy 315 livres

Pour un voyage fait à Choisy avec M. Boisseau pour porter les terres et les faire voir à Madame, dépenses et voitures 18 livres

Pour frais du Brancard 12 livres

Pour avoir porter les 3. groupes à Versailles, employé 4. ouvriers qui sont partis la nuit et ne sont revenus que le lendemain au soir ; parce qu'ils attendaient les ordres de Madame, sçavoir si elle décideroit qu'on les laissât à Versailles ou qu'on les fît remporter à Paris ; Ce qui a fait chacun 2. journées à 4. livres 32 livres

Pour mon voyage de Paris à Versailles 12. livres Cy 12 livres

Total : 10 331 livres

Autres fournitures frais de Raccommodages et autres Dépenses.
Avoir fourni un feu à Lion pour la Chambre à coucher de Madame, deprix convenu de 1 200. livres Cy 1200 livres

Pour un voyage de Brancart 12 livres

Pour avoir raccommodé des moulures à une table 15 livres

Réparations, et Reposage des Bronzes au Pavillon et les Violets rétablis à neuf.
Pour 70. pieds de moulures en gorge faites en Bronze pour placer derrière les garnitures de Basses-cules ; Chaque pied évalué à 55 sols, fait pour les dits 70. Pieds la somme de 192. livres Cy 192 livres

Pour l'argenture à 40. sols par pied, fait pour les dits 70. pieds 140 livres

Pour 20. pieds de platte-bandes d'un pouce de largeur pour la Cheminée du Salon oval ; Chaque pied à 45. sols, C'est pour les 20. pieds 45 livres
Pour l'argenture à 40. sols par pied 40 livres
Pour 12. bouts pour les Basses-cules à 40. sols la pièce fait 24. livres Cy
 24 livres
Pour l'argenture des 12. bouts à 30. sols 18 livres

Argenture de toutes les autres pièces du Salon oval.
Pour les 2. Vases des trépieds de la Cheminée, les Cercles des Bandeaux, les 2. tyrses, et les 2. Pieds d'estaux, pour le tout 72. livres Cy 72 livres

Pour les 4. doublures des Boutons, les doublures des plaques à Soleils, Suports à charnières et mains d'Espagnolette 24. livres Cy 24 livres

Argenture du Salon quarré.
Pour les 3. serrures à 12. livres pièce 36. livres cy 36 livres

Pour les doublures des Boutons et plaques à Soleil ; ce qui monte à 24. pièces ou environ à 30. sols chacune fait 36 livres

Pour une serrure pour la salle à manger 12 livres

Pour avoir mis au violet toutes les pièces ci-dessus détaillées ; ce qui à couté beaucoup de peines et occasionné beaucoup de dépenses, par raport aux différens essais qu'il a fallu faire et fait des fours exprès pour rendre un degré de chaleur égal, pour letout 550 livres

Avoir fait partir de Paris, le 13. Mai 1772. 4. ouvriers pour faire les réparations des Bronzes et netoyer les dorures : Ces 4. ouvriers ont travaillé jusqu'au 5. Juin Suivant ; Ce qui monte à 23. journées pour chaque ouvrier ; C'est pour les 4. ouvriers 92. journées qui a 3. livres par jour montent à la Somme de 276. livres Cy 276 livres

Plus le 17. may 1772. envoyé 2. ouvriers qui ont travaillé jusqu'au 6. Juin Suivant ; ce qui fait 20. journées chacun et 40. journées pour les deux, à raison de 4. livres par jour, montent à Celle de 160. livres Cy 160 livres

Pour 6. voyages que j'ai faits pendant la durée de ce travail, à 12. livres par voyage, fait 72. livres Cy 72 livres

Pour une once et demie d'or fin qu'on a employé à redorer plusieurs pièces qui avaient été cassées et qu'il a fallû ressouder, à raison de 101. livres l'once d'or de valeur intrinsèque ; Ce qui revient pour l'once et demie à la Somme de 151 livres

Pour eau forte, Mercure, eau Seconde et Brosses 30. livres Cy 30 livres

Pour avoir remis toutes les Espagnolettes en couleur d'eau, à 12. pieds 8. pouces de hauteur par Chaque Espagnolette ; Ce qui revient à 63. pieds 4. pouces pour les Cinq Espagnolettes, à raison de 3. livres par pied, montant en total à 190. livres 190 livres

Pour 4. Voyages de Brancards pour avoir fait transporter et raporter les Espagnolettes, Serrures et autres pièces, à raison de 12. livres par

Chaque Voyage ; C'est pour les 4. voyages 48. livres Cy 48 livres

Pour la couleur d'eau des Basses-cules dela Salle à manger, portant 24. pieds, à raison de 30. sols par pied ; Ce qui revient pour les dits 24. pieds à la Somme de 36. livres Cy 36 livres

Payé à M. Tussot Aubergiste pour nourriture d'ouvriers, suivant son mémoire, la Somme de 181. livres Cy 181 livres

Pour voyage à Versailles d'un ouvrier, pour prendre les feux de la Chambre à coucher de Madame, payé à cet ouvrier pour sa journée et le transport des feux 6. livres Cy 6 livres

Pour avoir fait netoyer les fers et avoir fait raccommoder à neuf toute la dorure, pour le tout 12. livres Cy 12 livres

Pour voyage à Versailles par le même ouvrier pour y reporter les dits feux réparés et raccommodés 6. livres Cy 6 livres

Du 9 7bre 1772.
Avoir mené avec moy 2. ouvriers pour netoyer les Bronzes, et être resté avec eux 2. jours à 12. livres par jour ; c'est pour mes deux journées 24. livres Cy 24 livres

Pour journées de ces deux ouvriers qui ne sont revenus à Paris que le 15. du même mois de 7.bre 1772. et qui en étoient partis le 9. Ce qui fait pour chacun 7. jours et pour les 2. ouvriers 14 jours à 4. livres par jour revient à 42. livres Cy 42 livres

Payé à M. Tunot Aubergiste pour nourriture23. livres Cy 23 livres

Total 14 006 livres Réduit à 13 200 livres

J'ai reçu de Madame la Comtesse Du Barry, la Somme de Treize mille deux cents livres, à laquelle Mrs. Roettiers Orfèvres du Roy, ont réglés le présent mémoire, Dont quittance à Versailles le Trente un Décembre mil sept cents soixante treize.
A Prouvé [Approuvé] L'écriture cy dessus. *Gouthière*

Bon pour quittance 13 200 livres

1776, August 13. *Mémoire de quatre Portes de Poële en Bronze, exécutées par Gouthière, Ciseleur et Doreur du Roy, pour Monsieur de Cremail [Cramayel], sur le Dessin de M. Le Doux, Architecte du Roy, fournies en février 1776* (sold at the Hôtel Drouot, Paris, on June 15, 1984; Baulez 1986, vol. 2, 609, nn. 100, 620)

Pour avoir fait les modèles en bois d'une porte, payé au menuisier 18 livres
Pour la fonte brute des 4 portes, la dite fonte pesant 78 livres ½ à 50 sols la livre, fait 196 livres

Exécution d'une porte :
Pour avoir limé tout le tour du chassis, avec un champ renfoncé et une baguette tout à l'entour, dont une partie de la baguette forme les 2 char- nières tant hautes que basses. Ces charnières faites avec sujétion, de même que la plaque ajustée sur le marbre, pour arrêter les portes ; le dit chassis évalué à la somme de 100 livres

Pour avoir limé le milieu de la mosaïque 48 livres
Pour ciselure de 49 rosettes à 40 soles chaque 98 livres
Pour 5 pieds 7 pouces d'entrelacs double posés dessus et dessous, limure et ciselure comprises 72 livres
Pour quatre feuilles d'angles à 3 livres chaque 12 livres
Pour la monture entière d'une porte 72 livres
Total d'une porte 402 livres

Pour l'exécution des trois autres portes au prix de 402 livres chaque
 1 206 livres

Pour la dorure des quatre portes, y compris le violet, à 300 livres ; les quatre reviennent 1 200 livres

 Total : 3 022 livres

1777, February 27–March 25. *Catalogue raisonné des Marbres, Jaspes, Agathes, Porcelaines anciennes : d'effets précieux d'anciens Laques … faisant partie du Cabinet de Feu M. Randon de Boisset, Receveur Général des Finances. Par C.F. Julliot*

850 : une moyenne paire de bras à deux branches portées par un Terme figure d'enfant ; ces bras sont parfaitement finis, dorés d'or mat par Gonthier.
Lebrun [probably the expert painter and merchant Jean-Baptiste-Pierre Le Brun] *440 livres*

1778, April 2. *Catalogue de Tableaux, Dessins, Sculptures en bronze, yvoire, marbre et Médailles, Pierres gravées, Porcelaine ancienne, de Saxe, de Séve, et Vases de cristal de Bohême, ancien et nouveau Laque, et autres Objets de curiosité ; provenans de la Succession de feu Madame la Marquise de Langeac*

194 (**cat. 20**). Quatre autres [flambeaux] : ceux-ci sont supérieurs pour le modèle, et ils ont été dorés par Goutiere. Haut. 12 pouces, 6 lignes.

1781. *Mémoire des Modèles en Bronze, Ciselure et Dorure de Porcelaine, faites pour le service de Madame la Duchesse de Mazarin sous les ordres et dessins de Monsieur Bélanger premier architecte de Monseigneur le Comte d'Artois par Gouthière ciseleur doreur du Roi en 1781* (Véron 1884, 39; and Baulez 1986, 633-38)

Pour avoir fait porter chez M. Moreau architecte du Roi, une partie de la cheminée de granit, pour en faire un dessin, avoir conduit de la part de M. Moreau un de ses commis aux ateliers du Sr. Guillemin pour prendre la mesure de la traverse qui restait à ses ateliers qui ne m'avait pas été livrée, en avoir fait faire un bois d'après le dessin de M. Moreau, pour ce, déboursé 36 livres

Madame la Duchesse n'ayant pu retirer ces granits des ateliers du Sr Guillemin, a été obligée d'opter et de prendre le parti d'ordonner à Mr. Bélanger de nouveaux dessins pour la cheminée et les piédestaux.
Modèles en terre et cire de la cheminée du grand salon (**cat. 35**) telle qu'elle est exécutée actuellement sur les dessins de Mr. Bélanger, savoir :
Pour avoir modelé à l'hôtel une terre de grandeur de l'exécution, tous les corps de la dite cheminée et tous les détails tels qu'ils sont exécutés en bronze, avoir fait monter la dite cheminée, en avoir fait jeter un plâtre, avoir fait une épure et fait faire un bois bien fait, sur lequel M. Foucou a modelé ses figures, lui avoir fait faire un montant avec tous les détails des moulures en bois et modelé en cire tous les ornements comme à une frise arabesque, couronne de vigne, frise en lierre et carquois, moulure de la tablette, les avoir moulés et tirés d'épaisseur, reparés prêts à donner au fondeur en cuivre, faits porter aux ateliers de M. Adam marbrier pour être exécutés en bleu turquin estimé tous les dits modèles tant en terre, bois, cire, moulages, peines et soins à la somme de 1 400 livres (les deux articles réglés à 1 200 livres).

Modèle en terre pour les piédestaux (**cat. 49**), savoir :
Pour avoir fait deux esquisses en terre d'un piédestal de la grandeur de l'exécution ; il est composé d'une demi-colonne avec des arrière-corps, le dessous de la tablette est orné d'une moulure a oves avec des oves liss- es, des fleurs ornements entre les plates-bandes avec un rang de perles au dessous, les angles faisant partie en avant et arrière-corps, sont avec des feuilles d'ornements ; au dessous est une frise avec des ornements antique très riches sur la partie circulaire et sur les arrière-corps ; au des- sous, une moulure unie dans toute sa longueur, tant dans les parties cir- culaires que les renfoncements et retours.
Pour avoir modelé quatre forte guirlandes de fleurs et faites avec 3 chute sur chaque piédestal nouées avec des rubans et au dessous un embase orné de bruits d'ornements, faisant partie circulaire, avant et ar- rière-corps sur la partie renfoncées des deux cotes ; avoir fait des ara- besques ornées d'une thyrse et pampre de vigne ; avoir moulée en plâtre les dits piédestaux, avoir jetée un plâtre, l'avoir réparée, l'avoir donnée

au menuisier avec une épure pour en faire des bois bien corrects pour modeler en cire toutes les moulures, ornements, données à M. Adam pour en faire de marbres, estimé chaque esquissée pour modelé en terre, creux et exécution de deux plâtres ... 240 livres

Pour avoir fait exécutée deux bois pour faire l'exécution des modèles en cire ; il a fallu modelé les deux parce que les piédestaux ne sont pas de même grandeur, les trumeaux d'entre les croisées se trouvent plus étroits, ce qui occasionne les doubles modèles, avoir fait faire tous les nus des moulures en bois tirés d'épaisseur, avoir modelé en cire toutes es vues, les fleurons entre les plates-bandes, toutes les feuilles sur les onglets et sur les parties renfoncées, ajustées d'onglets, la moulure au dessous de la frise ; fait toutes les cires de la frise, avoir modelée les six guirlandes de fleurs et fruits, les 6 chutes bien finies, prêtés a donner au mouleur pour fondre en cuivre, avoir modelé toute la partie de la base avec partie et contrepartie ; tous ces modèles ont employé beaucoup de temps ; les avoir moulés en partie, tirés des cire d'épaisseur, les avoir réparées prêt a donner au mouleur en cuivre, en avoir fait des étains d'un autre pour être ajustés sur les marbres avant la moulures des cuivres ; envoyé à M. Adam les piédestaux en bois pour exécuter les marbres ; estimé chaque modèle de piédestal la somme de 600 livres ... 1 200 livres (les deux articles réglés à 1 200 livres)

Esquisse en terre de trépied à 9 lumières sur les groupes des figures faites par M. Foucou, sculpteur du Roi :
Avoir fait l'épure donnée au menuisier pour en faire des bois dont deux pour être bien modelés sur deux groupes en plâtre pour servir en attendant l'exécution des marbres et des bronzes, avoir fait tourner les 5 vases qui faisaient le milieu des dits trépieds, savoir, deux pour ceux qui ont été employés au groupe, un pour envoyer à Sèvres, pour être fait en porcelaine, le quatrième pour servir à M. Lepaute horloger pour disposer ses mouvements; ce quatrième a été fait en 2 pièces tirées de même épaisseur que devaient être les porcelaines, le cinquième est resté dans mes ateliers pour exécuter les cuivres; il y a également 4 bois, deux pour les trépieds qui étaient au groupe, un par détail pour le fondeur, un quatrième pour rester dans mes ateliers pour l'exécution des bronzes; ces modèles ont été très multipliés parce qu'ils ont servi à l'hôtel, une esquisse bien arrêtée pour servir de guide au monteur, un quatrième pour donner au fondeur en cuivre; ce quatrième a été très détaillé pour la facilité du mouleur en cuivre; avoir fait toutes les armatures en laiton, dont deux ont été faites très solidement avec les bobèches unies montées à vis sur les branches pour faire les modèles en cire, avoir ajusté avec sujétion ces armatures sur les groupes de figures en plâtre, toutes les cires bien finies, ces deux trépieds ont été dorés en feuilles; estimé pour tous ces modèles, tant pour les esquisses en terre, les épures, modèles en bois, en cire, armature, tournure des vases et beaucoup de cire et de

temps employé à la somme de 1 000 livres 1 000

Modèle de la grande table de marbre bleu turquin (**cat. 39**) :
Pour avoir fait une esquisse en terre de la grandeur de l'exécution d'après un dessin de Mr. Chalgrin, architecte du Roy ; cette première esquisse n'a pas servi ... 36 livres
Une autre esquisse en grand très avancée faite en terre ; cette dernière a été acceptée ; avoir fait un bâti en bois, fait mouler en plâtre et jeter un plâtre, en avoir fait toutes les épures pour donner au menuisier pour faire correctement pour servir au marbrier, avoir fait tous les modèles en cire bien exécutés de cette table qui porte ... de longueur sur ... de largeur dans un plan cintré aux deux bouts ; la tablette est ornée d'une moulure en gorge en dessous taillée à canaux, tigettes, dards, plate-bande évidée à jour, avec avant et arrière-corps au dessus des pieds ; dessous cette moulure, est une autre baguette ornée de perles longues, culots d'ornements et piastres, le milieu de la traverse est une partie renfoncée dans laquelle sont deux thyrses avec des pampres en lierre entrelacés autour, évidés à jour faisant partie et contrepartie ; le milieu est terminé par une tête ; le bas de la traverse est orné d'une natte dans toute sa longueur ; les côtés dans la partie cintrée de chaque bout sont ornés d'un rond à jour, autour est une doucine à rais-de-cœur ; le milieu est orné du chiffre de Madame évité à jour ; dans les deux parties cintrées des côtés, sont deux frises en ranceaux d'ornements très riches, faisant partie et contrepartie avec des perles autour sur les quatre parties saillantes à la même travers ; au dessus des quatre chapiteaux des pieds, sont trois couronnes de chêne avec des trompettes en sautoir au milieu ; chaque pied carré est orné d'un chapiteau très riche ; dans chaque face, sont des panneaux renfoncés avec des arabesques dans toute leur hauteur avec une bordure de perles autour ; le bas se termine en culot de feuille, d'ornements avec une tigette montante sur chaque face et boule allongée au dessous, ce qui termine le pied, tous les dits modèles faits avec grand soin, tant en bois et cire, les avoir en partie montées à bon creux pour en tirer des cires d'épaisseur ; les avoir bien réparés prêts à donner au fondeur en cuivre ; avoir fait plusieurs parties en étain pour les ajuster sur les marbres, avant de les faire fondre en cuivre ; pour les dits modèles bien finis eu égard à la grande difficulté, estimée à ...
 1 000 livres (réglé à 720 livres)

Suite des modèles en terre et cire pour le Grand Salon
Pour ceux des bras, savoir,

Pour avoir fait plusieurs esquisses en terre, l'une composée de plusieurs branche de lys avec des branches de roses et d'œillets.
Une autre composée d'un vase avec des branches en ornement, d'autres avec deux enfants posant des fleurs dans un vase, une avec un carquois ornée de branche de pavots ; cette dernière a été acceptée (**cat. 22**) ;

avoir fait des armatures en laiton pour chaque esquisse, estimé pour les quatre … 120 livres (réglé à 320 livres)

Exécution du modèle de ce dernier :
Pour l'avoir modelé en cire, partie et contrepartie, détaillé chaque partie pour la facilité du fondeur en cuivre, avoir fait tourner en bois deux brandons, avoir modelé en cire tous les ornements qui le décorent, fait les armatures en laiton, pour les dits modèles, estimé pour le tout, cire comprise, la somme de 300 livres

Modèle d'un feu composé d'un aigle sur un piédestal oval (**cat. 26**) :
Pour avoir fait une esquisse en terre bien terminée, l'avoir moulée pour avoir un plâtre, avoir fait toutes les épurés ; donné au tourneur en bois un dessin pour faire deux pieds en bois pour modeler en terre et en cire les dits feux ; en avoir tourné un troisième tiré d'épaisseur pour donner au fondeur en cuivre ; modelé en cuivre tous les ornements du pied qui est d'une forme ovale allongée avec un avant-corps à chaque bout orné de couronnes de chênes et au dessus d'une rosace en feuilles d'eau ; la face sur l'ovale est ornée d'une frise ou rinceau d'ornements dans une partie renfoncée ; les dessus est une doucine ovale d'un carrée et d'une gorge lisse ; la doucine est ornée de feuilles à côtes tournantes, faisant partie et contrepartie ; le dessous du pied trois fortes boules dessous chaque partie saillante ; elles sont ornées de godrons sur le dit pied est une grand aigle ouvrant les ailes, tenant dans ses griffes un fort foudre et une salamandre ; chaque aigle fait partie et contre partie ; avoir moulé à bon creux chaque groupe, en avoir fait des plâtres bien réparés ; les avoir remontés sur leurs pieds pour servir de modèles pour l'exécution des bronzes, avoir jeté des cire d'épaisseur, les avoir réparées prêtés à donner au fondeur en cuivre ; estimé tous les dits modèles, la somme de 600 livres … (réglé à 500 livres)

Modèle du décor des espagnolettes :
Pour avoir modelé en cire un vase et son lacet carré et uni ; le vase est orné de feuilles de persil tournantes et d'une tigette entre chaque feuille ; le bout se termine en une baguette à rubans de feuilles d'eau ; le milieu est en deux parties avec des rais-de-coeur ; la poignée est à jour en forme de lyre ornée de feuilles d'ornements ; sur l'épaisseur de la dite poignée sont des parcelles de perles en dedans avec un brandon au milieu entouré de branches de myrte à jour, le bouton orné du chiffre de Madame évidé à jour avec des perles autour ; plus, le support à charnières de la dite poignée est évidé à jour avec des perles, ornements et cannelures ; le crochet à pattes est orné avec des feuilles d'eau ; le support pour le derrière des volets avec pannetons et agraffes à contour évidé à jour, orné de perles, feuilles d'ornements et d'un trophée avec des couronnes de myrte ; estimé pour tous les dits modèles ; tant en bois qu'en cire et cuivre, à la somme de 240 livres (réglé à 200 livres)

Modèles pour le Salon Arabesques Cheminée :
Pour avoir fait un modèle en terre de la cheminée composé de deux colonnes ornées d'un chapiteau de feuilles d'ornements, de rais-de-coeur, canaux et d'un tore lisse ; au milieu de la dite colonne sont deux cercles ornés de perles et rais-de-coeur et le milieu une frise antique, la base ornée d'un faisceau à ruban, d'une doucine en antique, la base ornée d'un faisceau à ruban, d'une doucine en feuilles de soleil et d'un carre lisse, la traverse décorée de 3 frises séparées de rosaces antiques et perles pour servir de bordure, la tablette est ornée d'une doucine unie dans tout son contour ; l'intérieur du dedans du chambranle est une moulure à oves faisant cadre.
Puis avoir moulé le dit modèle, en avoir jeté un plâtre, en avoir fait toutes les épures, fait faire un bois pour donner à Mr Adam marbrier pour exécuter les marbres, avoir fait tous les modèles en cire, fait tourner des bois d'épaisseur pour le chapiteau, base et socle carré ; un bois pour la moulure de la tablette, un autre bout de moulure pour les oves, estimé tous les dits modèles, tant pour celui en terre que ceux en bois et cire, à la somme de 300 livres (réglé à 180 livres)

Modèles des piédestaux :
Pour avoir modelé en terre un piédestal pour le trumeau d'une croisée, avoir modelé une demi-colonne avec des arrière-corps aux côtés ; avoir fait une forte moulure d'oves en pommes de pin, culots d'ornements et perles ; au dessous de la tablette, des guirlandes et chutes de fleurs nouées avec des rubans, des cannelures torses avec des chandelles et tigettes montantes en culots d'ornements et au bas, une forte doucine avec une baguette à ruban, et sur la doucine des feuilles d'eau et d'ornements ; avoir moulé le dit modèle, en avoir fait un plâtre, l'avoir reparé, fait toutes les épures en bois pour le marbrier, fait faire toutes les moulures en bois avec les cannelures pour modeler en cire, fait tous les modèles des guirlandes de fleurs en cire pour les deux piédestaux à l'effet de varier les fleurs sur chaque guirlande et chute, ce qui a donné un ouvrage très considérable ; modelé toutes les feuilles sur la moulure du bas et celle des oves pour le dessous de la tablette, tiré tous les dits modèles d'épaisseur ; en avoir reparé toutes les cires prêtes à donner au fondeur en cuivre, estimé la somme de 600 livres (réglé à 450 livres)

Esquisse et modèle d'un bras :
Pour avoir fait plusieurs esquisses en terre, l'une en ornement, faisant arabesque, une en lyre avec des branches de fleurs et une troisième en lyre avec des branches d'olive, en avoir fait le modèle en cire bien fini à quatre branches ; la lyre ornée d'une tête d'Apollon, de guirlandes de fleurs avec une écharpe, fait toutes les coupes nécessaires pour la facilité du mouleur en cuivre, avoir reparé toutes les cires prêtes à mouler en cuivre, estimé les dits modèles la somme de 150 livres (réglé à 150 livres)

Esquisse et modèle d'un feu :
Pour avoir fait une esquisse en petit pareille à celle du salon du château de Bagatelle, l'avoir modelée cire, fait la cassolette et le pied en bois tiré d'épaisseur, les deux sphinx, ornements en cire, comme la frise du milieu et des bouts, les pieds, trépieds et serpents, estimé tous les dits modèles 120 livres (réglé à 100 livres)

Pour une grande esquisse d'une girandole composée de deux enfants qui ornent un vase de plusieurs espèces de fleurs, dont les principales branches faisaient les branches pour porter les lumières, déboursé 70 livres (réglé à 70 livres)

Un autre modèle d'un lustre pour le même salon en grand pareil à celui de feu Monseigneur le Duc d'Aumont, estimé 96 livres (réglé à 96 livres)

Exécution en bronze des modèles détaillés ci-contre
Pour le Grand Salon

Pour la cheminée (**cat. 35**) :
Avoir fait une moulure pour la tablette ornée de godrons, dards et plate-bande avec des feuilles sur les angles de chaque avant-corps et arrière-corps au dessus des têtes des faunes.
Cette moulure porte 9 pieds de tour en comprenant tous les avant-corps et les retours 9 livres de développement.
Plus 8 pieds 4 pouces de moulure sur un pouce de développement pour le dessous de la même tablette; cette moulure en doucine faisant avant et arrière-corps est ornée de feuilles d'eau et d'ornements; les feuilles d'eau sont riflées pour être brunies.
Pour la traverse de la dite cheminée, 20 pieds de perles pour les cinq panneaux dont un grand au milieu, deux au dessus des têtes, 2 au bout; ces perles sont pour les cadres.
Plus, deux frises en arabesques pour chaque panneau des côtés de la dite traverse; ces arabesques sont composées de flèches, de branches de lierre nouées avec des rubans; elles portent chacune 11 pouces de longueur sur 2 pouces 1/2 de hauteur, le tout bien évidé à jour sur le marbre.
Plus, deux couronnes composées de branches de vigne entrelacées avec des grappes de raisin; ces couronnes sont posées dans les panneaux au devant du dessus de la tête de la figure; elles portent 5 pouces 1/2 de longueur sur 4 1/2 de hauteur.
Plus, pour le grand panneau de devant de la même traverse ornée de 17 fleurons d'ornement avec des perles au milieu; il porte 2 pouces 1/2 de hauteur sur 2 1/2 de large, 9 autres milieux composés en ecossats de pois, ornements et tigettes montants avec des grappes de graines, 9 autres milieux en palmettes d'ornements et feuilles d'eau et culots avec des graines au milieu.

Plus, pour la moulure à oves du grand cadre de l'intérieur de la cheminée, fait 42 fortes oves avec unies et 2 demies, toutes faites chacune séparément, deux dans les angles avec des feuilles d'ornement; le corps de cette moulure est bien riffé et les plates-bandes mattées; 42 fleurons et deux et demi en ornements rapportés à vis dans les parties renfoncées de cette moulure, 9 pouces de fortes perles posées à vis dans la gorge. cette moulure faisant cadre dans l'intérieur porte 2 pouces 1/2 de développement sur 10 pieds 2 pouces de longueur.
Plus, pour deux grands cadres pour les panneaux du côté des montants; chaque cadre porte 6 pieds de moulure à rais-de-coeur et ¾ de pied de développement.

Plus, pour les mêmes panneaux, deux arabesques composées d'une tête de satyre couronnée de lierre; au dessous sont des branches de lierre entrelacées dans lesquelles sont des trompettes et flutes, tambours de basque garnis de ses grelots et piastres, cymbales, sifflets de faune et cylindre; le tout noué avec une écharpe et des glands, branches de vigne au bas avec des grappes de raisin; ils portent chacun de hauteur (...) sur (...) de largeur.
Plus, pour la moulure qui est posée sur le bas du socle ou pose la figure; cette moulure à boudin est ornée de canaux, plates-bandes ciselées, culots d'ornements; elle est cintrée sur le devant de chaque socle faisant avant-corps de chaque côté avec des feuilles d'ornements dans chaque angle; chaque porte 2 pieds 2 pouces ce qui fait 4 pieds 4 pouces de longueur sur 3/4 de pouces de développement.
Plus, pour deux figures de femmes en faunes ornées d'une ceinture de feuilles de lierre avec des graines couronnées de pampres de vigne; une ceinture en bandoulière retroussant une draperie et portant un tambour de basque avec des grelots, des rubans aux pattes et grelots, les cheveux retroussés avec des nattes tombantes sur la gorge et les cheveux retroussés avec des nattes tombantes sur la gorge et les cheveux pendants par derrière; ces figures sont d'après les modèles de Mr Foucou et ont été bien ciselées et chairées en totalité; une porte une paire de cymbales au lieu d'un tambour de basque; elles sont posées sur un pilastre de 7 pouces dont les draperies le couvrent dans toute sa largeur, chaque figure porte 2 pieds 8 pouces de hauteur.
Pour, avoir ciselé, monté tous les dits bronzes détaillés ci-contre tous dépendant de la dite cheminée; le tout a été fait avec la plus grande sujétion et supérieurement fini à la satisfaction et sous la conduite de Mr Bélanger; tous les oves de la moulure et fleurons on été montés à vis, tous les autres bronzes sont posés sur les marbres sans aucune vis apparente; estimé la totalité des dits bronzes pour ciselure; et moulure la somme de huit mille livre 8,000 livres
 (réglé avec ci-dessous à 11,000 livres)

Plus, pour en avoir fait toutes les dorures au mat; les figures en deviennent très couteuses étant obligé de les surdorer pour réussir à les pouvoir bien mettre en couleur tant au rouge qu'au mat; faire des armatures en fer pour les pouvoir maneuvrer sur un feu très ardent; toutes ces précautions deviennent très couteuses eu égard a tous ces grands frais, le danger à craindre par l'évaporation du mercure, estimé pour la totalité des dites dorures, la somme de 6,000 livres

Pour 39 pezt. de bronze à 4 1ivres, la somme de	156 livres
Pour 35° à 3 livres	105 livres

Pour l'exécution des feux (**cat. 26**)
Pour avoir ciselé les aigles, les avoir montés, soudés, réparés, fait les foudres, tant la ciselure, riflure, les salamandres, les socles ovales finis proprement et bien avec des feuilles tournantes sur les doucines ; avoir bien limé les architectures des pieds, ciselé les frises, les quatre couronnes, tous les pieds au nombres de 12, les quatre rosettes de dessus les avant-corps, fait toutes les moulures avec la plus grande sujétion sans aucune vise apparente, l'avoir monté sur les fers, fait toutes les soudures et ragréures, le tout conformément aux modèles détaillés ci-contre, le tout fait d'après les cires ce qui devient très couteux, estimé le tout 3 600 livres 3 600 livres
Pour 18 livres 8 pouces de fonte à 3 l. 10° la livre 64 livres
Pour en avoir fait la dorure au mat bien surdorée, m'ayant été bien recommandée, estimé la somme de 2 500 livres 2 500 livres
(le tout réglé à 5 000 livres)

Exécution des bras à 4 branches à pavots (**cat. 22**) :
Pour avoir fait toute la ciselure d'une paire, chaque fleur bien finie, toutes très variées et exécutées d'après les cires ; toutes les branches bien riflées et les feuilles bien finies, bien variées, des entrelacs de branches d'olivier sur es carquois, les carquois très riches doublés en bleu, les bas ornés de feuilles de graines, les hauts, une moulure à godrons et dards au dessous des entrelacs et un bandeau orné de perles avec des anses ; les dessus est couronné de flèches avec des plumes ; le tout a été fait d'après les cires et conformes au modèle ci-dessus, en avoir fait toutes les moulures et ragreures, estimé la somme de 3, 240 livres
Pour en avoir fait toutes les dorures au mat et mis les fonds des brandons au bleu, estimé la somme de 3, 000 livres
Pour 21 litres de fonte à 4 livres 85 livres

Exécution d'un piédestal du côté du jardin (**cat. 49**) :
Pour avoir fait une forte moulure à oves pour le dessous de la tablette faisant le cintre avec les côtés en retour formant arrière-corps ; cette moulure a été bien finie ; tous les ornements en sont séparés pour la facilité de bien finir toutes les parties lisses, 23 oves unies, huit avec des feuilles d'ornements servant d'onglet ; chaque fleuron est également rapporté dans la gorge ; 6 pieds 8 pouces de perles également rapportées, cette moulure porte de tour, en comprenant les côtés, 6 pieds 9 pouces sur 2 pieds ½ de développement.

Plus, pour la frise au dessous, 23 fleurons d'ornements avec des graines et des spirales unies et graines dont 2 sont en onglet rentrant et 2 saillant ; ils portent chacun 2 po d'écartement sur 2 po ¾ de hauteur, 31 milieux en palmettes portant chacun 2 po ½ de hauteur sur 1 po ½ de largeur.

Plus, 6 pieds 8 pouces de moulure unie faisant l'astragale au dessous des fleurons et formant tous les contours du pied ; elle porte de développement un pied ½.
Plus, pour 2 cadres des panneaux de côté huit pieds 8 po de moulures à rais-de-cœur portant ¾ de pouce de développement dans le milieu de chaque panneau, une arabesque composée de branches de vigne avec des grappes de raisin et un thyrse au milieu ; il porte 1 pied 6 pouces de haut sur 5 pouces de large au milieu.

Plus, 5 fortes chutes de fleurs et fruits avec culots d'ornements à chaque bout et nœud de cuir et de corde noué avec un bout d'écharpe ; chacun porte un pied ; deux sont posés dans les angles et une au milieu ; deux autres chute très fortes également composées de fleurs et de fruits ; culots d'ornements, à chaque bout des nœuds de cuir, corde et écharpe ; elle porte chacune 2 po 4 pi de tour sur 7 po de développement au milieu.
Plus, un fort nœud de rubans au milieu faisant la jonction des guirlandes et chutes qui portent de face 14 po deux autres demi nœuds sur les côtés.
Plus, trois forts clous d'un po ½ de large orné d'un fleuron au milieu dans une partie lisse et concave avec une corde sur la partie plate.
Plus, une forte doucine faisant la base du pied ornée de 29 feuilles de persil et 33 feuilles d'eau dont 4 feuilles d'ornements font les deux angles saillants et deux rentrants ; toutes ces feuilles sont bien finies ; celles d'eau sont riflées ; elles portent 8 pi de tour en y comprenant les côtés et retours sur 4 po de développement.
Plus, pour une baguette à ruban bien évidée à jour avec des feuilles d'ornement sur les quatre angles rentrants et saillants ; elle est posée au dessous de la base dans une gorge lisse ; elle porte 6 pieds 8 pouces de longueur ; toutes les dites garnitures et ornements ont été bien ciselés d'après les modèles en cire détaillées à l'article des modèles ; ce qui a coûté considérablement dans la partie des fleurs et fruits ; toutes les moulures faites avec sujétion sans aucune vis apparente ; avoir percé tous les trous nécessaires dans les marbres ; estimé pour ciselure, moulure, soudures, repartagé, limure et posage, la somme de 8 500 livres

Plus, pour en avoir fait toutes les dorures au mat bien surdorées, eu égard à la force des guirlandes qui ont employé considérablement d'or, estimé la somme de 7 000 livres

Pour 78 l de fonte à 2 livres 234 livres

Pour avoir exécuté un deuxième piédestal pareil, dont il a fallu, également à celui ci-dessus détaillé, faire des modèles étant un peu au dessous, savoir le haut de la moulure à oves, les chutes et festons ; la moulure servant de base, estimé le premier piédestal à la somme de 15 734 livres, tout compris estimé le deuxième à 14 000 livres
 14 000 livres
 (réglé pour les deux 24 300 livres)

Exécution de tous les bronzes d'une grande table de bleu turquin suivant les modèles détaillés à leur article (**cat. 39**) :
Pour la traverse, une frise très riche ornée de branches de lierre tournantes, évidées à jour avec des thyrses au milieu et une tête coiffée de lierre faisant le milieu de la dite traverse, d'où partent de chaque côté des branches de lierre faisant partie et contrepartie dans la partie renfoncée de la dite traverse, ce qui fait un ouvrage très dispendieux.
Plus, pour les retours cintrés sur les côtés de la dite table faisant la continuation de la traverse, deux frises en arabesque faisant partie et contrepartie composées de rinceaux d'ornements avec des parties, faisant les encadrements autour de chaque arabesque ; le milieu de la même traverse est évidé á jour en rond et dans ce rond est posé le chiffre de Madame orné de branches de myrte sur un plan bombé avec un cadre de rais-de-cœur ; la deuxième traverse est également ornée ; plus quatre clés tenant à la même traverse, ornés chacun de deux couronnes de chêne avec des trompettes ; le dessous de cette traverse qui fait tout le contour de la table est ornée d'une natte double assemblée en onglet ; sous la table est une moulure en gorge avec des canaux et dards évidés à jour et tigette au milieu et au dessous une baguette à culots d'ornements, piastres et de perles.
Plus, 4 pieds de pareil marbre en gaine carrée ; chacun orné d'un chapiteau avec son tailloir ; quatre guirlandes de fleurs et fruits à chaque chapiteau avec un tore en feuilles de chêne au dessous ; sur chaque face du dit pied sont des ronds concaves ornés d'un cadre de perles et d'une rosette antique au milieu au-dessous dans les panneaux renfoncés ; sur les 4 faces sont ornés de cadres de perles et au milieu des arabesques dans toute la longueur de chaque panneau ; au dessous pour chaque pied quatre culots de 4 feuilles d'ornements montantes avec 4 tigettes à fleurs au milieu de chaque face.
Plus, 4 pieds ronds avec des canaux tournants ce qui finit tous les bronzes de la dite table, lesquels sont restés entre mes mains parce que la dorure n'en est pas achevée à cause du décès de Madame la Duchesse ; c'est pourquoi je suis autorisé à demander une indemnité de ces ouvrages qui sont très considérables, les marbres restant pour mon compte et qu'il me soit alloué pour ce une somme de 3 000 livres 3 000 livres
 (réglé à 2 000 livres)

Pour les bronzes de 4 espagnolettes :
Savoir·
Pour avoir fait une espagnolette, 5 embases très riches ornés comme elles sont détaillés à l'article des modèles; ces embases sont chacune montées à vis en 3 parties dont une forte au milieu pour monter le lacet carré portant sa vis montée sur le corps de la croisée et bien alesé dans toute leur longueur, chaque lacet porte (...) de longueur; plus 4 fortes poignées évidées à jour avec leurs boutons; le tout très riche plus 4 supports à charnières très riches, 4 autres pour le derrière des valets, estimé pour les bronzes d'une seule croisée 750 livres, ce qui revient pour les 4 à 3,000 livres
 (réglé à 2 400 livres)

Salon Arabesque
Pour l'exécution en bronze de la cheminée, savoir :
Une moulure unie en doucine pour le dessus de la tablette; elle porte de tour 9 pieds 6 pouces sur 8 lignes de développement faisant 2 parties cintrées au dessus des chapiteaux des colonnes.
Plus, deux forts chapiteaux portant chacun 5 pouces de hauteurs sur 18 de tour par haut et par bas 11 pouces, ce chapiteau est orné d'une doucine taillée en rais-de-cœur de 6 lignes, d'un carré au dessus; au dessous du rais-de-cœur une plate-bande unie de 5 lignes de hauteur et d'un filet au dessous une moulure en talon renversé ornée de feuilles d'ornements, de feuilles d'eau et d'une baguette unie; le dessous est décoré de 30 cannelures formant la cuillère bien divisée et pris sur pièce et 32 plate-bandes ciselées et, au dessous pour terminer le chapiteau, un tore uni.
Plus, au trois-quarts de chaque colonne, fait deux cercles ornés chacun d'un rang de perles prises sur pièce, d'une doucine ornée de rais-de-cœur et d'une plate-bande unie au milieu; ils portant chacun de tour 13 pouces sur 9 livres de haut; entre chaque cercle est un champ de marbre de 2 pouces 1/2 dans lequel sont posés des postes unies et rinceaux d'ornements avec des palmettes d'ornements et écossats de pois au nombre de 9.
Plus, pour les bases des dites colonnes sont composées d'un fort bouement orné de feuilles d'eau et d'une natte à plate-bande au dessus avec un socle carré dessous.
Plus, avoir orné la traverse, savoir, deux rosettes antiques pour chaque bout; elles portant chacune 2 pouces 1/2 de haut, 2 autres demi-rosettes pareilles pour chaque bout de la table saillante.
Plus, deux arabesques servant de frise composés de deux couronnes, l'une de myrtes et l' autre de roses, toutes deux entrelacées avec un brandon et un arc orné de perles, chaque frise porte 8 pouces de longueur sur 2 de hauteur.
Plus, pour la frise pour le milieu de la table saillante est composé d'une tête en soleil dans un rond bombé et sablé avec une platebande unie avec des perles prises sur pièce et un sphinx de chaque côté dont les queues se terminent de chaque côté en rinceaux d'ornements; cette frise porte 13 pouces de longueur sur 2 pouces 4 livres de haut.

Plus, pour 6 pieds 8 pouces de perles pour les cadres des 3 panneaux.
Plus, pour le cadre de l'intérieur de la dite cheminée, une moulure à oves unies ornée de plate-bandes avec des fleurons d'ornements entre; elle porte de tour 8 pieds 7 pouces sur 13 lignes de développement; tous les dits bronzes bien ciselés d'après les modèles montés sur les marbres sans aucune vis apparente, avoir percé tous les trous sur les marbres, estimé pour ciselure, monture, limure et soudure, la somme de 2 600 livres
Pour 33 livres de fonte à 3 livres, fait 99 livres 99 livres
Pour en avoir fait toute la dorure au mat, estimé 1 500 livres
(le tout réglé à 3 500 livres)

Une paire de bras à 4 branches composés d'une lyre ornée d'une tête d'Apollon de 4 branches de laurier et d'une écharpe :
Avoir exécuté d'après les cires comme il est expliqué à l'article des modèles; le milieu de la lyre est garni de corde posée sur une plaque bleue, le tout bien exécuté; estimé pour bronze, ciselure, moulure et dorure au mat la somme de 2 600 livres (réglé à 2 300 livres)

Plus, pour avoir exécuté un petit feu à sphinx d'après les cires comme il est détaillé à l'article des modèles; ce feu est exécuté en bronze; n'a pas été doré et est resté entre mes mains; en le gardant j'évalue l'indemnité à 300 livres (réglé à 200 livres)

Exécution des bronzes des deux piédestaux de marbre blanc d'entre les croisées :
Savoir:
Pour avoir fait et ciselé une forte moulure à oves en pommes de pin rapportée à vis dans les parties renfoncées de moulure et entre chaque ove de fleurons d'ornements également rapportes à vis dans la gorge des perles; le tout monté sur le nu de la moulure bien limée et ciselée sur chaque plate-bande avec des feuilles d'ornements sur les angles rentrants et saillants faisant avant et arrière-corps; cette moulure placée sous la tablette porte de tour 3 pieds 2 pouces en comprenant les arrière-corps et le tour de la colonne.
Plus, au dessous dans une gorge du même pied, une moulure ronde ornée de feuilles de persil, faisant partie et contrepartie, tournantes autour d'une baguette unie sur laquelle chaque feuille est rapportée à vis et isolée à jour de dessus la baguette, cette moulure devenant très couteuse pour la ciselure et monture.
Plus, pour la ciselure de quatre chutes de fleurs et trois guirlandes toutes ciselées, d'après les cires avec leurs rubans; ces guirlandes et chutes ont employé beaucoup de temps pour l'ébauche, la riflure et la ciselure.
Plus, pour 26 cannelures torses de 11 pouces avec leurs chandelles et tigettes rapportées à vis dans chaque cannelure.
Plus, pour une forte doucine servant de base ornée de feuilles de persil et feuilles d'eau unies et d'un ruban tournant évidé à jour dans la gorge ;

cette moulure a été ciselée d'après les cires ; ce qui a employé beaucoup de temps ; estimé pour ciselure, monture, limure et riflure d'un seul pied 6 800 livres
Pour l'exécution du 2ième pied 6 000 livres
Pour une partie des dorures faites sur les deux pieds 8 000 livres
Pour le poids des bronzes 150 livres

20 950 livres

Comme ces ouvrages sont entre mes mains et qu'ils ne sont d'aucune valeur ayant été montés sur les marbres qui sont restés à l'hôtel comme immeubles, je demande qu'il me soir permis de les livrer moyennant le prix ci-dessus ou bien que les marbres me soient remis pour indemnité avec 2 400 livres par chaque pied ce qui ferait pour les deux pieds 4 800 livres (réglé à 3,400 livres)
[a les marbres ne seront point remis]

Plus, pour les appartements du rez-de-chaussée de l'aile donnant sur le jardin, savoir:

Salle des bains
Deux forts boutons ronds pour les poignées des espagnolettes ornés d'une doucine taillée de rais-de-cœur et d'une rosette tournante en feuilles d'ornements au milieu ; pour chaque bouton, ciselure, tournure, bronze et dorure d'or moulu estimé 18 livres pour les deux 36 livres

Pour la dorure de 4 petites tringles en fer de chacune d'un pied 9 pouces ce qui fait pour les quatre 6 pieds 4 pouces à 3 livres 19 livres
Huit pitons à 2 s 18 s

Première antichambre :
Un pareil bouton à la poignée de l'espagnolette, estimé 18 livres
Deux tringles dorées en fer et quatre pitons 9 livres 18

Seconde antichambre :
Un pareil bouton à la poignée de l'espagnolette 18 livres

Grand Salon :
Trois pareil boutons pour les poignées de l'espagnolette à 18 livres 54 livres
Plus 6 petites tringles en fer pour les petits rideaux de chacune 2 pieds faits 12 pieds à 3 livres 36 livres
Douze pitons à 2 s 16 s

Chambre à coucher :
Deux boutons aux poignées d'espagnolettes à 10 livres pièces 30 livres
Quatre tringles de 2 pieds chaque, font huit pieds à 3 livres 24 livres
Huit pitons à 2 s 16 s

Boudoir donnant sur la cour :
Un bouton de l'espagnolette 18 livres
Deux tringles de deux pieds 12 livres
Quatre pitons à 2 s 8 s
Plus 4 poignées pour les serrures des quatre portes des angles à 15 livres
 50 livres
 Total : 83 235 livres
 (ramené à 66 235 livres)

Nous soussignés Martincourt et Raimond [Rémond] tous deux ciseleurs et doreurs experts nommés pour vérifier, priser, et estimer les ouvrages et fournitures de bronze, ciselure et dorure faits par le sieur Gouthière aussi ciseleur et doreur pour feu Madame la duchesse de Mazarin et le mémoire d'iceux fourni par le sieur Gouthière aux créanciers de la D. Dsse de Mazarin la nomination d'experts iceux faits savoir, de moi Martincourt pour la direction Mazarin par la délibération des sieurs créanciers … , et de moi Raimond pour la direction des créanciers Gouthière par la délibération des dits créanciers Gouthière ….

Après avoir vu et vérifié tous les dits ouvrages de bronze et dorures portés audit mémoire, pour l'effet de laquelle vérification nous nous sommes transportés, tant dans ledit hôtel qu'occupait Mme la Dsse de Mazarin lors de son décès, situé quai des Théatins, que dans les différents endroits ou se sont trouvés ceux des dits ouvrages qui avaient été vendus lors de la vente qui a suivi le décès de la Dme Desse de Mazarin. Comme aussi après avoir vu et vérifié tous les artistes du dit mémoire fourni par ledit sieur Gouthière, contenant vint quatre pages … Avoir prisé et estimé en notre âme et conscience tous ledits ouvrages à la somme de soixante six mille deux cents quatre vingt onze livres six sols,
Fait par nous experts susdits en vertu des pouvoirs sus donnés à Paris ce deux décembre mil sept cents quatre-vingt neuf.
François Rémond
Martincourt

1781, February 14. *Catalogue d'une Belle Collection de Tableaux, des Trois Écoles ; Bronzes, Marbres, Porcelaines anciennes, beaux Meubles de Boule [...] qui composent le Cabinet de M. l'Abbé Leblanc, Historiographe des Bâtiments du Roi. Par J.B Le Brun*
77. Un très beau Vase de Serpentin, d'espèce rare et richement monté par Gouttier. On y voit deux enfants tenant une chûte de Guirlandes qui retombent en traversant le devant du vase. Il est posé sur un socle de

bronze doré d'or mat. Hauteur totale 14 pouce.
Le Brun *000 livres*
[who sold it to the Duchess of Mazarin. See 1781: December 10-15, lot 2].

1781, May 15. *Inventaire après le décès de Madame La duchesse de Mazarin* (AN, M.C.N., XXIII 778)

Dans le petit salon en arabesque
157. Item. une paire de bras de Gouttière en forme de l'arc prisée trois cents livres 300

Dans la Grande Galerie
160 (**cat. 35**). item les bronzes de la cheminée de la galerie par Gouttière une partie démontée et une partie montée à vis … 1500

161 (**cat. 26**). Item une paire de feux de cheminée représentant des aigles, les tenailles, pelles et pincettes faits par Gouttière… 1000

162 (**cat. 49**). Item. Deux socles de marbre gris veiné formant Entre deux de croisée de la gallerie, ornés de bronzes très riches montés à vis … 2000

163 (**cat. 22**). Item. Deux bras de cheminée à fleurs de pavot faits par Gouttière… 500

Dans le Garde Meuble
Objets présentés par Sr Leveillé doreur
277. Item. Un vase de serpentine monté par Gouttière orné de deux enfans de bronze … 500

Objets représentés par M. Dumon [Dumont] serrurier
279. Item. Un feu à cassolette de bronze doré par Gouttière … 400

1781, December 10-15. *Catalogue Raisonné des Marbres, Jaspes, Agates, Porcelaines anciennes, Laques, beaux Meubles, lustres, Feux & Bras de Bronze doré par Gouttier [...] formant le Cabinet de Madame la duchesse de Mazarin. Par J.B. Le Brun*

2. Un très beau Vase de Serpentin d'espèce rare et richement monté par Gouttier. On y voit deux enfants tenant une chûte de guirlandes, qui retombe en traversant le devant du vase. Il est posé sur un socle de bronze doré d'or mat, hauteur totale 14 pouces.
Le Brun [who sold it to Jean-Louis Lebeuf] *1 220 livres*

281 (**cat 35**). Une garniture de Cheminée, composée de deux Bacchantes,

les mains croisées sur la tête et supportant l'avant-corps ; elles sont ceintes de feuilles de vignes et de draperie, avec cymbales et tambours de basque. Hauteur 32 pouces et demi ; le renfoncement offre une grande moulure à oves, et enfilage de pois d'un pouce et demi de profil sur 118 pouces de pourtour ; le devant de l'appui garni d'une grande frise richement ornée de 3 pouces de haut sur 57 de long ; au deux bouts de la frise sont deux ceps de vigne avec grappe de raisin de 3 pouces de haut sur 6 pouces de long ; deux autres ornements de feuilles d'eau et godrons font le pourtour de la tablette ; les socles des cariatides sont enrichis de réseaux ornés ; les retours ornés de deux longues frises, représentant différents attributs : le tout est doré d'or mat, par Gouttier.
Legué

282. La garniture d'une Cheminée de bronze, consistant en deux colonnes en avant-corps, des faces de trois frises, dont une à tête de soleil, rosasse et demi-rosasse, avec moulures à ores et carderon de bronze dorés d'or mat par Gouttier.
Legué

283 (**cat. 49**). Deux piédestaux de forme circulaire, avec arrière-corps, tablette et plinthe de marbre bleu turquin. Hauteur totale 38 pouces. Largeur 48. Les ornements en bronze de ces piédestaux sont composés d'une grande ove et pois au dessous de la tablette, d'une large frise et de carderons de 5 pouces de profil ; sur la partie circulaire se détachent de grandes guirlandes de fruits avec trois chûtes attachées par des boutons de rosasse noués de rubans : on y voit encore deux panneaux où des pampres de vigne, des grappes et des ceps entrelacés forment la frise, au bas est une large moulure en feuille d'eau et enlas de ruban de trois pouces et demi. Ces ornements sont dorés d'or mat par Gouttier.
Legué

284 (**cat. 26**). Un très beau Feu représentant un Aigle les ailes déployées, tenant dans une de ses serres un dragon ou salamandre qu'il terrasse, et dans l'autre le foudre de Jupiter ; il est posé sur un socle ovale à grandes feuilles d'eau et ornements de ficelle avec une base dont le milieu est de forme circulaire à renfoncement bleu, sur lequel se détache une frise à rinceaux d'ornements ; les deux arrière-corps de forme carrée sont décorés de guirlandes avec chiffres dessus et rosasse sur les côtés, chacun posé sur huit pieds à cannelures de bronze doré d'or mat par Gouttier. Hauteur 16 pouces. Largeur 16 pouces 6 lignes.
Legué

285. Un feu à Vases, ou Trépied, orné de têtes sur le devant, et terminé par quatre consoles posées sur une base carrée, avec renfoncement et médaillon de feuilles de vigne, sur fond bleu ; le milieu garni de deux flambeaux d'amour, se détachant sur fond bleu ; on y remarque encore des fûts de colonnes cannelées, surmontés d'une pomme de pin, le tout doré d'or mat

par Gouttier. (Il n'y a ni garniture de fer, ni pelle, ni pincette). Hauteur 14 pouces. Largeur 13 pouces. Sous cage de verre. *1 090 livres*

291 (**cat. 22**). Une paire de Bras à cinq branches formés de fleurs de pavots sortant de deux tiges nouées sur un brandon d'Amours, armés de ses flèches avec frise d'entrelacs et branchages de laurier détachés, sur fond bleu et ornés d'une gorge, cercles et culots chargés de différents ornements dorés d'or mat, par Gouttier. Hauteur totale 29 pouces. Largeur 18 pouces.

292. Une paire de Bras à quatre Bobèches, entourée de deux branches de laurier, nouées d'un ruban au-dessous d'une lyre, et surmontée d'un masque de soleil attaché d'une autre touffe de rubans. Largeur 12 pouces. Le tout doré d'or mat par Gouttier. *800 livres*

1782, May 1. *Inventaire fait après le décès de Monseigneur le Duc d'Aumont, Pair de France, commencé le 1ᵉʳ mai 1782* (AN, M.C.N., XXIII 783)

584 (**cat. 8**) : Deux vases en porphyre rouge évidés forme Médicis sur piédouches et plinthes de même marbre et socle quarré ouvragé en bronze doré d'or mat. Estimés 1 000 livres

593 (**cat. 10 and 43**): Deux colonnes de marbre vert antique de sept pieds sept pouce de haut d'ordre composite, chapiteaux à feuilles déreliées fleurons et tors en bronze doré d'or mat sur socle de marbre serpentin surmontées de deux vases d'albatre oriental couvert sur deux piédouches ornés de bronze doré d'or mat aux socles d'oves antique Estimées 4 000 livres

594 (**cat. 42**) : Une colonne de porphyre rouge de six pieds de proportion avec son chapiteau d'ordre corinthien Tors à feuilles de laurier et plinthe le tout en bronze doré d'or mat sur socles plaqués de marbre Brocatelle d'Espagne surmontée d'une boulle milliere en marbre serpentin sur son piédouche et socle de porphyre Estimée 1 500 livres

595 : Une colonne de marbre jaune antique de même proportion et ordre que la précédente au chapiteau en bois sculpté doré torée et plinthe en bronze doré sur socle aussi plaqué de Brocatelle surmontée d'une boulle milliere d'albatre Estimée 600 livres

596 (**cat. 45**) : Une colonne en marbre africain de six pieds de proportion avec chapiteau composé, torée à feuilles de laurier en bronze doré d'or mat sur socle de porphyre rouge Estimée 1 000 livres

598 (**cat. 46**) : Deux fûts de colonne de marbre granit gris de trois pieds de haut sur plinthe de même matière, garnis de tors et autres ornements

dans le goût arabesque en bronze doré d'or mat Estimées 1 200 livres

600 (**cat. 47**) : Deux fûts de colonne cannelée de marbre bleu grec de cinq pieds quatre pouces de haut ornés de bronze doré d'or mat sur socle de marbre Granitelle Estimés 800 livres

602 : Deux moyen fûts de colonne cannellée de marbre granitelle de deux pieds quatre pouces et demi ornés de bronze doré d'or mat avec socle de marbre vert de mer Estimés 500 livres

603 (**cat. 12**) : un vase couvert de marbre serpentin de forme ronde orné de bronze doré d'or mat dans le genre arabesque, sur son pied douche de même matière. Estimé 650 livres

604 (**cat. 11**) : un vase de marbre serpentin couvert, orné de figures de femme satyres et autres accessoires en bronze doré d'or mat sur son pied douche de même matière. Estimé 1000 livres.

606 (**cat. 9**) : Deux vases couverts forme de cassolette, de marbre de porphyre noir supportés par trois consoles et autres ornements en bronze doré mat sur une plinthe de jaspe vert, aussi ornée de bronze doré mat Estimés 1 600 livres

609 : Un vase couvert de jaspe universel à pands [à pans] garnis de bronze doré sur un fut de colonne d'agathe aussi garni en bronze doré Estimé 360 livres

610 (**cat. 13**) : Un vase de jaspe rouge agatifié formant cassolette garni de riches [?] consoles à tete de faune et autres ornements ouvragés en bronze doré d'or mat sur plinthe ronde de même jaspe et socle de marbre serpentin Estimé 1500 livres

611 (**cat. 38**) : Deux tables de porphyre à gorge de trois pieds de long sur vingt un pour six lignes de profondeur épaisseur de dix sept lignes, ornées de baguettes dans la gorge à entablement de porphyre et ornements ouvragés supportées par quatre pieds à gaine aussi de porphyre aux chapiteaux à tete de femme, termes adossées dans le style égyptien ornées en bronze doré d'or mat comme l'entablement
 Estimées 6 000 livres

628 (**cat. 14**) : deux cassolettes à côtes couvertes, à côtes, dessins à dragons et bouquets garnies de boutons, gorges ouvrages à jours, trépied à tête d'enfans forme de console sur pieds à avant-corps en bronze doré d'or mat, sur socle de porphyre aussi garni de bronze doré d'or mat Estimé 900 livres

768 (**cat. 23**) : Un petit lustre à six branches soutenu par des chaines et

autres ornements dans le gout chinois le tout en bronze doré d'or mat avec guirlandes de perles Estimé 480 livres

770 : Trois lanternes dont deux garnies de cordes guirlandes et cercles de perles en bronze doré d'or mat et de quatre panneaux de verre blanc et chapiteau, l'autre de forme ronde et verre bombé d'un seul morceau pareillement garni en bronze doré d'or mat Estimées sur l'ensemble 780 livres

771 : Deux paires de bras composés de figures de femmes termes drappées dans le stile égyptien, terminées en console avec guirlandes et branches de rose le tout en bronze doré d'or mat Estimées 2 000 livres

772 : Une paire de bras à deux branches composées d'une figure d'enfant terme sur consoles à guirlandes et fleuron en bronze doré d'or mat Estimée 200 livres

780 : Une pendule mouvement par Ferdinand Berthoud renfermé dans la boiserie du petit salon Estimée 400 livres

1782, November 16 (1). *Procès-verbal d'estimation dressé par François Rémond, maître fondeur, ciseleur et doreur, des ouvrages de dorure et ciselure exécutés par Pierre Gouthière, doreur, ciseleur du roi, pour feu Louis-Marie d'Aumont; duc et pair de France, ouvrages dont ledit expert estime la valeur à la somme de 102,175 livres.* (AN, Y 1905 ; Wildenstein 1921, 121-128)

Je, soussigné, François Rémond, maître fondeur, cizeleur, doreur, demeurant à Paris, rue des Petits Chams Saint Martin, en exécution de trois ordonnances rendues par monsieur le lieutenant civil en son hôtel, les vingt septembre, sept et vingt neuf octobre dernier, entre M. le duc de Villequier, d'une part, au nom et comme exécuteur testamentaire de messire Louis Marie d'Aumont, duc d'Aumont, pair de France, et le sieur Pierre Gouthière, doreur, cizeleur du roy, d'autre part: par la première desquelles ordonnances il avoit, entr'autres choses, été ordonné qu'il seroit par le sieur Rémond et par le sieur Guyard, maître fondeur-cizeleur, en la présence du sieur Paris, architecte, qui les départageroit, procédé à la visite, prisée et estimation des ouvrages de dorures, cizelures, faits par le sieur Gouthière pour mondit feu seigneur duc d'Aumont; par la seconde, il a été donné lettres au sieur Paris de son déport comme tiers expert, et par la troisième, qu'attendu le déport du sieur Guyard, il seroit procédé auxdittes visite, prisée et estimation par moi, Rémond, conjointement avec le sieur Duplessis, aussi maître fondeur et cizeleur, en vertu des pouvoirs à moi donnés par les susdittes ordonnances, après avoir prêté ès mains de monsieur le lieutenant civil le serment en pareil cas requis, et sur les réquisitions qui m'en ont été faites par toutes

les parties, je me suis transporté les huit, douze et quinze septembre dernier, huit heures du matin, en vertu de la première ordonnance de monsieur le lieutenant civil du cinq dudit mois, accompagné du sieur Guyard, nommé par la susditte ordonnance pour procéder conjointement avec moy, et en présence dudit sieur Paris, auxdittes visittes, prisées et estimation desdits ouvrages, grande rue du Faubourg Saint Martin, dans une maison à droite après le laissez-passer, où demeure ledit sieur Gouthière. Où étant, après nous être fait représenter les ouvrages faits par ledit sieur Gouthière pour mondit feu seigneur le duc d'Aumont, nous avons procédé auxdittes visittes, prisées et estimation desdits ouvrages, lesquels en partie n'étoient point montés, et que nous avons détaillés avec la plus grande exactitude. Et n'ayant pu finir notre estimation, attendu le déport du sieur Paris, duquel il lui a été donné lettres, comme tiers expert, et en continuant nos vacations pour arriver à une juste estimation, je me suis transporté, les douze et quinze octobre dernier, huit heures du matin, et le dix huit dudit, trois heures de relevée, toujours accompagné, comme dessus, du sieur Guyard, en un hôtel scis en cette ville, place de Louis Quinze, appelé l'hôtel d'Aumont, où lesdits ouvrages étoient alors. Où étant, nous avons, par suitte, continué de procéder auxdittes visittes, prisées et estimation desdits ouvrages qui ont été interrompues par 1e déport du sieur Guyard, ainsi qu'il résulte de la troisième ordonnance de monsieur le lieutenant civil du vingt neuf octobre dernier, qui dit qu'il sera procédé auxdittes visittes, prisées et estimations par moy, Remond, conjointement avec ledit sieur Duplessis. En vertu des mêmes pouvoirs à moy donnés par lesdittes ordonnances, et sur les réquisitions réiterées qui m'en ont été faites par toutes les parties, je me suis transporté les premier et trois du présent mois, trois heures de relevée, audit hôtel d'Aumont, accompagné dudit sieur Duplessis, aussi maître fondeur et cizeleur, nommé par l'ordonnance du vingt neuf octobre dernier pour procéder conjointement avec moy auxdittes visittes, prisées et estimations des ouvrages de bronze, cizelures et dorures qui avoient été transportés le cinq octobre dernier chez le sieur Gouthière, audit hôtel d'Aumont. Où étant, et après nous être fait représenter lesdits ouvrages, que nous avons trouvés alors tout remontés, et nous être aussi fait remettre par ledit sieur Gouthière lesdits deux mémoires desdits ouvrages et avoir pris lecture, à notre première vacation, des expéditions délivrées par maître Serreau, commissaire, desdites trois ordonnances qui nous ont été remises par ledit sieur Gouthière, et, en l'absence de toutes les parties, nous avons conjointement procédé à laditte visite, prisée et estimation desdits ouvrages. Et encore, en vertu de la sommation qui m'a été faite le onze du présent mois de novembre, à la requête dudit sieur Gouthière, je me suis transporté audit hôtel le douze dudit mois, huit heures du matin, accompagné dudit sieur Duplessis. Où étant, nous avons de nouveau procédé auxdittes visittes, prisées et estimations desdits ouvrages; mais, ne nous étant pas trouvés d'accord sur l'estimation de plusieurs articles desdits mémoires, nous avons chacun séparément rédigé notre avis.

En conséquence de tout ce que dessus et vu les mémoires du sieur Gouthière, contenant dix articles, qui ne peuvent être réduits suivant le détail ci-après:
Savoir:
Le premier article, suivant le premier mémoire du sieur Gouthière, portant une somme de quatre vingt seize livres pour models faits sur un céladon, cy 96
Le second article, pour nettoyage de bronze fait à l'hôtel d'Aumont 40
Le troisième article, pour raccommodage d'un cercle 12
Le quatrième article, pour un modèle en cire pour une girandole dans un pot violet 144
Le cinquième article, pour un moule en plâtre 15

Le sixième article pour plusieurs esquisses d'une autre girandole et modèle en cire posés sur lesdits vases de plâtre, portés la somme de cent cinquante livres, cy 150
Le septième article, pour quatre pilastres payés au sieur Pigal, maître menuisier 30
Le huitième article, payé au sieur Aubert pour la peinture, quarante huit livres, cy 48
Le neuvième article, payé au sieur Pigal une grande planche pour poser la pendule 12
Le dixième article, pour les sciottes fournies à M. Bouchardy [Bocciardi], marbrier 36

Total 591

Laquelle somme de cinq cent quatre vingt onze livres j'estime devoir être payée audit sieur Gouthière, sans aucune diminution, attendu que c'est purement ses déboursés.
A l'égard des ouvrages de bronze, cizelures et dorures cy après, lesquels j'ai examiné scrupuleusement dans toutes ses parties, j'ai pensé qu'il étoit de la justice et de l'équité de les détailler, pour mieux en connoître la juste valeur, ainsi qu'il suit:

Premièrement, avoir vu et examiné en détail une table de jaspe (**cat. 40**), dont les pieds composés d'un sabot à feuilles d'ornement, de frizes, arabesques sur la longueur du pied de différens models, surmonté d'une tête égyptienne portant une corbeille, chapiteau et autres accessoires relatifs à l'exécution, estime la totalité d'un pied pour façon de cizelure à la somme de onze cent cinquante livres, les quatre faisant ensemble la somme de quatre mille six cent livres, cy 4,600
Une frize au pourtour de ladite table, composée de cent fleurons et postes, estimé sept cent livres, cy 700

Pour cordes doubles en nattes au pourtour de ladite table, porté à la somme de cent cinquante livres, cy 150

Huit couronnes de vigne, estimées chacune cinquante quatre livres, faisant ensemble la somme de quatre cent trente deux livres, cy 432

Pour cent quarante quatre pommes de pain ou oves rapportés à la moulure de dessous la tablette, à six livres la pièce, les cent quarante quatre faisant ensemble la somme de huit cent soixante quatre livres, cy

864

Pour la moulure avec cent quarante fleurons, y compris les feuilles d'angles, estimée cinq cent soixante livres, cy 560

Pour la moulure de dessus la tablette de dix pieds, à quinze livres le pied, cent cinquante livres au total, cy 150

Dix pieds de perles, estimé vingt livres, cy 20

Pour monture fer et autres fournitures, évalué trois mille huit cents livres, cy 3,800

Dorure de la totalité d'une table, estimée trois mille trois cent livres, cy 3,300

Pour fonte de ladite table, estimée quatre cent cinquante livres, cy 450

Pour la seconde table, estimée au rapport du détail de celle cy-dessus à la somme de quinze mille vingt six livres, cy 15,026

Pour tous les models, tant en terre, cire, que ceux de cuivre pour parvenir à l'exécution desdites tables, estimé le tout la somme de deux mille quatre cent livres, cy 2,400

Secondement, chapitre de la pendule:

Pour deux glands et bout d'écharpe, estimé cent quatre vingt livres, cy 180

Pour guirlandes de fleurs et fruits, en cinq pièces, estimé trois cent quatre vingt dix livres, cy 390

Deux bouts de branches de chêne au dessous des cornets, évalué cent soixante livres, cy 160

Pour deux cornets d'où sortent des fleurs et fruits, y compris le noeud de l'écharpe, évalué six cent livres, cy 600

Toute la lunette en totalité, cizelure et tournure, évalué deux cent livres, cy 200

Les deux branches de chêne, depuis les cornets jusqu'à l'anneau de la lunette, estimé trois cent quarante livres, cy 340

Les deux branches, depuis l'anneau jusqu'à leur fin, estimé huit cent quarante livres, cy 840

Le bout d'écharpe et ruban portant la lunette, estimé cent soixante livres, cy 160

Pour le clou et la rosette, estimé trente six livres, cy 36

Pour la monture de ladite pendule et ajustage, neuf cent livres, cy 900

Pour la fonte de ladite pendule, deux cent vingt livres, cy 220

Pour la dorure de ladite pendule, estimé deux mille huit cent livres, cy 2,800

Pour les models de ladite pendule, estimés quatre cent cinquante livres, cy 450

7,276

Troisième chapitre. Des bras:

Pour un bras, un trophée faisant le bas de la plaque d'en bas, estimé cinq cent soixante livres, cy 560

Pour un carquois découpé à jour et doublé, évalué trois cent quatre vingt dix livres, cy 390

Pour les quatre branches, composées de vingt fleurs de feuillage de roze, estimé douze cent soixante livres, cy 1,260

Pour arabesques en lierre faisant la plaque dudit bras, estimé dix huit cent cinquante livres, cy 1,850

Pour rubans et clous à rozette, évalués cent quarante livres, cy 140

Une couronne de fleurs, estimé cinq cent quatre vingt livres, cy 580

Pour la monture, évaluée mille livres, cy 1,000

Pour la fonte, estimé deux cent soixante dix livres, cy 270

Pour la dorure de la totalité d'un bras, estimé trois mille huit cent livres, cy 3,800

9,850

Pour les autres trois bras, au rapport du détail du premier montant à la somme de neuf mille huit cent cinquante livres, les trois faisant ensemble celle de vingt neuf [mille] cinq cent cinquante livres, cy 29,550

Pour les modèles nécessaires à l'exécution des quatre bras, estimés douze cent livres 1 200

Quatrième chapitre. D'un pot en forme de baril de porcelaine verd céladon (**cat. 15**):

Pour un cercle faisant socle au pied dudit pot, ornement de raye de coeur et perles, trois pieds courants, estimé deux cent seize livres, cy 216

Trois pieds de frize de vigne sur dix huit lignes de large sur le pied aussi dudit pot, évalué trois cent soixante livres, cy 360

Pour un sphinx, dont le derrière se termine en rinceaux d'ornemens, estimés cent quatre vingt livres chacun, ce qui revient pour les quatre à la somme de sept cent vingt livres, cy 720

Pour quatre filtons de perles doubles, estimés trente livres, cy 30

Pour un grand cercle à laurier au pourtour dudit pot, évalué cent cinquante livres, cy 150

Un autre à feuille conjointement avec celui cy dessus, estimé cent quatre vingt douze livres, cy 192

Deux arabesques sortants des gueules figurées en porcelaine audit pot,

y compris les quatre cornets d'ou sortent des fleurs et fruits, estimés six cent cinquante livres, cy 650

Pour quatre serpents faisant ance audit pot, estimé cent soixante huit livres, cy 168

Pour la gorge dudit pot, partie de raye de coeur et perles de trois pieds courants, estimés cent quatre vingt dix livres, cy 190

Pour la partie à jour de ladite gorge, composée de trèfle, fleurons et autres, evalué trois cent soixante livres cy 360

Pour le cercle à gaudron et épis estimé cent quatre vingt douze livres, cy 192

Pour la monture, à cause des difficultés et moyens d'éviter des trous dans ledit vase, estimé mille quatre cent livres, cy 1,400

Pour la fonte dudit pot, estimé cent dix livres, cy 110

Pour la dorure dudit pot, estimée dix huit cent livres, cy 1,800

 6,538

Pour le second pot, montant du produit de celui cy dessus détaillé à la somme de six mille cinq cent trente mille livres, cy 6,538

Pour les models en cire et cuivre à l'effet d'exécuter lesdites garnitures, estimé trois cent quatre vingt livres, cy 380

Cinquième chapitre. Des girandoles (**cat. 21**) :
Pour deux petites girandoles à trois branches posées dans des vases d'ancien blanc après m'en être rendu compte par détail, j'estime les deux girandoles en totalité, c'est-à-dire modèles, fonte, cizelure, monture et dorure à la somme de dix huit cent livres, cy 1,800

Sixième chapitre. Des cadres :
Pour quatre cadres à rayes de coeur posées sur un socle de granite rose, estimé tant pour fonte, cizelure, monture et dorure à la somme de deux cent quarante livres, cy 240

Septième chapitre. De deux pots bleues à côtes (**cat. 17**) :
Apre avoir bien examiné et détaillé les garnitures des deux pots bleues à côtes j'ai trouvé que ces deux objets n'étoient susceptibles d'aucune diminution et qu'ils vallent la somme de trois mille livres pour laquelle ils sont portés au mémoire, cy 3,000

Huitième chapitre. Des urnes (**cat. 16**) :
Pour deux aiguières en forme d'urnes, lesdites garnitures composées de deux figures, avec un bec de coquille et tête de satyre décorée de pampres de vigne, un pied orné d'entrelacs et d'une dousine à feuille d'ornemens et perles, estimé les deux pour modèles, fonte, cizelure, monture et dorure, à la somme de dix huit cent livres, cy 1,800

Neuvième et dernier chapitre. Des girandoles :
Pour deux petites girandoles dans un bambou de porcelaine céladon, après les avoir examiné et détaillé, je les estime pour modèles, fonte, cizelures, montures et dorure, à la somme de neuf cent soixante livres 960

Le premier article du mémoire, ainsy que les suivants, formant ensemble la somme de cinq cent quatre vingt onze livres, n'ayant point été comprise dans l'addition général, est portée icy pour 591

Total 102,175

A laquelle somme de cent deux mille cent soixante quinze livres j'ay estimé tous les ouvrages cy dessus énoncés et détaillés, sous le bon plaisir de monsieur le lieutenant civil. Fait, dresse rédigé et signé audit hôtel d'Aumont, tant les jours que dessus que ce jourd'hui seize novembre mil sept cent quatre vingt deux.
Rémond

1782, November 16 (2). *Procès-verbal d'estimation dressé par Jean-Claude Thomas Duplessis, maître fondeur-ciseleur, des mêmes ouvrages, dont ledit expert estime la valeur à la somme de 75,550 livres* (AN, Y 1905 ; Wildenstein 1921, 129-130)

Je, soussigné, Jean Claude Thomas Duplessis, maître fondeur cizeleur, demeurant à Paris, cul de sac Sainte Marine, en exécution de trois ordonnances rendues par M. le lieutenant civil en son hôtel, les 5 septembre, 7 et 29 octobre derniers, entre M. le duc de Villequier, d'une part, et comme exécuteur testamentaire de M. Louis Marie Daumont, duc Daumont, pair de France, et le sieur Gouthière, doreur cizeleur du roy, d'autre part. Sur la première desquelles, etc
[Rappel des ordonnances et sentences citées dans le rapport de Rémond.]
..... mais ne nous étant pas trouvés d'accord sur l'estimation de plusieurs articles desdits mémoires, nous avons chacun rédigé notre avis séparément. Et ayant trouvé tous lesdits ouvrages parfaitement exécutés en tout point, j'estime un bras en arabesque de six pieds deux pouces de haut, sur environ dix huit de large, à la somme de 8,060 livres, les quatre par conséquent font 32,240

Ensuite une table de jaspe (**cat. 40**), ornée de bronze doré au mat, frize, couronne de vigne, tête égiptienne, etc., etc., estimé 10,548 livres, les deux faisant 21,096

Ensuite un vase forme de baril (**cat. 15**), décoré de bronze doré au mat, ledit vase orné de serpents, de cornets d'abondance, de sphinx, de frize de vigne et guirlande, etc., etc., estimé 4,664 livres, les deux formant ensemble 9,328

Une pendule en grand cartel de cinq pieds d'hauteur sur deux pieds de largeur et composé d'une cocarde de ruban écharpe, de deux cornets d'abondance, de branches de chêne entrelassés, etc., etc., estimé 4,667

Un vase ou urne bleue à cotte (**cat. 17**), orné de bronze doré au mat, fait dans le genre arabesque, estimé à la somme de 1,600 livres, les deux formant au total 3,200

Une aiguière (**cat. 16**) ornée de figures de bronze doré au mat avec autres ornements, estimé 860 livres, les deux faisant ensemble 1,720

Une girandole sortant d'un vase d'ancien blanc (**cat. 21**), décoré de cornets d'abondance, branchages de vigne et de têtes de petits bouquetins, etc., etc., estimé 770 livres, les deux faisant 1,540

Une petite girandole dans son rozeau de porcelaine, orné de bronze, doré au mat, estimé 440 livres, les deux faisant au total 880

Pour les onze articles que j'ai trouvé épars dans les deux mémoires, qui se montent ensemble à la somme de 879 livres, j'estime qu'ils ne sont susceptibles d'aucune diminution 879

———

Total 75,550

A laquelle somme de 75,550 livres de l'autre part, j'ai estimé tous lesdits ouvrages de bronze et dorures au mat tels et sous le bon plaisir de M. le lieutenant civil. L'estimation faite cy dessus par moy de tous lesdits ouvrages faits par ledit sieur Gouthière pour mondit feu seigneur duc Daumont. Fait, dressé, rédigé et signé audit hôtel Daumont, tant les jours que dessus que ce jourd'huy seize novembre mil sept cent quatre vingt deux.

Duplessis

1782, December 12-21. *Catalogue des effets précieux qui composent le Cabinet de feu M. le duc d'Aumont. Par P.F. Julliot fils et A.J. Paillet*

2 (**cat. 42**) Une colonne, ornée de chapiteau corinthien, de base à tore de laurier, avec plinthe de bronze doré mat, sur socle de brocatelle d'Espagne plaquée ; elle est surmontée d'une boule milliaire de marbre serpentin, avec piédouche, garnie de culot à feuilles d'ornemens, et tore à rosettes aussi de bronze doré en or mat, et socle rond de porphyre, G. ; hauteur totale, 10 pieds ; diamètre de la colonne, 8 pouces 6 lignes.
Julliot pour le Roi *6 999 livres*

3 (**cat. 8**) : Deux Vases, forme de Médicis, parfaitement taillés, & évidés d'une grande légèreté d'épaisseur ; posés sur socle carré, entouré de fil de perles, à panneaux renfoncés à entrelacs à rosettes, de bronze doré

d'or mat. G. [pour Gouthière]; hauteur compris le socle : 13 pouces, sur 8 pouces de diamètre.
Julliot pour le Roi *3 134 livres*

6 (**cat. 9**). Deux vases ronds couverts, forme de cassolette à gorge ; cul de lampe pris dans la masse, terminé par un bouton de même qualité, garnis d'un fil de perles sur le bord, supportés chacun par 3 consoles à rinceaux d'arabesques, formant anses, accompagnées de guirlandes à roses et fruits sur la panse, terminées chacune par deux pieds de biches ; ils sont placés sur socle triangulaire de jaspe vert aussi garni de moulures à feuilles d'eau et boules à cannelures torses de bronze doré d'or mat, G (Gouthière) : hauteur, 13 pouces ; diamètre, 10 pouces.
Paillet pour la Reine *3 001 livres*

7 (**cats. 10 and 43**) : Deux colonnes, à chapiteau d'ordre composite, à feuilles d'ornemens prise dans le bloc en relief saillant, enrichi de rinceaux d'arabesques, terminés en volute sur angles ; branches de laurier entrelacées, dominant en espece de couronne sur le milieu de chaque face, et base à entrelacs, gorge unie et double baguette à feuilles d'eau, le tout de bronze doré d'or mat ; placées sur socle carré de marbre serpentin, plaqué à un pouce d'épaisseur ; elles sont surmontées d'un un vase rond, forme cassolette, d'albâtre oriental orné sur chaque côté de deux branches de laurier en console, formant anse, et de cul de lampe à feuilles d'eau et fleurons de bronze en or mat, posé sur un socle de vert antique, G. ; hauteur des Colonnes, 8 pieds ; diamétre, 9 pouces ; hauteur des Vases, 12 pouces 6 lignes.
Paillet pour le Roi *13 801 livres*

10. Un vase oblong, couvert, à deux méplates, en consoles, prises dans le bloc, parfaitement dégagées à jour, à volute posant de chaque côté sur le haut de la gorge, et se terminant en légère saillie sur le long de la partie inférieure de la panse ; posé sur un fût de colonne de marbre antique, nommé fleur de pêcher, à base carré de granit rose à panneaux renfoncés, garnis de frise à ornement d'arabesques de bronze doré d'or mat, G. ; hauteur du Vase, 23 pouces sur 14 pouces 3 lignes de diamètre, y compris les anses ; celle du fût, 40 pouces 6 lignes sur 11 pouces 6 lignes de diamètre.
Paillet pour le Roi *3 599 livres*

11 (**cat. 11**). Un autre Vase rond, à gorge, forme de cassolette, de première qualité, garni de bouton, rosasse sur le couvercle, godrons & fleurons ornant le bord, de figures, sujet de femme, formant anse de chaque côté, l'une à pieds de Satyre, l'autre caractérisée Syrene, tenant chacune une branche de myrte entrelacée de ruban, assises, avec espèce de tapis, sur le haut de la panse, qui est entourée de moulure à cordes & à feuilles d'ornement, & de piédouche à baguettes de laurier, avec socle rond uni, le tout de bronze doré d'or mat, G.; hauteur, 13 pouces 6 lignes sur 14

pouces 6 lignes de diamètre, y compris la saillie des anses.
Paillet pour le Roi 5 000 *livres*

12 (**cat. 12**). Un Vase rond, à gorge, de ton foncé, garni de bouton, ro-sasse sur le couvercle, tête de bouc de chaque côté, figurant anse, ban-deau renfoncé à frise d'ornement d'arabesques sur le haut de la panse, et socle rond uni de bronze d'or mat, G. ; hauteur, 14 pouces sur 14 pouces 6 lignes de diamètre, y compris les ornemens.
Julliot pour le Roi 1 511 *livres*

14 (**cat. 44**). Une Colonne d'ancienne roche, garnie de chapiteau à feu-illes d'acanthe, baguette à fil de perles, et de base à tore de feuilles de laurier, entrelacé de rubans, de bronze doré d'or mat, G. ; placée sur so-cle de porphyre ; hauteur, 7 pieds 9 pouces sur 11 pouces 4 lignes de diamètre.
Paillet pour le Roi 2 261 *livres*

15 (**cat. 45**). Une Colonne, garnie de même chapiteau et base que la précédente, en bronze doré d'or mat, posée sur socle de granit vert, G. ; hauteur, 7 pieds 9 pouces ; diamètre, 11 pouces 2 lignes.
Paillet pour le Roi 3 320 *livres*

17 (**cat. 46**). Deux autres fûts de Colonne sur leur socle, à panneaux ren-foncés de même espece, garnis chacun du haut de fil de perles, de base à tore à entrelacs, feuilles d'acanthe et baguette nouée de ruban, le so-cle de frise à rinceaux d'arabesques, avec sujet de Dauphin, et à quatre boules, le tout de bronze doré d'or mat, G. ; hauteur, y compris le socle, 44 pouces 6 lignes sur 8 pouces de diamètre.
Julliot pour le Roi 3 450 *livres*

22 (**cat. 47**). Deux fûts de Colonne, cannelés, garnis de base à tore de lau-rier entrelacé de ruban, à feuilles d'acanthe en doucine et à moulure ou-vragée, de bronze doré d'or mat ; posés sur double socle de granit gris, G. ; hauteur, y compris le socle, 39 pouces ; diamètre, 9 pouces 6 lignes.
Paillet pour le Roi 1 720 *livres*

23 (**cat. 48**). Deux fûts de Colonne, garnis de base à tore à entrelacs, avec gorge unie à baguette nouée par un ruban, le tout de bronze doré, cha-cun sur socle de G. griotte d'Italie, supporté par quatre boules aussi de bronze doré ; hauteur, 44 pouces ; diamètre, 8 pouces.
Châtelet, peintre 800 *livres*

25 (**cat. 13**). Une Coupe ronde, en forme de cuvette, bien évidée, à gorge, travaillée à côtes et cannelures sur le pourtour ; garnie de bord peu élevé à ornement découpé à jour ; baguette de laurier avec fil de perles sur le haut de la panse, cul de lampe à rosasse à feuilles de laurier, fleurons et

bouton à graines ; elle est supportée par un trépied à trois consoles, cha-cune à volute et à tête de faune, avec pilastre formé de deux moulures ouvragées séparées par un fil de perles à jour et terminées par double pieds de biche ; ces consoles sont accompagnées, entre les volutes, de branches de vigne chargées de raisins formant guirlandes, et tenue par un triangle à frise d'entrelacs à jour, entre deux fils de perles, avec avant corps à rosettes et fleurons : on voit dans l'intérieur du trépied un ser-pent sortant du cul de lampe et qui s'avance vers une espece de fruit placé au centre d'une rosasse qui orne le milieu du socle, le tout posé sur une plinthe ronde, aussi de Jaspe fleuri, garnie de six pieds, à gaines et à cannelures torses, distribuées en trois parties relative au composé de la garniture, dorée d'or mat, G. ; hauteur, 17 pouces 9 lignes.
Le Brun pour la Reine 12 000 *livres*

43 (**cat. 14**). Deux Cassolettes rondes à côtes peu sensibles, ce qui aug-mente leur mérite : l'une à trois cartouches de dragon entremêlés de bouquets et grenade, l'autre à trois cartouches d'oiseau séparés aussi par des bouquets, tant sur le pourtour que sur le couvercle de chacune ; elles sont ornées d'un bandeau à fil de perles entre deux moulures ouvragées servant de gorge, de trépied à culot en cannelures torses, chaînons en-tre les trois consoles à tête d'enfants terme, se terminant d'un cercle à entrelacs découpés à jour, avec double socle de porphyre garni du haut d'un cercle à fils de perles, de guirlandes de roses sur les faces et de socle à tore de laurier, le tout de bronze doré d'or mat, G.; diamètre de la por-celaine 5 pouces 3 lignes ; hauteur, y compris les ornements, 9 pouces ; hauteur du socle de porphyre, 2 pouces 9 lignes ; diamètre 4 pouces.
Julliot pour le Roi 2 703 *livres*

110 (**cat. 15**). Deux Vases, en forme de baril, à têtes de chimère, avec anneaux en relief saillant pris dans la porcelaine, garnis d'une gorge décorée à bord à godron et épis avec arcades entrelacées, enrichies de fleurons, travaillée deux côtés à jour, cordon à fil de perles et moulures à feuilles d'eau, de serpents faisant enroulements des côtés sur le bord de la gorge, qui descendent poser leur tête sur deux cornets d'abondance à rinceau d'arabesque, avec autres ornements faisant le couronnement des têtes de chimères, et par cet ensemble forment anses aussi agréables que particulières; ils sont supportés chacun par un pied à moulures à feuilles d'eau et laurier avec quatre sphinx ailés et à rinceau d'arabesque et guirlandes de perles; le tout posé sur un socle de même sorte de por-celaine céladon entouré d'un fil de perles; bandeau à branchages de feu-ille de vigne et raisins, terminés par une moulure à fil de perles, feuilles d'eau et plate-bande unie et plinthe de porphyre, avec boules, le tout doré d'or mat, G.; hauteur, 18 pouces, sur 13 de diamètre.
Julliot pour le Roi 7 501 *livres*

114 (**cat. 16**). Deux Vases à panses de *lisbet* de ton foncé, fond gaufré & à feuilles de Roseau en demi relief sur la partie inferieure. Ils sont artis-

tement montés en buire, garnis chacun de collet en coquille servant de bec, enrichis d'une tête de faune à branchages de vigne et raisins, de fil de perle sur son pourtour, de laquelle les bords de côté servent d'appui à une figure de femme à pieds de satyre formant l'angle, et de pied à bandeau d'entrelacs à jour sur un fond couleur d'eau d'un agréable effet avec moulures à feuilles d'ornements, le tout de bronze doré d'or mat, placés sur socle de prime verte. G. ; hauteur des Vases, 17 pouces ; socle 6 pouces en carré ; épaisseur, 2 pouces.
Abraham *2 600 livres*

133. Deux troncs d'Arbre, fond jaunâtre, à léger dessin d'arbuste, fleurs et feuillages coloriés ; ils forment flambeau et sont garnis de bord, de pied tond à tore, avec moulure à feuilles d'ornement et avant-corps de bronze parfaitement fini et doré d'or mat, G. ; hauteur, 6 pouces 6 lignes.
Le président Haudry *370 livres*

134. Un autre tronc d'Arbre pareil aux deux précédents, et garniture du même fini ; hauteur, 6 pouces 6 lignes.
Le vicomte de Choiseul *175 livres*

148 (**cat. 21**). Deux urnes oblongues d'ancien blanc de Saxe, portant girandole à trois branches, chacune à rinceau d'arabesques avec cornet d'abondance orné de fruits servant de bobèche, et autres ornements ; ces deux Urnes sont garnies de bord à godron, de trois têtes de bélier à rinceaux, guirlandes à feuilles de lierre, chûte de feuilles de vigne à raisins et de pied à avant-corps, avec cul de lampe et supports à double pied de biche en bronze doré d'or mat, G. ; hauteur, 16 pouces.
Le duc de Villequier *1 180 livres*

159. Un Vase couvert, de forme un peu ovale, à petites feuilles en relief ; garni de bouton, gorge à jour ; console servant d'anse, à deux rinceaux du haut avec branchages de myrte, supportée de chaque côté par une tête de faune et piédouche à tore de laurier avec plinthe de bronze doré d'or mat ; hauteur, 8 pouces 6 lignes, G.
M. Destouches *480 livres*

163 (**cat. 17**). Deux Urnes à côte, garnies chacune de bouton, rosettes, cercles à oves et dards sur le couvercle, gorge à fleurons à jour avec baguette figurant l'ozier, têtes de bélier servant d'anses, nœuds de rubans et perles formant guirlandes sur le collet, tige à fleurons avec raisins montant entre chaque côte de la partie inferieure de la panse, et pied à petit cordon natté ; à festons de rosettes et perles, et à quatre griffes de lion posant sur une base cintrée entourée d'un fil de perles, et avant-corps à panneaux d'entrelacs à fleurons découpés à jour et à quatre boule à côtes, servant de supports, le tout de bronze doré d'or mat, G. ; hauteur 15 pouces.

Julliot pour le Reine *4 320 livres*

181. Un grand Vase, forme d'Urne antique, de ton foncé, à feuilles sur le collet ; tête de chimère avec anneau de chaque côté, et à dessin chinois sur le pourtour de la panse, le tout en relief ; garni de gorge travaillée à gordon en fil de perles, moulure en doucine, à fleurons et feuille d'eau, pied à tore de baguettes entrelacées d'un ruban avec plinthe à panneaux renfoncés à frise d'ornement, et avant-corps arrondis, relevé chacun d'une rosasse, le tout de bronze doré d'or mat ; placé sur socle de granit rose de 10 pouces 6 lignes en carré sur 2 pouces d'épaisseur ; hauteur du vase, y compris la garniture, 21 pouces 6 ligne. G.
Julliot pour le Roi *1 501 livres*

182. Deux Troncs d'arbre, de ton clair, à roseau et petit feuillages en relief, garnis de pied à godron, surmontés chacun d'une girandole à trois branches, composée d'une touffe de feuillage, tiges à rinceau d'ornements de goût d'arabesques, et de petit chapiteau portant une cassolette ornée de guirlandes, chaînons et perles, le tout de bronze doré d'or mat, G. ; hauteur, 16 pouces.
Julliot pour le Roi *800 livres*

318 (**cat. 38**). Deux Tables de porphyre, de 36 pouces de long, 21 pouces 6 lignes de profondeur, à filet encadré d'une baguette à fleurons et perles, sur leur pied à entablement à carrés en ressaut, supporté par quatre gaînes, le tout de porphyre ; chaque pied est relevé, dans son entablement, d'une frise à branches de roses à entrelacs en forme de couronne, ces entrelacs renferment un fleuron tenant à une petite baguette qui passe dans cette frise régnant entre deux moulures, l'une à feuille d'acanthe et perles, l'autre à petites rosettes ; les gaînes sont richement ornées de chapiteau soutenu par deux figures de Femme terme, adossées, de style Egyptien, formant console à volutes avec guirlande de roses et fruits, et les panneaux renfoncés pris dans le bloc, de cadre à feuilles d'eau et chûte de myrte, avec pied à culot aussi à feuilles d'eau, d'un fini parfait en bronze doré d'or mat, G. ; hauteur 32 pouces, épaisseur 16 lignes.
Julliot pour la Reine *23 999 livres*

319 (**cat. 40**). Deux Tables de jaspe vert, de 36 pouces de long, 21 pouces 6 lignes de profondeur, à filet encadré d'une baguette à fleurons et perles, sur leur pied à entablement à carrés en ressaut, supporté par quatre gaines pleines, le tout de jaspe ; chaque entablement est orné d'une frise à entrelacs et fleurons de différents genres entre deux moulures, l'une à oves et fil de perles, l'autre à double baguettes travaillées en cordes, et de couronnes à feuilles de vigne et raisins sur les carrés ; les gaînes sont enrichies d'une figure de femme-terme, drapée dans le style Egyptien, portant une corbeille surmontée d'un chapiteau, les faces le sont aussi d'un caducée, feuilles de myrte & fleurons d'arabesques

formant chûte, les côtés de thyrse entrelacé de branches de lierre et fleurons, et terminées chacune par un pied à culot à feuilles d'ornements et boule : le tout de bronze doré d'or mat. G.
Paillet pour le Roi *19 580 livres*

338. Une autre Pendule aussi faite pour être placée dans l'intérieur d'un panneau de boiserie, mouvement par M. Ferdinand Berthoud à Paris ; elle est à demi-secondes, à équation, à deux aiguilles, sonnant les heures et les quarts, reporte l'heure au quart, silence par-tout quand ont veut, sans être sujet à mécompter ; l'échappement est un ancre à repos ; pendule de compensation à baguette, suspension à ressort, mouvement à fusée et pied de biche pour la remonter. Ce mouvement est revêtu d'une face de cartel, genre d'arabesques, de 5 pieds 6 pouces de haut, dont l'encadrement, travaillé à oves et fil de perles, soutenu du haut par un ruban à nœud, accompagné de branches à feuilles de chêne entrelacées, est enrichi, sous sa partie inférieur, de cornets d'abondance ouvragés, et d'une suite de branches de chêne, avec guirlandes de fleurs et fruits noués par une écharpe, le tout se terminant par deux forts glands. L'ensemble de son cartel, d'un effet supérieur, est aussi des plus recherchés par le goût et le fini de ses ornements en bronze doré d'or mat. G.
Le duc de Villeroi *3 799 livres*

343. Une paire de Bras de goût d'arabesques de six pieds de haut, dont la partie principale présente un carquois très ouvragé, enrichi de quatre branches de rose entrelacées et attachées par un noeud de ruban, avec bobeche, chacune formée d'une fleur relative à leur espece ; ce carquois est soutenu par trois chaînons passant entre deux branches de lierre contournées en lyre, surmontées d'une couronne de rose nouée avec les chaînons à un cartouche oval, aussi à branche de lierre, et terminé par un clou à nœud de ruban ; l'un de ces Bras est orné au-dessous du carquois d'un trophée de flèches, tenues par un nœud de ruban, qui garnit le milieu d'un cartouche oval figuré par deux branches de myrte, dont une descend former chûte d'ornements en s'entrelaçant avec deux rubans à glands ; l'autre l'est d'un trophée de thyrse et d'attributs de faune, et même cartouche d'ornements en lierre, avec chûte de feuilles de vigne, raisins et rubans.
Ces Bras et les deux suivans sont d'un effet surprenant par l'ensemble, la richesse et le fini de leurs ornements de bronze doré d'or mat. G.
Le duc de Villequier *9 127 livres*

344. Une autre paire de Bras entièrement pareils aux deux précédents, à l'exception du genre des ornements qui sont au-dessous du carquois, dont l'un, à trophée de caducée, massue, castagnettes et autres attributs, renfermés par un cartouche oval à branches de chêne, se termine par deux bouts de rubans ; l'autre, à trophée de cors de chasse, carquois, houlette, dans un cartouche à branches de jasmins s'entrelaçant en chûte d'ornement, avec deux rubans à glands.

Paillet pour la Reine *9 100 livres*

345. Une paire de Bras à quatre branche, à figures de femme-terme, drapée dans le goût égyptien, formant console à pilastre orné d'épis entre deux moulures à feuilles d'eau et fil de perles, se terminant par un rouleau à fleur de soleil ; la figure tient de chaque main deux branches, l'une de roses, l'autre de grenades, portant bobeches en fleurs relatives à leur espece, et est enrichie sur la face de guirlandes de fleurs et fruits qui naissent des volutes de la console. G. ; hauteur, 20 pouces 6 lignes.
Julliot pour le Roi *3 001 livres*

346. Une autre paire de Bras exactement semblable à la précédente.
Paillet pour le Roi *2 999 livres*

347. Une paire de moyens Bras, à figures d'enfants-terme, sur console à volutes, d'où sortent deux branches ornées de guirlandes, se terminant par un pilastre, de fond ouvragé et à moulures à feuilles d'eau. G. ; hauteur, 13 pouces.
Donjeux *500 livres*

348. Une paire de Bras à deux branches, le corps en forme de gaîne, à panneaux ouvragé et à chapiteau surmonté d'un vase à pans, à bords d'entrelacs, avec anneaux et culot à feuilles d'ornement. G.
Payé comptant *301 livres*

349. Deux petits Flambeaux à colonnes cannelée à tore de laurier et socle à feuilles d'eau ; hauteur, 5 pouces 4 lignes. G.
Le duc de Chaulnes *124 livres*

350. Deux autres Flambeaux comme les précédens
Le duc de Chaulnes *124 livres*

351 (**cat. 23**). Un Lustre à six branches à rinceaux d'arabesques, cul de lampe à fil de perles, cannelures à jour enrichie de fleurons, culot à godron et rosasse, soutenu par quatre doubles chaînons, ornés sur le milieu d'une couronne de rose, passant dans couronnement de goût Chinois et terminé par un cordon de même genre figurant guirlande. G. ; hauteur, y compris le cordon d'ornement, 27 pouces 6 lignes ; diamètre, 20 pouces.
Paillet, pour le Roi *2 500 livres*

1782, December 20. *Procès-verbal de l'expert Chéret* (AN, Y 5100 ; Guiffrey 1877, 163–65)

Je soussigné Jean-Baptiste Chéret, marchand orfèvre à Paris, y demeurant quai des Orfèvres, en vertu d'une ordonnance sur référé ren-

due par M. le lieutenant civil en son hôtel, le 25 novembre dernier, entre Monsieur le duc de Villequier exécuteur testamentaire, et les sieur et dame héritiers et représentants de feu messire Louis Marie d'Aumont, duc d'Aumont, d'une part ; le sieur Gouthières, doreur-ciseleur, d'autre part ; et le procureur plus ancien des créanciers opposans aux scellés apposés après le décès de mondit feu seigneur duc d'Aumont, d'autre part ; par laquelle ordonnance j'ai été nommé tiers expert à l'effet de procéder à la visite, prisée et estimation des ouvrages de dorure et ciselure faits par led. sieur Gouthières pour mondit feu seigneur duc d'Aumont, en la présence de deux premiers experts qui ont déjà procédé à l'estimation des ouvrages de ciselure et dorure et ont donné leur avis séparément, attendu leur contrariété, après avoir prêté le serment en tel cas requis, dont m'a été donné acte, me suis, sur la réquisition de toutes les parties, accompagné des sieurs François Rémond et Jean-Claude-Thomas Du Plessis, tous deux doreurs-ciseleurs, premiers experts, transporté en un hôtel sis en cette ville, place Louis XV, appelé l'hôtel d'Aumont, où étant, j'ai, en présence desdits premiers experts, après m'être fait remettre leurs rapports, et avoir pris l'avis de différences personnes à ce connoissant, et en l'absence des parties, procédé à la visite, prisée et estimation desd. ouvrages ainsi qu'il suit :

J'estime les ouvrages qui enrichissent deux tables de jaspe (**cat. 40**) tant pour ciselure, monture, que pour valeur de bronze, pour dorure et modèle, valoir ensemble la somme de 27,040 livres

J'estime les ouvrages qui enrichissent deux vases verd celadon (**cat. 15**), tant pour bronze, ciselure, monture, dorure et modèle, valoir ensemble la somme de 10,710 livres

J'estime les ouvrages qui enrichissent la pendule, tant pour bronze, ciselure, monture, dorure et modèle, valoir ensemble 5,232 livres

J'estime les ouvrages qui composent les quatre bras de cheminée tant pour bronze, ciselure, monture, dorure et modèles, valoir ensemble la somme de 36,360 livres

J'estime les deux petites girandolles sortant des vases blancs de porcelaine (**cat. 21**), tant pour bronzes, etc. 1,640 livres

J'estime deux petites girandolles sortant d'un tronc de verd céladon, tant pour bronze, etc. 920 livres

J'estime les ouvrages qui enrichissent deux vases de porcelaine bleue à côte (**cat. 17**), tant pour bronze, etc. 3,000 livres

J'estime les ouvrages qui enrichissent deux vases verd céladon formant aiguières (**cat. 16**), tant pour bronze, etc. 1,768 livres

J'estime que les onze articles de dépenses portés dans les deux mémoires de fournitures que le s. Gouthières m'a mis sous les yeux pour être par moi examinés, et montant lesd. mémoires à la somme de 879 livres doivent être modérés à la somme de 800 livres attendu qu'une partie des modèles en terre et en plâtre portes auxd. articles ont servi de moyens pour parvenir à l'exécution de plusieurs articles d'ouvrages.
800 livres

Indépendamment des ouvrages et Mémoires mentionnés cy-dessus, le s. Gouthières m'a représenté différents desseins et projets desd. ouvrages, lesquels ont été ordonnés par Monsgr le duc d'Aumont et n'ont pas eu leur exécution entière; mais partie d'iceux ont été exécutés en cire, en plomb, en cuivre, réparés et prêts à mettre en place, et ont exigé de la part du sieur Gouthières des frais considérables et de fréquents transports de sa personne en l'hôtel d'Aumont, ce qui a occasionné beaucoup de tems et qui l'ont éloigné de ses affaires ; j'estime le tout valoir pour indemnité la somme de 1,000 livres Total. 88,470 livres

Fait, dressé et rédigé audit hôtel d'Aumont, après avoir vaqué à ce que dessus, les 28 novembre, 1er et 3 décembre 1782.
J.-B. Chéret.
Contrôllé à Paris le 20 décembre 1782, reçu quinze sols.
Lezan.

1783, April 8. *Catalogue raisonné d'une très-belle collection de tableaux des écoles d'Italie, de Flandres, de Hollande et de France, pastels, miniatures, figures & bustes de marbres, beaux bronzes, porcelaines anciennes de première qualité, coloriées du Japon, d'ancien Celadon, de la Chine, de Saxe & de Sêve, vases & colonnes de porphyre, verd antique, granit, serpentin, agathes & autres matières, riches meubles de Boule, de laque, feux de Boule & autres objets de curiosité, provenans du Cabinet de M*** [Lebeuf], par J. B. P. Le Brun*

Lot 169. Un très beau vase de serpentin, d'espèce rare, et richement monté par Gottiere : on y voit deux enfant tenant une chute de guirlandes, qui retombent en traversant le devant du vase. Il est posé sur un socle de bronze doré d'or mat. Hauteur totale 14 pouces. Il vient des ventes que nous avons faites de M. L'abbé Leblanc, n° 77, et de madame la duchesse de Mazarin, n°2.
Jean-Baptiste Lebrun *850 livres*

1784, July 27. *Notice d'objets rares et précieux provenans de la succession de Madame la duchesse de Mazarin, dont la vente sera faite en son hôtel, quai Malaquais …*
Bronzes dorés par Gouttier :
9 (**cat. 26**). Un très beau Feu représentant un aigle, les aîles déployées, tenant dans une de ses serres un dragon ou salamandre qu'il terasse, et dans l'autre le foudre de Jupiter ; il est posé sur un socle oval à grandes feuilles d'eau et ornemens de ficelle, avec une base dont le milieu est de forme circulaire à renforcement bleu, sur lequel se détache une frise à rinceaux d'ornemens ; les deux arrieres-corps de forme quarrée sont décorés de guirlandes avec chiffre dessus et rosasse sur les côtés, chacun posé sur huit pieds à cannelures de bronze doré d'or mat par Gouttier. Hauteur 16 pouces, largeur 16 pouces 6 lignes.

10 (**cat. 22**). Une Paire de bras à cinq branches formés de fleurs de pavots sortant de deux tiges nouées sur un brandon d'Amour armé de ses fleches, avec frise d'entrelas et branchages de laurier détachés sur fond bleu, et orné d'une gorge, cercle, et culots chargés de differens ornemens dorés d'or mat par Gouttier. Hauteur totale 29 pouces, largeur 18 pouces.

1784, November 29. *Catalogue de dessins, gouaches, estampes encadrées, bronzes, vases & tables de marbre rare, porcelaines anciennes, pendules, meubles, bijoux, buste & plaques d'agate, & autres effets précieux, appartenans à M***, par Ph. Julliot fils, la vente se fera au plus offrants & derniers enchérisseurs le lundi 29 novembre 1784, à quatre heures précises, & jour suivant s'il y a lieu, dans la grande salle de l'hôtel de Bullion, rue Plâtrière*

Ancien Céladon du Japon

46 (**cat. 16**). Deux Vases à panse de lisbet de ton foncé, fond gauffré & à feuilles de roseau demi-relief, montés en buyre, garnis de collet servant de bec, enrichis d'une tête de faune à branchages de vigne & raisins, & de fil de perles sur son pourtour, & à anse formée par une figure de femme à pieds de satyre, & de socle à entrelacs à jour sur un fond couleur d'eau, avec moulures à feuilles d'ornemens en bronze doré d'or mat par *Gouthière*, sur socle de prime verte : hauteur 17 pouces, socles 6 pouces en quarré, épaisseur 2 pouces

Ces deux Vases, rares par leur qualité, flattent encore par le goût & le fini de leur garniture.

1785, November 15. *Catalogue de Tableaux Italiens, Flamands, Hollandais et Français, Dessins, Estampes [...] Bronzes, Vases de Porphire et autres matières ; Meubles de bois d'acajou, Pendules, Lustres, Feux et Bras de bronze doré ; quatre-vingt Bagues de pierres précieuses ... provenant du Cabinet de M. Godefroy. Par J.B. LeBrun*

226: Deux Médaillons, l'un de Louis XIV et l'autre Louis XV, d'après Bouchardon, dans une bordure de bronze doré, par Goutiere *35 livres*

1787, June 26. *Mémoire des Ouvrages de Modèles, Bronzes, Cizelure et dorure faites pour Messieurs Thélusson, par ordre de Mr. Rumel Sous la Conduite et d'après les desseins de Mr Ledoux Architecte du Roy par Gouthière Cizeleur doreur de Sa Majesté dans le courant de l'année 1784 et 1785* (AN, AB XIX; Baulez 1986, 639-42)

Extrait du Mémoire de Mr. Gouthière
Cheminée du grand Salon
Sçavoir
Pour avoir modelé en terre la cheminée d'après un dessein. Cette cheminée était composée d'une traverse dont la frise était ornée, pa-

reille à celle des piedestaux des côtés ; les montants ornés chacun d'une colonne cannelée avec des tigettes, d'une Baze et d'un chapiteau. Sur ce model il a été fait un bois par M. Pigal menuisier qui lafait poser en place, et d'après, il a été fait plusieurs changemens au désir de M. Le Doux ; et après les avoir faits, il a été arrêté par lui de mettre deux colonnes en bois à chaque montant après ces changemens. Les models en bois ont été portés chez Mr. Le Doux qui a fait plusieurs corrections. Les dits models ont été rapportés dans mes atteliers pour être exécutés sur les colonnes en marbre blanc.

Avoir fait les models des bazes et Chapiteaux et Exécuté en Bronze avec les chandelles, les cannelures et tigettes, tout ajusté sur les marbres.
Pour tous les dits Models, tant en bois, terre et exécution des Bronzes, estimés la Somme de 560 livres
Plus un autre model en terre ou esquisse pour la même cheminée
Savoir
Un côté composé d'une gaine avec un Enfant et l'autre d'une Bacchante ornée d'une draperie de pampre de vignes, d'une ceinture de feuilles de lierre et d'un tambour de basque. Ce dernier model a été arrêté et exécuté tel qu'il est actuellement 192 livres
Avoir fait faire par M. Pigal menuisier, tous les models en bois nécessaires pour les models des deux figures qui font partie et contrepartie et un model entier pour l'exécution des marbres qui a été porté dans les atteliers de M. Le Prince, à lui payé pour tous ces modèles la somme de
 163 livres (payé)
Payé à M. Métivier pour le dessein en grand de ladite cheminée
 120 livres (payé)

 Total 1 035 livres

Cheminée dans le Salon de Musique de Stuc Blanc :
Avoir modelé en terre de grandeur de l'exécution, une cheminée ornée d'une frize dans la traverse avec une moulure en nattes, deux petits Panneaux au dessus des montants ornés de la même moulure et d'une Couronne de Vigne au milieu
au dessous de l'astragale une doucine à feuilles d'Eau faisant le tour de la traverse et avant et arrière corps.
Plus une Baguette ornée de rubans tournant dans tout le tour de l'intérieur.
Plus le panneaux des montants sont ornés d'un tirse dans toute Sa hauteur et par un fleuron d'ornements d'où Sort une branche de lierre montant en feston dans toute la hauteur, le panneau est également orné de la même moulure de celle de panneau de traverse. Cette cheminée porte de l'argeur h.p. [huit pieds] 8 pouces ½ sur 3 pds 5 pouces de hauteur et 11 pouces de saillie
Avoir fait faire un bois sur les Epures qu'en a fait M. Métivier, estimé pour le dit model en terre et celui en bois, sans y comprendre l'Epure de

M. Métivier la somme de 120 livres

Pour avoir fait lesdits models en cire en cire [sic] tels qu'ils Sont détaillés cy dessus, tous tirés d'Epaisseur pour fondre en Cuivre estimés 150 livres

Pour avoir cizelé, limé et reparé tous les models en cuivre Sujets à diminution, Savoir :

Un bout de frize pour la traverse, Un bout de moulure en natte, une couronne de vigne, un Bout de doucine en feuilles d'Eau, un bout de Baguette à Ruban et du montant de feuilles de lierre et tirse pour les jambages de ladite cheminée, estimé la somme de 172 livres (réglé à 120 livres).

Exécution des Bronzes :

Pour avoir fait la frize de la traverse ornée de 26 fleurons d'ornement et d'une grappe de graine à chaque, 27 cossats de pois en palmette avec une grappe de graine, les fleurons en cossats sont posés entre des postes lisses qui font la Baze. Cette frize porte 3 pieds 7 pouces de longueur sur 1 pied 9 lignes de hauteur

Pour le même panneau un cadre en moulure double en corde faisant la natte, il porte de tour 7 pieds 10 pouces.

Plus pour les deux petits panneaux, deux couronnes de vigne et de cadre d'un pied chaque, ce qui fait pour les deux 2 pieds.

Plus pour une moulure en doucine ornée de feuilles d'Eau pour le tour de l'Estragale, elle porte de tour 4 pieds 9 pouces sur 7 lignes de développement, faisant à chaque bout arrière corps sur la face.

Plus une Baguette à Ruban pour le Cadre de l'intérieur de la cheminée, il porte de tour 8 pieds 8 pouces avec deux onglets où on a pris sur pièce une feuille de chaque. Cette moulure fait partie et contre partie.

Plus pour chaque panneau des montants, avoir fait deux montans ornés chacun d'un Tirse avec une pomme de pin et d'un ruban ; Le bas se termine par un fleuron d'ornemens dont Sort une branche de lierre montante en feston autour de chaque Tirse, il porte chacun 2 pieds 3 pouces de hauteur sur 3 pieds de large

Pour les cadres 10 pieds 4 pouces de tour de la même monture de celle du panneau de la traverse estimé pour toutes les dites cizelures la Somme de 778 livres

Monture

Plus, pour la mouture, avoir percé dans les marbres 42 trous pour monter les cadres, avoir ajusté à vis 42 broches, avoir fait tous les onglets au nombre de vingt, les avoir soudés et reparés

Plus, pour avoir monté la frize, les deux couronnes De vigne, et les deux montans, percé dans le marbre 44 trous, fait à vis 44 broches et fait toutes les soudures

Plus pour avoir monté la doucine de dessous l'estragale, percé 9 trous et fait 9 broches à vis, fait les Soudures et reparages.

Avoir monté la moulure à Ruban pour le cadre de l'intérieur, fait les onglets, toutes les Soudures, percé 10 trous dans les marbres et 10 broches à vis, estimé pour la dite monture la somme de 350 livres

Pour avoir doré, surdoré et mis au mat tous les Bronzes d'Italie [sic] cy dessus estimée 540 livres

Pour avoir fourni 14 livres ½ de fonte à 3 livres cy 43 livres

Pour port Et rapport des marbres 12 livres

[note in left margin] Total : 1 500 livres compris models, bronzes et montures quoique le marché comprenne models et montures.

Pour la Cheminée de la Bibliothèque :

Pour avoir fait de grandeur de l'exécution tous les models en terre et en bois pour une cheminée ornée d'une frize d'entrelacs et de fleurons en ornemens et cossats de pois, pour la traverse avec un cadre en Rayes de cœur.

Plus un petit cadre de chaque côté de même moulure avec une Rosette d'ornement pour les panneaux de la console du montant faisant l'avant corps de la traverse sur la face, une tête de Mercure entourée de Branches de lierre

Plus au dessous de l'Estragale, une moulure ornée de feuilles d'ornement et d'un Carré lissé saillant sur le bas des feuilles. Cette moulure passe sur la face et la traverse et se continüe en avant corps tout autour de la console du montant.

Plus une Moulure à Baguette taillée en perle dont une longue et trois rondes, cette moulure fait tout le tour dans œuvre du Chambranle.

Plus, trois cannelures avec leur chandelle et tigette pour chaque Console. Cette cheminée porte 3 pieds 6 pouces de hauteur sur 4 pieds 6 pouces de large et 11 pouces de saillie.

Avoir fait un bois sur l'Epure qu'en a fait M. Mitivier d'après la terre estimé pour le dit model en terre en bois la somme de 144 livres

Plus, avoir fait tous les models en Cire tels qu'ils sont détaillés ci contre, les avoir tous moulés en plâtre tiré d'Epaisseur et reparé pour remettre au fondeur, estimé la Somme de 160 livres

Plus, avoir Cizelé et limé tous les models en Cuivre sujets à la diminution savoir

Un bout de Moulure des Cadres d'un pied de longueur

Un pied de celle à feuilles d'ornement pour l'Estragale

Un pied de frise, la Rosette, une Tigette et une tête en Etain avec sa couronne estimé 172 livres

Exécution des Bronzes :

Avoir fait 11 pieds 10 pouces de moulures à rayes de cœur pour le grand cadre de la traverse et les petits des côtés ; chaque pied de moulures porte 44 Rayes de cœur et 45 perles entre chaque feuille

Plus pour la frize en entrelacs très riche ornée de platebande concaves avec des istets mats sur les côtés ; Le bas des Entrelacs se termine en rouleaux avec un lien en perles, les vides sont remplis avec des Cossats de pois, tigette d'ornement et graines, Elle porte de longueur 3 pieds 6 pouces sur 2 pouces de hauteur

Plus 4 rosettes pour les petits panneaux composés de feuilles d'ornement avec des graines

Plus Sur la face de la Console, deux Têtes de Mercure entourées de branches de lierre avec des paquets de graines

Une moulure en gorge ornée de feuilles d'ornements entre chaque feuille, une Tigette avec une perle ; Elle porte de longueur 7 pieds 6 pouces sur un pied de développement ; chaque pied porte 19 feuilles

Plus la moulure à perles de cadre du dans œuvre de la dite Cheminée, ; Elle porte de tour 8 pieds 7 pouces, chaque pied porte 9 longues perles et 24 rondes.

Plus pour chaque console, trois cannelures de 2 pieds 6 pouces de longueur, sur un pouce de développement chacune une chandelle de 9 pouces de longueur avec une Tigette de 6 pouces ½ de long, Elles portent chacune 4 fleurons et 4 revers en feuilles d'ornement et feuilles d'Eau et un paquet de graines, estimé pour toutes les dites ciselures et riflures la somme de 830 livres

Montures :
Pour avoir monté toute la frize de la traverse avec ses moulures, les couronnes et têtes Sur les avant corps, fait tous tous [sic] les onglets, Soudures et Ragréures, percé tous les trous au nombre de 36 dans les marbres ; fait toutes les broches montées à Vis Sur les cuivres.

Plus pour La monture des deux montans, percé 56. trous pour Les Cannelures et fourni toutes les broches montées à vis, avoir monté à Vis les champs et les tigettes, fait tous les onglets de la moulure, gorge, percé tous les trous dans les marbres et fourni toutes les broches ; avoir monté la moulure à perles faisant cadre dans l'intérieur de la dite Cheminée pour toute la monture, Soudure et Ragréure estimé la somme de 420 livres

Fonte :
Pour 27 livres 8 onces de fonte à 3 livres 82 livres
[note in left margin] Total 1 600 livres à cause du changement de la dorure
Pour port et rapport des marbres, déboursé pour ce 12 livres

Dorure au mat
Pour avoir doré et Surdoré et mis au mat tous les dits Bronzes détaillés ci contre
les avoir remontés
Estimé La Somme de 750 livres

Cheminée du Salon d'automne :
Pour avoir fait un modèle en terre de grandeur de l'exécution orné d'une moulure à Boudin pour le dessous de la tablette, faisant avant corps cintré au dessus des pilastres. Cette moulure est taillée en plate bande et feuilles d'ornement.

Plus les ornemens de la frise et la continuation des mêmes ornemens Sur la partie ceintrée au dessus des colonnes.

Plus, les dites colonnes sont ornées par le haut de guirlandes de fleurs et fruits, le milieu de deux Bandeaux Lisses à perles Et entrelacs, au milieu, Le bas se termine en feuilles d'Eau, Tigette d'un [côté et] lisse avec des perles et d'un culot d'ornement qui termine le bas.

Cette cheminée porte 5 pieds 2 pouces de longueur sur 13 pouces de saillies Et 3 pieds 6 pouces de hauteur

Pour en avoir fait faire un bois sur l'Epure qu'en a fait M. Métivier d'après la terre Estimé pour les dits models en terre et en Bois La Somme de
 130 livres

Plus, pour avoir modelé en cire tous les ornemens détaillés ci contre, les avoir moulés, Reparés prêts à donner au fondeur, estimé la somme de
 150 livres

Plus pour avoir cizelé, Limé les models sujets à diminution pour un bout de moulure d'un pied pour le dessous de la Tablette avec la partie en arrière corps et ceintrée.

Plus un fleuron d'Ornement et un autre en cossats de pois, un demi culot de feuilles d'Eau, un fleuron et un culot d'ornement le tout estimé la somme de
 172 livres

Exécution des Bronzes :
Avoir fait la moulure de dessous la tablette, elle porte de tour 7 pieds 4 pouces de Longueur Sur 14 lignes de dévélopement, Elle est ornée de 7 feuilles d'ornement par pied dans des plates bandes entrelacées au milieu des tigettes à feuilles et pomme de Sapin au bout dans une partie champ Levé les deux parties au dessus des pilastres ceintrées partout chacune 4 feuilles d'angle.

Plus pour la frize, 9 fleurons d'Ornemens Et deux moitiés portant chacun 3 pieds ½ de hauteur.

Plus pour 10 palmettes en cossats de poix avec un aspirail au milieu de même hauteur.

Sur les parties ceintrées deux fleurons d'Ornement Et quatre palmettes de cossats de pois.

Plus pour le haut des deux Colonnes avoir cizelé d'après les cires huit festons et 6 chutes de fleurs Et fruits noués avec des Rubans ; ils portent de tour, 11 pouces sur 4 pouces de hauteur.

Plus au milieu de chaque colonne un bandeau de deux platebandes unies à perles et Entrelacs au milieu ; il porte de tour 9 pieds sur 4 pouces ½ de hauteur, au dessous un culot de feuilles d'Eau montantes de 8 pouces de hauteur Sur 8 de tour avec 8 tigettes à feuilles et graines, au dessous un bandeau lisse avec de fortes perles.

Plus les culots de 16 feuilles d'ornement et 6 feuilles d'Eau Lisses estimé pour toutes les cizelures et Riflures la somme de 856 livres

Monture
Avoir fait toutes les soudures des onglets de la moulure de dessous la

tablette soudé 7 tenons et percé tous les trous dans les marbres.

Plus monté tous les fleurons et palmettes, percé 54 trous dans le marbre Et fourni 54 broche à vis

Plus pour les Guirlandes fait toutes les Soudures percé tous les trous et fourni les broches

Plus pour les tournures des Bandeaux Et la monture.

Pour les culots, toutes les Soudures, Tournures et Ragréures de la total-
ité Estimé la somme de 460 livres

Pour 37 livres ½ de fonte à 3 livres 112 livres

Dorure au mat

Pour avoir doré, surdoré Et mis en couleur mate tous les Bronzes détaillés ci contre faisant la décoration de la dite cheminée Estimé la somme de
 776 livres

Port des marbres 14 livres

[note in left margin] Prix total : 1 600 livres

Chambre à coucher Cheminée :

Pour avoir fait un model en terre de la grandeur de l'exécution de la cheminée, orné de deux consoles sur les montans enrichis au dessus d'une tête de satire coiffée avec des Lieres les Balustres des consoles sont ornées de feuilles d'Eau avec une tigette et des graines, un rang de perles au milieu et des cordes sur les quarrés des côtés ; au dessous des Volutes une grande Branche de pavots avec une fleur sous le Volute ; Le bas se termine par un culot d'ornement, d'où sort la Branche.

Le milieu de la traverse est orné d'un Bouclier orné de deux têtes de Chimère, d'un serpent et deux branches de hoüe soutenües par deux Sphinx dont les queües Se terminent par des Rinceaux d'Ornement, Le dessous de la table Et tout le tour de la traverse est orné de perles. Cette cheminée porte 5 pieds 2 pouces de longueur sur 14 pouces de saillie

Plus pour avoir fait un Bois de grandeur de l'exécution pour donner au marbrier d'après une Epure fait par M. Mitivier [Métivier] Sur le model en terre, estimé pour les dits models la somme de 168 livres

Avoir fait tous ceux en cire pour le fondeur en cuivre tels qu'ils Sont détaillés ci-contre, tous faisant partie et contrepartie tirés d'Epaisseur estimé la somme de 200 livres

Pour avoir cizelé les models des feuilles d'Eau pour Les consoles fait un tête de Satire en Etain, estimé 90 livres

Exécution des Bronzes :

Pour la Tablette et le tour de la traverse, avoir fait 7 pieds 5 pouces de perles et pour le bas de la traverse 9 pieds 6 pouces de la même gros-
seur ; chaque pied porte 46 perles ; Le milieu de la traverse est orné d'une frize composée au milieu d'un Bouclier antique Bretelé dans un fond champlevé, avec une plate bande lisse autour ; le haut se termine par deux têtes de chimères d'où sortent un Serpent et deux branches de hoë posées en Sautoir dessous le Bouclier.

Plus deux Sphinx ailés faisant partie et contre partie qui Supportent le Bouclier ; les queües se terminent en Rinceaux d'ornement aux quels il y a des brandilles de licres de vigne avec des grappes de grains

Cette frise porte 3 pieds 9 pouces de longueur Sur 3 pouces ½ de largeur. Chaque quarré de la traverse faisant avant corps au dessus des Consoles est orné d'une tête de satire coiffée de Liere. Elle porte 4 pouces sur pouces [sic].

Plus chaque console des montans est ornée d'un fort Rang de perles au milieu, posé Sur un quarré ceintré suivant le contour, il porte chacun un pied, chaque pied produit 35 perles en filées

Plus de chaque côté des perles Sur le profil des Balustres, Sont des feu-
illes d'Eau avec des tigettes à fleurons et grappes de grains Sortant d'en-
tre chaque feuille portant 1 pouce de dévelopement deux pieds de ces ornements ; chaque pied porte 21 tigettes, 20 feuilles

Plus 2 pieds 2 pouces de corde de chaque côté des quarrés.

Le Bas d'un des montans est orné d'une forte branche de pavots dont une forte fleur orne le bas de la volute ; cette branche Se termine par un culot d'Ornement, Le tout porte 1 pied 10 pouces de hauteur sur 4 pouces de largeur, chaque montant fait partie et contre partie et cizelé d'après les cires, Estimé pour toutes les Cizelures dont le détail est ci contre, par-
tie desquelles a été faits Sur les cires, le tout terminé avec soin, porté à la Somme de 1 150 livres

Monture :

Pour toutes les perles 24 Broches à Vis, fait tous les trous dans les marbres.

Pour la frize, toutes les Soudures, Ragréures, fait 16. broches à vis et Ecroux, tous les trous à travers le marbre, pour les 2. têtes 4 broches, la monture de chaque Console et montant ont été faite avec sujétion ; fait dans des broches au nombre de 30 pour chaque Console Et 4 pour chaque montant, percé tous les trous dans les marbres dont la grande partie la été tout à travers.

Pour toutes Soudures, Ragréures, percement des trous dans Les marbres, toutes les Vis et Ecroux, fil de fer, Laiton, Eauforte et autres fournitures comprises, Estimé pour tous ces articles la somme de 550 livres

Pour cuivre Brut 36 livres à 3 livres 108 livres

Dorure au Mat

Pour avoir doré, et surdoré, tous les bronzes détaillés ci contre faisant la décoration de la ditte cheminée Estimé la somme de 800 livres

Pour port et Rapport des marbres 15 livres

Payé à M. Mitivier [Métivier] pour les desseins en grand des 4 chem-
inées 144 livres

[note in left margin] Total 1806 livres

[note in left margin] Total général 6840 livres

Total : 11 665 livres

Réccapitulation des 4 cheminées :

Grand Salon pour art. des models	1035 livres
Salon de Musique	2465 livres
Bibliothèque	2570 livres
Salon d'Automne	2670 livres
Chambre à coucher	3225 livres

Arrêtté le présent mémoire par nous architecte du Roy soussigné à la somme de 6 840 livres eu égard aux changements, et à la base établie par les marchés à Paris ce 26 juin 1787 compris les marbres
LeDoux

1787, November 26. *Catalogue de meubles de Boule, bronzes dorés au mat et autres objets précieux, suivi de la Feuille Distribution, de la Vente de M ***[de Vaudreuil]. Par M. Le Brun, Garde des Tableaux de Mgr. Comte d'Artois*

(**cat. 26**) Bronze doré d'or mat. Par Gouttier & autres
372. Un très-beau feu représentant un aigle les ailes déployées, tenant dans une de ses serres, un dragon ou salamandre qu'il terrasse, & dans l'autre, le foudre de Jupiter ; il est posé sur un socle oval, à grandes feu-illes d'eau & ornemens de ficelle, avec une base dont le milieu est de forme circulaire, à renfoncement bleu, sur lequel se détache une frise à rinceaux d'ornemens ; les deux arrière-corps de forme quarrée, sont décorés de guirlandes avec chiffres dessus, & rosaces sur les côtés, chacun posé sur huit pieds à cannelures de bronze doré d'or mat, par Gouttier. Hauteur 16 pouces, largeur 16 pouces 6 lignes. Ils viennent de la vente de Madame la Duchesse de Mazarin. [2000 / *Malas* (Mala)]

(**cat. 22**) Idem, par le même
373. Une paire de bras à cinq branches, formés de fleurs de pavots sortant de deux tiges, nouées sur un brandon d'amour, ornés de flèches, avec fris-es d'entre-lacs & branchages de lauriers détachés sur fond bleu, & ornés de gorge, cercles & culots, chargés de différens ornemens dorés d'or mat, par Gouttier. Hauteur totale 29 pouces, largeur 18. [*1380 / Malas*]

Idem.
374. Une paire pareille aux précédens, de même grandeur. [*1200 / Malas*]

1787, December 10. *Suite et supplément au catalogue de M. le duc de Ch*** [duc de Chabot] vases de porphyre, d'agate et autres matieres précieuses, porcelaines anciennes, meubles de Boule et autres ob-jets rares et curieux, par J. B. P. Le Brun, garde des tableaux de mgr. Comte d'Artois, la vente en sera faite le lundi 10 décembre 1787, et jours suivans, rue de Cléry, n° 96*

299 : Un vase [vert d'Egypte] bien évidé, forme d'ove tronquée, avec couvercle à godron et pomme de pin ; le devant enrichi de têtes d'Apollon & de chutes de draperies venant s'attacher sur les anses de forme quarrée, avec culot à feuilles d'acanthe et guirlande de laurier, le tout en bronze doré d'or mat, par *Gouttier*, hauteur 14 pouces, largeur 8 pouces.

323. Une paire de Bras à deux branches de genre arabesque, suspen-due à un brandon, supérieurement finis & dorés au mat par Gouttière. Hauteur 18 pouces.

1788, March 17. *Catalogue de tableaux, dessins montés et en feuilles, Figures de bronze, de marbre et de terre cuite, Vases de porphyre, serpentin et autres, Pierres gravées, Bijoux, Meubles, Pendules, Montres et autres objets de curiosités ; Provenant du cabinet de M. B*** [Bellangée]*

143 bis. Une garniture de cheminée, composée de deux grands vases de marbre blanc, portant deux girandoles dorées au mat, par Gouthière. La partie du milieu portant une pendule, mouvement de Paris, à sonnerie, ornée de fleurs de bronze dorées au mat.

1792, April 16. *Catalogue d'objets rares et précieux en tout genre formant le Cabinet de M. Aranc [Harenc] de Presles*

Lot 460 : Une paire de flambeaux en fûts de colonnes cannelées, en bobèche formant vase, avec chutes de feuilles et pieds à ornemens, cis-elés avec soin et dorés par Gonthier.
Haut. 8 pouces, diamètre 4. *Non vendu*

1794, January 15 (26 Nivôse An II). *Inventaire et Prisée des tableaux marbres et autres objets trouvés dans la maison de Noailles, sis rue honoré* (AN, F^{17} 1268)

83. Un vase de serpentin antique de belle matière, formé de trois morceaux, monté et enrichi d'Enfants en bronze doré, d'or mat, par Gouthier 720 livres

1794, June 18 (30 Prairial An II). *Inventaire des Objets trouvés au dépôt national de Nesle provenant de Condé Emigré* (AN, F^{17} 1191, 3, item 12)

Suite dans la gallerie
251. une paire de bras à 2 Branches en cariatide d'enfans doré au math par gouthier

253. un autre feu à vases et guirlandes le tout doré au math par gouthier

1794, August 16 (29 Thermidor An II). *Registre des objets d'art du Dépôt national de la rue de Beaune remis aux membres du Conservatoire du Muséum national des arts, etc […] du quatre Germinal, l'an second de la République française, une et indivisible* (Furcy-Raynaud 1912, 275–76)
No. 85–99 (**cat. 7**). Deux pots pourris en forme de melons à côtes, d'ancien bleu, avec têtes de cygnes en bronze doré ; ces deux vases, forme de nacelles, sont montés par Gouthière, l'un d'eux est cassé. Hauteur 8 pouces ; largeur 13 pouces.

1795, April 30. *Catalogue d'objets rares et précieux en tout genre formant le Cabinet de M. Aranc [Harenc] de Presles. Par J. A Le Brun Jeune*

297: Une paire de flambeaux en fûts de colonnes cannelées, en bobèche formant vase, avec chutes de feuilles et pieds à ornemens, ciselés avec soin et dorés par Gonthier.
Haut. 8 pouces, diamètre 4. *71 livres*

1795, October 8. *Catalogue de quelques tableaux […] statues […] Vases et autres objets Du Cabinet du Citoyen Houdon, Sculpteur*
1081: Une paire de Bras à deux branches, formées par des cornes d' abondance, le corps à caducée, enlacé de branches de lauriers, supporté par un nœud de ruban ; ils sont soigneusement ciselés en bronze et dorés par Goutière ; hauteur 21 pouces. *Non vendu*

1796, July 30 and following (12 Thermidor An IV and following). *Livre de Commerce de Collignon* (AD 75, D⁵ B⁶ 2578)

Art 3ème.
Le S. Bertrand Me de dorure boullevard Montmartre près la rue Grange Batelière vis à vis le jardin dit di Frascati, à déposé aujourdhui 26 thermidor pour être vendu au plus offrant et dernier enchérisseur lors de la plus prochaine vente
1. une paire de feux à Syrenne, modèle de Goutière exécutés en bronze doré d'or moulu, les dits defectueux, Pelles, Pinces et Tenailles … 600
2. une paire idem modèle à Lyon, Les figures en couleur vert antique, les accessoires dorés d'or moulu susceptibles de netoyage … 260
3. une paire idem les figures en bronzes couleur vert antique, enrichi de plus que les précédents de deux Boulles [?] de cuivre dorés d'or ainsi que les accessoires 230
- une paire de vases fond bleu ornés de bronzes dorés d'or moulu, Porcelaine du Japon 400 (*propriétaire Bertrand*)

Les quatre articles ci-dessus montant ensemble à la somme de mil quatre cent quatre vingt dix francs sont reportés et réinscripts [?] sous le n° Vingt Sept, 27, ci après, page 5 articles Bertrand.

1797, June 21. *Catalogue des Tableaux capitaux et précieux, miniatures, gouaches, marbres, bronzes, porcelaines, beaux meubles, pendules, dorures […] après décès du Cn Duruey. A. J. Paillet*

57 : Deux deventures de feu, de la plus grande richesse et du meilleur goût dans leur ensemble et leur exécution. Chaque pièce est composée d'une cassolettes montée en trépied, et accompagnée de deux sphinx aîlés, avec plinthes décorées sur la face d'un masque d'Apollon, et des cornes d'abondance. Cet article, de la plus belle dorure au mat et bien ciselé, présente un des ouvrages soignés de Goutière
Delage *902 livres*

1797, November 15. *Vente d'une quantité de beaux Meubles de tous genres, Bronzes, Porcelaine, dont une partie après le décès de ***, et d'autres provenant de la Liste-Civile, dans la maison de feu M. de Choiseul, rue Grange-Bateliere, no. 3, ex-hôtel de la Guerre, près le boulevard des Italiens, auj. 25 et jours suivans, depuis 5 heures jusqu'à 10 de relevée …* (*Annonces, affiches et avis divers*, November 15, no. 53, 1045)

15 novembre 1797 : … magnifique cheminée en marbre, avec figures de bronze et camées, établie par *Goutieres…*

1797, December 11. *Vente de très-beaux Meubles, Dorures, Pendules, Vases, Bronzes, Porcelaines, Tableaux et autres Effets, dans la grande Salle de la maison de Bullion …* (*Annonces, affiches et avis divers*, no. 81, 1510).

…joli meuble formant console et secrétaire, orné de bronze doré au mat par *Gouture* [Gouthière]…

1798, August 13. *Bronzes d'ameublement et meubles français achetés par Paul Ier pour le château Saint-Michel de Saint-Pétersbourg en 1798-1799. Livraison André Cholzen* (Zek 1994, 158)

1: Deux girandoles à 4 lumières chaque, branches de lys et de roses, dorées chez le célèbre Guttierre portées par des figures de femmes debout sur des nuages, piédestaux ronds à 3 faces ornés de bas-relief et de plintes, le tout supérieurement doré au mat, porte jusqu'à la bobèche supérieure 34 pouces, la longueur de la plinte 8 pouces *800 Roubles*

1798, October 28. *Bronzes d'ameublement et meubles français achetés par Paul Ier pour le château Saint-Michel de Saint-Pétersbourg en 1798-1799. Livraison Xavier Labensky* (Zek 1994, 161)

30 : Deux vases en bronze forme Médicis, piédestal en porphyre oriental orné de bronze par Goutier *1 000 Roubles*

1799, September 29 (7 Vendémiaire An VIII). *Notice de Tableaux et Objets curieux de tout genre*

Lot 62 : Un précieux Vase de marbre serpentin de belle qualité ; il est richement décoré de belles figures et autres ornemens dorés au mat par *Goutière*.

1800, December 6. *Catalogue d'Objets Rares et Curieux en tout genre, du plus beau choix. [Robit]. Par Le Brun Jeune.*

175 : Un petit autel triangulaire, copié par Sigisbert, d'après l'antique. Il est enrichi sur trois faces, d'une figure en bas-relief, et de bronze doré au mat par Goutier. Ce joli morceau, d'un ensemble agréable, est placé sur un double socle en marbre vert de mer, avec ornemens de bronze doré. Haut. 32c, larg. 16c. (12 pouces sur 6).

1801, May 11. *Catalogue d'une riche collection de tableaux [...] Le tout provenant du célèbre Cabinet du Citoyen Robit. Par A. Paillet*

206 : Un petit autel triangulaire, copié par le même [Sigisbert], dans les plus belles proportions de l'antique. Ses trois faces sont décorées de bas-reliefs de bronze dorés au mat par Goutière. Ce morceau très-curieux est placé sur un double socle en marbre vert de mer, avec ornemens de bronze. Haut. 32, larg. 16 c. (12 sur 6 pouces)
Lagrange *116 francs*

1802, May 6 (16 Floréal An X). *Vente de BEAUX MEUBLES et EFFETS, Bijoux, Garderobe d'homme, et Linge, rue du Bouloy, maison Paillet, le 17 floréal, 10h du matin...*

...riches Bras de cheminée, de Goutière...

1803, April 18. *Catalogue de Tableaux [...] Groupes et Figures en Marbre et en Bronze [...] Vases de Porphire rouge, Vert antique [...] Porcelaines du Japon, de la Chine, de Saxe et de Sèvres ; riches Meubles de Boulle, et autre dans son genre, etc. Par A. Paillet et H. Delaroche*

372 : Et magnifique Feu en bronze doré par Goutière

1808, February 25. *Envoi des deux mémoires d'ouvrages en bronze, ciselure et dorure faits an l'An 9 (Sept. 1800-1801) par le Sr Gouthière pour la salle des séances du Corps Législatif* (AN, Γ13 1072)

Paris, ce 25 février 1808

Monseigneur,
J'ai l'honneur d'adresser à Votre Excellence les deux mémoires d'ouvrages en bronze, ciselure et dorure faits en l'An 9 par le Sr Gouthière pour la salle des séances du Corps Législatif, au sujet desquels je vous ai prié de me donner vos ordres, par mon rapport du 5 octobre dernier. Les ouvrages que concernent ces 2 mémoires ne pouvant être considérés en effet que comme faisant partie de l'établissement de cette salle, j'ai procédé à leur règlement conformément à la lettre que Votre Excellence m'a fait l'honneur de m'écrire le 31 du même mois : vous verrez, Monseigneur, que celui pour la pendule est réglé à la somme de 3 845 francs
Et celui pour les ornements de l'autel de la Patrie et autres, réglé à celle de 2 890 francs Total 6 736 francs

J'ai l'honneur d'assurer Votre Excellence que j'ai pris toutes les mesures nécessaires pour l'exactitude et la justice de ces règlements qui n'ont pu être terminés plus tôt à cause des réclamations du Sr Gouthière qui ont occasionné beaucoup de révisions, etc.

Je supplie maintenant Votre Excellence de vouloir bien ne pas différer la transmission de ses mémoires à Son Excellence le Ministre des Finances, attendu le temps écoulé depuis que ces ouvrages ont été exécutés et surtout le besoin pressant où se trouve le Sr Gouthière. J'observe qu'il lui a été accordé dans le temps et seulement sur les ouvrages de la pendule, plusieurs acomptes montant ensemble à 1.350 francs environ. Je n'étais pas alors l'architecte du Palais du Corps Législatif mais ces acomptes doivent se trouver inscrits sur les registres de comptabilité du ministère. Je joins à ces mémoires, mais pour la compétence des Bâtiments civils, un 3e mémoire de même ciseleur au sujet de quelques réparations d'ornement qu'il a faits à cette salle pour la Séance de Sa Majesté le 16 août dernier, lequel mémoire j'ai réglé à 209 francs 15 centimes.

Je suis avec un profond respect
Monseigneur
de Votre Excellence
Le très humble et très obéissant
Serviteur.
(signé) Poyet.

A – Mémoire des ouvrages en modèles tant en plâtre qu'en cire, bronze, ciselure, monture et dorure pour la pendule posée dans la salle du Corps Législatif, faits et livrés par les ordres de la Commission des Inspecteurs

et d'après les dessins de M. Gisors jeune, architecte du Conseil, dans le cours et livrés le 4ème jour complémentaire de l'An 9 (21 septembre 1801)
Par Gouthière, ciseleur doreur, demeurant à Paris rue du faubourg Saint Martin, n° 88

Savoir,
Article des modèles pour la pendule du Conseil :
Pour avoir tourné en plâtre un cartel rond qui a 7 pieds 8 pouces de tour sur 7 pouces de large et 5 pouces d'épaisseur, l'avoir disposé au désir de M. Lepaute horloger, pour y placer son mouvement fourni au fondeur en cuivre
Plus avoir modelé en cire tous les ornements qui décorent la pendule, les avoir tous disposés sur des noyaux en plâtre pour donner au fondeur la totalité de tous les bronzes, comme cartel et ornements, pesaient brut sortant des moules 191 livres à 3 ≠ 15s eu égard à la difficulté du cartel qu'il a fallu fondre deux fois, montent à la somme de 717 livres
(réglé à 573 livres)
Plus pour tous les modèles, tant en plâtre qu'en cire,
Estimé à la somme de 272 livres (réglé à 225 livres)

Plus pour un modèle en bois que j'ai fait faire à M. Travers serrurier pour poser le cartel qui m'a été fourni tout limé, pour ce modèle, avoir payé au menuisier la somme de 6 livres
Pour une grande plaque en cuivre rouge qui est posée sur le derrière du cartel pour renfermer le mouvement où l'on a fait une porte qui ferme à charnières, le tout bien plané et dressé, pesant 28 livres 8 onces à 4 livres eu égard au planage et la porte monte à la somme de 114 livres (réglé à 103 livres)

Exécution :
Pour avoir tourné le cartel en cuivre, eu égard au mandrin fait exprès, estimé la somme de 150 livres (réglé à 132 livres)
Pour avoir tourné la grande moulure à godrons qui s'enclave dans la plaque
qui ferme le cartel, estimé cy 48 livres (réglé à 36 livres)
Pour tous les modèles en bois pour la lunette, avoir fourni les bois au tourneur,
vaut pour ce 36 livres (réglé à 30 livres)

Pour le tourneur en cuivre qui a fait tous les cercles de la lunette, ceux qui posent sur le cadran et le cercle qui porte le « grageoir » pour recevoir le verre ajusté sur le grand cercle à rais de cœur, le tout fait avec sujetion, estimé la somme de 136 (réglé à 120 francs)
Pour l'exécution de la ciselure, savoir : le godron du grand cercle, tous les ornements de la gorge du cadran, les branches d'olives et graines qui forment couronne sur la partie plate du rond du cadran, tous les rais-de-

cœur du grand cercle de la lunette, les fleurons qui assemblent toute la jonction des branches d'olives qui font partie et contrepartie ; toute cette ciselure bien finie, estimée la somme de 878 (réglé à 750 francs)
Pour la monture, limure et ajustage bien faits, le tout monté à vis pour faire le nettoyage des dorures, sans risques de refaire le vert antique ; estimé la somme de 640 (réglé à 550 francs)

Dorure au mat :
Avoir doré et surdoré toutes les parties des ornements qui décorent la pendule, détaillées ci-dessus et mis au vert antique le cartel, qui reçoit tous les ornements dorés, le tout bien fini, estimé à la somme de 1 500 (réglé à 1 320 francs)

Total 4 491 (réglé à 3 847 francs)

Le présent mémoire d'ouvrages en bronze, ciselure, dorure etc, faits en l'An 9 pour la pendule de la salle des séances du Corps Législatif, par suite de ceux relatifs à l'établissement de cette salle, vérifié, réglé et modéré à la somme de trois mille huit cent quarante cinq francs, soixante centimes, par moi architecte de ce corps.

Fait à Paris ce 23 février 1808
(signé) Poyet

Nous, membres du Conseil des Bâtiments Civils, après avoir examiné le présent mémoire conjointement avec l'Inspecteur Général de division et les vérificateurs, après avoir revisé les calculs et comparé les prix des ouvrages y mentionnés avec ceux fixés pour l'année où les dits ouvrages ont été faits ; l'avons réglé et arrêté définitivement à la somme de trois mille huit cent quarante sept francs quarante cinq centimes, Paris le 17 mars 1808.

(signé) Raymond, Heurtier,
Peyre, Chalgrin.

B – Mémoire des ouvrages de modèles, bronze, ciselure et monture faits pour orner l'autel de la Patrie, d'après les dessins de M. Gisors jeune, architecte du Corps Législatif et par suite sous la conduite de M. Poyet architecte ; les dits ouvrages faits et fournis le 20 Brumaire An 9 (11 novembre 1800).
Par Gouthière, ciseleur doreur du Corps Législatif demeurant à Paris, rue du faubourg Saint Martin, n° 88.
Savoir,
Article des modèles :
Pour l'exécution de modèles, bronzes, ciselure et monture sur le marbre de l'autel, avoir coulé et moulé tant en plâtre que cire, tiré d'épaisseur les quatre guirlandes ornées de fleurs, feuilles, fruits et patères ; les avoir reparés, mis sur noyau en plâtre pour donner au fondeur en cuivre ; es-

timé pour les dits ouvrages à la somme de 272 (réglé à 225 francs)
Tous les bronzes fondus présent ensemble 125 livres 8 onces à 3 francs,
fait la somme de 439 (réglé à 376 francs)
Pour l'exécution des quatre guirlandes, l'ébauche, riflure et ciselure
bien finie, à 360 (réglé à 330 francs) chaque, fait pour les quatre 1 440
(réglé à 1 320 francs)
Pour les quatre garnitures des rubans, biens fini 400 (réglé à 300 francs)
Pour les quatre patères à 36 (27 francs) pièce, fait 144 (réglé à 108 francs)
Pour la monture en totalité de tous les bronzes, soudure, reparure, vis,
tous les trous percés dans le marbre et reparure, estimé la somme de 640
francs en égard au déplacement des ouvriers réglé à 525 francs

Avoir recuit tous les bronzes et les avoir passés à l'eau forte,
Estimé à 48 francs (réglé à 36 francs)
Total 3 383 francs (réglé à 2 890 francs)

Le présent mémoire d'ouvrages en bronze, ciselure, etc, faits dans la
salle des séances du Corps Législatif en l'An 9, par suite de son établissement, vérifié, réglé et modéré à la somme de deux mille huit cent
quatre vingt dix francs, cinquante centimes.

Fait à Paris ce 23 février 1808
(signé) Poyet
(suit le règlement par les membres du Conseil des Bâtiments Civils,
Raymond, Heurtier, Peyre et Chalgrin)

C – Mémoire du mettage [de la mise] en couleur d'or des six couronnes
de bronze, dont deux en feuilles de chêne, deux en feuilles de laurier et
deux en feuilles d'olivier, avec leurs rubans, posées dessous les niches
de chaque côté du bureau, dans la Salle du Conseil au Palais du Corps
Législatif, d'après les ordres de M. Poyet, architecte.
Par Gouthière doreur, demeurant à Paris rue du faubourg Saint Martin
n° 43.

Savoir,
Pour la couleur d'or des six couronnes de 18 pouces de diamètre, feuilles de laurier et nœud de ruban, les avoir recuites et passées à l'eauforte ; estimé chaque couronne à 30 (22 francs) fait pour les six, 180
(réglé à 135 francs)
Pour les avoir reposées en place, refait plusieurs vis ; estimé chaque à 4
(3 francs), font 24 (réglé à 18 francs)
Pour avoir fait 14 pieds de bande en bronze qui représentent les traits
d'appareil, sur les stucs semblables à ceux qui y sont, à 6 (4 francs) le
pied font 84 (réglé à 56 francs)
Plus dix rosettes en cuivre de 2 pouces de diamètre, ciselées à 2 (1,75 francs)
font 20 francs (réglé à 17,50 francs)
Pour la monture et vis, compris, 10 (réglé à 6 francs)

Total 318 (réglé à 232 francs)

Le présent mémoire, vérifié, réglé et modéré par moi, architecte du
Palais du Corps Législatif à la somme de deux cent trente deux francs
cinquante centimes, sur laquelle il n'a pas été proposé d'acompte.
Fait à Paris ce 20 ventôse An 13 (11 mars 1805)
(signé) Poyet

1808, December 21. *Catalogue des articles curieux et de tout genre,
Composant le riche Mobilier de feu M. De Lagrange*

149. Charmant Cartel à tirage, du nom de *Robin*, dans sa boite du plus
riche modèle, ciselé et doré au mat par *Gouttière*. Cette pièce du meilleur
goût, a fait partie d'un des plus beaux mobiliers de la France. Ouvrage le
plus soigné et parfait de cet Artiste.

1809, December 19. *Catalogue d'une magnifique collection de tableaux flamands et hollandais, bronzes, dorures et objets de curiosité du plus beau choix provenant du cabinet de M. Amman de
Schwanberg de La Haye*

Gouthière :
131 : Un vase de serpentin oriental.
132 : Un bas-relief en marbre blanc statuaire représentant Adam et Eve
dans le paradis terrestre.
133 : Une Coupe en marbre brèche universel, richement montée sur base
à culasse. Les anses et les bords sont précieusement ciselés et dorés.
134 : Deux Vases forme de cassolettes, marbre vert antique, avec anses à
têtes de griffons, et sur des bases de fonte dorée.
135 : Deux coupes d'albâtre montées sur trois pièces de griffe en bronze
vert antique, posés sur un socle de marbre griotte.
Le tout d'un très beau style
146 : Un morceau d'ivoire en relief, représentant le Mariage de Saint
Catherine, encadré sous verre. Ce morceau provient du cabinet de M.
Degang.
137 : Une Coupe en stuc jaune de Sienne

1810, March 14-15. *Catalogue de Tableaux de Grands Maîtres, et autres des Trois Ecoles ; dessins de Bouchardon, et divers articles de
belle curiosité ; Dont la vente au plus offrant et dernier enchérisseur,
aura lieu le Mercredi 14 et Jeudi 15 Mars 1810, de relevée, rue J.-J.
Rousseau, grande salle de l'hôtel de Bullion*

56. Une belle devanture de feu, ciselure et dorure de *Goutière*.

1810, March 20-25. *Vente et ordre de la rare et précieuse collection
de M. Lebrun*

Granit rose d'Egypte :

102 . Deux très beaux vases, forme d'œuf, élevés et évidés, de la plus riche couleur, garnis de bronze de la plus belle exécution, doré au mat, par Gonthier. Ils viennent du premier cabinet de Boisset, no. 453 de sa vente et adjugés 2 000 livres [non attribués à Gouthière dans le catalogue de Randon de Boisset du 27 février au 25 mars 1777].

Appendix 2

BY CHRISTIAN BAULEZ

This appendix is intended to help in understanding Gouthière's personal and professional milieu and to provide a basis for further research. Until now, most of these individuals had been forgotten, but they are here brought back to life through new research into invoices, marriage contracts, bankruptcy records, estate inventories, tax brackets,[1] and other documents held in French archives.

Adan (or Adam), Jacques (ca. 1723–1795)

Marble cutter, received as a master sculptor in 1746. A member of a large family of marble cutters to the king, Jacques was the eldest of the five sons of Jean, marble cutter to the Duke of Orléans, and Edmé Thibeuf. Like his brothers, he followed his father into the family trade. He married Marie-Claude Dumont in 1748[2] and was a *juré* (elected official) of the guild from 1752 to 1754,[3] when he lived on Rue des Filles du Calvaire; after 1773, he lived on Rue Popincourt. Adan worked with top craftsmen on numerous sumptuous residences and civic and religious edifices. About 1775, he met Gouthière, with whom he collaborated at the homes of the Marquis of Voyer, the Duchess of Villeroy, and the Duchess of Mazarin (cats. 35, 49).

Aimé, Nicolas-Joseph

Gilder. In 1783, Aimé married the widow of Louis-Barthélémy Boulanger, another master gilder.[4] In the same year, he and François Rémond[5] were asked to complete the gilding of the bronzes for a large Sèvres vase that had been taken from Duplessis *fils* and entrusted to Pierre-Philippe Thomire. Aimé was in the fifth tax bracket in 1785 and in the seventh in 1786 and 1787. From 1780 to 1785, he was a client of Rémond's, who, on December 7, 1795, was still working on "Aimé pinecones."[6] Aimé had a prestigious clientele, including the Garde-Meuble de la Couronne, for which he cleaned the bronzes for the Château de Rambouillet.[7] The Garde-Meuble de la Reine employed him at the Château de Trianon and the Tuileries, for which he cast, chased, and gilded the small cupid representing Silence that was made for Marie Antoinette's bed.[8] In 1787, he was owed money by Gouthière[9] and Baudart de Saint-James.[10] In 1806, he described himself as a former gilder to the "Mesdames de France" (the king's daughters).[11]

Allenet, Jean-Baptiste (b. 1739)

Caster; resided on Rue des Vieilles-Tuileries. At the age of fifteen, Allenet began an apprenticeship under Antoine-Louis Jobbé (master in 1750).[12] He worked with Gouthière in the early 1780s. Among his most recognizable models are wall lights with three branches, one representing Cupid firing an arrow and another symbolizing Silence; these were chased by Jacques Tiverny and a member of the Lebrun family, assembled by

Boudet, and gilded by Jean-Joseph Brochin (master in 1763).[13] Two pairs from this model belong to the Wrightsman Collection.[14] Allenet went bankrupt in 1786.[15]

Auger, Louis

Sculptor, received as a master in 1782. A pupil of Augustin Pajou's, Auger collaborated with Claude-Nicolas Ledoux at Louveciennes[16] and at the Thélusson residence;[17] with François-Joseph Bélanger;[18] with François-Simon Houlié (ca. 1710–1787); at the dowager Princess Kinsky's residence;[19] and with François Soufflot le Romain (d. 1801) and Jean Lequeu (1757–1826) at the president of Montholon's residence.[20]

Bavelier, Pierre (b. 1759)

Chaser. Little is known of Bavelier's career other than his work for Rémond. He served his apprenticeship under Jean Dubuisson (master in 1765)[21] and was owed money by Forestier's widow from 1781 on.[22] In 1802, he was listed, together with Damerat, as a chaser by the estate of the sculptor Louis-Alexandre Regnier (known as Alexandre) (1750–1802), who collaborated with his brother-in-law, Jacques-Mathieu Lamare, a manufacturer of bronzes.[23]

Bocciardi, Augustin (ca. 1729–1797)

Marble cutter. Born in Genoa, Bocciardi collaborated with Gouthière on work for the Count of Artois, the Duke of Aumont, and the Thélussons. For Marie Antoinette at Fontainebleau, he modeled the ornaments of the chimneypiece in the Cabinet Turc.[24] He also worked with other bronze-makers, including François Rémond, who delivered to him the gilt bronzes for a chimneypiece on October 20, 1789.[25] Other clients included the Marquis of Marigny at Ménars, the Count of Maurepas at Pontchartrain,[26] the Count of Balincourt,[27] and the Duchess of Villeroy.[28] Almanacs of the time cite his skill in creating mausoleums and other ceremonial objects, but he also sculpted figures, as is demonstrated by his submissions to the exhibitions of the Académie de Saint-Luc in 1762 and 1764.[29] Following his death, on April 1, 1797, his workshop was subject to a sale (without a catalogue) that took place on June 8, 1797.[30]

Boivin family

Numerous Boivins were working on metals in the eighteenth century, including some who sold the finest cast-iron firebacks for the Bâtiments du Roi's fireplaces.[31] The Boivin who worked with Gouthière may have been Jacques-Denis Boivin or, more probably, Eloi Boivin. Jacques-Denis began an apprenticeship on March 11, 1764, under the caster François Vast (master in 1763).[32] Eloi commenced his apprenticeship on April 24,

1768, under the caster Antoine Dincre, continuing from December 17, 1769, under Jean-Baptiste Osmont (master in 1764).[33] The sculptor Jean Hauré used Eloi's services, notably in 1786 for the model for the Apollo-mask frieze made for the base of the firedogs for Marie Antoinette's bedchamber at Versailles.[34] Eloi also worked for François Rémond, whose accounting records reflect payments such as 72 *livres* on March 11 and April 10, 1786, for two "goat friezes" and 36 *livres* on May 13, 1786, for "three goats' heads for the large tripods."[35]

Boizot, Louis-Simon (1743–1809)

Sculptor. Boizot supplied Gouthière with the models for the Avignon clock (cat. 19), for Mme Du Barry's chimneypiece at Fontainebleau (cat. 28), and for the silver-gilt candelabra made for Louveciennes. On May 14, 1777, Gouthière paid a Boizot 1,200 *livres* for part of the work "done by him and supplied by the aforementioned Mr. Boizot"[36] (the nature of this is unknown). Gouthière and Boizot seem to have continued to do business together for a long time, as the sculptor's estate owed him 4,326 francs in 1809.[37] Gouthière was not the only chaser-gilder to call upon Boizot's talents: François Rémond equally used his models, from 1785 on, for furniture by the cabinetmaker David Roentgen (1743–1807), for firedogs for Bagatelle, and for candelabra and clocks.[38] Boizot also worked for the Garde-Meuble de la Couronne. In 1786, he made the models for the lions for the firedogs in the Salon de la Paix at Versailles, which were cast by the Forestiers, chased by Thomire, and gilded by Claude Galle.[39] In the same year, again for Versailles, he modeled two sphinxes for the firedogs in the queen's bedchamber, which were chased and gilded by Thomire and Galle.[40] For the desk in Louis XVI's wardrobe at Compiègne, Boizot modeled a figure of a woman from antiquity that was cast by the Forestiers, chased by Thomire, and gilded by Galle; the ornamentation of the same piece of furniture was modeled by Jean Martin.[41] It was again from his models that the main bronzes were produced for the jewelry cabinet ordered in 1787 by Marie Antoinette's Garde-Meuble from the cabinetmaker Jean-Ferdinand-Joseph Schwerdfeger (1734–1818), with casting and chasing by Martincourt and Thomire and gilding by Jean Baptiste Godegrand-Mellet (1750–after 1825).[42]

Boullez (or Boulet), Nicolas (1737–1778)

Gilder, received as a master on May 24, 1766.[43] Son of Pierre, a plowman and innkeeper in Fitz-James (near the town of Clermont-en-Beauvaisis in Oise), Boullez began his first apprenticeship on December 7, 1752, under master caster Simon Noé,[44] starting another on December 6, 1754, with master François Chiboust.[45] He signed his name *Boullez* although his apprenticeship contracts spell his name *Boulet*, which could have led to his being confused with Nicolas Boulet, who became apprentice to master caster Nicolas-Guillaume Morel on August 19, 1737.[46] Boullez lived on Rue Grenetat at the time of his marriage, on June 21, 1768, to the daughter of a plowman and innkeeper.[47] The Portuguese ambassador gave his name to Colonel St. Paul of Ewart[48] for his directory: Boulez, "'At the Pearl of Spain,' 4th floor, Rue Grenetat, between Rue Bourg l'Abbé and Rue Saint-Denis, opposite the mirror maker 'Upon the call of the Indies,' the name on the alley door."[49] On February 29, 1772, the estate inventory of the wife of the cabinetmaker Maurice Bernard Evalde cites Boullez as a creditor for 500 *livres*.[50] On May 28, 1775, Boullez took on Louis-François Duval as his apprentice.[51] That same year, he was a creditor of the sculptor Jean-Baptiste Julia for 1,648 *livres*.[52] In 1776, Philippe-Charlemagne Gérard, a journeyman gilder, owed Boullez 941 *livres*, "after subtraction of days worked at the said Boullez's workshop."[53] On August 19, 1776, the Prince of Nassau-Siegen paid him 658 *livres* for supplies.[54] In 1777, Boullez was a creditor of Jean-Joseph Caille for 1,072 *livres*, after the latter was declared bankrupt. The same year, Caille took over the gilt-bronze manufactory created the year before by the merchant of luxury goods Antoine Magnien.[55] On April 29, 1779, Boullez was cited as a creditor in the settlement of the estate of master caster Étienne Forestier, who died on March 19, 1768.[56] Boullez died in the Couvent de la Charité on March 1, 1778; the appraisal of his workshop conducted by Adrien Dartois and Charles-Louis Berta as part of the estate inventory (begun on March 28),[57] confirms the observations of Colonel St. Paul of Ewart, by mentioning the quality of the models for girandoles, candlesticks, clocks, as well as Boullez's relationships with celebrated clockmakers (Barancourt, Courieult, Gault, Goret, Hardy) and his high-profile clients (Duke of Villequier, Duchess of Villeroy, the farmer-general Ménage de Pressigny). His models seem to have been used by other casters. On November 14, 1780, for the casters Jean-Rémi Carrangeot and Jean-Baptiste Martin Piedeleu, Rémond gilded "a pair of girandoles with figures, model by Boulet" and another pair on January 18, 1781, and also executed for Nicolas-Pierre Delaporte the "matte gilding of a pair of candlesticks with a Boulet tripod."[58] When Carrangeot went bankrupt on July 23, 1787, the inventory mentions "a pair of girandoles, of the Boulet model, with 2 rose branches."[59]

Bourbelain, Michel

Sculptor. Bourbelain began an apprenticeship on August 18, 1757, under the sculptor Charles Carbillet.[60] He went bankrupt on August 20, 1773;[61] Luc-Philippe Thomire and his son Pierre-Philippe then owed him 297 *livres* and a certain "Gauthière" (Gouthière?) 190 *livres*.

Caron, Pierre-Étienne

Caster. A member of an important family of casters related to the Rousseaus, Caron sold cast iron to his uncle Rousseau, then to his aunt Rousseau, Rousseau *le cadet* (the youngest), and his cousins Rousseau *l'aîné* and Rousseau *le jeune*.[62] He worked for Gouthière at least between

1770 and 1780 and may be the same Pierre Caron who was received as a master caster on January 5, 1758.[63] Caron went bankrupt on February 28, 1780; his accounting records reflect minor provisions of cast iron.[64]

Ceriset, François (d. 1758)

Gilder, received as a master in 1739. Ceriset's workshop was on Quai Pelletier in a building bearing the sign of the Soleil d'Or (Golden Sun), where Gouthière apprenticed in the second half of the 1750s. After Ceriset's death, Gouthière married his widow, Marie-Madeleine Henriet, and took over his workshop. Ceriset had three children: Jeanne-Françoise, Claude-François, and Anne-Marguerite. In 1749, he took on Jean-François Ferinet as an apprentice,[65] followed in 1754 by his nephew Jean Va (or Vast).[66] His daughter, Anne-Marguerite, who was tutored by the gilder Nicolas-Claude Hamelin (master in 1750), married a lapidary, Jacques-Louis Noblet.[67] In 1777, a court appointed Claude-Joseph Cerisey (*sic*) trustee of the estate in abeyance of Margueritte Henriet(te), widow of Jean Croutelle.[68] All these individuals belong to the world of metalsmiths, and most originate in the Champagne region.

Collin (or Colin), Pierre

Caster, received as a master in 1783; resided on Rue Saint-Martin. Collin was associated with a certain Fouet, both of whom worked for Gouthière, François Rémond, the Forestiers, and the gilder Marcel-François Noël (master in 1766), who owed them 700 *livres* when he went bankrupt in 1778.[69] Joseph and Pierre Collin, who may have been related, were taxed between the tenth and thirteenth brackets in the years 1785 to 1787.

Damerat, François-Aimé (ca. 1756–1839)

Caster-chaser, received as a master in 1781. Damerat (spelled *Dammeras* in Gouthière's union of creditors)[70] was taxed in the sixteenth or seventeenth bracket in the years 1785–87. In 1789, he resided on Rue Sainte-Avoye, on the corner of Rue de Braque. Beginning in 1785, he seems to have worked with Rémond, specializing in chasing groups of figures and figurative bas-reliefs.[71] He cast a statue of Jean-Dominique Cassini after Jean-Guillaume Moitte.[72] He later chased some of the bas-reliefs of the column for the Place Vendôme and, for the silversmith Louis-Jean-Baptiste Chéret, the silver statue of Peace after the sculptor Antoine-Denis Chaudet (1763–1810).[73] François-Aimé was the elder brother of Pierre-André, known as *le cadet*, and of Nicolas-Antoine, known as *le jeune*, who were also chasers. In 1805, François-Aimé Damerat co-signed with Rémond the bust of Napoleon after Lorenzo Bartolini (1777–1850).[74] He also signed the little statuettes of Napoleon and Marie-Louise that were cast after the antiques in the collection of Dominique-Vivant Denon (1747–1825), the diplomat, designer, man of letters, and director of the Louvre.[75]

Dartois, Adrien

Gilder, received as a master in 1761. The *Almanach Dauphin* indicates that in 1777 Dartois was on Rue Bourg-l'Abbé, where he ran a "manufactory and shop considerable in all areas." He was still there in 1788, in partnership with Edme Sauvageot (master in 1778).[76] In 1786 and 1787, he was taxed in the eleventh bracket, while Sauvageot was in the ninth in 1785 and in the eighth in 1786 and 1787. The partnership seems to have dated back to at least 1783, since on December 17 of that year Dartois and Sauvageot were both owed 312 *livres* by the caster Michel Poisson (master in 1772) upon the latter's bankruptcy.[77] In 1787, he was owed money by Gouthière.[78]

Delaplanche, Pierre-Jean-Baptiste

Sculptor and marble cutter, received as a master in 1774. Delaplanche, who was among Gouthière's creditors in 1787,[79] worked for the Menus-Plaisirs,[80] as well as the Duke of Aumont, producing vases after designs by Bélanger that were intended to be embellished with gilt bronzes by Gouthière. In 1786, Delaplanche was still producing models for vases after designs by Pierre-Adrien Pâris.[81] He was sometimes called upon to assess the collections of his deceased colleagues, such as that of the Tyrolean Joseph Goutheinze (1754–1793), a talented marble cutter and stucco worker who lived at the Hôtel des Arts and was one of Gouthière's neighbors.[82]

Delaporte, Nicolas-Pierre

Gilder, received as a master in 1757. In 1763, Delaporte was among those who challenged the estate of Jean-François Oeben;[83] he was then living on Rue Chapon, where the *Almanach Dauphin* indicates he was still residing in 1777. In 1778, he lived on Rue du Roi de Sicile and was beginning to collaborate with Rémond.[84] Delaporte also worked with the gilder Marcel-François Noël, who owed him 557 *livres* at the time of his bankruptcy in 1778.[85] His business grew to the point where he was taxed in the third bracket in 1786 and in the fourth in the following year. In 1787, he was owed money by Gouthière.[86]

Delunésy, Nicolas-Pierre Guichon

Clockmaker. Delunésy seems to have produced very little work, and his clocks are rare. He went bankrupt on December 20, 1779.[87] His relationship with Gouthière seems to have been a difficult one; in his statement of accounts, he mentions an "entirely new movement for a wall clock bearing my name, which is fitted in a lyre-shaped case of gilded wood that is in my clock display vitrine. Observation: the aforementioned case belongs to Mr. Gouthière who has the copper barrel

and the case for the bezel in which this clock is fitted and then the clock would be complete; but he does not wish to return it to me, nor pay what he owes me according to the sentences I have against him. See in the following claims, the item on Mr. Gouthière. I judge the value of the aforementioned movement with the case 177 *livres*." Delunésy was among those who objected to the total sum of the sale of Gouthière's furniture on November 11, 1784;[88] he declared he was creditor of a sum of 116 *livres* when the bronze-maker surrendered his assets.

Desouches, Jacques-Marie

Caster-chaser. Desouches was a member of a large family of well-known metalsmiths. Marcel Desouches, the father, had three sons who practiced the same profession. Jacques-Marie, living on Rue Geoffroy-l'Angevin in 1779, collaborated with Jean-Louis Prieur and Jean-Joseph de Saint-Germain.[89] He also worked for the Bâtiments du Roi on models by the sculptor Joseph Guibert[90] and produced the bronzes for the opera house[91] and the Sacré-Coeur chapel at the Château de Versailles,[92] as well as those for the dauphin's mausoleum in the cathedral of Sens.[93] Beginning in 1778, he described himself as a master caster and master *tabletier* (a craftsman specializing in the creation of small luxury items, particularly in marquetry in ivory or bone, such as board games).[94]

Doublet, Pierre-Louis

Painter and draftsman. Doublet, who studied at the Académie Royale de Peinture et de Sculpture, collaborated with Gouthière in the early 1770s. In December 1772, he offered Louis XV "an allegorical drawing to serve as a frontispiece for the *Recueil général de tous les ornements antiques et modernes de l'Italie et de la France*,"[95] which may be related to an allegory showing Apollo and Minerva.[96] He became a painter-decorator but in 1778, after a difficult period, had to surrender his assets to his creditors.[97] He had decorated part of the Château de Neuilly for Claude-Pierre-Maximilien Radix de Sainte-Foy—the walls and ceilings of the gallery, the library, and the summer salon.[98]

Dufour, François

Gilder, received as a master in 1774. Dufour was living on Rue Montorgueil when the Duke of Villequier started settling the debts of his father, the Duke of Aumont[99] (who died in 1782), and was living on Rue Saint-Sauveur in 1787 at the time of the bankruptcy of Gouthière,[100] for whom he worked in the 1780s.

Duplessis *fils* (Jean-Claude-Thomas Chambellan-Duplessis) (ca. 1730–1783)

Designer, sculptor, and caster. Son of the sculptor, designer, and silversmith Jean-Claude Chambellan Duplessis (1699–1774), Duplessis *fils* was praised in 1777 for "the handsome candelabra on the corner tables of Mr. [Gaspard Grimod] de La Reynière's fine salon."[101] He also produced the models for the clocks, vases, and candlesticks that were gilded by François Rémond for Dominique Daguerre.[102] His style is easy to recognize because of his mounts for the Sèvres porcelain factory, for which he had the monopoly from 1774 to 1783. When he died, many sought to succeed him as bronze-maker at Sèvres and also to finish the monumental vases commissioned by the Count of Angiviller. Thomire, who was the best placed, criticized "Duplessis's excessive fondness for detached flowers" and recommended clustered garlands, these being "less expensive to gild than separate flowers."[103]

Duval, Jean-Baptiste-François

Gilder, received as a master in 1785; lived on Rue du Temple at the Café de Malte. Gouthière owed Duval money in 1787.[104] Many metal craftsmen shared his surname. One Duval worked with the Garde-Meuble de la Couronne from 1784 to 1788 and had billings for a total of 404 *livres*,[105] and with Rémond from 1783 to 1789.[106] It may have been his workshop that was dispersed beginning on March 20, 1807, and that included tools, some large candelabras with seven lights (of a unique model), and clocks in the form of waterfalls. He was already called modeler (*modeleur*) and chaser (*ciseleur*) when he offered them in 1803 to the first Consul Bonaparte Palais des Tuileries.[107]

Feuchère, Pierre-François (1737–1823)

Gilder-chaser, received as a master in 1763. Feuchère was taxed in the fifth bracket in 1785 and 1787 and in the seventh in 1786, when, like his brother, Jean-Pierre Feuchère (master in 1767), he was at the start of a brilliant career, the beginning of what would become an important dynasty of craftsmen.[108] Between the last quarter of 1784 and the first half of 1788, Feuchère earned 34,774 *livres* for work carried out for the Garde-Meuble de la Couronne.[109] Gouthière owed him money in 1787.[110]

Feuillet, Jean-Baptiste (1737–1806)

Sculptor and marble cutter, received as a master in 1760. Feuillet was taken on as an apprentice in 1750 by Jacques-François Martin (master in 1732).[111] Five architects attended his first marriage in 1761,[112] including Pierre-Noël Rousset, described as a friend; the others were Nicolas-Eustache Frère, Antoine-Joseph Debourge (1737–1811), Pierre Blondel, Jean-Baptiste Le

Boursier (act. 1764–ca. 1795), and Nicolas Durand (1739–1811). His second marriage in 1768 was to the daughter of the sculptor Dominique Pineau (1718–1786).[113] Records reflect his collaboration with Claude-Nicolas Ledoux as early as 1770 and with François-Joseph Bélanger in 1772. Soon after, records place him at Louveciennes, working with Joseph Métivier.[114] Feuillet initially lived on Rue Poissonnière, in premises rented by Louis Trouard (1700–1763), marble cutter to the Bâtiments du Roi. His move in 1772 to Rue du Faubourg Saint-Martin—to a building rented from Jean-Alexandre Martin (1743–after 1795), a painter-varnisher to the king—where he would soon have Thomire as a neighbor, suggests that his business was expanding. This was probably a result of the exploitation of the mines and quarries at Giromagny that belonged to the Duchess of Mazarin; a company had been created on the basis of these deposits in 1765[115] and was modified in 1773.[116] It was Feuillet who presented samples from these quarries on February 7, 1774, at the Académie d'Architecture.[117] He was "entrusted with the task of ornamenting and decorating" these porphyry and granite pieces, which were supposed to "make the Seine a rival of the Nile." They were stored on his premises and listed in an eight-page brochure.[118] In 1776 and 1777, Jacques-François-Dieudonné Lebrun's *Almanach historique* dedicated one of its columns to these "works in porphyry, bloodstone, granite, serpentine, in various colors," emphasizing the lengths to which Feuillet had gone in their creation and the drawings he had volunteered to produce at his clients' request.[119] Among the latter were the architects Jacques Cellerier (1743–1814)[120] and François-Victor Perard de Montreuil.[121] At the same time, Feuillet launched a career as an artist, merchant, and appraiser; his name appeared from then on among the purchasers at the auction sales of the period,[122] which sometimes included his work.[123] His success led him to open an office on Rue du Coq, near Rue Saint-Honoré, the center of the market for luxury goods.[124] Later, he may have suffered from the Duchess of Mazarin's decision to reduce the activity at her mines and quarries to protect her forests,[125] because he left Rue du Coq in 1784 for the Faubourg Saint-Martin. There, under the name of the marble merchant Jérôme-Robert Millin Du Pereux (1735-1794), on March 23, 1784, he sold "a precious collection of marble pieces from Alsace, such as porphyry, granite, serpentine, etc., comprising vases of various forms such as stemmed bowls, basins, and column drums, in both large and small sizes, several of them mounted with matte-gilded bronze and others ready to be gilded, executed after the fine outlines and models of Mr. Feuillet" which was catalogued by Jean-Baptiste-Pierre Le Brun.[126] In his preface, Le Brun lamented the dissolution of the business and invited onlookers to compare "the antique material with that which we call modern." The harsh reality was confirmed soon afterward, on April 6, with the dispersal of his workshop, containing fine pieces and all the tools and utensils of a sculptor.[127] Feuillet then moved to Versailles, where he was a judicial officer (*huissier*) in the chamber of the Count of Artois and the Duke of Berry. When the revolution began, he retired to Provins. Feuillet may have had competition from the lapidaries and agents Jacques

Poncet and Nicolas Perruchot (or Perruchaut) de Longueville (1756–1794), owners of the quarries of "Vosges, and those of Lorraine," which were also rich in granite and porphyry, and who had presented samples for the approval of the Académie Royale d'Architecture in 1786. Charles De Wailly, acting as *commissaire* (a nominated officer officially representing the Académie),[128] seems to have used their materials as early as 1783 for the granite chimneypiece of the new foyer of the Odéon theater in Paris: that year, Poncet requested 2,000 *livres* for this chimneypiece,[129] which is notable, among other things, for its two Egyptian sphinx jambs, though the bronze-makers who produced them are unknown.[130]

Fleyssac, Guillaume

Caster, received as a master in 1775. Fleyssac worked with famed artists and craftsmen such as Gouthière and Jean-Louis Prieur.[131] He declared bankruptcy on June 3, 1777.[132]

Fouet (or Fouay or Fouette)

Caster; resided on Rue du Faubourg Saint-Antoine. Fouet was associated with Pierre Collin.

Gadan, Didier-Hippolyte

Caster. On May 5, 1830, Gadan married Eulalie-Joséphine Jouard,[133] with whom he had three children: Joseph-Casimir (b. 1831), Marie-Clotilde (b. 1833), and Zoé-Françoise (b. 1835). On March 18, 1839, his widow married Louis François, *ouvrier monteur en cuivre* (assembler on copper).[134]

Gilet, Claude-François (1763-1844)

Marble cutter. Gilet went bankrupt in June 1799.[135] Gouthière was among his creditors for 2,000 francs, half of which was due from the financier Nicolas Grandin, who lived on the Place Vendôme (in the former Hôtel de Gramont, which is now the Ritz Hotel), "on behalf of the citizen Gouthière."

Gouthière, Pierre II (d. 1833)

Sculptor and son of Pierre Gouthière. It is not known whether Gouthière's only son took over his father's business or if they ever collaborated. Like his father, he was also living at 88 rue du Faubourg Saint-Martin in 1816, when he was described as a sculptor.[136] He never married. His estate amounted to the potential credit from Du Barry's heirs and a few effects that were returned to the hospice next to the Incurables, where he died. His heirs were the two daughters of Edme-Claude Gouthière, his first cousins, who resided at Chaumont in Champagne.[137]

Guillemain, Charles

Sculptor and marble cutter. Guillemain worked with Gouthière around 1769 on objects sold by the merchant of luxury goods Henri Lebrun. In 1766, Guillemain presented an invoice for 23,080 *livres* to the Duke of Richelieu listing thirty-six items, but the sculptors Philippe Cayeux (1688–1769) and Louis-Eustache Maingot (master in 1749), who were asked to appraise the works, settled the invoice for 15,633 *livres*, declining to mention articles 17 to 20, which were porphyries and probably the most expensive lots.[138] For the carving of four vases out of porphyry column fragments brought back from the Duke of Richelieu's travels in Italy, Guillemain charged the duke 235,000 *livres*, an enormous sum reduced after a lengthy court case. Two of these vases, bought by the Duke of Aumont and then by King Louis XVI, are now in the Louvre.[139] In 1773, Guillemain's name was alongside Gouthière's on the list of the creditors of the box-maker and packer Martin Pailliard, known as Delorme, who had just lost his wife.[140] Guillemain invented the machines that cut the granite discovered in the Vosges and gave it a polished finish. Parisians were able to admire his talent when they viewed the two fonts that Louis XVI had donated to the cathedral of Paris in 1777.[141] In the late 1770s, the Duchess of Mazarin asked him to supply the granite for the chimneypiece in her gallery, and it was after Guillemain's withdrawal that Gouthière was asked to fit his bronzes to blue turquin marble.[142]

Guyart (or Guyard), Jean-Baptiste (act. until 1792)

Caster, received as a master in 1760. There were numerous bronze-makers with this surname. According to the bankruptcy records of Jean-Baptiste Guyart, on June 16, 1774, he was engaged in business with sculptors, casters, and gilders for a very prestigious clientele that included the Duke of Duras.[143] After the reform of the trade communities in 1776, he described himself as a gilder of metals and finally as a caster-chaser-gilder. In 1779, he was working for the Duke of Aumont, perhaps independently of Gouthière.[144] He appears in Rémond's accounting records from 1782[145] and in 1785 was a creditor of the Duchess of Villequier's estate.[146]

Henriet (or Henriette) family

Gouthière's first wife, Marie-Madeleine Henriet, was a daughter of Pierre Henriet, plowman at Donmartin L'Estrée, near Châlons-sur-Marne (today Châlons-en-Champagne). She had a younger sister, Catherine, who on March 2, 1764 married the chaser Pierre Larsonnier (d. 1778)[147] and, after being widowed, married the painter-gilder Nicolas Mangard. The name *Henriet* (sometimes written phonetically as *Henriette*) was shared by several casters and gilders in the eighteenth century, so Marie-Madeleine may also have come from a family of bronze-makers. Jacques Henriet

was admitted as a master caster in 1768, Paul Henriet in 1774, and Jean-Louis Henriet in 1775. All three must have had fairly modest businesses because they were taxed in the sixteenth bracket in 1786 and 1787. In 1799, the caster Claude Galle (1759–1815) had among his stock a clock called "Henriette" representing "Love awakened by the Dawn" and owed 120 *livres* to the same chaser at Rue Monceau Saint Germain.[148]

Hermand, Jean-François

Stucco worker; resided at 158 rue du Faubourg Poissonnière. One of Paris's best stucco workers, Hermand worked for the clients of the architects Jean-Benoît-Vincent Barré (ca. 1730–1824), Antoine-Mathieu Le Carpentier (1709–1773), and Victor Louis (1731–1800).[149] His first known works were the vases executed in 1764 for François-Thomas Germain with gilt-bronze mounts by Gouthière (p. 31 and cat. 3). The same year, he made for the Marquis of Voyer a pedestal intended to support a porphyry vase, both of which are now in the Wallace Collection in London.[150] Between 1770 and 1772, he worked on the stucco decoration for the dining room at the Hôtel de Lassay in Paris.[151] His invoice, settled at 30,000 *livres*, mentioned that the "walls were in stucco in white with veins and parts imitating amethyst prism in wooden frame."[152] In 1787, he produced another pedestal for the *hôtel* of the Garde-Meuble de la Couronne, this time in imitation green granite ornamented with bronzes by Forestier, after drawings by Antoine-François Peyre.[153]

Jacot, Charles

Chaser-gilder; resided on Rue Saint-Anne. Jacot worked with Gouthière between 1785 and 1789. He also worked for Rémond, who billed him on January 8, 1786, for gilding some pedestal bronzes and, in 1788, for ornaments for a clock, candelabra, and firedogs.[154]

Jeannest family

Bronze-makers. Gouthière sold his workshop and models to a certain Jeannest.[155] Originally from Saint-Florentin in the diocese of Sens in central France, Edme-François-Hilaire Jeannest (ca. 1747–1803) was described as a painter-sculptor at the time of his marriage in 1772 to Catherine-Marguerite Gondon.[156] They had three surviving sons: Pierre (b. ca. 1778), Louis-François, and Hilaire-Vital (ca. 1784–1855). Hilaire-Vital was the father of Émile Jeannest (1813–1857), who distinguished himself mainly in England at Elkington & Co., a silver manufacturer in Birmingham.[157] Hilaire-Vital was recorded in 1818 as also living on Rue Sainte-Anastase. Pierre worked as a chaser for François Rémond from 1799 to 1804, but it was Louis-François (ca. 1781–1856), a pupil of the sculptor Philippe-Laurent Roland (1746–1816), who achieved the greatest fame.[158]

Julia, Jean Baptiste (1742–1803)

Sculptor. Julia may have worked with Gouthière in 1774. After he left Toulouse, he tried his luck in Paris, possibly in the workshop of the sculptor Augustin Pajou where he was employed from 1768 to 1770 on the construction of the opera house at the Château de Versailles.[159] He declared bankruptcy in 1775; related documents allow for identification of his professional circle.[160] This included the sculptors Nicolas Auvray, Laurent-François Boichard (this Boichard, known as *l'aîné*, was the brother of Jean-Antoine [1727–1802], who was also a sculptor; the elder brother went bankrupt on May 18, 1776, and among his creditors was a certain Lebeau, possibly Gouthière's chaser),[161] Jean-Baptiste-Joseph Boutry (act. 1782–90), and Jean-Baptiste Rougé; the caster Jean-Louis-Antoine Lebrun (master in 1768); the gold-beater Jean-Bernard Bachellé; Gouthière; the clockmaker Hoguet (probably François II or Jean-Gatien, known as the elder); and the painters Thomas Feron (master in 1757) and Lhuillier. Like Gouthière, several of his collaborators experienced reversals of fortune. In 1777, Julia had to abandon the vast workshops in a house on Rue Poissonnière he had rented from the farmer-general Pierre-Isaac Marquet de Peyre since 1773 (having taken them over from his fellow craftsman Jean-François-Antoine Boulanger, master in 1759).[162] He then set himself up on the Grande Rue du Faubourg Saint-Martin, perhaps not far from Gouthière. However, the move was not sufficient, and he had to leave Paris. Returning to Toulouse, he enjoyed renewed success, notably in the service of Jean Du Barry (1723–1794) and Guillaume Du Barry (1732–1811), the brother-in-law and husband of Louis XV's mistress.[163]

Laplatte, Jean-Benoît (b. 1762)

Caster-chaser. Apprenticed in 1785 to Pierre-François Boitard (1727–after 1804),[164] Laplatte worked for Rémond from 1786 to 1804.

Le Barbier, Jean-Jacques-François (1738–1826)

Illustrator, painter, and draftsman. Le Barbier chose to be called *l'aîné*—probably in 1770—to distinguish himself from a younger brother, Jean-Louis (1742–1792), who died in Rome, where he had been living for five years, and who had set out on the same career path; their work is nonetheless sometimes confused. The youngest brother, Louis (1743–1795), described himself more modestly as an "artiste dessinateur" (artist draftsman). Le Barbier *l'aîné* began and ended his career working for the Bourbon kings, in between experiencing a long period of republican zeal.[165] Among his earliest known works are two allegories of the death of the dauphin, son of Louis XV, which he presented in 1766 and 1767 to the future Louis XVI.[166] In 1781, he composed an allegory of the birth of the new dauphin[167] and in 1784 presented an allegory of the Golden Age to Louis

XVI.[168] In 1785, he completed a circular enamel piece celebrating the birth of the queen's second son.[169] At the same time, he tried his hand at a career in decorating, with work at the Maison du Roi, and in 1770 he received 240 *livres* from the Menus-Plaisirs for a design for theatrical scenery.[170] He collaborated with Ledoux and in 1781 worked with the painter Antoine-François Callet on the decoration of the Hôtel Thélusson, painting a frieze composed of the signs of the zodiac at the base of the cupola of the large salon.[171] Three years later, he produced a perspective view of the *hôtel* itself.[172] In 1785, he and Jean-Démosthène Dugourc organized a new display of the Garde-Meuble de la Couronne's painting and bronze collection, painted some overdoors, made several designs for fabrics, and sold a picture by Mme Vallayer-Coster, as well as his own painting of the Siege of Beauvais (8,000 *livres*).[173] In 1788, the Sèvres porcelain manufactory paid him for the decoration of plates.[174] In the same year, several drawings by Le Barbier are recorded in the sale of a certain Sir Bélangée's collection, among works by Dugourc, Claude-Louis Chatelet (ca. 1758–1794), Doublet, and Gouthière. In 1786, Le Barbier produced his most important decorative work: the Beauvais tapestry manufactory commission for a wall hanging and seats dedicated to the Four Parts of the World.[175] Le Barbier was again associated with the Menus-Plaisirs in 1797, through the sale of the collections of Denis-Pierre-Jean Papillon de La Ferté, the body's former general administrator, which included two of his drawings, *Sacrifice to Love* and *Sacrifice to the God Pan*.[176]

Lejeune, Antoine

Caster, received as a master in 1761; resided on Rue Saint-Martin. Lejeune was appointed assistant syndic for his guild in October 1780. He seems to have been taxed in the seventeenth bracket in 1786 and in the thirteenth in 1787. He worked for Gouthière, as well as for Jean-Louis Prieur.[177]

Lepaute, Jean-André (1720–1789) and Jean-Baptiste (1727–1802)

Clockmakers. The collaboration between Gouthière and various members of the Lepaute family is difficult to establish because clockmakers rarely mentioned the names of the bronze-makers with whom they worked. We know only that when the two Lepaute brothers—Jean-André (*l'aîné*) and Jean-Baptiste (*le jeune*)—set up a company in 1759, they owed money to Luc-Philippe Thomire, the father of Pierre-Philippe, for wall-clock cases.[178] But they also owed money to the caster Charles Benard and Robert Osmont. The name *Lepaute* also appears on the invoice for work Gouthière carried out for the Duchess of Mazarin. Each of the two blue turquin marble pedestals (cat. 49) were to be decorated by a group of female figures sculpted in marble by Jean-Joseph Foucou; each group was to carry a gilt-bronze tripod holding a Sèvres porcelain vase, which would contain a clock movement by Lepaute; each tripod also then served as a nine-candle candelabrum.[179] The duchess's death brought

this ambitious project to a halt, with only the plaster and wax models completed. However, in 1801 Gouthière made a bronze wall clock, again housing a Lepaute movement, for the Salle des Séances of the Corps Législatif (parliament chamber).[180]

Lepine (or Lespine or Delespine), François

Saddler and coachmaker to Marie Antoinette. Lepine was recorded on Rue Saint-Nicaise from 1769[181] and on Rue du Faubourg Montmartre from 1779 on.[182] In the *Supplément aux Tablettes royales de renommée*, an almanac listing the names of famous artists, artisans, merchants, and other professionals, he is mentioned as having "executed the first carriages known as *à la Polignac*, which are of the most pleasurable form and of the finest taste."

Leprince, Louis-François (d. 1814)

Sculptor and marble cutter. Leprince went into partnership with fellow craftsmen Claude-François Gilet, Claude-Jean Declerck, and Jean-Baptiste-Théodore Declerck to establish a "manufactory for marbles, granites, porphyries and other stones, based in the hamlet of La Mouline in the commune of Tillot [Le Thillot, Vosges]."[183] This enabled him, in 1788, to supply the granite for the chimneypieces and altars of the Château de Saint-Cloud to the architect Richard Mique (1728–1794).[184]

Léveillé, Charles (ca. 1729–1795)

Gilder, received as a master in 1763.[185] Léveillé resided on Rue Taranne when he took on his first apprentice, Louis-Baptiste Huot, on March 20, 1764. By 1768, when he was elected *juré* (an elected official) of his guild for two years, he had moved to Rue de Sèvres, where he spent the rest of his career. Contemporary almanacs reflect this address and mention his great skill.[186] The spaces were rented to him by Gilles-Paul Cauvet (1731–1788), the famous ornament designer and sculptor. On June 23, 1770, he was already a creditor of the caster Nicolas-François Delepine's, for the sum of 7,000 *livres*.[187] By testament of January 20, 1774 Marie-Catherine Huot, first wife of the caster Louis-Gabriel Feloix (1730–after 1790), made Charles Léveillé her sole legatee,[188] which could mean that the Huot and Feloix families were bound by a master-student relationship. By 1776, Charles Léveillé started investing in real estate with his second wife, Marie-Françoise Garnier.[189] The same year, he and Louis-Barthélémy Hervieu (1719–1779) appraised a Lepaute clock in the Salon de Compagnie of the Palais Bourbon.[190] On January 23, 1777, Gouthière transferred a debt payment to him,[191] and on October 1 of the same year the Duchess of Mazarin gave him an annuity of 150 *livres* in payment for 3,321 *livres*' worth of supplies she owed since 1771.[192] In 1777, he began to sign the records as one of the suppliers to the Count of Artois for his residence in

the Temple quarter of Paris;[193] between 1781 and 1791, he was also supplier to the Count of Provence (brother of King Louis XVI) and his wife for their residences in Versailles, Rocquencourt, Brunoy, and Paris.[194] The absence of an estate inventory after his death, confirmed by an affidavit dated July 5, 1795,[195] makes it difficult to explain Colonel St. Paul's inclusion of him in his directory of the best craftsmen in Paris.[196] He was the favorite of a number of his clients, among them, the Marquis of Saint-Contest in 1779;[197] Mademoiselle de Condé in 1781;[198] the Prince of Chalais in 1782, who paid 350 *livres* for a sphinx-adorned firedog;[199] Claude-Pierre-Maximilien Radix de Sainte-Foy in 1783 for his *hôtel* on Rue Basse du Rempart;[200] the Marquis of Marigny through his succession settlement of 1783;[201] Nicolas-François Bourgogne, living on the Quai des Théatins;[202] the Count of Canillac residing in the Palais Bourbon;[203] the Marquise of Brunoy, living on Rue du Faubourg Saint-Honoré in 1787;[204] Anne-David-Sophie Cromot of Fougy, superintendent of the Count of Provence's buildings;[205] and Antoine, Duke of Gramont.[206] Also among his clients were the architects François-Victor Perard de Montreuil (recorded in 1782 and on the occasion of his bankruptcy in 1784)[207] and Jean-Baptiste Collin (also known as Cuelin in 1791) during works for the Countess of Provence in Rocquencourt in 1783,[208] as well as the great clockmaker François Berthoud.[209] After the death of the Duchess of Mazarin, it was in Charles Léveillé's workshop that were found the "serpentine vases mounted by Gouthière, adorned by two cherubs in gilt-bronze, and a cup of bloodstone, held up by three cherubs in gilt-bronze," which Léveillé was to clean.[210] The Duchess of Mazarin owed Léveillé 12,383 *livres* for casting, chasing, and gilding work dating back to 1778.[211]

Lhuillier (or L'Huillier), Nicolas-François-Daniel (1736–1793)

Sculptor. Lhuillier collaborated with Gouthière in the 1770s on a *Recueil d'ornements*. When Lhuillier died in 1793, his employees—the sculptors Jean-Pierre de Monpellier, François Feyard, and Jean-Baptiste Jaune—assessed the value of his impressive collection of molds, models, drawings, and engravings, which his patron François-Joseph Bélanger was to buy. Two-thirds of the collection, which was well known among Parisian decorators, was kept in three workshops on Rue du Faubourg Saint-Martin, while the rest was with Gouthière.[212] The most highly prized piece—"an antique bronze bas-relief representing female figures dancing, known as the borgeze hours," valued at 1,000 francs—was stored on the premises of a certain Mollard, the justice of the peace who had affixed the seals. In the various workshops and at Gouthière's, several more or less complete casts of these Borghese dancers were found. The marble originals are now in the Louvre, and a bronze example is in the Wallace Collection.[213] They were among the most widely used antique models in the eighteenth century, and Bélanger employed them very often; they appear in the decoration of Gouthière's house, most of the plaster decorations for which were from Lhuillier's molds,[214] giving it a

style similar to that of Bélanger. However, this decoration was probably made for Nicolas-Hercule Arnoult, Gouthière's notary and the new owner of his *hôtel particulier*. Around 1768, after a long period of training in Rome, where he was a pupil of the architect Charles-Louis Clérisseau (1721-1820) and became acquainted with Giovanni Battista Piranesi (1720-1778), Lhuillier returned to Paris with a rich collection of drawings and molds that he would use throughout his career. After his partnership with Jean-Siméon Rousseau was dissolved in 1772,[215] he collaborated with the architect Alexandre-Théodore Brongniart for Charles-Louis de Preissac, Count of Esclignac (d. 1777); at the home of Paul-François of Quelen, Marquis of Saint-Maigrin, for the dauphine Marie Antoinette; and for a certain Delaborde, who was probably the banker Jean-Baptiste de Laborde (1724-1794). He competed for the sculpture of the new wing at Versailles at the same time as Jules-Antoine Rousseau and his two sons.[216] He appears again in 1778–79, working under Chalgrin at the Duchess of Mazarin's residence.[217] He was then living on Rue du Faubourg Saint-Denis, not far from Gouthière. Debts were probably the cause of his being jailed in 1782 at La Force prison, following work he had commissioned in 1779 from the painter-gilder Léonard Delafond for the Salle des Spectacles des Élèves at the Opéra.[218] In 1788, he was involved in a dispute with Thomire for models of sculptures.[219] In 1791, he was owed money by Anne-David-Sophie Cromot de Fougy (1760-1845), superintendent of the Count of Provence's Bâtiments, apparently for work at his home and at the Palais du Luxembourg.[220] He was then living at 200 rue du Faubourg Saint-Martin, perhaps even closer than before to Gouthière, who was living on the same street, at number 88. One of his last recorded works, for the architect Jacques Cellerier (1743-1814), was the decoration of the hearse taking Voltaire's ashes to the Panthéon.[221]

Ligois (or Liegois or Leligois), Jean-Barthélémy

Gilder, received as a master in 1784; resided on Rue Guerin-Boisseau. Ligois came from a family of gilders. His father was Jean-Jacques Ligois (master in 1757). Ligois *père* and *fils* appear on lists of taxation in the fifteenth bracket in 1785, in the fourteenth in 1786, and in the thirteenth in 1787. In 1787, Jean-Barthélémy was owed money by Gouthière and 500 *livres* by fellow gilder Marcel-François Noël at the time of the latter's bankruptcy.[222]

Martin, Jean (d. 1800)

Sculptor; lived on Rue Frépillon "at a baker's, opposite the lottery ticket seller near the Saint-Martin Market." A member of the Académie de Saint-Luc,[223] Jean Martin might have been the Jean-Louis Martin, admitted as master sculptor on October 26, 1772.[224] He worked on the ornamentation of the École de Chirurgie built by Jacques Gondoin, designer to the Garde-Meuble de la Couronne,[225] and also collaborated with Jean-Louis Prieur,

a designer, sculptor, and chaser.[226] His longest collaboration was with his brother-in-law, the designer Jean Pierre Bureau (b. 1749).[227] However, it was for his contribution to the production of royal furniture with the sculptor Jean Houré that his work is best documented. For the Tuileries, Versailles, Compiègne, Fontainebleau, and Saint-Cloud, Martin modeled wall lights, a chandelier, beds, chairs, and bronze mounts for chests of drawers and secretaires.[228] He seems to have modeled bronze ornaments regularly for several bronze-makers; his name comes up again on February 13, 1781, in relation to models he made of the chimneypiece bronzes in the autumn salon and bedroom at the Thélusson residence. He also worked for the Duchess of Mazarin and was one of her estate's creditors.[229] Martin was clearly one of the best craftsmen in Paris, but the details of his involvement with Gouthière are not known. It is, however, established that on May 23, 1780, the Rousseau brothers had to pay him 1,200 *livres* by fund transfer "for works of sculpture by him made for Gouthière."[230] He also appears in François Rémond's archives from 1786 on, making ornaments for furniture by David Roentgen, for numerous wall clocks and candelabra, and for chandeliers for the Spanish royal court (after designs by Charles Percier).[231] It was with him that Claude-Jean Pitoin had taken modeling lessons in 1776.[232] Jean Martin is still often confused with Gilles-François Martin (master in 1748), sculptor to the Prince of Condé, who lived from 1753 on Rue Meslée.

Mesnard, Nicolas

Sculptor; resided on Rue Saint-Honoré. In 1787, Gouthière owed Mesnard 587 *livres*.[233]

Morant, Louis-Pierre

Chaser, received as a master in 1774. Morant, who worked with Gouthière around 1776, was one of the chasers who worked on the bronzes cast by Joseph-Noël Turpin for the furniture that Jean-Ferdinand-Joseph Schwerdfeger made in 1788 for Marie Antoinette's bedchamber at the Château de Trianon.[234]

Moreau, Georges-Alexandre

Caster, received as a master in 1755. In 1774, Moreau was owed money by the caster Philippe Caffieri (1714-1774).[235] Two years later, in 1776, he was described by the chaser Vincent Guilliard as "Mr. Gouthière's caster". He was also one of Julia's creditors at the time of his bankruptcy in 1775.[236] He was taxed in the tenth bracket in 1786 and in the eleventh in 1787.

Morel *le jeune* (Jean-Baptiste Morel) (d. 1779)

Caster, received as a master in 1761. One of the main casters of the

merchant of luxury goods Dominique Daguerre, Morel was responsible for casting the lily candelabra now at Versailles.[237] At his death, he owed money to Gouthière.

Pitoin (or Pithoin or Pitouin) family

The Pitoin family produced a number of Parisian sculptors. The branch of the family of interest here are the children of Charles Pitoin, who had two sons: (Jean-)Claude and Jean-Baptiste I, himself the father of Jean-Baptiste II, known as *l'aîné,* and who worked in partnership with the sculptor Claude Roumier (master in 1738), whose daughter he married in 1746.[238] Among the attendees at his marriage were the director of the Garde-Meuble de la Couronne, Gaspard-Moïse-Augustin de Fontanieu (1694–1767), as well as Claude Nerot (1673–1750), Charles Tourolle, and Claude-Germain Sallior (d. 1770), the king's specially appointed interior decorator and upholsterer with his wife, Geneviève Tilliard.

(Jean-)Claude Pitoin (d. January 12, 1774),[239] master sculptor in 1730 and subsequently director of the Académie de Saint-Luc, lived his entire life on Rue Meslée, a street that was home to many sculptors. Father to Marie-Madeleine, who in 1775 married the painter Étienne Prussurot,[240] (Jean-)Claude also had a son, Quentin-Claude (ca. 1725–1777), who in 1752 married Élisabeth, daughter of Antoine Lelièvre (d. 1784).[241] Lelièvre became master gilder on metals in 1738.[242] Quentin-Claude was described as "chaser-gilder to the king on metals" as early as 1753 and he supplied the bronzes for the Garde-Meuble de la Couronne for the next fourteen years. He was the first of his family to leave the wood industry for metalwork, taking over from his father-in-law as supplier of bronzes to the Garde-Meuble de la Couronne from 1763 to 1777, with the title of "sculptor, gilder, and silver plater on all metals." His wife died on December 19, 1763, and the inventory of her estate[243] cites 2,212 *livres* owed by the Garde-Meuble and another 1,009 *livres* owed by the Marquise of Pompadour (1721–1764). Mentioned in the list of his debts were 3,806 *livres* owed to his father Claude for sculptural work carried out by their firm; 359 *livres* owed to the master caster and chaser Dangeville (1716–1767);[244] 114 *livres* owed to a gilder named Demellier; and 50 *livres* to the caster Moreau, probably Georges or his son Georges-Alexandre, who became master casters in 1736 and 1754, respectively. He owed a further 84 *livres* to the gold-beaters Simon *fils* and Varnade. Quentin-Claude, then very ill, made his will on May 16, 1777, and added a codicil on June 1.[245] He died two days later,[246] and the inventory of his estate drawn up starting on June 11 reveals a comfortable situation, with 172,130 *livres* owed by the Garde-Meuble de la Couronne for the years 1773–76 alone. His merchandise and tools, which were appraised by two caster-gilders, Louis-Gabriel Feloix (1730–ca. 1789) and Nicolas Henry (act. 1771–ca. 1806), point to a modest workshop, with only two workbenches and two tables. Further investigation of his papers reveals several ledgers tracking activity with his collaborators

and suppliers, such as the widow of the caster Nicolas Agy (Charlotte-Élisabeth Leschevin, 218 *livres* as of September 12, 1776); the casters Louis-Gabriel Feloix (24,168 *livres* as of April 4, 1771, then 3,846 *livres*) and Nicolas Franche (179 *livres* as of March 15, 1764); the silver plater Charles-Nicolas Benoist (394 *livres*); the gilder Nicolas Henry (3,000 *livres*); and the gold-beater Jean-Baptiste-François Villemsens and his mother (371 *livres* as of January 24, 1764, then 914 *livres*). Among his secondary suppliers, for whom there is no specific register, appear the names of the casters Denisot (Jean-Claude [?] for 146 *livres*) and Bernard Douet (1,074 *livres*); the gilders François Dufour (317 *livres* for applying a light blue gilding [*couleur d'eau*] to the grates of a pair of firedogs) and Petitpas (Jean-Jacques?) (1,210 *livres*); the bronze-maker Christophe Lathuilière (387 *livres*); and the locksmiths Jean-Antoine Dangé, his son-in-law (213 *livres*) and Laurent-Augustin Gariby (184 *livres*). As early as September 3, 1776, Quentin-Claude sent his son Claude-Jean to apprentice with Jean-Martin, the most skillful modeler of the time. Quentin-Claude also had a daughter, Diane-Élisabeth, who, on May 30, 1771, married the sculptor Louis-Pierre Fixon (1743–1792), a member of a famous family of sculptors that François-Thomas Germain had employed and that included several painters.[247]

Claude-Jean Pitoin (1757–d. before 1806) took over from his father with the title of "gilder and silver plater of metals to the Garde-Meuble du Roi" and continued to supply pieces in an arabesque style until 1786. He was replaced by craftsmen recruited by the sculptor Jean Hauré, under the leadership of the newly appointed director of the Garde-Meuble de la Couronne, Marc-Antoine Thierry de Ville d'Avray (1732–1792), after which he entered into a risky partnership with Foldekey. Their firm, which acted as an intermediary between various companies, went bankrupt in 1791.[248] He then returned to gilding; at the Exposition des Produits de l'Industrie de l'an IX (1800–1801), he received a silver medal for having perfected the art of gilding on crystal.

The invoices to the Garde-Meuble de la Couronne from Quentin-Claude Pitoin and then from his son, Claude-Jean Pitoin, reveal a dramatic increase in prices caused by the introduction of their rare commissions of matte-gilded objects from 1774 on, all exclusively reserved for the king and queen and the director of the Garde-Meuble de la Couronne, Gaspard-Moïse-Augustin de Fontanieu. Matte-gilded bronzes represented a value of 42,775 *livres* out of a total of 238,135 *livres* for the twenty-two years from 1764 to 1786. This was a little less than a quarter of the total and for only four firedogs, seven pairs of wall lights, six candlesticks, and two ewers, the latter ordered on May 27, 1777, for Marie Antoinette at the Trianon.

Rameau, Jean (ca. 1730–ca. 1806)

Sculptor and silversmith. Rameau collaborated with Gouthière from 1763 to 1766, when he worked in the workshop of François-Thomas Germain,

after which he worked with Pierre-Adrien Jacquemin (1720–1773).[249] His proudest achievement was in 1770, when he produced a group of three Vestals for the Sèvres manufactory; he was so delighted with it that he had the model featured in a portrait that his son-in-law, the painter Joseph-Benoît Suvée (d. 1807), painted of him in 1793.[250] Rameau subsequently worked for Robert-Joseph Auguste (1723–1805) and in 1783 claimed to have been his associate.[251]

Rousseau brothers: Jules-Hugues (1743–1806) and Jean-Siméon, called Rousseau de la Rottière (1747–1820)

Sculptors. Jules-Antoine Rousseau had two sons—both sculptors of the Batiments du Roi. One son, Jules-Hugues, lived in Versailles. The other, Jean-Siméon was based in Paris on Rue du Faubourg Saint-Denis, not far from Gouthière. Gouthière moved in with him in 1786, when he was evicted from his own building. Admitted as master caster on September 16, 1786,[252] Rousseau de la Rottière was taxed in the twelfth bracket around 1787. At the Feuchère sale of December 12–14, 1831, lot 6 was a cupid with tambourine (*amour tambourin*) from a model by Rousseau de la Rottière, chased by Thieret.

Tirel (or Thirel), Pierre-François (1721–after 1810)

Caster, received as a master in 1760. By 1768, Tirel resided on Rue de la Planche-Mibray. He was either extremely active or very unlucky since his name appears often in the proceedings of the bankruptcies of his coworkers: gilders A. Lemaire,[253] Gouthière,[254] and Félix Va (or Vast);[255] casters Jean-Baptiste Guyard,[256] Marcel-François Noël,[257] Charles-François Tournay,[258] and Pierre-Étienne Caron;[259] the dealer Antoine Magnien;[260] and the cabinetmaker Jean-Baptiste Goyer.[261] He was taxed in the fifth bracket in 1786 and 1787, at the same level as Hauré, Chaumont, Mellet, and Thomire.

Turpin, Joseph-Noël (b. 1741)

Caster, received as a master in 1773.[262] Son of Nicolas Turpin and originally from Reims in the Champagne region, Turpin spent most of his career in Paris, though he also distinguished himself in his native town. Denis Dodin, probably his former master, signed his marriage contract in 1778.[263] As early as 1773, he became the associate of Charles-Louis Berta, a caster and chaser, while Turpin himself was really only a caster.[264] His business survived the death of the gilder Nicolas Boullez[265] and the caster Pierre Mathieu Michel,[266] as well as the bankruptcies of many of his coworkers, among them, the gilders Jean-Pierre Cailleux,[267] Nicolas-Louis Gérard,[268] Gouthière,[269] Pierre-Joseph Jollivet,[270] Marcel-François Noël,[271] and Joseph-Denis Rabut;[272] the casters Jean-Rémi Carrangeot,[273] François-Jean Leclair,[274] Pierre-Antoine Dhallut,[275] and Robert Osmond;[276]

the clockmaker and jeweler Hubert Martinet;[277] and the merchants Jean-Charles Fauvelle[278] and Antoine Magnien.[279] He also worked for cabinetmakers François Bapst, Léonard Boudin, and Pierre Roussel. Turpin and Charles-Louis Berta appear in François Rémond's accounting records as early as 1779, for the modeling and gilding of firedogs.[280] Turpin was employed by Hauré for the Garde-Meuble de la Couronne in 1786,[281] and it was in Turpin's workshop that Hauré found the model for a firedog figuring a cherub warming himself up, bought for the Salon des Nobles of the queen.[282] Pierre-Charles Bonnefoy du Plan entrusted Turpin with the casting of bronze work for furniture commissioned from Jean-Ferdinand-Joseph Schwerdfeger (1734–1818) for Marie Antoinette: "to the caster Turpin all the casting and chasing work of the commodes, console tables and other tables for Trianon."[283] In 1787, he was elected manager of his guild of master casters, chasers, and engravers on all metals. During the revolution, he spent his time between L'Isle-Adam and his country house in Nogent-sur-Oise. The Museu Calouste Gulbenkian in Lisbon owns a clock by "Thomas of Paris," surmounted by a gilt-bronze group representing Hercules at the foot of Omphale, signed by Turpin.[284]

Villemet (or Vilmet)

Chaser. Little is known of Villemet (who signed his name *Vilmet*) other than the work he did for Rémond. He is listed as a creditor in the bankruptcy records of casters Louis-Philippe Thomire in 1773[285] and Guillaume-Emmanuel Chenevières (master in 1785) in 1788.[286]

1. AN, H 2118. In 1786, the guild of caster-chaser-gilders was organized into seventeen tax brackets, the first bracket including those paying the highest taxes and therefore those with the highest income (known from the tax lists for 1785–86). See also Verlet 1950, 156; and Verlet 1987, 450–53.
2. AN, M.C.N., XXXVIII 365, March 21, 1748.
3. Guiffrey 1011 15, 162.
4. AN, M.C.N., XV 952, March 28, 1782.
5. On Rémond, see pp. 101–4 in this publication.
6. AN, 183 AQ 7, archival documents relating to Rémond preserved at the Archives du Monde du Travail in Roubaix.
7. AN, O^1 3302, fol. 99, June 10, 1784.
8. AN, O^1 3629, 4th folder.
9. AN, M.C.N., XIV 496, December 10, 1787; T 1725-19, sheet 55; and AD 75 D^4 B^6, box 100, folder 7061.
10. Bibliothèque Marmottan, Boulogne-sur-Seine, rare manuscript 03020, February 1787.
11. AN, O^2 535, folder 3, item 33, July 30, 1806.
12. AN, M.C.N., LXXXV 541, November 10, 1754.
13. AD 75, D^5 B^6 1301, February 6, 1786.
14. Watson 1966, vol. 2, 421, no. 233A-D.
15. AD 75, D^5 B^6, 1301, February 6, 1786.
16. BnF Richelieu, Département des Manuscrits, MS 8158, 136.
17. AN, R^1 317 (1777), R^1 327 (1783).
18. Gallet 1979, 106.
19. Baulez 1984, 118–20.
20. AN, M.C.N., XIV 488, September 23, 1785.
21. AN, M.C.N., CVI 438, October 6, 1771.
22. AN, M.C.N., LV 170, inventory of May 17, 1797.
23. AN, IV 937, September 20, 1802.
24. Cochet and Lebeurre 2015, 56.
25. AN, 183 AQ 1–9.
26. Baulez 1995a, 22–23.
27. AN, M.C.N., XV 921, October 3, 1778.
28. AN, M.C.N., C 866, October 29, 1783.
29. Lami 1910–11, vol. 1, 71–72.
30. *Annonces, affiches et avis divers*, no. 6, September 28, 1802, 87.
31. Palasi 2014, 25.
32. AN, M.C.N., CVI 395, March 2, 1764.
33. AN, M.C.N., CVI 417, April 24, 1768.
34. Verlet 1987, 214–15.
35. AN, 183 AQ 1–9.
36. Baulez 2001a, 276.
37. Picquenard 2001, 32.
38. Baulez 2001a, 274–300; Koeppe 2012, 31–37.
39. Baulez 2001a, 280.
40. Verlet 1987, 214–15.
41. Verlet 1963, 155–57.
42. Baulez 2001a, 281–82; Rondot 2008, 304–5.
43. AN, Y 9330, fol. 189v.
44. AN, M.C.N., LXXX 533.
45. AN, M.C.N., XXXVIII 418.
46. AN, M.C.N., XXXVIII 287.
47. AN, M.C.N., X 603.
48. See pp. 34–35 in this publication.
49. Pradère 1993.
50. AN, M.C.N., LX 400.
51. AN, M.C.N., X 648.
52. AN, M.C.N., XIV 447, August 3, 1775.

53. AN, M.C.N., X 654, liability of May 25, 1776.
54. AN, M.C.N., 750.
55. AN, Y 10794 A, sealed on January 19, 1777; and M.C.N., XLIV 525, invoice of February 10, 1777.
56. AN, M.C.N., XLV 558.
57. AN, M.C.N., XIX 830.
58. AN, 183 AQ 1.
59. AD 75 D^4 B^6, box 99, folder 6943.
60. AN, M.C.N., XXXVIII 437.
61. AD 75, D^4 B^6, box 40, folder 2912.
62. Verlet 1987, 429.
63. AN, Y 9329, fol. 120v.
64. AD 75, D^5 B^6, February 28, 1780.
65. AN, M.C.N., XXXVIII 373, April 13, 1749.
66. AN, M.C.N., XXXVIII 411, April 24, 1754.
67. AN, M.C.N., XXXVIII 373, April 13, 1749; XXXVIII 411, April 24, 1754; XXIV 778, January 10, 1762.
68. AD 75, DC^6 20, fol. 142v, May 3, 1777.
69. AD 75, D^4 B^6, box 68, folder 4469; Augarde 1986; L'Espée 1986.
70. See note 9.
71. AN, 183 AQ 6, 7, 8, 9.
72. AN, 183 AQ 8, fol. 48.
73. Héricart de Thury 1819.
74. Laveissière et al. 2004, 48.
75. Ledoux-Lebard and Ledoux-Lebard 1952, 73–80.
76. Gournay 1788, 484, indicates a Dartois *jeune* living between Rue aux Ours and Rue Bourg l'Abbé, as well as Dartois and Sauvageot on Rue Saint-Honoré.
77. AD 75, D^4 B^6, box 86, folder 5898.
78. See note 9.
79. See note 9.
80. AN, O^1 3072.
81. AN, O^1 3080, folder 3, no. 1001.
82. AN, M.C.N., XXXV 963, May 16, 1793.
83. *Nouvelles archives de l'art français* 1899, 301.
84. AN, 183 AQ 4, fol. 3.
85. AD 75, D^4 B^6, box 68, folder 4409, bankruptcy of July 31, 1778.
86. See note 9.
87. AD 75, D^4 B^6, box 55. Document drawn to the author's attention by Dominique Augarde.
88. AN, M.C.N., XIV 490, November 11, 1784.
89. Augarde 1986, 524; Baulez 2015–16.
90. AN, M.C.N., LXV 374, March 19, 1772.
91. AN, O^1 1203, fol. 187, July 20, 1772.
92. AN, M.C.N., XXXVIII 577, June 23, 1774.
93. AN, O^1 1905, August 12, 1777.
94. AN, M.C.N., XXXVIII 617, May 15, 1779.
95. *Gazette de France*, 1772, no. 103, December 25, 1772, 471.
96. J. Masson sale, September 7, 1923, lot 60.
97. AD 75, DC^6 21, fol. 90v, September 6, 1778.
98. Dulaure 1786, 146–47.
99. AN, M.C.N., VII 457, January 29–30, 1783.
100. See note 9.
101. Lebrun 1777, 188; Darr 1996, 134–38.
102. AN, 183 AQ 1, September 9, 1779, et seq.
103. AN, O^1 20601, item 272, August 31, 1783.
104. See note 9.
105. AN, O^1 3650, folder 1.
106. AN, 183 AQ 1 fol. 284 et seq.; 183 AQ 5, May 6, 1789.
107. *Annonces, affiches et avis divers*, no. 75, March 16,

1807, 1174; AN F^{12} 2282.
108. Ledoux-Lebard 1986, 668–81; Lemaire 1998.
109. AN, O^1 3650.
110. See note 9.
111. AN, M.C.N., XXXVIII 380, March 1, 1750.
112. AN, M.C.N., XXVI 511, April 4, 1761.
113. Biais 1892, 38; Lami 1910–11, vol. 1, 341.
114. Biais 1892.
115. AN, M.C.N., XXIII 672, July 6, 1765.
116. AN, M.C.N., XCI 1109, March 25, 1773.
117. Lemonnier 1911–29, vol. 8, 180–81.
118. "Approbation de Lenoir et Crebillon," September 14, 1776; BnF, Vz 2476 (2462–78). *Mercure de France*, January 1777, 211–15.
119. Lebrun 1776, 143–45; Lebrun 1777, 99.
120. AN, M.C.N., LIII 530, February 23, 1777; ibid., Z^1 J 1023, September 15, 1777.
121. AD 75, D^4 B^6, box 91, folder 6225, June 30, 1784.
122. *Annonces, affiches et avis divers*, February 5 and 11, 1776; June 20, 30 (et seq.), 1779; Conti, Randon de Boisset, Blondel de Gagny, Aumont, Leboeuf, and Saint-Julien sales.
123. Prault sale, November 27, 1780, lot 93.
124. *Nouvelles archives de l'art français* 1885, 121–25.
125. AN, M.C.N., XCI 1196, February 18, 1781.
126. Du Pereux sale, March 23, 1784, which states that Feuillet's workshops were at "Grande rue du Faubourg Saint-Martin, the house of Mr. Martin, varnisher."
127. Feuillet sale, April 6, 1784, catalogued by Lebrun; Baulez 2003, 161–62.
128. Lemonnier 1911–29, vol. 9, 177, 183.
129. AN, O^1 2801, folder 1, December 31, 1783.
130. Thiéry 1787, vol. 2, 389; Rabreau 2007, 113.
131. Baulez 2015–16, 3–5.
132. AD 75, D^4 B^6, box 63, folder 4068 and D^5 B^6 4677.
133. AN, M.C.N., CXXII 1976, inventory of March 8, 1839; remarriage of March 18, 1839.
134. Ibid.
135. AN, M.C.N., XLVI 617, June 25–30, 1799; Chevallier 1989, 68, n. 161.
136. AN, M.C.N., XIX 951B, September 26, 1816.
137. AN, M.C.N., LXXVI 727, August 26, 1837.
138. AN, Y 1902, March 25, 1766.
139. Musée du Louvre, MR 2863 and MR 2864 (Stern 1930, vol. 1, 37–40).
140. AN, M.C.N., XLII 532, inventory of March 15, 1773.
141. Bachaumont 1783–89, vol. 10, 213; vol. 13, 319.
142. See cat. 35 in this publication.
143. AN, M.C.N., XXXIII 602, June 16, 1774.
144. Bibliothèque Municipale, Besançon, Fonds Pâris, MS 7, fols. 30v and 31r.
145. AN, 183 AQ 2, June 22, 1782–December 3, 1784.
146. AN, M.C.N., VII 470, inventory of September 17, 1785.
147. AN, C 672, March 2, 1764.
148. AN, M.C.N., VIII 1325, inventory of 4 Fructidor in the year VII (August 21, 1799). Ledoux-Lebard 1986, 719.
149. Gallet 1995.
150. Wallace Collection, London: F291 (pedestal) and F354 (vase).
151. Macon 1903, 128.
152. Ibid.
153. AN, O^1 3648, folder 3; O^1 3653, folder 1.

154. AN, 183 AQ 6 and 8.
155. Champeaux 1885–1902, 70.
156. AN, XXXIX 539, January 15, 1772.
157. Metman 1989.
158. Ibid.
159. Stein 1912, 187, 342–43.
160. AN, M.C.N., XIV 447, August 3, 1775.
161. AD 75, D⁵ B⁶, 4733, May 18 1776.
162. AN, M.C.N., LVI 185, May 2, 1777 (see also Baulez 2007b); AN, M.C.N., LVI 217, January 15, 1777.
163. Bruand 1992, 284–86.
164. AN, M.C.N., CVI 463, December 24, 1775; AN, 183 AQ 6–7.
165. This artist has recently been the subject of several studies by Thiébault (1987), Jacq-Hergoualc'h (2014), and Viroulaud (2011).
166. *Mercure de France*, March–April 1767, 137.
167. Ibid., November 1781, 45–46, engraved by Godefroy.
168. "A picture comprising an illuminated drawing representing an Old Man crowned by two women with groups of children and animals, with a glass pane over it and with its frame measuring 17 by 21 in. made by Le Barbier the elder in 1784"; an engraving was made of this subject in the following year under the title of *Coronation of La Fontaine by Aesop in the Elysian Fields* by Macret and Guttenberg.
169. AN., O¹ 3634, first half of 1785.
170. AN, O¹ 3114, no. 91.
171. AN, AB XIX 215, December 1784, folder 2, 393.
172. Musée Carnavalet, Paris, E.D.1854.
173. AN, O¹ 3634, first half of 1785; O¹ 3645, Capin's invoice for 1787; O¹ 3295, fol. 13v; O¹ 3651, folder 1 (1788–89); O¹ 3290, fol. 78, line 94.
174. Fuhring 2005, 224–27, 341.
175. Standen 1989.
176. Sale, Paris, Drouot-Richelieu, December 3, 1991, lot 24.
177. AD 75, D⁴ B⁶, folder 68, item 4505, September 22, 1778; Baulez 2015-16.
178. AN, M.C.N., LXIV 366, company founded October 28, 1759.
179. Appendix 1: 1781.
180. Appendix 1: 1808, February 25.
181. Roze de Chantoiseau 1782-92, 67.
182. AN, M.C.N., LXXXV 703, September 5, 1786.
183. AN, M.C.N., XLII 702, December 14, 1799.
184. AN, O¹ 1708, items 209-10.
185. AN, Y 9330, fol. 76v.
186. Lebrun 1776, 188.
187. AN, M.C.N., L 551 (June 23, 1770) and L 559 (June 23, 1771).
188. AN, M.C.N., LXXXII 536, will registered on May 9, 1775.
189. AN, M.C.N., XXVII 387, May 11, 1776.
190. Condé Archives in the Château de Chantilly, AC 7.
191. AN, M.C.N., XIV 456 (debt record).
192. AN, M.C.N., XXIII 756.
193. AN, R¹ 345.
194. AN, R⁵ 49; R⁵ 522.
195. AN, M.C.N., XXVII 545.
196. See pp. 34-35 of this publication.
197. AN, M.C.N., 673, February 5, 1779.
198. Dufour 1977, 372.

199. AN, T 861-63.
200. AN, M.C.N., XV 963, February 18, 1783.
201. AN, M.C.N., L 681, June 13, 1783.
202. AN, M.C.N., CXVII 914, March 6 and 19, 1784.
203. AN, M.C.N., January 27, 1785.
204. AN, T 1094 (7).
205. AN, M.C.N., XXX 517, agreement of March 16, 1791.
206. AN, M.C.N., XCVII 590, agreement of December 10, 1791.
207. AD 75, D⁴ B⁶, box 51, folder 6225, bankruptcy of June 30, 1784.
208. AN, R⁵ 17.
209. Augarde 1984, 74.
210. AN, M.C.N., XXIII 778, March 15, 1781.
211. AN, M.C.N., May 1781.
212. AN, M.C.N., XXII 95, inventory of June 19, 1793.
213. Wallace Collection, London, S155.
214. Marmottan 1927, pls. 9-15.
215. AN, M.C.N., XXXI 193, October 24, 1772.
216. AN, O¹ 1764A.
217. AN, Y 15391, fol. 62v; M.C.N., XLVIII 267, July 31, 1781.
218. AN, M.C.N., CXVII 906, September 27, 1782.
219. Deshairs 1907.
220. AN, M.C.N., XXX 517, March 16, 1791.
221. *Révolution française* 1983, 27-28.
222. AD 75, D⁴ B⁶, box 68, folder 4469, bankruptcy of July 31, 1778.
223. Guiffrey 1914-15, 382.
224. AN, Y 9332.
225. Defives 1996; Champeaux 1898, 62; Baulez 1991a; Gougeon 2014.
226. AN, M.C.N., XLVIII 267, July 3 and 31, 1791; XXIII 803, February 25, 1785; XXIII 812, May 1, 1786.
227. AN, M.C.N., VIII 1261, invoice of August 19, 1784.
228. Verlet 1987, 165, 236, 310, 328.
229. Ibid.
230. AN, M.C.N., XIV 469, May 23, 1780.
231. AN, 183 AQ 1-9.
232. AN, M.C.N., LXXVIII 823.
233. See note 9.
234. Baulez 1980, 113-14.
235. Guiffrey 1885, 52, October 8, 1774.
236. AN, M.C.N., XIV 447, August 3, 1775.
237. AN, Y 121696, July 29, 1779; Rondot and Gautier 2011, 167-69.
238. AN, M.C.N., LXI 431, September 11, 1746.
239. AN, M.C.N., LXXVIII 787, January 21, 1774.
240. AN, M.C.N., LXXVIII 793, March 16, 1775.
241. AN, M.C.N., LII 360, January 21, 1752.
242. AN, M.C.N., LXXVIII 898, October 16, 1784.
243. AN, M.C.N., XLII 488, December 19, 1763.
244. AN, M.C.N., XXXVIII 243, April 22, 1728.
245. AN, M.C.N., LXXVIII 823, June 7, 1777.
246. AN, M.C.N., LXXVIII 823, June 11, 1777.
247. AN, M.C.N., XXXIII 584, May 30, 1771.
248. AD 75, D⁴ B⁶, box 112, folder 8000, June 28, 1791.
249. Nocq 1926-31, vol. 3, 383.
250. The painting is now at the Groeningemuseum in Bruges, Belgium. My thanks to Anne Leclair for this information. See also Préaud and Sherf 2015, 153.
251. Nocq 1926-31, vol. 1, 31, vol. 3, 382-83.
252. AN, Y 9334.

253. AN, M.C.N., CXXI 483, January 18, 1781.
254. AN, M.C.N., XIV 496, December 20, 1788.
255. AD 75, D⁵ B⁶, 4045, December 5, 1772; and ibid., D⁵ B⁶, box 46, folder 2716.
256. AN, M.C.N., XXXIII 602, June 16, 1774.
257. AD 75 D⁵ B⁶, box 68, folder 4469, July 31, 1778, and AN, Y 12478.
258. AN, M.C.N., III 1199, March 30, 1789.
259. AD 75 D⁵ B⁶, 739, February 28, 1780.
260. AN, M.C.N., LXXXIX 717, January 20, 1777.
261. AN, M.C.N., CXXI 461, November 5, 1776.
262. AN, Y 9332, May 28, 1773.
263. AN, M.C.N., VI 817, contract of December 26, 1778.
264. Baulez 1995b, 79.
265. AN, M.C.N., XIX 830, inventory of March 28, 1778.
266. AN, M.C.N., XXXVII 121, inventory of December 31, 1778.
267. AD 75 D⁵ B⁶, 3057, bankruptcy of October 7, 1785; and AN, M.C.N., XIX 874, October 4, 1785.
268. AN, M.C.N., XXVIII 525, February 1, 1787.
269. AN, M.C.N., XIV 496, December 18, 1788.
270. AD 75, D⁴ B⁶, box 47, folder 2759, bankruptcy of February 8, 1773.
271. AD 75 D⁴ B⁶, box 69, folder 4469, fraudulent bankruptcy of July 6, 1778; AN Z² 3806; and ibid., Y 12 478, July 24, 1778.
272. AN, M.C.N., XXIX 570, May 20, 1783.
273. AD 75 D⁵ B⁶, 5237 and D⁴ B⁶, box 99, folder 6943, bankruptcy of July 27, 1787.
274. AN, M.C.N., LXI 631, April 1, 1788.
275. AD 75 D⁴ B⁶, box 84, folder 5632, bankruptcy of March 16, 1782.
276. AN, M.C.N., LXXVI 472, September 23, 1779; and AD 75 D⁴ B⁶, box 90, folder 6142, March 22, 1784. Also L'Espée 1986, 547.
277. AD 75 D⁴ B⁶, box 63, folder 4077 and D⁵ B⁶ 1113, May 10, 1777.
278. AN, M.C.N., CXVI 569, April 29, 1788.
279. AN, M.C.N., LXXXIX 717, renunciation (*abandonnement*) of January 20, 1777.
280. AN, 183 AQ 1-2.
281. AN, O¹ 3640-41 and 3648-50.
282. Verlet 1987, 85.
283. Paulin 2003.
284. Verlet 1987, 260.
285. AD 75, D⁴ B⁶, box 48, folder 2879.
286. AD 75, D⁴ B⁶, box 101, folder 7075.

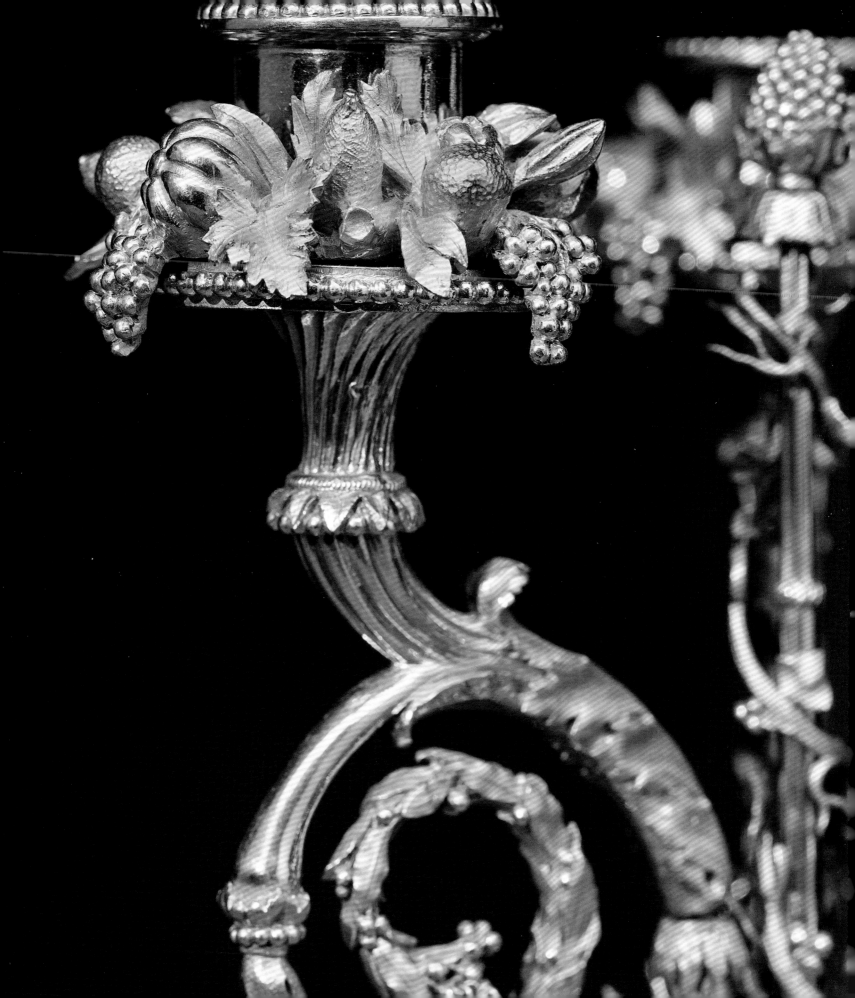

Bibliography

A Encomenda Prodigiosa 2013
A Encomenda Prodigiosa: da Patriarcal à
Capela Real de São João Baptista. Exh. cat.
Lisbon (Museu nacional de arte antiga, Museu
de São Roque), 2013.

Alcouffe 1974
Alcouffe, Daniel. Louis XV: un instant de
perfection de l'art français. Paris: Hôtel de la
monnaie, 1974.

Alcouffe, Dion-Tenenbaum, and Mabille 2004
Alcouffe, Daniel, Anne Dion-Tenenbaum, and
Gérard Mabille. Les Bronzes d'ameublement
du Louvre (Gilt Bronzes in the Louvre). Dijon:
Éditions Faton, 2004.

Augarde 1984
Augarde, Jean-Dominique. "L'atelier de
Ferdinand Berthoud: ses fournisseurs et ses
clients." In Ferdinand Berthoud, 1727–1807
horloger, mécanicien du roi et de la marine,
67–80. Exh. cat. La Chaux-de-Fonds (Musée
international d'horlogerie), 1984.

Augarde 1986
Augarde, Jean-Dominique. "Jean-Joseph
de Saint-Germain, Bronzearbeiten zwischen
Rocaille und Klassizismus," 521–38. Vol. 2. In
Ottomeyer and Pröschel 1986.

Bachaumont 1783–89
Bachaumont, Louis Petit de. Mémoires secrets
pour servir à l'histoire de la République des
Lettres en France, depuis MDCCLXII jusqu'à
nos jours, ou Journal d'un observateur,
contenant les analyses des pièces de théâtre
qui ont paru durant cet intervalle, les relations
des assemblée littéraires . . . London: John
Adamson, 1783-89.

Bailey 2011
Bailey, Colin B. Fragonard's Progress of Love
at The Frick Collection. New York: The Frick
Collection in association with D Giles Ltd, 2011.

Bapst 1886
Bapst, Germain. "Le ciseleur Gouthière,
créancier de l'orfèvre Germain." Courrier de
l'Art (Dec. 1886): 513-14.

Bapst 1887
Bapst, Germain. Études sur l'orfèvrerie française
au XVIIIe siècle: les Germain, orfèvres-
sculpteurs du roy. Paris: J. Rouam et Cie, 1887.

Bapst 1892
Bapst, Germain. L'Orfèvrerie française à la
cour du Portugal au XVIIIe siècle. Paris: Société
d'encouragement pour la propagation des livres
d'art, 1892.

Barbier 2005
Barbier, Muriel. "Les cheminées en marbre du
château de Fontainebleau: étude historique et
topographique," Ph.D. dissertation, École du
Louvre, Paris, 2005.

Bassett and Bewer 2014
Bassett, Jane, and Francesca Gabriella Bewer.
"The Cut-back Core Process in Late 17th- and
18th-Century French Bronzes." In French Bronze
Sculpture: Materials and Techniques 16th-18th
Century, 205-14. London: Archetype, 2014.

Baulez 1980
Baulez, Christian. "Jean-Ferdinand-Joseph
Schwerdfeger: Console." In Cinq années
d'enrichissement du Patrimoine national,
1975-1980, 113-14. Paris: Réunion des musées
nationaux, 1980.

Baulez 1981
Baulez, Christian. "L'Hôtel de Clermont." In Le
faubourg Saint-Germain, la rue de Varennes,
64-74. Exh. cat. Paris (Musée Rodin), 1981.

Baulez 1984
Baulez, Christian. "L'Hôtel Kinsky." In
Le faubourg Saint-Germain, la rue Saint-
Dominique: hôtels et amateurs. Exh. cat. Paris
(Musée Rodin), 1984.

Baulez 1986
Baulez, Christian. "Pierre Gouthière (1732–
1813)," 561–642, 639-42. Vol. 2. In Ottomeyer and
Pröschel 1986.

Baulez 1987
Baulez, Christian. "Le goût turc: François
Rémond et le goût turc dans la famille royale au
temps de Louis XVI." L'Estampille–L'Objet d'art,
no. 2 (Dec. 1987): 34-45.

Baulez 1988
Baulez, Christian. "Bronzes et bronziers de
Bagatelle." In La Folie d'Artois, 142-57. Paris:
Antiquaires à Paris, 1988.

Baulez 1990
Baulez, Christian. "Les imaginations de Dugourc."
In De Dugourc à Pernon: nouvelles acquisitions
graphiques pour les musées, 11-43. Exh. cat. Lyon
(Musée historique des tissus de Lyon), 1990.

Baulez 1991a
Baulez, Christian. "Deux sièges de Foliot et
Sené pour Versailles." Revue du Louvre 1 (Mar.
1991): 76-81.

Baulez 1991b
Baulez, Christian. "Le luminaire de la princesse
Kinsky." L'Estampille–L'Objet d'art, no. 247 (May
1991): 84-99.

Baulez 1992
Baulez, Christian. "Le mobilier et les objets d'art
de madame Du Barry." In Madame Du Barry,
de Versailles à Louveciennes, 25-85. Exh. cat.
Louveciennes (Musée-promenade de Marly-le-
Roi-Louveciennes), 1992.

Baulez 1995a
Baulez, Christian. "Bocciardi." In Allgemeines
Künstlerlexikon, 22-23. Vol. 12. Munich: K. G.
Saur, 1995.

Baulez 1995b
Baulez, Christian. "Toute l'Europe tire ses
bronzes de Paris." In Bernard Molitor, 1755-1833:
ébéniste parisien d'origine luxembourgeoise,
77-109. Exh. cat. Luxembourg (Galerie d'art de la
ville de Luxembourg-Villa Vauban), 1995.

Baulez 1997
Baulez, Christian. "L'ameublement du comte
d'Artois." In Bagatelle dans ses jardins, 89-97.
Exh. cat. Paris (Pavillon de Bagatelle), 1997.

Baulez 2001a
Baulez, Christian. "Les bronziers Gouthière,
Thomire et Rémond." In Boizot 2001, 274-301.

Baulez 2001b
Baulez, Christian. "Le grand cabinet intérieur de Marie-Antoinette: décor, mobilier et collections." In *Les Laques du Japon: collections de Marie-Antoinette*, 28–41. Exh. cat. Versailles (Musée national des châteaux de Versailles et de Trianon), 2001.

Baulez 2003
Baulez, Christian. "Le marquis de Marigny, le comte d'Angiviller et le goût des amateurs de porphyre à Paris au XVIIIᵉ siècle," 152–62. In Malgouyres 2003.

Baulez 2005
Baulez, Christian. "Versailles, la salle des bains de Louis XV restaurée." *L'Estampille-L'Objet d'art*, no. 399 (Feb. 2005): 24–43.

Baulez 2007a
Baulez, Christian. "François Rémond and Chimneypieces for Carlton House, 1787–90." *Furniture History* 43 (2007): 9–19.

Baulez 2007b
Baulez, Christian. "Les boiseries du cabinet intérieur du duc de Choiseul à Chanteloup: Essai d'attribution." In *Chanteloup: un moment de grâce autour du duc de Choiseul*, 234–39. Exh. cat. Tours (Musée des beaux-arts), 2007.

Baulez 2009
Baulez, Christian. "Un auxiliaire du commerce de l'art: Martin Pailliard dit Delorme (1718–1799)." In *Le Commerce du luxe à Paris aux XVIIᵉ et XVIIIᵉ siècles*, 335–52. Bern: Peter Lang, 2009.

Baulez 2014
Baulez, Christian. "Louis-Joseph Maurice (1731–1820), peintre, marchand et antiquaire." *Les Cahiers de l'Histoire de l'Art*, no. 12 (2014): 83–98.

Baulez 2015–16
Baulez, Christian. "Jean-Louis Prieur, une vie au service du bronze doré." In *Dessiner et ciseler le bronze*, edited by Sylvie Legrand-Rossi. Exh. cat. Paris (Musée Nissim de Camondo), 2015–16 (online).

Bellaigue 1974
Bellaigue, Geoffrey de. *The James A. de Rothschild Collection at Waddesdon Manor: Furniture, Clocks and Gilt Bronzes*. Fribourg: Office du Livre, 1974.

Benois 1902
Benois, Alexandre. *Les Trésors d'art en Russie*. Vol. 2. St. Petersburg: Société impériale d'encouragement des Beaux-Arts en Russie, 1902.

Bertrand 1780
Bertrand, Jean Élie. "De la façon de mouler en sable." *Descriptions des arts et métiers*. Vol. 2. Neuchâtel: Imprimerie de la Société typographique, 1780.

Beurdeley 1988
Beurdeley, Michel. *Trois siècles de ventes publiques*. Paris: Tallandier, 1988.

Biais 1892
Biais, Émile. *Les Pineau: sculpteurs, dessinateurs des bâtiments du Roy, graveurs, architectes (1652–1886)*. Paris: Société des bibliophiles françois, 1892.

Billon 2001
Billon, Anne. "Catalogue des modèles de Louis-Simon Boizot à Sèvres," 195–254. In *Boizot* 2001.

Boizot 2001
Louis-Simon Boizot, 1743–1809: sculpteur du roi et directeur de l'atelier de sculpture à la Manufacture de Sèvres. Exh. cat. Versailles (Musée Lambinet), 2001.

Boucher 1927
Boucher, François. "Une collaboration de Gouthière et de Bouchardon." *Bulletin de la Société de l'histoire de l'art français* (1927): 63–66.

Bouilhet 1908
Bouilhet, Henri. *Musée centennal de la classe 94: l'orfèvrerie française à l'exposition universelle internationale de 1900 à Paris*. Saint-Cloud: Belin Frères, 1908.

Brault-Lerch 1986
Brault-Lerch, Solange. *Les Orfèvres de Troyes en Champagne*. Geneva: Droz, 1986.

Bresc-Bautier and Scherf 2008
Bresc-Bautier, Geneviève, and Guilhem Scherf (eds.). *Bronzes français: de la Renaissance au siècle des Lumières*. Paris: Somogy and Musée du Louvre, 2008.

Brette 1906
Brette, Armand. *Atlas de la censive de l'Archevêché dans Paris*. Paris: Imprimerie nationale, 1906.

Brière 1955
Brière, Gaston. "Les transformations du musée de Versailles." *La Revue des Arts* 1 (1955): 2–10.

Bruand 1992
Bruand, Yves. "Les rapports Paris-province: l'hôtel du comte Jean Dubarry à Toulouse." In *Le Progrès des arts réunis 1763–1815: mythe culturel, des origines de la Révolution à la fin de l'Empire? Actes du colloque international d'histoire de l'art, Bordeaux-Toulouse, 22–26 mai 1989*, edited by Daniel Rabreau and Bruno Tollon, 281–89. Bordeaux: CERCAM, Université Michel de Montaigne; Toulouse: Université de Toulouse Le Mirail, 1992.

Brunet and Préaud 1978
Brunet, Marcelle, and Tamara Préaud. *Sèvres: des origines à nos jours*. Fribourg: Office du Livre, 1978.

Cabinet de l'amateur 1845–46
"Ventes publiques: Angleterre, Hollande et Belgique. 1846." In *Le Cabinet de l'amateur et de l'antiquaire*, 425–32. Paris: Techener, 1845–46.

Cabinet de l'amateur 1956
Le Cabinet de l'amateur. Exh. cat. Paris (Orangerie des Tuileries), 1956.

Castellane 1924
Castellane, Boni de. *How I Discovered America: Confessions of the Marquis Boni de Castellane*. New York: A. A. Knopf, 1924.

Castelluccio 2011
Castelluccio, Stéphane. "Louis Marie Augustin, duc d'Aumont (1709-1782): un grand collectionneur de porcelaines orientales." *The French Porcelain Society Journal* 4 (2011): 70-95.

Champeaux 1885-1902
Champeaux, Alfred de. "Gouthière." In *La Grande Encyclopédie: inventaire raisonné des sciences, des lettres et des arts par une société de savants et de gens de lettres*. Vol. 19. Paris: H. Lamirault et Cie, 1885-1902.

Champeaux 1890-91
Champeaux, Alfred de. *Portefeuille des arts décoratifs*. Paris, 1890-91.

Champeaux 1896-97
Champeaux, Alfred de. *Portefeuille des arts décoratifs*. Paris, 1896-97.

Champeaux 1898
Champeaux, Alfred de. *L'Art décoratif dans le vieux Paris*. Paris: Charles Schmid, 1898.

Chevallier 1989
Chevallier, Bernard. *Malmaison: château et domaine, des origines à 1904*. Paris: Réunion des musées nationaux, 1989.

Ciancioni 1950-57
Ciancioni, Gina. "Sur deux pendules de Passemant du musée de Versailles." *Archives de l'art français*, new per., vol. 22 (1950-57): 179-86.

Claeys 2009
Claeys, Thierry. *Dictionnaire biographique des financiers en France au XVIIIᵉ siècle*. Paris: Éditions SPM, 2009.

Cochet and Lebeurre 2015
Cochet, Vincent, and Alexia Lebeurre. *Refuge d'Orient: le boudoir turc du château de Fontainebleau de Marie-Antoinette à Joséphine*. Saint-Rémy-en-l'Eau: Éditions Monelle Hayot, 2015.

Connaissance des arts 1959
"L'énigme de la cheminée la plus extraordinaire." *Connaissance des arts*, no. 85 (Mar. 1959): 86-88.

Cordier 2007
Cordier, Sylvain. "The Dispersal of Furniture by Bellangé from the Maëlrondt Collection." *Furniture History* 43 (2007): 29-41.

Considine and Jamet 2000
Considine, Brian, and Michel Jamet. "The Fabrication of Gilt Bronze Mounts for French Eighteenth-Century Furniture." In *Gilded Metals: History, Technology and Conservation*. London: Archetype Publications, 2000.

Couilleaux 2016
Couilleaux, Benjamin. *Jean-Baptiste Huet: le plaisir de la nature*. Exh. cat. Paris (Musée Cognacq-Jay), 2016.

Courtin 1825
Courtin, Eustache Marie Pierre Marc Antoine. *Encyclopédie moderne, ou Dictionnaire abrégé des sciences, des lettres et des arts*. Vol. 7. Paris: Au bureau de l'Encyclopédie, 1825.

Cunha Saraiva 1934
Cunha Saraiva, José da. *A baixela Germain: subsídios para a sua história*. Lisbon: Bertrand (Irmãos), 1934.

Cuzin, Gaborit, and Pasquier 2000
Cuzin, Jean-Pierre, Jean-René Gaborit, and Alain Pasquier. *D'après l'Antique*. Exh. cat. Paris (Musée du Louvre), 2000.

Dakers 2011
Dakers, Caroline. *A Genius for Money: Business, Art and the Morrisons*. London and New Haven: Yale University Press, 2011.

D'Arcet 1818
D'Arcet, Jean-Pierre-Joseph. *Mémoire sur l'art de dorer le bronze: ouvrage qui a remporté le prix fondé par M. Ravrio et proposé par L'Académie royale des sciences*. Paris: De l'imprimerie de Mme Veuve Agasse, 1818.

Darr 1996
Darr, Alan Phipps. *The Dodge Collection of Eighteenth-Century French and English Art in the Detroit Institute of Arts*. New York: Hudson Hills Press and Detroit Institute of Arts, 1996.

Davillier 1867
Davillier, Charles. "Deux chefs-d'œuvre de Gouthière." *La Chronique des arts et de la curiosité, supplément à la Gazette des Beaux-Arts* 5 (Apr. 7, 1867): 107.

Davillier 1870
Davillier, Charles. *Le Cabinet du duc d'Aumont et les amateurs de son temps: catalogue de sa vente avec les prix, les noms des acquéreurs et 32 planches d'après Gouthière*. Paris: Aubry, 1870.

Defives 1996
Defives, Geraldine. "Recherches sur l'architecte Jacques Gondoin (1737-1818)," Master's diss., Université de Paris–X Nanterre, 1996.

Dell 1992
Dell, Theodore. *The Frick Collection: An Illustrated Catalogue*. Vol. 6, *Furniture and Gilt Bronzes*. New York: The Frick Collection and Princeton University Press, 1992.

Deshairs 1907
Deshairs Léon. "Recherches sur le sculpteur Lhuillier." *Bulletin de la Société de l'histoire de l'art français* (1907): 66-71.

Dezallier d'Argenville 1779
Dezallier d'Argenville, Antoine-Nicolas. *Voyage pittoresque des environs de Paris.* Paris: De Bure, 1779.

Dictionnaire portatif de commerce 1762
Dictionnaire portatif de commerce, contenant la connoissance des marchandises de tous les pais etc. Copenhagen: C. et A. Philibert, 1762.

Diderot and d'Alembert 1751–72
Diderot, Denis, and Jean le Rond d'Alembert. *Encyclopédie, ou Dictionnaire raisonné des sciences, des arts et des métiers.* Paris, 1751–72.

Dilke 1901
Dilke, Emilia Frances Strong. *French Furniture and Decoration in the 18th Century*. London: G. Bell, 1901.

Dodge Collection 1933
A Catalogue of Works of Art of the Eighteenth Century in the Collection of Anna Thomson Dodge. Detroit: Detroit Institute of Arts, 1933.

Dodge Collection 1939
A Catalogue of Works of Art in the Collection of Anna Thomson Dodge: Paintings, Tapestries, Furniture, and Objets d'Art. Detroit: Detroit Institute of Arts, 1939.

Dorival 1989
Dorival, Bernard. "De la tabletterie à la collection d'œuvres d'art. La 'saga' Beurdeley (1814-1919)." *Bulletin de la Société de l'histoire de l'art français* (May 20, 1989): 191-241.

Dreyfus 1913
Dreyfus, Carle. *Catalogue sommaire du mobilier et des objets d'art du XVII^e et du XVIII^e siècle: meubles, sièges, tapisseries, bronzes d'ameublement, porcelaines et marbres montés en bronze, objets d'orfèvrerie.* Paris: Gaston Braun, 1913.

Dreyfus 1922
Dreyfus, Carle. *Catalogue sommaire du mobilier et des objets d'art du XVII^e et du XVIII^e siècle: meubles, sièges, tapisseries, bronzes d'ameublement, porcelaines, marbres et laques montés en bronzes, objets d'orfèvrerie.* Paris: Musées nationaux, Palais du Louvre, 1922.

Dreyfus 1923
Dreyfus, Carle. *Les Objets d'art du XVIII^e siècle.* Paris: Albert Morancé, 1923.

Duclaux 1973
Duclaux, Lise. *La Statue équestre de Louis XV: dessins de Bouchardon sculpteur du Roi.* Exh. cat. Paris (Musée du Louvre), 1973.

Duclos 2009
Duclos, Cyril. "À propos de la paire de bras de lumière de Pierre Gouthière conservée au musée du Louvre." *Revue du Louvre et des Musées de France*, no. 3 (June 2009): 74-78.

Ducrot 1993
Ducrot, Brigitte. *Porcelaines et terres de Sèvres.* Paris: Musée national du château de Compiègne-RMN, 1993.

Du Colombier 1961
Du Colombier, Pierre. "Le duc d'Aumont: la point de l'avant-garde en 1780." *Connaissance des arts*, no. 113 (July 1961): 25-30.

Dulaure 1786
Dulaure, Jacques-Antoine. *Nouvelle description des environs de Paris.* Pt. 1. Paris: Lejay, 1786.

Dulaure 1787
Dulaure, Jacques-Antoine. *Nouvelle description des environs de Paris.* Pt. 2. Paris: Lejay, 1787.

Durand, Bimbenet-Privat, and Dassas 2014
Durand, Jannic, Michèle Bimbenet-Privat, and Frédéric Dassas. *Décors, mobilier et objets d'art du musée du Louvre de Louis XVI à Marie-Antoinette.* Paris: Somogy and Musée du Louvre, 2014.

Dutilleux 1886
Dutilleux, Adolphe. "Le Muséum national et le Musée spécial de l'École française, à Versailles (1792-1823)." In *Réunion des sociétés des Beaux-Arts des départements à la Sorbonne*, 101-30. Paris: E. Plon, Nourrit et Cie, 1886.

Ephrussi 1879
Ephrussi, Charles. "Inventaire de la collection de la reine Marie-Antoinette." *Gazette des Beaux-Arts* 20 (July-Dec. 1879): 389-408.

Eriksen 1974
Eriksen, Svend. *Early Neo-Classicism in France: The Creation of the Louis Seize Style in Architectural Decoration, Furniture and Ormulu, Gold and Silver, and Sèvres Porcelain in the Mid-Eighteenth Century.* London: Faber, 1974.

L'Espée 1986
L'Espée, Roland de. "Die Osmond, ein Familienbetrieb und seine Produktion," 539-47. Vol. 2. In Ottomeyer and Pröschel 1986.

Exposição de ourivesaria 1955
Exposição de ourivesaria portuguesa e francesa. Exh. cat. Lisbon (Fundação Ricardo do Espírito Santo Silva), 1955.

Exposition universelle 1900
Catalogue officiel illustré de l'exposition rétrospective de l'art français des origines à 1800. Paris: Imprimeries Lemercier, 1900.

Faraggi 1995
Faraggi, Catherine. "Le goût de la duchesse de Mazarin: décor et ameublement de son hôtel parisien." *L'Estampille–L'Objet d'art*, no. 287 (Jan. 1995): 72-98.

Fiquet 1780
Fiquet, M. "Art du mouleur en plâtre." In *Descriptions des arts et métiers, faites ou approuvées par Messieurs de l'Académie royale des sciences de Paris.* Vol. 14. Neuchâtel: Imprimerie de la Société typographique, 1780.

Foz 1926
Foz, Tristão Guedes de Queiroz Correia Castello-Branco, marquês da. *A baixela Germain da antiga côrte portuguesa.* Lisbon: Ediçao dos "Amigos do Museu," 1926.

Frégnac 1977
Frégnac, Claude. *Belles demeures de Paris: 16e-19e siècle.* Paris: Hachette, 1977.

Freyberger 1980
Freyberger, Ronald. "The Randon de Boisset Sale, 1777: Decorative Arts." *Apollo* (April 1980): 298-303.

Fuhring 2005
Fuhring, Peter. *Designing the Décor: French Drawings from the Eighteenth Century.* Exh. cat. Lisbon (Museu Calouste Gulbenkian), 2005.

Furcy-Raynaud 1905
Furcy-Raynaud, Marc. *Nouvelles archives de l'art français . . . Correspondance de M. d'Angiviller avec Pierre.* Vol. 21. Paris: Jean Schemit, 1905.

Furcy-Raynaud 1912
Furcy-Raynaud, Marc. "Les tableaux et objets d'art saisis chez les émigrés et condamnés et envoyés au Muséum central." *Archives de l'art français.* Paris: Société de l'histoire de l'art français, 1912.

Gady 2011
Gady, Alexandre. *L'Hôtel de la Marine.* Paris: Nicolas Chaudun, 2011.

Gallet 1964
Gallet, Michel. *Demeures parisiennes: l'époque de Louis XVI.* Paris: Éditions du Temps, 1964.

Gallet 1974-75
Gallet, Michel, "Ledoux et sa clientèle parisienne." *Bulletin de la Société de l'histoire de Paris et de l'Île-de-France* (1974-75): 131-73.

Gallet 1978
Gallet, Michel. "Trois décorateurs parisiens du XVIIIe siècle, Michel II Lange, J.-B. Boiston, Joseph Métivier." *Bulletin de la Société de l'histoire de Paris et de l'Île-de-France* (1978): 75-87.

Gallet 1979
Gallet, Michel. "Ledoux à Paris et en Île-de-France: guide de l'exposition." *Cahiers de la rotonde,* no. 3 (1979): 61-131.

Gallet 1980
Gallet, Michel. *Claude-Nicolas Ledoux, 1736-1806.* Paris: A. et J. Picard, 1980.

Gallet 1990
Gallet, Michel. "Les Inédits de Cl. N. Ledoux: un versant ignoré de son utopie." *Gazette des Beaux-Arts* 132 (July-Aug. 1990): 9-28.

Gallet 1991
Gallet, Michel. *Architecture de Ledoux – Inédits pour un tome III.* Paris: Éditions du Demi-cercle, 1991.

Gallet 1992
Gallet, Michel. "Madame Du Barry et Ledoux, l'histoire d'une amitié." In *Madame Du Barry, de Versailles à Louveciennes,* 11-23. Exh. cat. Louveciennes (Musée-promenade de Marly-le-Roi–Louveciennes), 1992.

Gallet 1995
Gallet, Michel. *Les Architectes parisiens du XVIIIe siècle: dictionnaire biographique et critique.* Paris: Mengès, 1995.

Gautier 2007
Gautier, Jean-Jacques. "Paire de feux." In *Fastes du pouvoir: objets d'exception, XVIIIe – XIXe siècles. Collections du Mobilier national,* 20-21, no. 6. Exh. cat. Paris (Galerie des Gobelins), 2007.

Goodison 2002
Goodison, Nicholas. *Mathew Boulton: Ormolu.* London: Christie's, 2002.

Gougeon 2014
Gougeon, Catherine. "Deux exceptionnelles maquettes de meubles en cire provenant du Garde-Meuble de la Couronne." *La Revue des musées de France. Revue du Louvre,* no. 3 (Sept. 2014): 88–93.

Gournay 1788
Gournay, B.-C. *Almanach général du commerce, des marchands, négocians, amateurs etc. . . .* Paris: chez l'auteur and Belin et Onfroy, 1788.

***Grands salons littéraires* 1927**
Les grands salons littéraires (XVIIe et XVIIIe siècles): catalogue du musée Carnavalet (1927). Paris: Musée Carnavalet, 1927.

Guettier 1844
Guettier, André. *De la fonderie telle qu'elle existe aujourd'hui en France et de ses nombreuses applications à l'industrie.* Paris: Carilian-Coeury et Dalmont, 1844.

Guiffrey 1877
Guiffrey, Jules. *Les Caffieri, sculpteurs et fondeur-ciseleurs: étude sur la statuaire et sur l'art du bronze en France au XVIIe et au XVIIIe siècle.* Paris: Damascène Morgand et Charles Fatout, 1877.

Guiffrey 1885
Guiffrey, Jules. *Nouvelles archives de l'art français . . . Scellés et inventaires d'artistes,* Vol. 6. Paris, 1885.

Guiffrey 1914-15
Guiffrey, Jules. "Histoire de l'Académie de Saint-Luc." *Archives de l'art français* (1914-15).

Guiffrey and Marcel 1908
Guiffrey, Jean, and Pierre Marcel. *Inventaire général des dessins du musée du Louvre et du musée de Versailles: école française.* Vol. 2. Paris, 1908.

Handbook of the Jones Collection 1883
Handbook of the Jones Collection at the South Kensington Museum. London: Chapman and Hall, 1883.

Hans 2008
Hans, Pierre-Xavier. "Créer des intérieurs raffinés plus que collectionner." In *Marie-Antoinette*, 152. Exh. cat. Paris (Galeries nationales du Grand Palais), 2008.

Harris, Bellaigue, and Millar 1968
Harris, John, Geoffrey de Bellaigue, and Oliver Millar. *Buckingham Palace and Its Treasures*. London: Nelson, 1968.

Haskell and Penny 1988
Haskell, Francis, and Nicholas Penny. *Pour l'amour de l'antique: la statuaire gréco-romaine et le goût européen, 1500–1900*. Paris: Hachette, 1988.

Heginbotham 2014
Heginbotham, Arlen. "Bronzes Dorés: A Technical Approach to Examination and Authentication of French Gilt Bronze." In *French Bronze Sculpture: Materials and Techniques 16th–18th Century*, 150–65. London: Archetype, 2014.

Heginbotham et al. 2015
Heginbotham, Arlen, et al. "The Copper Charm Set: A New Set of Certified Reference Materials for the Standardization of Quantitative X-Ray Fluorescence Analysis of Heritage Copper Alloys." *Archaeometry* 57, issue 5 (Oct. 2015): 856-68.

Héricart de Thury 1819
Héricart de Thury, Louis-Étienne-François. *Rapport du jury d'admission des produits de l'industrie du département de la Seine, à l'exposition du Louvre, comprenant une notice statistique sur ces produits*. Paris: C. Ballard, 1819.

Hessling and Hessling n.d.
Hessling, Egon, and Waldemar Hessling. *Bronzes d'appliques: style Louis XVI*. Berlin, Paris, New York, n.d.

Hézecques 1983
Hézecques, Félix, comte de France. *Souvenirs d'un page de la cour de Louis XVI*. Saint Pierre-de-Salerne: G. Monfort, 1983.

Horbas 1996
Horbas, Claudia. "Gefäße aus Steinimitat: drei frühklassizistische Vasen im Potsdamer Neuen Palais." *Weltkunst* (Nov. 21, 1996): 2656–60.

Hughes 1996
Hughes, Peter. *The Wallace Collection: Catalogue of Furniture*. 3 vols. London: The Trustees of the Wallace Collection and Paul Holberton Publishing, 1996.

Huisman and Jallut 1970
Huisman, Philippe, and Marguerite Jallut. *Marie-Antoinette: l'impossible bonheur*. Paris: Vilo; Lausanne: Edita, 1970.

Hunter-Stiebel 1985
Hunter-Stiebel, Penelope. "Exalted Hardware, the Bronze Mounts of French Furniture. Part II: Early Neoclassicism, Louis XVI, and Empire." *Antiques* 127, no. 2 (Feb. 1985): 454–63.

Iskierski 1929
Iskierski, Stanislas. *Les Bronzes du château royal et du palais Lazienski à Varsovie*. Warsaw, 1929.

Jacq-Hergoualc'h 2014
Jacq-Hergoualc'h, Michel. *Jean-Jacques François Le Barbier l'aîné: la vie et l'art, catalogue de l'œuvre peint*. Tokyo: Texnai, 2014.

Kisluk-Grosheide and Munger 2010
Kisluk-Grosheide, Danielle, and Jeffrey H. Munger. *The Wrightsman Galleries for French Decorative Arts*. New York: The Metropolitan Museum of Art, 2010.

Kjellberg 2000
Kjellberg, Pierre. *Objets montés: du Moyen Âge à nos jours*. Paris: Éditions de l'amateur, 2000.

Koeppe 2012
Koeppe, Wolfram. *Extravagant Inventions: The Princely Furniture of the Roentgens*. Exh. cat. New York (The Metropolitan Museum of Art), 2012.

Ładyka and Saratowicz 1997
Ładyka, Natalia, and Anna Saratowicz. "Zamówienia dla Stanisława Augusta w pracowni François-Thomasa Germaina" [Orders from Stanislas-August for the workshop of François-Thomas Germain]. *Kronika Zamkowa* [The Chronicle of the Castle], no. 1 (1997): 24-37.

Laer 1721
Laer, Willem van. *Weg-wyzer voor aankoomende goud en zilversmeeden . . .* Amsterdam: Fredrik Helm, 1721.

La Monneraye 2001
La Monneraye, Jean de. *Terrier de la censive de l'archevêché dans Paris: 1772*. Vol. 2. *Deuxième partie, notices n° 2784 à 5749*. Paris: Éditions des Musées de la ville de Paris, 2001.

Lami 1910–11
Lami, Stanislas. *Dictionnaire des sculpteurs de l'école française au dix-huitième siècle*. 2 vols. Paris: H. Champion, 1910-11.

Lapine 1999
Lapine, Michelle. "Mixing Business with Pleasure: Asher Wertheimer as Art Dealer and Patron." In *John Singer Sargent: Portraits of the Wertheimer Family*, 43–53. Exh. cat. New York (Jewish Museum), 1999.

Launay 1827
Launay, Jean-Baptiste. *Manuel du fondeur sur tous métaux, ou Traité de toutes les opérations de la fonderie*. Paris: Roret, 1827.

Laveissière et al. 2004
Laveissière, Sylvain, et al. *Napoléon et le Louvre*. Paris: Fayard and Musée du Louvre, 2004.

Lebon 2012
Lebon, Élisabeth. *Fonte au sable, fonte à cire perdue: histoire d'une rivalité*. Paris: Orphys, Institut national d'histoire de l'art, 2012.

Lebrun 1776
Lebrun, Jacques-François-Dieudonné, called *l'abbé. Almanach historique et raisonné des architectes, peintres, sculpteurs, graveurs et cizeleurs.* Paris: Delalain, Lejay, Duchesne, Esprit, 1776.

Lebrun 1777
Lebrun, Jacques-François-Dieudonné, called *l'abbé. Almanach historique et raisonné des architectes, peintres, sculpteurs, graveurs et cizeleurs.* Paris: Delalain, Lejay, Duchesne, Esprit, 1777.

Leclair 2002
Leclair, Anne. "Les plafonds peints de l'hôtel d'Argenson: commande d'un amateur parisien (1767-1773)." *Gazette des Beaux-Arts* 140 (Nov. 2002): 273-306.

Ledoux-Lebard 1975
Ledoux-Lebard, Denise. *Le Grand Trianon: meubles et objets d'art (inventaire général du musée national de Versailles et des Trianons).* Paris: Éditions des musées nationaux, 1975.

Ledoux-Lebard 1986
Ledoux-Lebard, Denise. "Bronziers des Empire—Die Feuchere, A.-J.-E. Fossey, Derniere, P.-V. Ledure, A.-A. Ravrio, L.-S. Lenoir-Ravrio, die Galle" 667-726. Vol. 2. In Ottomeyer and Pröschel 1986.

Ledoux-Lebard and Ledoux-Lebard 1952
Ledoux-Lebard, Guy, and Christian Ledoux-Lebard. "Les statuettes de Napoléon Ier et de Marie-Louise moulées d'après l'antique et ciselées par Damerat sous la direction de Denon." *Bulletin de la Société d'histoire de l'art français* (1952): 73-80.

Lefebure et al. 1999
Lefebure, Amaury, et al. *Les Bronzes de la Couronne.* Paris: Réunion des musées nationaux, 1999.

Lemaire 1998
Lemaire, André. *Les Feuchère: dynastie de fondeurs, 1785-1840.* Paris: Galerie André Lemaire, 1998.

Lemonnier 1911-29
Lemonnier, Henry. *Procès-verbaux de l'Académie royale d'architecture.* 10 vols. Paris: J. Schmit: 1911-29.

Lemonnier 1991
Lemonnier, Patricia. "Une collection exceptionnelle de vases montés." *L'Estampille- L'Objet d'art*, no. 244 (Feb. 1991): 38-49.

Leribault 2010
Leribault, Christophe. "Chambre à coucher de monseigneur comte d'Artois à Bagatelle." In *L'Antiquité rêvée: innovations et résistances au XVIIIe siècle*, 384-87, nos. 127, 128. Exh. cat. Paris (Musée du Louvre), 2010.

Levenson 1993
Levenson, Jay A. *The Age of the Baroque in Portugal.* Exh. cat. Washington (National Gallery of Art), 1993.

Loiseau n.d.
Loiseau, Arthur. *Nécrologie de François-Joseph Belanger.* Paris: G. Ballard, n.d.

Lorentz 1951
Lorentz, Stanisław. "Prace architekta Louisa's dla zamku warszawskiego." *Biuletyn historii sztuki* 13, no. 4 (1951): 39-74.

Lorentz 1958
Lorentz, Stanisław. *Victor Louis et Varsovie.* Exh. cat. Bordeaux (Bibliothèque municipale), 1958.

Lunsingh Scheurleer 1980
Lunsingh Scheurleer, Daniel F. *Chinesisches und japanisches Porzellan in europäischen Fassungen.* Braunschweig: Klinkhardt & Biermann, 1980.

Mabille 1992
Mabille, Gérard. "Bouton de porte au chiffre de madame Du Barry." In *Madame Du Barry, de Versailles à Louveciennes*, 172. Exh. cat. Louveciennes (Musée-promenade de Marly-le-Roi–Louveciennes), 1992.

Mabille 2003a
Mabille, Gérard. "Les bras de lumière en bronze doré et patiné de la duchesse de Mazarin par Pierre Gouthière (1732-1813)." *Revue du Louvre et des Musées de France* 53, no. 2 (2003): 18-21.

Mabille 2003b
Mabille, Gérard. *Nouvelles acquisitions du département des Objets d'art 1995-2002.* Paris: Réunion des musées nationaux, 2003.

MacColl 1922
MacColl, Dugald Sutherland. "The Governor's Clock." *The Saturday Review* (December 2, 1922).

Macon 1903
Macon, Gustave. *Les Arts dans la maison de Condé.* Paris: Librairie de l'art ancien et moderne, 1903.

Macquer 1789
Macquer, Pierre-Joseph. *Dictionnaire de Chymie contenant la théorie et la pratique de cette science, son application à la physique, à la histoire naturelle, à la médecine et à l'économie animale.* Neuchâtel: Imprimerie de la Société typographique, 1789.

Malgouyres 2003
Malgouyres, Philippe. *Porphyre: la pierre pourpre des Ptolémées aux Bonaparte.* Exh. cat. Paris (Musée du Louvre), 2003.

Mantz 1865
Mantz, Paul. "Musée rétrospectif: la Renaissance et les temps modernes. III. Bijouterie, horlogerie." *Gazette des Beaux-Arts* 19 (Nov. 1865): 459-81.

Marcel 1919
Marcel, Adrien. "Aubert d'Avignon: joaillier du roi et garde des diamants de la couronne 1736–1785." *Memoires de l'Académie de Vaucluse*, 2nd ser., vol. 19 (1919): 89–120.

Marmottan 1927
Marmottan, Paul. *Le Style Empire: architecture et décors d'intérieurs*, vol. 4. Paris: F. Contet, 1927.

Maze-Sencier 1885
Maze-Sencier, Alphonse. *Le Livre des collectionneurs*. Paris: Librairie Renouard, 1885.

McCormick, Ottomeyer, and Walker 2004
McCormick, Heather, Hans Ottomeyer, and Stephanie Walker (eds.). *Vasemania: Neoclassical Form and Ornament in Europe*. Exh. cat. New York (Bard Graduate Center), 2004.

Meuvret and Frégnac 1963
Meuvret, Jean, and Claude Frégnac. *Les Ébénistes du XVIIIᵉ siècle français*. Paris: Hachette, 1963.

Metman 1989
Metman, Bernard. "La petite sculpture au XIXᵉ siècle: les éditeurs." *Archives de l'art français* 30 (1989): 175–218.

Molinier 1898
Molinier, Émile. *Le Mobilier au XVIIᵉ et au XVIIIᵉ siècle et pendant les premières années du Iᵉʳ empire*. Paris: Librairie centrale des Beaux-Arts, 1898.

Molinier 1902a
Molinier, Émile. *Le Mobilier français du XVIIᵉ et du XVIIIᵉ siècle: musée du Louvre*, Paris: Émile Lévy, Librairie centrale des Beaux-Arts, 1902.

Molinier 1902b
Molinier, Émile. "Le Mobilier français du XVIIIᵉ siècle dans les collections étrangères." *Les Arts*, no. 1 (Jan. 1902): 19–23.

Molinier n.d.
Molinier, Émile. *La Collection Wallace: meubles et objets d'art français des XVIIᵉ et XVIIIᵉ siècles*. Paris and London, n.d.

Monteiro 2002
Monteiro, Inês Líbano. "Uma baixela para servir a quatro cobertas," 38–91. In Silveira Godinho 2002.

Morisseau 2009
Morisseau, Céline. "Une Antiquité rêvée. Le costume à l'antique dans la sculpture française de la seconde moitié du XVIIIᵉᵐᵉ siècle: la *Sibylle d'Erythrée* et les *Torchères* du pavillon neuf de Louveciennes." *Revue du Louvre et des Musées de France* 4 (2009): 51–60.

Mosser and Rabreau 1979
Mosser, Monique, and Daniel Rabreau. *Charles De Wailly: peintre architecte dans l'Europe des Lumières*. Exh. cat. Paris (Hôtel de Sully), 1979.

Mouton 1911
Mouton, Léo. "Histoire d'un coin du Pré-aux-clercs et de ses habitants: du manoir de Jean Bouyn à l'École des beaux-arts." *Bulletin de la Société historique du VIᵉ arrondissement de Paris* (1911): 128–91.

Müntz de Raïssac 1990
Müntz de Raïssac, Muriel. "Quatre vases en porphyre de la collection Richard Mique." *Revue du Louvre et des Musées de France*, no. 5 (1990): 386–90.

Niclausse 1947
Niclausse, Juliette. *Thomire: fondeur-ciseleur (1751–1843): sa vie, son oeuvre*. Paris: Gründ, 1947.

Nocq 1926–31
Nocq, Henri. *Le Poinçon de Paris: répertoire des maîtres-orfèvres de la juridiction de Paris depuis le Moyen-Âge jusqu'à la fin du XVIIIᵉ siècle*. Paris: Henri Floury, 1926–31.

Oberkirch 1970
Oberkirch, Henriette-Louise de Waldner de Freundstein, baronne d'. *Mémoires sur la cour de Louis XVI et la société française avant 1789*. Paris: Mercure de France, 1970.

Orey 1991
Orey, Leonor d'. *A Baixela da coroa portuguesa*. Lisbon: Edições Inapa, 1991.

Orey 1993
Orey, Leonor d'. "L'histoire des services d'orfèvrerie française à la cour du Portugal." In *Versailles et les tables royales en Europe, XVIIᵉᵐᵉ–XIXᵉᵐᵉ siècles*, 165–70. Exh. cat. Versailles (Musée national des châteaux de Versailles et de Trianon), 1993.

Orey 1999
Orey, Leonor d'. *Mesas reais europeias: encomendas e ofertas*. Exh. cat. Lisbon (Museu nacional de arte antiga, Instituto português de museus), 1999.

Ottomeyer and Pröschel 1986
Ottomeyer, Hans, and Peter Pröschel (eds.). *Vergoldete Bronzen: die Bronzearbeiten des Spätbarock und Klassizismus*. 2 vols. Munich: Klinkhardt & Biermann, 1986.

Ozanam 1969
Ozanam, Denise. *Claude Baudard de Saint-James: trésorier général de la Marine et brasseur d'affaires (1738–1787)*. Paris and Geneva: Droz, 1969.

Palasi 2014
Palasi, Philippe. *Plaques de cheminées héraldiques: histoire d'un support métallique des armoiries, fin XVᵉ–XXᵉ siècle*. Paris, 2014.

Panckoucke and Lacombe 1784
Panckoucke, Charles-Joseph, and Jacques Lacombe. *Encyclopédie méthodique: arts et métiers mécaniques*. Vol. 3. Paris: Panckoucke, 1784.

Panckoucke and Lacombe 1788
Panckoucke, Charles-Joseph, and Jacques Lacombe. *Encyclopédie méthodique: arts et métiers mécaniques*. Vol. 5. Paris: Panckoucke, 1788.

Pappot forthcoming
Pappot, Arie. "The Coloring of Gilt Bronze Mounts: Historic Recipes, Detection, Treatment." *Stichting Ebenist 12th International Symposium on Wood and Furniture Conservation, Amsterdam, November 14–15, 2014*. Forthcoming.

Paris et ses curiosités 1804
Paris et ses curiosités: avec notice historique et descriptive des environs de Paris. Paris: Marchand, 1804.

Pariset 1962
Pariset, François-Georges. "Jeszcze o pracach Wiktora Louisa dla zamku warszawskiego." *Biuletyn historii sztuki* 24 (1962): 135–55.

Paulin 2003
Paulin, Marc-André. "Schwerdfeger, ébéniste de Marie-Antoinette." *L'Estampille–L'Objet d'art*, no. 384 (Oct. 2003): 66–79.

Penny 1992
Penny, Nicholas. *Catalogue of European Sculpture in the Ashmolean Museum, 1540 to the Present Day*. Vol. 2. Oxford: Clarendon Press; New York: Oxford University Press, 1992.

Penny 1993
Penny, Nicholas. *The Materials of Sculpture*. New Haven and London: Yale University Press, 1993.

Perrin 1993
Perrin, Christiane. *François-Thomas Germain, orfèvre des rois*. Saint-Rémy-en-l'Eau: Monelle Hayot, 1993.

Picquenard 2001
Picquenard, Thérèse. "Biographie et étude de l'œuvre de Louis Simon Boizot" and "Catalogue de l'œuvre sculpté de Louis-Simon Boizot," 25–176. In *Boizot* 2001.

Pons 1995
Pons, Bruno. *Grands Décors français, 1650–1800*. Dijon: Faton, 1995.

Pradère 1993
Pradère, Alexandre. "Les bonnes adresses à Paris autour de 1770." *Antologia di Belle Arti*, no. 43–47 (1993): 88–105.

Priore 1996
Priore, Alicia. "François Boucher's Designs for Vases and Mounts." *Studies in the Decorative Arts* 3, no. 2 (1996): 2–51.

Przewoźna 1986
Przewoźna, Maria Wanda. "Bronzearbeiten 'à la grecque': die Bestellungen des Warschauer Hofes in den Jahren 1766–1768," 549–60. Vol. 2. In Ottomeyer and Pröschel 1986.

Préaud and Scherf 2015
Préaud, Tamara, and Guilhem Scherf. *La Manufacture des Lumières: la sculpture à Sèvres de Louis XV à la Révolution*. Exh. cat. Sèvres (Cité de la céramique), 2015.

Prost 1936
Prost, L. H. *Collection de Madame et du Colonel Balsan*. Vol. 1. 1936.

Rabreau 1979
Rabreau, Daniel. "L'architecte de la vie brillante." In Mosser and Rabreau 1979, 38–79.

Rabreau 2005
Rabreau, Daniel. *Claude-Nicolas Ledoux*. Paris: Monum, Éditions du Patrimoine, 2005.

Rabreau 2007
Rabreau, Daniel. *Le Théâtre de l'Odéon: du monument de la Nation au théâtre de l'Europe*. Paris: Belin, 2007.

Raïssac 2011
Raïssac, Muriel de. *Richard Mique, architecte du roi de Pologne Stanislas Ier, de Mesdames et de Marie-Antoinette*. Paris: Honoré Champion, 2011.

Ramazzini 1940
Ramazzini, Bernardino. *De Mortis Artificum Diatriba* [Diseases of Workers]. Translation and notes by W. C. Wright. Chicago: University of Chicago Press, 1940.

Révolution française 1983
La Révolution française, le Premier Empire: dessins du musée Carnavalet. Exh. cat. Paris (Musée Carnavalet), 1983.

Ricci 1913
Ricci, Seymour de. *Le Style Louis XVI: mobilier et décoration*. Paris: Hachette, 1913.

Robinson 1914
Robinson, Edward. *The Metropolitan Museum of Art: Guide to the Loan Exhibition of the J. Pierpont Morgan Collection*. New York: The Metropolitan Museum of Art, 1914.

Robiquet 1912
Robiquet, Jacques. *Gouthière, sa vie, son œuvre: essai de catalogue raisonné*. Paris: Henri Laurens, 1912.

Robiquet 1920–21
Robiquet, Jacques. *Vie et œuvre de Pierre Gouthière*. Paris: Société de propagation des livres d'art, 1920–21.

Rochebrune, Sourisseau, and Bastien 2014
Rochebrune, Marie-Laure de, Anne-Cécile Sourisseau, and Vincent Bastien. *La Chine à Versailles: art et diplomatie au XVIIIe siècle*. Exh. cat. Versailles (Musée national des châteaux de Versailles et de Trianon), 2014.

Roland-Michel 1984
Roland-Michel, Marianne. *Lajoue et l'art rocaille*. Neuilly: Arthena, 1984.

Rondot 1865
Rondot, Nathalis. "Gouthière, ciseleur, doreur du Roi." *La Chronique des arts et de la curiosité* (Nov. 26, 1865): 315–16.

Rondot 1891
Rondot, Nathalis-Cyr-François. "Les orfèvres de Troyes du XIIe au XVIIIe siècle." *Nouvelle revue de l'art français* 7 (1891): 279–393.

Rondot 2008
Rondot, Bertrand. "Feux aux chameaux." In *Marie-Antoinette*, 209–10, no. 148. Exh. cat. Paris (Galeries nationales du Grand Palais), 2008.

Rondot and Gautier 2011
Rondot, Bertrand, and Jean-Jacques Gautier. *Le Château de Versailles raconte le Mobilier national: quatre siècles de creation.* Exh. cat. Versailles (Château de Versailles), 2011.

***Royal French Silver* 1996**
Royal French Silver, the Property of George Ortiz. Sotheby's, New York, Wednesday, November 13, 1996.

Roze de Chantoiseau 1782-92
Roze de Chantoiseau, Mathurin. *Supplément aux tablettes royales de renommée, d'indication des négociants, artistes célèbres et fabricants des six corps, arts et métiers de la ville de Paris et autres villes du royaume etc.* Paris: Desnos, 1782-92.

Salmon and Cochet 2012
Salmon, Xavier, and Vincent Cochet. *Un parfum d'exotisme: le boudoir turc du château de Fontainebleau.* Dijon: Faton, 2012.

Salverte 1927
Salverte, François de. *Les Ébénistes du XVIIIᵉ siècle: leurs œuvres et leurs marques; ouvrage contenant un millier de notices présentées dans l'ordre alphabétique avec de nombreuses planches.* Paris: Librairie nationale d'art et d'histoire, 1927.

Samoyault 1971
Samoyault, Jean-Pierre. "Les remplois de sculptures et d'objets d'art dans la décoration et l'ameublement du palais de Saint-Cloud sous le Consulat et au début de l'Empire." *Bulletin de la Société de l'histoire de l'art français* (1971): 153-91.

Samoyault 1992
Samoyault, Jean-Pierre. "L'appartement de madame Du Barry à Fontainebleau." In *Madame Du Barry, de Versailles à Louveciennes,* 86–93. Exh. cat. Louveciennes (Musée-promenade de Marly-le-Roi-Louveciennes), 1992.

Saratowicz-Dudyńska and Ładyka 2006
Saratowicz-Dudyńska, Anna, and Natalia Ładyka. "Brązy wykonane przez Philippe'a Caffierego l'Aîné dla Stanisława Augusta." *Kronika Zamkowa* 1–2, 2006, nos. 51–52: 79 100.

Scherf 1997
Scherf, Guilhem. "Le décor de l'hôtel de Voyer d'Argenson." In *Pajou, sculpteur du Roi, 1730–1809,* 77–128. Exh. cat. Paris (Musée du Louvre) and New York (The Metropolitan Museum of Art), 1997.

Schwartz 2008
Schwartz, Selma. "Un regard vers l'orient." In *Marie-Antoinette,* 188–211. Exh. cat. Paris (Galeries nationales du Grand Palais), 2008.

Silveira Godinho 2002
Silveira Godinho, Isabel da (ed.). *A Baixela de Sua Majestade Fidelíssima.* Lisbon: Ministério da Cultura, Instituto Português do Patrimonio Arquitectónico, and Palácio Nacional da Ajuda, 2002

Silvestre de Sacy 1940
Silvestre de Sacy, Jacques. *Alexandre-Théodore Brongniart, 1739–1813: sa vie, son oeuvre.* Paris: Plon, 1940.

Silvestre de Sacy 1953
Silvestre de Sacy, Jacques. *Le Comte d'Angiviller: dernier directeur général des Bâtiments du roi.* Paris: Plon, 1953.

Slitine 2002
Slitine, Florence. *Samson: génie de l'imitation.* Paris: Charles Massin, 2002.

Standen 1989
Standen, Edith Appleton. "Jean-Jacques-François Le Barbier and Two Revolutions." *Metropolitan Museum Journal* 24 (1989): 255–74.

Starcky 2013
Starcky, Emmanuel. *Folie textile: mode et décoration sous le Second Empire.* Exh. cat. Compiègne (Musées et domaines nationaux du Palais impérial de Compiègne), 2013.

Stein 1912
Stein, Henri. *Augustin Pajou.* Paris: Librairie central des Beaux-Arts, 1912.

Stern 1930
Stern, Jean. *À l'ombre de Sophie Arnould: François-Joseph Bélanger, architecte des Menus-Plaisirs.* 2 vols. Paris: Plon, 1930.

Suverkrop 1912
Suverkrop, E. A. "The Molding of Bronze Statuary." *American Machinist* 37, no. 23 (Dec. 5, 1912): 923-28.

Taillard 2009
Taillard, Christian. *Victor Louis (1731-1800): le triomphe du goût français à l'époque néo-classique.* Paris: Presses de l'Université Paris-Sorbonne, 2009.

Thiébault 1987
Thiébault, Claude. *Recherches sur Le Barbier l'Aîné: essai de catalogue de son œuvre peint.* Paris: Université Paris-Sorbonne, U.E.R. d'Art et d'Archéologie, 1987.

Thiéry 1787
Thiéry, Luc-Vincent. *Guide des amateurs et des étrangers voyageurs à Paris . . .* 3 vols. Paris: Hardouin et Gattey, 1787.

Thomine 1997
Thomine, Alice. "La période anglaise." In *Bagatelle dans ses jardins,* 111–34. Exh. cat. Paris (Pavillon de Bagatelle), 1997.

Thornton 1998
Thornton, Peter. *Form and Decoration: Innovation in the Decorative Arts, 1470–1870.* New York: Harry N. Abrams, 1998.

Trésors de l'orfèvrerie 1954
Les Trésors de l'orfèvrerie du Portugal. Exh. cat. Paris (Musée des Arts décoratifs), 1954.

Triomphe du baroque 1991
Triomphe du baroque. Exh. cat. Brussels (Palais des beaux-arts), 1991.

Tuetey 1914
Tuetey, Alexandre. "Inventaire des laques anciennes et des objets de curiosité de Marie-Antoinette confiés à Daguerre et Lignereux marchands bijoutiers le 10 octobre 1789." *Archives de l'art français* 8 (1914): 286-319.

Vacquier 1923
Vacquier, Jules. *Les vieux hôtels de Paris: décorations extérieures et intérieures. 9, La Place Vendôme dite aussi de Louis le Grand ou des Conquêtes: notices historiques et descriptives,* 9th ser. Paris: F. Contet, 1923.

Vera-Cruz Pinto and Alves 2002
Vera-Cruz Pinto, Eduardo, and Sílvia Alves. "O caso da baixela Germain: os factos e o direito," 246-69. In Silveira Godinho 2002.

Verlet 1935
Verlet, Pierre. "Les chenets de François-Thomas Germain." *Bulletin des Musées de France* (Dec. 1935): 153-55.

Verlet 1945
Verlet, Pierre. *Le Mobilier royal français, meubles de la Couronne conservés en France.* Paris: Éditions d'art et d'histoire, 1945.

Verlet 1950
Verlet, Pierre. "The Wallace Collection and the Study of French Eighteenth-Century Bronzes d'ameublement." *The Burlington Magazine* 92, no. 567 (June 1950): 154-57.

Verlet 1963
Verlet, Pierre. *French Royal Furniture: An Historical Survey Followed by a Study of Forty Pieces Preserved in Great Britain and the United States.* New York: Clarkson Potter, 1963.

Verlet 1980
Verlet, Pierre. "Bronzes d'ameublement français au XVIIIeme siècle: notes et documents." *Bulletin de la Société de l'histoire de l'art français* (1980): 200-210.

Verlet 1987
Verlet, Pierre. *Les Bronzes dorés français du XVIIIe siècle.* Paris: Picard, 1987.

Véron 1884
Véron, Eugène. "Mémoire des modèles de bronze, cizelure et dorure de porcelaines faites pour le service de Madame la Duchesse de Mazarin sous les ordres et dessins de Monsieur Belanger premier architecte de Monseigneur le Comte d'Artois par Gouthière cizeleur doreur du Roy en 1781." *L'Art* 1-2, 38-40. Paris: Librairie de l'art, J. Rouam, 1884.

Vial 1901
Vial, Henri. "La faillite de Gouthière, doreur et ciseleur du roi: sa maison, faubourg St. Martin." In *La Correspondance historique et archéologique* (April/May 1901): 131-42.

Vial 1908
Vial, Henri. "Pierre Gouthière, doreur et ciseleur du roi: son séjour au quai Pelletier." *La Cité. Bulletin trimestriel de la Société historique et archéologique du IVe arrondissement de Paris,* 7th annual, no. 28 (Oct. 1908): 330-36.

Vigée Le Brun 2015
Vigée Le Brun, Élisabeth. *Souvenirs.* Paris: Citadelles et Mazenod, 2015.

Vignon forthcoming
Vignon, Charlotte. *London–New York–Paris: Duveen Frères et le commerce d'objets d'art entre 1880 et 1940.* Paris: Mare et Martin, forthcoming.

Viroulaud 2011
Viroulaud, Julie. "Jean-Jacques-François Le Barbier l'Aîné et les francs-maçons: autour d'une œuvre d'inspiration maçonnique, la Déclaration des Droits de l'Homme et du Citoyen." *La Revue des Musées de France,* no. 4 (Oct. 2011): 80–86.

Vissac 1910
Vissac, Marc de. "Le lieutenant-général Marquis de Rochechouart. Troisième réunion d'Avignon et du Comtat à la France (1768-76)." *Mémoires de l'Académie de Vaucluse,* 2nd ser, vol. 10 (1910): 245-66.

Vriz 2011
Vriz, Sylvia. "Une exceptionnelle paire de vases de la collection du duc d'Aumont." *L'Estampille–L'Objet d'art,* no. 474 (Dec. 2011): 58-61.

Vriz 2013
Vriz, Sylvia. "Le duc d'Aumont et les porcelaines d'Extrême-Orient de la collection de M. Jean de Julienne." *Sèvres,* no. 22 (2013): 89-98.

Wackernagel 1966
Wackernagel, Rudolf H. *Der französische Krönungswagen von 1696-1825.* Berlin: Walter de Gruyter, 1966.

Wagner 1858
Wagner, Johann Rudolf von. *Theorie und Praxis der Gewerbe: Hand- und Lehrbuch der Technologie.* Leipzig: Otto Wigand, 1858.

Walpole 1965
Walpole, Horace. *The Yale Edition of Horace Walpole's Correspondence with the Countess of Upper Ossory.* Vol. 32. New Haven: Yale University Press, 1965.

Wannenes and Wannenes 2004
Wannenes, Giacomo, and Rozenn Wannenes. *Les Bronzes ornementaux et les objets montés, de Louis XIV à Napoléon III.* Milan: Vausor, 2004.

Waresquiel 2014
Waresquiel, Emmanuel de. *Fouché: les silences de la pieuvre.* Paris: Tallandier et Fayard, 2014.

Watson 1956
Watson, Francis J. B. *Wallace Collection Catalogues. Furniture: Text with Historical Notes and Illustrations.* London: W. Clowes and The Wallace Collection, 1956.

Watson 1960
Watson, Francis J. B. *Louis XVI Furniture*. London: Tiranti, 1960.

Watson 1966
Watson, Francis J. B. *The Wrightsman Collection, Vol. 2: Furniture, Gilt Bronze and Mounted Porcelain, Carpets*. New York: The Metropolitan Museum of Art, 1966.

Westgarth 2009
Westgarth, Mark. *A Biographical Dictionary of Nineteenth Century Antique and Curiosity Dealers: with Full Explanation and Plates*. Glasgow: M and M Press, 2009.

Wildenstein 1921
Wildenstein, Georges. *Rapports d'experts, 1712-1791: Procès-verbaux d'expertises d'œuvres d'art, extraits du fonds du Châtelet, aux Archives nationales*. Paris: Les Beaux-arts, édition d'études et de documents, 1921.

Wildenstein 1962
Wildenstein, Georges. "Simon-Philippe Poirier, fournisseur de madame Du Barry." *Gazette des Beaux-Arts* 60, no. 1124 (Sept. 1962): 365-77.

Williamson 1883a
Williamson, E. *Salles d'exposition permanente du Garde-Meuble: catalogue*. Paris: J. Baudry, 1883.

Williamson 1883b
Williamson, E. *Les Meubles d'art du Mobilier national: choix des plus belles pièces conservées au Garde-Meuble et dans les palais nationaux* … Paris: Baudry, 1883.

Williamson 1892
Williamson, E. *Musée du Garde-Meuble, 103, Quai d'Orsay: catalogue*. Paris: Baudry et Cie, 1892.

Williamson 1897
Williamson, E. *Musée du Garde-Meuble: catalogue*. Paris: Baudry et Cie, 1897.

Wilson and Hess 2001
Wilson, Gillian, and Catherine Hess. *Summary Catalogue of European Decorative Arts in the J. Paul Getty Museum*. Los Angeles: The J. Paul Getty Trust, 2001.

Winokur 1971
Winokur, Ronald L. "The Mr. and Mrs. Horace E. Dodge Memorial Collection." *Bulletin of the Detroit Institute of Arts* 50, no. 3 (1971): 43-51.

Winokur 1977
Winokur, Ronald. "An Ostrich Egg Painted by Le Bel and Mounted by Gouthière." *Bulletin of the Detroit Institute of Arts* 55, no. 3 (1977): 157-60.

Zek 1994
Zek, Iouna. "Bronzes d'ameublement et meubles français achetés par Paul Ier pour le château Saint Michel de Saint Pétersbourg en 1798-1799." *Bulletin de la Société de l'histoire de l'art français* (1994): 141-68.

Photography Credits

Andrzej Ring, Lech Sandzewicz: cat. 3
© Ashmolean Museum, University of Oxford: figs. 82, 93
© Musée des Beaux-Arts et d'Archéologie, Besançon / Pierre Guenat: fig. 41
Bibliothèque des Arts Décoratifs, Paris, Collection Maciet: fig. 44
© Bibliothèque Municipale, Besançon: figs. 13, 42, 103, 105, 131, 134
© Bibliothèque nationale de France, Paris: figs. 12, 18, 98–102, 104, 106, 110, 116, 119, 123, 125, 130, 131, 134–36, 140–43
Collection du Mobilier National / Isabelle Bideau: cat. 26
© Cooper Hewitt, Smithsonian Design Museum / Art Resource, NY: fig. 112
© Daniel Martin: fig. 96
Federico Carò, Department of Scientific Research, The Metropolitan Museum of Art, New York: figs. 50, 72–75
François Doury: fig. 9
Guillaume Benoit: figs. 14, 15
© Hessische Hausstiftung, Kronberg im Taunus, Germany: fig. 132
Joseph Godla: cats. 10, 15; figs. 50–52, 56, 58–64, 67, 77, 78, 92; pp. 16, 19, 24, 138, 161, 179, 188, 202, 235, 261–63
Les Arts Décoratifs, Paris / Cyril Bernard: cat. 27
Les Arts Décoratifs, Paris / Jean Tholance: figs. 36, 37, 45
L'Estampille-L'Objet d'art, no. 287, January 1995: cat. 49
Michael Bodycomb: cats. 5, 9, 21, 24, 29, 32; figs. 49, 54, 55, 57, 65, 68 (top), 76, 121; pp. 2, 6, 106, 150, 219, 232–33, 252, 254–55
© Musée Calvet, Avignon: fig. 107
© Musée Carnavalet / Roger-Viollet: figs. 2, 39
© Musée des Arts et Métiers-Cnam, Paris / S. Pelly: figs. 30, 31
Musée-Promenade / Marly-le-Roi-Louveciennes: fig. 11
© Philadelphia Museum of Art: fig. 114
RIBA Library Drawings Collection: fig. 6
© RMN-Grand Palais / Art Resource, NY: cats. 7, 8, 11, 12, 28, 31, 36, 37; figs. 23, 38, 43, 46, 47, 115, 129, 137, 138; pp. 94, 245, 285
© RMN-Grand Palais / Art Resource, NY / Christophe Fouin: fig. 22
© RMN-Grand Palais (Château de Versailles) / Daniel Arnaudet: fig. 8
© RMN-Grand Palais (École Nationale Supérieure des Beaux-Arts) / Art Resource, NY: figs. 16, 19, 111
© RMN-Grand Palais (Musée du Louvre) / Les frères Chuzeville: fig. 5
© RMN-Grand Palais (Musée du Louvre) / Art Resource, NY/ Martine-Beck Coppola: cat. 22, pp. 222, 223
© RMN-Grand Palais (Musée du Louvre) / Thierry Ollivier: cats. 25, 32, 42; figs. 3, 32; p. 326
Roland Handrick: fig. 91
Royal Collection Trust / © Her Majesty Queen Elizabeth II 2015: figs. 79, 113
© Th. Hennocque: cats. 6, 14, 27, 43, 44, 45; figs. 24, 25, 27, 40, 139; pp. 4, 12, 176, 201, 203, 307, 309, 311
© The Frick Collection / Michael Bodycomb: cat. 39; pp. 2, 291
© The Metropolitan Museum of Art / Art Resource, NY: fig. 89
© The Metropolitan Museum of Art; courtesy Department of Objects Conservation: figs. 48, 66, 68 (bottom), 69
© The National Trust, Waddesdon Manor / Mike Fear: figs. 7, 10
© The Wallace Collection: cats. 13, 19; figs. 20, 80, 81, 83–86; pp. 198, 214, 402
© Victoria and Albert Museum: figs. 26, 88

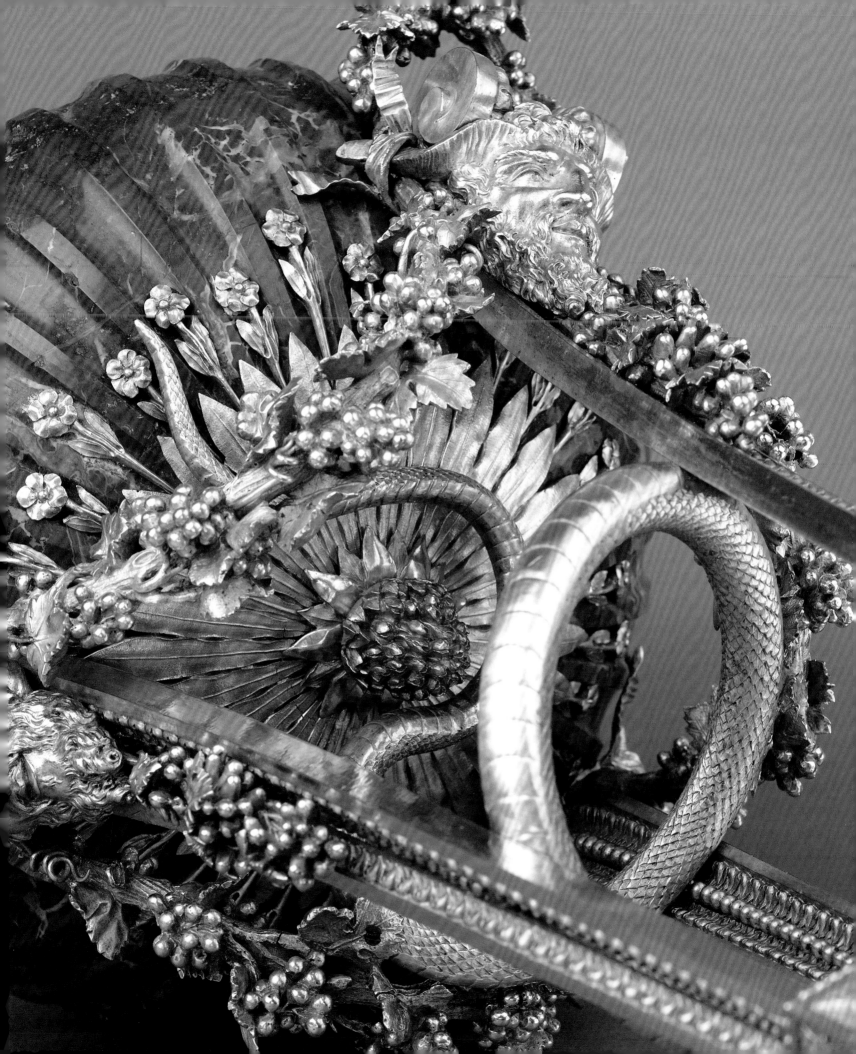

Index

Page numbers in *italics* refer to the illustrations